Photography
from 1839 to today
George Eastman House
Rochester, NY

Front image: Cindy Sherman, (American, b. 1954), *Untitled #85*, 1981,
Museum Purchase, L.A.W. Fund
Spine image: Imogen Cunningham, (American, 1883–1976), *Magnolia Blossom*, 1925,
Museum purchase
Back image: Lewis Wickes Hine, (American, 1874–1940), *Power House Mechanic*, 1920,
Gift of Photo League, New York, ex-collection Lewis Hickes Hine

Editors:
Therese Mulligan and David Wooters
Authors:
William S. Johnson, Mark Rice, Carla Williams
Editorial Coordination:
Therese Mulligan, David Wooters, and Amy Winward,
George Eastman House
Ann H. Stevens, East River Editorial
Image Reproduction:
Barbara Puorro Galasso, Head of Photographic Services,
George Eastman House

Editing and Layout: Simone Philippi, Cologne
Editorial Coordination: Gimlet & Partner, Cologne
Production: Martina Ciborowius, Cologne

Printed in Italy by Graphicom srl
ISBN 3–8228–7073–0

Photography
from 1839 to today
George Eastman House
Rochester, NY

TASCHEN

KÖLN LONDON MADRID NEW YORK PARIS TOKYO

Contents

Foreword

This is a book that leads toward investigation. Heuristic rather than definitive, it proposes possible ways of approaching the George Eastman House collection for pleasure or scholarship, providing just one structure and arrangement out of many that are possible. This book, presented in the museum's 50th anniversary year, is an invitation for discovery, as discovery is vital to the museum's mission.

Therese Mulligan, curator of photography, has led the process of selecting and interpreting the images. The categories she has used to group the images, while comprehensive in spirit, make propositions about the collection without defining it. Informed by scholarship, wisdom, and the strengths of the collection, Ms. Mulligan's choice of images and her essay are intellectually and emotionally satisfying *because* they are contingent and personal. And while each of the pictures may be considered to be a representation of the collection as a whole, the selection is in no way proportionate to the sum of the collection.

David Wooters, the photo archivist for nearly two decades, often speaks of the invitation to discovery the collection offers its visitors. In this way the collection is a lure that summons the joy of interpretation, and this book extends a special invitation to that educational process. Mr. Wooters' essay suggests the pleasures of looking, and looking repeatedly, viewing a selection of images in such a way that a history is reflected as it was created – with purpose and at random, always with surprise.

A close reading of the text with reflection upon the images points to the very human narrative of how this collection was developed, assembled through a series of contingencies and opportunities, through both chance and plan. The result of collecting over the past 50 years is a body of work that stands for quality not only because of its aesthetic or educational value, but also because of its diversity. Its value ascribed through breadth as well as depth, social content as well as cultural

invention, the George Eastman House photography collection derives
special interest and influence. Great collections, it seems, are not
formed by following the rules, but by being open to discovery.

On behalf of the Board of Trustees, I wish to acknowledge and thank
the entire staff of George Eastman House for their constant contribu-
tions and to say that it is our pleasure to present through Benedikt
Taschen the treasures and pleasures of George Eastman House.

ANTHONY BANNON
Director

The photography collection at George Eastman House is justly world famous, unrivaled in both its scope and depth. Its strength is magnified by its place among the other great image-related collections at the museum: motion pictures, technology, and library. The restored home and gardens of George Eastman, who made photography accessible to the general public, complete the collections that *are* the museum.

From the beginning, the Museum's strength has been rooted in its foundation of multiple collections of international artifacts. The seminal Gabriel Cromer collection set the tone, quality, and diversity of the institution. Rare and often unique camera apparatus, pamphlets, and books, as well as hundreds of the finest early European daguerreotypes and prints were acquired from other collections and became the basis for this interrelated research facility. All four of the collections related to photography have excellent representations of American artifacts, including magazines, movies, photographs, and equipment, many from the earliest times that the medium was practiced in this country.

In 1950 the Dryden Theatre was added to the complex to allow the growing number of motion pictures in its collection to be shared with the public. The motion picture collection's silent film collection is unsurpassed. Other highlights include all the surviving films of Greta Garbo and Louise Brooks, a large holding of German Weimar cinema, and the MGM Studio collection, including their Technicolor negatives. The private collection of director Martin Scorsese, which includes hundreds of fiction features from post-World War II American art cinema is another important acquisition. Like the other collections, motion pictures is aggressively seeking both rare and contemporary items to add to its archive.

The photographic technology collection is one of the largest in the world. It embraces all aspects of photographic and cinematographic equipment and accessories. The oldest item in this collection is an 18th-

century camera obscura. The world's first commercially manufactured camera, the famous Giroux, is also here. This pristine artifact is said to have been made for Daguerre himself and bears the photographer's signature across the manufacturer's label. The Bemis daguerreotype camera and outfit from Boston, built in 1840, is preserved here, complete with its bill of sale. The Edison Kinetoscope from 1894, a viewer for individuals to watch a three-minute film loop, also resides in the technology collection. The collection includes modern technology as well; selected examples of digital imaging technology have been acquired as gifts from manufacturers.

The Richard and Ronay Menschel Library is the axis where all the collections meet. No other library has the breadth and depth of coverage of all aspects in the history, aesthetics, and technology of photography and cinema combined. Not only is it a collection of artifacts, but it is an informational resource to the general public and scholars alike. Here one can find *Humphrey's Journal*, the first American periodical on photography, among other rare and historical books and periodicals. This collection covers the optical and chemical advances that preceded the invention of photography as well as books by contemporary artists.

Because the collections share interlocking issues, such as history, period styles, changes brought on by evolving camera and projector design, and public taste, the visitor can conduct research across the artificial boundaries of collection management. The idea and representation of the expansive American West or the impetus towards documentary style, for example, can be traced through the period literature, images (both fictional and factual), and the technology that made a particular point of view and way of working possible.

The collections are maintained in a modern facility dedicated to public access. They reach the public through the museum's continuing program of changing exhibitions; shows that travel throughout the country

and the world; educational outreach; viewing, screening, or study rooms for each collection; and two theaters that present film series nearly every day of the week.

Because of the museum's commitment to educate the public and share the wealth of its collections, the conservation and preservation lab and schools were established to train a new generation of specialists. The L. Jeffrey Selznick School of Film Preservation and the Andrew W. Mellon Advanced Residency Program in Photograph Conservation form a vital part of the institution's life.

The collections at George Eastman House could be seen as discreet groups of artifacts, but this would be missing their vital strength as an interwoven whole. Whether used as a resource to explore the world of George Eastman, his enterprises, and the times in which he lived, or to examine the history of motion pictures and photography, the sum of these collections is truly greater than their individual parts.

MARIANNE FULTON
Chief Curator

A Legacy in the Making

The publication of this collection guide marks the 50th anniversary of the opening of George Eastman House in 1949 as a collecting institution. Though it was only the second museum dedicated to photography – Louis Walton Sipley's American Museum of Photography holds the distinction as the first – it was the first to unite photography and technology with its sister art of motion pictures. While this alone secures the museum's place in history, more important, it became a prominent feature in the shifting landscape of American photography, which had yet to be mapped by singular institutional missions, marked by an academic imprint, or recognized by a burgeoning marketplace. The founding of George Eastman House would change all that, irrevocably shaping American photographic practice and thought with a mission devoted to preservation, education, and interpretation.

Given the fitful economy of postwar America, the museum's origin can, in part, be traced to a question of the future use of the home of George Eastman. The founder of Eastman Kodak Company, George Eastman had bequeathed his home and its surrounding twelve acres to the University of Rochester as a residence for its presidents: indeed, he never made a provision for a museum. But the rising costs of its upkeep and the shift of the campus' location led university officials to reconsider maintaining the property. On June 3, 1948, nine men assembled at the offices of Eastman Kodak Company to hold the first meeting of the Board of Trustees of George Eastman House, Inc. Comprised of prominent Rochesterians, including the presidents of the university, Eastman Kodak, and Bausch and Lomb, the board undertook to transform the home of George Eastman into a museum, citing in an incorporated charter an institutional mission to found a "museum of photography and allied pursuits" that would "establish a graphic and continuing history of photography," by teaching "photography by demonstration and exhibition." While the museum's charter was far-reaching in its language,

its impetus was clear and sprung from a deep resolve: to create a memorial to George Eastman, still a primary mandate of the museum's mission today.

At the same June meeting, the trustees named Dr. C. E. K. Mees, the head of Kodak's Research Laboratory, as president of the museum and General Oscar Solbert, a Kodak public relations executive, as its director. In the hands of these two men, the museum and its early mission took shape, with Mees actively involved in aspects of photography and technology, and Solbert involved in those relating to motion pictures. The trustees also appointed the museum's first curator – the photographic historian Beaumont Newhall.

The decision to hire Newhall was not without its twists and turns. He was well known to Kodak executives, in particular Dr. Walter (Nobby) Clark who, in 1939, engaged Newhall to catalogue the Gabriel Cromer collection, which had recently been acquired as part of Kodak's Eastman Historical Photographic Collection (EHPC). Newhall had maintained close contact with Clark, who later played an important advisory role at the new museum, counseling Clark on acquisitions for the EHPC. At this time, Newhall was curating photographic exhibitions at the Museum of Modern Art, where he worked as the librarian, and in 1940, led the initiative to establish that museum's department of photography, the first of its kind in the United States. Yet Newhall was not appointed head of the department; that position went to the photographer Edward Steichen. And although Steichen had once been considered as a candidate for the curatorial position at George Eastman House, it was Newhall who was unanimously chosen. He held the role for ten years, until the death of Gen. Solbert in 1958, at which time he became the museum's second director.

As curator and director during its formative years, Newhall did more than any other person to define the character of George Eastman House

and its mission. His strongly held opinions as to the aesthetic possibilities of photography, clearly iterated in his seminal *History of Photography*, did much to form the newly emerging fields of photographic scholarship and connoisseurship. Although often the subject of dispute and reevaluation, Newhall's modernist teleological approach created a historical framework for photography grounded in institutional authority. In exhibitions, he posited an art history of photography, converting rooms in Eastman's home into monuments of aesthetic interpretation. Similarly, he built a vast collection, richly diverse in its holdings, organized along the lines of master works by master photographers. In these ways, Newhall firmly posited the museum at the center of photographic discourse, formulating its presence as the primary voice of the study of photography both nationally and internationally.

To fill the museum's curatorial ranks, Newhall engaged individuals who not only shared his institutional philosophy and ambitions, but who were also strong forces on the contemporary photographic scene. His wife, Nancy Newhall, a well-respected writer on photography, played a significant role at the museum. In collaboration with her husband, she advocated for contemporary acquisitions, exhibitions, and publications, including those of long-time acquaintances and close friends Ansel Adams, Margaret Bourke-White, Alfred Stieglitz, Paul Strand, and Edward Weston.

In 1953 Beaumont Newhall invited the photographer Minor White to the museum to assist in editing the museum's journal, *Image*. White, editor of the periodical *Aperture*, which he founded in 1952 with support that included the Newhalls, had earlier declined an offer for a curatorial position at the Museum of Modern Art. White moved to Rochester and for twelve years called it home. The first three years were spent at George Eastman House as editor of *Image*, and then, as a curator. He left in 1956 to teach in Rochester Institute of Technology's newly

established photography program. While his tenure at the museum was short-lived, White's influence in curatorial and educational matters was nonetheless profound. It accompanied the period of the 1950s and 1960s, often called the museum's "golden age."

As his initial responsibility White helped shape the pictorial and textual content of *Image* as a journal of the art and science of photography, technology, and motion pictures. An educational arm of the museum, the journal delved into the archives, presenting a history of the media in critical essays and fine art reproductions. It reported on museum exhibitions, research, and collection resources while keeping in touch with current trends in photography occurring beyond the museum's walls through reviews and editorials. For editors Newhall and White, *Image* became a primary vehicle for the museum to present itself and its encompassing activities to a larger national and international audience. Outside of the museum, White continued editing *Aperture*, relocating its production to Rochester. *Image* and *Aperture* constituted the most significant interpretive periodicals of the day, and, as a consequence, reinforced the status of the museum and the city of Rochester as a critical site for photography. This status was enhanced by the exhibitions White curated, as well as those who were drawn to study and work at the museum with Newhall and him.

In thematic exhibitions such as *Camera Consciousness, The Pictorial Image,* and *Lyrical and Accurate,* White united image and word in intellectually designed didactic displays. Ever the educator-philosopher, he realized in his curatorship a public forum for his theoretical views of photography, which he concurrently advanced in *Aperture*. White reveled in the purely rendered photograph that could be "read" in terms of its psychological, metaphorical, or spiritual messages. Like Newhall, White endeavored to release photography from its traditional documentary role in order to champion its aesthetic potential. Such a view, while

certainly not new to the medium, struck a deep chord among many young American photographers who regarded photography as a means of self-expression and exploration. For many, George Eastman House was a training ground as well as a public venue for the most contemporary photographic practices and thought.

In the late 1950s and 1960s the number of staff, interns, and students at the museum grew with photographers, historians, and critics: Peter Bunnell, Walter Chappell, Robert Doty, Harold Jones, and Nathan Lyons. With the departure of White, Chappell and Lyons assumed curatorial and editorial responsibilities, especially as Newhall, then director, turned his attention to administrative and personal publishing demands. It was Lyons who most directly determined the curatorial course of the museum during the 1960s. In exhibitions and publications, he looked to the present and future of photographic practice. But most important, he imagined the institutional realm of the museum, its galleries and collections, as a radical space of investigation and education.

With contemporary acquisitions, Lyons leveled, in part, Newhall's authorial hierarchy of photographic masters. His ground-breaking contemporary surveys and group exhibitions, such as *Photography 63, Photography 64, Toward a Social Landscape,* and *Vision and Expression,* introduced a new generation of photographers who pushed beyond the traditional boundaries of technique and subject, many illuminating the current social and political conflicts in the United States or probing the photograph's role in mass media as a cultural commodity. Lyons' exhibitions were the most provocative and influential of their time, as was his exhibition design. In the 1968 exhibition *Conscience: The Ultimate Weapon,* he conceived, in his words, "a thematic environmental experience" that engaged the audience with both sight and sound. In this exhibition, part performance, part traditional wall display, Lyons merged slides (from 11 projectors) of the political documentary photographs of Ben Fernandez

with synchronized sound to create a consuming multimedia experience. Such exhibitions and their design, now commonplace, were at the time radically new, especially when cast within the traditional halls of a museum. In his curatorial work, Lyons realized that the world of the museum and the world that lay beyond the museum walls were not mutually exclusive, but inextricably bound one to the other in cultural and communicative necessity.

Like Newhall and White, Lyons used his curatorial position to promote his educational aspirations for photography. In 1962, he organized the first meeting of the Society for Photographic Education (SPE), a group of university and college photography educators. Drawing inspiration, in part, from Minor White, whose workshops and classes had served numerous photographers and educational professionals, SPE became a reality due to the coordinating abilities of Lyons, who was its chair. He saw within the educational scope of SPE a mission that fit well with that of the museum. As in all his activities, Lyons sought a direct and deeper reciprocal relationship between educational institutions and photographic practitioners. Under Lyons' direction the educational objectives of SPE would bear fruit in the form of extension programs, symposia, fellowships, and a museum training program at George Eastman House. SPE grew to a position of prominence in the 1960s and 1970s as an acknowledged representative of photography's changing role in the United States, especially the acceptance of the medium within educational institutions.

During the 1970s photography experienced nothing less than an explosion in popular, professional, and institutional awareness in the United States. Museums and galleries dedicated solely to photography were founded, like the influential Light Gallery in New York, whose director, Harold Jones, had been a curator at George Eastman House. Art museums began to establish photographic collections, and universities

and colleges collected photographs for study, display, and as accompaniments to emergent photographic history or applied curriculums. Concurrent with these developments, the market for photography rapidly escalated, leading auction houses to establish departments and seasonal sales devoted to the medium. From its origins, George Eastman House had advanced this future of photography, where the aesthetics and the history of the medium would be prized, critically studied, and practiced.

Now, the museum did not hold this institutional vision alone. Throughout the 1970s and into the 1980s, it expanded and refined its mission of preservation, education, and interpretation. It established a conservation department that in ensuing years assumed a teaching function, enrolling students from around the globe. The museum's internships and fellowships included many individuals who would emerge as many of photographic history's most important scholars.

Lyons left the museum in 1969 to create Visual Studies Workshop, and Newhall left for a teaching position at the University of New Mexico in 1970. Still the museum employed curatorial staff who were not only historians, critics, and writers, but working photographers as well. The photographer-curator, long a mainstay in photographic interpretation, would with this generation reach its apex. Due to the professionalization of the field, the photographer-curator became eclipsed by curators who specialized in the discipline of photographic history.

As active photographers, museum curators, including Thomas Barrow, Robert Fichter, and William Jenkins, sought to maintain the museum's pivotal role as an interpretive site for new trends in contemporary photography. Barrow and Fichter belonged to a loosely knit circle of local colleagues – Betty Hahn, Joan Lyons, Bea Nettles, and John Wood – whose interest in neglected 19th-century photographic processes, which they revived, and new technologies of mass reproduction, such as xerography, which was developed in Rochester, merged photogra-

phy's past and present in a new and experimental approach to picture-making. Broad in scope, their influential work drew on prevailing issues of the time: feminism, autobiography, political conflicts, and the persuasive role of the photograph in mass culture.

Simultaneously, Jenkins, with the assistance of photographer Joe Deal, who had also joined the museum's staff, identified a group of contemporary photographers who carried on the time-honored theme of photographing the American landscape. Jenkins' 1975 exhibition *New Topographics: Photographs of a Man-Altered Landscape,* characterized a dominant movement in photography that addressed the changes in the American landscape due to industry, new technologies, and population migration. Well versed in photography's past and pictorially aligned with its landscape traditions, this influential movement dismantled the myth of the American landscape as a national metaphor of promise and prosperity and put in its place concerns of environmental abuse and suburban sprawl.

In the late 1970s and 1980s the curatorial vitality with which the museum addressed contemporary issues in photography was met with a similar spirit for rediscovering and exploring photography's various histories in past eras – science, popular culture, and journalism. In two major exhibitions, Janet Buerger, curator of 19th-century photography, drew upon the museum's Gabriel Cromer collection to reveal how French practitioners of the daguerreotype and calotype defined the formative years of photography and its future cultural applications. Curators Robert Sobieszek and Marianne Fulton, each following a personal course of investigation, turned their attention to photography's central role in the rise of popular culture and media. In 1989, Sobieszek's *The Art of Persuasion: A History of Advertising Photography,* and Fulton's *Eyes of Time: Photojournalism in America,* pointed to photography's predominance as a cultural vehicle of mass communication, propaganda, and consumerism.

At the close of the 1980s, the museum encountered monumental challenges that would cause a reevaluation of its interpretive pursuits, and most important, its mission. In part, these challenges were a result of broader cultural questions concerning the institutional purpose of museums and the place of photography within them. Among the issues at hand were the museum's interpretive and educational functions, as well as its direct relationship to audiences. For George Eastman House, the question of future interpretation, which sought greater public access to the collections, led to a revitalization, especially in the nature of museum facilities. Like many institutions of the day, the museum faced the financial challenge to preserve its collections for posterity amidst the declining economy of the late 1980s. As they had done in its initial years, Rochester's corporate, civic, and private donors generously supported the museum, resulting in the 1992 inauguration of a new building, adjoining the restored Eastman mansion, to serve as the public site for its library, conservation department, collections, and new galleries.

Over the course of the last 50 years, George Eastman House helped transform photographic thought and practice. Today, the museum and its continuing mission of preservation, interpretation, and education are transformed by the history it helped create. Where once it was one of the few institutions in the world devoted to photography, it now numbers among many. Its early objective to attain for photography a recognized status equal to that achieved by other visual arts, the museum embraces a cultural discourse that addresses how public and private institutions – like itself – have influenced and shaped the aesthetics of the medium and its public reception. Building upon its past, the museum also recognizes that photography's history is no longer singular nor exclusive, but consists of multiple, intertwining histories. Aspects of these histories are revealed not only in the photography collection, but also in the museum's collections of technology, motion pictures, and library, as

well as in two recently established collections – landscape and the George Eastman Archive. It is the sum of these collections – how they inform one another and touch the human experience – that will write the museum's next 50 years of history. For like the medium to which it is dedicated, George Eastman House's legacy is one of continuous invention and transformation.

THERESE MULLIGAN
Curator of Photography and Co-editor

The Blind Man's Elephant

One of the great joys of working in the Eastman House photography collection is never knowing what questions the collection will be asked to answer on any given day. The photograph that only yesterday served as a specimen of albumen printing is today an example of Timothy O'Sullivan's work and tomorrow may be an illustration of wet plate photography or of Manifest Destiny. Photographs are not fixed in meaning, and neither can collections of them be. Rather, they are amorphous things whose shape is dictated by the questions they are asked.

This shape-taking begins early in a collection's life. Collections are formed to answer questions. The question the Eastman House collection answers so well is, "What does the practice of photography look like?" Such a broad question, one that encompasses not only the photograph's physical appearance but also its technical applications and social manifestations, requires an equally broad range of answers. To help formulate these answers, over time Eastman House has acquired a number of disparate collections.

In 1939, ten years before Eastman House opened its doors as a public museum, Eastman Kodak Company purchased the Gabriel Cromer collection. Cromer was a Frenchman who was educated in the law but whose life was immersed in photography. A practicing photographer and a collector, Cromer was highly regarded for his portraiture and known as a master of carbon printing. It is, however, his collection, not his own photography, that has become his legacy.

With a keen interest in and broad knowledge of photographic history, Cromer amassed nearly 6,000 photographs, a substantial library of photographic books, and a collection of apparatus that filled the rooms of his home outside Paris. With 19th-century French photography as the body and soul of Cromer's collection, its heart is Louis-Jacques-Mandé Daguerre. Creating a veritable shrine to the man, Cromer gathered portraits of Daguerre, his drawings, paintings, diorama-related material,

personal ephemera, a daguerreotype signed by Daguerre, and a Giroux camera Cromer believed had belonged to Daguerre. These objects were, it seems, as much relics for Cromer as they were artifacts. Five hundred daguerreotypes, nearly all French, completed Cromer's homage to Daguerre.

Early French paper photography is also well represented in Cromer's collection and includes Baldus' photographic albums, Le Gray's seascapes, and Le Secq's paper negatives, while later photographers such as Disdéri, Adolphe Braun, and Delmaet and Durandelle represent the course of photography through the 19th century.

Cromer's enthusiasm for photography is evident in the breadth of his collection. Cartoons and cameras are as much a part of his collection as photographic prints. Crossing the boundaries between images and apparatus with ease, and collecting pre-photographic engravings along with photomechanical specimens, only one boundary seemed to confine Cromer's interest, the border of his own country.

The French photo-historian, Georges Potoninée, prefaced his 1924 *History of the Discovery of Photography* with the bold statement, "The history of photography is essentially French." The bulk of Cromer's collection supports this rather nationalistic claim, providing excellent examples of the practice of photography in France. Though there are notable exceptions, for the most part Cromer did not focus on photographic activity outside of his own country.

Cromer's dream that his collection would become the cornerstone of a national museum of photography faded with his death in 1934 and the growing threat of war. His widow, unable to find a suitable offer for the collection in France, sought other options. An Eastman Kodak Company scientist, Dr. Walter Clark, who had established the Kodak Research Laboratories at Harrow, England, before coming to the United States, took a great interest in Cromer's collection. With his prompting, Eastman

Kodak Company purchased for $13,000 what would become the foundation of the George Eastman House photography collection.

Though Cromer's collection was the largest and most notable acquisition for Kodak's Eastman Historical Photographic Collection, it was not the first. Early in the century the company had begun collecting examples of photographic apparatus, both of their own and others' manufacture. To this they added, in 1920, a number of items belonging to the Austrian photographic scientist and historian Josef Maria Eder. Eder's many contributions to improving the sensitivity of photographic materials, his prolific writing, and his monumental *History of Photography* (1905) made him a world-renowned figure in photography. In the course of his work he had gathered many specimens of photographic and photomechanical processes. From this material Eastman Kodak Company purchased a selection of predominantly photomechanical prints. To these two collections the Cromer collection was added.

Kodak continued to collect: Samples of color photography, Hill and Adamson salt prints, early Kodak snapshots, and Crimean War photographs by Roger Fenton all found a place in their collection. The Eastman Historical Photographic Collection was thus able to present, according to *The New York Times*, a "reasonably comprehensive history of photography from the days of Daguerre to the present time" when 300 items from it were exhibited at the New York Museum of Science and Industry in Rockefeller Center in 1940. The entire collection was transferred to Eastman House in 1948.

This broad approach to collecting continued for more than 20 years under the direction of Beaumont Newhall, the museum's first curator and later director. Dozens of important acquisitions were made during Newhall's tenure. American daguerreotypes from a California high school teacher, Zelda Mackay; 5,000 stereos from collector Fred Lightfoot; Civil War photographs from Philip Medicus; Eadweard Muybridge's

Animal Locomotion studies; 500 photographs by Atget; nearly 10,000 photographs by Lewis Hine; and collections of work by Newhall's friends and colleagues, Ansel Adams, Alvin Langdon Coburn, László Moholy-Nagy, Charles Sheeler, Alfred Stieglitz, and Edward Weston.

With these collections, a solid foundation for the study of photography was being laid. Newhall's name will always be associated with the textbook history that introduced a generation of students to the history of photography. In the 1964 edition of his *History of Photography*, Newhall also introduced that generation to the Eastman House collection, with half of his nearly 200 illustrations coming from the museum. This stands in sharp contrast to both the earlier and later editions of the same history in which less than 15 percent of the illustrations are drawn from the museum's collection. Today, with the large number of photograph collections available to historians and the broader view of what constitutes photographic history, it is unlikely that any single photograph collection will ever again be so closely identified with the history of photography as the Eastman House collection was during that time.

The history Newhall wrote and the collection he curated became interwoven in many instances. However, his collecting had a much broader range than his *History*, which focused on photography as one of the visual arts. This will not surprise anyone who remembers that Newhall also authored *The Daguerreotype in America* (1961) and *The Airborne Camera* (1969), as well as a variety of articles in the museum's own *Image* magazine, revealing his broad understanding of the practice of photography. Consequently, in addition to acquiring work by photographers such as Stieglitz and Weston, Newhall also acquired work that would never find its way into his *History* – early color screen plate processes, salon photographs, and commercial photography. Advertising photography, omitted from Newhall's *History*, is well represented at Eastman House with sizable collections acquired during Newhall's

tenure, with work by two of New York's most successful commercial photographers, Victor Keppler and Nickolas Muray.

Newhall's willingness to acquire and preserve such a broad range of photographic practice that did not fit the scope of his own *History* has served today's historians well. Much of this material is now being used in the writing of new histories, histories that expand the narrative of photography to include such previously overlooked practices as advertising photography or camera club pictorialism. Ironically, while today's historians construct their histories, pointedly aware of Newhall's omissions, many often overlook the fact that the very material they are studying was acquired for Eastman House by Beaumont Newhall. This is one of the challenges and pleasures of a public collection: to be open to many interpretations, and to preserve not only the icons of a chosen history, but the contradictions as well.

Such an open approach to the practice of photography is best seen in one of the largest collections to come to the museum during Newhall's years, the collection of Alden Scott Boyer. Stories of Boyer are the stuff of legend. A wealthy perfume manufacturer living in Chicago, Boyer housed his diverse collections in what had been an old bank building. Here he spent his days among his slot machines, high-wheeled bicycles, and photographic books, images, and apparatus. Though the extent of his interest in slot machines and bicycles is not known to us, Boyer's love of photography is evident in his collecting and the enthusiastic notes that mark his books. In his own copy of Newhall's *History* he enthused over images with his green pen. "Jesus!" "Get this!" And, for the most part, Boyer did "get this," and that, and more.

Boyer's collection of more than 13,500 photographs as well as a rich photographic library and equipment collection came to Eastman House after a very brief negotiation in which Boyer asked Newhall if he wanted to buy the collection or receive it as a gift. When Newhall answered

that he wanted it as a gift, Boyer responded, "That's what I like, plain talk. When are you coming out to pack up?" Boyer's collection, a semi-trailer full of photographs, books, and apparatus was delivered to Rochester and registered as part of the Eastman House collection on April 27, 1951.

The Boyer collection is as intriguing as its creator. The familiar names of Blanquart-Evrard, Julia Margaret Cameron, Maxime DuCamp, P. H. Emerson, Roger Fenton, Francis Frith, H. P. Robinson, and Boyer's beloved Hill and Adamson are well represented, while his 1,000 daguerreotypes by Southworth and Hawes and 260 paper negatives by the Irish photographer John Shaw Smith constitute an embarrassment of riches.

Though these names are almost recitations from Newhall's canon, Boyer did not shape his collection to fit Newhall's history. He threw a wider net around photography, including Fischer & Brothers' early American views of the U. S. Naval Academy, an 1863 Harvard Yearbook, and a small album titled *The Story of a Sunkist Orange*. Boyer embraced 19th-century photographic practice in a more international way than Cromer had. But as broad as Boyer's interests were, he had little concern for 20th-century photography. Acquisitions in this area would be made by Newhall and many other curators at Eastman House.

Straying from Newhall's historical path by collecting with an eclectic and open attitude towards photography has always been more the norm than the exception at Eastman House. This was epitomized by the acquisition of the Sipley/3M collection. Louis Walton Sipley operated his American Museum of Photography from 1940 until his death in 1968. Though Sipley had a boyhood interest in photography and, as an adult, a professional interest in images, he literally stumbled across the photographic history that grew to become his museum.

As part of the visual education movement that gained momentum in

the 1920s, Sipley produced filmstrips for schools and universities. In 1930, in order to acquire images for these educational projects, Sipley purchased one of America's oldest photographic businesses, the Caspar W. Briggs Company. In addition to 10,000 stock negatives of religious and historical illustrations, Sipley found himself with the remnants of what had been America's largest lantern slide manufacturer, and consequently, with a growing interest in photographic history.

Just as Cromer's collection focused on France, Sipley's museum concentrated on American photography, with Philadelphia, the location of Sipley's museum, taking pride of place. Here, beyond the pages of any photographic history yet written, was the work of George Schreiber and Sons, commercial photographers specializing in animal photography; Samuel Fisher Corlies, member of the Photographic Society of Philadelphia; Elias Goldensky, the Russian immigrant who became Philadelphia's pictorialist portrait photographer; as well as examples of the short-lived lenticular stereo "VitaVision," thousands of lantern slides, and a substantial collection of 20th-century photomechanical specimens.

The story of Sipley's collection after his death is strikingly similar to that of Gabriel Cromer's collection. Sipley's widow, like Cromer's, was unsuccessful in her attempts to find a home for the collection. And Sipley's collection, like Cromer's, was then purchased by a large American corporation – in this case, 3M – to add to their historical collections. After plans for a museum of their own were abandoned, in 1977 3M gave Sipley's collection to Eastman House.

The size of the collection was staggering – 61,000 photographs and photomechanical reproductions, the majority falling outside the scope of traditional photographic history. Of course, Sipley's collection was not outside the scope of his own history, *A Half Century of Color Photography* (1951). It is here that Frederic Ives, Lejaren à Hiller, Anton Bruehl, and Fernand Bourges are all prominently mentioned. And while pieces

by Robert Cornelius, F. Holland Day, William Henry Jackson, Gertrude Käsebier, and William and Frederick Langenheim were among Sipley's holdings, it is the work of William Jennings, Schreiber and Sons, and Henry Troth that more accurately characterize the collection.

The museum's interest in the many forms photography can take has not waned since the acquisition of the Sipley/3M collection. In 1979, at the bequest of Joanna Steichen, Eastman House received more than 3,000 photographs by Edward Steichen, predominantly portraits of celebrities from his *Vanity Fair* years. Other smaller, but equally notable, gifts have come from The Associated Press and the American Society of Magazine Photographers. More recently, Donald Weber has given the museum his collection of daguerreotypes, ambrotypes, and tintypes and has expanded its holdings of stereo photography with his substantial collection of Viewmaster views.

The breadth of the Eastman House photo collection is only suggested in this publication, and in several instances the depth of particular holdings is noted to give the reader a better guide to the collection. Still, this is only a glimpse. For every photograph illustrated here, more than 500 are not. Even with the 743 illustrations contained within this volume, describing the Eastman House photo collection is still very much like the story of the five blind men, each trying to describe an elephant. Whichever part of the elephant each man bumped into, whether it was a leg, an ear, or the trunk, that part became his understanding of the elephant. Each was both right and wrong in his interpretation. And so it will always be with any description of the Eastman House collection.

It may be easier to understand this collection by first looking at its purpose rather than its photographs. Purpose is what gives a collection its character, its shape. Because Cromer, Boyer, and Sipley all differed in purpose, their collections differ in content. So too, the museum's purpose shapes its collection. This shaping is more than metaphorical.

The physical shape the collection is given, its acquisitions and arrangement, grows out of the collection's purpose.

The primary purpose of this collection – to preserve examples of what the practice of photography looks like – is quite different from simply being a picture collection with drawers of photographs arranged by subject. Illustrating subject matter is not the primary concern. If it were, the collection would be something very different. The museum has focused more on the how and the why and the who of photography. Attention to subject matter in photographs grows out of those interests. That the museum has photographs of what is now Yellowstone National Park is of less consequence than knowing that these photographs were made by William Henry Jackson for a U.S. government survey, and that Jackson's photographs were part of the visual evidence submitted to Congress during its debate over whether to designate Yellowstone a national park. With that knowledge, one's attention is then particularly drawn to an albumen print (page 208) that shows Jackson's negative was retouched, changing a daytime scene into a starry night and making Yellowstone appear as strange and otherworldly as popular written accounts described it.

This fascination with the practice of photography grows out of viewing photographs not simply as transcriptions of the world, but as the products of an interaction between the world, the photographic medium, the photographer, and even the audience. To see photographs only as windows onto the world and to miss their richer story would be a disservice to the collection. It is this outlook that guides the collection, that distinguishes Eastman House as a photography museum and not a stock photo agency.

For the picture researcher interested in using the collection, cataloging records provide access to the subject matter in photographs. Subject headings are assigned so researchers looking for photographs

of airplanes, for example, can know if the collection holds any. Ironically, this type of access requires that photographs be narrowly defined, which actually limits their possibilities. Placing images into pigeonholes using words can have a greater influence on the photograph's use than the image itself, as they end up being perceived as nothing more than a collection of nouns – boats, cats, dogs, and trains – rather than a collection of photographs.

This is unfortunate because photographs are about more than their nominal subjects, richer and deeper in meaning than simple nouns can ever capture. Personal associations, nuances of presentation, or the idiosyncrasies of a photographer's vision create a world of possibilities within each frame. Photographs are, indeed, more like oracles than inventories, as much about what is implied as what is delineated. This is what keeps them alive, what makes a collection part of the present, not merely a record of the past.

Like in a tightly woven tapestry, there is always something to discover in a photograph if one is willing to look. Photographs are full of promise, but they are at the viewer's mercy. Viewed without insight, they become dull. If the viewer is mired in old histories, so are they. Photographs and photographic collections challenge us to ask better questions and to look at old pictures in new ways. By doing so, we are rewarded with new understandings of ourselves, our world, and the transformative power of photography.

DAVID WOOTERS
Photo Archivist and Co-editor

Acknowledgements

We are greatly indebted to those individuals who generously gave their talent, time, and energy to this publication. In particular, we gratefully acknowledge the photography collection staff, whose unflagging commitment and good humor saw this complex project through to its successful realization. We cannot sufficiently thank these staff members for their professional assistance and abiding friendship: Amelia Hugill-Fontanel, curatorial assistant; Del Zogg, senior cataloguer; Janice Madhu, assistant archivist and manager of rights and reproduction; and Joseph Struble, assistant archivist. We offer special thanks to Barbara Puorro Galasso, head of the museum's photographic services department , for her expertise in creating the reproductions for this publication.

Our deep appreciation goes to William S. Johnson, Mark Rice, and Carla Williams, who authored this publication. With consummate skill and collegiality, they met the many challenges required, not the least of which were editorial demands and looming deadlines. Their scholarship and dedication led to new research and fresh insights. For their contributions we are truly grateful.

We would also like to extend our thanks to this publication's editor, Ann Stevens. She brought to the project both a critical eye for exacting detail and an understanding of its subject. We are deeply appreciative of her skillful work and guidance.

During the book's preparation, professional colleagues offered important assistance and advice. We wish to express our gratitude to Grant Romer, director of the museum's conservation department; Amy Winward, art director; and photographic historians Thomas Barrow, Eugenia Parry, Larry Schaaf, and Roger Taylor.

The support of the museum's Publication Trust and the German publisher Taschen together allowed this book to become a reality. We especially thank Taschen's Simone Philippi and Susanne Uppenbrock

for their invaluable assistance and collegial spirit throughout the book's production.

Finally, we wish to recognize the generous encouragement of our families. We are particularly thankful to Charlie Wooters for his insights and his weekends, and Jack and Margaret Mulligan for their constant and enduring support.

THERESE MULLIGAN and DAVID WOOTERS

About This Publication

The George Eastman House's photography collection holds 400,000 artifacts. While no one volume can adequately address a collection of such enormity and diversity, it is the goal of this publication to provide a survey of the scope and depth of the photography collection for a varied audience. Organized thematically and chronologically, images, both familiar and unknown, offer a view into the collection, with its multitude of subjects, genres, and processes. These images reveal the boundless story of photography and its history, from its pre-photographic origins, to its present-day cultural, aesthetic, and personal manifestations. The accompanying text relates aspects of this story, while furnishing information about the depicted work and/or its maker.

In many instances, the text provides information pertaining to particular collection holdings, including their number and subject. Where appropriate, the library, technology, and motion picture collections are noted within the text as being the repositories of depicted work and associative materials.

Each image in this publication is accompanied by a caption that indicates maker (when known), nationality, life dates, title, date, process, source, and the museum's accession number for reference. Often works shown here were given no title by their maker. In such cases, a descriptive title is given in italics.

Due to the limitations of space, the original sources – albums, books, and portfolios – do not appear in the caption. These sources, as well as other important information about particular holdings in the photography collection, are available through the museum's on-line catalogue. This database can be accessed via the museum's World Wide Web address at: www.eastman.org. The photography collection staff can be contacted by writing to: Photography Collection, George Eastman House, 900 East Avenue, Rochester, New York, 14607, U.S.A.; or by telephone at: (716) 271-3361.

The Photographs

All Things under the Sun

In 1839 the invention of two distinct photographic processes, the da-
guerreotype by Louis-Jacques-Mandé Daguerre and the negative/positive
process by William Henry Fox Talbot, were almost simultaneously an-
nounced in France and England. Daguerre's process produced a one-
of-a-kind, highly detailed image on a silver-coated copper plate, while
Talbot's was a paper-based negative/positive process that could produce
multiple prints from a single negative. Both are based in two fundamen-
tal principles of chemistry and physics: the reaction of particular chemi-
cal compounds to light, and the creation of an image when light passes
through an aperture in a dark room or box. The light sensitivity of certain
chemicals had been experimented with as early as 1727 by the German
natural philosopher Johann Heinrich Schulze. Experimentation with opti-
cal principles can be dated back to the 4th century BC and the writings of
Aristotle. Long before the invention of photography, artists utilized the
"camera obscura," a Latin phrase meaning dark room, as a drafting aid.
Light entering a dark box or room through a small hole is reflected on the
opposite side as an upside-down, backward image of the scene outside.
Its orientation is corrected with a mirror. An engraving from an article in
Denis Diderot's *L'Encyclopédie* (ca. 1751) (right) identifies a variety of
camera obscuras and illustrates their functions.

Unidentified artist
French?,
active ca. 1800

The Miraculous
Mirror, ca. 1800

Engraving
72:0079:0088

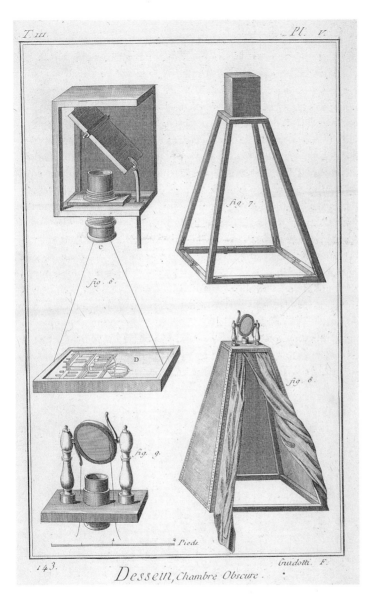

T. III. Pl. V.

fig. 7.

c

fig. 6.

D

fig. 8.

fig. 9.

1 2 Pieds.

143. Guidotti. F.

Dessein, Chambre Obscure.

F. Guidott
French, active 1700s

Dessein, chambre
obscure (Drawing of
a Camera Obscura),
ca. 1751

Engraving
MUSEUM PURCHASE
84:0962:0002

Applying another basic optical principle of shadow and form, the silhouette portrait, named for the French government official and amateur profile maker Étienne de Silhouette, became popular in the late 18th century as a growing middle class began to clamor for more affordable – and reproducible – likenesses of themselves. To create a silhouette, a light source is placed in front of a subject, and the outline of their profile is traced onto a paper placed behind them, as demonstrated in this 1874 engraving, "Professor Charles' Experiment."

Taking silhouette art a step further, Gilles-Louis Chrétien invented the physionotrace drawing in 1786. To create the physionotrace, "the sitter's profile was traced through a movable sight connected by levers to a stylus that recorded on a reduced scale its every movement in ink on a copper plate, which was then engraved." In 1807 English scientist William Hyde Wollaston designed the camera lucida, a clear prism suspended on a brass rod at eye level over drawing paper. "Looking through a peephole centered over the edge of the prism, the operator saw at the same time both subject and drawing paper" and traced the reflected image, with all of its shading and nuance, onto the paper. But all of these methods still involved the hand of man, and inevitably, some drafting skills were required. The invention of photography would ultimately unite chemistry and optics, permitting the light itself to draw the image, and creating a new artistic medium.

Unidentified artist
French?,
active 1870s

Professor Charles'
Experiment, ca. 1874

Engraving
GIFT OF EASTMAN
KODAK COMPANY,
EX-COLLECTION
GABRIEL CROMER
72:0079:0089

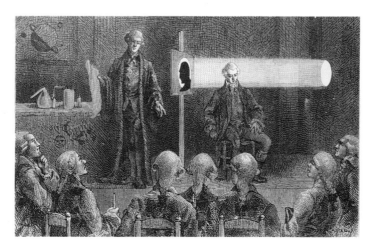

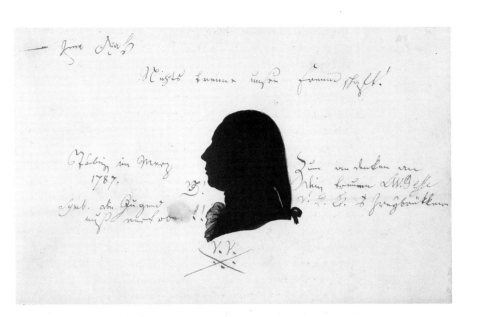

J. H. Schwartz
German,
active ca. 1787

*Silhouette Portrait of
a Man*, ca. 1787

Silhouette
83:1610:0020

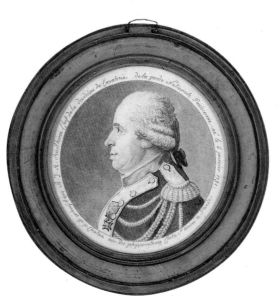

Jean Fouquet
French,
active ca. 1790

A. J. A. Ruihiere chef de la division de cavalerie
de la garde nationale parisienne né l [sic] 6 jan-
vier 1731. Dess. P. Fouquet. Gr. P. Chrétien inv.
du physionotrace cloître 3D honoré à Paris
(A. J. A. Ruihiere Leader of the Cavalry Division
of the National Guard of Paris. Born January 6,
1731. Drawing by Fouquet. Engraving by
Chrétien, Inventor of the Enclosed Physio-
notrace 3D. Honored in Paris), ca. 1790

Physionotrace engraving
72:0079:0074

Daguerre and the Daguerreotype

Louis-Jacques-Mandé Daguerre was apprenticed to an architect at age 13 after showing an early talent for drawing. Following a brief career as a revenue officer, he became a set designer and painter. This small pencil drawing, the "Promenade dans les pins," is an example of Daguerre's early, pre-photographic imagery of which the Eastman House holds 13 drawings and paintings. From 1822 until 1850, in partnership with Charles Marie Bouton (1781–1853), he ran the highly successful Dioramas in Paris and London. The Dioramas were exhibitions of pictorial views with various effects induced by changes in lighting. About 60 of Bouton's drawings and five watercolors are in the Eastman House collection. Daguerre also painted the illusionistic canvases used in the displays with the aid of the camera obscura, and his involvement with the Diorama's optical illusions soon led to photographic experimentation.

In 1829 he entered into a partnership with Joseph Nicéphore Niépce (1765–1833), who is credited with making the first permanent photograph, or "heliograph," of rooftops from his window around 1826 or 1827. Daguerre experimented for over a decade with Niépce and his son, Isidore, and in January 1839 the French Academy of Science published an announcement of the invention of the daguerreotype process. The French government purchased the formula for the public's use, and while both Isidore and Daguerre received lifetime government pensions, it was Daguerre's name that became associated with the invention. In August the Academy of Science publicly disclosed the instructions for making daguerreotypes in a joint meeting with the Academy of Fine Arts. "Daguerreotypemania" swept through Europe, and the daguerreotype became the premier method of making photographs around the world.

Daguerre was made an officer of the Legion of Honour; his Order of Merit rosette is preserved in the Eastman House collection. It is somewhat ironic that Daguerre, one of the inventors of photography, frequently declined to have his portrait made. The Eastman House contains an early photographic portrait of Daguerre, an 1844 daguerreotype by Jean-Baptiste Sabatier-Blot. Daguerre appears anxious to have the entire ordeal over with, yet Sabatier-Blot

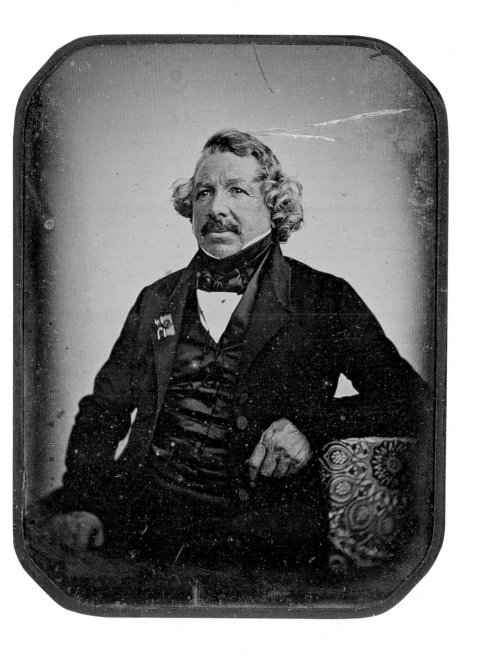

captured an agreeable likeness of him, appropriately using his own invention to immortalize him.

From 1820 until 1833, while still experimenting with photography, Daguerre made ten lithographs that illustrate Baron Isidore-Justin-Séverin Taylor's *Voyages pittoresques et romantiques dans l'ancienne France.* All of Daguerre's illustrations, including this 1820 lithograph of the Ruines de l'Abbaye de Jumièges on the Côte du Nord in Brittany, are preserved in the museum's collection. Taylor's multivolume publication included more than 3,000 lithographs illustrating notable medieval monuments in nine French provinces. Daguerre's atmospheric rendering of clouds and ruins against a threatening sky evokes the drama of his Diorama work. It is, however, photography and the portrait for which Daguerre is best remembered. Although the first portrait daguerreotypes in 1839 required exposure times of 15 to 20 minutes in bright sunlight, improvements in the chemistry had reduced sitting times to a more manageable few seconds by the time Daguerre made his "Portrait of an Artist." This is one of only three extant portraits by Daguerre and the only one in an American collection. The artist, possibly Charles Arrowsmith or Hippolyte Sebron, poses against a landscape backdrop that Daguerre probably painted. Sporting an artist's smock and holding a palette and brushes, he embodies the Romantic ideal of the artist, his faraway glance connoting an artist's vision.

In addition to its large collection of materials by and relating to Daguerre, Eastman House holds approximately 500 French daguerreotypes. This rivals that of the Cabinet des Estampes in the Bibliothèque Nationale, the largest collection in Paris. Among the finest examples of the medium at Eastman House is a portrait of a young girl by Sabatier-Blot (page

Jean Baptiste
Sabatier-Blot
French, 1801–1881

*Portrait of a Young
Girl (Sabatier-Blot's
Daughter?)*, 1852

Daguerreotype
GIFT OF EASTMAN
KODAK COMPANY,
EX-COLLECTION
GABRIEL CROMER
76:0168:0022

44). A dozen Sabatier-Blot portraits in the collection are of the artist's wife and child and are exquisitely intimate, relaxed family portraits. The choice of a round format in which to frame the sweet-faced child, who is clearly at ease in front of the camera, focuses attention on her large round eyes and intense gaze. In a similar use of a framing device, the oval shape of a dual portrait by Legendre of a seated woman and standing boy holding a horn emphasizes the interaction between the sitters and eliminates the distraction of blank space behind them. It also mimics the shape of their open, oval faces, which clearly reveal that they

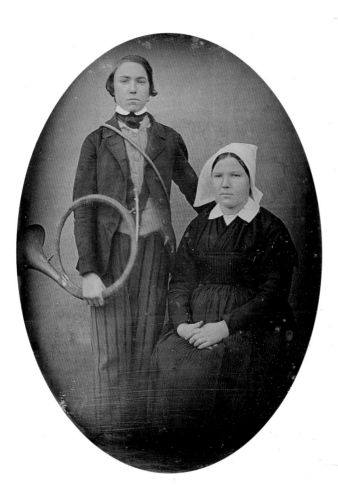

Legendre
French,
active ca. 1850s

*Portrait of Boy
and Woman*, 1853

Daguerreotype
GIFT OF EASTMAN
KODAK COMPANY,
EX-COLLECTION
GABRIEL CROMER
76:0168:0009

regarded the daguerreotype sitting as a solemn occasion. The modesty of their dress further supports the notion that the luxury of having their likenesses made was not something to be taken for granted.

Although portraiture became the daguerreotype's most popular application once exposure times were shortened, other genres were successfully explored using the young medium. Louis Jules Duboscq-Soleil constructed his "Still Life with Skull" (page 46), a photographic memento mori using the traditional iconography of a skull and hourglass as sobering reminders of human mortality. The addition of a crucifix connotes a

Louis Jules Duboscq-Soleil
French, 1817–1886

Still Life with Skull, ca. 1850

Daguerreotype
GIFT OF EASTMAN
KODAK COMPANY,
EX-COLLECTION
GABRIEL CROMER
70:0001:0187

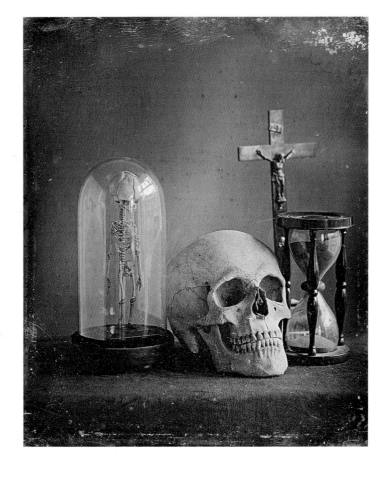

decidedly Christian theme, while the tiny skeleton in a glass vitrine refer-
ences the natural sciences that were highly popular in the mid-19th cen-
tury, presaging the debate between creation and evolution. In stark con-
trast, this sumptuous nude study of a woman reclining on a lace-draped
divan is both a celebration of the fleshy pleasures of life and a study of
form and shape. Artists in other media such as painting and sculpture
used such photographic images as aids in modeling the female figure.

Occasionally daguerreotypes were more explicit in exploring the fe-
male body. Imagine this immodestly draped – if somewhat bored-look-
ing – nude model (page 49) brought to life when viewed through a

Unidentified photographer
French?,
active ca. 1840s

Odalisque, ca. 1840s

Daguerreotype
70:0001:0184

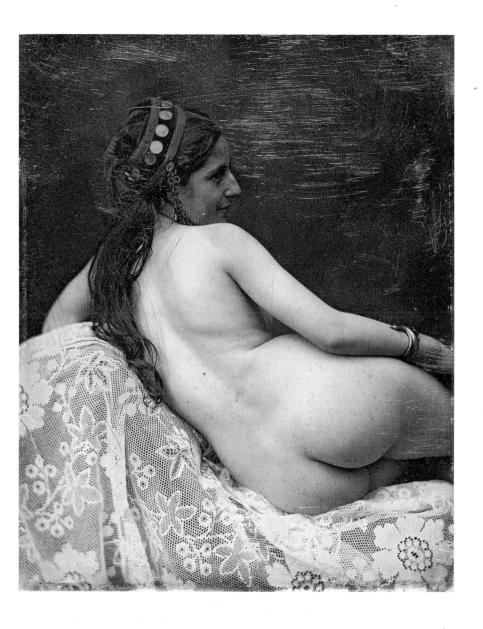

stereograph viewer, her flesh highlighted with handcoloring to achieve a closer approximation of her natural complexion.

Popularized in the early 1850s, the stereograph was composed of two nearly identical photographs made from slightly different angles to approximate binary vision. When seen together through a viewer that superimposed the two, the photograph appears in vivid three-dimension. A more modest example, by Louchet, of a woman in exotic costume provides its salacious appeal through the vaguely ethnic drapery and accoutrements surrounding the model. The dangerously bared shoulder was acceptable in a non-European guise (even though the model was likely European), and provided ample provocation for a genteel but curious 19th-century consumer. The female form was not the only focus of the photographer's lens. Antoine Claudet's portrait of his bare-chested, muscular son Francis George Claudet shows him nude to the waist and posed holding a pulley rope. As much a study of flexed musculature as a kind of occupational, if fictional, portrait of a laborer, this image is one-half of a stereograph and was thus also intended for close-up, intimate viewing.

At least as seductive as the exploration of the human form was the ability to record in vivid detail a cityscape that had previously been interpreted only through the painter's brush or draftsman's pencil. The engraver Friedrich von Martens' view of Paris is a panoramic daguerreotype achieved by using a special panoramic camera that von Martens

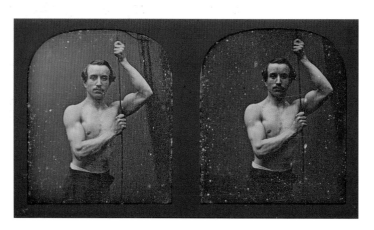

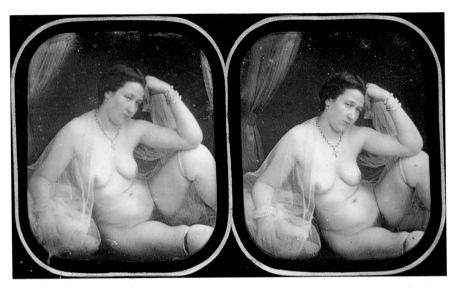

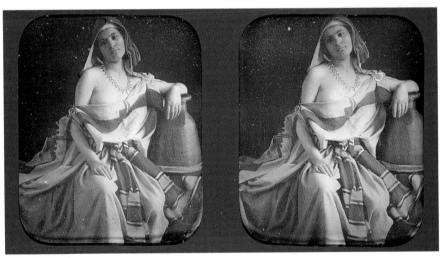

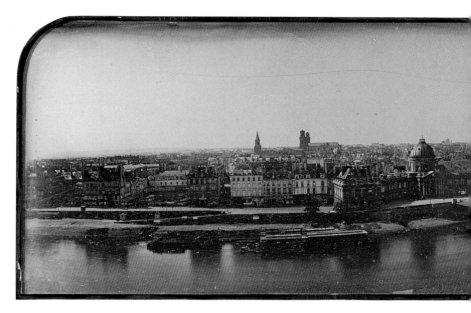

Nöel-Marie-Paymal Lerebours
French, 1807–1873

Russia. Saint Basil's Church at Moscow, 1842

Engraving from daguerreotype
GIFT OF ALDEN SCOTT BOYER
LIBRARY COLLECTION

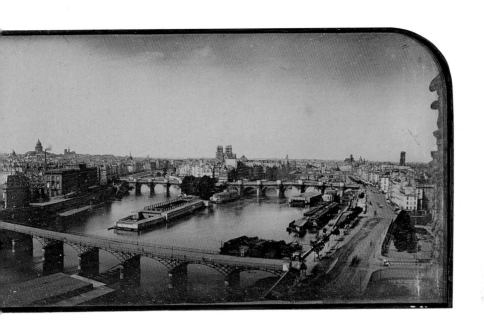

created himself it could capture a broad vista on a single daguerreotype plate. In order to make this exposure, von Martens positioned his camera atop one of the Louvre Museum pavilions. In vivid detail the cityscape is laid out before the viewer, with a delicate precision. Easily recognizable in the distance on the right are the Pont Neuf and cathedral of Notre Dame encased in scaffolding. The veracity of the photographic image locates every landmark in accurate relation to the next. Equally compelling was the ability of travelers to record views previously accessible only through the written word. Because daguerreotypes were one of a kind, this view of Saint Basil's Church at Moscow, Russia, was made into an engraving and published in Lerebours' book *Excursions Daguerriennes,* an early photographic travelogue of engravings made after daguerreotypes of many faraway, "exotic" locales.

Cromer's Amateur is an unidentified daguerreotypist, named after collector Gabriel Cromer. The Eastman House collection contains around 100 daguerreotype plates made between 1845 and 1851 by this extraordinarily talented, albeit unknown, amateur photographer. Taken as a whole, the collection provides a rare, personal glimpse into mid-century Parisian life, encompassing genre scenes, landscapes,

Friedrich von Martens
French, b. Germany,
1809–1875

La Seine, la rive gauche et l'île de la cité (The Seine, the Left Bank and L'île de la Cité), ca. 1845

Panoramic daguerreotype
GIFT OF EASTMAN KODAK COMPANY, EX-COLLECTION GABRIEL CROMER
76:0168:0136

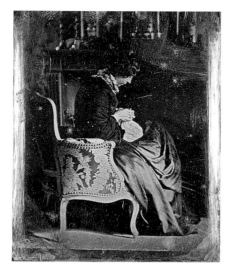

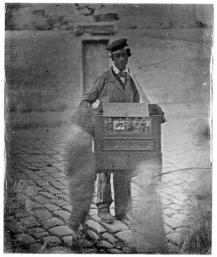

Cromer's Amateur
French?, active
1840s–1850s

*Interior with a
Woman Sewing,*
ca. 1850

Daguerreotype
GIFT OF EASTMAN
KODAK COMPANY,
EX-COLLECTION
GABRIEL CROMER
76:0168:0079

Cromer's Amateur

*Organ Grinder on
Street with Children
Passing,* ca. 1850

Daguerreotype
GIFT OF EASTMAN
KODAK COMPANY,
EX-COLLECTION
GABRIEL CROMER
76:0168:0050

portraiture (including numerous possible self-portraits), and still lifes. The image of an interior with a woman sewing is an exceptional early accomplishment in daguerreotypy, given the exposure restrictions required by the necessity of ample available light. The subtle yet sophisticated lighting illuminates the recessed space, giving the image considerable depth and revealing details of the fireplace mantle, silver candlesticks, and ornate mantle clock in the background. At the same time, the lush upholstery of the chair in which the woman sits is highlighted in crisp detail. The image is a privileged glimpse into a private, wealthy world that was most likely that of the photographer, as the time and money needed to practice daguerreotypy were considerable.

Stepping outside of his personal realm, Cromer's Amateur directed his attention to the street, capturing a spontaneous scene of daily life in this portrait of an organ grinder at work, as passing children dissolve among the cobblestones into spectral blurs during the long exposure. Making yet another compositional departure, Cromer's Amateur made a still life of a vase of flowers, transforming the eclectic bouquet into a tower of cascading sunflowers, daisies, and softly wilting roses. Striking in its simplicity against a mottled background that swirls out of focus, the daguerreotype demonstrates an almost modernistic attention to form and texture. One of the most arresting portraits among the group

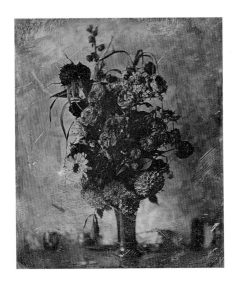 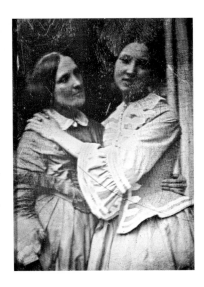

is an affectionate grouping of two women, possibly a mother and daughter and probably from the photographer's family. With a steady arm around her companion's waist, the older woman looks lovingly at the young girl who, in turn, engages the photographer directly with a familiar smile. These women appear again in several other daguerreotypes with different groupings of women and children that also suggest a familial context. The group of images is one of the largest extant bodies of nonprofessional artistic work in the daguerreotype medium and is remarkable for its "snapshot"-like casualness and ardent enthusiasm to record disparate aspects of the daily world unfolding before the camera's eye.

Amidst a burgeoning interest in the physical sciences in the mid-19th century, the photographer E. Thiesson traveled to Sofala, Mozambique, a Portuguese colony in Southern Africa, in order to photograph the local population. There he made a seated profile portrait of a Sofala woman, age 30, her short-cropped hair prematurely white (page 54). The use of the profile became a standard of ethnographic photography, whose objective was to document physical types from every angle in order to show difference. The woman is seated in a high-backed, European-style caned chair, removed from her cultural context and photographed against a plain backdrop that contrasts with her half-naked, presumably

Cromer's Amateur

Still Life, Bouquet of Flowers, ca. 1850

Daguerreotype
GIFT OF EASTMAN
KODAK COMPANY,
EX-COLLECTION
GABRIEL CROMER
76:0168:0068

Cromer's Amateur

Portrait of Two Women, ca. 1850

Daguerreotype
GIFT OF EASTMAN
KODAK COMPANY,
EX-COLLECTION
GABRIEL CROMER
76:0168:0069

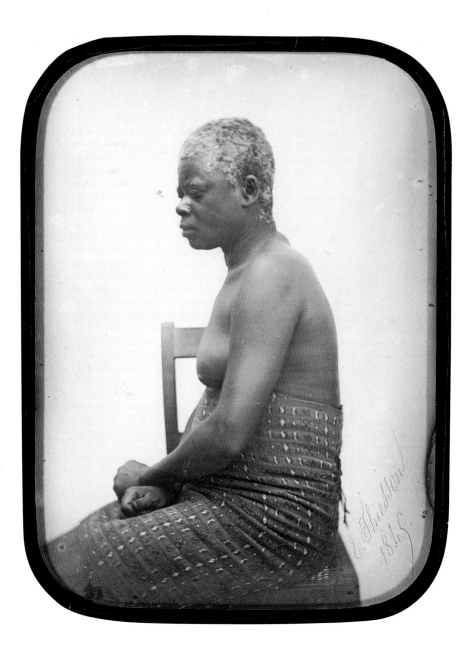

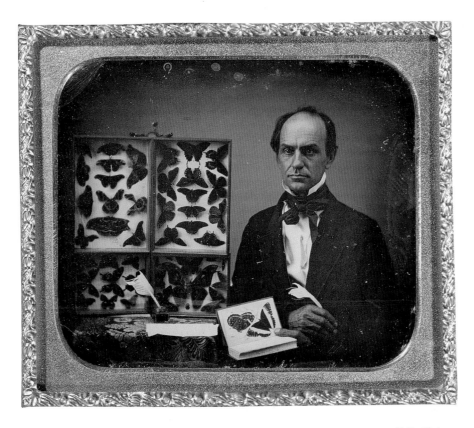

E. Thiesson
French, active
ca. 1840s

Native Woman of
Sofala (Mozam-
bique), 30 Years Old
with White Hair, 1845

Daguerreotype
GIFT OF EASTMAN
KODAK COMPANY,
EX-COLLECTION
GABRIEL CROMER
69:0265:0140

**Unidentified
photographer**
American,
active 1850s

Butterfly Collector,
ca. 1850

Daguerreotype
79:3292:0001

native costume. A similar example of photography as record-maker is an image of a man displaying his butterfly collection, which catalogs specimens from the insect world (page 55). He holds a book illustrated with images of butterflies and a quill pen, indicating his position as either a scientist or a student of science. Both images are examples of the early use of photography as a cataloguing tool.

In America – a young democracy eager to see itself reflected on the mirrored plate – daguerreotypes enjoyed their greatest popularity through the mid-1850s. The unflagging belief in photographic "truth" was a powerful tool that could easily be exploited by photographers. Occasionally, fictionalized "documents" were made, intended as records after the fact or for illustrative purposes. In "Dr. Macbeth in the Costume in Which He Crossed the Plains, Fleeing from the Cholerea [sic] of Which He Died," Dr. Macbeth poses in the studio in the wardrobe and with the iconography of the western adventurer. A pickax rests beside

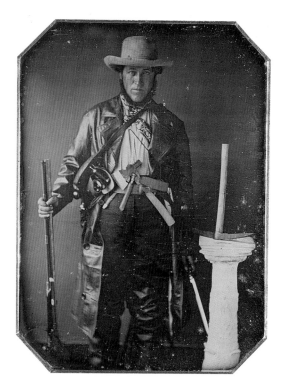

Unidentified photographer
American,
active 1840s

Dr. Macbeth in the Costume in Which He Crossed the Plains, Fleeing from the Cholerea [sic] of Which He Died, ca. 1845

Daguerreotype with applied color
GIFT OF
DR. JOHN RECHT
78:1706:0013

him on an elegant white pedestal, a standard photographic studio prop incongruous in this context. The photographer paid careful attention to recording the symbols of his subject's life, especially the tools and weapons with which he hoped to forge a new life.

In keeping with the prevalent 19th-century interest in things scientific, Robert Cornelius made this self-portrait. It is compositionally unconventional, with the photographer's hand almost obscuring his face. It is the activity depicted that is important here, not the subject's likeness. Though not an actual scientist, Cornelius holds a beaker in either hand and pours the unknown chemical substances into a funnel on a stand. As an obvious indication that the scene is staged, he is seemingly unmindful

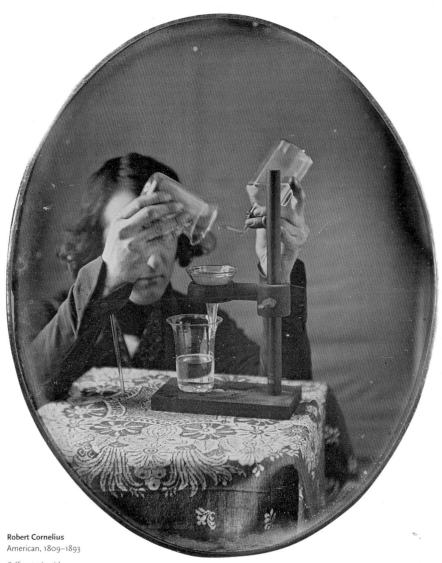

Robert Cornelius
American, 1809–1893

*Self-portrait with
Laboratory Instruments,* 1843

Daguerreotype
GIFT OF THE 3M COMPANY,
EX-COLLECTION LOUIS
WALTON SIPLEY
77:0242:0003

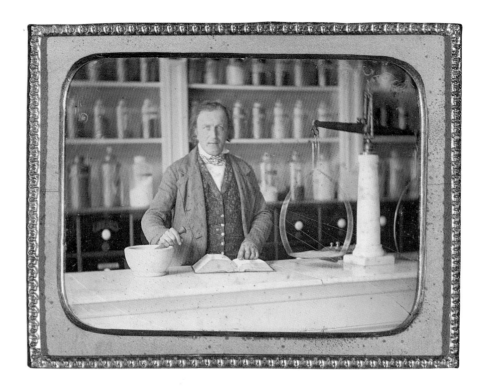

of the fancy damask cloth that covers the table, which would surely not have been present during an actual experiment. The image was likely used as the basis for an engraved illustration that appeared in an *Encyclopedia of Chemistry* article by Hans Martin Boye, a chemist colleague of Cornelius's who was also photographed by him during this same sitting and whose portraits are also in the Eastman House collection.

Artisans, craftspeople, and professionals shown in their own studios or shops was a popular genre of portraiture. The subject would often commission such a portrait in order to commemorate his or her achievement or to advertise a particular skill. An interior view of an apothecary shop shows a chemist standing at his table. His right hand grips a pestle resting in its mortar, while his left hand is poised over the page of an open book. Rather than the blank backdrop of the studio, bottles and jars of chemistry, tools of his trade, line the shelves and frame the chemist in his natural setting.

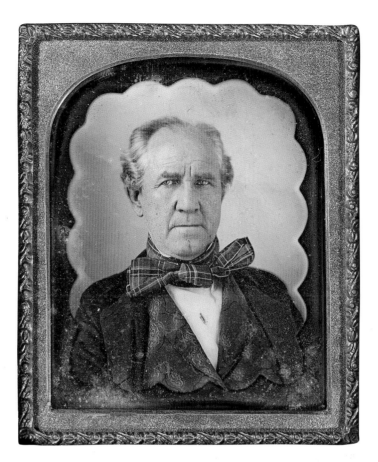

Unidentified photographer
American,
active 1850s

Sam Houston,
ca. 1850–1855

Daguerreotype
GIFT OF ALDEN
SCOTT BOYER
78:0758:0001

If the portrait subject was a public figure, reproductions of his or her likeness were valued and collected by the public as emblems of the subject's achievement. Samuel Houston (1793–1863), a lawyer and politician, led the triumphant battle at San Jacinto, which secured the independence of Texas from Mexico. Houston was elected president of the Republic of Texas, and once Texas was admitted to the Union in 1845, he was elected one of the state's first two senators. This daguerreotype, taken about ten years after the end of his senatorial term, is the forceful portrait of a man who had influenced the course of a nation.

Stephen Arnold Douglas (1813–1861) was a gifted orator and Illinois

Marcus Aurelius Root
American,
1808–1888

Small Girl Standing on Table, ca. 1850

Daguerreotype with applied color
GIFT OF MRS. J. LESLIE CROWELL
79:3144:0001

senator who was defeated in his bid for the presidency by Abraham Lincoln. Heavyset and only five feet four inches tall, Douglas was dubbed the "Little Giant" by his contemporaries. This daguerreotype depicts Douglas in the dynamic posture for which he was best known. Although the pedestal on his right gives a sense of scale regarding his diminutive size, his steady gaze and gesticulating left index finger emphatically underscore the strength of his implied oration. Even the empty chair in the background suggests his unwillingness to "take a seat" regarding the hotly debated issues of the day.

On the other side of the portrait spectrum, Marcus Aurelius Root's image of a small girl is a sweet, yet forlorn, likeness of its young subject. Standing atop a table in an unusual costume of fur-trimmed, satin, off-the-shoulder dress and scalloped pantaloons, she appears rather like a miniature circus performer, isolated on her stage against an empty

Unidentified photographer
American,
active 1840s

Stephen A. Douglas,
ca. 1845

Daguerreotype
MUSEUM PURCHASE,
EX-COLLECTION
ZELDA P. MACKAY
69:0201:0037

**Unidentified
photographer**
American,
active ca. 1850

*Girl with Flowered
Hat Leaning on
Table*, ca. 1850

Daguerreotype
79:3273:0012

Charles Evans
American, active
1854–1856

*Girl with Doll, Hold-
ing Mother's Hand*,
ca. 1854–1856

Daguerreotype
GIFT OF THE 3M
COMPANY, EX-
COLLECTION LOUIS
WALTON SIPLEY
77:0240:0024

backdrop. A portrait of a girl wearing a flowered hat demonstrates another, more casual approach to photographing children. She leans on a table, her arm resting on a pile of books. While the inclusion of books may suggest her literacy, it is more probable that the books supported her during the lengthy exposure. With her right hand on her hip and her left foot thrust forward, she conveys an easy comfort with the camera.

Charles Evans' portrait of a girl holding a doll in her right hand evokes the familial relationship through a simple gesture. Sparing her child the discomfort of a head clamp or other such awkward sitting apparatus, the mother insinuates her presence in the frame as she steadies and comforts her child for the portrait sitting by firmly grasping her hand.

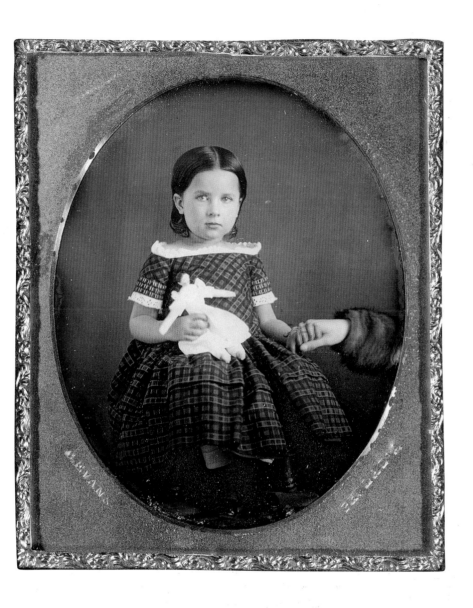

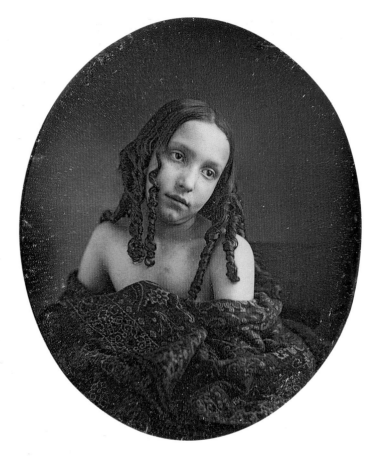

Samuel Leon Walker
American,
1802–1874

*The Photographer's
Daughter, Possibly
Josephine Walker,*
ca. 1847–1854

Daguerreotype
MUSEUM PURCHASE
78:0150:0004

**Unidentified
photographer**
American,
active ca. 1850s

*Portrait of Blind
Man Holding a Cat,*
ca. 1850

Daguerreotype
MUSEUM PURCHASE,
EX-COLLECTION
ZELDA P. MACKAY
69:0201:0012

The availability of family – husbands, wives, daughters, and sons –
proved irresistible to early photographers who were often still struggling
with the daunting task of successfully rendering any image on the sil-
vered copper plate. Samuel Leon Walker's portrait of one of his daugh-
ters, likely Josephine, displays a child's comfort and trust toward a par-
ent. Trust was also surely a factor in another portrait sitting, which
resulted in a striking portrait of a blind man and his cat. Unable to expe-
rience the daguerreotype magic for himself, the subject nevertheless un-
derstood the importance of having his likeness made and relied fully on
the photographer to make a faithful and sympathetic portrayal.

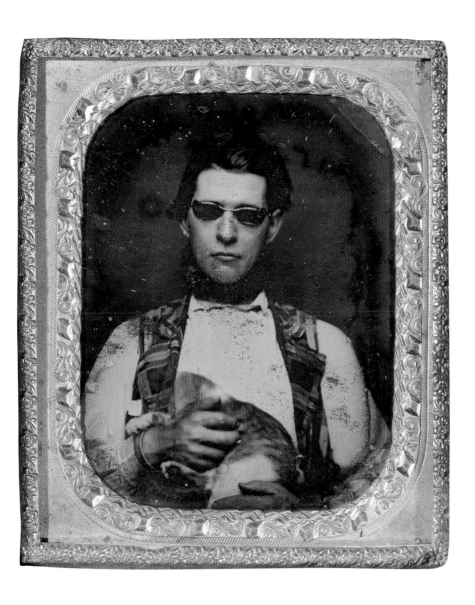

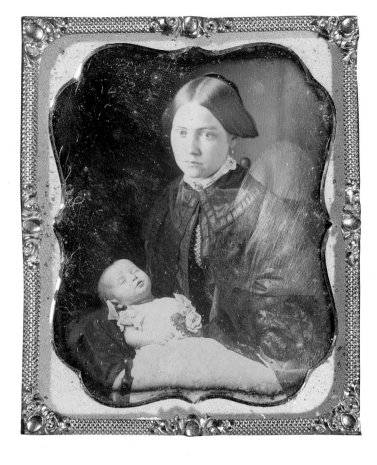

Sometimes portraits were made of those tiny members who had bare-
ly assumed their places in the family before succumbing to one of the
myriad illnesses that claimed countless infants in the 19th century. This
post-mortem portrait, a common subject in photography through the

early 20th century, depicts a mother with a vacant gaze holding her de-
ceased child as if it were sleeping upon her lap, reconstructing a tender
scene from a life of which they were cruelly and prematurely deprived.

In another portrayal of the familial relationship, Luther Holman Hale's
portrait of a couple turns gender convention on its head by showing the
man seated and the woman standing above and beside him.

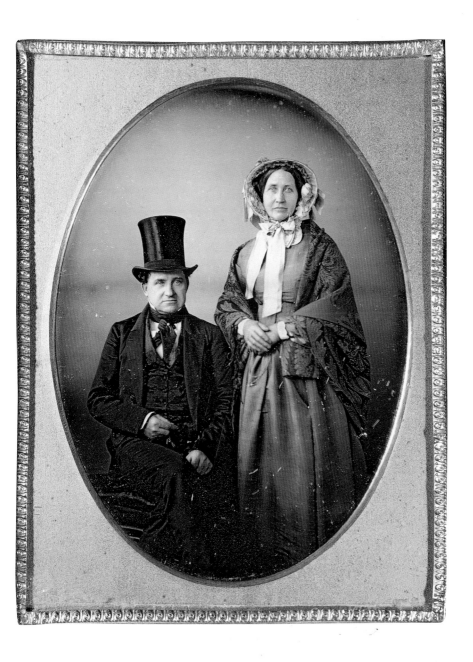

**Unidentified
photographer**
American,
active ca. 1850s

*Portrait of an
Unidentified Black
Woman*, ca. 1850

*Daguerreotype
with applied color*
MUSEUM PURCHASE,
EX-COLLECTION
ZELDA P. MACKAY
69:0201:0020

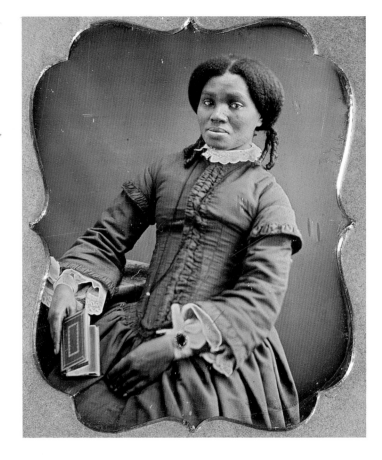

A portrait of a black woman, taken about 13 years before emancipa-
tion, reveals from the sitter's handsome dress and grooming that she
was probably a free woman. Furthermore, the small, open book that she
holds in her right hand suggests she was literate, a rare achievement for
19th-century blacks, who were systematically denied access to learning.
She presents herself confidently to the camera, her steady gaze com-
manding the viewer's respect and attention and conveying the intensity
and strength of her character. A solo portrait, this daguerreotype was
probably intended as a rare keepsake for family members who could
be assured of the woman's well-being and prosperity, probably in
the North.

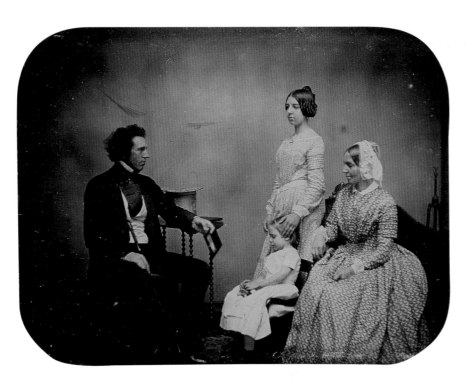

This group portrait of the Webb family depicts the patriarch, George James Webb, seated and holding a daguerreotype, facing his wife and two daughters. An animated presence, he rests his arm on a table, while the oldest daughter carefully holds her sister's head steady. So rigid are they in their attempts to remain still during the exposure that they reveal little interaction with or emotion toward one another.

Still, there were other inventive ways to make family portraits, even when not every member of the family could be present for the sitting. The woman in the portrait on page 70 holds a daguerreotype of a man, presumably her husband. Whether he had passed away or was simply not available for this particular sitting, the image preserves a record of their relationship as well as both their likenesses on a single plate.

Even when family members posed for daguerreotypes, a true likeness of the sitter was not always the daguerreotypist's goal. Dubbed "The Poet Daguerrean," actor and painter Gabriel Harrison made a daguerreotype titled "The Infant Saviour Bearing the Cross" (page 71).

Unidentified photographer
American,
active 1840s

Mr. George James Webb, Mrs. Webb, Mary Isabella Webb, Caroline Elizabeth Webb, ca. 1845

Daguerreotype
MUSEUM PURCHASE
79:3297:0001

Unidentified photographer
American,
active ca. 1850

*Woman Seated,
Holding Daguerreo-
type*, ca. 1850

Daguerreotype
GIFT OF UEDA
L. BURKER
79:3300:0001

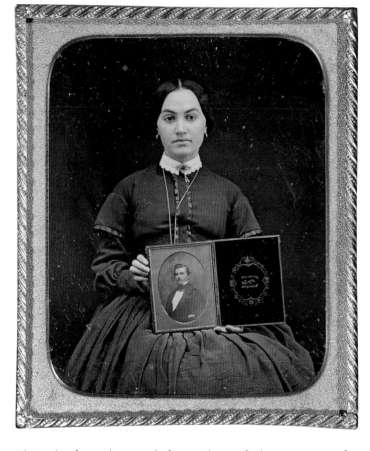

Obviously a fictional portrayal of Jesus Christ, a further suspension of disbelief is required by the viewer since the boy pictured, Harrison's son George Washington Harrison, is far from an infant. Best known for his allegorical imagery, Harrison utilizes the drape to connote the swaddling of the Christ child in the manger and the cross that is emblematic of Christ's suffering and death in order to condense the time frame of his life into a photographic icon of Christianity. Thus, his image evokes a familiar theme while exercising poetic license in its execution.

Gabriel Harrison
American, 1818–1902

The Infant Saviour
Bearing the Cross,
ca. 1850

Daguerreotype
GIFT OF CLARA
L. HARRISON
81:1660:0001

While an image like Harrison's seeks to portray an idea rather than depict a truthful representation, the portrait of a family posing in front of a log cabin (page 72) is the exact opposite, identifying a group in

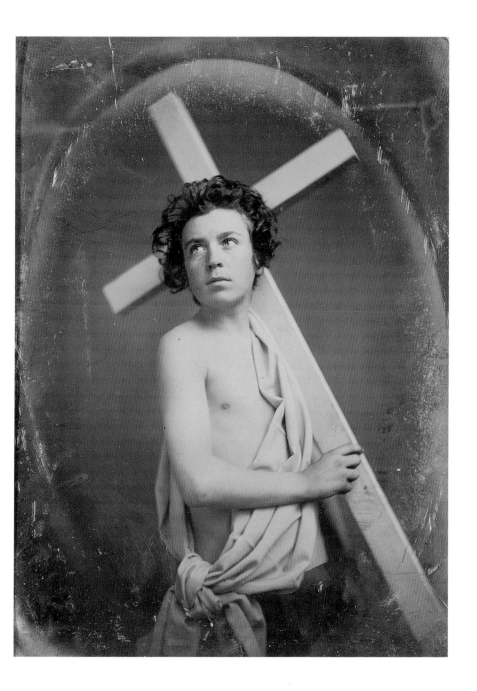

direct relation to their living conditions. Solidly placing them in a particular time and location, this image was probably made to commemorate their pride of ownership. Like a valued member of the family, the house unifies the bond between the men, women, and children as they assemble around the doorway for the camera. Moreover, the image plainly illustrates their circumstances at the time the photograph was made. The house represents the result of their hard work and determination to stake their claim in the uncharted West. This picture is a valuable document of some early settlers. Given the rural locale, it was probably the work of an itinerant daguerreotypist who traveled the country with a portable daguerreian studio in search of customers eager to see themselves immortalized.

Hard work and the pioneer spirit are nearly synonymous with the sturdy men and women who ventured west to make their fortunes during the California gold rush. A smattering of prospectors near a sluice at a dig site provides a glimpse into an often rough and difficult world that was created seemingly overnight by the discovery of gold by a carpenter at Sutter's Mill near San Francisco in 1848. By 1853 more than a quarter

Unidentified photographer
American,
active ca. 1850s

Family Posing in Front of Log Cabin,
ca. 1850

Daguerreotype
MUSEUM PURCHASE
68:0134:0003

million had found their way to California in search of their fortune, including Albert Sands Southworth, whose considerable photographic achievements are discussed on page 78. Most of them never found it. This daguerreotype, made around the peak of the gold rush, shows the primitive conditions that existed in the field. It is all the more remarkable, then, that an intrepid photographer, with the heavy, bulky equipment required to make daguerreotypes, was present to make group portraits such as this. A testament to the desire to use the medium as record-maker, such an image now immortalizes the early American adventurers and opportunists whose voracious greed for the nearly two billion dollars worth of precious metal eventually taken from the hills forever transformed the region's geography.

Man's engineering of nature has always been an integral element of European settlement in America. In the late 18th century, the use of water power was found to be more cost-efficient than steam, and major bodies of water across the country were harnessed to provide power to

Unidentified photographer
American, active ca. 1850s

Gold Miners at Dig, ca. 1850

Daguerreotype
MUSEUM PURCHASE
79:3157:0001

William Southgate Porter
American, 1822–1889

Fairmount Waterworks, 1848

Eight whole-plate daguerreotypes
GIFT OF 3M COMPANY, EX-COLLECTION LOUIS WALTON SIPLEY
77:0503:0001

the burgeoning American cities. William Southgate Porter's "Fairmount Waterworks," made at Fairmount Park in Philadelphia, Pennsylvania, is a spectacular seven-plate panoramic daguerreotype of the waterworks, a pumping station built in 1815 on the Schuylkill River. In 1828 the city purchased 24 acres of land around the site and created a picturesque retreat for public use. The park soon became a popular destination for visitors, and images of it were commemorated on china and in engravings. However, the veracity and detail of the daguerreotype provided a far more vivid image of the scene than previous media could claim. As a testament to the extraordinary range that Porter captured, the dam spans four of the whole plates, while the neoclassical millhouse fills another two. In a gesture of authenticity, Porter mounted atop the panorama a daguerreotype of the "[p]oint from which this view was taken," perceptually extend-

MOUNT

W. S. PORTER.

AY 22d 1848.

ing the panorama beyond 180°. The use of elaborate framing with gold-edged columns between each section skillfully hides the seams between the plates while maintaining the continuity of the entire scene. The additional decorative elements of the impressive frame complement the grandeur of the photographic spectacle, providing a fitting presentation for this photographic masterpiece. Later the same year, Porter repeated this success, creating a prize-winning daguerreotype panorama of the Cincinnati waterfront with his partner Charles Fontayne.

Farther north, Platt D. Babbitt captured the spectacle of natural water power in his images made from the American side of Niagara Falls. Although industry had already blighted the landscape surrounding the falls by the mid-1850s, Babbitt managed to capture the purity of the natural setting, intruded upon by only a handful of adventurous tourists

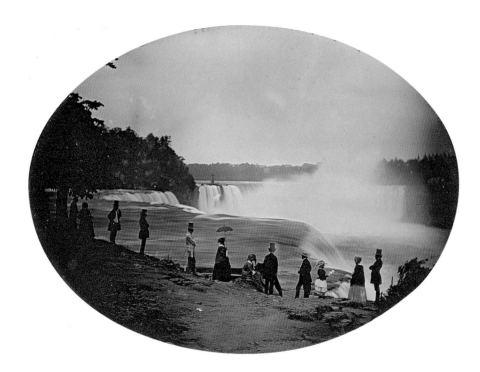

Platt D. Babbitt
American, d. 1879

Tourists Viewing
Niagara Falls from
Prospect Point,
ca. 1855

Daguerreotype
with applied color
GIFT OF EASTMAN
KODAK COMPANY,
EX-COLLECTION
GABRIEL CROMER
78:0608:0001

standing precariously close to the edge. Indeed, in this daguerreotype, one of four in the Eastman House collection made by Babbitt at the falls, a young girl, third from right, appears to have ventured into the water itself. Although countless photographers had made their way to Niagara over the years (and over 1,000 of their images have made their way into the Eastman House collection), Babbitt was the first photographer-in-residence at the American Falls. A colorful character and tenacious businessman, he controlled the lucrative pavilion at Point View. There he set up his camera and photographed tourists against the spectacular natural backdrop, selling them their daguerreotype likenesses. Who could resist such a stunning memento of their holiday?

As tourism blossomed in the 19th century, the ability to record scenes found on holiday or of places that many people would never see firsthand was further enhanced by the advent of the camera. Breathtaking images of distant locales were brought home into parlors and sitting rooms. From 1853 to 1854 Edward Meyer Kern was a daguerreotypist

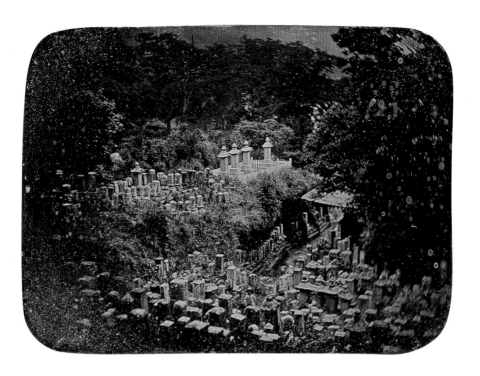

and artist aboard the sloop *Vincennes,* accompanying an exploration group and survey of the China Seas and Bering Straits. This daguerreotype of the American Cemetery at the Gyokusen-Ji Temple was likely made by him during the survey, around the time that the Japanese signed their first treaty with a Western nation. The Treaty of Kanagawa resulted from pressure by American Commodore Matthew C. Perry, who sailed into Tokyo Bay and demanded that the Japanese open their ports to U.S. ships for supplies. The 1854 treaty marked the end of Japan's period of isolation and established a U.S. consul at the port city of Shimoda where this image was made. The existence of the cemetery is evidence of a sustained American presence in Japan before the treaty was signed, and the image provides a rare view of a previously undocumented American presence there.

Attributed to
Edward Mayer Kern
American, 1823–1863

American Cemetery,
Gyokusen-Ji Temple,
Shimoda, Japan,
ca. 1853–1854

Daguerreotype
MUSEUM PURCHASE,
EX-COLLECTION
ZELDA P. MACKAY
69:0201:0057

Southworth and Hawes

"We aim in our profession to please Artists, and those whose taste for the fine arts has been cultivated and refined," read a mid-1850s advertisement from the Southworth and Hawes studio. Albert Sands Southworth and Josiah Johnson Hawes are without question the finest American portrait photographers of the 19th century, and the Eastman House collection contains about 1,200 daguerreotypes by the partners. Both men, unbeknownst to one another, had learned the daguerreotype process while attending a series of lectures in Boston given by Daguerre's pupil François Gouraud in 1840. They entered into partnership in 1843, and until 1861 their studio at 5-1/2 Tremont Row was situated in the heart of Boston's artistic and literary community. Rather than hire operators, as most large studios did, Southworth and Hawes were unique in that they made all of their studio's images themselves. Pages from Hawes' sitters book from around 1864 show albumen print examples of his work and suggest the scope of patronage, even though most of the once-prominent faces catalogued within are now forgotten. Luckily, the faces of Southworth and Hawes themselves endure, as they periodically turned the camera on one another. This unusual portrait of Southworth, the only portrait of him and the only vignetted male portrait by the pair in the Eastman House collection,

Josiah Johnson Hawes
American, 1808–1901

Pages from Sitters Book, ca. 1864

Albumen prints
LIBRARY COLLECTION

Albert Sands Southworth & Josiah Johnson Hawes
American, 1811–1894 & American, 1808–1901

Albert Sands Southworth, ca. 1848

Daguerreotype
74:0193:1129

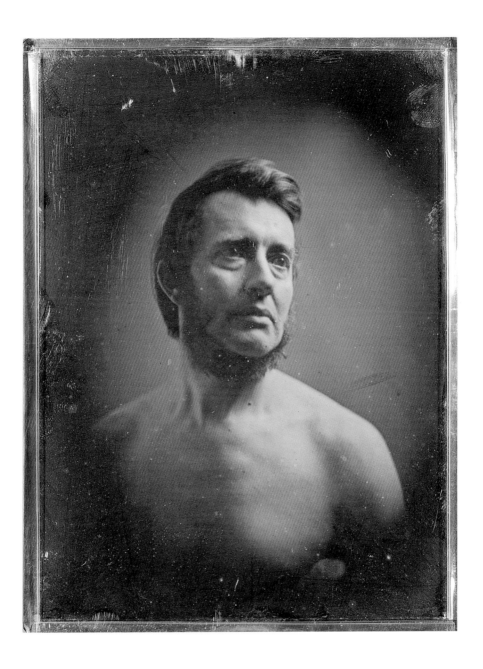

**Albert Sands
Southworth & Josiah
Johnson Hawes**
American, 1811–1894
& American,
1808–1901

Unidentified Female,
ca. 1850

Daguerreotype
74:0193:0400

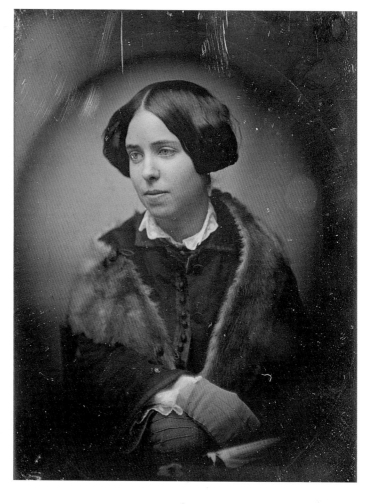

**Albert Sands
Southworth & Josiah
Johnson Hawes**

Rollin Heber Neal,
ca. 1850

Daguerreotype
GIFT OF ALDEN
SCOTT BOYER
74:0193:0141

is radical for its early depiction of the nude male body. Two daguerreo-type portraits of Hawes are also in the collection. [1]

The bulk of their portrait work was with the fashionable citizens of Boston, such as this unidentified young woman draped in a fur stole, as well as prominent public personalities like Rollin Heber Neal, pastor of the First Baptist Church in Boston. In keeping with the partners' belief that daguerreotypy was an art form, the process of sitting for a South-worth & Hawes daguerreotype portrait was an elaborate, somewhat

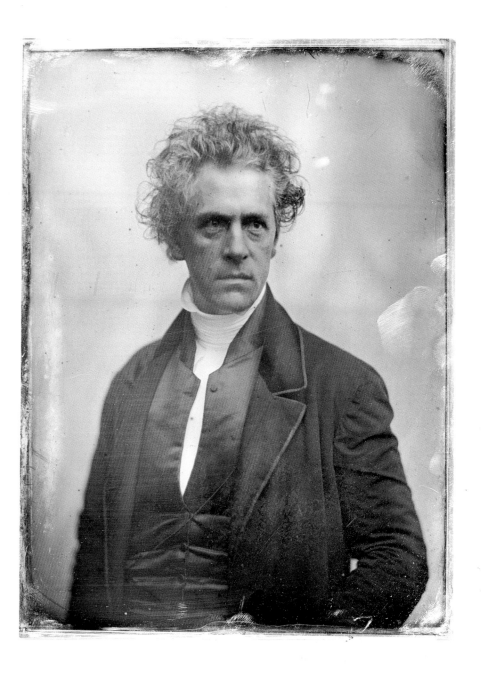

formal experience. One's first stop upon entering the studio was to become prepared for the sitting. For the female clients, there were available (according to a Southworth & Hawes invoice), "two Ladies … [to assist] in arranging their dress and drapery, and consult them as to colors most appropriate and harmonious for the Daguerreotype process." Among those women who helped arrange the sitters was Nancy Niles Southworth, Albert's sister, who became Hawes' wife in 1849. She also hand-colored daguerreotypes for the studio.

To ensure that they maintained an elite clientele, a Southworth & Hawes whole-plate portrait daguerreotype, such as this one of a well-dressed young woman, cost $15, compared with an average cost of $2 for a standard 1/6-plate size elsewhere. Oversized plates, which were used more rarely, could cost as much as $50.

Southworth and Hawes' families were also frequent subjects. As their children were constant fixtures around the studio, they consequently made many portraits of them, including 12 of the Hawes' daughters, which are in the Eastman House collection. This portrait of Josiah and Nancy's daughter, either Marion Augusta or Alice Mary Hawes, is among the finest examples of the photographers' special sensitivity in rendering children sympathetically. The soft, modeled lighting illuminates the child, bathing her in a gentle glow.

Albert Sands Southworth & Josiah Johnson Hawes
American, 1811–1894 & American, 1808–1901

Unidentified Female, ca. 1850

Daguerreotype
74:0193:0028

Albert Sands Southworth & Josiah Johnson Hawes

Marion Augusta Hawes or Alice Mary Hawes, ca. 1852

Daguerreotype
GIFT OF ALDEN SCOTT BOYER
74:0193:0823

Although the young girl was undoubtedly well versed in the necessity of maintaining her composure during an exposure, her contemplative expression is subtly evocative and poignant without dramatic excess.

Southworth and Hawes were equally successful at portraying the sweetness and spontaneous charm of very young children. In this portrait of a young girl, the camera is pulled back to reveal a small child illuminated in dappled sunlight. Her diminutive size is emphasized by framing her in the large, undefined space.

"A picture more lovely than this have ye not, / Softly gaze – softly breathe – and ye pause on the spot; / Then veil the fair figure, like Isis of old, / And keep the young heart in the vows it hath told" waxed one poetic enthusiast after seeing the bridal portraits displayed in the Southworth & Hawes studio. Photographs of brides, such as this example of a young woman resplendent in her wedding dress, have long been a staple of the commercial photographer's income. The grandeur of the whole-plate-sized portrait aptly preserves the commemorative importance of the occasion.

Southworth & Hawes' lesser-known images are their landscapes, marine views, and interiors. Mount Auburn Cemetery was the favored resting place for proper Bostonians. As a logical extension of their portrait work, this daguerreotype of plots at Mount Auburn (page 86) may have served as a treasured record of loved ones buried there. The emphasis on the lush, tranquil setting provides a comforting scene of eternal rest.

Albert Sands Southworth & Josiah Johnson Hawes
American, 1811–1894 & American, 1808–1901

Portrait of a Young Girl, ca. 1852

Daguerreotype
GIFT OF ALDEN SCOTT BOYER
74:0193:1122

Albert Sands Southworth & Josiah Johnson Hawes

Unidentified Female in Wedding Dress, ca. 1850

Daguerreotype
74:0193:0006

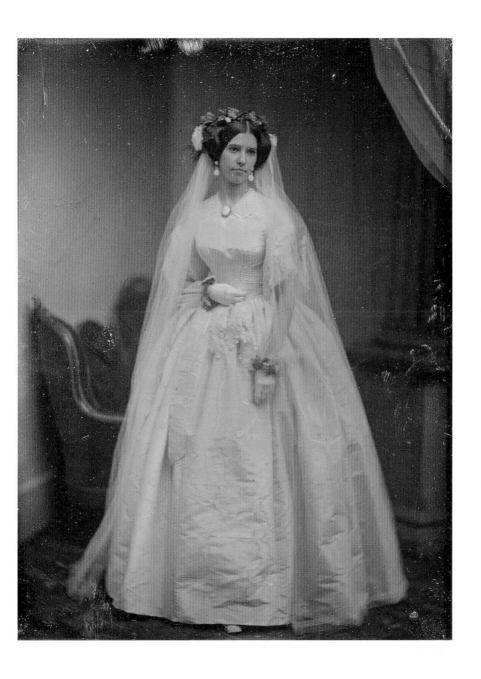

Albert Sands
Southworth & Josiah
Johnson Hawes
American, 1811–1894
& American,
1808–1901

*Mount Auburn
Cemetery,* ca. 1850

Daguerreotype
GIFT OF ALDEN
SCOTT BOYER
74:0193:0107

The view of the second-floor reading room at the Boston Athenaeum is one-half of a Grand Parlor stereoscopic pair. Natural light illuminates the scene of men gathered around the reading tables. The Eastman House technology collection includes the Grand Parlor Stereoscope from the Southworth & Hawes studio, one of only three ever made, which attracted tremendous publicity for the studio. The partners patented their creation in 1855, which was priced at an astronomical $1,160.

Progress of the 19th century was also captured by Southworth and

Albert Sands Southworth & Josiah Johnson Hawes

Boston Athenaeum, Interior View, ca. 1855

Daguerreotype
MUSEUM PURCHASE
74:0193:1116

Hawes. The image of a sloop of war in dry dock at the Boston navy yard (page 88) is as much a portrait of the dock, an engineering feat that took five years to construct, as it is of the sailing vessel. The Niagara Suspension Bridge (page 89), completed in 1855, emerges from the wintry landscape like beacons of progress in the bleak surroundings. In addition to the impressive collection of daguerreotype images, 2,310 individual items of photographic ephemera are now part of the Southworth & Hawes manuscript collection in the Menschel Library at Eastman House.

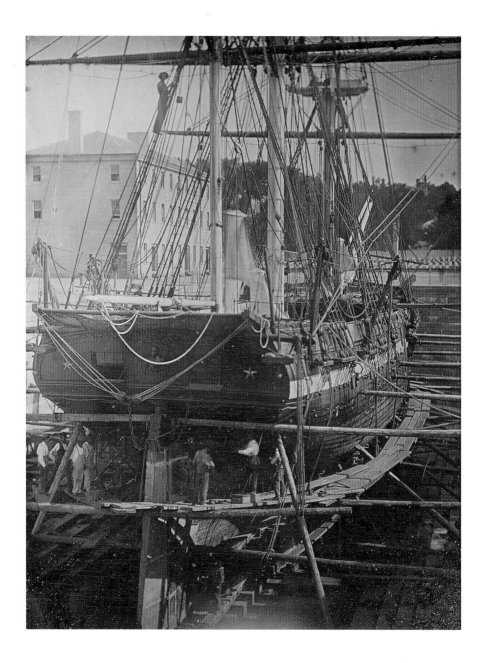

Talbot and the Paper Negative

Although immediately popular and available without patent restriction from the very beginning, the daguerreotype was not the only photographic medium announced in 1839. William Henry Fox Talbot, an amateur scientist in England, had been corresponding with his friend and colleague, the scientist Sir John Herschel (1792–1871), about their mutual discoveries using the cameras obscura and lucida, and their experiments with light sensitivity. In January 1839, stirred to action by the announcement of Daguerre's invention, Talbot announced the development of his "photogenic drawings," with which he had his first success in 1835. In fact, Talbot became the first to show his photographs to the public on January 25, 1839, exhibiting his early experiments at the Royal Institution in London. A month later, he published the complete instructions for his process. Although photogenic drawings initially required long exposures, Talbot continued to improve upon the process, increasing their sensitivity, and two years later he dubbed the improved process, "the calotype," from the Greek *Kalos* meaning beautiful and fine, and *typos* meaning outline or sketch. Talbot patented his calotype process in 1841 and began to charge rather high fees for its use, effectively curtailing its potential popularity. Unlike the daguerreotype, his process utilized a single negative image from which multiple positive prints could be made. This process would become the basis for photography as it is most commonly practiced today. For some, however, the soft focus of the calotype print on paper was no match for the crisp clarity of the daguerreotype image, which sat glimmering on the surface of a polished metal plate.

In 1844 Talbot published *The Pencil of Nature*, the first major book to be illustrated with origi-

William Henry
Fox Talbot
English, 1800–1877

Cover of *The Pencil of Nature*, 1844

Lithograph
MUSEUM PURCHASE,
EX-COLLECTION
ALDEN SCOTT BOYER
LIBRARY COLLECTION

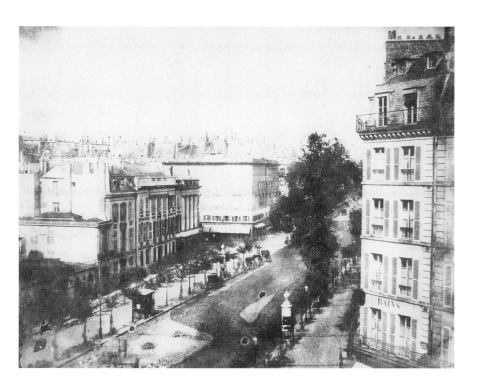

nal photographs. The publication was comprised of six fascicles with a total of 24 plates and was published over a two-year period between June 1844 and April 1846. The Menschel Library at Eastman House contains two copies. In order to produce the volume of prints necessary for the publication, Talbot set up a printing studio, called the "Reading Establishment," at Reading, England, in 1843. This was run by his assistant Nicholas Henneman (1813–1898). Plate II in the volume was Talbot's "View of the Boulevards at Paris," made from the window of his hotel room. It was no coincidence that Talbot brought his process to Daguerre's home turf to make photographs – he had traveled there with Henneman in order to introduce the calotype to France. His photographic achievements in Paris rivaled the best daguerreotypes. Carriages line the otherwise empty boulevard at the center, and every roof spire and window mullion is delineated by light in this highly detailed image. Talbot wrote vividly of the scene in his accompanying text: "The spectator is looking Northeast. The time is the

William Henry Fox Talbot
English, 1800–1877

Articles of China, before 1844

Salted paper print
MUSEUM PURCHASE
LIBRARY COLLECTION
74:0043:0003

afternoon. The sun is just quitting the range of buildings adorned with columns: its façade is already in shade, but a single shutter standing open projects far enough forward to catch a glimpse of sunshine. The weather is hot and dusty, and they have just been watering the road." However vivid, the evocation of the scene through words is no match for all of the details made visible by this new invention.

"Articles of China," an assembly of Talbot's teacups and statuary, became plate III in *The Pencil of Nature*. In his accompanying text, Talbot extolled photography's ability to "[depict] on paper in little more time than it would take ... to make a written inventory" the entire contents of a china collection. Presciently, he immediately identified the medium's evidentiary usefulness "should a thief afterwards purloin the treasures," thus foreseeing its future use by law enforcement. Talbot also demonstrated the medium's capacity for revealing the particularities of the china itself as the distinct personality of each piece comes

forth in the photograph. Regarding the potential interest for the collec-
tor in this new medium, Talbot wrote, "The more strange and fantastic
the forms of his old teapots, the more advantage in having their pictures
given instead of their descriptions." To this end, Talbot also included
calotypes of shelves of glassware and shelves of books as separate
plates in the book.

Before completing the final installment of *The Pencil of Nature,* Talbot
decided to photograph, as he wrote, "scenes connected with the life and
writings of Romantic author Sir Walter Scott," by whom he was greatly
influenced. Talbot made a trip to Scotland in October 1844 to photo-
graph Scott's home in Abbotsford and other locations mentioned in
Scott's writings. Talbot produced a new book of 23 "sun pictures," as he
called them, of views in Scotland. Unlike *The Pencil of Nature, Sun Pic-
tures in Scotland* was exclusively pictorial and was the second book print-
ed at the Reading Establishment. Talbot's view of Loch Katrine, plate 16

**William Henry
Fox Talbot**

Loch Katrine, 1844

Salted paper print
GIFT OF ALDEN
SCOTT BOYER
LIBRARY COLLECTION
74:0044:0011

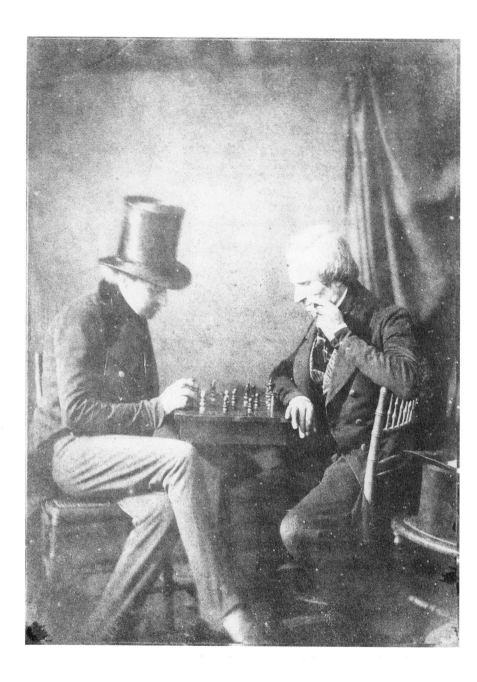

**Attributed to
Antoine Claudet**
English, b. France,
1797–1867

The Chessplayers,
ca. 1843

Salted paper print
GIFT OF MISS
M.T. TALBOT
81:2847:0007

in the book, depicts the glassy stillness of the lake and the picturesque, remote landscape reflected in its smooth surface. Queen Victoria was among the 103 subscribers to the publication, but the Reading Establishment ultimately proved to be a bad business venture. The problem of fading prints persisted, and after only three more publications, Henneman closed shop in 1846 and moved to London.

**William Henry
Fox Talbot**
English, 1800–1877

The Cloisters at
Lacock, 1844

Salted paper print
GIFT OF DR. WALTER
CLARK
81:2836:0002

Another subscriber to *Sun Pictures* was the Reverend Calvert Richard Jones, the son of a Welsh landowner who was a marine painter, draftsman, and daguerreotypist before turning to the calotype. "The Chessplayers," showing Antoine Claudet at left and possibly Jones on the right, is attributed to the circle of Talbot, although variant prints from the same sitting have been attributed to Claudet or another photographer in Talbot's circle. Clearly posed, the scene is nevertheless casual and fun, indicating the nature of the gentlemen's relationship. It also suggests the level of interaction between these early amateur practitioners, who shared ideas and images freely. In September 1845 Jones visited Talbot at Lacock Abbey, where Talbot made a portrait of him seated at the ancient Vestry at Talbot's ancestral estate. "... [T]o make a good figure in a photographic picture requires considerable steadiness of

Unidentified photographer, plate by William Henry Fox Talbot
English, 1800–1877

Window Tracery and Detail Arc de Triomphe, ca. 1858–1860

Photoglyphic engraving
GIFT OF THE SMITHSONIAN INSTITUTION
67:0048:0009

character but only for the fraction of a minute. This valuable quality, together with many others too long to mention, my friend possesses in an eminent degree," wrote Talbot of this sitting with Jones, in a text that was to have accompanied this image in a future, unrealized installment of *The Pencil of Nature.* Jones is barely distinguishable from the surrounding stone, recognizable only by the prominent shape of his top hat.

Simple objects and close observations were frequently the subjects of Talbot's early photographs as he continued to experiment with perfecting the recalcitrant medium, shortening exposure times and increasing the permanency of the calotype prints. "Window Tracery and Detail Arc de Triomphe" is a photoglyphic engraving from the late 1850s. Architectural details and sculpture were favored subjects for Talbot, including this detail of the lower half of the Arc de Triomphe de l'Étoile in Paris. The detail of arch and window below it is also clearly delineated. Similarly, the intricate texture of lace proved to be a perfect subject, as every stitch reveals its structure under the camera's scrutinizing eye. This positive print was made from a negative photogram without the use of a camera. Talbot laid the lace on the sensitized paper and exposed it to light. The pattern of lace was thus transferred onto the photographic paper in relation to the areas of density. In the original photogram, the lace appeared white against a black ground. Either was acceptable as a finished image to Talbot. As he wrote, "The picture ... is but a succession or variety of stronger lights thrown upon one part of the paper, and of deeper shadows on another. Now Light, where it exists, can exert an action." By printing the negative, Talbot more accurately reproduced

William Henry Fox Talbot

Lace, early 1840s

Salted paper print
GIFT OF DR. WALTER CLARK
81:2836:0001

the object's original appearance while maintaining the detail of its web-like construction.

Because Talbot's patent restricted its use, the calotype had limited use in the United States. Brothers William and Frederick Langenheim wrote to Talbot after seeing a copy of *The Pencil of Nature*. Initially they indicated that they wished to act as Talbot's agents in the United States and to teach the calotype process. William traveled to London to negotiate with Talbot, and the Langenheims purchased the U.S. patent to the calotype process in 1849. The Langenheims had begun their photographic partnership in 1843 and ran a successful daguerreotype studio at various addresses in the Mercantile Exchange in Philadelphia. "Merchant's Exchange, Philadelphia" is a calotype of the building that housed their studio. Calling their print a "Talbotype from Nature," the Langenheims sent this print to Talbot as an example of their work using his process. Eastman House acquired the print as a gift in 1952 – it had been sold to its previous owner by Talbot's granddaughter. Talbot held onto the work, no doubt encouraged by the Langenheims' aesthetic success.

Recognizing the calotype's potential, an article in a Washington, D. C., newspaper informed its American audience that "... independently of each other, Daguerre and Talbot found out the art of fixing upon metal and upon paper the light of the sun. The former has obtained the more immediate success; but the other has, perhaps, hit upon the better form of the discovery." Sadly ahead of their time, the Langenheims failed to realize that the fervent popularity of the daguerreotype, with its extraordinary detail, had in 1849 yet to wane in the United States. Having sold only five licenses in six months, the brothers begged Talbot to postpone payments on the balance of the $6,000 purchase of the patent. Talbot apparently never responded, which led to bankruptcy for the brothers. They were not alone. Even in England, studios were unable to sustain a profitable business using the calotype. Still, the Langenheims continued to use the process, producing calotypes that were exhibited at the Crystal Palace exhibition in London in 1851. The studio eventually closed in 1874 following William's death. The Eastman House collection contains a broad range of the Langenheims' work, including daguerreotypes, negatives, glass stereographs, microphotographs, and their own invention, the "Hyalotype," a modification of the albumen on glass process. The Menschel Library also holds a small amount of manuscript material relating to the Langenheims' studio.

William & Frederick Langenheim
American, b. Germany, 1807–1874 &
American, b. Germany, 1809–1879

Merchant's Exchange, Philadelphia, ca. 1849

Salted paper print
GIFT OF HAROLD WHITE
81:2914:0001

Hill and Adamson

The patent that Talbot had taken on the calotype process in England and Wales did not, fortunately, apply to Scotland. This allowed for Scots David Octavius Hill and Robert Adamson to create some of the most outstanding calotype images ever made. The Eastman House collection contains more than 400 prints and five negatives made by Hill and Adamson during their five-year partnership.

Within days of first exhibiting his photogenic drawings in London, Talbot sent examples to his friend Sir David Brewster (1781–1868), who was principal of the United Colleges at St. Andrews University in Scotland. Brewster introduced the calotype to his pupil, John Adamson, who became an accomplished photographer in his own right. He in turn instructed his brother Robert, an engineering student. In 1843 Robert moved to Edinburgh and opened a studio. D. O. Hill, Adamson's elder by nearly 20 years, was a well-known landscape painter and secretary of the Scottish Academy of Painting. A watercolor view of St. Andrews seen in the distance demonstrates Hill's early training and draftman's skill, which he later applied to the photographs he and Adamson made of the Scottish countryside. In an early portrait by the partners, Hill is pictured standing in a doorway.

Their brief partnership was tragically cut short by Adamson's premature death at age 26. Although it was initially believed that, because

David Octavius Hill
Scottish, 1802–1870

St. Andrews, ca. 1850

Watercolor
MUSEUM PURCHASE,
EX-COLLECTION
PETER POLLACK
66:0029:0001

**David Octavius Hill
& Robert Adamson**
Scottish, 1802–1870
& Scottish,
1821–1848

D. O. Hill, ca. 1843

Salted paper print
GIFT OF ALDEN
SCOTT BOYER
81:2398:0002

**David Octavius Hill
& Robert Adamson**
Scottish, 1802–1870
& Scottish,
1821–1848

Rev. A. Capadose of
The Hague, ca. 1843

Salted paper print
GIFT OF ALDEN
SCOTT BOYER
81:2398:0001

of their respective training, Adamson performed the mechanics of the calotype process while Hill contributed the aesthetic expertise, further study of their work reveals that they were equal partners in composition and form.

On May 18, 1843 Hill attended a meeting of the General Assembly of the Church of Scotland, at which 155 ministers resigned to establish the Free Church of Scotland. Deeply moved by the turn of events, Hill decided to create a grand-scale commemorative portrait of the signing, five days later, of the Act of Separation and the Deed of Demission. In order to produce likenesses of the 457 ministers and members of Edinburgh society that were present, Brewster suggested to Hill that he utilize the calotype process, and put him in contact with Adamson. Thus began their prolific partnership. This portrait of Doctor Abraham Capadose of The Hague, a physician and Calvinist writer, is one of those portrait studies. Reflecting Hill's painterly training and demonstrating a sophisticated use of light and shadow, the photograph utilizes the classic pictorial convention of a three-quarter pose as well as the iconography of a book to indicate that the sitter is a learned man. Although Hill completed the painting based on the photographs some 20 years later, the photographic portrait is a truer likeness and a more nuanced portrait study than the painted version, in which Capadose appears as a tiny bobbing head in a sea of faces. It is fitting that Hill also included a self-portrait in the canvas as well as a posthumous portrait of Adamson at his camera amidst the crowd.

Their portrait work extended beyond the massive Free Church project to other members of Edinburgh society, as well as to the workers in the fishing village of Newhaven. Hill and Adamson's portrait of Lady Mary Hamilton (Campbell) Ruthven (page 104) takes the radical positioning of its subject with her back to the camera from fashion illustrations in contemporary ladies' magazines. Rather than show Ruthven's likeness, this portrait demonstrates her *au courant* stylishness as well as her upper-class status. The photograph of a seated Mrs. Elizabeth Johnstone Hall (page 105), on the other hand, depicts a fisherwoman of Newhaven in an occupational portrait holding her basket. Hill sometimes captioned this photograph "A Newhaven Beauty," suggesting that, at least aesthetically, class did not determine his affinities.

Nor, however, did traditional portraiture exclusively define Hill and Adamson's subject matter. Their body of work includes landscapes and

**David Octavius Hill
& Robert Adamson**

Scottish, 1802–1870
& Scottish,
1821–1848

Lady (Mary
Campbell) Ruthven,
ca. 1843–1847

Salted paper print
GIFT OF ALDEN
SCOTT BOYER
81:2398:0042

**David Octavius Hill
& Robert Adamson**

Mrs. Elizabeth
Johnstone Hall,
ca. 1845

Salted paper print
GIFT OF ALDEN
SCOTT BOYER
81:2389:0005

genre scenes, and all manner of patrons sat for portraits at their out-
door studio at Rock House, Calton Hill. In the popular Victorian tradi-
tion of *tableaux vivants,* the pair constructed the elaborate "Medieval
Group" (page 106), in which Hill participates at right, strumming a lyre.
The attention to costume details and theatricality is also evident in "The
Porthole, Edinburgh Castle" (page 107), which shows guards at the royal
residence standing beside a cannon. The Finlay children – Arthur, John
Hope, and Sophia – are depicted leisurely fishing at the minnow pool
(page 108). Their youthful attentions are focused on the goings on below.
An image of the Martyrs' Memorial and McCulloch monument (page 109)
in Greyfriars' churchyard shows a standing Hill and a seated woman, pos-
sibly one of the Misses Watson, alongside a tomb as if visiting the grave of
a dearly departed soul. Like Talbot, Hill and Adamson succumbed to the
lure of Romantic subject matter and made numerous images in Greyfriars.
More than a dozen of these are in the Eastman House collection.

**David Octavius Hill
& Robert Adamson**
Scottish, 1802–1870
& Scottish,
1821–1848

A Medieval Group,
ca. 1843–1847

Salted paper print
GIFT OF ALDEN
SCOTT BOYER
81:2396:0032

**David Octavius Hill
& Robert Adamson**

The Porthole,
Edinburgh Castle,
April 9, 1846

Salted paper print
GIFT OF 3M COM-
PANY, EX-COLLEC-
TION LOUIS
WALTON SIPLEY
77:0502:0002

**Unidentified
photographer**
English, active 1850s

*Flowers in Vase and
Bird's Nest*, ca. 1851

Salted paper print
MUSEUM PURCHASE
81:1304:0010

Amateur photographers also took to the calotype process with enthusiasm and success, recording the world around them with great sensitivity and accomplishment. An arrangement of flowers in a vase alongside a bird's nest filled with eggs is a striking still life of the natural world. Naturalism was applied to scenes of casual repose as well; this unknown photographer focused his camera upon the Reverend J. and Mrs. Arrowsmith and Susan Bridges reading beneath the shade of a tree. A church, presumably Arrowsmith's, is visible in the background. Although certainly posed for the camera, the effect is entirely natural as each sitter appears thoroughly enthralled by their reading material, as though the photographer stumbled upon this scene of quiet contemplation and, unbeknownst to them, stopped to preserve it.

The surgeon and gynecologist Dr. Thomas Keith of Edinburgh was an accomplished amateur photographer who is thought to have learned

Unidentified photographer
English, active 1850s

Revd. J & Mrs. Arrowsmith and Susan Bridges, ca. 1851

Salted paper print
MUSEUM PURCHASE
81:1304:0032

the calotype process from his friend D. O. Hill. Keith specialized in architectural and landscape views in and around Edinburgh in the early 1850s. Professional commitments limited his photographing time to before 7:00 A.M. and after 4:00 P.M., and remarkably, he further limited his photographing to a few weeks in midsummer when light was optimal, explaining that "[t]he light is then much softer, the shadows are longer, and the half tints in your picture are more perfect and the lights more agreeable." In total, Keith photographed only for about three years, at which time his medical duties took precedence.

"Woman in Doorway" shows an elaborately carved portal from 1633 in which a woman stands raked by sunlight, lending a human element and scale to the architectural study. The detail view of an ancient archway is similarly cast in deep shadow, evoking a mystery surrounding what lies within. Both images are platinum prints made around 1915 by Alvin Langdon Coburn, who prepared prints from ten of twelve waxed paper Keith negatives, all of which are in the Eastman House collection.

The Calotype in France

Nowhere was the calotype more embraced than in France, but it was not precisely Talbot's process that was used. Although Talbot had visited Paris in 1843 in order to gain support for his process, only one calotype patent was sold in France in 1844. Still, there were numerous experimenters who had developed their own variations on the paper negative process. In 1847 Louis-Desiré Blanquart-Evrard, a cloth merchant from Lille, bypassed the patent restrictions by modifying Talbot's process – much to Talbot's consternation – and thus revolutionized the use of the paper negative. By reversing Talbot's sensitizing procedure, Blanquart-Evrard discovered a way to saturate the paper to increase tonal range and detail, and, significantly, to reduce exposure times by about 75 percent. However, negatives had to be exposed when wet, necessitating the use of a dark tent and chemicals immediately prior to exposure. Three years later, Blanquart-Evrard developed a dry negative paper that could be prepared in advance.

In addition to his early experimentation that revolutionized paper print technology, Blanquart-Evrard became most renowned for his printing, both of his own images and those of other photographers. As Talbot had done with his Reading Establishment, in 1851 Blanquart-Evrard set up a manufactory, the Imprimerie Photographique, at Loos-les-Lille, France, to produce large numbers of photographic prints for publications. Until its closure in 1855, Blanquart-Evrard's printing business produced 24 volumes of images by many of the most prominent French photographers of the day, including Maxime Du Camp, Auguste Salzmann, Charles Marville, Henri Le Secq, and J. F. Michiels. The Eastman House collection includes several prints from Blanquart-Evrard publications.

Artists above all else favored the paper negative and its poetic possibilities. Around 1850 the painter and photographic experimenter Gustave Le Gray introduced the dry "waxed" paper negative, which meant that the negative paper could be coated and kept up to two weeks before exposure and did not have to be developed for a couple of days after exposure. Le Gray was exceedingly influential in promoting the calotype in France, instructing any who made their way to his rural studio and home in Clichy. Ironically, British photographers were greatly influenced by the advancements made in France after French calotypes were displayed at the Great Exhibition of the Works of Industry of All Nations held in the Crystal Palace in 1851. Although Talbot's invention

was then being widely used, it was the French innovators who received the credit for perfecting the technique.

André Giroux was a painter whose father Alphonse (active 1840s) manufactured Daguerre's equipment. The technology collection at Eastman House contains two of these cameras made by Giroux, one bought by Boston dentist Samuel Bemis from Daguerre's agent, François Gouraud, and both featuring Daguerre's signature and Giroux's official seal. Giroux frequently painted directly on his paper negatives to render soft, atmospheric effects, even when he began to use collodion on glass negatives, treating the negative almost like a printing plate. His extremely manipulated style was rare in 19th-century French photography. He was schooled in the picturesque, Romantic landscape tradition, which lent itself well to his chosen subject matter. Seeking to obliterate the mechanical hand of photography, Giroux anticipated the pictorialist style that became popular around the turn of the century. A landscape

André Giroux
French, 1801–1879

Landscape, ca. 1855

Salted paper print
MUSEUM PURCHASE
76:0020:0062

scene of a river running through a bucolic French town is a delicate example of Giroux's *très pittoresques* images, although, despite his efforts, the photographic clarity of the print is nevertheless apparent and inviting.

With more than 100 prints and negatives, Eastman House has one of the largest collections in the world by painter and antiquarian Henri Le Secq. The son of a local politician, Le Secq studied painting under Paul Delaroche and specialized in genre scenes, using photography initially to make preparatory sketches for his paintings. He quickly shifted his interest to architecture and became a self-appointed preserver of Parisian monuments, taking it upon himself to photographically document the vanishing old city. In 1851 he became one of five photographers hired by the Commission des Monuments Historiques (founded in 1837) to create a photographic record of historically significant French buildings.

Henri Le Secq
French, 1818–1882

Rosheim, 1851

Salted paper print
MUSEUM PURCHASE
81:1465:0026

Le Secq was assigned to the regions of Alsace, Lorraine, and Champagne. His oeuvre included architectural studies, "académies," landscapes, still lifes, portraits, documentation and reproduction of works of art, as well as experiments using non-silver processes.

"Rosheim" is one of the images Le Secq produced for the commission of the local church in the Alsace region of northeastern France. He specialized in architectural details, prompting one critic to remark that Le Secq's photograph was better to study than the actual building! This detail of the 12th-century Gothic statues atop the support columns on Chartres Cathedral bears out such a claim, as Le Secq's camera captured details not easily visible to the casual observer. The print is from a rare

Henri Le Secq

Chartres Cathedral,
Detail, Jamb Statues
Supporting
Columns, 1852

Photolithograph
MUSEUM PURCHASE
79:2634:0002

portfolio in the Eastman House collection, *Fragments: Architecture et sculptures de la Cathédrale de Chartres,* which contains 25 photolithographs made using the *encre grasse* process invented by Thiel Aine and Co., of Paris. The Commission des Monuments Historiques published this portfolio, although by and large it did not publish or make use of any of the photographs it commissioned. Le Secq documented Chartres extensively, and the portfolio is a unique, intact collection of those images.

Le Secq also created a series of still life compositions. The frontispiece for a portfolio of his still lifes is perhaps one part self-portrait and one part symbol of his beloved France. A camera lens, wine bottle, and two filled glasses beckon invitingly, albeit with an air of mystery. "Fantaisies/clichés par/H. Le Secq" reads the bottle's label, leaving no doubt as to the artist's identity. Gabriel Cromer, whose collection included 15 Le Secq paper negatives, made this print from the original negative in the 1930s.

A cyanotype of a farmyard scene near St.-Leu-d'Esserent north of Paris is one of five cyanotype prints by Le Secq in the museum's collection. A process invented around 1848 by Sir John Herschel, the cyanotype is relatively simple to make, as it involves only two chemical compounds: ferric ammonium citrate and potassium ferricyanide. Cyanotypes, as their name suggests, are distinctively blue in color. In this picturesque, rustic view, the blue tone of the print contributes to the evocative quality of the scene. Dominated by a large central shadow, the photograph demonstrates the photographer's "habit of making memoranda of the shapes of shadows ... wholly without indication of their cause." Light creeps in at either side rather tentatively,

Henri Le Secq

Farmyard Scene, near St.-Leu-d'Esserent, ca. 1852

Cyanotype
MUSEUM PURCHASE
81:1465:0007

Charles Negre
French, 1820–1880

Arles: Porte des
Châtaignes, 1852.

Salted paper print
GIFT OF EASTMAN
KODAK COMPANY,
EX-COLLECTION
GABRIEL CROMER
80:0521:0001

insinuating its presence by sketching the windows and thatches on roofs and ground.

Le Secq's garden scene of a single urn upon a pedestal balancing the lower center of the frame is a "found object" variation on the composed still life. The haphazard arrangement of forms in nature suggests a scene that Le Secq stumbled upon and stopped to frame for the camera. A ladder appears midway through the right edge of the image and promptly disappears into the foliage; a sign is seemingly turned away from the path it is meant to mark. Moreover, the leaves cascade across the top of the urn as if this small pot holds the origins of the massive tree, its roots otherwise obscured. Favoring the paper negative exclusively, Le Secq virtually gave up photography after 1856 when collodion on glass became the preferred medium.

Like Le Secq, Charles Negre was trained as a painter with Delaroche and took up photography as a complement to his painting. Negre and Le Secq had even photographed together in Chartres; one of Negre's most famous images is of Le Secq on the tower there. Already part of the tradition of genre painting, Negre initially used the daguerreotype and became known for genre photographs that he made on the streets of Paris. Eventually, he would earn his reputation as a photographer of architecture. Each summer he photographed his home region, the Midi,

(left)
Henri Le Secq
French, 1818–1882

Garden Scene,
ca. 1855

Salted paper print
MUSEUM PURCHASE
81:1465:0008

Unidentified
photographer
French, active 1850s

Church of
Saint Martin,
Candes, ca. 1851–1855

Salted paper print
GIFT OF EASTMAN
KODAK COMPANY,
VINCENNES, VIA THE
FRENCH SOCIETY OF
PHOTOGRAPHY,
EX-COLLECTION
HENRI FONTAN
81:1115:0019

where he made hundreds of negatives that he eventually published as *Le Midi de la France, sites et monuments historiques photographies*. Unlike Le Secq, Negre was concerned less with the preservation of crumbling monuments than with the rich atmosphere of living places. His townscape view of the Porte des Châtaignes at Arles is accented by the human presence of two villagers sitting atop the wall, as well as another figure barely discernable at the top of the path leading down to the water's edge. Rather than focus on the crumbling architecture of the gate, Negre incorporates past with present by pulling back the camera to show a still-active port despite the inevitable, visible ravages of time.

Often some of the finest examples of calotypes from this period remain unattributed. The Eastman House collection contains a group of 123 paper negatives and 90 salt and albumen prints of architectural views and studies of Normandy and other regions of France, as well as some scenes in Belgium, which are believed to have been made by

either a single photographer or group of photographers. Included among them are these two images, one of the Church of Saint Martin at Candes and the other an urban view "Une des arcades du pont de pierre livre au public en 1829" at Rouen. The image of the church was made from relatively close up on the façade, eliminating the sky in favor of particular details in the architecture of the main building and its surrounding structures. Unlike the scene by Negre, this one is unpopulated, leaving the viewer to speculate about the present and future of this local church. The opposite visual approach was taken in this long view of one of the arcades of the Pierre Bridge as it arches across the river. The original bridge, constructed in 1812, had been replaced in 1829, no doubt to accommodate the construction of the railroad that would facilitate modern travel. Evidence of further modernization is seen at right in the tarpaulin-covered pile.

The photographic work of Édouard-Denis Baldus revolved, in part,

Unidentified photographer
French, active 1850s

Rouen. Une des arcades du pont de pierre livre au public en 1829. (Rouen. One of the Arcades of the Stone Bridge Given to the Public in 1829.), ca. 1851–1855

Calotype negative
GIFT OF EASTMAN KODAK COMPANY, VINCENNES, VIA THE FRENCH SOCIETY OF PHOTOGRAPHY, EX-COLLECTION HENRI FONTAN
81:3198:0008

around the expansion of the railroad in France, and the commission he received to document their routes. The Prussian-born Baldus was trained as a painter and began his career in photography the same year he became a naturalized French citizen, 1849, just as paper negatives were becoming popular. At the height of his career, Baldus was the most successful photographer in France, specializing in views of architectural monuments and landscapes. The Eastman House collection contains more than 200 photographs and 140 photogravures by this master. Like Le Secq, he received a heliographic mission from the Commission des Monuments Historiques. The most extensive mission given, Baldus' ranged from Paris to Fontainebleau, Burgundy, the Rhône Valley, Arles, and Nîmes.

In 1861 the Administrative Council of the Southern Region of the Compagnie du Chemin de Fer de Lyon à la Mediterranée commissioned Baldus to produce a collection of photographic views along the train line from Lyons to Marseilles and Toulon. A copy of the album he produced, *Chemins de fer de Paris à Lyon et à la Mediterranée*, is now in the Eastman

Édouard-Denis **Baldus**
French, b. Prussia, 1813–1889

Maison Carrée à Nîmes, ca. 1855

Salted paper print
GIFT OF EASTMAN KODAK COMPANY, EX-COLLECTION GABRIEL CROMER
74:0050:0017

(left)
Édouard-Denis **Baldus**

Orange. Théâtre antique, ca. 1861

Albumen print
MUSEUM PURCHASE
74:0055:0023

House collection. It includes this view at Orange of the exterior of the Théâtre Antique. Radically angled to encompass the entire façade, Baldus's composition energizes the architecture and exaggerates the sense of movement across its front. Ten years earlier at Nîmes, Baldus demonstrated a similar precision of framing, photographing the Maison Carrée at an angle to show both its front and side views. In an earlier unretouched view, the buildings in the distance were clearly visible, but Baldus later painted on the negative to isolate the structure within its surroundings, including the road in the foreground, transforming it into a piece of monumental public sculpture (see page 125).

An image attributed to Blanquart-Evrard, "Peasant Family at Rest in Front of a Thatched Shed," is from his 1853 publication, *Études photographiques.* Although some of the subjects are at repose, not all of them are idle. The two men, standing on either side of the frame with their backs to the camera, appear to be concentrating on their tasks at hand.

It is a richly detailed scene of rural life poetically composed for the camera.

Charles Marville was known as a landscape and architectural photographer, and in the late 1850s the city of Paris commissioned him to document its rapidly vanishing ancient quarters. In 1862 he was named Paris' official photographer. This image, "Cabane des moutons au Jardin des Plantes à Paris," is attributed to Marville, and was published in another Blanquart-Evrard volume, *Mélanges photographiques, complément des nouvelles instructions sur l'usage du daguerréotype.* The first half of the album shows reproductions of artworks, while the second half is a mixture of Parisian views and paintings. This photograph is characteristic of Marville's approach, in which he centers the composition around a strong vertical line, placing the primary structures at the edges of the frame.

**Attributed to
Charles Marville**
French, 1816–1879

Cabane des moutons au Jardin des Plantes à Paris
(Lamb Shed at the Jardin des Plantes, Paris), ca. 1851

Salted paper print
GIFT OF ALDEN
SCOTT BOYER
81:1108:0006

Auguste Salzmann
French, 1824–1872

Temple Wall: Triple
Roman Portal, 1854

Salted paper print
MUSEUM PURCHASE
79:2893:0001

Painter Auguste Salzmann traveled to Jerusalem to make photographic records of Greek and Judaic architecture. The Ministry of Public Instruction had commissioned him to photograph monuments and make archaeological discoveries of the Holy Land. Salzmann created more than 200 negatives of the architecture there, documenting Arab, Turkish, Byzantine, Latin, and Romanesque influences. Seventy-two images were published by Blanquart-Evrard in 1854 under the title *Jerusalem, époques judaique, romaine, chretiénne, arabe, explorations photographiques par A. Salzmann,* including this print of "Temple Wall: Triple Roman Portal" in the Eastman House collection. The close-up photograph is divided horizontally between ground and brick, with any reference to scale obliterated in favor of a more graphic, detail-oriented approach.

Marville's "Cathédrale de Chartres, Grandes figures des pilastres du portail septentrional" shows a sculptural detail on Chartres Cathedral, which Le Secq and Negre had also documented. The two lifelike figures atop the ornate pillars stand in stark juxtaposition with the plain brick construction and wooden fence running in the background. In this,

Charles Marville
French, 1816–1879

Cathédral de
Chartres, Grandes
figures des pilastres
du portail septen-
trional (Chartres
Cathedral, Large
Pilaster Figures on
the Northern Portal),
ca. 1853–1855

Salted paper print
GIFT OF EASTMAN
KODAK COMPANY,
EX-COLLECTION
GABRIEL CROMER
81:1530:0008

Marville contrasts the expressive beauty of the past with the practical
functionality of the present. This, too, appeared in a Blanquart-Evrard
publication, *L'Art religieux. Architecture. Sculpture. Peinture.*

Undoubtedly inspired by the great successes being achieved with the
calotype in France, many photographers from other European nations
went there to practice photography.

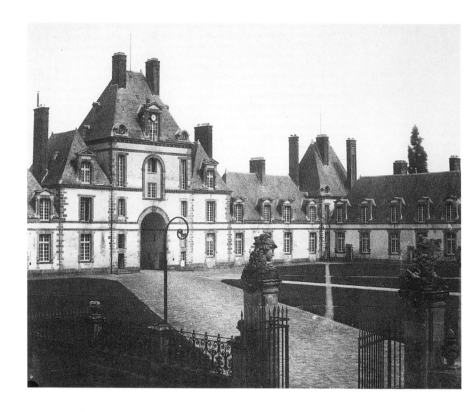

Ladislas Chodzkiewicz
Polish, active
ca. 1850s

Fontainebleau: la
Cour de Chasse, 1853

Salted paper print
GIFT OF EASTMAN
KODAK COMPANY,
EX-COLLECTION
GABRIEL CROMER
81:2935:0001

Fourteen prints and nine negatives by Ladislas Chodzkiewicz are in the Eastman House collection, the only public collection with works by this little-known photographer. He was possibly a wealthy amateur, which afforded him the time and money to travel and make views of the French countryside. In 1851 he contributed 20 francs for a monument honoring Niépce and Daguerre, which indicates that he was aware of the importance of preserving photography's history, even though it had not yet existed for very long. He also subscribed to *La lumière*, originally the weekly journal of the Société Héliographique, yet was not a member of the organization. Mounted and with engraved titles, his 13 views of the royal chateau at Fontainebleau were accorded great care in their presentation.

Calotypists working elsewhere in Europe contributed images to Blanquart-Evrard's publications, suggesting the scope of the small community

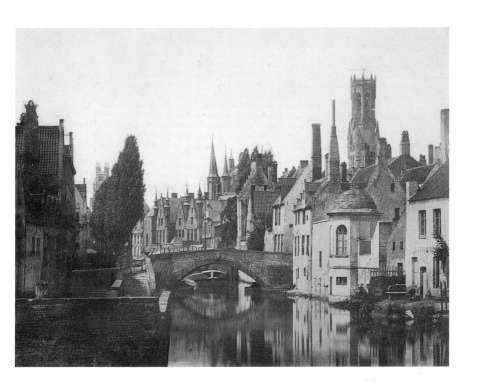

that existed of working photographers. Johann Franz Michiels was a German photographer who specialized in architectural views. "Lateral View of the Franc de Bruges" is from the Blanquart-Evrard publication, *Variétés photographiques*. The view across the river toward the Pont du Moulin in Belgium, reveals the medieval charm of the city carefully drawn in minute detail against the blank sky.

From 1849 until 1851 the French Ministry of Public Instruction sent writer and critic Maxime Du Camp, accompanied by Gustave Flaubert, to the Holy Land and Egypt to photograph archaeological sites. Du Camp was also a painter and champion of all things modern, declaring of photography, "My only master is the light of day ... I have only to look at the most difficult contours and intractable drawings ... Painters on the road, I seize nature and place it in your hands!" It is somewhat ironic, then, that this modernist is best known for the passionately detailed photographs he made of these ancient ruins.

J. F. Michiels
Prussian,
b. Belgium,
1823–1887

Lateral View of the
Franc de Bruges
Taken from the Pont
du Moulin, ca. 1853

Salted paper print
GIFT OF EASTMAN
KODAK COMPANY,
EX-COLLECTION
GABRIEL CROMER
81:1640:0001

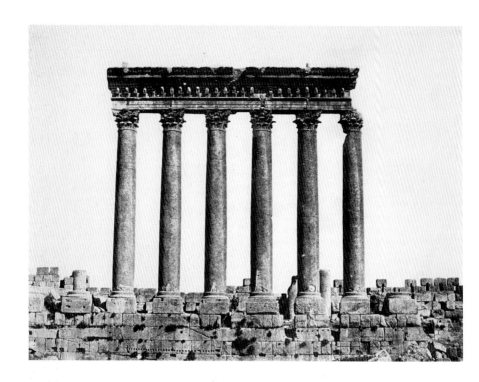

Maxime Du Camp
French, 1822–1894

Syrie. Baalbeck [*sic*] (Héliopolis) Colonnade du Temple di Soleil (Syria: Baalbek (Heliopolis) Colonnade of the Temple of the Sun), 1849–1851

Salted paper print
GIFT OF EASTMAN
KODAK COMPANY,
EX-COLLECTION
GABRIEL CROMER
LIBRARY COLLECTION
79:0031:0054

Du Camp built his early reputation on his travels and made this trip having learned photography from Le Gray. The calotype process was lighter and more portable than the daguerreotype and was well suited to expeditionary photography. Initially his attempts met with technical failure, until a fellow traveler introduced him to Blanquart-Evrard's improvement on the calotype, which improved his results considerably. In 1852 Blanquart-Evrard published Du Camp's *Egypte, Nubie, Palestine et Syrie; dessins photographiques recueilles pendant les années 1849, 1850, et 1851, accompagnes d'un texte explicatif et précédes d'une Maxime Du Camp ...*, in which 125 photographs by Du Camp appeared. These views, "Syrie. Baalbeck (Héliopolis) Colonnade du Temple du Soleil," and "Thèbes. Palais de Karnak. Piliers Devant le Sanctuaire de Granit," were included in volumes two and one, respectively, of the publication, now housed in the Menschel Library. The photographs made on this trip were Du Camp's only foray into photography.

Maxime Du Camp

Thèbes. Palais de
Karnak. Piliers de-
vant le Sanctuaire
de Granit (Thebes.
Palace of Karnak.
Pillars in Front of the
Granite Sanctuary),
1849–1851

Salted paper print

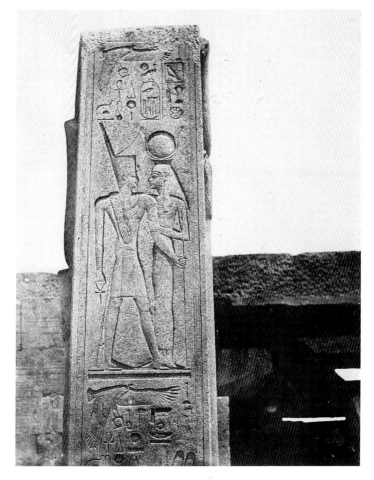

Genevieve-Elisabeth Disdéri, née Francart, was the wife of André-Adolphe-Eugène Disdéri, inventor of the carte-de-visite photograph. They were married in 1843, and the family moved to the seaside town of Brest in 1848, where A.-A.-E. Disdéri opened his first photographic studio. Mme. Disdéri collaborated with her husband on portrait sittings. After he left Brest in 1852, she ran her own studio until the late 1860s, producing cartes-de-visite with the assistance of employees and other family members. She is one of France's few known female photographers whose work has survived, and Eastman House, with 28 photographic prints, is the only public collection with holdings of her work. Evidencing her considerable talent, in 1856 Mme. Disdéri published these two images, "Cimetière de Plougastel, groupe de paysans," of a group of peasants visiting loved ones' graves; and "Interior of St. Mathieu" in the portfolio *Brest et ses environs*. In 1872 Mme. Disdéri moved to Paris and set up a studio in competition with her husband's. She maintained this studio until her death in 1878.

Giacomo Caneva
Italian, 1810–1890

Landscape, ca. 1855

Salted paper print.
79:1998:0003

Italian artist Giacomo Caneva moved to Rome from Venice in 1838. He originally used the daguerreotype process and first gained recognition for his photography around 1850. Caneva was associated with a group of amateur photographers including Count Frederic A. Flacheron and Eugène Constant, who met at the Caffe Greco in the Piazza di Spagna to exchange information and ideas about photography. Caneva later turned professional, selling his views of Rome and its environs, which he published in 1855. He also published a practical treatise on photographic processes and compiled a catalogue of Tommaso Cuccioni's photographic material after Cuccioni's death. Ten calotypes of Italian views by Caneva are in the Eastman House collection, including this landscape of a still lake surrounded by bare winter trees, which fits into the Romantic picturesque tradition of landscape.

The precise clarity of collodion on glass negatives began to replace the slower, more nuanced calotype paper negative in the mid-1850s, especially following the Universal Exposition in 1855, where the Bisson

Frères won a first-class medal for their albumen prints from glass negatives. Commercial tastes hungered for the glass negative, and photographers rose to meet the demand. Albumen prints followed soon thereafter, replacing salt prints as the preferred medium. Édouard Fierlants, also known as Edmond, was a Belgian photographer specializing in topographical and architectural views. The Eastman House collection contains 17 such works by Fierlants, primarily scenes in Brussels, and more than 100 reproductions of works of art. Fierlants was the first in Belgium to reproduce paintings photographically, and he founded the Société Royale Belge de Photographie around 1861. His photograph of the Hôpital St. Jean in Bruges shows the chapel of the medieval hospital reflected in the canal, which has risen to flood levels around it. Charles Baudelaire called Bruges a "phantom city, mummified city," and this haunting image evokes his description.

The Bisson Frères were Louis-Auguste and Auguste-Rosalie. Louis-Auguste, an architect, had learned daguerreotypy directly from Daguerre

Édouard Fierlants
Belgian, 1819–1869

Hôpital St. Jean,
Bruges,
ca. 1860–1862

*Albumen print,
varnished with gelatin*
GIFT OF EASTMAN
KODAK COMPANY,
EX-COLLECTION
GABRIEL CROMER
70:0049:0021

himself and soon after established one of the earliest professional studios, Bisson Père et Fils, in Paris. He used the daguerreotype through the 1850s and went directly to the large-format, glass-negative processes in 1853, bypassing paper negatives entirely. In 1858 and 1860 the brothers unsuccessfully attempted to ascend Mont Blanc (at 15,781 feet the highest peak in the Alps) to photograph its summit, providing its audience with a spectacular view of a world that few people would ever experience firsthand. Nevertheless, they made photographs during the 1860 expedition, including "Pyramide de l'Impératrice, Mer de Glace," which they published in the album *Haute-Savoie, Le Mont Blanc et ses glaciers, souvenir du voyage de LL. M. M. L'Empereur et L'Impératrice.* A copy of the album, consisting of 24 views created to commemorate Emperor Napoleon III and Empress Eugenie's 1860 visit to Switzerland, is in the Eastman House collection. At one time, this album was in the library of the empress and emperor's palace at Campeigne.

Auguste-Rosalie Bisson made "Ascension au Mont-Blanc" during his first successful ascent, with the assistance of a guide and 25 porters to carry his photographic equipment, including a portable darkroom tent. Because of the treacherous conditions, he made only three exposures at the summit. The brothers sold their studio in 1864; Louis-Auguste retired, and Auguste-Rosalie went to work for other photographers.

Bisson Frères

Ascension au
Mont-Blanc, 1860

Albumen print
GIFT OF EASTMAN
KODAK COMPANY,
EX-COLLECTION
GABRIEL CROMER
81:1014:0016

Bisson Frères
French, active
1841–1864

Pyramide de
l'Impératrice,
Mer de Glace
(The Pyramid
of the Empress,
Sea of Ice), 1860

Albumen print
GIFT OF EASTMAN
KODAK COMPANY,
EX-COLLECTION
GABRIEL CROMER
81:1014:0015

An Even Greater Measure

Italy – Rome

James Anderson
Italian, b. England,
1813–1877

Foro romano,
ca. 1860

Albumen print
MUSEUM PURCHASE,
EX-COLLECTION
WADSWORTH
LIBRARY
76:0336:0032

The subject of these two views, the Roman Forum, was at the heart of the Roman Empire. Nearly 2,000 years later Rome had become the center of a large tourism industry due to its historical importance. A cultural magnet for scholars, artists, and tourists, the city was able to support almost 750 photographers who made at least part of their living by selling views of the city to the never-ending stream of visitors between 1840 and 1915. The Eastman House collection contains more than 1,000 photographs of Rome taken during that time, ranging from daguerreotypes and paper negatives to lantern slides and snapshots. Competition was fierce, and at times it seems as if view photographers were placing their tripod legs into the holes created by previous photographers at favored sites, which lends a generic quality to much of this work. Nevertheless, the work of some photographers did stand out.

Unidentified photographer
French?,
active ca. 1880s

Temple de la
Fortune, ca. 1880

Albumen print
GIFT OF EASTMAN
KODAK COMPANY,
EX-COLLECTION
GABRIEL CROMER
73:0208:0006

James Anderson studied painting before moving to Rome to make
miniature bronze copies of the city's sculptures. In 1853 he opened
a studio to make photographic reproductions of Rome's many
works of art as well as photographs of the city's monuments and
views, which he did with diligence and skill through the remainder
of the century.

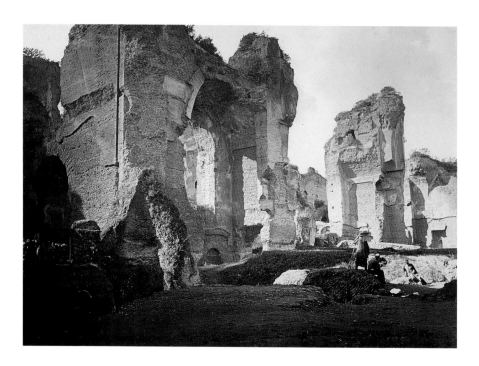

This picturesque view of a group standing amid the ruins of Cara-
calla's Baths reveals Gioacchino Altobelli and Pompeo Molins's artistic
training. Both had studied to be painters before taking up photography
and forming a commercial partnership that lasted from 1858 to 1865.
Their Piranesiesque compositions and dramatic use of light and shade
impart an artistic quality that raises their photographs beyond topo-
graphic description. Altobelli and Molins provided a Romantic air of
faded grandeur to their depiction of Rome's ruins, a mood sought out
by many of Rome's visitors.

Highly demanded by tourists, images of the ruins of the classical past
were first in priority for view makers. These photographs were followed
in popularity by views of ecclesiastical or Renaissance architecture and
monuments and copies of the many works of art gracing the city. Views
of the modern city of Rome would come much later and were a minor
part of this body of the topological genre.

This wonderful view of a modest shop tucked into the corner of the
much grander architectural remains of the Theater of Marcellus was

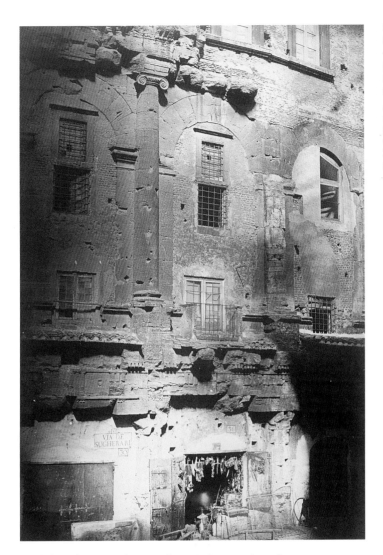

Robert MacPherson
Scottish, 1811–1872

The Theatre of
Marcellus, from the
Piazza Montanara,
ca. 1858

Albumen print
MUSEUM PURCHASE,
EX-COLLECTION
WADSWORTH
LIBRARY
76:0020:0038

made by Robert MacPherson about 1858, approximately seven years
after he had taken up the craft that he would later turn into an art and
would become his life's endeavor.

MacPherson studied medicine, then painting, in his native Scotland
before visiting and falling in love with Rome in 1840. He settled there,
converted to Catholicism, and became an active part of the arts

community that flourished there at the time. After he married in 1851 MacPherson learned the new system of photography on glass to "better his fortunes." He quickly established himself as a leading photographer of Roman antiquities and Italian landscapes. Over the next decade MacPherson built up a collection of views of Rome and vicinity, as in the dramatic view of the "Temple of the Sibyl" and the mysterious image of the "Grotto of the Sibyl," which are among the 61 photographs by MacPherson held by the museum. His photographs lent a feeling of grandeur to the remains of the classical past, and so they were well received by those schooled in a Romantic aesthetic sensibility. His work gained an international reputation among the more sophisticated tourists visiting Rome, and at mid-century his work was always considered superior to the average: "... the subjects chosen with fine taste and the pictures executed with skill and delicacy ... Mr. MacPherson's name alone is sufficient guarantee for their artistic excellence."

Unlike the growing list of dozens of topographic view photographers in Rome, many of whom would establish large commercial companies in the 1860s and 1870s, MacPherson continued to operate on an individual, almost personal level. He never released or sold his negatives to distributors or indulged in the other mass marketing or distribution schemes that expanded and commercialized photographic practice in the 1860s. MacPherson's career flourished through the 1860s, and his home was the lively center of a constant stream of artists, patrons, and foreign and Italian visitors. But his good fortune began to wane towards the end of the decade. He seems to have often been ill and needed money. He died in 1872, "... leaving no provision for his wife and family," however his work remains still some of the best photographs ever taken of The Eternal City.

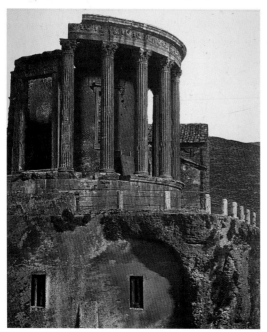

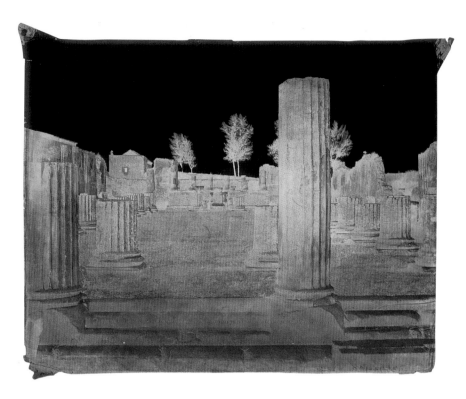

John Shaw Smith
Irish, 1811–1873

Basilica Ruins,
September 1851

Calotype negative
GIFT OF ALDEN
SCOTT BOYER
81:1683:0148

Italy – Pompeii

During the 19th century Pompeii drew its share of wealthy foreign visitors who were on the Grand Tour, an extended trip to monuments and sites that were considered to be the greatest achievements of Western civilization. Photographers, therefore, were eager to provide a bounty of images for tourists to take home. These two photographs convey some of the range of Pompeii's attractions to an ever-increasing tourist class.

John Shaw Smith was a wealthy Irish landowner whose amateur avocation of photography apparently did not survive the decade of the 1850s. More than 300 of the approximately 370 images known to have been made by Smith were taken in the early 1850s during his two-year tour down the Italian coast and through the Mediterranean region, Egypt, and the Holy Land. The museum holds 22 calotype negatives made by Smith during his visit to Pompeii in 1851.

This view depicts a Victorian gentleman lounging comfortably amid the

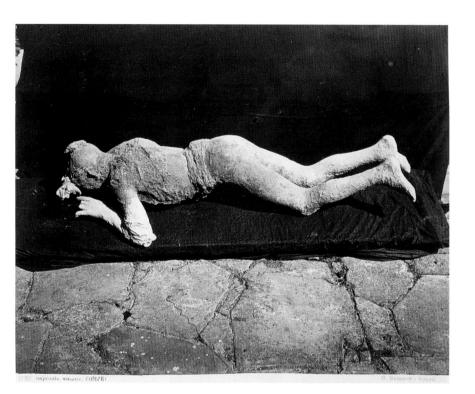

imprunte umane. POMPEI O. Sommer - Napoli

rows of elegant columns that embody the idea and the authority of the classical past – history that was literally dug up and recovered in time to help define and buttress the aspirations and ideals of the major industrialized nations of Western Europe, many of which were intent on empire building.

The second photograph was made by the highly regarded professional photographer Giorgio Sommer, a German who opened a commercial studio in Naples in 1857. He and his employees traveled all over Italy, Malta, Tunisia, Switzerland, and Austria during the next 50 years, making thousands of views for the tourist trade. Sommer photographed Mt. Vesuvius and Pompeii several times between 1865 and 1885. The museum holds 100 of these views among its total collection of 350 Sommer photographs in the form of album-sized albumen prints, stereo cards, cabinet cards, and lantern slides.

By the 1880s steamships and railroads had made travel available to people from a wider range of socioeconomic backgrounds. And for those

Giorgio Sommer
Italian, b. Germany,
1834–1914

Impronte umane.
Pompei (Human
Imprint, Pompeii),
ca. 1880s

Albumen print
GIFT OF MRS.
V. NEUSCHELER
87:0344:0002

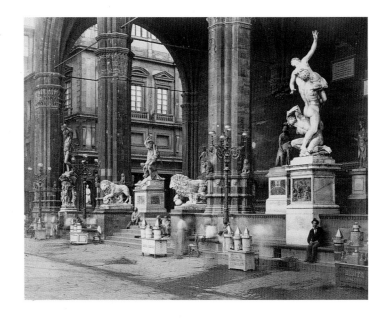

Giorgio Sommer
Italian, b. Germany,
1834–1914

Loggia dei Lanzi,
Firenze, ca. 1880

Albumen print
GIFT OF 3M COM-
PANY, EX-COLLEC-
TION LOUIS
WALTON SIPLEY
77:0194:0001

tourists with less regal concerns and aspirations than Smith's Victorian
gentleman, there is Sommer's spectral floating figure, a bizarre example
of a sculptural casting technique that provides its own *frisson*. Pompeii,
historically famous as a site of destruction and death since 79 A.D., al-
lowed tourists to experience the darker fringes of a Romantic sensibility.

Italy – Florence
This view of classical sculpture littering a square in Florence (above)
is another example of the type of photograph that brought financial
and critical success to Giorgio Sommer's studio.

Fratelli Alinari
Italian, active
ca. 1854

Il portico degli Uffizi
e il Palazzo Vecchio,
ca. 1860

Albumen print
MUSEUM PURCHASE,
EX-COLLECTION
WADSWORTH
LIBRARY
76:0020:0023

By the 1880s photographic technologies had improved to the extent
that it was possible to successfully capture all the tones and qualities
and most of the moving figures in this complex, layered image and pre-
sent them with deceptively straightforward simplicity. At that time there
were so many competing views of the various buildings and monuments
of every Italian city that Sommer was forced to pursue the idiosyncratic
viewpoint from which he made this charming image, even though his
studio already had 10, 20, or an even greater number of more "informa-
tional" views of this area, its buildings, and its sculptures in stock.

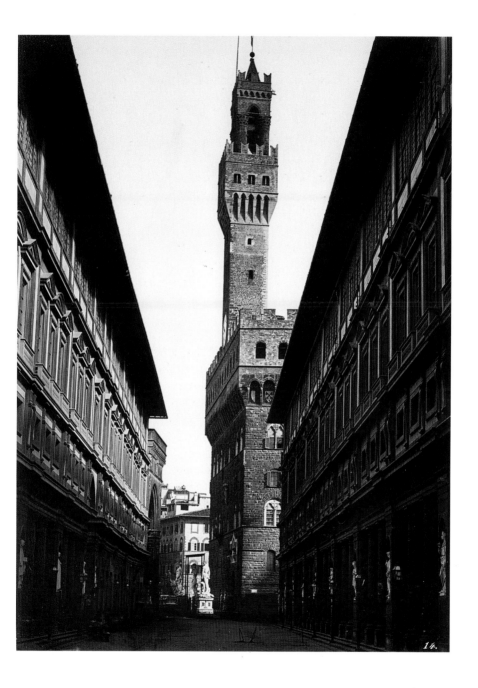

14.

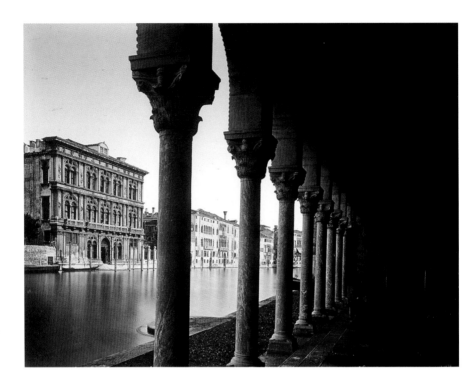

Carlo Naya
Italian, 1816–1882

Venezia. Portico
of the Fondaco
(Warehouse) dei
turchi and Palace
Vendramin on the
Grand Canal, 1875

Albumen print
78:0662:0013

The photograph of the Uffizi Gate (page 149) is one of 500 prints in
the museum's collection taken by the Fratelli Alinari – three brothers,
their sons, families, dependents, and employees – who opened a
small studio in Florence in 1852 and built it into a major family-owned
business, employing over 100 people by 1880. The concern became a
major producer and distributor of topographic views and photographic
reproductions of art and architecture in Italy. Nearly 400 of the muse-
um's Alinari prints are reproductions of art objects. Many came as part
of the Alvin Langdon Coburn collection.

Italy – Venice
Venice was one of the key cities on the Grand Tour and had drawn a
steady stream of tourists since the 18th century. Generations of artists
had made their livings by creating and selling views of the city. In the
mid-1850s photographs, being easier and cheaper to produce, gradually
began to supplant the earlier printing technologies of etching and

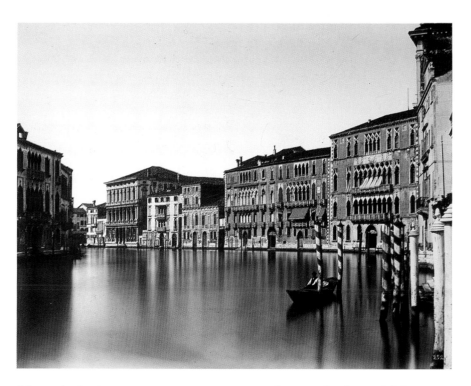

lithography. For the most part, camera operators simply recapitulated earlier subjects, viewpoints, and interpretations as best they could with the new medium. These two views of Venice are from the album *Ricordo di Venezia* published by Carlo Naya in 1875. The 20 photographs in this album complement the 150 other photographs by Carlo Naya owned by the museum. Carlo Naya, the son of a wealthy landowner, took a degree in jurisprudence at the University of Pisa in 1840, then traveled with his brother for 15 years throughout Europe, Asia, and Africa. After his brother's death and when he was over 40 years old, he moved to Venice in 1857. At some point during these travels, Naya practiced photography as an amateur.

After settling in Venice, Naya decided to become a professional photographer. He briefly published and distributed his views of Venice through the established studio of Carlo Ponti, a business arrangement that did not last long and ended badly, with both parties litigious until Naya's death in 1882. In 1868 Naya opened a larger photographic shop

Carlo Naya

Venezia. Palaces Foscari, Giustinian and Rezzonico, on the Grand Canal, 1875

Albumen print
78:0662:0010

in the Piazza San Marco, and his business grew to rival Ponti's. Edward Wilson, possibly the most experienced and knowledgeable writer on photography of that era, briefly described Naya's studio at his death in 1882 as: "... the largest establishment we think we ever saw devoted to photography, in an old palace on the other side of the grand canal." Naya and Ponti's firms were considered the leading photographic concerns in the city throughout the second half of the century. Naya employed a large staff, including Tommaso Filippi, his principal cameraman, who probably took many of the photographs in Venice after the 1860s, while Naya continued to travel and photograph throughout Italy.

The photographs on this and the three following pages are among the 85 attributed to Carlo Ponti in the museum's photography collection. They show something of the range of Ponti's work, a range that would have been considered very broad by his contemporary viewers, who were precisely aware of different "categories" of landscape. The "Detail of the Ducal Palace" and "Bridge of Sighs" (page 155) would have been read as architectural views and considered to be almost technical studies; the "View of the Wharf and Ducal Palace" would have been regarded a picturesque landscape to be viewed for pleasure, and the day and night views of St. Mark's Square (page 154) would have been deemed as entertainment for tourists.

Carlo Ponti moved from Switzerland to Venice in the early 1850s and sold optical and photographic instruments, some of his own design. He also became the first major dealer of photographic views in Venice. Like the more famous Mathew Brady, it is possible that Ponti may have taken very few of the photographs that bear his name. Rather, he organized a large and efficient printing, distribution, and sales system for photographic prints and frequently hired or

Attributed to Carlo Ponti
Italian, b. Switzerland, ca. 1823–1893

Detail of the Ducal Palace, Venice, ca. 1862

Albumen print
MUSEUM PURCHASE
76:0020:0078

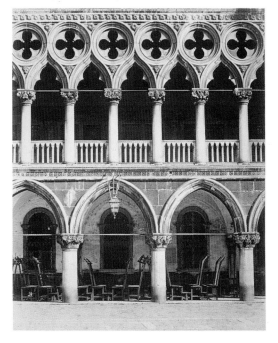

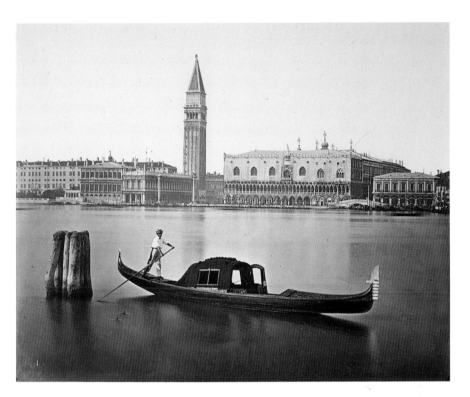

purchased negatives from other photographers and then distributed them under his own name, a customary practice. The Venetian photographers Giuseppi Bresolin, Giovanni Brusa, and Paolo Salviati, now virtually unknown, were a few of the actual makers of the photographic views that brought an early international fame to the Carlo Ponti studio.

Carlo Ponti developed and sold various devices for viewing photographs, all given such resounding names as the Alethoscope, the Graphoscope, and the Megalethoscope. The Megalethoscope, which won him a coveted gold medal in the 1862 World Exhibition in London, was a photographic viewer designed to display large prints that could be viewed first by reflected light, then by transmitted light from the back (see page 154). The 11 x 14-inch albumen prints were stretched over a wooden frame, with selected areas on the back of the print broadly painted or drawn upon by hand. When viewed from the front, the coloring could not be seen. Increasing the light behind the print made it translucent enough to allow the color and

Attributed to Carlo Ponti

Veduta del molo e palazzo ducale con la gondola (View of the Wharf and Ducal Palace by Gondola), ca. 1870

Albumen print
MUSEUM PURCHASE, EX-COLLECTION WADSWORTH LIBRARY
82:2007:0004

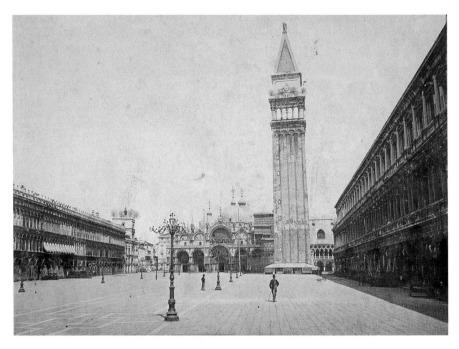

(above and left)
Attributed to
Carlo Ponti
Italian, b. Switzer-
land, ca. 1823–1893

Place St. Marc
avec l'église. Venise
(Square and Church
of St. Mark. Venice),
ca. 1875

*Albumen print with
applied color (Mega-
lethoscope slide)*
84:0852:0013

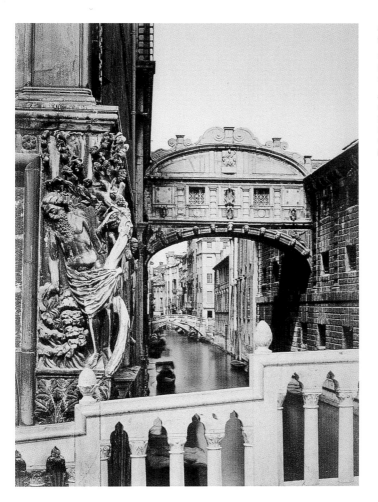

**Attributed to
Carlo Ponti**

*Bridge of Sighs, on
Canal of Canonica,*
1864

Albumen print
GIFT OF EASTMAN
KODAK COMPANY,
EX-COLLECTION
GABRIEL CROMER
81:0944:0017

drawing to show through, causing a visual transformation. The effect produced an illusion of change by simulating the passage of time, just as Daguerre's dioramas had done years before. These pictures could be especially vivid, as seen here in Ponti's imaginative view of a festive night scene, which photography was still incapable of recording. These novelties were popular with the tourist trade and were a valuable weapon in Ponti's arsenal in a business that was both crowded and competitive. The museum holds 135 Megalethoscope views, most of them Italian scenes.

B354 Ascent of Great Pyramid Cheops. The blocks are upwards 3 ft. in height & the traveller will find the assistance of guides acceptable. Escorted usually by 3 Bedouins, one holding each hand and a third who pushes behind the traveller begins the ascent of the large granite blocks. The space at the top measures about 12 sq. yds. in area

so that there is abundant room for a large party of visitors.

The Middle East – Egypt

Every European or American with an education felt that the foundations of their culture were based on the ideas of classical Greece and Rome and on the ideals of the Christian religion, which had sprung out of the rocky wastes fronting the Mediterranean Sea. Throughout the 19th century the force of religious belief pervaded the structure of educated thought in a way that is difficult to appreciate today. There was a literature of travelogues for the "Holy Lands," and tourists braved the difficulties to experience these significant places firsthand.

A flood of photographers washed through the Middle and Near East during the second half of the 19th century, and more than 250 of them are known to have photographed there before 1885. In the 1850s the first photographers tended to be either wealthy amateurs, such as John B. Greene, Leawitt Hunt, and John Shaw Smith, who could afford to support the expenses of both their trip and of their avocation of photography, or individuals, including Louis De Clercq and Maxime Du Camp, who received official or semi-official backing from various governmental or academic bodies.

During the 1860s and 1870s indigenous professional photographers, such as J. Pascal Sébah, opened shops in those cities that had become major tourist centers. This view by Sébah of tourists being pushed and pulled up Cheops' pyramid is from a set of four albums titled *Berlin to Cairo*, which were gathered together by a tourist to record their trip with photographs purchased at stops in each city along the way. Since the prosperity of these professional studios depended upon the quantity and variety of their picture files from which tourists would select the photographs that appealed to their specific tastes, the best of these studios steadily and continuously added images to their collections.

J. Pascal Sébah owned one of the largest studios in Constantinople from the 1870s to the 1890s, yet he also constantly sent photographers into Egypt or purchased negatives taken in Egypt until his stock of views reached over 400 items. The continued presence of indigenous studios, whose familiarity with local customs and languages allowed access not otherwise available to traveling tourists and photographers, expanded the corpus of imagery from these regions. Some of these studios, such as the J. Pascal Sébah Studio and the Abdullah Frères in Constantinople, or the Bonfils Studio in Beirut, gained acclaim and in effect became international businesses that often flourished into the 20th century.

J. Pascal Sébah
Turkish, 1838–1890

Ascention de la
Pyramide Cheops,
ca. 1885

Albumen print
GIFT OF MRS.
PHIL PORTER
86:0309:0094

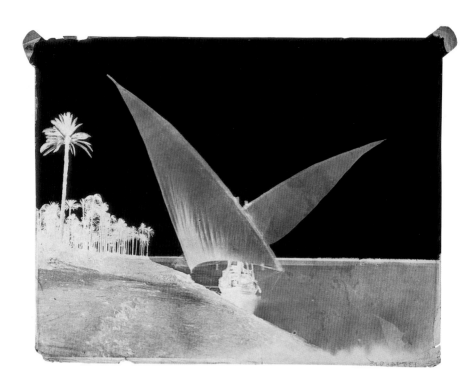

John Shaw Smith
Irish, 1811–1873

Nile, ca. 1851–1852

Calotype negative
GIFT OF ALDEN
SCOTT BOYER
81:1683:0218

Photographic practice expanded enormously in the early 1850s as modifications and improvements made to Talbot's calotype process and, later, the development of a difficult but practical wet-collodion process brought many more photographers to the medium. The sovereign virtue of these various processes was that they, unlike the daguerreotype, produced a negative image from which multiple positive prints could be made and sold, thus making landscape photography a potentially viable business.

The George Eastman House collection holds almost 600 paper negatives taken by various photographers during the early 1850s. More than 260 of these and almost 100 salt or albumen prints made from those negatives are by John Shaw Smith, most of them taken during his trip through Italy and the Mediterranean basin from December 1850 to May 1852. This collection affords a unique opportunity to follow this early photographer's working methods.

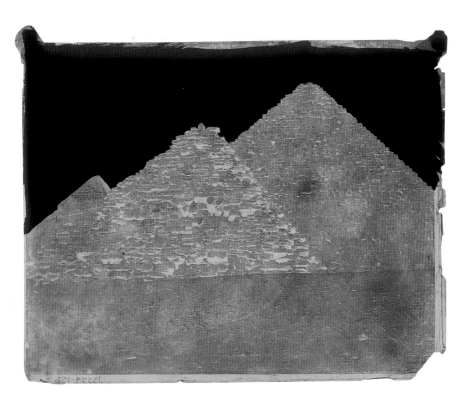

A wealthy amateur, Smith could photograph whatever he liked, and he used his camera almost exclusively to document ruined buildings of the ancient past. There are only three or four landscapes without architecture, just as there are only three or four images containing human figures. Smith approached his viewmaking in an orderly fashion, often taking a distant view that situates the architectural structure in its surrounding terrain, then moving closer, then even closer for a detailed picture. He was attracted to strong, simple forms, which he balanced superbly within and against the borders of his pictures to achieve a perspective more forceful and frequently more graceful than the typical topographic view. The dynamic juxtaposition of the sails of the boat silhouetted against the sky, the shore, and the waters of the Nile forms a complex grouping of overlapping triangles. This conveys a sense of improbable and precarious balance, which might well have been what riding on the Nile in such boats felt like to Smith.

John Shaw Smith

Two Small Pyramids, Pyramid of Ekphrenes in Distance, February 1852

Calotype negative
GIFT OF ALDEN
SCOTT BOYER
81:1683:0156

The son of a wealthy American banker living in Paris, John B. Greene shared with many of France's artist-savants a passionate interest in Egyptology. In 1853 he set out on the first of three self-financed expeditions to Egypt and Syria to collect "archaeological, historical and geographic information of interest." On these trips Greene used Gustave Le Gray's waxed-paper process to make a few hundred paper photographs, which he divided into two categories, Monuments and Landscapes. Greene died unexpectedly in 1856, at age 24, during his third trip to Egypt.

Greene was either a very bad photographer or a very good one. Most new photographers, when first faced with the problem of photographing a large scene, place the central subject of the view so far away and surrounded by so much empty space that its emotional impact is diluted and lost. Every professional photographer knows tricks to overcome this problem by moving in closer, changing the angle to get a more dramatic perspective, or introducing an additional element to make a more exciting picture. In this photograph Greene accepted the huge empty skies, the barren horizons, the desolate ruins smothered in the drifting sands of the desert, the futile works of man overwhelmed by time and fate. And the soft, granular, faded quality of his salted paper print lends

John B. Greene
American, b. France,
1832–1856

Bords du Nil à Tèbes
[*sic*] (The Banks of
the Nile at Thebes),
1854

Salted paper print
MUSEUM PURCHASE,
CHARINA FOUNDA-
TION PURCHASE
FUND
92:0384:0001

Leawitt Hunt
American, active
1851–1852

Convent of
Mt. Sinai, ca. 1850

Salted paper print
MUSEUM PURCHASE
76:0020:0064

a feeling of time's passage as well. So, do these romantic, expressive images of a dead civilization result from bad technique and happy accident, or are they the crafted result of an exceptional young man with the vision to do all the wrong things to make all the right pictures?

Leawitt Hunt was the youngest of five children brought to Europe in the 1840s by their widowed, wealthy mother, described by a contemporary as "… a woman of rare mental power and force of character." For ten years the family, either all together or in shifting pairs, traveled and studied extensively throughout Italy, France, England, Switzerland, and Germany.

Leawitt Hunt, 21 years old in the winter of 1851, cultured, and sophisticated, celebrated his obtaining a law degree at the University of Heidelberg in the manner customary to his family – by traveling. On this journey Hunt crossed the Mediterranean Sea to Egypt, then went on to the Levant and east to Damascus. An ardent practitioner of the newly fashionable hobby of photography, Hunt brought his camera and made the first photographs taken in Egypt by an American. Leawitt's older brother Richard Morris Hunt, who would become one of the leading American architects of the 19th century, followed his brother's itinerary a year later, also bringing a camera and making photographs of ancient sites.

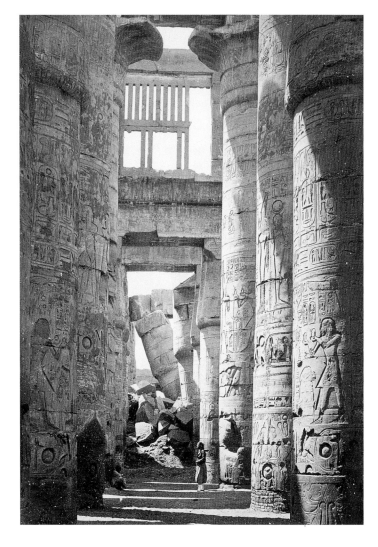

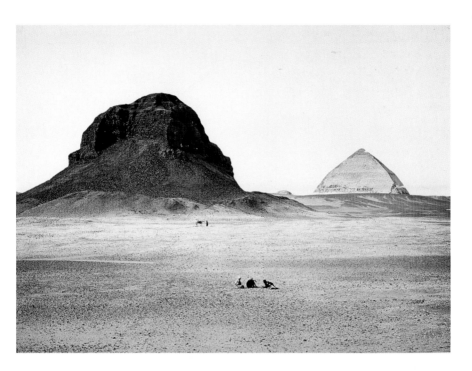

Starting at 16 as an apprentice in Liverpool, Francis Frith proved to be an excellent businessman who established and then sold several businesses to his advantage, so that in 1856, at age 34, he was able to retire from business comfortably well off. During this time he had also become an amateur photographer. Freed from his business concerns and financially able to support his new pursuit, Frith decided to take a photographic tour through Egypt and the Middle East. "I have chosen as a beginning of my labours, the two most interesting lands of the globe – EGYPT and PALESTINE." Preparing for the arduous travel ahead, Frith bought a steam yacht, then equipped himself with thousands of pounds of photographic equipment and supplies – fragile glass plates, lenses, bottles of chemicals, and all the other apparatus necessary to successfully photograph hundreds of miles away from any resources or support. Afterwards he spent almost two years on a frequently uncomfortable and occasionally dangerous journey photographing under very difficult conditions.

Frith's photographic endeavors proved to be another extraordinarily astute business decision. The photographs from his first trip to Egypt in

Francis Frith

The Pyramids of Dahshoor, from the East, ca. 1858

Albumen print
MUSEUM PURCHASE,
EX-COLLECTION
HELMUT GERNSHEIM
LIBRARY COLLECTION
79:0068:0005

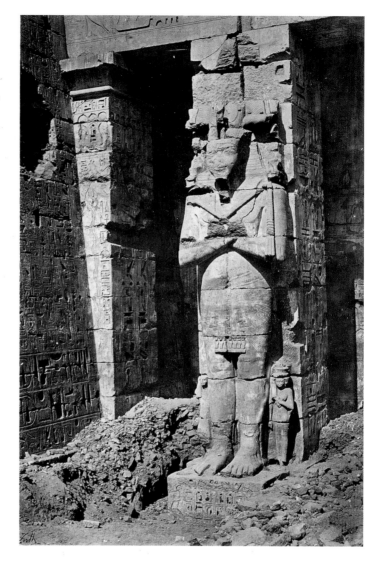

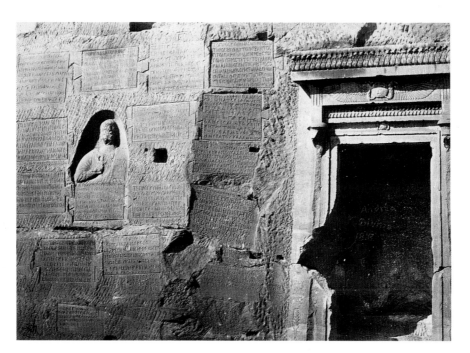

1856 and 1857 attracted great attention and many favorable reviews. His work was distributed in stereo views and then published in a book illustrated with original prints. *Egypt and Palestine Photographed and Described by Francis Frith* formed the keystone for what became an exceptional publishing activity and an extraordinarily successful photographic career throughout the rest of the century. Frith returned to the Middle East twice before 1860 and took photographs in Palestine, Syria, and Egypt. He published nine more books of photographs from these three trips. George Eastman House holds eight of Frith's publications from his Middle Eastern trips, which together contain more than 450 photographs.

Considered to be one of the premier landscape photographers of his generation, he founded the firm Francis Frith & Co., which became one of the largest photographic concerns of the century. By 1870 Francis Frith and other photographers working for the company had taken more than 1,000,000 views throughout the British Isles and continental Europe, and these were published and widely distributed in the form of stereo cards or prints, which were sold singly, in portfolios, or in illustrated books, and were later reproduced as postcards.

Francis Frith

Greek Tablets at
Wady Kardassy –
Nubia, ca. 1857

Albumen print
GIFT OF MRS. ALDEN
SCOTT BOYER
LIBRARY COLLECTION
93:0648:0022

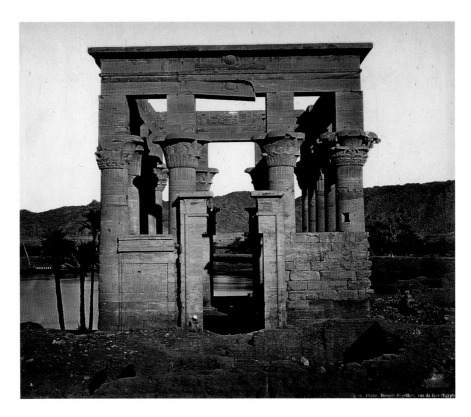

Félix Bonfils
French, 1831–1885

Phyle, Temple
Hypère, vue de face
(Egypte), 1877–1878

Albumen print
MUSEUM PURCHASE
73:0074:0043

Félix Bonfils was born in Saint Hippolyte du Fort, France, in 1831. His son Adrien was born there as well in 1860. Félix had served in the French army occupying Lebanon in 1860. He liked the area and later decided to emigrate. The Bonfils family moved permanently to Beirut in 1867 and opened a photographic studio there. Félix traveled and photographed often throughout Egypt, Palestine, Syria, Greece, and Jerusalem, and by 1871 the studio claimed a stock of 15,000 prints and 9,000 stereo views from almost 600 negatives. The Maison Bonfils grew into a large, active, and financially successful business with branches in Alexandria and Cairo in Egypt, and even in France. Like many such business concerns, they sent their views throughout the 1870s and 1880s to international expositions in Paris, Brussels, and elsewhere, where they won awards. And they published catalogs and retailed their work through dealers in the larger cities of Europe and

34. Antinoé. — Palmier de Cheik-Abaddeh (Egypte)

America so that the Bonfils' name was one often associated with Middle Eastern views to the Western viewer. George Eastman House holds 635 photographs by the Bonfils Studio, among them 350 lantern slides.

In 1878, at age 17, Adrien took charge of photographing while his parents managed the studio, and, of course, as did all larger concerns, the studio hired other photographers to work for them. As is also often seen in the work of other commercial studios, the later photographs bearing the Bonfils name seem to be both more professional in their technical execution and less interesting as images. The earlier Bonfils photographs made by Félix, just as the earlier photographs of Francis Frith or Francis Bedford (even when they are of the same or similar subjects) seem somehow infused with a quality of exploration, a sense of energy, or a simple love of the medium that is not found as frequently in the later work of their studios.

Félix Bonfils

Antinoe. Sheikh Abaddeh's Palm Tree. (Egypt), ca. 1867–1876

Albumen print
MUSEUM PURCHASE
73:0074:0021

Antoine Beato
Italian,
ca. 1825–1903

Island of Philae,
ca. 1870

Albumen print
MUSEUM PURCHASE,
EX-COLLECTION
A. E. MARSHALL
79:0067:0017

The Middle East – Palestine and Syria, Baalbek, Palmyra, Jerusalem
This serene, distant, and lovely view of the Egyptian temples on the island
of Philae was made by Antoine (Antonio) Beato. The museum holds 50
views of Egypt by Antonio Beato, ranging from architectural details to
scenic landscapes. Antonio was the younger brother of Felice Beato and
the brother-in-law of James Robertson, both photographers of note who
formed a partnership and photographed in Constantinople, Athens, the
Crimea, Malta, and the Holy Land from about 1851 until about 1857. It
seems probable that Antonio joined the partnership towards the latter
1850s, then followed his brother to Calcutta in 1858 and opened a studio
there while Felice traveled throughout India, photographing in the wake
of the British army. Antonio returned to open a studio in Cairo in 1860 and
1861. In 1862 he moved to Luxor, which was situated near a series of major
archeological digs. Antonio's studio at Luxor flourished until his death
around 1905, and he became one of the best-known and most respected
photographers of the Middle East while building up a stock of 1,500 nega-
tives, working with archaeologists documenting sites under excavation,
and photographing new finds as well as making views for tourists.

Hippolyte Arnoux established himself as a commercial photographer in Port Said, Egypt, in the mid-1860s and worked there at least through the 1870s. With photographs such as this along with more commonplace scenes of the port and architectural views of Muslim mosques and other buildings, Arnoux established a special niche for himself in the field of view photography. Port Said, at the head of the Suez Canal, was under construction at the time. The building of the Suez Canal was a feat of modern engineering and construction, as important to the expanding world of commerce as the building of the Union Pacific Railroad in the United States, then stretching across the Western frontier.

Arnoux transformed a boat into a floating darkroom from which he periodically documented the construction of the canal until its completion in 1869. The scale of the project made the canal itself a tourist attraction, and Arnoux's photographs of the modern engineering marvel (in effect, a form of industrial photography) could in some measure

Hippolyte Arnoux
French, active
1860s–1880s

Phare de Port-Said,
ca. 1869

Albumen print
MUSEUM PURCHASE,
EX-COLLECTION
A. E. MARSHALL
79:0056:0006

Félix Bonfils
French, 1831–1885

Baalbek. Chapel
of Douris,
ca. 1861–1871

Albumen print
MUSEUM COLLEC-
TION, BY EXCHANGE
74:0196:0073

compete with the more traditional views of the ancient ruins, then the staple diet of the tourist. The museum holds an album of 25 photographs, *Album du Canal, Port Said,* published by Arnoux.

Generations of tourists drawn to Syria and Palestine seem to have had a similar response – dismay at the present condition of these countries mingled with awe at their rich and varied past. "The land has sadly declined, its commerce depreciated, and its industries and high civilization no longer exist ...", but nevertheless, tourists still came. "Palestine will always continue an object of sacred interest, as the land of the Bible, of the Prophets, Patriarchs and Kings, the land where our Savior was born. ..."

Along with over 500 other photographs by the Bonfils Studio, the museum holds an album published in 1878 titled *Souvenirs d'Orient. Album pittoresque ... Photographie par Félix Bonfils,* which has this statement in the foreword: "The Orient, with the most splendid ruins in the world,... is here revealed in all its splendor. Grandiose conceptions of the Pharaohs, places made famous by the Prophets, Christ and his

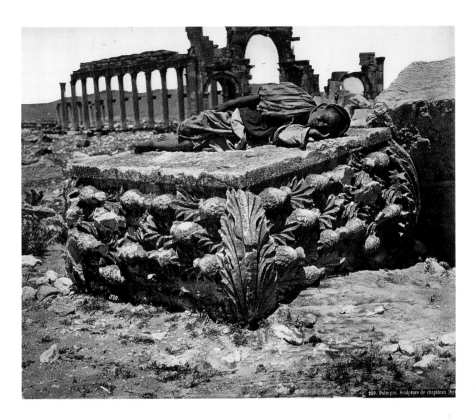

239. Palmyre. Sculpture de chapiteau [Sy

Apostles, colossal structures of Baalbek, vast horizons of Palmyra; such
is the immense field where the reproducer of so many marvels takes our
vision. ..." While the language is exalted, in fact this listing of marvels is
actually a rather narrow range of subjects, which is far from comprehen-
sive of all that could have been photographed at the time. "Baalbek.
Chapel of Douris," one of 81 prints in the album *Palestine and Syria* held
by the museum, and "Palmyra. A Sculptured Capital, Syria" are both
excellently conceived – even novel – photographs of subjects already
thoroughly known and frequently depicted. The "... vast, world-famous
ruins of Baalbek ..." were first known to Europeans in the 16th century.
A book on Palmyra was published in London in 1696, and at least five
scholarly books on that site alone came out between 1819 and 1877.
The author of the 1874 edition of *Harper's Hand Book for Travellers*
claims that there had been more than 200 books written about the

Félix Bonfils

Palmyra:
A Sculptured Capital,
Syria, ca. 1867–1876

Albumen print
MUSEUM PURCHASE
73:0074:0006

so-called Holy Lands. In other words, the subject matter of Bonfils' photographs had been determined for him well before he was born and before photography was invented.

Bonfils – and every other commercial landscape photographer who wished to stay in business – had to photograph what his customers, the tourists, wished to purchase. And the tourists wanted to see the well-known, established sites. They also wanted to purchase photographs of what they had already seen. Furthermore, they were not looking for images that interpreted those sites too creatively. They wanted the emotional charge from the photograph to reside in their memory of the subject, not in some other person's response to that scene. They wanted a distinct and clearly transcribed image or representation of the objects that they had spent so much time, money, and energy to visit.

So, if both the content (the subject) and its mode of interpretation (the style) of the photographs were defined by criteria outside the photographer's control, how then could a professional excel in his work? First, he had to display the virtues of any good businessperson by providing a good, well-made, and inexpensive product at the right place

Félix Bonfils
French, 1831–1885

Jerusalem.
Damascus Gate,
ca. 1870

Albumen print
MUSEUM COLLEC-
TION, BY EXCHANGE
74:0196:0020

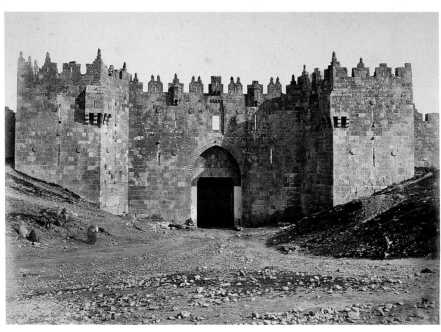

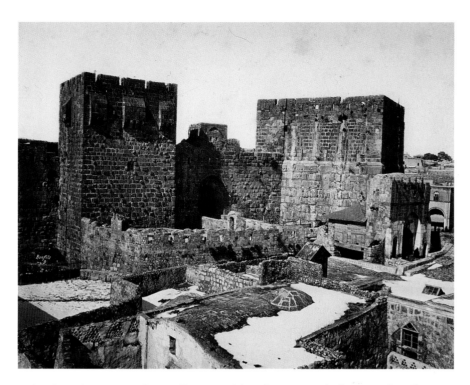

and at the right time. All of the really successful studios were in the big cities, near the hotels and shops that the tourists frequented, and the studios all had exceptionally well-organized mail-order distribution systems in place. The photographer also needed to provide a wide variety of stock to select from, with more and better views of more places, for different tastes and moods. Beyond having those sound business practices, good topographic photographers had to be, in a sense, unobtrusive. They had to place their own private interpretation of a subject aside and adopt a very transparent style or mode of presentation. Their images were there to help define an experience and to enhance a memory of that experience. The best photographers could do this by making the image itself interesting, well composed, and sharply seen, in such a fashion that it allowed viewers a clearer, more coherent, more helpful recollection of what they had experienced or hoped to experience.

Félix Bonfils

Jerusalem. Tower
of David, ca. 1870

Albumen print
MUSEUM COLLEC-
TION, BY EXCHANGE
74:0196:0007

Abdullah Frères
Turkish, active
1850s–1890s

Bain Turc (Vieux
Serail) (Turkish
Bath [Old Harem]),
ca. 1869

Albumen print
MUSEUM PURCHASE
77:0005:0081

The Middle East – Turkey

Three Christian Armenian brothers named Biraderler opened a studio in
Constantinople in 1858. They soon converted to Islam and took the name
Abdullah Frères after being appointed photographers to the court of the
Sultan Abdul Aziz in 1862. The Abdullah Studio specialized first in por-
traiture, however architectural views that were sold to the tourist trade
also made up a portion of their income. These two images of complexly
patterned architectural details are from an album of 96 photographs
titled *Constantinople ancienne et moderne,* by Abdullah Frères. The Ab-
dullah Frères and Hippolyte Arnoux also participated in another kind of
"topographic" photography. These "types and costumes" photographs
formed a secondary body of salable images for the commercial photogra-
pher, becoming an important staple in the studio's income. These genre
portraits were often made by bringing the subjects into the photograph-
er's studio, sometimes even using available "models," dressing them in
different clothes, and posing them in "representative" activities.

Abdullah Frères

Corridor aboutifsant
[*sic*] à Kherkhai-
Sherif (Vieux Serail)
(Abutting Corridor at
Kherkhai-Sherif [Old
Harem]), ca. 1869

Albumen print
MUSEUM PURCHASE
77:0005:0084

Hippolyte Arnoux
French, active 1860s–1880s

*Date-Grower and
Family*, ca. 1875

Albumen print
MUSEUM PURCHASE, EX-COLLECTION
FRED S. LIGHTFOOT
80:0112:0002

Unidentified photographer
French?, active 1880s

North African (?) in Costume,
ca. 1880

Albumen print
GIFT OF ALDEN SCOTT BOYER
83:1367:0001

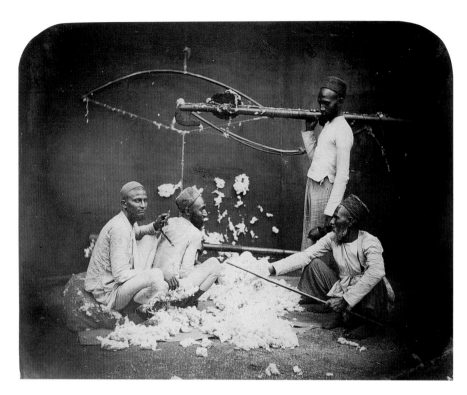

Johnson & Henderson
English?, active 1850s

Costumes and Characters of Western India: Group of Pinjaras, or Cotton-Carders, ca. 1857

Albumen print
MUSEUM PURCHASE, EX-COLLECTION A. E. MARSHALL
79:0065:0012

India

This group of pinjaras, or cotton carders, were demonstrating their craft and trade to the camera of the photographic team of Johnson & Henderson in Bombay sometime in the mid-1850s. During the 1850s, a time of huge expansion of photographic practice, India was under British rule, and the first photographers there were usually British administrators or military officers who took up the medium as a useful hobby or as a tool to aid them in their ethnological or archaeological research.

One such individual, William J. Johnson of the Bombay Civil Service, was a founding member (in 1854) of the Photographic Society of Bombay. He was also co-editor, with W. Henderson, of the *Indian Amateurs Photographic Album,* a work they published in fascicles each month from 1856 to 1868. Each unit contained three original prints by various photographers. George Eastman House holds a cumulated and bound album of this publication, containing 73 photographs by 12 photographers.

Lala Deen Dayal was an extraordinarily intelligent and talented man who, born to a family of modest wealth and position in India in 1844, became recognized as the most accomplished Indian photographer of the 19th century. Dayal entered Thompson's Civil Engineering College in Roorkee in the mid-1860s, successfully completing the five-year course in three years, and, on merit, he obtained a position as an estimator and draftsman in the British administered Public Works Department in the princely state of Indore in Central India. He taught himself photography in 1874, and, with the patronage of top British officials, he was permitted to make portraits of British dignitaries, including the Viceroy of India and, in 1875 and 1876, the visiting Prince of Wales. These photographs brought him local fame and support from the British and Indian upper classes. Broadening his photographic activities, Dayal also took a series of landscapes and views of Indian temples. Building upon his success, Dayal took a two-year furlough to photograph archaeological sites and monuments throughout India. This work was seen and used widely, and prints were accepted by the Archaeological Survey of India and published in several scholarly books as well as in numerous albums, including the album of 124 prints held at George Eastman

Lala Deen Dayal
Indian, 1844–1910

Kalka Temple,
ca. 1890

Albumen print
GIFT OF THE
UNIVERSITY OF
ROCHESTER LIBRARY
82:2736:0111

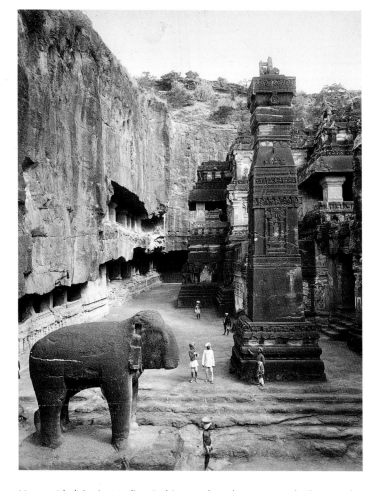

House titled *Ancient Indian Architecture by Lala Deen Dayal, Photographer to H. H. Nizam, Hyderabad, Deccan 1893.*

In 1878 Dayal founded his first studio in Indore, and in 1880 opened shops in Hyderabad and Bombay. More importantly, in the Anglo-Indian social structure of that time, he obtained a continued series of letters of appointment to various high-level dignitaries of the British government, to the court of the Maharajah of Indore, and finally, in 1884, to the court of the Nizam of Hyderabad – the wealthiest, most powerful prince in India. Dayal's court appointment produced a wide range of work

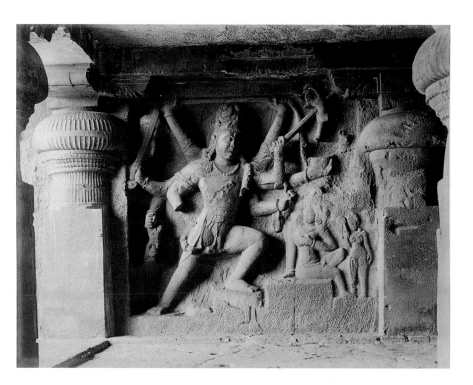

including formal portraits, photographs of official events and functions, and an extensive documentation of activities such as army maneuvers, railroads under construction, and government relief efforts during periods of famine. In 1894 the Nizam bestowed on Dayal the title of Raja Bahadur Mussavir Jung, and in 1896 Dayal opened an expansive studio in Bombay. At the height of Dayal's career, he employed 16 operators, most notably his sons Gyan Chand and Dharam Chand, and 35 additional people in his various studios.

The two images on pages 182 and 183 are among the 354 prints in a magnificent album entitled *Indian Photographs* in the museum's collection. The album, which offers a fascinating look into the diverse range of interests and activities of the upper-class ranks of the Anglo culture in 19th-century India, was probably compiled in the mid-1870s from photographs made by several individuals, among them the amateur photographer Lieutenant W. W. Hooper of the Madras Light Cavalry and the professional photographer Samuel Bourne. "Tiger Hunting – No. 5.

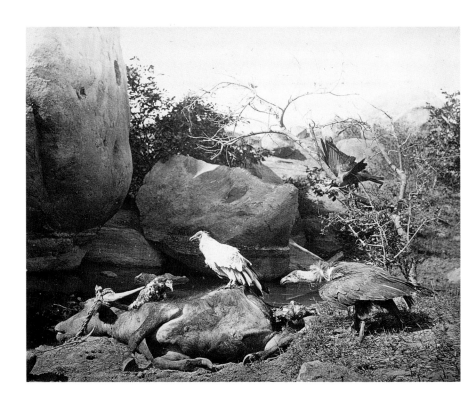

Buffaloe [sic] Killed by Tiger ...” is one image in an unusual narrative sequence recreating the events of a tiger hunt in 12 posed scenes. The birds' intent concentration on their potential dinner kept them fixed in the bright sunlight just long enough for the photographer to capture this unusually candid and arresting moment in nature. “Col. Michael ...” posed with the fossil of an extinct species, is arresting in its own way. This strange image embodies a profound paradigm shift, as it presents an example of the movement of educated practice away from discourse on divine revelation to the observation of the natural world.

The photograph of devastated buildings in Lucknow, India (page 184), was taken by Felice Beato in 1858. Eastman House holds 49 similar photographs taken by Beato during the aftermath of the Indian rebellion of 1858. Felice Beato was photographing in the Middle East when he heard about the uprising and immediately left for Calcutta. Upon his arrival, Beato found the city filled with rumors of incidents and massacres

**Unidentified
photographer**
English?, active
ca. 1870s

Col. Michael, Mili-
tary Secretary to
Government, with
Bones of the Leg
of the Australian
Dinornis, ca. 1872

Albumen print
MUSEUM PURCHASE
79:0032:0052

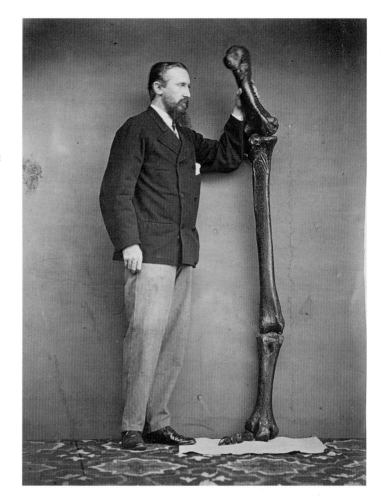

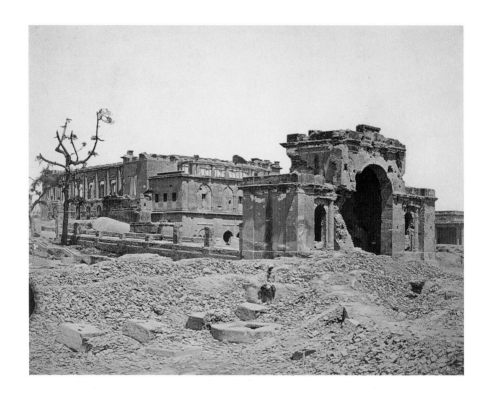

Felice Beato
British, b. Italy,
ca. 1830–ca. 1906

The Baillie
Guard Gateway
and Banquetting
Room, 1858

Albumen print
GIFT OF ALDEN
SCOTT BOYER
81:2937:0039

further upcountry where armed insurgents were still fighting for territorial advantage. Beato quickly joined the British forces in the field and followed the fighting from Cawnpore to Lucknow and back to Cawnpore. He photographed British and loyal Indian military units, the captured Indian prisoners, and the sites of earlier battles – in effect practicing an early form of photojournalism. The final campaign ended in December 1858, and Beato returned to Calcutta in March 1859. He spent the next year traveling throughout India, photographing in Agra, Simla, and Lahore before returning to Calcutta again in February 1860 to accompany the Allied Anglo-French military expedition leaving for North China and the Second Opium War.

This peaceful pastoral (right) was taken in Kashmir by Samuel Bourne in 1864, and is from the album of his works titled *Indian Photographs* now held at George Eastman House. This album contains 41 prints, divided between landscape views and portraits of various ethnic groups in

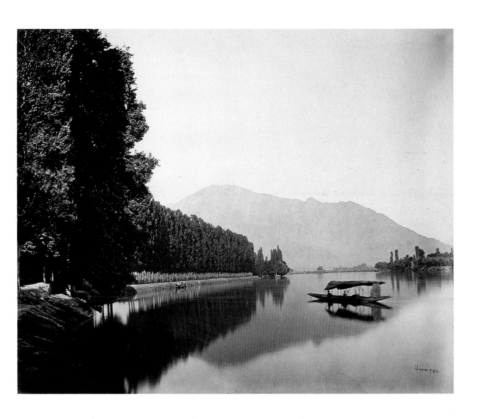

Northern India. Over 100 photographs by Bourne appear in a variety of albums owned by the museum. "Kashmir. Up the Jhelum,..." shows all the felicitous points of a picturesque landscape that calls to mind views of the Lake District in Britain. In fact, it was taken on a 10-month photographic expedition to the area around the Vale of Kashmir in 1864, during which Bourne made almost 500 negatives. He found the region around Srinagar particularly stimulating, as its climate and landscapes reminded him of his homeland. Bourne quit clerking in a Nottingham bank in 1863 and sailed for India to work as a professional landscape photographer, where he traveled and photographed almost incessantly until 1869, before he returned to England and abandoned professional photography.

Samuel Bourne
English, 1834–1912

Kashmir. Up the Jhelum, from below the Island, 1864

Albumen print
GIFT OF EASTMAN KODAK COMPANY, EX-COLLECTION GABRIEL CROMER
79:0004:0035

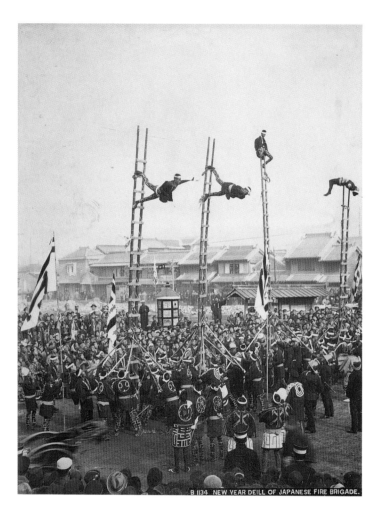

B 1134 NEW YEAR DEILL OF JAPANESE FIRE BRIGADE.

**Attributed to
Kusakabe Kimbei**
Japanese, active
1890s

New Year Deill [*sic*]
of Japanese Fire
Brigade, ca. 1890

*Albumen print with
applied color*
MUSEUM COLLEC-
TION, BY EXCHANGE
74:0034:0016

The Far East – Japan
George Eastman House holds over 500 hand-colored views of Japan.
They are difficult to date accurately because earlier negatives were fre-
quently acquired and reissued by later photographers. The genres of
both "landscape" and "costume or type" portraiture remained stylis-
tically stable over several generations, and accurate chronologies
of Japanese photographers are still being investigated by scholars.

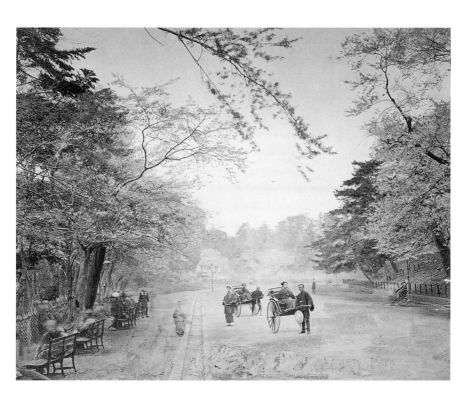

Felice Beato opened the first photographic gallery in Japan in 1863, specializing in "depicting the noted places, scenery, and dress of Japan." In 1866 fire destroyed many of his negatives, but he was still able to publish two volumes of views of Yokohama in 1868. In 1870 he reopened as F. Beato & Co., the studio operated by John Goddard, H. Woolett, and several Japanese photographers during Beato's frequent travels. Beato sold this studio and stock in 1877. The museum owns an album of 51 prints by Beato, including "Public Gardens at Uyeno – Tokiyo."

Kusakabe Kimbei probably worked for Felice Beato in the 1860s and then for his successor in the 1870s before opening his own studio in Yokohama in the 1880s. His photograph of the New Year's drill of the Japanese fire brigade is not only visually exciting and technically adept, it also extends a long tradition of visual documentation of such festivals by the woodblock artist Hokusi and others. Costume

Attributed to Felice Beato & Co.
Italian, 1870–1877

Public Gardens at Uyeno – Tokiyo, ca. 1875

Albumen print with applied color
MUSEUM PURCHASE
79:0059:0036

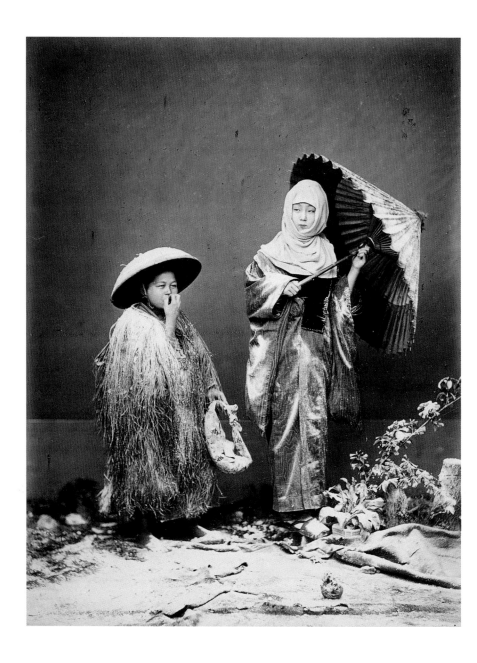

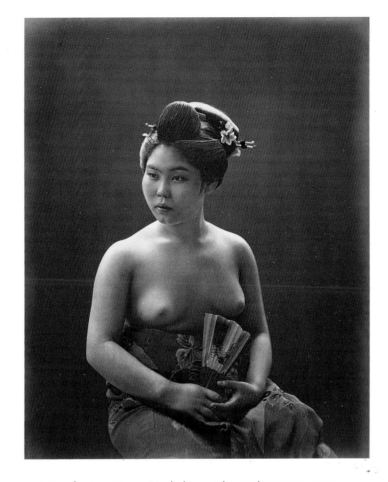

portraits of various "types," including geishas and actresses, were also a staple in the Japanese woodblock tradition. Photographers adeptly incorporated Japanese visual heritage into their photographic work, often with hand-applied color of great range and delicacy.

John Thomson
Scottish, 1837–1921

Physic Street,
Canton, ca. 1869

Albumen print
GIFT OF ALDEN
SCOTT BOYER
73:0219:0091

The Far East – China

John Thomson left Scotland for the Far East in 1865 and spent a decade traveling and photographing in Malaysia, Indochina, Cambodia, and China. Thomson published numerous albums and books including *The Antiquities of Cambodia* and *Illustrations of China and Its People*, both in the museum's Menschel Library. His work in China combines elements of an indefatigable energy, an extremely broad range of cultural interests, and a beautiful visual sensibility for the exotic, making his documentation of this culture both unique and extraordinary. These two photographs demonstrate both Thomson's mastery of light and his ability to transform detailed and complex scenes into well composed and elegant pictures. The raking light of this interior view is illuminating the famous Hall of Saints of the Hua-lin-szu (Wah Lum Chu), or Magnificent Forest Temple, in Canton, noted for containing 500 statues of Buddhist saints.

John Thomson

Wah Lum Chu,
Canton, ca. 1869

Albumen print
GIFT OF ALDEN
SCOTT BOYER
73:0219:0066

The Americas

These two temples representing an ancient and mighty culture at Chichen-Itza in the Yucatán Peninsula also attracted archeological attention, as Egypt's remains had done for generations. Further removed from European culture, both in miles and in heritage, this interest was followed up by fewer individuals but was still pursued with equal passion. Reports of the earliest discoveries and first explorations were accompanied by drawings that seemed inadequate and confusing, particularly since the visual syntax of Meso-American culture was so different from established and well-known European forms.

Désiré Charnay, born and educated in France, was teaching school in New Orleans, Louisiana, in 1850 when he read John Lloyd Stevens' popular accounts of travel in Central America. Enticed by what he read, Charnay first journeyed to France where he learned to photograph and acquired the support of the French Ministry of Public Instruction to

make a trip to the Yucatán. Then, in 1857, he spent eight months travel-
ing around the United States before leaving for Mexico, which was in
the midst of a civil war. Charnay spent ten months in Mexico City before
arriving at his long-sought destination, the Yucatán, where in 1858 and
1860 he photographed the pre-Columbian ruins. In 1861 he returned to
France and published a portfolio titled *Cités et ruines américaines, Mitla,
Palenque, Izamal, Chichen-Itza, Uxmal.* George Eastman House holds a
variant of this work, containing 31 views, including those on these pages.

Spurred on by his passion for little-explored but culturally rich
places, Charnay spent the rest of his life visiting distant countries.
Later, he wrote popular novels based on these experiences. He returned
to Mexico in the mid-1860s and lived there until 1867, when the
Maximilian government collapsed. In 1880 he returned to the Yucatán
yet again and spent two years excavating and photographing pre-
Columbian ruins.

Désiré Charnay

Tiger's Bas-Relief
on a Portion of Ball
Court of Chichen-
Itza, ca. 1857–1861

Albumen print
GIFT OF EASTMAN
KODAK COMPANY,
EX-COLLECTION
GABRIEL CROMER
73:0199:0002

Ricardo Villalba is considered to be one of the most creative photographers working in Peru during the 19th century. He produced a fine album of views of the Southern Railroad, which ran from the coastal plains to the highlands in Peru. He is thought to have run a portrait gallery in Arequipa, Peru, in the mid-1870s. He also made several hundred portraits of working-class subjects – porters, servants, soldiers, etc. – which were sold as "types" in the popular carte-de-visite format and collected in Peru and throughout the world. In the 1870s, he created a rare album of indigenous subjects, now at George Eastman House. This album, identified only with a penciled note as "Indians of Peru & Bolivia – Types & Costumes ...," consists of 192 carte-de-visite-sized

Attributed to Ricardo Villalba
Peruvian?,
active 1870s

Man Looking in Mirror, ca. 1875

Albumen print
MUSEUM PURCHASE
71:0010:0086

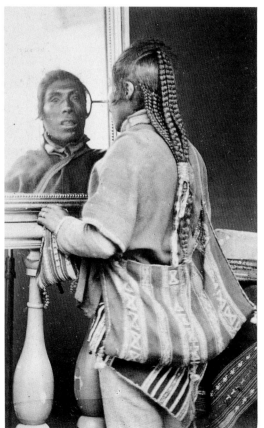

prints mounted side by side, two per page. At first the portraits all seem to have been taken in a studio, with either a painted or a plain backdrop amid various items of studio furniture and props, even including a neck brace. Closer scrutiny reveals that many were taken at different times in the streets of various towns in southern Peru and Bolivia. This was a project involving planning, patience, and an extended effort, with a duration and consistency that makes it an exceptional volume.

The print from this album of a man looking in the mirror demonstrates Villalba's ethnographic pursuits. He had to photograph the subject from the rear to show the braids, the woven pouches, and the characteristic attributes he wanted to display in this "type." Yet Villalba also wanted to make an interesting portrait. The man's startled glance in the

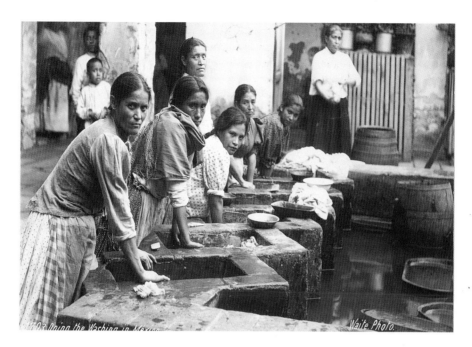

1103 Doing the Washing in Mexico. Waite Photo.

mirror and the casual arm placed against the rail, which lends a sense of movement while actually providing the stability needed during the long exposure, all combine to give this portrait a sense of spontaneity and intimacy unusual for this time and photographic genre.

"Doing the Washing in Mexico," by Charles B. Waite, a professional photographer working in Los Angeles, California, in the mid-1890s, also contains both a sense of place and a feeling of activity that allow the viewer to believe in the scene and share something of the mood. The difference is that Waite, who took photographic trips through the American Southwest and Mexico in search of picturesque scenes, is working with a photographic technology that is far more flexible than Villalba's. Waite's improved lenses and glass plates allowed him to photograph out-of-doors, to include groups of people without fear that one or more would move and blur the image, and to compose his photograph with a depth of field far deeper than the shallow space found in most portraits from the 1870s. Waite used all these advantages very well in his Mexican photograph, an ethnographic tourist image, emphasizing cultural difference and the "exotic."

Charles B. Waite
American, active
1890s–1900s

Doing the Washing
in Mexico, ca. 1900

Albumen print
GIFT OF JOHN
SEARS WRIGHT
83:1296:0017

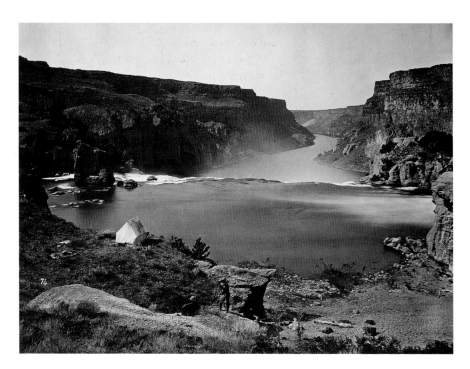

Timothy H. O'Sullivan
American, b. Ireland, 1840–1882

Shoshone Falls, Looking over Southern Half of Falls, September, 1868

Albumen print
GIFT OF HARVARD UNIVERSITY
81:1887:0055

The American West

This photograph of Shoshone Falls, Idaho, was taken by Timothy O'Sullivan in September 1868 as he made photographs for the Geological Explorations of the Fortieth Parallel under Clarence King, United States Geologist-in-Charge. The King Survey was the first of a number of post-Civil War scientific expeditions mapping the American West that were sponsored by the federal government. O'Sullivan was the first of several respected photographers hired to photograph these surveys. He is known to have photographed at Shoshone Falls two different times, making at least 50 glass-plate negatives of the area. This photograph conveys why it was a favored spot of O'Sullivan's. The image is divided into four distinct visual layers, moving from bottom to top, near to far. The closest layer presents men encamped and resting at the edge of a cliff, overlooking water pooled to gain energy before racing over another edge, the dramatic drop of the falls. Then the river winds picturesquely between the cliffs and into the distance. The final layer is the blank and distant sky. The image visually embodies the idea of a restful stop before an arduous journey, a peaceful calm followed by dangerous movement, and ultimately the classic journey of exploration from the mundane, the known, to the unknown infinite.

From the very beginning the American wilderness – felt to be an unspoiled Eden with a heady mixture of freedom, opportunity, and danger – seemed to physically embody the American ethos. By the 19th century that wilderness had become the American frontier, always shifting westward and filled with landscapes of such extraordinary dimensions that they fostered a sense of special favor and pride within the American citizenry. Throughout the century these lands were explored and described by dozens of survey expeditions sponsored both by the government and by private capital. Beginning with the 1803 Lewis and Clark expedition and continuing into the 1880s, these expeditionary parties of armed men had to be self-sufficient for months on end until their return to a distant "civilization." A misjudgment or accident so far away from any possible assistance might prove fatal, and, indeed, did so often enough, as more than one explorer on these forays into the wilderness died from starvation, illness, or hostile attack. Nevertheless, many artists and photographers were so attracted to the Western landscape that they braved a considerable number of hardships and dangers in order to depict this extraordinary scenery for their fellow citizens.

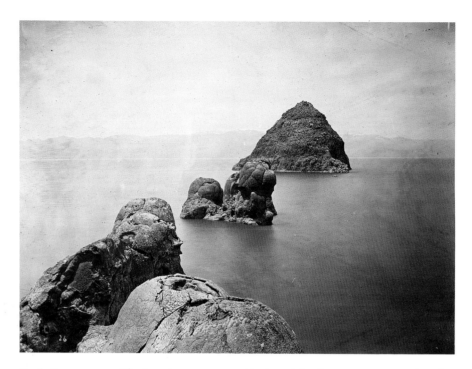

Timothy H.
O'Sullivan
American, b. Ireland,
1840–1882

"Pyramid," Pyramid
Lake, Nevada, 1868

Albumen print
GIFT OF HARVARD
UNIVERSITY
81:1887:0015

The American government had used the documentary properties of photography as early as the summer of 1840, when Edward Anthony took several daguerreotype views in Maine to assist in settling a boundary dispute with Canada. Several other expeditions used daguerreotypists, most notably when Eliphalet Brown, Jr., accompanied Commodore M. C. Perry's expedition to the China Seas and Japan from 1852 to 1854. But a serious body of landscape photography was not created in the United States until after the wet-collodion process became widely established during the final half of the 1850s. Even then, photographers did not become a standard component of most of the government-sponsored survey expeditions until after the end of the American Civil War. The post-war geological and geographical expeditions became laboratories in which more accurate tools of scientific measurement and interpretation of the physical world were pioneered or adopted while new scientific ideas and methodologies were brought to the public through the extensive publications resulting from the surveys. As photographic technology improved to the point where field photography was

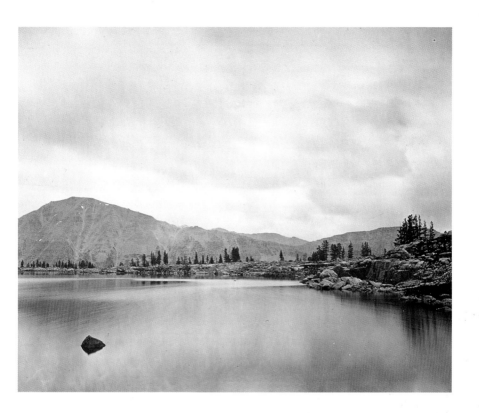

practical, even if extraordinarily difficult by present-day standards, many of these expeditions regularly used photographs as part of the increasingly rigorous scientific structure of their practice.

Timothy O'Sullivan had been an active field photographer during the Civil War and at its end was one of the most experienced outdoor photographers in the country. He joined Clarence King's survey in 1867 and photographed on King's expeditions during the next two years, covering western Nevada and eastern California, then north to Idaho, and in 1869, traveling to northern Utah and southern Wyoming. O'Sullivan rejoined King again in 1872, where he photographed in Nevada and Utah, then the Green River area in Wyoming and Colorado. The museum holds over 130 photographs from the King surveys, ranging from distant landscapes to detailed views of specific and sometimes startling geological formations, along with photographs of mineral deposits and

Timothy H.
O'Sullivan

Uintah Mountains,
1869

Albumen print
GIFT OF HARVARD
UNIVERSITY
81:1888:0027

mining operations. O'Sullivan continued as an expeditionary photographer until 1874, taking more than 1,000 photographs of the American West while working for King and for Lieutenant George Wheeler's expeditions on the Colorado River as well as to Arizona, New Mexico, Nevada, Utah, and California in 1871, 1873, and 1874.

O'Sullivan proved brave, resourceful, and steady, an altogether valuable companion to have on these arduous ventures, and most of the comments about his work written by members of these expeditions reflect his steadfast reliability. Although this was probably considered of secondary importance to the expeditionary members, O'Sullivan proved to be far more than just a reliable companion and a competent craftsman. He became one of the best photographers ever to interpret the American landscape.

There is nothing in the historical record to fully explain how or why this happened. Throughout O'Sullivan's career he simply did his job. It is only within the actual borders of his photographs, where O'Sullivan intuitively

**Timothy H.
O'Sullivan**
American, b. Ireland,
1840–1882

Gould and Curry
Mill, Virginia City,
1867

Albumen print
GIFT OF HARVARD
UNIVERSITY
81:1886:0026

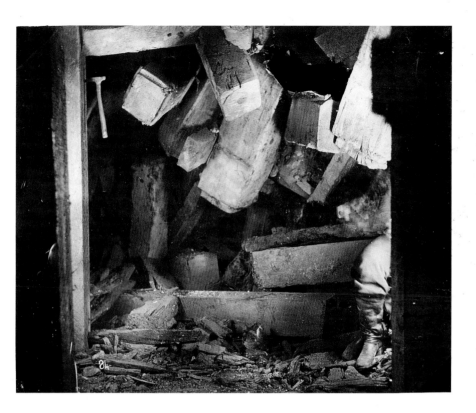

Timothy H.
O'Sullivan

Crushed Timbers,
Gould and
Curry Mine,
January–February,
1868

Albumen print
GIFT OF HARVARD
UNIVERSITY
81:1887:0001

balanced subject and form to achieve the visual strength that imbues his images with emotion and the possibility of additional meaning, that O'Sullivan ever made any statement about being an artist. Every competent stereo view maker knew the trick of placing the camera so that there was an interesting object or shape in both the foreground and in the far background of the composition and composing the image with a relatively open or clear middleground space, or even better, with a structure or shape presenting a strong receding diagonal line between the foreground and background. This generates a sense of distance in the view and a sense of depth in the image when seen through a stereo viewer. O'Sullivan used these tricks as often as any other view photographer, but he was somehow able to infuse those conventions of composition and framing with sufficient authority and power so that his photographs have a presence that transcends the simple delineation of their subject.

Modern research confirms that O'Sullivan consciously and deliberately worked with those tools available to him to achieve the best possible photograph. He was known to wait, for hours if necessary, to get the best light. He would make several slight variations of the same subject from different angles (not an easy task with the cumbersome wet-collodion system) while looking for the photograph that "worked" the best – the one in which the various landscape elements came together into the strongest composition. This could include tilting his camera to alter his horizon line to bring objects into less accurate but more dramatic visual relationships.

All of these are tactics used by modern photographers but not commonly discussed in the photographic literature of O'Sullivan's time. In fact, if O'Sullivan had ever written about his manner of approaching photographic practice (which he never did), most of his peers would not have understood what he was trying to do. The photographs taken at the Gould and Curry Mine in Virginia City, Nevada, show these practices. The outside view of the mine is composed so that no horizon line exists, and the strongest device tying these buildings together across the flattened surface of this image is their visual relationship to each other and to the borders of the image. In other words, a relationship of form is established that rivals any possible content relationship existing in the picture.

In 1871, 1873, and 1874 O'Sullivan accompanied the Army Corps of Engineers's Lieutenant George Wheeler's exploration and surveys west of the 100th meridian, missing the 1872 expedition because he was back

Timothy H.
O'Sullivan
American, b. Ireland,
1840–1882

Historic Spanish
Record of the
Conquest. South
Side of Inscription
Rock, N.M., 1873

Albumen print
MUSEUM PURCHASE,
EX-COLLECTION
PHILIP MEDICUS
79:0014:0040

Timothy H.
O'Sullivan

Ancient Ruins in the
Cañon de Chelle [sic],
N.M. in a Niche 50
Feet above Present
Cañon Bed, 1873

Albumen print
MUSEUM PURCHASE,
EX-COLLECTION
PHILIP MEDICUS
79:0014:0041

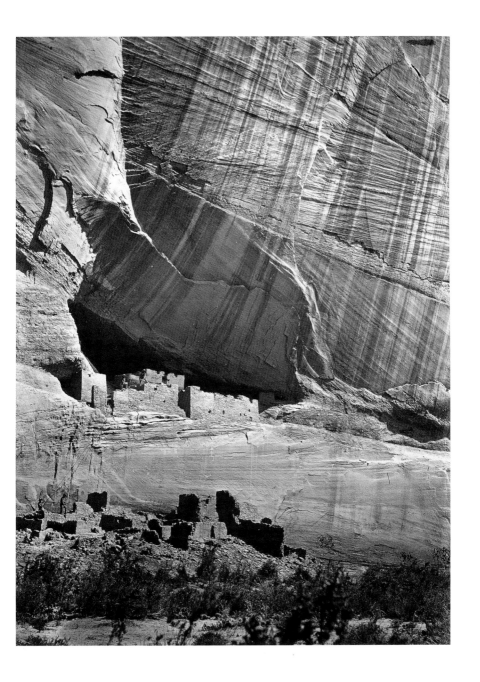

William Bell
American,
b. England,
1830–1910

Perched Rock,
Rocker Creek,
Arizona, 1872

Albumen print
MUSEUM PURCHASE,
EX-COLLECTION
PHILIP MEDICUS
79:0014:0030

working for King in that year. George Eastman House owns an album of
50 albumen prints assembled in 1875 to accompany a few special copies
of the seven-volume final report of the Wheeler survey. This work con-
tains prints from each survey in the years 1871, 1872, and 1873. Thus, 15
prints taken by William Bell in 1872 (including the one above) are sand-
wiched between 35 prints taken by O'Sullivan in 1871 and 1873.

The two O'Sullivan photographs on pages 202 and 203 are from
the 1873 expedition, when the party explored northern Arizona and New

Mexico. In this expedition the photographer focused his camera on ethno-graphic issues, photographing the Apaches in the Sierra Blanca Moun-tains in Arizona, the Navajos and Zunis of New Mexico, the historical re-minders of the Spanish Conquistadors, and the even older Anasazi ruins at Canyon de Chelly.

O'Sullivan could handle both the very near object and the very distant landscape equally well. The "Historic Spanish Record of the Conquest" displays the qualities of a formal still-life rendering. By imposing a visual clarity and coherence on ordinary, everyday objects, he invested his pho-tographs with an attraction that complements and extends the interest engendered from the content of the subject alone. O'Sullivan could also bring this skill and authority to essays of larger scope. Other photogra-phers and even O'Sullivan himself made more informational images of the ruins at Canyon de Chelly, when the light displayed the structures more fully, and where the camera position revealed more of the relation-

John K. Hillers
American,
b. Germany,
1843–1925

Goblin's Archway,
ca. 1875

Albumen print
78:0768:0001

ships between the ruins and the surrounding terrain. In this photograph, by choosing a vertical composition, placing the camera so that the ruins in the cliff echo the ruins on the canyon bed, and framing his subject so that the gracefully sweeping, dramatic lines of water seepage lift the eye up, O'Sullivan created an image capable of evoking a sense of wonder. He has, in fact, transformed these pictures from documents into creative statements – or from records into art.

William Bell of Philadelphia is often confused with another William Bell also photographing out west in the early 1870s. The Philadelphia Bell served in the Union Army, fought at Antietam and Gettysburg, and was the chief photographer of the Army Medical Museum in Washington, D.C., from 1865 to 1869. This Bell went on only one western expedition, when he replaced O'Sullivan, who was again photographing for Clarence King, on Lieutenant George Wheeler's 1872 trip down the "Grand Gulch" of the Colorado River. Thus O'Sullivan missed the Grand Canyon and gave Bell a chance to make his way into western (and photographic) history with images that excellently convey the spectacular nature of the scenery of the Grand Canyon region in Arizona. Bell used a 10 x 12-inch camera and a lens that flattened the visual space in his pictures. He often chose vertical compositions, giving an intense, even claustropho-

John K. Hillers
American,
b. Germany,
1843–1925

Kaibah Paiute.
"Ku-ra-tu," ca. 1875

*Albumen print
stereograph*
MUSEUM PURCHASE,
EX-COLLECTION
FRED S. LIGHTFOOT
81:0967:0116

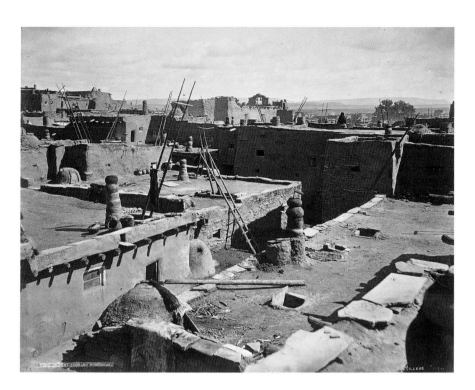

John K. Hillers

View in Zuni,
Looking Northeast,
ca. 1875

Albumen print
MUSEUM PURCHASE
70:0148:0007

bic, feeling to many of his landscapes, which was both unusual and effective for his views.

John K. (Jack) Hillers was hired by John Wesley Powell to replace a boatman on Powell's second survey of the Green and Colorado Rivers in 1871. Hillers, born in Germany but raised in the United States, had fought for the Union in the battles of Petersburg, Cold Harbor, and Richmond, then reenlisted in the army after the war and served on the frontier until 1870. In 1871 Hillers was working as a teamster in Salt Lake City when he and Powell, another army veteran, met and began a friendship that lasted the remainder of their lives. During the 1871 canyon voyage, Hillers assisted the expedition's photographer, E. O. Beaman, until Beaman left the expedition. Then Hillers helped Beaman's replacement, James Fennemore, who taught him photography in the field. When Fennemore became ill and had to leave the expedition in 1872, Hillers took over all photographic duties. He also photographed for all of Powell's later expeditions until those surveys ended in 1879. In 1881 J. W. Powell was

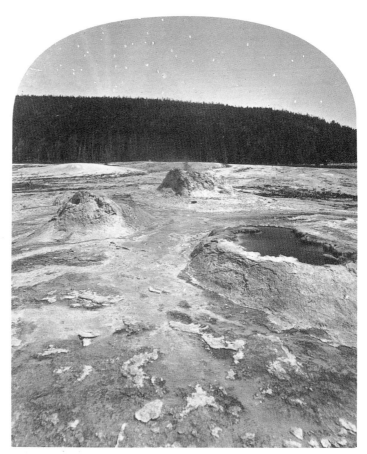

William Henry Jackson
American, 1843–1942

Hot Spring Basin,
Upper Fire Hole,
1872

Albumen print
MUSEUM PURCHASE
74:0041:0337

made the head of the U. S. Geological Survey, and Hillers was made its photographer, a position he held until his retirement in 1900. This position was based in Washington, D. C., and although Hillers did take occasional trips back to the West, most of the work of his final years was done in the government studios in Washington.

Hillers was the first to photograph the Grand Canyon, and he participated in ethnographic studies of American Indian tribes in the Southwest. It's in his views of the pueblos that Hillers' photography grows into a mature vision, when he is capable of assembling the complex shadows and shapes created by the pueblo dwellings into dynamic and interesting photographs. His portraits of various Ute and Paiute

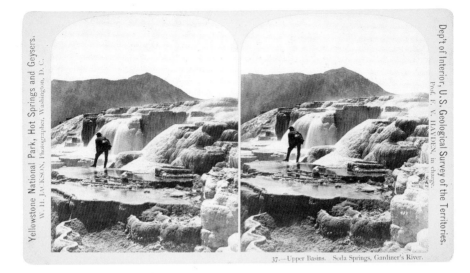

37.—Upper Basins. Soda Springs, Gardiner's River.

tribes in Utah, on the other hand, are almost naively simple, and they seem tainted to the modern eye. It is now known that Powell brought clothing from an ethnological museum collection back to Utah to dress tribesmen for these staged photographs. George Eastman House owns approximately 130 stereo views and 48 photographic prints by Hillers.

William Henry Jackson was widely considered one of the best landscape photographers of the western United States during most of his professional career from the 1870s through the turn of the century. He won this reputation with his resourcefulness and skill, his luck, his capacity for hard work, his longevity, and his talents as a photographer and a businessman. Jackson could and often did create images of the Western landscape that were large in size and grandiose in scale, confirming the grandest ideals of those exponents of America's Manifest Destiny. His mountain ranges were longer and higher, his vistas stretched farther, his terrains were wilder, more rugged, and more filled with a sense of wonder than conventional topographic views, highlighting a wilderness that was waiting to be tamed and made available to the American citizen.

Ferdinand Hayden, director of the U. S. Geological Survey of the Territories from 1870 to 1878, employed Jackson each year to join the large self-contained expeditions into still uncharted parts of the American

William Henry Jackson

Upper Basins. Soda Springs. Gardiner's River, 1871

Albumen print stereograph
82:1582:0001

West. The survey's most famous expedition was its 1871 trip into the Yellowstone region, where the spectacular nature of the scenery attracted national media. Many articles in journals and newspapers brought Hayden and even Jackson a measure of celebrity. Their 1875 and 1877 trips into Colorado, New Mexico, and Arizona generated reports of the ancient abandoned cliff dwellings, which again stirred popular interest in the expeditions and in the photographs.

George Eastman House holds over 900 prints and more than 220 stereo views taken by William Henry Jackson during every phase of his long career, including an extraordinary compilation album of more than 400 small prints once owned by Henry Gannett, an astronomer and topographer for the Hayden surveys, showing the activities and personnel of the survey parties, as well as scenes and views of the territory. The museum also has an elegant presentation album of 37 photographs, *Photographs of the Yellowstone National Park and Views in Montana and Wyoming Territory*, printed by the Government Printing Office in 1873. This, according to legend, helped persuade members of Congress to establish the National Park System.

While Jackson was the master of the eloquent public statement, as in the view of Mystic Lake (right), he was also able to make images that appear personal, conveying a sense of casual informality otherwise absent from 19th-century photographs. His image "John, the Cook, Baking Slapjacks," which is from the Gannett album, pulls the viewer into the very heart of the mundane daily activities of a group of men on a long camping trip, who also happen to be a part of the very fabric of the history of the developing American West. Since the cameras of the 1870s simply could not capture the quick movement of the flipping pancake, nor, for that matter, the poetic light of the "star-filled"

William Henry Jackson
American, 1843–1942

John, the Cook, Baking Slapjacks, 1874

Albumen print
MUSEUM PURCHASE
74:0041:0212

skies over the Yellowstone geyser at "Hot Spring Basin, Upper Fire Hole" (page 208), Jackson had to help his image by painting those items onto his negatives by hand. Jackson occasionally manipulated other prints by combining negatives to create a panoramic print to get the scale and sweep of the large vista he needed, or scratching in an outline of the occasional bird or tourist to balance the composition, or combining negatives to make a composite print, later even rearranging the topography of the famous Mountain of the Holy Cross to make a better picture. But he did this with the authority of someone who had actually been there and had seen it, who was a real witness to those scenes of the making of the Western frontier.

Jackson lived to be nearly 100 years old. His career – or more accurately, careers – could be regarded as a paradigm for the role commercial landscape photographers played, and thus the types of landscape photography made, in America from the 1860s until after the turn of the century. Working for eight years in the 1870s as a member of various

William Henry Jackson

Mystic Lake, 1872

Albumen print
GIFT OF GEORGE
H. CANNAN
81:2245:0022

government-sponsored survey teams, Jackson had at least a partial mandate to photograph expansively, to speak with a public voice, to find and depict the spectacular and the unusual aspects of the scenery of America. When these government positions ended at the close of the decade, Jackson returned to private entrepreneurship. He moved to Denver, Colorado, and made his living by selling views to tourists and making publicity photographs for the railroads, the remaining sponsors of this type of imagery. He also sold stock photographs to the new market of inexpensive illustrated books and periodicals that exploded into publication after the improvements in photoengraving technologies were developed in the 1880s. They enabled inexpensive halftone screen reproductions from photographs to appear on the same page as letterpress copy.

The photograph "High Bridge in the Loop. Near Georgetown (page 214)." is a dramatic image of the exciting train ride available for the adventurous traveler visiting Colorado. By 1885 probably every other photographer in Colorado and even a few photographers just passing through the state had also taken this view, and most of them were willing to sell a print for less than what Jackson charged. To survive and prosper, the Jackson studio had to become a sort of stock picture agency,

William Henry Jackson
American, 1843–1942

"Tea Pot" Rock, 1870

Albumen print
MUSEUM PURCHASE
74:0041:0087

William Henry Jackson

Waterfall Gorge, ca. 1890

Albumen print
GIFT OF
3M COMPANY,
EX-COLLECTION
LOUIS WALTON
SIPLEY
77:0533:0011

constantly gathering an increasing number of views of more diverse places. Jackson hired photographers such as William H. Rau and purchased negatives from other photographers, including those made by Adam Clark Vroman and Ben Whittick. Here he followed an established pattern. Jackson traveled constantly on the expanding network of railroads throughout the United States, venturing into Mexico and traveling up the eastern seaboard of the United States. These railroads hired Jackson to provide them with photographs of the landscapes along their routes and allowed him access to views, hoping to attract tourists.

The financial panic of 1893 severely damaged Jackson's business. He still traveled extensively, even around the world in 1895 and 1896, accompanying the World Tour of the Transportation Commission of the Field Columbian Museum. In 1898 Jackson folded his business into the Detroit Publishing Company, a firm that printed and distributed post cards and inexpensive photolithograph prints to an ever larger and more diffuse market. But by then Jackson was working as a commercial photographer, and his latter photographs are no longer filled with the sweep and grandeur of the older expeditionary pictures that he had taken when his camera was one of the first to document the Western landscape.

William Henry Jackson
American, 1843–1942

High Bridge in the Loop. Near Georgetown, ca. 1885

Albumen print
74:0013:0316

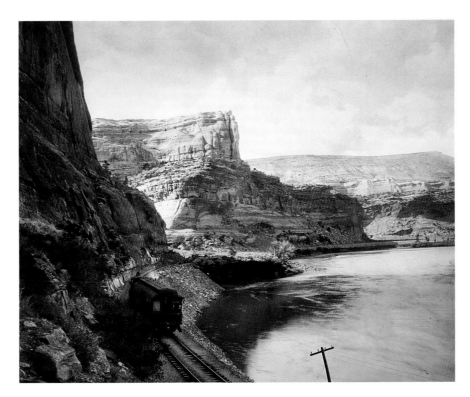

California and the Far West

The California Gold Rush in 1849 brought a flood of adventurers, settlers, and even photographers to California. The Yosemite Valley was discovered by these settlers in the mid-1850s, and almost instantly Yosemite joined Niagara Falls in the American pantheon symbolizing the beauty, richness, and promise of its land. Yosemite was visited by a steady stream of tourists, artists, and photographers such as Charles L. Weed, Carleton E. Watkins, and Eadweard Muybridge. Charles Weed carried a stereo view camera and apparatus into the valley for the first time in 1859. Watkins followed in 1861, and Muybridge, in his turn, attempted to create images of a size to match both the scale and emotional dimensions of the place toward the end of the decade.

Thomas Houseworth & Co. was a large commercial gallery that flourished in San Francisco in the 1860s and 1870s. Its major business was portraiture, but the gallery also was a publisher and distributor of stereo

William Henry Jackson

Cañon of Grand River. Utah, ca. 1885

Albumen print
GIFT OF HARVARD UNIVERSITY
81:2248:0038

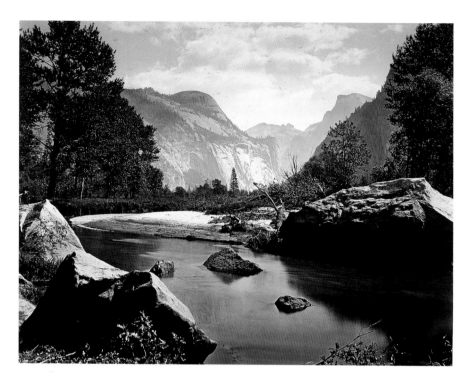

views and other views, which it printed from negatives purchased from
various photographers. Among the views represented were Charles L.
Weed's of Yosemite taken in the early 1860s. The museum holds six
large, "mammoth"-sized photographic prints of Yosemite, as well as
more than 140 stereo views, 68 landscape cartes-de-visite, and six
portraits from the Houseworth Studio in its collection.

Isaiah West Taber opened one of San Francisco's major photographic
studios in 1871. Taber was a skilled photographer, he hired many opera-
tors to work for his gallery, and he also acquired negatives from other
photographers. The museum holds 300 prints from the Taber Studio in
its collection. In 1874 Taber purchased Carleton E. Watkins' gallery, pho-
tographic equipment, and some 15 years' worth of accumulated nega-
tives of landscape views in a bankruptcy sale and then frequently reprint-
ed them under his own trademark name throughout the 1880s. Though
imprinted with Taber's name, it is possible that the Yosemite view "The
Vernal Fall ..." was from a negative taken by Watkins in the 1860s.

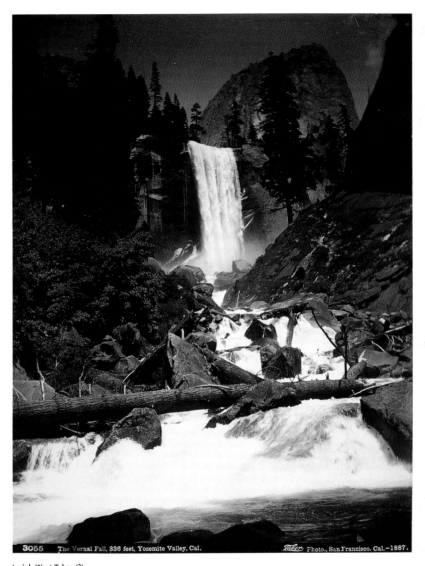

3055 The Vernal Fall, 336 feet, Yosemite Valley, Cal. Taber Photo., San Francisco. Cal.—1887.

Isaiah West Taber (?)
American, 1830–1912

The Vernal Fall 336 Feet, Yosemite Valley, Cal., ca. 1885

Albumen print
GIFT OF ALDEN SCOTT BOYER
81:2265:0015

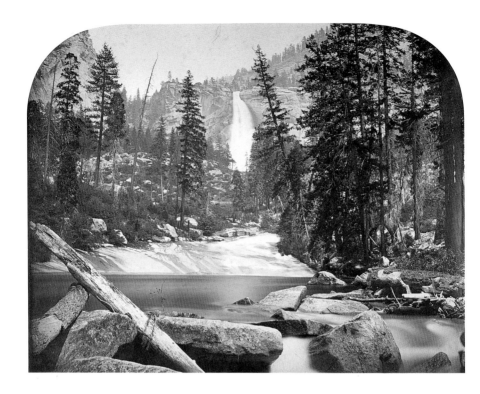

Carleton E. Watkins
American, 1829–1916

Yo-Wi-Ye or Nevada
Falls, 1861

Albumen print
GIFT OF ALDEN
SCOTT BOYER
81:2899:0024

Carleton E. Watkins began his long and extraordinary photographic career in 1854, making daguerreotype and then ambrotype portraits. By 1856 photographers in California were experimenting with the new wet collodion process, which made taking landscape views a much more feasible, practical, and economical activity. Watkins learned the new process and by 1858 was using it to establish his reputation as a field photographer. Some of his earliest and best work was in the Yosemite Valley, which he first visited in 1861 and returned to again and again during the next 20 years, often rephotographing the same scenery from the same spot. George Eastman House has 25 large Yosemite views by Watkins among the more than 150 photographs and more than 300 stereos in its collection.

Eadweard Muybridge began working as a landscape photographer in California in 1867. He created dramatic landscapes with an operatic grandeur that matched the wondrous vistas he was photographing.

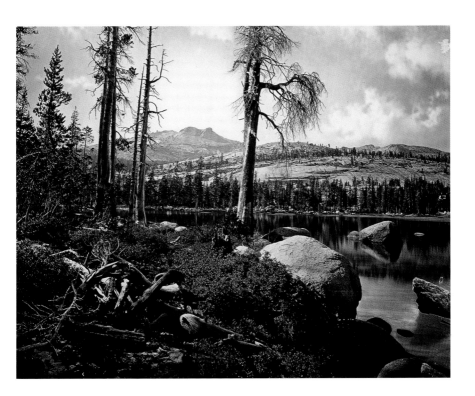

His photographs featured the play of light on steam or clouds. These transitory events were very difficult to capture with the camera, and Muybridge often achieved these effects by double printing negatives of clouds into the blank white skies dictated by the blue-sensitive photographic chemicals of the day. Sophisticated critics acclaimed these views to be more expressive and artistic than the photographs of previous photographers. The museum holds 25 large views by Muybridge in its collection.

While the spectacular scenery of northern California seemed to call forth very large and spectacular photographic prints, it should be remembered that the largest number of scenic views were sold in the form of stereos, or, less often but more frequently than the mammoth prints, in the form of cartes-de-visite. Though smaller in scale and therefore possessing less visual impact, many of these images are excellent photographs. The "Bridge at the Second Crossing of the Truckee River ..."

Eadweard J. Muybridge
American,
b. England,
1830–1904

Mount Hoffman,
Sierra Nevada
Mountains, from
Lake Tenaya,
ca. 1870

Albumen print
GIFT OF HARVARD
UNIVERSITY
81:2377:0011

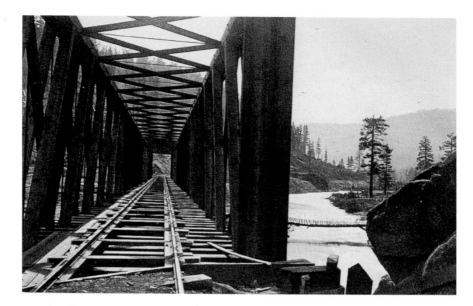

Attributed to
Charles Leander
Weed
American,
1824–1903

Bridge at the
Second Crossing of
the Truckee River,
Nevada, Central
Pacific Railroad,
ca. 1865

*Albumen print
carte-de-visite*
MUSEUM PURCHASE
81:3822:0068

is one such image, composed so as to take advantage of every part of its available space. (The image shown here is almost twice the size of the original print.) The photographer has achieved an improbable balance between the rigid, busy linearity of the bridge and the ideal natural setting of the river. The museum holds 68 landscape cartes-de-visite issued by Thomas Houseworth & Co. The photographer of this work is thought to be Charles L. Weed. Weed had been photographing in California since 1854 and was the first photographer in the Yosemite Valley. In 1864 Weed formed a business arrangement with Lawrence & Houseworth, precursor of Thomas Houseworth & Co., and rephotographed the Yosemite Valley with both stereo and mammoth-plate cameras. Weed continued his relationship with the Houseworth Studio throughout the 1870s and photographed widely through the American West, even traveling to Hawaii, Hong Kong, and Japan.

This stereo view of two boys fishing off the bridge at the "First Crossing of the Truckee River" has several charming features. The photographer's own shadow is visible in the lower right corner of the image, and the little white dog lends the image an unusual sense of spontaneity and presence. Research has revealed that both the dog and the shadow belonged to the photographer Alfred A. Hart, although for years this print was

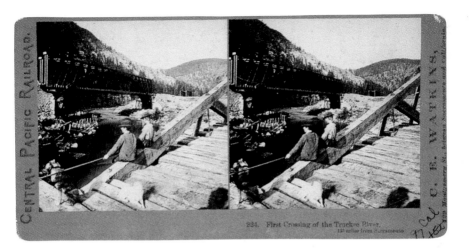

published under Carleton Watkins' name. Carleton E. Watkins knew the frustration of losing his negatives to other photographers who then sold prints of his images under their own names. But Watkins had done this as well. In the late 1860s, in what seems to have been an act of pure favoritism, Watkins was hired to be the official photographer of the Central Pacific Railroad, replacing Alfred A. Hart in that position. Starting in January 1866, Alfred A. Hart had documented the construction of the Central Pacific Railroad across the Sierra Nevada mountains to its famous juncture with the Union Pacific at Promontory Point, Utah, in 1869. These stereo negatives were turned over to Watkins when he replaced Hart, and Watkins then sold copies of this work under his own name throughout the early 1870s. The museum collection holds over 25 stereos from this series. Alfred Hart, who had been at various times a painter of portraits, landscapes, and religious scenes; a creator of panoramas; a daguerreotypist; a merchant of picture frames, engravings, and photographic supplies; as well as an author and publicist for the railroad, simply gave up photography and returned to painting for the remainder of his life.

Frank Jay Haynes made the photograph of the Cap of Liberty and Mammoth Springs Hotel in Yellowstone Park (page 222) probably no more than 15 years after William Henry Jackson's first photographs of Yellowstone helped bring international attention to that previously unknown and mysterious area. The museum holds 175 photographs,

Alfred A. Hart
American, 1816–1908

First Crossing of
the Truckee River,
ca. 1869

*Albumen print
stereograph*
MUSEUM PURCHASE,
EX-COLLECTION
RICHMOND
W. STRONG
81:6003:0002

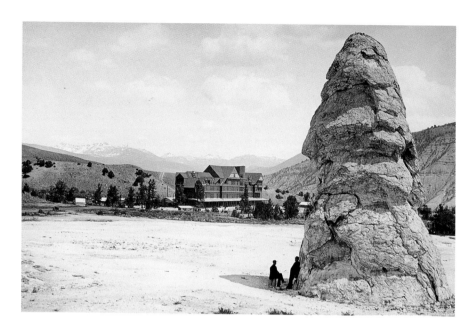

Frank Jay Haynes
American, 1853–1921

Cap of Liberty and
Mammoth Springs
Hotel, ca. 1885–1916

Albumen print
MUSEUM PURCHASE
70:0181:0004

220 stereographs, and 50 lantern slides by Haynes. Frank Jay Haynes opened his first photographic studio in Minnesota in 1876 and began photographing in the Yellowstone area for the first time in 1881. By then Yellowstone had been made into a national park and was the center of a growing tourist trade, swelled by the completion of the Northern Pacific Railroad in 1883. Haynes became the park photographer and even built a studio at the site of the Old Faithful geyser and worked there until his retirement in 1916. This photograph delivers a complex message to its viewer. First, Haynes foregrounds the startling and extraordinary scenery of the Yellowstone area by featuring the giant cone towering over the two human figures dwarfed in its shadow. But by placing the hotel, securely nestled in the surrounding hills, in the visual center of the picture so that the horizontal weight of that building is balanced against the vertical thrust of the cone, Haynes delivers the message that any tourist can enjoy this spectacular scenery in the utmost comfort.

The three photographs on pages 223 to 225 are from an album titled *North American Indians,* which contains 26 photographs of Northern Plains tribes in western Canada in the 1880s and 1890s. Nine of the photographs of Blackfeet and Cree were taken by a Notman Studio

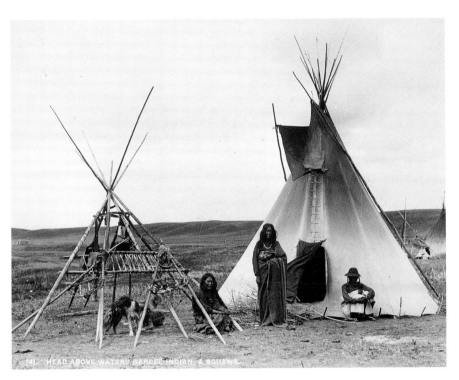

141. "HEAD ABOVE WATER" SARCEE INDIAN & SQUAWS

photographer. Fourteen portraits of the Sarcee Indians in Calgary, North West Territory (now Alberta) were taken by Boorne & May. In 1886 W. Hanson Boorne, an immigrant from England, set up a photography studio in Calgary with his cousin Ernest May. An 1892 article describes the gallery this way: "[Boorne & May own] a large building devoted to the production of stock photographic views and numerous specialties, souvenir albums, lantern slides, etc. Besides this, they occupy a portrait studio and art repository ... [which] is well worth a visit by tourists and other travellers,... well stocked with engravings, pictures and art goods of all descriptions, including the numberless photographic views of ranching, prairie and mountain scenery ... besides these, a large variety of articles of buckskin and beadwork, manufactured by the native Indians...."

Eight of Boorne's photographs of "the native Indians" are documents of the Sarcee tribe, dressed in their everyday mixture of native and European clothing, with their teepees and dogs, camped on the prairie near

Boorne & May
Canadian, active
1880s–1890s

"Head above Water",
Sarcee Indian &
Squaws, ca. 1889

Albumen print
MUSEUM PURCHASE,
EX-COLLECTION
A. E. MARSHALL
75:0087:0008

(right)
Boorne & May
Canadian, active
1880s–1890s

Sarcee Indians, 1891

Albumen print
MUSEUM PURCHASE,
EX-COLLECTION
A. E. MARSHALL
75:0087:0014

Boorne & May

Sarcee Indian, 1891

Albumen print
MUSEUM PURCHASE,
EX-COLLECTION
A. E. MARSHALL
75:0087:0009

Calgary. But seven of the photographs in the album were taken during a one-day session in Boorne's studio. These are "costume portraits" of a small group of young men posed in several contrived and stilted tableaux before a painted studio backdrop. Even the "articles of buckskin and beadwork" that they wore were probably supplied by Boorne. In one portrait two men are sitting companionably side-by-side, while a second view, shown here, presents them awkwardly posed in the melodramatic and patently fictional depiction of a fight. Boorne's Indian portraits were not made for the sitter, but for the "tourists and other travellers." So individual sitters are altered into stereotypes, and the photographic oeuvre is transformed from portraiture (where the emphasis is placed upon delineating individual character) to costume genre (where the emphasis is placed upon delineating attributes or roles thought to define the general nature of the culture).

The 19th century thrived on such typology: the act of categorizing and classifying anything and everything – from rocks and butterflies to groups of people – then attempting to extract scientific data from these unified categories to establish guidelines for directing useful behavior, which led to such disciplines as physical anthropology. The same impulse also led to such popularized semi-scientific pursuits as phrenology. The "costume portrait" seems to fall somewhere in between anthropology and phrenology – in part hard science, in part popular scientism. These portraits may have found their way into schools and museums, where they could be used for research and teaching, but the photographer's major customers were the tourists, who collected these images like stamps to remind them of the varied and exotic peoples and places they had visited.

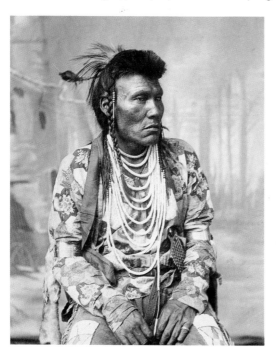

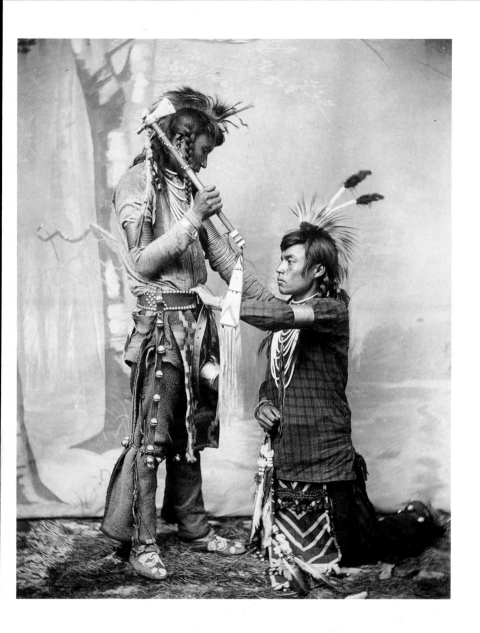

Technology and War

Technology

Philosophical instruments (right), as well as the vacuum apparatus and group of metallic barometers pictured on the following page, were all on display at the Exhibition of the Industry of All Nations held in London in 1851. Popularly known as the Crystal Palace Exhibition, it brought together a large number of consumer goods, ranging from artworks to wallpaper, crafted or manufactured by almost 14,000 exhibitors to be seen by well over 6,000,000 people during the exhibition's duration of 140 days. Almost immediately the exhibition became a key symbol defining at least one aspect of what the modern world should look like, while simultaneously solidifying the position of Britain as the leading industrialized nation. Thus the event accrued cultural, social, and even political significance far greater than its ostensible purpose. It was the first international trade fair, which by tying together art, education, and industrial

Attributed to Claude-Marie Ferrier or Friedrich von Martens
French, 1811–1889 &
French, b. Germany, 1809–1875

View of East End of Building
Crystal Palace, 1851

Salted paper print
MUSEUM PURCHASE
LIBRARY COLLECTION
90:0667:0044

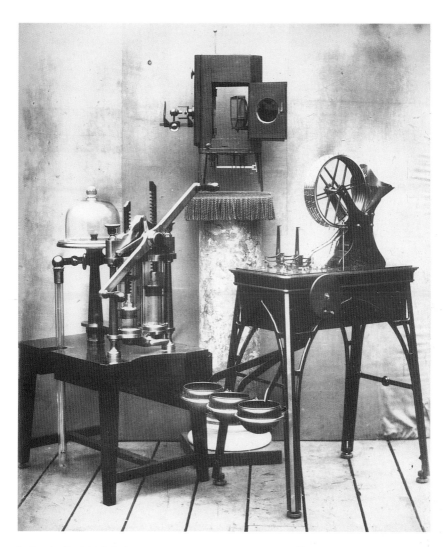

Attributed to Claude-Marie Ferrier
French, 1811–1889

Philosophical
Instruments, 1851

Salted paper print
MUSEUM PURCHASE
LIBRARY COLLECTION
90:0667:0032

production, set a conceptual pattern for international exhibitions and fairs that continues to the present day. Almost overlooked in the success of the exhibition is that it was also a key event in Victorian sociocultural ideology. It became an icon in the liberal/reform argument that art and education should be extended to the working classes. The project's controversial and embattled beginning, overcome only through the determination, will, and effort of the populist Prince Albert and his ministers, has slipped from many histories of this exhibition.

The exhibition produced a flurry of articles and books, many of them illustrated with hundreds of "engravings of works exhibited." And, on a "suggestion from the throne," a commemorative publication illustrated with actual photographs of the displayed objects was published in 1852 to "be forwarded to every foreign country which has participated in this universal exhibition." The museum's Menschel Library holds a copy of this lavishly illustrated four-volume work, the *Exhibition of the Works of Industry of All Nations, 1851. Reports by the Juries on the Subjects in the*

Thirty Classes into Which the Exhibition was Divided, which contains over
150 salted paper prints. Four or five photographers may have been in-
volved in the project, though the majority of the negatives was taken by
the British photographer Hugh Owen, who used the calotype process,
and the French photographer Claude-Marie Ferrier, working with an al-
bumenized glass process. Approximately 140 copies of this lavishly illus-
trated work were produced and distributed as commemorative gifts.

The museum holds 79 albumen prints taken between 1855 and 1857
documenting the construction of the ocean steamship officially named
the Great Eastern but also known as the Leviathan. These prints are
from an album of that title and are all the work of the Photographic In-
stitution, an important London concern that fostered the publication
of photographically illustrated books, owned in partnership by Joseph
Cundall and Robert Howlett. The earlier images in this album were
taken by Cundall and the later, more visually interesting photographs
are by the younger partner Howlett. The Leviathan was a massive
ship of 32,000 tons displacement, nearly ten times that of any other

Attributed to Claude-
Marie Ferrier

Metallic Barometers,
1851

Salted paper print
MUSEUM PURCHASE
LIBRARY COLLECTION
90:0667:0038

contemporary ship, and a source of great interest, speculation, and patriotic pride for the British public. The popular press avidly followed the ship's construction, and both the *Illustrated London News* and the *Illustrated Times* published frequent articles, illustrated with wood engravings, in many cases drawn from Cundall's and Howlett's photographs. Howlett's skill as a photographer is amply demonstrated in the images on these pages. Both of these images go beyond mundane documentation or reportage. By posing Isambard Brunel, the ship's engineer and builder, in front of its huge anchor chains, Howlett found a backdrop that functions both visually and symbolically, extending the connotative and emotional range of the image. Brunel fought through enormous difficulties and against many doubters to build this ship, and his cocky confidence and indomitable will are all embodied in this portrait.

Howlett was typical of the first generation of British photographers. He, like Roger Fenton and Philip H. Delamotte, was from the upper middle class and was well educated in both the sciences and the arts. He took up photography in the 1850s first as an avocation, then as a way

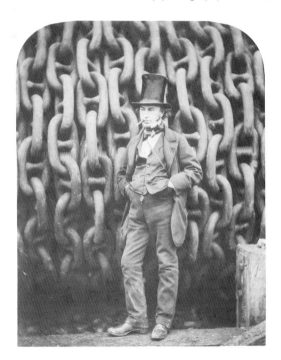

Robert Howlett
English, 1831–1858

Isambard Kingdom
Brunel, Builder of
the Great Eastern,
the Largest
Steamship, ca. 1855

Albumen print
MUSEUM PURCHASE
81:1647:0079

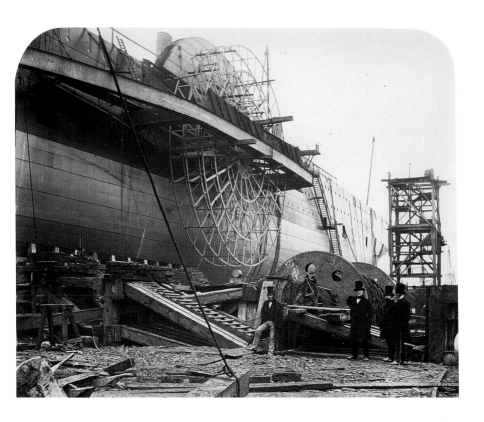

to make a living, when the medium was still an exciting and new art/science and a profession worthy of gentlemanly pursuit. Howlett always preferred outdoor photography, and by the mid-fifties he was an acknowledged specialist in "instantaneous pictures," using advancements in photographic materials for a more spontaneous approach to picture-making. The museum holds 10 other landscape or architectural prints by Howlett in addition to those of the *Great Eastern* under construction. In 1856 the British painter William Powell Frith drew on Howlett's expertise when he commissioned him to photograph the crowds attending the horse races on Derby Day, which the painter later used as studies for his large painting of the same title. In 1856 Cundall and Howlett published the series *Crimean Heroes and Trophies*, taken not in the studio but at the military hospital at Woolwich.

In 1858 Howlett died suddenly at age 27; some of his friends believed

that his death was hastened by overwork and his extended exposure to photographic chemicals.

Thomas Annan's Glasgow photographic studio was an important publisher of photographically illustrated books and albums from the early 1860s until after 1910. Many of these were commemorative volumes for a number of Glasgow cultural or historic organizations. George Eastman House holds over 220 photographs in five of these books. "Close, No. 193 High Street" is from an extensive documentary effort for the Glasgow City Improvement Trust, which hired Annan in 1868 to photograph buildings important "from a historical point of view" in the city's slums before they were torn down. The Annan studio published an album of 40 carbon prints in 1878 and 1879 titled *Photographs of Old Closes and Streets of Glasgow Taken 1868–1877*.

Commissions from public institutions and organizations, as well as from the developing national or international businesses, provided

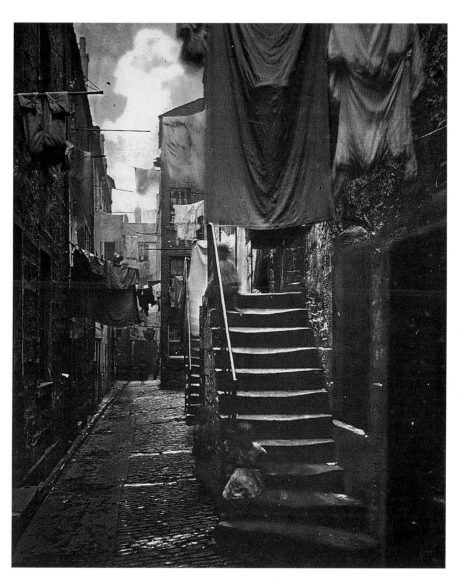

Thomas Annan

Close, No. 193 High
Street, ca. 1868–1877

Carbon print
MUSEUM PURCHASE
75:0054:0009

Bisson Frères
French, active
1841–1864

The Locomotive,
"La Vaux,"
ca. 1854–1858

Albumen print
GIFT OF EASTMAN
KODAK COMPANY,
EX-COLLECTION
GABRIEL CROMER
81:1009:0003

additional sources of income for many professional photographers of the 1850s and 1860s. They expanded their practice beyond portraiture and landscape views to include other commercial-oriented subjects such as architectural and industrial photographs. Howlett's photographs of the *Great Eastern* extolled Britain's shipbuilding industry, the source of its sea power, as photographers in France and America recorded the railroads, which were the most manifestly visible examples of new industrial engineering and commerce in these countries. This photograph taken by the Bisson Frères, a leading professional studio in Paris, of the sleek, streamlined, absolutely "modern" locomotive *La Vaux* is an example of this new type of photographic practice. This practice demanded a new kind of vision that displayed a different, more modern character as well as a new photographic style to convey that vision. Earlier softer, picturesque landscapes began to give way to photographs with harder-edged compositions, sharper delineations of space, and harsher contrasts of tonalities within the print. This new look was perceived as being more accurate and thus more appropriate for the new modernizing age. By the end of the century, the hallmark of style for a professional photographer – in portraiture as in landscape practice – was a detailed, sharply rendered image.

"Paysage près du Viaduc de Chantilly" presents the viewer with the beauty of one of France's new industrial landscapes. This bridge is at once elegant and dramatic, as functional and modern as tomorrow and yet evocative of France's storied past, its arches replicating the graceful passages of the picturesque Roman aqueducts that could still be seen throughout southern France. The photograph is from the *Chemin de fer du Nord: Ligne de Paris à Boulogne* album, one of five albums in the George Eastman House collections that record the expansion of the railroads throughout France during the Second Empire. The *Chemin de fer du Nord* is an elegant album, with a printed title page and letterpress captions for 50 large and beautiful prints. It was long thought to have been solely the work of the photographer Édouard-Denis Baldus. But recent scholarship has found that though many of the views of the stations and the towns along the railway are by Baldus, others were made by Auguste Collard. Collard, self-identified as Photographe des Ponts et Chaussées (Photographer of Bridges and Roads), specialized in topographical views of the many new bridges and streets under construction in and around Paris at mid-century. He set up a photographic studio in 1856 and within a year began to document new constructions springing up around the city. The Ministry of Agriculture, Commerce, and Public Works became a major client of Collard's, and for the next

Hippolyte-Auguste Collard
French, before
1840–after 1887

Paysage près du Viaduc de Chantilly
(Landscape near the Chantilly Viaduct),
1858–1859

Albumen print
GIFT OF EASTMAN
KODAK COMPANY,
EX-COLLECTION
GABRIEL CROMER
74:0051:0018

20 years his studio produced thousands of images of bridges and viaducts for them, as well as photographs of France's growing railway system.

At mid-century Édouard-Denis Baldus was widely regarded as one of France's best photographers. He seems to have learned to make photographs around 1848 or 1849, and by 1851 he had worked out his own variant of a paper negative process. It was described as having "the clarity of glass" and possessing "a depth and vigor of tone," both attributes serving him well when he began photographing for the Commission des Monuments Historiques in 1851, the first of his many government-sponsored assignments. From 1855 to 1857 Baldus was commissioned to document the building of the new Louvre and the renovation of the Tuileries. This architectural effort was the largest construction project of the Second Empire, in the heart of a city undergoing an immense urban renewal project under Baron Georges-Eugène Haussmann's direction to build the most modern city in the world. Baldus worked on this project for several years, ultimately making over 2,000 photographs of every aspect of the construction of the Louvre. The museum holds eight albumen prints from this series as well as others located in two albums of views of Paris, one with 32 prints, the other containing 35 prints. Baldus shifted from his paper negative process to making glass negatives when he started working on the Louvre series, which allowed him to make even larger, finer-detailed, and more spectacular architectural views. These deeply impressed his contemporaries and earned

Édouard-Denis Baldus
French, b. Prussia, 1813–1889

Pavillion de Flore, ca. 1871

Photogravure print
MUSEUM PURCHASE
LIBRARY COLLECTION
76:0036:0039

him an even greater reputation. However, after the mid-sixties, support from the government and private commissions began to dwindle. The large, splendid, and expensive photographs in which Baldus specialized were replaced by smaller, cheaper stereo views, cartes-de-visite, and smaller prints to fit into tourists' albums or the picture collections of schools and libraries.

From the 1860s to the early 1880s, Baldus invested a great deal of his time, energy, and money into perfecting a functional photogravure printing process to publish his work for a larger audience. He produced several volumes of works illustrated with his photogravure prints, including two of his three portfolios now in the museum's collections, titled *Palais du Louvre et des Tuileries,...* published in 1871 and containing 140 "heliogravures." But this work was not financially successful. By 1887 Baldus had to sue for bankruptcy, having already turned most of his stock of prints and plates over to his son-in-law. Baldus died in December 1889 in a suburb of Paris at age 76. Neither the photographic nor the national

Édouard-Denis
Baldus

The Louvre, Detail, Windows of Upper Story, ca. 1855

Albumen print
GIFT OF EASTMAN
KODAK COMPANY,
EX-COLLECTION
GABRIEL CROMER
74:0050:0001

Delmaet & Durandelle
French,
active 1862–1890

Construction of the Paris Opera, ca. 1866–1870

Albumen print
GIFT OF EASTMAN KODAK COMPANY, EX-COLLECTION GABRIEL CROMER
80:0099:0017

press recorded his death; his magnificent achievements of the 1850s and 1860s were forgotten even within the photographic community, which his vision had once so much impressed and influenced.

Despite a popular and persistent tradition (dating at least as far back as Gaston Leroux's 1910 novel) that insisted that the Paris Opera was inhabited by phantoms, the ghostly image inhabiting the lower corner of this photograph is no more than an employee who is working hard, thereby moving just a little too quickly to be fully captured by the slow photographic chemicals of the 1860s. On the other hand, the young man stiffly facing the camera in the middle of the image, and the others scattered across the iron girders of the Paris Opera's new roof, have managed to stay still long enough to be captured clearly for posterity.

Charles Garnier's Paris Opera is a major monument of European architecture. In 1862 Louis-Émile Durandelle, of the Parisian firm of Delmaet & Durandelle, began to photographically document key phases of the construction of this edifice. In 1865 this documentation expanded

to include a comprehensive and exacting delineation of the many architectural flourishes and sculptures created to decorate the building. This was done apparently at the pleasure of the architect, who felt that once all the decorative fancies were put into their locations on the facades and ceilings, they would be hard to see and difficult to study.

Durandelle continued this documentation for 10 to 12 years, making approximately 200 photographs during this interval. Fifty of these photographs are in the museum's photography collection. Eventually, the architect Garnier wrote *Le Nouvel Opéra de Paris*, published in eight volumes from 1875 to 1881. It consisted of two volumes of text, two engraved and lithographed picture atlases, and four volumes containing 115 of

Louis-Émile Durandelle
French, 1839–1917

School for Infants,
ca. 1885

Albumen print
MUSEUM PURCHASE
78:0693:0006

Durandelle's albumen prints of the sculptured decorations. Durandelle's studio made many similar documents of new public and private construction projects throughout Paris until his retirement in 1890.

These two images are from a group of photographs made by the Louis-Émile Durandelle studio in 1882 for Eschager Ghesquiere & Co., an industrial foundry located in northern France. George Eastman House has seven of these albumen prints, all of them large (in the range of 17 x 21 inches) and mounted on identical 24 x 28-inch boards with descriptive letterpress titles. The identifying series title for the group is *Fonderies et Laminoirs de Biache St. Vaast.* The large size, the texts, and the uniform presentation of the pieces all indicate that this body of work was designed for public display, either in the offices of the manufacturing company or in one of the large international industrial exhibitions that were held every few years throughout the century in France and the other major industrial countries.

Five of the prints in the museum's collection are either interior shots or exterior views of the company's factory buildings, while the other two depict company-built "workers' housing" and a "school for infants," pictured here. The latter decades of the 19th century saw the spread of many social and political problems stemming from industrialization. Both private and public sectors were brought into play in an attempt to eradicate or alleviate some of these ills. Political parties evolved, social reform movements were initiated, and organizations and institutions were formed and implemented to establish child labor laws and provide better education, health care, and appropriate housing for workers. Throughout Europe and America, certain progressive companies pioneered in addressing these issues, and it may well be that Eschager Ghesquiere & Co. was one of them, and further, was proud enough to hire a photographer to record their efforts.

Louis-Émile Durandelle

Bancs à étirer (Extrusion Benches), ca. 1885

Albumen print
MUSEUM PURCHASE
78:0693:0001

L. Lafon
French, active
ca. 1870s

Canon Hotchkiss à
tir rapide de 37 m/m
(Rapid-Fire 37mm
Hotchkiss Cannon),
1879

Albumen print
MUSEUM PURCHASE,
EX-COLLECTION
PHILIP MEDICUS
81:1191:0001

L. Lafon

Matériel de mon-
tagne, système
Hotchkiss (Military
Equipment for the
Mountains, Hotch-
kiss System), 1879

Albumen print
MUSEUM PURCHASE,
EX-COLLECTION
PHILIP MEDICUS
81:1191:0019

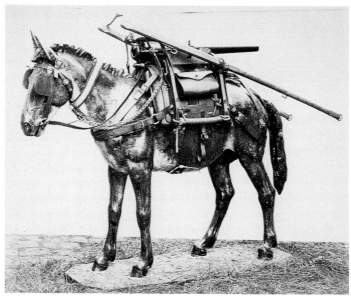

The images of a man aiming the rapid-fire Hotchkiss cannon and a stuffed mule bearing the weight of a packed Hotchkiss mountain gun are from a portfolio of 25 photographs depicting the factory and products of the Hotchkiss armaments company of Paris. The view of the gas and steam works is from a group of 15 photographs depicting the various buildings of the U.S. Naval Academy. These prints represent the evolution of commercial photography from its documentary roots using photographs as vehicles for advertising. Twenty or thirty different views of a subject could be made in the time it took a draftsman to make one or two, and photographs possessed the virtue of containing more complete and more accurate information than any artist could hope to capture. Entrepreneurs began to collect groups of photographs into albums to present more persuasive narratives about whatever they wanted to sell. Initially the purview of governments or international industries, this practice moved quickly into the hands of local photographers who soon were at the service of local businessmen.

Fischer & Brothers
American,
active 1850s–1860s

Gas and Steam
Works, U.S. Naval
Academy, ca. 1860

Salted paper print
GIFT OF ALDEN
SCOTT BOYER
80:0273:0003

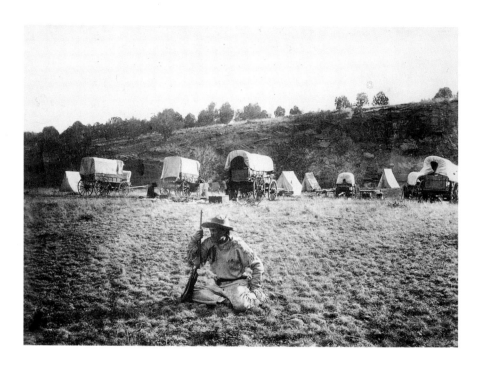

Dr. William A. Bell
English, 1839–1915

Camp of Surveying
Party at Russel's
Tank, Arizona,
ca. 1867–1868

Albumen print
MUSEUM PURCHASE
70:0075:0032

This buckskin-clad young man leaning on his new carbine rifle is kneeling at Russel's Tank, Arizona, exactly 1,271 miles west of the Missouri River. The people perched on the train sitting on the bridge crossing a wash near Fort Harker, Kansas, are 216 miles west of the Missouri River. And the bridge shown on page 246 is crossing Muddy Creek, Kansas, at a spot 162 miles west of the Missouri River. This detailed information giving the exact location where each of these photographs was taken is included in the letterpress on the mount of each print in a series published by Alexander Gardner in 1868 under the title *Across the Continent on the Kansas Pacific Railroad*. The museum has 39 photographs from this series. In its entirety, the series may have contained as many as 127 prints.

In 1867 Alexander Gardner was hired as the chief photographer for the Union Pacific Rail Way, Eastern Division, renamed the Kansas Pacific Railroad, and still later reborn as the Union Pacific Railroad. Gardner, his son Lawrence, and his friend and fellow photographer William Pywell all left Washington, D.C., for Kansas in September 1867 where

they, using both stereo and larger view cameras, photographed along the route of the railroad until mid-October when they returned to Washington. They included in their views the railroad, new boom towns such as "Hays City, Kansas, Aged Four Weeks," the cattle stockyards of Abilene, and marks of "civilization" along the way including "St. Mary's Mission, Kansas, Pottawatamie Indian School," as well as the open prairie landscapes they found along the way. At about the same time, a British physician named Dr. William A. Bell, hired by a different railroad official, had joined the engineering party surveying the best route for a transcontinental railroad along a southern route from Kansas to California. Bell photographed with this survey as it made its way west, following the 32d parallel from Kansas to New Mexico, then through Arizona into California. As was customary practice, Bell's photographs were turned over to Gardner, who, as chief photographer for the railroad, published both bodies of work as a single sequence of views under his own name.

Alexander Gardner
American, b. Scotland, 1821–1882

View Near Fort Harker, Kansas, 216 Miles West of Missouri River, ca. 1867–1868

Albumen print
MUSEUM PURCHASE
70:0075:0019

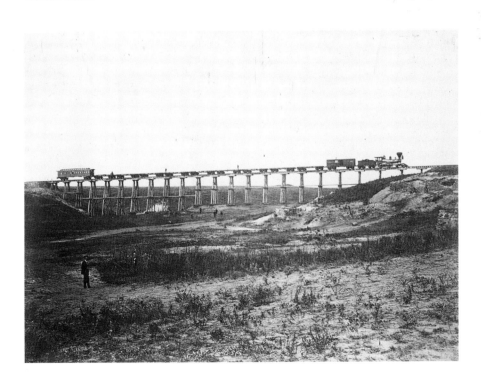

Alexander Gardner
American, b. Scot-
land, 1821–1882

Muddy Creek,
Kansas, 162 Miles
West of Missouri
River, ca. 1867–1868

Albumen print
MUSEUM PURCHASE
70:0075:0015

The "O. & C. R. R., Loop Showing Three Trestles ..." is one of almost
300 photographs by the Isaiah West Taber Studio that are now housed
at George Eastman House. Trestles, bridges, even looped tracks climb-
ing difficult mountain passes became common icons in the genre of
railroad scenic views. This photograph is a stark illustration of the con-
flicting national ideals that 19th-century Americans faced in a land that
was being changed daily by the spread of industry and technology. The
rolling waves of mountains in this view would remind many of Taber's
contemporaries of the spectacular natural beauty of their country. They
would also have responded with great pride to this pictorial evidence of
the American engineering skills and the national drive that subdued the
most rugged frontier and bent it to the service of mankind. The railroad
became one of the most common icons symbolizing the power of
modern technology. This photograph, like the ideology that produced
it, skillfully keeps these two potentially incompatible ideals in a
tenuous balance.

3740 O. & C. R. R., Loop showing three Trestles, Siskiyou Mts., Cal. *Taber* Photo., San Francisco.

Isaiah West Taber
American, 1830–1912

O. & C. R. R., Loop Showing Three Trestles,
Siskiyou Mts., Cal., ca. 1885

Albumen print
GIFT OF ALDEN SCOTT BOYER
81:2266:0002

William H. Rau
American, 1855–1920

Broad Street Station,
Pennsylvania Rail-
road, Philadelphia,
Pennsylvania,
ca. 1892

Modern gelatin silver
print from original
gelatin on glass
negative, 1978
GIFT OF 3M COM-
PANY, EX-COLLEC-
TION LOUIS
WALTON SIPLEY
78:1267:0003MP

These two photographs are modern prints made from "mammoth" 18 x 22-inch glass plate negatives taken by William H. Rau about 1891 as part of his commission to document the Pennsylvania Railroad. The museum holds 11 variously sized glass plate negatives of railroads taken by Rau in the 1890s. The dramatic, swooping black curve in the sky of the image on page 249 is a reminder of the sad fate suffered by many glass plate negatives. Of the 650 plates Rau made for this project, only 11 are extant, all of which are held in the museum's collection.

In 1891 Rau was hired as the official photographer for the Pennsylvania Railroad and tasked with the mission to document "The Greatest Highway to the West," including the associated scenery, adjacent towns and cities, industries and businesses along its routes, as well as the railroad's rolling stock and stations. This work was first exhibited at the World's Columbian Exposition in 1893. The railroad furnished Rau with his own train and a specially designed photographic car with a living and working area, a darkroom (including a 300-gallon water tank), and space to store the glass plates, large cameras, and other equipment and supplies he used on these trips. A large platform was added to the roof of Rau's car to enhance the expansiveness of his views.

William H. Rau

Manayunk Bridge
*Pennsylvania
Railroad,* ca. 1892

*Modern gelatin silver
print from original
gelatin on glass
negative, 1978*
GIFT OF 3M COM-
PANY, EX-COLLEC-
TION LOUIS
WALTON SIPLEY
78:1267:0002MP

Rau began photography at age 13 as William Bell's assistant in
Philadelphia, and learned photography so proficiently that by 1874,
at only 19, he accompanied the United States Scientific Expedition to
Chatham Island in the South Pacific off the coast of New Zealand to
photograph the transit of Venus across the face of the sun. This expedi-
tion lasted well over a year, with the photographers using wet plates and
requiring "tons of materials." Rau worked for Edward Wilson's Centen-
nial Photographic Company at the great exhibition in Philadelphia in
1876, and then as an operator in studios in Philadelphia before moving
to Colorado in 1881 to work for William Henry Jackson, photographing
landscapes in Colorado and in New Mexico. In 1881 and 1882, Rau ac-
companied Edward L. Wilson on a well-publicized photographic tour
to the Middle East when, as he later said, "... the weight of glass (dry
plates) and outfit for 1,800 negatives was about 2,000 pounds...." By
1887 Rau, with a wide range of photographic experience, established
himself as one of the leading photographic businesses in Philadelphia,
where he continued to receive major commissions to photograph sever-
al railroads and international expositions. His prolific career stretched
into the early decades of the 20th century.

Roger Fenton
English, 1819–1869

Plains of Balaklava,
1855

Salted paper print
MUSEUM PURCHASE,
EX-COLLECTION
ALDEN SCOTT BOYER
81:1238:0001

Crimea

This view of the desolate and barren plains of Balaklava is one of 91 salted paper prints at George Eastman House taken by Roger Fenton in the Crimea in 1855. The Crimea was the major battleground of the war being fought between Russia and the allied forces of England, France, and Turkey. The war began in the spring of 1854 when the Russians crossed the Danube into the Ottoman Empire, drawing England and France into the conflict to protect the balance of power in the Balkans. In September 1854, in "one of the most gigantic military movements ever undertaken," the allied armies launched an invasion force of 600 ships carrying 57,000 troops into the Crimea. The forces secured the harbor of Balaklava, then after a series of inconclusive battles, fell into the stalemate of a siege war punctuated with sharp, bitter, bloody skirmishes lasting through the winter into 1855. Disease and exposure caused great hardships for the ill-equipped allied troops, killing more soldiers than enemy fire. The British public, informed of these problems by the first newspaper war correspondents, began to question the policies and leadership of the military and the government.

Other attempts had been made by the British government to attach a photographic unit to the Crimea Expedition, the first floundering when a hurricane sank the ship with all hands, the second when the hastily trained army officers could not master the extraordinary technical difficulties of photographing in inhospitable conditions. Finally the army approached the newly formed Photographic Society in London for help, and Roger Fenton, a leading force in British photography at the time, volunteered to go to the Crimea. He obtained financial support from Thomas Agnew & Son, a publisher of illustrated works on current events, and official support from both the Crown and the Secretary of War. Fenton then had a photographic van built, hired an assistant and a cook, furnished his expedition with 36 large crates and chests of equipment and supplies for the wet-collodion process he chose to use, and sailed for Balaklava in February 1855 where he became one of the first war photographers.

Fenton overcame many extreme difficulties in the Crimea, ranging from photographing at dawn to prevent his developing baths from boiling in the intense heat to avoiding the fire of the Russian artillery attracted to his distinctive and mysterious photographic van. He also had to face the more mundane, but still difficult, problems of finding a means for transporting his bulky van and supplies in a horse-starved army in chaos, or the harassment of British troops wanting to have their portraits made by this new and strange phenomenon in their midst. Fenton photographed the allied forces from March to the end of June before returning to England. Racked by the cholera that had already killed many British soldiers, Fenton was forced to leave Crimea before the decisive final battle for Sebastopol. Upon his return to England, Fenton found himself heralded as a celebrity. He was presented to the queen and, due to his illness, allowed to recline on a couch during the royal interview. His unprecedented photographs were displayed in several exhibitions that received extensive critical and popular acclaim. Thomas Agnew & Son began issuing sets of original prints mounted on boards with letterpress captions on a weekly basis from November 1855 to April 1856. The photographs gained even greater public attention when published as wood engravings in illustrated weekly magazines in England and America.

The museum's collection offers an unusual opportunity to see something of the range of Fenton's practice in the Crimea. Fenton made several types of photographs, including a series of formal or semiformal portraits of the military and political leadership of the allied forces.

These portraits compare favorably with the better studio portraiture of the day, in Fenton's ability to bring out the character of a sitter. They are otherwise distinguished by the photographer's care to fully illustrate the various allied forces that had come together on Crimea's barren plains. Taken out-of-doors, the second type of portrait appears more spontaneous. These portraits combine the veracity of the surrounding scene – the forceful truthfulness of the tents or rock huts under the harsh sun – with a slight degree of posing or role-playing by the subjects portrayed. Attempting to provide a fuller narrative of the war, Fenton created tableaux of valorous generals and soldiers, the camaraderie of the campsite during meals, and the tedium of standing watch, as seen here in "A Quiet Day in the Mortar Battery."

Fenton's Crimean landscapes are again divisible into several related categories. The first are views of the occupied port, the campsites of the various military forces, and British fortifications. These are, in a sense, news pictures designed to satisfy the public's curiosity about

Roger Fenton
English, 1819–1869

General Bosquet,
1855

Salted paper print
MUSEUM PURCHASE,
EX-COLLECTION
ALDEN SCOTT BOYER
81:1238:0041

scenes and events that they had read about in the newspaper dispatches. Fenton also made some very distant views of the besieged city of Sebastopol and the surrounding terrain. These images set the "scene" of the conflict, and are handled with Fenton's usual consummate skill as a landscape photographer. Fenton captured with quiet drama the sweep and scale of this arid land with its vast, harsh skies. He was thus able to bring to his British audience, at home in the picturesque and verdant landscape of the British Isles, something of the inhospitable conditions of this foreign land and the tumultuous conflict that had cost so many British lives.

Fenton did not take any battlefield photographs of the dead, dying, or wounded soldiers. Nor did he take photographs of the hospitals or of the sick soldiers. Fenton's report of this war is singularly bloodless. This has raised the unanswerable question of whether this was done from some Victorian sensibility about what was proper to display in a public medium that would be seen by women and children, or whether Fenton worked as an apologist for the British government.

It is clear from all sources that Fenton's intent was to provide, as much as he could with his limited photographic technology, illustrative documentation of the peoples, places, and events of the war. His report was primarily intended to inform the citizenry about what was happening to everyone's fathers or sons in a distant land and to shape public opinion. In this sense, Fenton assumed the mantle of "public witness" – one who sees and reports events not through the focus of his individual perception, but rather as an observer, a stand-in for the general polity. Fenton was working in an age when photography's role as a mode of journalism was in the process of being forged, and national propaganda was one of its earliest applications. The public's strong belief in the "objective truth

Roger Fenton

A Quiet Day in the Mortar Battery, 1855

Salted paper print
MUSEUM PURCHASE,
EX-COLLECTION
ALDEN SCOTT BOYER
81:1238:0052

of photography" was fundamental to this type of journalistic practice. Perhaps it is easy for the contemporary viewer to overlook what may have been the most important quality of this work to its public, an audience that received most of its war news in the form of rhetorical, jingoistic prose or in overdramatized, romantic sketches and wood engravings. For all of its propagandist intent, the banal, unfinished, rough honesty of Fenton's views and portraits would have been revelatory of war's harsh realities.

These two photographs show the aftermath of war, though they were taken sufficiently after the battles so that the dead and wounded had already been removed. While "The Battlefield of Tchernaya" relies on its title to help the viewer comprehend the full range of emotional dimension that this otherwise deceptively bland landscape might convey, there is no chance of mistaking that some horrific event has visited the site of "The Barracks Battery." The tumbled cannon, the chaotic disarray of the scattered objects tell by themselves that some disaster has occurred. The photographs of this conflict by the British photographer James Robertson are drawn from a group of 59 salted paper prints in two albums held at George Eastman House, both albums originally having been in the possession of British military personnel who had served

James Robertson
English, 1813–1888

The Battlefield of
Tchernaya, ca. 1855

Salted paper print
GIFT OF EASTMAN
KODAK COMPANY,
EX-COLLECTION
GABRIEL CROMER
79:0001:0037

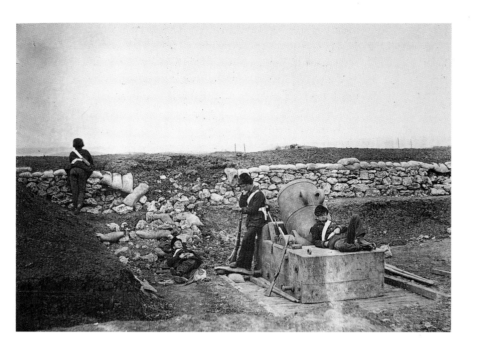

Fenton did not take any battlefield photographs of the dead, dying, or wounded soldiers. Nor did he take photographs of the hospitals or of the sick soldiers. Fenton's report of this war is singularly bloodless. This has raised the unanswerable question of whether this was done from some Victorian sensibility about what was proper to display in a public medium that would be seen by women and children, or whether Fenton worked as an apologist for the British government.

It is clear from all sources that Fenton's intent was to provide, as much as he could with his limited photographic technology, illustrative documentation of the peoples, places, and events of the war. His report was primarily intended to inform the citizenry about what was happening to everyone's fathers or sons in a distant land and to shape public opinion. In this sense, Fenton assumed the mantle of "public witness" – one who sees and reports events not through the focus of his individual perception, but rather as an observer, a stand-in for the general polity. Fenton was working in an age when photography's role as a mode of journalism was in the process of being forged, and national propaganda was one of its earliest applications. The public's strong belief in the "objective truth

Roger Fenton

A Quiet Day in the
Mortar Battery, 1855

Salted paper print
MUSEUM PURCHASE,
EX-COLLECTION
ALDEN SCOTT BOYER
81:1238:0052

of photography" was fundamental to this type of journalistic practice. Perhaps it is easy for the contemporary viewer to overlook what may have been the most important quality of this work to its public, an audience that received most of its war news in the form of rhetorical, jingoistic prose or in overdramatized, romantic sketches and wood engravings. For all of its propagandist intent, the banal, unfinished, rough honesty of Fenton's views and portraits would have been revelatory of war's harsh realities.

These two photographs show the aftermath of war, though they were taken sufficiently after the battles so that the dead and wounded had already been removed. While "The Battlefield of Tchernaya" relies on its title to help the viewer comprehend the full range of emotional dimension that this otherwise deceptively bland landscape might convey, there is no chance of mistaking that some horrific event has visited the site of "The Barracks Battery." The tumbled cannon, the chaotic disarray of the scattered objects tell by themselves that some disaster has occurred. The photographs of this conflict by the British photographer James Robertson are drawn from a group of 59 salted paper prints in two albums held at George Eastman House, both albums originally having been in the possession of British military personnel who had served

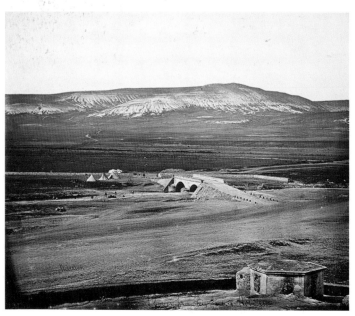

James Robertson
English, 1813–1888

The Battlefield of
Tchernaya, ca. 1855

Salted paper print
GIFT OF EASTMAN
KODAK COMPANY,
EX-COLLECTION
GABRIEL CROMER
79:0001:0037

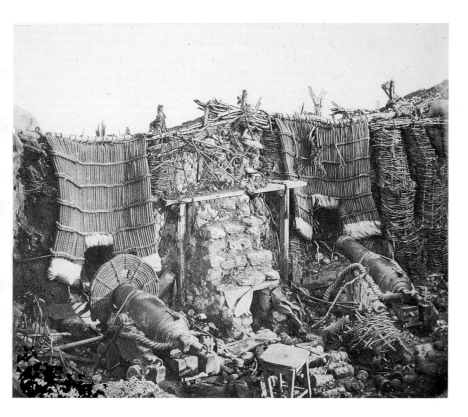

in the Crimea. Just after Roger Fenton had become ill and returned to England in September 1855, the war's long stalemate broke, and Sebastopol finally fell to the allied forces. James Robertson had joined his partner Felice Beato in the Crimea that summer, arriving from Constantinople, where he had been sketching and photographing troops at the major allied staging center for the Crimean campaign. Robertson was able to photograph the overrun Russian positions around Sebastopol and the gradual disbursement of the armies from the regions as the "Russian War" gradually dragged to an inconclusive and ragged end in 1856. A few of Robertson's views of Sebastopol were exhibited along with Fenton's in London in 1856. Robertson's work was also used to illustrate several books published about the war, including Henry Tyrrell's *The History of the War with Russia* and *Report on the Art of War in Europe in 1854, 1855, and 1856*, by Colonel Richard Delafield, U.S. Army.

James Robertson

The Barracks Battery, 1855

Salted paper print
GIFT OF EASTMAN
KODAK COMPANY,
EX-COLLECTION
GABRIEL CROMER
79:0001:0045

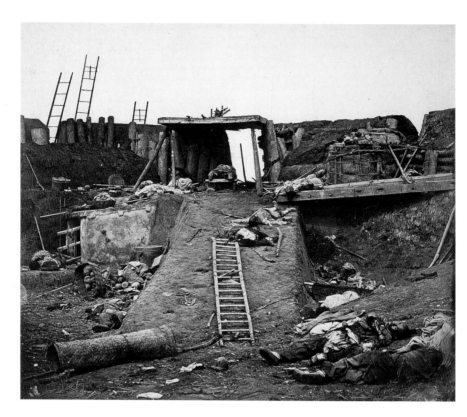

Felice A. Beato
British, b. Italy
ca. 1830–ca. 1906

Interior of English
Entrance. – Taku,
1860

Albumen print
MUSEUM PURCHASE
76:0134:0005

The Opium War

In March 1860 Felice Beato sailed from Calcutta for Hong Kong with General Sir Hope Grant, commander of the British forces, to join the Anglo-French Expeditionary Force marshaling to invade China. This military invasion by allied British and French troops carried by warships and transports was launched in late July against the fortress at Pei-tang (Beitang) which fell on August 1. The allied forces then marched inland, storming and taking T'ang-ku (Tanguu) Fort in mid-August, and moving against the Taku (Dagu) forts, which formed the major line of defense for the Chinese capitol of Peking (Beijing). On August 21 the Taku forts were attacked. Under intense shelling, an ammunition magazine in the North Fort exploded, breaching the walls, and the fort was taken. A contemporary wrote that British troops entered the fort to "... a distressing scene of carnage ... with groups of dead and dying meeting the eye in every

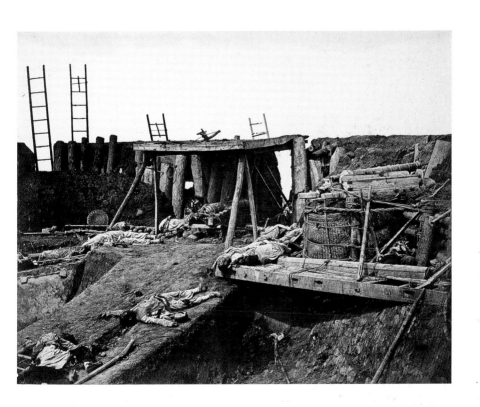

direction. ..." This was the horrifying scene that Beato encountered, as reproduced in the two images on these pages. They are among the seven views of this engagement that are owned by the museum, along with four other pictures taken by Beato in China during the course of the expedition. The allied forces continued on, taking and burning the emperor's summer palace outside of Peking, before the Chinese forces surrendered. Beato photographed both Allied and Chinese notables during and after the treaty discussions as well as views around Peking before returning to Hong Kong in mid-November. In all, Beato may have taken up to 95 photographs documenting the Anglo-French expedition, which brought what is variously known as the Second Opium War, or the Arrow War, to a conclusion. Beato also made approximately 200 stereo views of Canton, which were sold in England by the British stereoscopic firm Negretti & Zambra.

Felice A. Beato

Interior of Fort Taku Immediately after Capture, 1860

Albumen print
MUSEUM PURCHASE
75:0034:0004

Various photographers
American, active 1860s

Panel of Cartes and Tintypes, Received by Post Office Dead Letter Office, 1861–1865

Albumen prints and tintypes
MUSEUM PURCHASE,
EX-COLLECTION
PHILIP MEDICUS
85:1103:0001–35

The American Civil War

Scores of photographers were active during the American Civil War, most of them in temporary studios set up at the military encampments, where they made and sold inexpensive tintype or carte portraits of soldiers. The soldiers sent their portraits home to their loved ones and friends, and waited for similar portraits of their wives and children in the return mail. This was the most common use made of photography during this war.

This panel of photographs, comprised of cartes and tintypes received by the U.S. post office's dead letter office, is itself a poignant, haunting message of missed communications and lost hopes. In an age of high infant mortality, incurable diseases, and early death, and during a time of an uncertain and bloody war, each of these men was performing, however ritualistically, an act of mingled courage and fatalism: "I was here. Remember me when I'm gone." The literature of the age makes it all too clear how the memorializing function of photography was often

Unidentified photographer
American, active 1860s

U. S. Grant, ca. 1862

Albumen print
MUSEUM PURCHASE, EX-COLLECTION
CHESTER A. PHILLIPS
85:1081:0001

CAMP WINFIEL

Entered according to act of Congress, by GARDNER & GIBSON, in

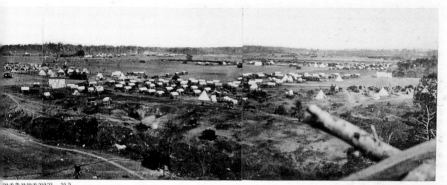

YORKTOWN, VA.
the District Court of the United States for the District of Columbia.

called into service to commemorate a loved one's presence, no matter how fleeting, in this uncertain world.

Although hundreds of individuals photographed various aspects of the Civil War, the majority of the photographic documentation of the armies in the field was in the hands of a few dozen men. An even smaller number had the skills, determination, and opportunity to actually photograph events taking place between the two battling armies. Photographic processes were simply too slow and the equipment and procedures too cumbersome to record the heated exchange of battle, focusing instead on its prologue and aftermath. Still, a few photographers found the means to extend their craft beyond anything previously thought possible to bring a larger and more significant range of the experience of civil conflict under the camera's deliberate eye.

Alexander Gardner, James Gibson, and George Barnard were among the first and most capable of these photographers. Gardner & Gibson's panoramic view of Camp Winfield is an image made up of five separate negatives taken by Gibson in May 1862 during General McClellan's abortive Peninsula Campaign. In order to capture the sweeping dimensions of the military encampment, Gibson placed his camera on a hilltop and made a series of overlapping views across the face of the camp. Prints were then made from these negatives by Gardner, who positioned them and trimmed the prints to create an almost seamless panorama of McClellan's bivouacked troops.

Though portraits of soldiers posed with their weapons were common during the war, George Barnard's photograph on is more memorable

Alexander Gardner & James F. Gibson
American, b. Scotland, 1821–1882 & American, b. Scotland, 1828/9

Camp Winfield Scott, Yorktown, Va., May 1862

Albumen print panorama
MUSEUM PURCHASE, MILLER-PLUMMER FUND
86:0564:0001

George N. Barnard
American, 1819–1902

Fort Richardson, at Quarleshouse, near Fair Oaks, June 1864

Albumen print carte-de-visite
MUSEUM PURCHASE, EX-COLLECTION PHILIP MEDICUS
82:0561:0012

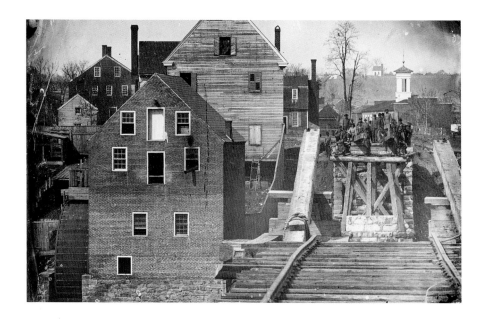

**Attributed to
Andrew J. Russell**
American,
1830–1902

Fredericksburg
End of Bridge,
December 13, 1862

Albumen print
MUSEUM COLLEC-
TION, BY EXCHANGE,
EX-COLLECTION
A. HYATT MAYOR
81:1081:0001

than most. By placing himself on a diagonal to the subject, by fore-
grounding and cropping the cannon against the edge of his picture, by
achieving a balance between the soldier holding the ramrod and the
other soldiers scattered throughout the picture, Barnard has created a
scene with a sense of impending action, a photograph not only of what
was, but what was to come.

Nearly all of the best photographers of the Civil War were civilians.
Captain Andrew J. Russell was an exception. In 1862 Russell enlisted in
the 141st New York Volunteers and was assigned to the U.S. Military
Railroad Construction Corps. Here Russell documented the bridge-
building activities, railroad construction techniques, as well as the
troops, battlefields, and the carnage of war. His technical skill, artistic
sensibility, and dedicated workmanship provided some of the most en-
during documentation of the war, including many striking photographs
of the new technologies of transportation. Russell photographed at
Marye's Heights during the battle of Fredericksburg, and at Peters-
burg, Alexandria, and the fall of Richmond. This view was taken at
Fredericksburg during a lull in the siege. The close proximity of the
armies is emphasized by Russell as he and his camera stand at the

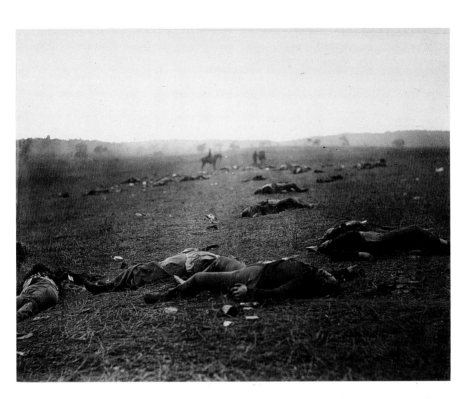

abrupt end of a damaged bridge, looking towards the town and the enemy troops that the Union army would soon engage. Russell's disjunctive positioning of the bridge and the stepladder arrangement of buildings with their constellation of windows flattens the compositional space while accentuating the anticipatory tension of battle.

This horrifying litter of bodies is the wrack left by the "high tide of the Confederacy" at Gettysburg. The bodies in this field mark the end of any further chance of offensive war by General Robert E. Lee's Army of Virginia and, effectively, the end of any hope of Confederate victory. The war would go on for almost two more years and kill many more young men, but its final result was determined here, during three days in July 1863.

It was unusual that Alexander Gardner and his employees Timothy O'Sullivan and James Gibson were nearby during the battle, as this war was not fought for the convenience of photographers. Gardner, learning

Timothy H.
O'Sullivan
American, b. Ireland,
1840–1882

A Harvest of Death,
Gettysburg, Pennsylvania, July 1863

Albumen print
MUSEUM PURCHASE
81:0004:0036

**Attributed to
Thomas C. Roche**
American,
1826/7–1895

Fortifications and
Bomb-Proofs, in
Front of Peters-
burgh, Va., 1865

*Albumen print
stereograph*
81:6547:0002

that a major battle was imminent near the school where his teenage son was boarded, had rushed to Gettysburg to rescue his son, then waited nearby for the battle to conclude. His group began to photograph the battlefield immediately after the Union victory, before the dead were buried and the debris of the battle was cleared away. This is the second major battle aftermath that Gardner and his team had documented, and their photographs display the tragedy of war with great force and immediacy.

In 1912 Thomas C. Roche was described in the *Photographic History of the Civil War* as "... an indefatigable worker in the armies' train ...", but scant other information is given. Roche was remembered with fondness in a brief article written in 1882 by Captain Andrew J. Russell reminiscing about the Civil War. Little else has been written about this important war photographer, although throughout his lifetime he was always regarded with great respect by his peers. Roche worked for E. & H. T. Anthony & Co. as the war was starting and then worked with the Brady studio and Alexander Gardner, perhaps as a consultant on the carte-de-visite printing arrangements then in effect between the Anthony Company and the Brady Studio. But Roche was soon photographing under General Meigs in the Quartermaster Corps and may have worked with Captain Andrew J. Russell later in the war. It is known that Roche photographed the battle of Dutch Gap Canal while under cannon fire and that he made powerful images of dead Confederate soldiers in the trenches at Petersburg

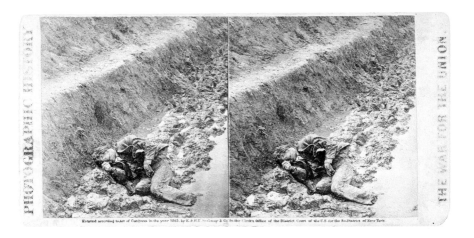

after it fell to the Union forces in April 1865. The Anthony Company printed these and others of Roche's stereo photographs throughout the war.

The stereo cards from the series *The War for the Union* printed on these pages are two of approximately 120 stereos depicting the war that are held by the museum. They forcefully display the quality most often remarked upon by Roche's contemporaries when viewing battlefield scenes – that photographs display the real, unglamorous face of war. Critics were impressed by the insistent factuality of photography and always came away from their viewing experiences in a somber frame of mind. It seems fairly certain, from many of the documents of the day, that the average American citizen had little notion that the Civil War would be so long, so difficult, and so devastating. Further, it seems clear that most Americans had little understanding of what war actually meant, and throughout the conflict their ideas about warfare evolved and changed. Certainly the patriotic rhetoric and romantic sentiment about the glamour of fighting for one's country and defending one's ideals was replaced by a more sober outlook as the war dragged on. An increasing demand by the American citizenry for more accurate and more factual descriptions of the war led to an expanded use of photography in the illustrated press by the end of the war, even though the photograph had to be translated into wood engravings to be printed. This same desire to better understand the grim reality of war's events is what helped to fuel the popularization of stereo cards, cartes, and albums.

Attributed to
Thomas C. Roche

A Dead Rebel
Soldier, As He Lay in
the Trenches of Fort
Mohone, 1865

*Albumen print
stereograph*
GIFT OF 3M COM-
PANY, EX-COLLEC-
TION LOUIS
WALTON SIPLEY
79:1484:0046

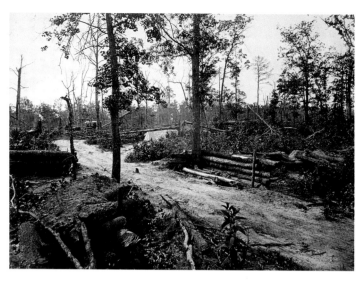

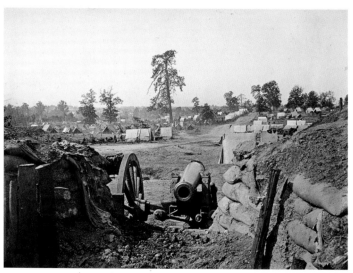

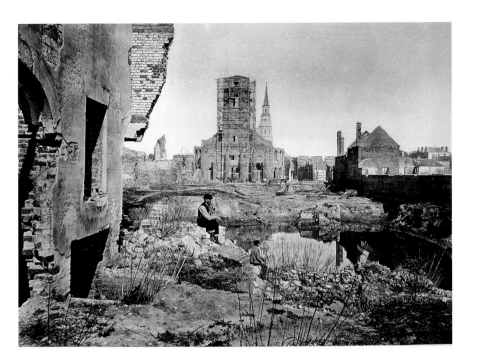

These three views are from a book published by George Barnard in 1866 commemorating General William T. Sherman's famous march to the sea. Attached to Sherman's command in 1864, Barnard photographed the fall of Atlanta, then followed Sherman's troops on their dash across Georgia to join with other federal forces in Savannah. That campaign moved too fast for Barnard to be able to take photographs, but he conceived the idea of combining some of his existing photographs with others that he would take on a return trip over the same route after the war. Barnard and his assistant, James W. Campbell, spent the spring of 1866 photographing sites of skirmishes and battles that he had not been able to take before. This elegant publication contains 61 large, beautifully crafted prints – some of them with clouds carefully overprinted onto the blank skies – organized to follow the army's course from Nashville, Tennessee, to Atlanta, Georgia, then on to Charleston, South Carolina, and ending symbolically at nearby Fort Sumter, where the war began.

The life and death of President Abraham Lincoln was portrayed to Americans in diverse popular genres, including mechanical lantern

George N. Barnard

Ruins of Charleston, S. C., ca. 1865

Albumen print
MUSEUM PURCHASE, EX-COLLECTION PHILIP MEDICUS
81:0001:0060

C. W. Briggs Company
American, active 1868–1930

Assassination of Lincoln, ca. 1890

Transparency, gelatin on glass (mechanical lantern slide) with applied color
GIFT OF 3M COMPANY, EX-COLLECTION LOUIS WALTON SIPLEY
78:0468:0032

Alexander Gardner
American, b. Scotland, 1821–1882

Lewis Payne [*sic*], One of the Lincoln
Conspirators before His Execution, 1865

Albumen print
MUSEUM PURCHASE
72:0033:0032

Alexander Gardner
American, b.
Scotland, 1821–1882

Execution of the
Lincoln Assassina-
tion Conspirators.
The Scaffold, 1865

Albumen print
MUSEUM PURCHASE
72:0033:0023

slides (see page 268) and photographic albums. *The Lincoln Conspiracy*,
an album compiled by retired Colonel Arnold Rand, 4th Cavalry Regiment
of Massachusetts Volunteers, contains wood engravings and lithographs
relating to Lincoln's assassination and the search, trial, and execution
of the conspirators. Of particular note is a group of 25 photographs by
Alexander Gardner and his assistants, made during the harrowing
period following Lincoln's death.

 During the course of the war, Alexander Gardner left Mathew Brady's
studio to set up his own rival business in Washington, D.C. He gathered
a small corps of the best war photographers around him and amassed
an extensive document of the war. As a result, Gardner had established
an excellent reputation among his peers and among the political and
military leadership in Washington. It was because of this that he was
asked by Colonel Lafayette Baker, chief of the Secret Service, to record
the complex and difficult events following Lincoln's assassination.

 The portrait of conspirator Lewis Payne [*sic* Paine] (page 269) was
taken aboard the naval monitor U.S.S. *Saugus*, where he was held after

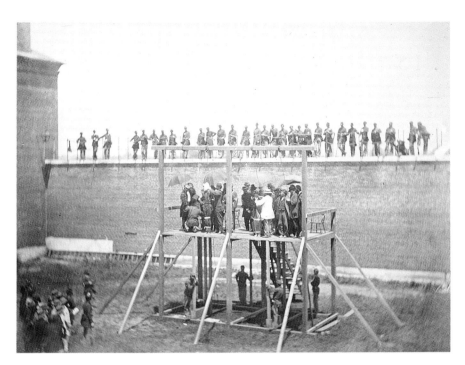

his capture by federal forces in April 1865. It is one of four similarly posed portraits of Paine by Gardner. In total, the album assembles 19 portraits of the eight suspected conspirators, including those of Paine. The two photographs of the gallows featured above are the first and fifth views in a sequence of at least eight images that Gardner, with Timothy O'Sullivan's assistance, took of the conspirators' executions on July 7, 1865. In a bravura performance of skill, the photographers were able to document the execution in a sequential manner – unusual for the day – thus rendering a disturbingly haunting narrative of the conspirators' final moments.

During the war, Gardner had established a working relationship with *Harper's Weekly*, one of the country's most popular illustrated journals. His war photographs, and later the conspirators' portraits, were translated into wood engravings for the publication. The extensive use of wood engraving in the popular press at this time prefigures later-day photojournalism as a dynamic visual record of memorable human events.

Alexander Gardner

Execution of Lincoln Assassination Conspirators. Adjusting the Ropes, 1865

Albumen print
MUSEUM PURCHASE
72:0033:0035

A Matter of Fact

Photography was a child of science. Early photographers often came from scientific backgrounds. For example, William Henry Fox Talbot was an amateur scientist who made photogenic drawings of botanical specimens; and it was Sir John Herschel, a renowned astronomer, who coined the word "photography." The technical complexities of the early photographs precluded many other amateurs from using the medium with any degree of success. Furthermore, it was photography's early practitioners who made the constant, ongoing advancements to the medium: photographers with scientific backgrounds and knowledge tirelessly experimented with the medium in order to achieve optimum clarity of detail and permanence in the final image. It was the public's faith in photography as an accurate transcription of the natural world that made it more than simply another tool of science. Its perceived truthfulness bestowed on it the mantle of scientific proof.

Frederick Gutekunst
American, 1831–1917

Leaves and Flowers
of Cundurango de
Tumbo Grande,
ca. 1873

Albumen print
MUSEUM PURCHASE
LIBRARY COLLECTION

Anna Atkins
English, 1799–1871

Carix (America),
ca. 1850

Cyanotype
MUSEUM PURCHASE,
FORD MOTOR COM-
PANY & MORRIS
FOUNDATION FUNDS
95:2633:0001

Carde –
(America)

Frederick Gutekunst was a Philadelphia photographer who became a leader in photomechanical reproduction. During the latter half of the 19th century, Gutekunst ran a photo-reproduction business selling portraits of famous Americans, an early version of the photographic stock house. He also made photographs of botanical specimens for a medical text on the therapeutic plant Cundurango, including an image of leaves and flowers of the species, which looks almost like a photogram in its direct presentation of the plant's basic forms (page 272).

Englishwoman Anna Atkins was a botanist who learned directly about the invention of photography through correspondence with Talbot. She took up photography to record botanical specimens for a scientific reference book, *British Algae: Cyanotype Impressions,* which became one of the first books to be illustrated with photographically derived images. The book's handwritten text and illustrations were created using the cameraless photogram technique with the cyanotype process. Atkins printed and published part one of *British Algae* in 1843, thus establishing photography as an accurate medium for precise scientific illustration.

Henry Troth was born into a Quaker family of chemists in Philadelphia. Specializing in landscapes and botanical studies, he exhibited his

(above)
Dr. James Deane
American, 1801–1858

Ichnographs, 1861

Salted paper print
GIFT OF ALDEN
SCOTT BOYER
LIBRARY COLLECTION

(right)
Lewis M. Rutherford
American, 1816–1892

Moon, March 4, 1865

Albumen print
MUSEUM PURCHASE, MARGARET T.
MORRIS FOUNDATION FUND IN MEMORY
OF DR. WESLEY T. "BUNNY" HANSEN
89:0403:0001

Louis M. Rutherford
New York March 4 1865

James Hall Nasmyth
English, 1808–1890

Normal Lunar Crater
Model, 1874

Woodburytype
MUSEUM PURCHASE
LIBRARY COLLECTION

photographs internationally around the turn of the century, and both
Alfred Stieglitz and F. Holland Day exhibited his work. He became a
professional photographer of architecture and outdoor scenes for
popular magazines. Troth's images also illustrated volumes of poetry
and essays on nature, as well as the botanical study *Phytogeographic
Survey of North America*. The Academy of Natural Sciences used Troth's
images in its records of flower studies. The uprooted lady fern (species
Athyrium filix-femina) (page 274) was a large, feathery, mostly ornamen-
tal fern that Troth photographed as if suspended in space, its exposed
roots dangling. "Tulip Poplar Blossoms" (page 275) displays an ener-
getic arrangement of delicate flowers peeking out amidst a bevy of spiky
leaves and demonstrates photography's capacity to simultaneously
record information and render beauty.

Dr. James Deane of Greenfield, Massachusetts, made drawings and
photographs of footprint fossils in the stratified sandstone at the quarry
at Turner's Falls (page 276). Deane's photographs of these "curious
impressions" were published posthumously in *Ichnographs from the*

James Hall Nasmyth

The Back of Hand and Wrinkled Apple, 1874

Woodburytype
MUSEUM PURCHASE
LIBRARY
COLLECTION

Sandstone of Connecticut River. In the volume's introductory text, Augustus A. Gould wrote: "We believe ... that these copies, rivalling [*sic*] as they do the actual specimens, will be really useful to those pursuing similar scientific investigations; they will also at least furnish a beautiful table-book, to excite an interest in the community in the marvels of nature."

Other photographer-scientists trained their lenses in the opposite direction, toward the heavens. Lewis Morris Rutherford was educated as a lawyer, but an interest in astrophysics and astronomical photography led him to abandon that profession in 1849. He became known for his photographs of the moon (page 277), especially his stereographs, which were sold by several publishers. Among his discoveries was a micrometer for the measure of astronomical photographs. In 1858, Rutherford became a founding vice president of the American Photographical Society, a group devoted to photographic amateurs with a scientific bent.

Scottish engineer James Hall Nasmyth was a founding member of the Manchester Photographic Society. James Carpenter, an astronomer at the Royal Observatory in Greenwich, England, collaborated with

First Photograph
of Lightning

V.N. Jennings

Ribbon Lightning

J.N. Jennings

William N. Jennings
American,
b. England,
1860–1946

First Photograph
of Lightning, 1882

Gelatin silver print
GIFT OF 3M COM-
PANY, EX-COLLEC-
TION LOUIS
WALTON SIPLEY
83:0679:0003

William N. Jennings

Ribbon Lightning,
ca. 1885

Gelatin silver print
GIFT OF 3M COM-
PANY, EX-COLLEC-
TION LOUIS
WALTON SIPLEY
83:0679:0006

Nasmyth on an 1874 publication, *The Moon: Considered as a Planet, a World, and a Satellite,* a 40-year culmination of lunar observation illustrated with Woodburytypes. The "Normal Lunar Crater" (page 278) is actually a photograph by Nasmyth of a plaster model of the moon. Nasmyth and Carpenter wanted to provide information about the moon's surface in all of "its marvellous [sic] details under every variety of phase in the hope of understanding its true nature as well as the causes which had produced them." The carefully detailed models helped bring the remote moon into closer view. In an attempt to expand the viewer's understanding, Nasmyth and Carpenter also included analogous photographs of more ordinary images such as a wrinkled hand and a rotten apple (page 279), because both exhibited richly textured and aged surfaces comparable to that of the moon.

An amateur photographer in Philadelphia during the early 1890s, William Nicholson Jennings became the first person to photograph lightning in 1882, thus defining the paths that lightning takes through the sky and undeniably refuting the commonly used "zigzag" design

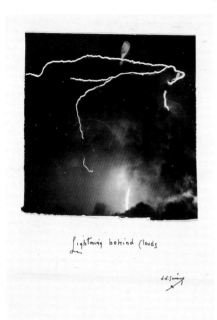

ʃightning behind Clouds

J.J.Jennings

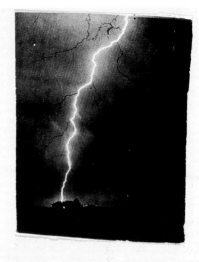

Vertical discharge
with dark branches

that artists had long employed. In a series of views made around 1885 to 1890, Jennings documented the appearance of several different patterns of lightning in the sky: ribbon lightning, lightning behind clouds, and vertical discharge. The powerful bursts of electricity and light illuminate the recognizable shapes of trees, branches, and rooftops, which lends a compelling reality to the evidence. Jennings made early experiments with color photography, and later made photographs of artificial lightning, experiments that eventually led to the development of "flash" photography. He is also credited with unknowingly making the first x-ray in 1890.

Belgian Adolphe Neyt's "Photomicrograph of a Flea" (page 282) was made under a microscope. With the crisp clarity of the lines delineating every hair and joint on its legs and the subtle gradation of shading in its body providing depth, the image looks rather like a careful pencil and charcoal drawing, yet it carries the stamp of photographic veracity. Photomicrography was used as early as 1840 and became increasingly popular between 1850 and 1870, recording photographically for the first time that which is invisible to the naked eye.

William N. Jennings

Lightning behind Clouds, ca. 1885

Gelatin silver print
GIFT OF 3M COMPANY, EX-COLLECTION LOUIS WALTON SIPLEY
83:0679:0004

William N. Jennings

Vertical Discharge with Dark Branches, 1890

Gelatin silver print
GIFT OF 3M COMPANY, EX-COLLECTION LOUIS WALTON SIPLEY
83:0679:0005

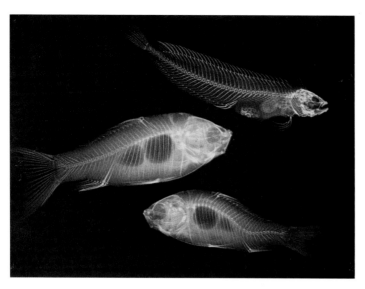

Josef Maria Eder & Edward Valenta
Austrian, 1855–1944 & Austrian, 1857–1937

Zwei Goldfische und ein Seefisch (Christiceps Argentatus) (Two Goldfish and a Sea Fish [Christiceps argentatus]), 1896

Photogravure print
GIFT OF EASTMAN KODAK COMPANY, EX-COLLECTION JOSEF MARIA EDER 79:3352:0001

Adolphe Neyt
Belgian, 1830–1893

Photomicrograph of a Flea, ca. 1865

Albumen print
GIFT OF 3M COMPANY, EX-COLLECTION LOUIS WALTON SIPLEY 77:0638:0015

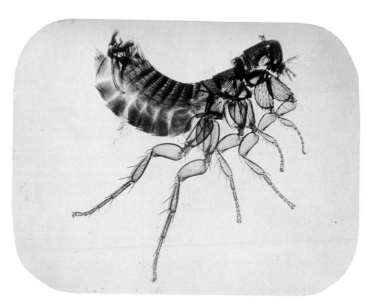

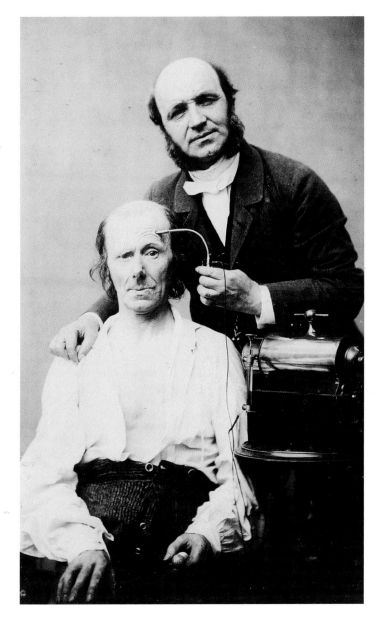

(top)
**Oscar Gustav
Rejlander**
English,
b. Sweden 1813–1875

(bottom)
**Dr. Guillaume-
Benjamin Duchenne
de Boulogne**
French, 1806–1875

*Illustrations from
Charles Darwin's*
The Expression of
the Emotions in
Man and Animals,
ca. 1862

Collotype print
LIBRARY COLLECTION

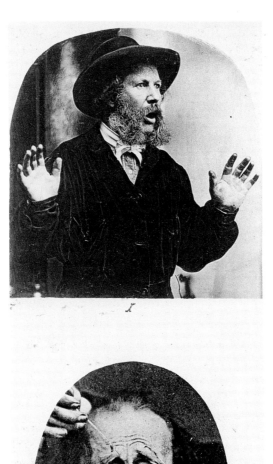

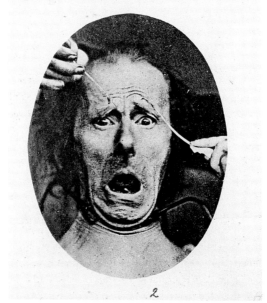

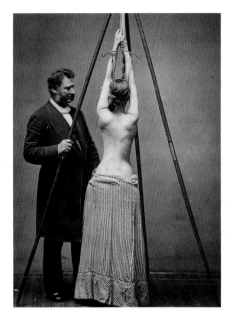
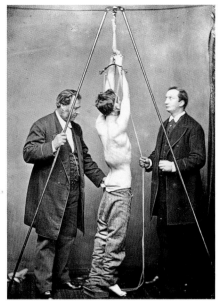

Josef Maria Eder and Edward Valenta were Viennese chemists who specialized in photographic chemistry. Eder was also a leader in the study of photographic technology. Revealing the complex beauty of the internal structure of simple goldfish, Eder and Valenta made an x-ray — or Röntgen photograph, as it was called after its inventor Wilhelm Röntgen — of three fish, their delicate, bony structures delineated with photographic precision (page 282). In 1896 they published a portfolio of 15 photogravures of x-ray images, *Versuche über Photographie mittlest der Röntgen'schen Strahlen*, or, *Experiments in Photography with Röntgen Rays*. Such photographic imagery provided invaluable information to scientists, enhancing their basic understanding of their subjects. It also provided artistic inspiration to later photographers; in the 1940s, Hungarian artist László Moholy-Nagy said of x-ray images: "... structure becomes transparency and transparency manifests structure."

Scientific photography was applied to many fields of medicine in its early years. Guillaume-Benjamin Duchenne de Boulogne was a medical doctor specializing in electrotherapy. In 1856 he began to photograph mental patients at the Salpêtrière Hospital where he worked in Paris. Adrien Tournachon, Nadar's brother, assisted him in taking the

Attributed to John Jabez Edwin Mayall
English, 1813–1901

Treatment for Spinal Curvature, ca. 1877

Woodburytypes
LIBRARY COLLECTION

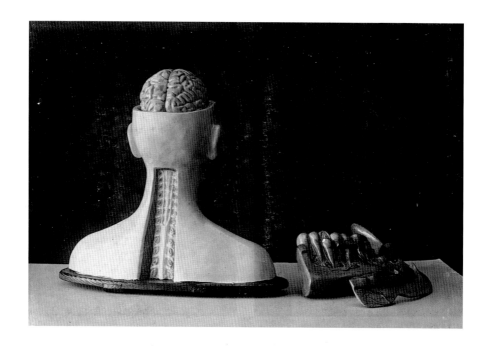

photographs, which often featured a gaunt, elderly man as the subject.
Duchenne de Boulogne's photographs were published in numerous vol-
umes; the photograph depicting Duchenne applying electrodes to a pa-
tient, "Faradisation du muscle frontal" (page 283), originally appeared
in *Album de photographies pathologique complementaire du livre intitulé
de l'electrisation localisée* from 1862. Charles Darwin used a selection
of these photographs by Duchenne de Boulogne and others by Oscar
Gustave Rejlander to illustrate his 1872 book, *The Expression of the
Emotions in Man and Animals*. Rejlander himself appears in the top
image on page 284, expressing surprise in a manner that appears overly
dramatic to the modern viewer, but in its day was believed to have been
a helpful illustration of emotion. In the lower image by Duchenne de
Boulogne, the elderly patient is subjected to an excruciating treatment:
two electrodes are applied to his brow, contorting his soft flesh, while
the camera records his reaction with shocking precision.

In 1877 Lewis Sayre, M. D., published the diagnostic medical text
*Spinal Disease and Spinal Curvature: Their Treatment by Suspension
and the Use of the Plaster of Paris Bandage*. Illustrated primarily with

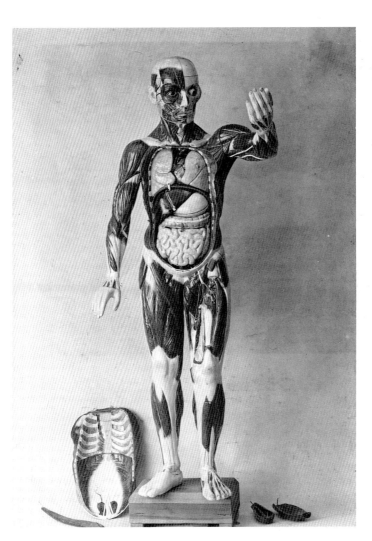

**Attributed to
Luis Soler Pujol**

Anatomical Model,
ca. 1920s

Gelatin silver print
MUSEUM PURCHASE
76:0089:0006

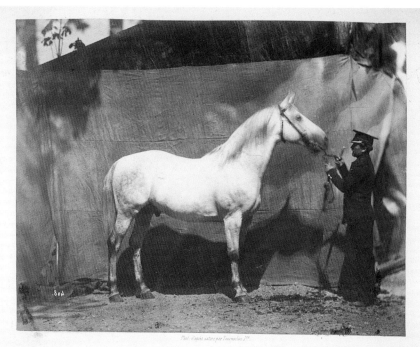

Phot. d'après nature par Tournachon J^{ne}

SÉBASTOPOL,

— *Né en 1852 — Son père, un étalon de pur-sang Arabe, Sa mère, une Jument croisée Anglaise*

II^e PRIX DES ÉTALONS, *Races diverses de demi-sang léger*

Adrien Tournachon
French, 1825–1903

Sébastopol,
ca. 1855–1860

Salted paper print
GIFT OF EASTMAN
KODAK COMPANY,
EX-COLLECTION
GABRIEL CROMER
79:0002:0033

engravings, it also included these Woodburytypes from photographs attributed to photographer John Jabez Edwin Mayall (page 285). Simple and direct, the images show a woman and man tied at the wrists to a tripod, their arms upraised. In these views, the patients' clothing is stripped down to the waist in order to show their spinal curvature while still retaining a modicum of modesty. In other photographs they are shown with the plaster casts applied.

Anatomical studies had appeared with some frequency in art for hundreds of years, and the most talented draftsmen were enlisted to give the truest rendering of the inner workings of human anatomy as aids to scientists and doctors. It is a testimony to the modeler's craft that their

Phot. d'après nature par Tournachon j^{ne}

RATTER-FILLY.

Née en 1851—*Son père,* Bolero, *pur sang Anglais, Sa mère,* Camargo, *par* Y.Ratter, *demi-sang*

1ᵉʳ PRIX DES JUMENTS, *Race Normande, de demi-sang léger*

renditions are so vivid and convincing. Luis Soler Pujol, a taxidermist and anatomical modeler working in the 1920s, made photographs of some of his models that he included in an illustrated price guide, which is stamped on the cover, "Luis Soler Pujol, Naturalista – Preparador, Barcelona." Under each image the price of the model is clearly indicated. Pictured on page 286, a head-and-shoulders bust is turned away from the camera, revealing a trellis-like deep cut where the flesh has been removed to expose tendons and muscles in the neck. Likewise, the top of the head has been removed to show the human brain resting in its cavity. There is a disconcerting aspect to the image, which unites the practical, scientific application of photography with the careful control of an artist's eye, leaving the viewer altogether uneasy with the

Adrien Tournachon

Ratter-Filly,
ca. 1855–1860

Salted paper print
GIFT OF EASTMAN
KODAK COMPANY,
EX-COLLECTION
GABRIEL CROMER
79:0002:0025

scene. A full-standing anatomical model of a male with flayed skin (page 287) is equally disarming, the liveliness of his stance contrasting sharply with a section of his chest and abdomen that has been cut away and rests on the table beside him.

Scientific applications, however, were not always gruesome renderings of inner realities, nor were they exclusively in the service of the natural sciences. Photography was employed frequently to document "types," whether of man or beast, and to visually reinforce distinctions within like species. Photographs of specimens proved to be valuable information, and all types of humans, animals, and plants were the focus of the photographer's eye. Adrien Tournachon made images for an album of horses, *Races Chevaline et Asine, Primés à l'Exposition de 1855, Photographies* (pages 288 and 289). Each image was mounted with a

description below it indicating the name of the animal, its birth date, parental lineage, and race history, while the photograph provided the satisfying visual "proof" of good breeding. Held steady by anonymous trainers, the animals were posed in profile against a simple backdrop, their magnificent forms revealed.

Humbler specimens, too, caught the photographer's eye. Compte de Montizon made numerous photographs of animals in zoos and parks, which preserved such accurate likenesses of the previously inaccessible creatures as to be true "portraits" of them. Beginning in the 19th century zoological parks and gardens provided the general public with the opportunity to view animals from all over the world, relatively close up, without having to travel great distances to find them. A pickerel swimming in an aquarium, betrayed as such by the shadows cast by the plant life against

Compte de Montizon (Juan Carlos María Isidro De Borbón)

The Hippopotamus at the Zoological Gardens, Regent's Park, 1852

Albumen print
GIFT OF MR. H.H. CLAUDET AND MRS. NORMAN GILCHRIST
77:0742:0004

Compte de Montizon (Juan Carlos María Isidro De Borbón)
Spanish, 1822–1887

Giraffe, ca. 1854

Albumen print
GIFT OF MR. H.H. CLAUDET AND MRS. NORMAN GILCHRIST
77:0742:0005

the wall, could just as easily be some predatory distant cousin of the shark, its sleek body suspended in perfect stillness in the water, contemplating its next prey. Reference to scale is sacrificed to show the fish close-up in its habitat, its stripes and fins identifying its species. Compte de Montizon also photographed a slumbering hippopotamus at the Zoological Garden in Regent's Park, London. The prominent crack of the animal's mouth reads like a contented smile as onlookers watch the non—spectacle — and the photographer — through zoo bars. From the photographer's perspective, the closely huddled humans become the caged creatures while the seemingly carefree hippo, a gift to Queen Victoria from the Pasha of Egypt, relaxes alongside his wading pool, tranquil in his manufactured habitat, unmindful of their curious gaze.

Compte de Montizon's photograph of a giraffe seated at the center of the frame is as elegant as it is simple. With its characteristic long, spindly legs tucked neatly beneath it, the giraffe is transformed into a

graceful, spotted swan adrift on a sea of grass. Despite the animal's regal posture, the vertical bars of the enclosure are visible in the distance as a reminder of its captive reality.

While useful as documents, de Montizon's images of animals are also lyrical likenesses of the individual animal, which transcend the circumstances of their habitats, restoring a modicum of their autonomous character. German-born Francis George Schreiber was the founder of Schreiber and Sons, the oldest photographic firm in America specializing in animal photography. Schreiber was a partner in the Langenheim Bros. firm in Philadelphia and continued that studio after the Langenheims retired before opening his studio. Schreiber is best known for photographs of domestic animals. He also photographed the exotic inhabitants of the local zoo. Nine photographs of these animals (pictured above) are mounted together on a page from an album of over 200 animal photographs. The numbered sequencing forms miniature

Francis George Schreiber
American,
b. Germany,
1803–1892

Photographs of Various Animals,
ca. 1890

Albumen prints
GIFT OF 3M COM-
PANY, EX-COLLEC-
TION LOUIS
WALTON SIPLEY
77:0250:0055–63

Eigenthümer Gustav DITTMAR, 4, Elisabeth-Ufer. Berlin.

ORIGINALPLATTE ANGEFERTIGT 1878.

Nº 1

DAS PFERD IN BEWEGUNG

Aufgenommen in 56 photographischen Augenblicksbildern von Muybridge in San Francisco

Für Deutschland debitirt von E. S. MITTLER & SOHN, Koenigliche Hofbuchhandlung und Buchdruckerei BERLIN s. w. Koch Str., 69 & 70

Das Pferd. *Abe Edgington* Geschwindigkeit. *10k* Meter per minute.

Die verticalen Linien haben eine Entfernung von 533ᵐᵐ, die horizontalen ein solche von 100ᵐᵐ von einander.

Muybridge, épreuve originale, 1878, provenant de dépôt allemand

Eadweard J. Muybridge
American,
b. England,
1830–1904

Das Pferd in Bewegung, "Abe Edgington" (The Horse in Motion, "Abe Edgington"), 1878

Albumen print
MUSEUM PURCHASE
73:0136:0002

narratives within the groups. The top three frames show a short-eared elephant along with his trainer in various postures near a watering hole. At left, the animal is seen at a distance facing left, possibly being fed; in the center, the camera has moved in closer, and the animal has turned to the right; and in the right frame, animal and man overlap. Similarly, the next three frames show a giraffe standing in its enclosure, which looks like a courtyard. Then it is shown seated in a pose reminiscent of the de Montizon, and standing again photographed somewhat closer up with a trainer alongside. Finally, and perhaps most intriguing, the bottom trio introduces a photograph of a predator in between two views of llamas and deer, extending the narrative structure beyond sequence into action. As simple as such pairings may seem, the overall effect of the sequencing and juxtaposition is to create a means of animating the animals' activity, and to draw relationships between frames that construct a story or movement.

No photographer, however, was more responsible for making still images move than Eadweard J. Muybridge. Born in Kingston-on-Thames, England, he moved to the United States in the early 1850s to make his

fortune. Although he first earned his reputation as a photographer of the western landscape, he is best remembered for the remarkable series of motion studies that he undertook, hired as the result of a legendary bet made by Leland Stanford, railroad magnate and ex-governor of California. Stanford contended that when a horse gallops, at some point all four of its feet are simultaneously off the ground. Étienne Jules Marey, a French physiologist and professor of natural history, had conducted studies that suggested the airborne phenomenon of a horse's gallop, and Marey's work came to Stanford's attention with the publication of his *Animal Mechanism, a Treatise on Terrestrial and Aerial Locomotion* in 1873. Muybridge worked with Stanford during the 1870s, refining his approach to the sequential presentation of motion. Using a system of electro-mechanical, trip-shutter, high-speed photography and 12 cameras,

Eadweard J. Muybridge

Two Models, 8 Drinking from Water-Jar on the Shoulder of 1, July 20, 1885

Gelatin silver printing out paper print
81:2379:0042

**Eadweard
J. Muybridge**
American,
b. England,
1830–1904

Jumping; Over Boy's
Back (Leap-Frog),
ca. 1884–1887

Collotype print
MUSEUM COLLEC-
TION, BY EXCHANGE,
EX-COLLECTION
LOU MARCUS
78:0802:0169

Muybridge photographed Stanford's purebred horse "Abe Edgington" at Palo Alto. As the animal galloped, the sulky wheels came in contact with wires stretched across its path, which instantaneously completed an electrical circuit and released the cameras' shutters in sequence. In effect, the horse photographed itself. The background was a white screen delineated by vertical stripes that measured the space. Marey was enthusiastic about Muybridge's triumph and was "lost in admiration." The German language on the mounting of this sequence of six frames indicates the international attention that Muybridge's groundbreaking work received.

After his success with racehorses, the photographer began to experiment with recording motion in humans and other animals. In 1884 the University of Pennsylvania commissioned Muybridge to conduct further studies in human and animal locomotion, fittingly in the city that had fostered so much earlier scientific photographic investigation.

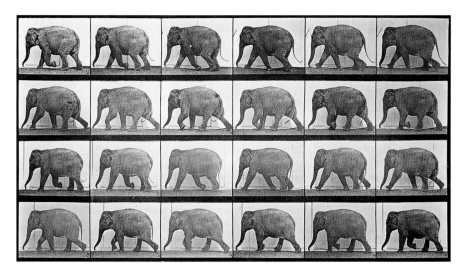

**Eadweard
J. Muybridge**

Elephant; Walking,
ca. 1884–1887

Collotype print
MUSEUM COLLEC-
TION, BY EXCHANGE,
EX-COLLECTION
LOU MARCUS
78:0802:0733

Enlisting the assistance of students and professional athletes as models, Muybridge completed the series of stop-action motion studies in 1887, which totaled more than 20,000 individual images. He published 781 motion sequences in the series titled *Animal Locomotion,* of which the Eastman House holds 683. The models' actions are simple, yet instructive in their simplicity: a nude woman drinks from a water jar that rests upon another nude woman's shoulder, the flexing and exertion of each muscle clearly visible due to the women's state of undress. The documentation was thorough – the activity was photographed from two angles, showing the models from the side and from the back. In another set of frames (above), an elephant lumbers along at its steady pace – every methodical step carefully recorded and measured by the camera. The barely discernible change in its movement is stark contrast to the image of two boys at left – like silhouettes in dark suits and hats – playing leap-frog for the camera, their silly fun in serious service to scientific investigation.

Muybridge's photo sequences led to the development of motion pictures. In 1878 some of his sequences were published in the journal *Scientific American,* with the exhortation to readers to clip the frames and insert them into their zoetropes in order to create the illusion of movement. The zoetrope, or "wheel of life," was a popular parlor diversion in the late 19th century. It is simply a rotating drum with 12 or 13 evenly spaced slits. A corresponding number of sequential pictures are placed

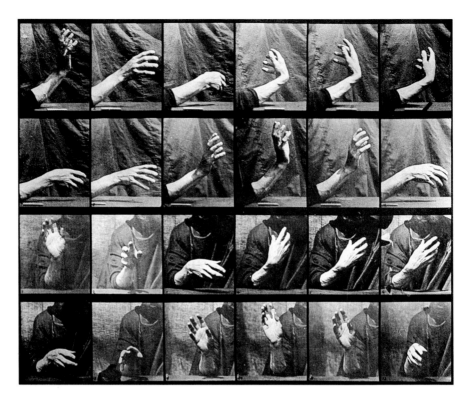

Eadweard
J. Muybridge
American,
b. England,
1830–1904

Movement of
the Hand; Beating
Time, ca. 1884–1887

Collotype print
GIFT OF ANSCO
78:0802:0535

on the inner wall, and when the drum is turned, the images become animated, inducing the illusion of movement. In 1880 at the San Francisco Art Association, Muybridge, using a revolving disk and a lantern-slide projector he had created, projected in rapid succession still photographs of a horse's movements, thus making the first actual motion picture.

"All the necessary researches into animal locomotion can only be effected by men especially interested in these inquiries, and placed in a favorable circumstance to understand them," wrote Étienne Jules Marey in *Animal Mechanism*. Marey, whose research had started the second phase of Muybridge's career, invented chronophotography, which produced an entire sequence of motion on a single frame. In this method the actions overlap slightly, yet clearly establish the continuum within the given action, such as pole vaulting. To study the movement of birds in flight, Marey invented the chronophotographic gun. This camera, in the shape of a rifle, "shot" in succession 12 (and later up to

**Eadweard
J. Muybridge**

A, Striking a Blow;
B, Throwing Disc;
C, Heaving a 75-lb.
Stone; D, Throwing
a Ball; E, Throwing
Disc; F, Heaving
75-lb. Stone,
ca. 1884–1887

Collotype print
MUSEUM COLLEC-
TION, BY EXCHANGE,
EX-COLLECTION
GEORGE NITZSCHE
78:0802:0523

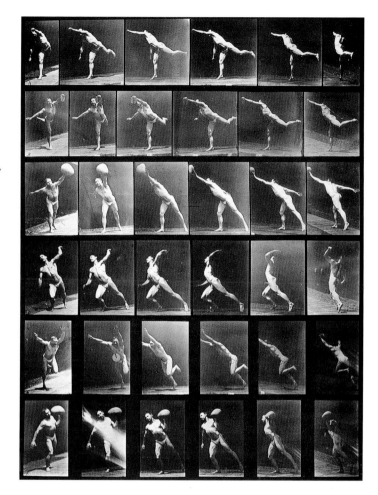

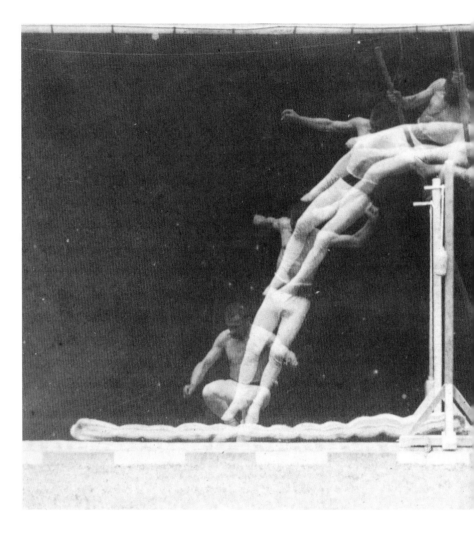

Étienne Jules Marey
French, 1830–1904

Chronophotographic
Study of Man Pole
Vaulting, 1890–1891

Albumen print
MUSEUM COLLEC-
TION, BY EXCHANGE
88:0795:0001

30) photographs per second, much faster than Muybridge had been able to accomplish. Like Muybridge, Marey projected these images in sequence, eventually abandoning cumbersome glass plates first for a strip of moveable paper film and later for Kodak flexible roll film that George Eastman used in his box cameras. Yet neither Muybridge nor Marey sought to reconstruct the continuous motion as would later be found in motion pictures; rather they wanted to stop it, frame by frame,

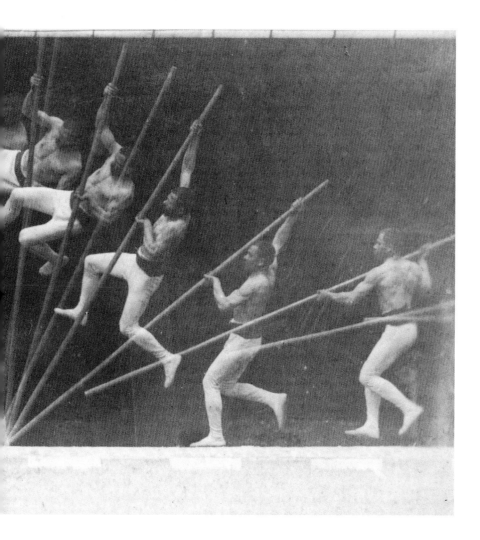

in order to make visible what the naked eye could never hope to see.

 While the work of Muybridge and Marey employed the special proper-
ties of photography in their attempts to record and analyze movement
with the greatest accuracy, elsewhere scientist-photographers were
working on ways to make the steadfastly monochrome medium resem-
ble the real, color-saturated world. In 1862 Louis Ducos Du Hauron de-
scribed in a letter to a friend several different methods for making color

Louis Ducos Du Hauron
French, 1837–1920

Still Life with Rooster,
ca. 1869–1879

*Print ca. 1982, by
Eastman Kodak
Company. Three-color
carbon transparency*
MUSEUM PURCHASE
82:1568:0001

photographs. Hauron's processes involved the following: "If I take a picture given to us by nature, which appears singular, but which is in reality triple in terms of color, and disassemble it onto three distinct pictures, one red, one yellow and one blue; and if I obtain a separate photographic image of each of these three pictures which reproduces its particular color; it will be sufficient to join the three resulting images into a single image in order to possess the exact representation of nature, color, and modeling all together." A combination of three colors – red, blue, and yellow – could be made into transparencies and overlaid to produce a full-color image. While Ducos Du Hauron's work laid the foundation for color photography, it was not until 1873 that H. W. Vogel discovered that dyes added to photographic materials would make the plates sensitive to colors other than blue. Nevertheless, before 1879 Du Hauron produced "Still Life with Rooster," a three-color carbon transparency of a brown stuffed rooster with blue tail feathers and strawberry red crown, alongside a lemon-yellow parakeet standing amidst artificial rocks and vegetation. For all the work at achieving the reality of color, the scene is unreal; the birds posed facing one another as though in conversation.

Even more bizarre are Ducos Du Hauron's series of self-portrait deformations, or "transformations." Using a slit diaphragm, the technique distorted his features like a fun house mirror; here the front half

of the head is elongated while the back remains fairly proportionate, resulting in a disturbing self-presentation.

"The thing that differentiates this from all those other high speed things, like Muybridge's work, is that we move the light," Harold E. Edgerton explained in 1994 of the difference between his work and that of his stop-motion precursors. Edgerton's photographic work was featured in the 1994 Eastman House exhibition and publication, *Seeing the Unseen: Dr. Harold E. Edgerton and the Wonders of Strobe Alley*. The Eastman House collection includes more than 300 prints by Edgerton. Strobe Alley – a 300-foot corridor at Massachusetts Institute of Technology (M.I.T.), where Edgerton earned his doctorate and taught for 41 years – was so named because Edgerton invented the stroboscope while a student there in 1931. A stroboscope is an electronic flash made up of a series of pulsing lights that can capture action up to 1/1,000,000 of a second. In Strobe Alley he displayed dozens of the photographs he made using the stroboscope. "High-speed" photography, according to Edgerton, is defined as "single exposure cameras that take photographs with exposures shorter than 1/10,000 of a second," and both of the photographs here were made at exposure speeds of 1/1,000,000 of a second.

Louis Ducos Du Hauron

Self-Portrait Deformation, ca. 1888

Albumen print
GIFT OF EASTMAN KODAK COMPANY, EX-COLLECTION GABRIEL CROMER
81:2913:0001

Edgerton's life's work using the strobe captured elements of movement to a degree previously unheard of, thus providing irrefutable evidence of the properties of a variety of substances when acted upon with force.

Describing his famous 1934 photograph of a man kicking a football, Edgerton explained: "I decided one day that I don't have a picture of somebody kicking a football and that it would be interesting to see what would happen. We don't waste any time with football at M.I.T., so I called up Harvard – it's a school up the river here a ways. ... So I went up there and we went into a dark room. I took three pictures – bang, bang, bang. I messed up two in the developing, but I got a good one. The ball accelerated so quickly it left the dust suspended in the air." The football itself made the picture. As it was kicked it pushed together two electrical wires that completed a circuit, which released the strobe flash.

Edgerton first showed the photograph of a 0.30 caliber bullet piercing an apple in 1964 during a lecture entitled "How to Make Applesauce at MIT." In this instance the strobe was tiggered by the sound wave of the bullet. Both the entry and exit of the bullet are shown surprisingly to be outward explosions; moments later, the apple collapsed completely. As he would later tell it, Edgerton had to use only one apple to achieve this remarkable image. Unmindful of the technical distinctions between strobes and regular electronic flashes, the unpretentious Edgerton said, "There are still purists who argue that you have to use the word 'stroboscopic' in a special way. But I don't go for that at all. I say if everybody calls them 'strobe,' I'll call them 'strobe.'" Both in his words and images Edgerton made scientific photography more accessible to a broad audience, creating images at once aesthetically pleasing and scientifically revolutionary.

Harold E. Edgerton
American,
1903–1990

*Wesley E. Fesler
Kicking a Football,*
1934

Gelatin silver print
GIFT OF THE
PHOTOGRAPHER
76:0111:0007

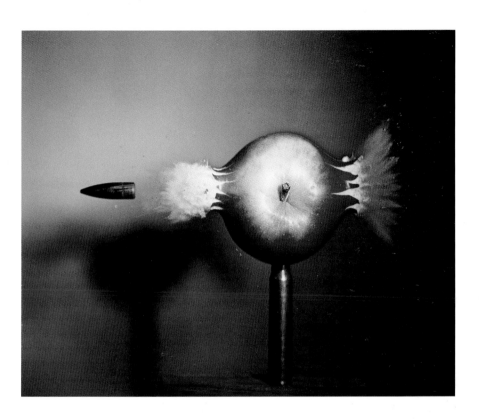

Harold E. Edgerton

.30 Bullet Piercing
an Apple, 1964. A Micro-
second Exposure of a Bullet
Travelling 2800 Feet per
Second. 1964; Print ca.
1984–1990, by Boris Color
Lab, Boston

*Color print, dye imbibition
(Dye Transfer) process*
GIFT OF THE HAROLD AND
ESTHER EDGERTON FAMILY
FOUNDATION
96:0347:0007

Photography's Public and Private Lives

Photography made the larger visual world collectible, and in the 19th century, one of the most popular places in which to collect evidence of that world was in the photographic album. From professional photographers such as Baldus to anonymous amateurs, people assembled albums of photographs for a variety of reasons: to commemorate specific events or travels, to validate social standing by associating their own images with those of celebrated people, and to create visual family trees by uniting family members who might be scattered far and wide.

Families constructed their histories through the selection and presentation of images. Sometimes these photographs documented rites of passage or lesser events, especially as photographs became more readily available and the portrait sitting became less formal and less costly. The assemblage of photographs in an album forged relationships between images that preserved collective memories and revealed both how we were and how we wished to see ourselves. Photographic albums often created a fiction by preserving an idealistic memory of the lives depicted, showing everyone and everything at their best. Each album, however, reveals the intimate longings and interests of the person who assembled the images and reflects a shared desire to construct order in life through the arrangement of images.

The Eastman House collection contains hundreds of these public and personal histories, including a rare volume known as the Victor Hugo album. The French Romantic author and poet Victor Hugo and his family were exiled to the isle of Jersey between 1851 and 1870, in part for his denouncement of Napoleon III. In 1854, Hugo and his wife Adele assembled an album of 41 prints made between 1852 and 1854 as a New Year's gift for Mademoiselle Euphémie Barbier, the daughter of house guests they had been hosting.

Their album was handsomely presented in a burgundy morocco leather binding, with full gilt embellishments. The album opens intimately with a written dedication from Hugo and a piece of algae from the isle of Jersey enclosed in a glassine envelope to remind the recipient of the common ground and poignant times they had shared. The sitters themselves signed many of the prints, with an additional few scattered inscriptions identifying people and places once thought important enough to photograph and preserve, but now forgotten.

Attributed to
**Charles Hugo and
Auguste Vacquerie**
French, 1826–1871 &
French, 1819–1895

Victor and Charles
Hugo Leaning out
Two Windows of
Hugo House,
ca. 1853

Salted paper print
GIFT OF EASTMAN
KODAK COMPANY,
EX-COLLECTION
GABRIEL CROMER
79:0023:0004

(right)
**Attributed to
Charles Hugo and
Auguste Vacquerie**
French, 1826–1871 &
French, 1819–1895

Enfant le Flô,
ca. 1850–1854

Salted paper print
GIFT OF EASTMAN
KODAK COMPANY,
EX-COLLECTION
GABRIEL CROMER
79:0023:0008

A glimpse of the poet and his eldest son, Charles, leaning out of second-story windows at the family's home (page 307), records a private moment as they overlook the greenhouse where Madame Hugo customarily took her afternoon rest. Charles Hugo and Auguste Vacquerie are credited as the camera operators, albeit under Victor Hugo's artistic direction.

Charles had traveled to Caen for two weeks to learn photographic processes, and he and Vacquerie took up photography as a way of filling their days at Jersey. The pictorial quality of their intimate photographs perfectly complemented their Romantic artistic visions. Vacquerie wrote of his collaborator: "Charles has the gift of doing what he wants. Photography is ... wonderful, it's a machine that defies Rembrandt, a science that produces art. ... The sun produces the form, but it is Charles who frames it."

With Victor suggesting poses and group arrangements, Charles and Vacquerie photographed their surroundings and neighbors on the island. Family, friends, and servants are all included in Hugo's carefully orchestrated construction of the familial ideal in the face of political and artistic exile. Their Romantic sentiment is evident in the portrait of a local girl, "Enfant le Flô," gently clasping her dark garment and staring ponderously away from the camera. Seated against a simple backdrop, the pale child is a study in chiaroscuro, light and dark. Mainly, however,

**Attributed to
Charles Hugo and
Auguste Vacquerie**

The Hand of
Madame Hugo,
ca. 1850–1854

Salted paper print
GIFT OF EASTMAN
KODAK COMPANY,
EX-COLLECTION
GABRIEL CROMER
79:0023:0010

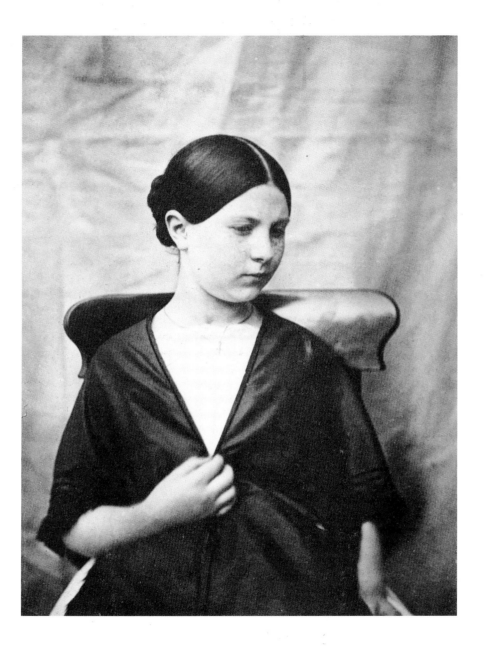

they photographed their home and themselves: Victor himself figured in numerous portrait studies in the album, although, curiously, no image of Mme. Barbier was included. Intimate details, such as Madame Hugo's hand, are shared and savored for their simple beauty.

Hugo was keenly aware of his public persona and the importance of documenting this difficult time in his life: Victor, Charles, and Vacquerie had planned a publication of verse, drawings, and photographs from this period, but it was never realized.

Other photographic albums were compiled for very different reasons. Thomas Mackinlay worked for a firm that sold music and made pianos in London. His interest in photography grew out of seeing a collection of letters and portraits of composers and musicians. As an amateur photographer, Mackinlay first tried his hand at daguerreotypy in the 1840s, but without much success. Active in the Society of Antiquaries, Mackinlay became familiar with early photographers such as Dr. Hugh Diamond, and in 1853 he became, along with Diamond, one of the founding members of the Photographic Society in London, a group of devoted amateurs and professionals later renamed the Royal Photographic Society.

As part of another amateur group, the Photographic Exchange Club, Mackinlay participated in two print exchanges. Members of such

Thomas Mackinlay
English, 1809–1865

Walkway, ca. 1855

Albumen print
MUSEUM PURCHASE
68:0087:0021

organizations would make a number of prints of an image and submit them in order to share their work with colleagues and learn about what others were doing. Often members would assemble the exchanged prints into albums such as *Pictures of the Photographic Exchange Club*, which includes Mackinlay's image of a walkway from around 1855.

Henry Alexander Radclyffe Pollock's image of a table evidencing the remains of a repast was included in another exchange club album from 1856. Pollock was a scientific experimenter and photographer and the son of Sir Jonathan Frederick Pollock, P.C., Lord Chief Baron of the Exchequer, a photographer and president of the Photographic Society. Henry's brother, Arthur Julius Pollock, was also a photographer whose work is represented in the museum's collection. Henry photographed his father's activities and preserved many of those images in a family album, but also shared some of the photographs with his Photographic Exchange Club members, who would surely have known of the senior Pollock's photographic work. This image, "After Luncheon," depicts the aftermath of one of his father's luncheons "on the circuit." As much a document that depicts a class and its activities as it is an absentee

Henry A. R. Pollock
English, 1826–1889

After Luncheon,
ca. 1856

Salted paper print
MUSEUM PURCHASE
68:0088:0038

portrait of his father, the image implies rather than represents the human presence. As a document, the photograph is reminiscent of some of Talbot's early visual inventories from *The Pencil of Nature* such as "Articles of China" (see page 92).

Pets were integral members of many households and thus frequently warranted equal treatment in the photographic process. "From the beginning of the Middle Ages ... the more [the dog] was loved the more artists began to regard it as an interesting subject," wrote one historian. Photography's popularity also coincided with the phenomenon of caring well for household pets in the 19th century. An anonymous portrait of a young smiling girl holding her dog epitomizes this kind of casual use of photography and preserves a fleeting moment in both of their lives that would never be revisited. The innocence, optimism, and spontaneity associated with photography, which was immediately put into service to record the natural world, is reflected in the openness of this portrait.

Children were also important subjects as parents clamored to preserve their progeny through photographs, especially given that their countenances were much quicker to change during their growing years; without photographs, those visual memories would be lost forever. The Walter family of Rochester, New York, assembled an album of their own family portraits around 1889, including the two pictured at right. A commercial photographer with a studio adjacent to his home, James P. Walter photographed his children against the elaborate painted studio backdrops and props in fictional tableaux. These devices were first made popular around 1870 as a means to "narrate" the portrait and were implemented by professional and amateur alike. This charming pair

Unidentified
photographer
English, active 1850s

Girl with Dog,
ca. 1853

Salted paper print
GIFT OF ALDEN
SCOTT BOYER
81:1263:0037

shows his daughter Florence with a dropped basket of eggs, wiping her eye in mock despair over her misfortune. In the companion image Florence kneels to re-gather the eggs, looking directly at the camera, determined to triumph over her temporary adversity. In just two frames Walter constructed a story, transforming a portrait sitting into a small fable. Walter was also skilled at composition and balance: Florence's white pinafore and the eggs provide bright visual contrast against the neutral, woodsy backdrop. The cabinet-card-sized photographs – about 5-1/2 by 4 inches – were inserted into an album for their final presentation. In the Walter album, each page was made up of a decorative, arched, gold-edged overmat printed with green leaves. The photographs were inserted from the bottom and framed by the mat, the popular style at the time. The album was covered with red velvet and closed with a metal clasp to complete the elegant presentation and provide a permanent home for the family photographs.

In Victorian England the assemblage of photographic albums was popularly women's work, and upper-class women often indulged their artistic proclivities in the animated construction of their visual family histories. These albums were then frequently shared among family members and handed down, from one generation to the next. Julia

James P. Walter
American, active
1880s–1890s

*Florence Walter with
Dropped Basket of
Eggs* (left), ca. 1889

*Florence Walter
Putting Eggs in Basket* (right), ca. 1889

*Albumen print
cabinet cards*
GIFT OF EDNA
L. TICHENOR
85:0972:0006
85:0972:0007

Leicester created a photomontage that illustrates an idyll of country living. Images of stately mansions, woods, lakes, and well-dressed men and women at leisure make up this constructed landscape. A whimsical portrait of Viscount Lumley, the Earl of Scarbrough, and Mr. G. Thompson utilizes montage in a carriage scene that is gleefully oblivious to accuracy of scale. Nevertheless, the relationship between the subjects is clearly established, and the scene is animated by the conflation of photographs and watercoloring.

Because early photography was monochromatic, the use of watercolor provided a means by which to integrate the photographic image into a world of color. In the Campbell family album, an elaborate watercolor of a sitting room interior is constructed around photographic portraits of family members. As identified by handwritten captions under the image, Clara Wellesley reads by the "light" of the window, Sarah Napier sits at her spinning wheel, Annabel O'Grady takes tea by the hearth while Cuckoo Gordon pours, Nancy Swetenham looks down from the frame above the mantle, and "Jack," the beloved dog, sleeps soundly at their feet. While most albums were not so elaborate, these examples are among the finest of the genre, revealing both the artistic talent and playfulness found in photographic albums.

Although photographs on paper were favored by the more artistic practitioners, the general public still desired cased – yet inexpensive – likenesses. As the popularity of the daguerreotype waned in the 1850s, newer, less-expensive media were developed to satisfy the market for photographs. In 1854, Boston scientist James A. Cutting received three patents for making glass positives, which were dubbed

**Constance
Sackville West**
English, active 1860s

Viscount Lumley;
Earl of Scarbrough;
Mr. G. Thompson,
1867

*Albumen print
photomontage
with watercolor
embellishment*
MUSEUM PURCHASE
76:0151:0026

Unidentified artist
English?,
active ca. 1870s

Cuckoo Gordon,
Annabel O'Grady,
Nancy Swetenham,
Sarah Napier,
Clara Wellesley,
and "Jack," ca. 1870s

*Albumen print
photomontage
with watercolor
embellishment*
MUSEUM PURCHASE
72:0043:0093

ambrotypes, or imperishable pictures. Used primarily for portraiture, they were made to resemble the more expensive, intimate, and more technically complex daguerreotype. Sometimes referred to as "glass daguerreotypes," ambrotypes were produced in the same standard sizes and were matted, framed, and cased the same. Not without their detractors, ambrotypes were also called "black, nasty, filthy, ghastly, dead, inanimate, flat, shade[s] of shadows," and further derided for their tendency to "burst, break, peel, turn, [and] change all colors (but the natural one)...." But such opposition did not decrease their popularity, and, as time has proven from these examples, such criticism was not always accurate.

Cutting's "invention" was nothing more than a collodion negative on glass mounted against a black background, a practice already used in England and France. Collodion, viewed by reflected light, is light gray in tone; against a black ground, the image appears as a positive, albeit with a limited tonal range. This bisected view of a double portrait ambrotype by Mathew B. Brady demonstrates the negative-positive duality of the ambrotype image with and without black backing. The Eastman House collection contains eight Brady ambrotypes among the nearly 150 works by this 19th-century master. Collodion could also be applied to other materials, including leather, slate, mica, and paper, and the Eastman House holds examples of each of these applications.

The museum's collection includes more than 1,300 ambrotypes. Though they are mostly portraits by professional photographers, the museum also holds a rare ambrotype of the Genesee River in Rochester made by George Eastman when he was learning photography from George Monroe in 1877. Ambrotypes were used to create records of places and events. This view of a Connecticut

Mathew B. Brady
American, 1823–1896

Portrait of an Unidentified Couple, ca. 1860

Ambrotype with applied color
GIFT OF
FLORENCE MAHON
81:2522:0001

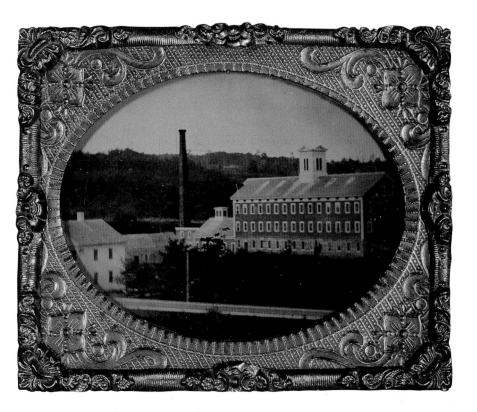

cotton mill displays the medium's impressive capacity for clarity of detail rivaling that of the daguerreotype. The elaborate gilded mat reinforces the importance of the image, which was likely commissioned by the mill's owner.

Indisputably, however, it was the portrait that most captivated the American imagination as the young nation clamored to preserve its collective likeness through photography. Inexpensive and easily accessible, photographic portraits were available to virtually everyone, either to share with loved ones or to keep near and to marvel at the young medium's ability to render such an accurate likeness. One popular genre was the occupational portrait, allowing the proud sitter to represent his or her skills, usually through the inclusion of the tools of their particular labor. A portrait of a man with a hammer represents his abilities as a blacksmith without portraying his

Unidentified photographer
American,
active 1860s

View of Cotton Mill Building, Rockville, CT, ca. 1860

Ambrotype
GIFT OF
DONALD WEBER
95:2641:0001

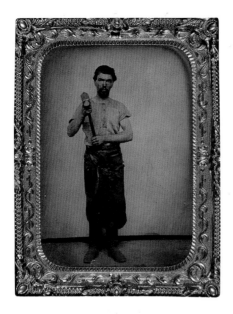 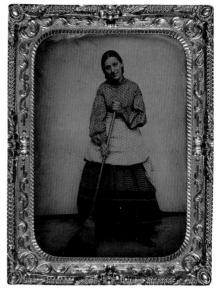

(left)
Unidentified photographer
American, active 1860s

Man with a Hammer, ca. 1865

Tintype
GIFT OF
DONALD WEBER
94:1464:0001

(right)
Unidentified photographer
American active, 1860s

Woman with a Broom, ca. 1865

Tintype
GIFT OF
DONALD WEBER
94:1464:0002

handiwork, while a portrait of a woman with a broom indicates her station as a domestic laborer. Like Saint Lucy's eyes on a plate or Saint Sebastian's arrows in Renaissance art, the hammer and broom are the modern iconography of these otherwise anonymous subjects.

Painter and photographer Isaac Rehn's portrait of a mother with her two daughters and son is a handsome portrayal of the family. The absence of the father from the group suggests that this may be the photographer's family.

The domestic dynamic involved non-family members as well, and these relationships were also portrayed in photographs. A portrait of a young black woman holding a white child reveals her role as a household servant, possibly a slave. While her presence is strong and undeniable as she engages the camera directly, the focus of the image is decidedly upon the fancily dressed child.

In another kind of "family" portrait, a small white dog lies recumbent on a fern-patterned cloth (page 320). Clearly a beloved pet, the small animal comports itself for the camera as though it is fully familiar with photographic etiquette.

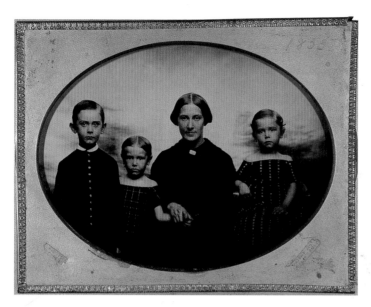

Isaac A. Rehn
American, active
1840s–1870s

Family Group, 1855

Ambrotype
GIFT OF 3M
COMPANY, EX-
COLLECTION LOUIS
WALTON SIPLEY
77:0267:0019

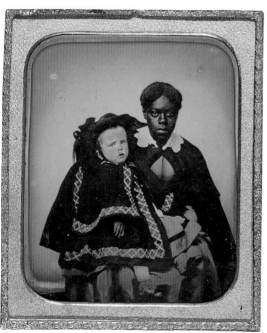

Unidentified photographer
American, active 1860s

*Portrait of Black Woman
Holding White Child*, ca. 1860

Ambrotype
GIFT OF DONALD WEBER
95:2687:0001

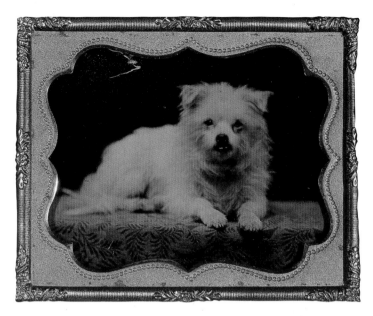

For such popular portraiture, ambrotypes virtually replaced da-
guerreotypes from the time they were introduced until around 1861,
when the less-expensive cartes-de-visite and tintypes replaced them.
Belying its name, the tintype is actually made on a thin sheet of iron,
enameled black. Iron was cheap and plentiful as well as lightweight and
durable. The public coined the name, favoring it over the more cumber-
some terms ferrotype and melainotype, as tintypes were initially called.
Its muted tonality is similar to that of the ambrotype and was thus its
natural successor.

A tintype of an adorable black puppy huddled against the high back
of a fainting couch is another example of the importance of beloved
pets as photographic subjects. Such images possess a timelessness
and immediacy for contemporary viewers.

The Eastman House collection has about 2,800 tintypes, including
two portraits of George Eastman: one at three years of age and another
as a teen. The museum holds in its technology collection a variety of ap-
paratus employed in the making of these popular images. The remnants
of a Wisconsin tintype studio came to the museum in 1951 as a part of
the Alden Scott Boyer collection. Included in the inventory were cameras

Unidentified photographer
American, active 1870s

Dog in Chair, ca. 1870

Tintype
GIFT OF ALDEN SCOTT BOYER
82:1523:0002

and equipment; studio props, including a posing chair and headrest; a painted backdrop; and plates, cardboard mounts, and chemicals.

The most popular-sized tintype was about 2-1/2 x 4 inches, roughly the same size as the carte-de-visite image. The tintype of a woman looking at framed tintype portraits in a studio (page 322) provides a sense of

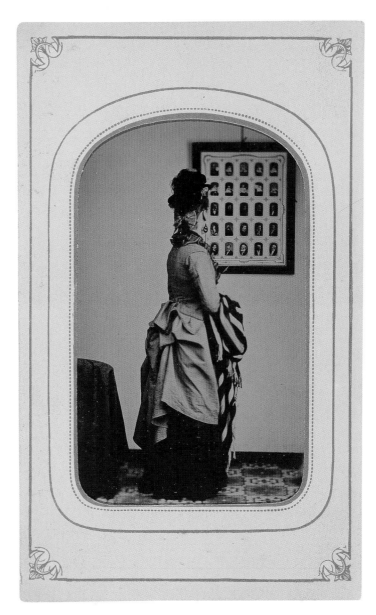

(right)
**Unidentified
photographer**
American,
active 1880s

Two Women Fencing,
ca. 1885

Tintype
82:1414:0001

(left)
**Unidentified
photographer**
American,
active 1870s

*Woman Looking
at Framed Tintype
Portraits,* ca. 1870

Tintype
72:0030:0001

(left)
Unidentified photographer
American?,
active 1870s

Man and Child's Hands, ca. 1875

Tintype
78:0829:0010

(right)
Unidentified photographer
American?,
active 1870s

Hand-Operated Device, ca. 1870

Tintype
MUSEUM PURCHASE,
HORACE W. GOLD-
SMITH FOUNDATION
FUND
83:0121:0001

scale for the images and also of possible presentation, as she ponders the images and her potential portrait before her own "formal" sitting. "Two Women Fencing" (page 323) is a staged joust between unlikely sparring partners in full skirts set against a painted landscape. "Two Women and Man in Studio Prop Boat" (page 323) is an example of the lengths to which photographers could go using props in the studio to represent more complex, outdoor leisure activities. While transparent in its artificiality, the setting nevertheless conveys the sense of a recreational outing, even if their solemn expressions do not.

The curious image of a man and child's hands is displayed in a fancy cardboard mat, a popular presentation for tintypes, which did not need to be protected in hard cases like ambrotypes and daguerreotypes. A photograph of what appears to be a hand-operated pump has a sense of scientific practicality, while the portrait of a woman looking into a mirror (right) slyly references the "mirroring" aspect of photography.

The first popular card-mounted photographs were cartes-de-visite, small images that were originally pasted on the back of engraved calling

**Unidentified
photographer**
American,
active 1870s

*Woman Looking into
Mirror*, ca. 1870

*Tintype with
applied color*
78:0829:0013

André-Adolphe-Eugène Disdéri
French, 1819–1889

Duc de Coimbe (?),
ca. 1860

*Albumen print, uncut
carte-de-visite sheet*
81:2326:0011

cards. In 1854 Parisian photographer André-Adolphe-Eugène Disdéri patented his invention to "take a glass plate which can contain ten images ... make [a] negative, either all at once or image by image; then ... use this negative to make ten prints all at once." It would seem that Disdéri modified his initial estimate, as cartes-de-visite were usually produced in series of eight per negative, demonstrated in this example of an uncut sheet of cartes by Disdéri himself. Numerous accounts suggest the existence of the carte format much earlier, but Disdéri receives and deserves the credit for its eventual success. As the celebrated French portrait photographer Nadar remarked: "... by giving infinitely more for infinitely less, [Disdéri] definitively popularized photography." Cartes-de-visite remained so until the late 1860s, sparking "cartomania," or "photomania," and revolutionizing the business of photography.

According to history, embellished with a good dose of legend,

**André-Adolphe-
Eugène Disdéri**

Les jambes de
l'opéra (The Legs
of the Opera),
ca. 1870

*Albumen print
carte-de-visite*
GIFT OF EASTMAN
KODAK COMPANY,
EX-COLLECTION
GABRIEL CROMER
81:1226:0002

Napoleon III stopped en route to Italy to have his portrait made at Disdéri's Paris studio. Using the carte-de-visite process, Disdéri made and sold thousands of copies of the monarch's portrait, thus determining the success of the carte overnight. Cartes of royalty remained a staple of many photographers' businesses. Their success was astounding: In England alone 10,000 cartes of Prince Albert were sold the week after his death in 1861. Even with such an extraordinary level of consumption in Europe, the desire to preserve photographic memories of departing soldiers during the American Civil War and pioneers migrating to the west shifted the center of carte production to the United States.

Widely collected, convenient to handle, easy to display, and diverse in their subject matter, cartes could serve as a tie between loved ones or be simply whimsical, like this playful image of a top hat suspended in space, made at Buel's Gallery in Pittsfield, Massachusetts. Perhaps an early advertisement or a symbol that now lies mute, this carte is among the 10,000 that are in the museum's collection.

"Spirit" photography was a phenomenon that began in Boston in 1861. In these "shadow pictures," as some photographers called them, it was claimed that ghosts would appear on the negative unbeknownst to the photographer until the image was developed. Celebrities as diverse as the bereft and widowed Mary Todd Lincoln and novelist Sir Arthur Conan Doyle championed this photographic offspring of the popular "mediumistic clairvoyance" that swept through the latter half of the 19th century. The photograph

Buel's Gallery (Pittsfield, Massachusetts)
American,
active 1860s–1870s

Top Hat, ca. 1870

*Albumen print
carte-de-visite*
MUSEUM PURCHASE
69:0183:0156

Unidentified photographer
American,
active 1860s

*Spirit Photograph –
Woman's Spirit
behind Table with
Photograph*, ca. 1865

*Albumen print
carte-de-visite*
MUSEUM PURCHASE,
EX-COLLECTION
ROBERT A.
SOBIESZEK
68:0325:0004

of a woman's "spirit" standing behind a table that holds another framed photograph (page 329) shows a vivid example of a "spirit's" presence. In actuality, many photographers merely superimposed separate images, as in this example in which the photographer left more than half of the frame free to accommodate his "unexpected" subject.

In 1862, Scotsman G. W. Wilson introduced the cabinet-size photographic print mounted on a card, about three times the size of a carte-de-visite. Four years later the cabinet card was introduced in England and the United States. Its greatest appeal was that its larger size rendered more facial detail than the smaller carte. Albums appeared in 1867 that could accommodate both formats. Although about 15 different portrait formats were eventually introduced, only the carte-de-visite and cabinet card proved successful.

Paul Nadar
French, 1856–1939

Dancer in Costume Holding Eggs,
ca. 1890

Albumen print
cabinet card
82:1228:0004

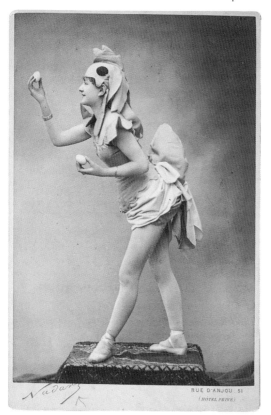

By 1890, Nadar had all but relinquished the photographing responsibilities at his studio to his son, Paul, who made this charming portrait of a costumed dancer holding eggs.

On the other side of the Atlantic, the well-regarded New York photographer Abraham Bogardus, who had bought his first daguerreian outfit in 1846 and opened his own gallery in New York, took to the card format despite his initial resistance against it. Bogardus trafficked in the highly popular genre of "freak" photography, including portraits of Tom Thumb and his wife. When clients complained that his portraits of them made them look like the devil, Bogardus retorted that he had "never met the devil and cannot say whether they ressemble [*sic*] him." Of the carte-de-visite format, he stated: "Too small: a man

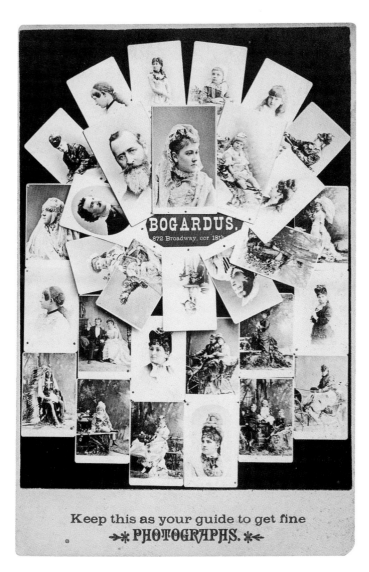

Keep this as your guide to get fine
→✳ PHOTOGRAPHS. ✳←

Abraham Bogardus
American,
1822–1908

"Keep This as Your
Guide to Get Fine
Photographs,"
ca. 1885

*Albumen print
cabinet card*
82:0679:0001

standing against the shaft of a column, his face the size of two pinheads. I laughed upon seeing it, scarcely thinking that before long I would be producing them at the rate of a thousand a day." On a cabinet card advertisement for his studio, Bogardus managed to squeeze 30 individual photographs into an especially small image area, effectively reducing the images to a fraction of the carte-de-visite format.

The proliferation of illustrated newspapers, magazines, and books signaled the beginning of the end for the carte-de-visite and cabinet card as photographic images became increasingly accessible through these alternate media. While patrons still had their own likenesses made, they were less inclined to collect individual photographs of famous or otherwise interesting subjects. Photomechanical processes made these reproductions cheaper and more accessible than card photographs.

Careers of artists like Honoré Daumier had been made through the reproduction of their work as lithographs in illustrated newspapers and journals. Daumier's caricature of Nadar precariously photographing from his balloon capitalized both on the international notoriety of the eccentric photographer as well as the popular mania for the medium itself, represented by a landscape populated almost entirely by photography studios. Nadar's fame rivaled that of his illustrious sitters, and the combination of his name with theirs proved lucrative, selling many larger prints for his studio. Nadar's portrait of celebrated

Honoré Daumier
French, 1808–1879

Nadar élevant la photographie à la hauteur de l'art (Nadar Elevating Photography to the Level of Art), May 25, 1862

Lithograph
GIFT OF EASTMAN KODAK COMPANY, EX-COLLECTION GABRIEL CROMER
82:2383:0001

Nadar (Gaspard Félix Tournachon)
French, 1820–1910

Georges Sand, ca. 1860

Print ca. 1880 by Goupil et Cie Woodburytype
97:1957:0001

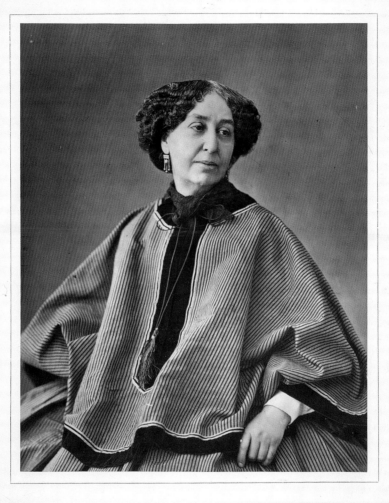

120, boul. Magenta. — Paris. Phot. Goupil et Cⁱᵉ. Cliché NADAR.

GEORGES SAND

Née à Paris, le 5 juillet 1804, morte à Nohant, le 8 Juin 1876.

**Nadar
(Gaspard Félix
Tournachon)**
French, 1820–1910

Mademoiselle
Delna, Mademoi-
selle Bonnefoy et
Monsieur LaFarge,
Mademoiselle
Jeanne Harding,
ca. 1860

Albumen print
MUSEUM PURCHASE
70:0139:0002

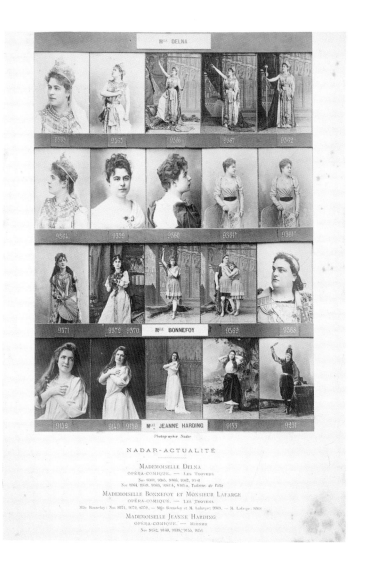

Photographie Nadar

NADAR-ACTUALITÉ

MADEMOISELLE DELNA
OPÉRA-COMIQUE. — LES TROYENS
Nos 9363, 9365, 9366, 9367, 9342
Nos 9364, 9359, 9360, 9361 A, 9361 B, *Toilette: de Ville*

MADEMOISELLE BONNEFOY ET MONSIEUR LAFARGE
OPÉRA-COMIQUE. — LES TROYENS
Mlle Bonnefoy : Nos 9371, 9372, 9370. — Mlle Bonnefoy et M. Lafarge : 9369. — M. Lafarge : 9368

MADEMOISELLE JEANNE HARDING
OPÉRA-COMIQUE. — MIGNON
Nos 9152, 9140, 9139, 9155, 9151

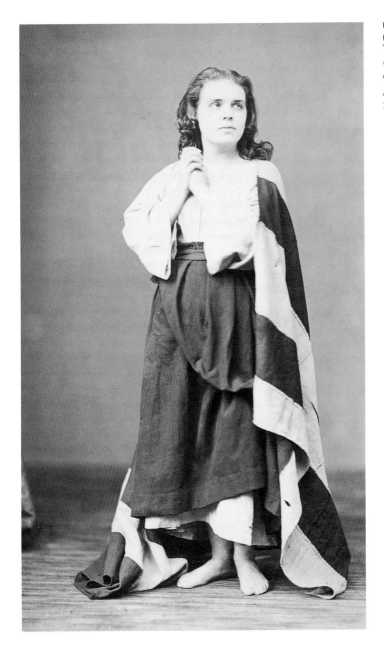

**Nadar
(Gaspard Félix
Tournachon)**

Woman in Costume,
ca. 1855–1865

Albumen print
78:0643:0001

writer Georges Sand is a Woodburytype that was part of "Galerie contemporaine, littéraire, artistique" a serial publication of 241 Woodburytypes distributed by the firm Goupil et Cie. in Paris.

Stars of the stage, too, were Nadar's subjects. Mademoiselle Delna, Mademoiselle Bonnefoy, Monsieur LaFarge, and Mademoiselle Jeanne Harding are names unfamiliar to modern viewers, but for contemporaries, the multiple views of comic actors in various guises mounted together on a single numbered card served as an advertisement. Nadar's portrait of an unidentified young woman in costume, striking a dramatic pose of supplication, is an endearing portrait of the actress as ingenue.

With the popularity of lithographic reproduction, photography began to be editorialized and serialized, just like popular novels of the day that were published in weekly or monthly installments. Photography also figured prominently in contemporary writings and thus had a level of familiarity with the general public that no other art form could claim. Edmond de Beaumont was the lithographer and the Maison Martinet the publisher of the series *Dialogues Parisiens*. An inscription under the image of this colored lithograph is a flirtatious dialogue between a young mistress and her older male companion; she stands beside him holding a stereo viewer. The text reads: " – *Comme c'est joli …, mon ami, toutes ces vues …; on croirait y être!…* – How lovely it is …, my love, all these views …; one believes that one is there!… – *Je suis de ton avis …, aussi, cet été, au lieu d'aller visiter la Suisse, comme tu m'avais demandé, je t'acheterai des vues de ce pays que tu t'amuseras a regarder au travers de ta lorgnette!…* – I agree with you …, also, this summer, instead of going to visit Switzerland, like you asked me, I'm going to buy you views of that country so you

Edmond de Beaumont
French, active ca. 1850s

Dialogues Parisiens, ca. 1855

Lithograph with applied color
GIFT OF EASTMAN KODAK COMPANY, EX-COLLECTION GABRIEL CROMER
82:2373:0004

can amuse yourself by looking through your opera glasses!..." Photography had become commonplace, an instantly familiar subject in popular imagery, and here the suggestion that the stereographic view could substitute for the real thing was being lampooned.

The introduction of the stereograph image created the next great wave of popularity in photography. Though the stereograph image had existed since the early days of photography, it was not widely produced until the early 1850s. It vied for popularity with the carte-de-visite during the 1860s, and by the late 1930s, countless millions of stereographs had been sold worldwide. During the 1880s stereoscopes were even sold door to door, like encyclopedias, by college students moonlighting as traveling salesmen.

Stereographs reached the height of their popularity in the 1870s and were a common diversion in fashionable Victorian parlors, providing hours of entertainment and edification through the diversity of the subject matter depicted. Their content increasingly reflected Victorian morals, mores, and humor. Although every conceivable subject, from architecture to zeppelins, was given the stereographic treatment, some of the more popular applications were constructed narratives, miniature comedies, and dramas played out in the stereo viewer, either on a single card or a sequential group.

Alfred Silvester was a master of fine tinting and specialized in genre scenes. His sensitively hand-colored image of a woman dreaming about

Alfred Silvester
English,
active ca. 1850s

The Dream of the
Wedding, ca. 1858

*Albumen print
stereograph with
applied color*
GIFT OF ALDEN
SCOTT BOYER
84:1434:0001

her wedding day (page 337) is a fine example of the strong narrative appeal that could be constructed through the photographic image. The superimposition of the minister and betrothed pair kneeling before him is visible to the viewer just beyond the conveniently tied-back drape. The dream scene conspicuously lacks color in order to emphasize its representation of a fantasy state separate from the color-coded "reality" of the sleeping woman in her sitting room. While reminiscent of spirit photography, Silvester's subtle work has survived the test of time, remaining movingly convincing in its manipulation of the medium for the sake of narrative. The museum's collection holds over 35,000 examples of the stereographic art.

Landscapes were also a popular subject for the stereograph image. Stereographs, because of their unique three-dimensionality, were perhaps most effective in scenes that rendered perspective. Charles Warren Woodward of Woodward Stereoscopic Company was a Rochester, New York, based publisher of stereoscopic views, who specialized in landscapes of the American West and New York State scenery. "Arnold Park" is from the series *Rochester and Vicinity*, which was offered for sale in 1876 at $1.50 per dozen views. The deep perspective of the street appears infinite in the stereoscope viewer, and the trees lining the street veritably dance along its length when viewed in stereo. The close-up view of a decorative urn in the left corner further emphasizes the dramatic depth of this view, making this a highly successful example of the format.

Charles Warren Woodward
American, 1836–1894

Arnold Park, ca. 1876

Albumen print stereograph
MUSEUM PURCHASE
81:8716:0024

A Slightly Damaged House, Johnstown, Pa., U. S. A.
Copyright, 1889, by Geo. Barker.

While idyllic views such as "Arnold Park" held vast appeal, the aftermath of natural disasters of every conceivable magnitude – earthquakes, volcanic eruptions, floods, tornadoes, hurricanes, tidal waves, and cyclones – were also photographed, and the stereograph brought the scope of these tragedies into view with vivid detail. George Barker was a prize-winning Canadian landscape photographer famous for his more than 800 views of Niagara Falls. Barker's images, made for a survey on the effects of commercial and industrial development, led to the establishment of park lands on both sides of the river. A prolific photographer, Barker operated Barker's Stereoscopic View Manufactory and Photograph Rooms above his variety store, in which he also sold souvenirs and curios.

Barker traveled to other states including Georgia, Kentucky, and Florida to make photographs of landscapes and disasters. After the infamous Johnstown flood of 1889, Barker went to Pennsylvania to photograph the results of the damage that had claimed many lives. Almost 20 photographers made stereographs of the aftermath of this tragedy. Among Barker's views were some stereographs with "posed" victims. "A Slightly Damaged House, Johnstown, PA ..." is an oddly jocular title, but was undoubtedly marketed to appeal to the public's macabre fascination with disaster.

George Barker
American,
b. Canada,
1844–1894

A Slightly Damaged
House, Johnstown,
PA., U.S.A., 1889

*Gelatin silver print
stereograph*
GIFT OF HENRY OTT
81:5912:0003

Edwin Emerson
American, 1823–1908

*Children by Wood-
stove*, ca. 1861

*From a collodion
on glass negative*
GIFT OF EDITH
EMERSON
80:0678:0027

Not everyone relied on commercial photographers to provide them with photographic views of the world. In no other artistic medium have amateurs made as significant a contribution as in photography. Even before the introduction of the Kodak camera made photography widely available, intrepid practitioners equipped themselves with photographic outfits and set about recording their lives and surroundings with the same skills as the professionals. Amateurs were founding members of nearly every early photographic society, creating forums in which to share ideas, formulas, and images with like-minded enthusiasts.

Edwin Emerson was a professor of rhetoric and belles lettres at Troy University in Troy, New York. His college roommate, an amateur photographer and chemistry professor, introduced Emerson to the medium. Within a month of his arrival in Troy, Emerson purchased photographic equipment from E. and H. T. Anthony and Company in New York, and photography remained a lifelong interest. Emerson was a member of both the Amateur Photographic Exchange Club and the Photographic Society of Philadelphia. More than 100 of Emerson's images and 80 of his negatives are held by the museum, given by Emerson's granddaughter, Edith. These two images from Emerson's original stereograph negatives are family photographs made in Troy. They reveal a striking sensitivity to light and shading. Two children sit on the floor by a wood stove illuminated by light softly flowing into the room from outside of the frame. In a portrait of two women seated near a window, the strong sunlight bathes the women in a warm, shadowy glow.

After leaving Troy in 1862 Emerson toured Europe, collecting work by Oscar Gustave Rejlander, a leading artistic photographer who made elaborate combination prints involving multiple negatives, including "The Two Ways of Life" and "Head of St. John the Baptist in a Charger" (see page 360).

Evidencing an eye for the dramatic – if, perhaps, not quite on Rejlander's level –, John Coates Browne photographed stars of a children's play dressed in their ghoulish costumes (page 342). Browne was an amateur photographer and a charter member of the Photographic Society of Philadelphia, regularly exhibiting his work there. In 1884 he wrote the *History of the Photographic Society of Philadelphia* and contributed frequently to the national magazine the *Philadelphia Photographer*. His photograph of a sleeping dog on a porch (page 342) revisits the perennially favorite photographic subject of man's best friend. More than 100 of Browne's negatives were acquired in 1975.

Samuel Fisher Corlies was another early member of the Photographic Society of Philadelphia, established in 1862 and still in existence. Corlies participated in the photographic excursions that were sponsored for its members. His 231 glass plate negatives, many annotated with the type of collodion or gelatin emulsion used, the date and location where the image was made, and often exposure information, are held by the museum. From a display of freshly caught trout to a group of photographers on an outing (page 343), Corlies carefully documented the events of his life, leaving a valuable photographic glimpse into another era. Both Browne's and Corlies' images presaged the informal photographic attention that would be given to everyday events by the snapshot

Edwin Emerson

Two Women Seated in Room, ca. 1861

From a collodion on glass negative
GIFT OF EDITH
EMERSON
80:0678:0030

John C. Browne
American, 1838–1918

A Children's Play,
ca. 1866

*Modern gelatin silver
print from the original
collodion on glass
negative*
MUSEUM PURCHASE
75:0130:0043MP

John C. Browne

Dog Asleep on Porch,
ca. 1866

*Modern gelatin silver
print from the original
collodion on glass
negative*
MUSEUM PURCHASE
75:0130:0044MP

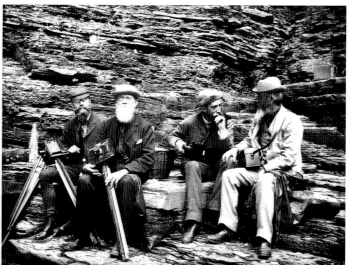

Samuel Fisher Corlies
American, 1830–1888

Trout and Rod, 1880

*From a gelatin
on glass negative*
GIFT OF THE 3M
COMPANY, EX-
COLLECTION LOUIS
WALTON SIPLEY
77:0703:0016

Samuel Fisher Corlies

Four Photographers
Group in Parlor at
Enfield Glen, 1885

*From a gelatin
on glass negative*
GIFT OF THE 3M
COMPANY, EX-
COLLECTION LOUIS
WALTON SIPLEY
77:0706:0001

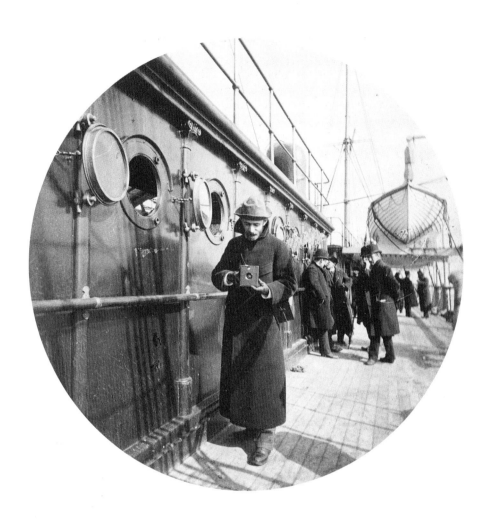

Frederick Church
American, 1864–1925

*George Eastman on
Board the S. S. Gallia,*
February 1890

*Albumen print
(Kodak # 2 snapshot)*
GIFT OF MARGARET
WESTON
81:1159:0026

camera, although their materials were the same as those used by professional photographers.

Not long after these images were created, the medium of photography was transformed by an invention that completely altered the means by which photographs were made, and the visual world would never be the same. Possibly the biggest blow to the card photograph and to studio photographers in general was the introduction of the box camera.

While on a transatlantic trip, Frederick Church photographed inventor and Eastman Kodak Company founder George Eastman with a No. 2 Kodak box camera, the same model that Eastman also holds. Eastman had sold insurance and worked for a bank before devoting himself to photography, first by selling dry plates. In 1892 the Eastman Dry Plate and Film Company was reorganized as the Eastman Kodak Company. The name Kodak, according to Eastman, "was a purely arbitrary combination of letters ... a word that would answer all the requirements for a trade name ... short; incapable of being misspelled so as to destroy its identity, [and with] a vigorous and distinctive personality."

"You press the button, we do the rest," was Kodak's advertising slogan, first published in 1888. The camera's instructions could not have been simpler: 1) Pull the cord. 2) Turn the key. 3) Press the button. The No. 1 Kodak was a small box – 3-1/4 by 3-3/4 by 6-1/2 inches – that came loaded with roll film for 100 exposures. Each image was 2-5/8 inches in diameter. The initial cost was $25, and around 13,000 were sold in the first year. After the film was exposed, the customer mailed the camera back to Kodak, which returned it reloaded with film for 100 more exposures and the 100 mounted prints, at a cost of $10. For the first time in the history of the medium, the means of photography could be put into the hands of any man, woman, or child.

Sir John Herschel coined the term "snapshot" in 1860. A British

Richard K. Albright
American,
active 1880s

Descending
Vesuvius, ca. 1888

*Albumen print
(Kodak # 1 snapshot)*
GIFT OF MRS.
RAYMOND ALBRIGHT
74:0250:0048

(left)
**Unidentified
photographer**
American,
active 1890s

Samuel Castner, Jr.,
ca. 1890

*Albumen print
(Kodak # 1 snapshot)*
GIFT OF 3M COMPA-
NY, EX-COLLECTION
LOUIS WALTON
SIPLEY
82:1797:0009

(right)
**Unidentified
photographer**
American,
active 1890s

Conesus Lake,
August 1893

*Albumen print
(Kodak # 1 snapshot)*
81:1294:0018

hunting term referring to shooting from the hip without careful aim, it was adapted to mean "the possibility ... of securing a picture in a tenth of a second. ..."

Richard K. Albright's photograph, "Descending Vesuvius" (page 345) is an example of a Kodak snapshot. Among the 38 Kodak snapshots that Albright made in Europe are, predictably, "Ascending Vesuvius" and simply "Vesuvius. Raymond," made at the summit. The button was probably pushed by a passerby or Albright's wife, whose daughter-in-law donated the collection of images to Eastman House.

Samuel Castner, Jr., was also the subject of one photographer's snapshot, standing directly in line with the tree and path in the center of the frame. Without the need for a darkroom, tripod, or other additional equipment, snapshots were able to record more fleeting moments than had previously been possible. They allowed the camera to record images from vantage points where larger cameras could not physically go, such as just above water level at Conesus Lake, New York, where four happy and bobbing heads made lasting memories of their holiday in the summer of 1893.

Early Kodak cameras did not have viewfinders, so the phrase "point and shoot" was no exaggeration. Thus new photographers were required to make their pictures by essentially guessing at framing, which accounts for this portrait of a baby in a carriage escorted by a woman whose head is only half-visible. The early Kodak snapshots were also round in format, because the inexpensive, wide-angle lens was distorted

around the outer edges. Eastman equipped the first three models of the camera with a circular mask to disguise it, giving the images a kind of "bull's-eye" aesthetic. The circular format was changed after 1896 to the more familiar rectangular formats.

Although men had previously far outnumbered women as photographers – even though many women had been employed on the production end – Kodak cameras were aggressively marketed to women. The museum's technology collection has numerous examples of these cameras, which later were sometimes marketed with matching lipsticks and compacts. The "Kodak Girl," introduced in the 1890s, was a ubiquitous advertising tool: sporty women traveled the globe, Kodak in hand. The snapshot of two men and two women standing by the entrance gate of a front yard was made by a woman, judging from the telltale puffed-sleeve shadow cast in the foreground as she made the exposure.

In 1900 Eastman introduced the Brownie camera, named after the popular cartoon characters and originally intended to be used by children. It cost only $1, and more than 100,000 were sold in the first year. Eastman had envisioned the Kodak camera as "a photographic notebook." He said: "Photography is thus brought within reach of every human being who desires to preserve a record of what he sees. Such a photographic notebook is an enduring record of many things seen only once in a lifetime and enables the fortunate possessor to go back by the light of his own fireside to scenes which would otherwise fade from memory and be lost."

(left)
Unidentified photographer
American,
active 1890s

Baby in Carriage,
ca. 1895

*Gelatin silver print
(Kodak # 2 snapshot)*
81:2862:0093

(right)
Ellen Dryden (attrib.)
American,
active 1880s–1890s

Two Men and Two Women in Yard,
ca. 1889

*Gelatin silver print
(Kodak # 2 snapshot)*
GIFT OF GEORGE
B. DRYDEN
81:2167:0056

Artful Ambitions

From the time of its invention, photography was embroiled in an ongoing debate over whether or not this mechanical medium could produce art. The great era of the calotype in France marked the first concentrated application of the medium by various artists as a fine art and not the handmaid of painting and drawing. Among the French calotype artists, the most ardent proponent and practitioner to explore photography's artistic capabilities was Gustave Le Gray. Trained as a painter in the studio of Paul Delaroche, Le Gray taught photography to Henri Le Secq, Charles Nègre, Adrien Tournachon (all of whom trained as painters), and others.

Although his photographic career lasted only a dozen years, Le Gray was one of the most influential practitioners of the 19th century. He became a founder of the Société Héliographique, the world's first photographic association, and published a handbook for artists titled *A Practical Treatise on Photography* that was so widely consulted that it was also published in England and the United States. It included rules for posing sitters in order to produce the liveliest portraits as well as procedures for technical manipulations. Declaring his disdain for rampant commercialism and his commitment to the application of photography as an art form, Le Gray wrote: "The future of photography does not lie in the cheapness but in the quality of a picture. If a photograph is beautiful, complete, and durable, it acquires an intrinsic value before which its price disappears entirely. For my part, it is my wish that photography, rather than falling into the domain of industry or of commerce, might remain in that of art. That is its only true place, and I shall always seek to make it progress in that direction."

Around 1855 Le Gray began to photograph at the Mediterranean port of Sète. His seascape of the sun setting over the water is a spectacular rendering of light and the nuance of shadow and reflection. At that time the chemicals used in photography were more sensitive to blue and ultraviolet light, so in exposing the negative for the water to look natural, the sky was rendered as a flat gray. To obviate this problem and to produce results such as "The Great Wave," Le Gray combined two negatives, one exposed for the water and the other exposed for the sky. Occasionally Le Gray would reuse the same negatives, and one can see the same formation of clouds appearing in different images.

Gustave Le Gray

The Great Wave,
Sète, ca. 1857

Albumen print
GIFT OF EASTMAN
KODAK COMPANY,
EX-COLLECTION
GABRIEL CROMER
82:1589:0001

Gustave Le Gray
French, 1820–1882

Seascape, ca. 1855

Albumen print
GIFT OF EASTMAN
KODAK COMPANY,
EX-COLLECTION
GABRIEL CROMER
81:1442:0001

Adolphe Braun
French, 1812–1877

Camellias and Lilacs, 1856

Albumen print
GIFT OF EASTMAN
KODAK COMPANY,
EX-COLLECTION
GABRIEL CROMER
81:1005:0004

Not a fine artist in the academic tradition per se, Adolphe Braun came to photography from a background in textile design. As the head of a textile mill, he took up photography around 1853 in order to create a "collection of studies for artists who used floral motifs." He later established his own design house specializing in textiles and wallpapers, as floral designs were extremely popular in Second Empire France. The Eastman House collection holds approximately 60 of these floral studies, most in an album of 52 albumen prints, including this floral still life artfully presented to an oval shape. His wreath-like arrangement of "Camellias and Lilacs" reveals an artist's sensibility in the arrangement of nature's most stunning offerings. The collection also contains nearly 200

Adolphe Braun

Floral Still Life, ca. 1857

Albumen print
MUSEUM PURCHASE
67:0045:0006

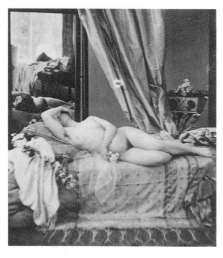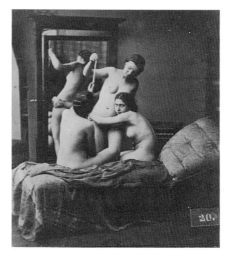

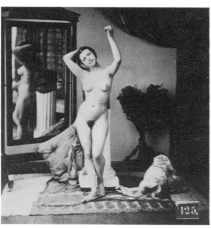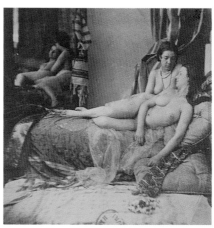

Louis-Camille d'Olivier
French, 1827–after 1870

Composition avec nu
(Composition with Nude), 1853–1856

Salted paper prints
MUSEUM COLLECTION, BY EXCHANGE
85:1007:0024 (top left)
85:1007:0027 (top right)
85:1007:0005 (bottom left)
85:1007:0014 (bottom right)

(right)
**Louis-Camille
d'Olivier**

Étude d'après nature
(Nature Study),
1853–1855

Salted paper print
MUSEUM COLLEC-
TION, BY EXCHANGE
85:1009:0002

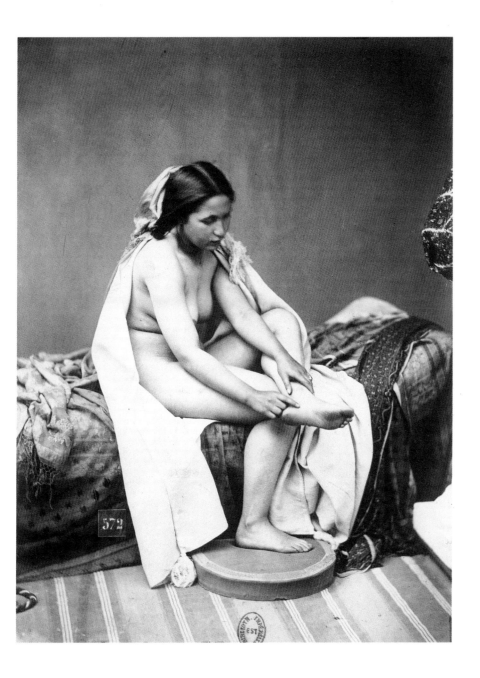

of Braun's images, representative of his artistic and business endeavors, including art reproductions and stereographs.

Another subject that was a favorite of the calotype artists was the female nude. Louis-Camille d'Olivier was a painter and photographer who established a commercial firm, the Société Photographique, which specialized in nude studies. Rather than merely present the women's bodies as *académies*, d'Olivier frequently depicted them in bedroom or toilette scenes, both alone and in groupings. The erotic nature of his work is evident in their languid poses of abandonment and pleasure as the models caress one another or themselves (pages 352 and 353). The inclusion of underarm and pubic hair and bare, dirty feet was shockingly frank and unconventional within the genre of traditional nude studies, adding an element of realism to d'Olivier's work.

By comparison, Eugène Durieu's nudes are more classical and chaste. Durieu was a lawyer and government administrator who started to photograph around 1845, assisting Baron Jean-Baptiste-Louis Gros in making astronomical daguerreotypes. Along with Le Gray, Durieu was a

Eugène Durieu
French, 1800–1874

Female Portrait (left),
Nude (top right),
*Female Portrait with
Bird* (bottom right),
ca. 1855

Salted paper prints
GIFT OF EASTMAN
KODAK COMPANY,
EX-COLLECTION
GABRIEL CROMER
79:0079:0062 (left)
79:0079:0063
(top right)
79:0079:0064
(bottom right)

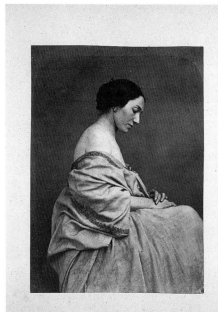

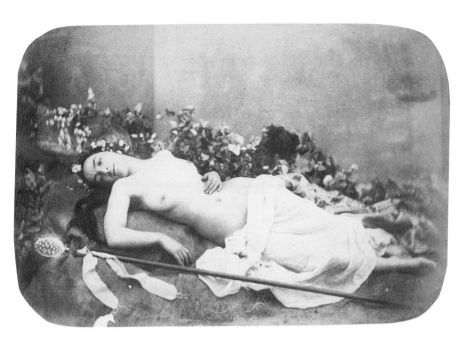

founding member of the Société Héliographique. As a member of the Commission des Monuments Historiques, Durieu was introduced to the practical and artistic merits of the calotype medium, declaring that "the future of Photography lies in paper." He is best known for his nude and costume studies for artists. The Romantic painter Eugène Delacroix, who met Durieu around 1850 after the latter had retired from his government post, is believed to have suggested this subject matter and helped pose many of his nudes. Delacroix later used Durieu's photographs from which to sketch. A group of images from *Photographie*, Durieu's personal album of 119 prints that is now in the Eastman House collection, suggests the subtlety and mastery of his art. An elegant portrait of a woman seated in profile, shoulders bare, mounted opposite one of a rare, smiling nude model with her arm upraised and another of a model holding a bird, demonstrates Durieu's open and experimental approach to the medium as well as the genre. In another view, an odalisque whose lower body is modestly yet seductively draped turns her head toward the camera. She acknowledges the viewer through the self-consciousness of her pose and gaze, submitting to voyeuristic fantasy.

Eugène Durieu

Reclining Nude with Scepter, ca. 1855

Salted paper print
GIFT OF EASTMAN
KODAK COMPANY,
EX-COLLECTION
GABRIEL CROMER
79:0079:0107

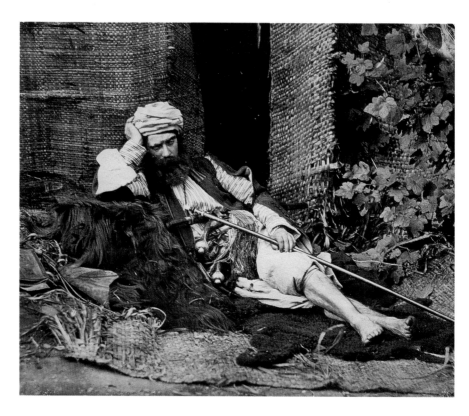

William M. Grundy
English, 1806–1859

Arab Reclining, 1857

Albumen print
GIFT OF G.C.
MONKHOUSE
76:0288:0045

Her left hand resting just below her breast is as deliberate as it is charmingly natural.

The recumbent pose was not exclusive to female models and French photographers. British amateurs also avidly pursued the artistic possibilities of the medium with very different subject matter. William Morris Grundy was a member of the Royal Photographic Society who illustrated the 1861 book *Sunshine in the Country: A Book of Rural Poetry* housed in the Menschel Library. Like many British contemporaries, he traveled and photographed in Egypt, exhibiting several of these images with the exotic title of "Turkish Scenes." Grundy's portrait "Arab Reclining" does not appear to be an Arab at all but rather a model posed in an Arab costume. His bare calves and feet are meant to suggest a kind of sensual abandon, especially to Grundy's Victorian British audience.

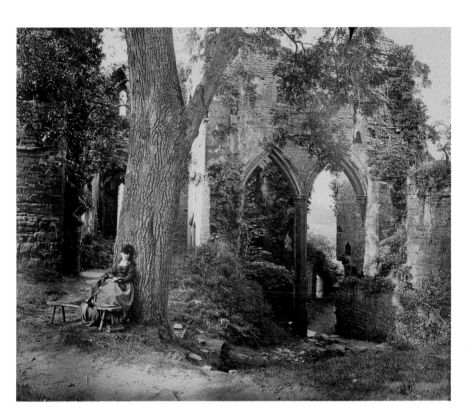

Captain George Bankhart was a founder of the Leicester and Leicestershire Photographic Society and was its president from 1887 until 1889. His views of Tintern Abbey and the countryside around his home are in the museum's collection. Bankhart's deliriously cluttered view of "Goodrich Castle from inside the Ruins" was published by the Amateur Photographic Association. Foliage and bricks overlap and intertwine as if grown up together, with perfectly intact arches revealing more complex views beyond. At left a woman rests against a tree that grows right out of the top of the picture frame. She holds an open book, suggesting a bucolic retreat.

Photographic artists often were not content to record the scene before them as nature presented it. Rather, they sought to perfect nature, believing it was the photographer's "imperative duty to avoid the mean, the bare, the ugly, and to aim to elevate the subject, to avoid awkward

Captain George Bankhart
English, 1829–1916

Goodrich Castle from inside the Ruins, ca. 1870

Albumen print
MUSEUM PURCHASE,
EX-COLLECTION
A. E. MARSHALL
82:2556:0001

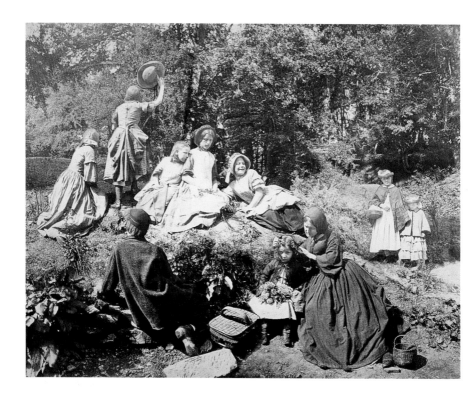

Henry Peach Robinson
English, 1830–1901

A Holiday in the Wood, 1860

Albumen print, combination print
GIFT OF ALDEN
SCOTT BOYER
70:0192:0001

forms and to correct the unpicturesque," as Henry Peach Robinson wrote in 1869. Robinson became one of the most vocal proponents of photography as a fine, or "High Art." He wrote numerous treatises on the subject and applied his theories to some of the most remarkable manipulated images of the 19th century.

"A Holiday in the Wood" is a composite print from six different negatives. Robinson described the complexities of working with both weather and a recalcitrant medium, a reminder that success in early photography was dictated by more than the artist's eye: "The year 1860 was the wettest, or one of the wettest, years of the century ... *A Holiday in the Wood*... was produced under great difficulties. The figures were done on the only two fine days of April. Then everything was kept ready to drive to Kenilworth for the Woodland background, on the first fine day – which did not occur until 12 September. I had to wait five months."

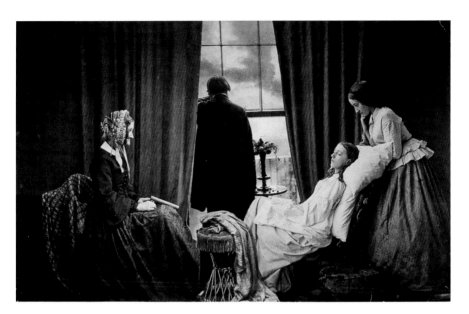

Henry Peach Robinson

Fading Away, 1858

Albumen print, combination print
GIFT OF ALDEN
SCOTT BOYER
76:0116:0001

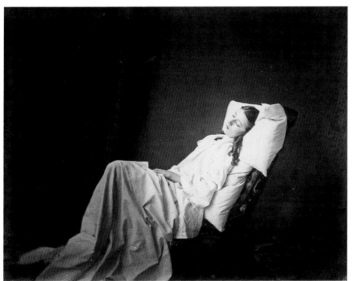

Henry Peach Robinson

She Never Told
Her Love, ca. 1858

Albumen print
MUSEUM PURCHASE
75:0091:0001

"Fading Away," Robinson's most famous image, which one critic called "an exquisite picture of a painful subject" (page 359) is a composite print from five negatives, and Robinson's staff made an astounding 200 prints before an assistant accidentally ruined the negatives. Robinson appended a verse from Percy Bysshe Shelley's poem *Queen Mab* to the print. "She Never Told Her Love" is a variant of the central image of the fading girl posed by Robinson's favorite model, Miss Cundall; it takes its title from Shakespeare: "She never told her love/But let concealment, like a worm i' the bud,/Feed on her damask cheek."

Oscar Rejlander was Robinson's contemporary, friend, and eventual rival, especially regarding the debate over whether such blatant manipulation in photography was an acceptable means to an artistic end. Given photography's claims to veracity, Rejlander, who was trained as a painter in Rome, originally took up photography to aid his painting. Like Robinson, he wrote often and eloquently about photography, championing it as a High Art medium. Often called "The Father of Art Photography," Rejlander produced what is perhaps the best-known composite print image of the 19th century: "The Two Ways of Life," made from 30 negatives. Making an about-face in 1859, Rejlander stated: "I am tired

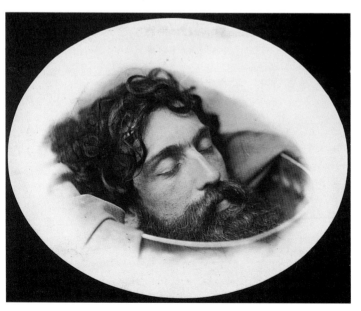

Oscar Gustav
Rejlander
English, b. Sweden,
1813–1875

Head of St. John the
Baptist in a Charger,
ca. 1859

*Albumen print,
combination print*
MUSEUM PURCHASE,
EX-COLLECTION
A. E. MARSHALL
81:1791:0003

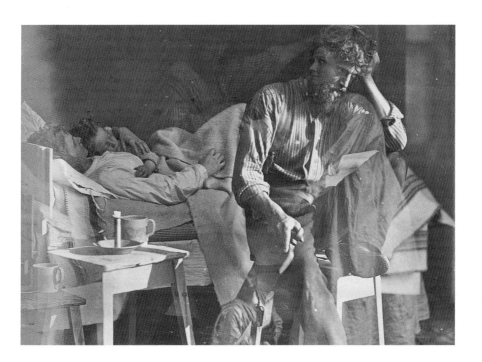

of photography-for-the-public, particularly composite photographs, for there can be no gain and there is no honour, only cavil and misrepresentation. My next exhibition will be composed only of landscapes, ruins covered with ivy, and, of course, portraits." Instead, one of his next images was the "Head of St. John the Baptist in a Charger" made from two negatives. Despite the gruesome scene, Rejlander depicted St. John's countenance in a peaceful, almost resting fashion, explaining that he wanted to portray the expression of "holy resignation" he believed St. John would have wanted to wear upon meeting his Maker. Robinson described Rejlander's tenacious approach to securing the model for St. John: "Rejlander saw his head on the shoulders of a gentleman in the town. ... The curious thing is, that he did not so much see the modern gentleman as always the picture which the head suggested. It was some months before the artist ventured to ask the model to lend his head ... and years before he obtained his consent."

"Hard Times" appeared in at least two versions; in this one, an image of a carpenter, his wife, and child is superimposed over a similar

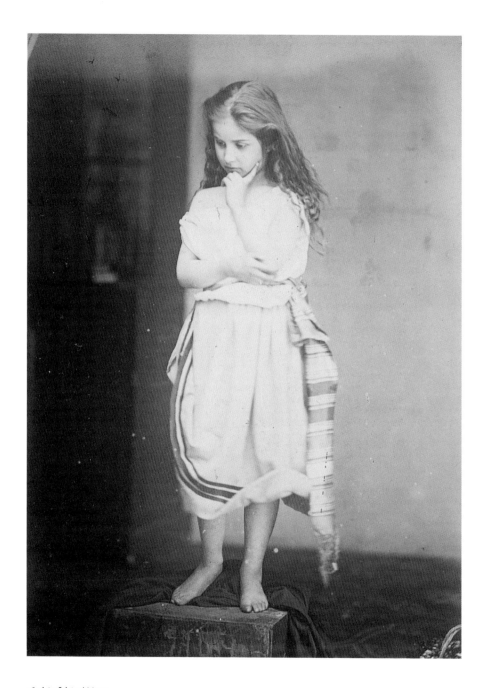

view, suggesting the mental torment afflicting the man unable to provide for his family. Rejlander also photographed local children in dramatic tableaux, such as this study (left) of a pensive girl posing on a box.

No photographer excelled with photographs of children, particularly young girls, more than Lewis Carroll. Carroll, the pseudonym of mathematician and writer Charles Lutwidge Dodgson, was the author of *Alice's Adventures in Wonderland* and its sequel *Through the Looking-Glass*. Taking up photography around 1856, Carroll was an avid practitioner for 25 years. Alexandra "Xie" Kitchin was the daughter of the Reverend George William Kitchin and the godchild of Queen Alexandra. She was one of Carroll's favorite models; Carroll stated that the way to guarantee excellence in a photograph was "to get a lens and put Xie before it." He began to photograph her in the late 1860s. Many of Carroll's portraits of Xie depict her in costume. Here the young girl reclines upon a bamboo chaise holding an umbrella aloft in this remarkably candid and self-assured portrait.

Lewis Carroll
(Rev. Charles Lutwidge Dodgson)
English, 1832–1898

Xie Kitchin with Umbrella, ca. 1875

Albumen print
MUSEUM PURCHASE
83:1546:0002

(left)
Oscar Gustav Rejlander
English, b. Sweden, 1813–1875

Pensive Young Girl, Posing on a Box,
ca. 1860

Albumen print
MUSEUM PURCHASE,
EX-COLLECTION
A. E. MARSHALL
72:0249:0002

Julia Margaret
Cameron
English, b. India,
1815–1879

"Wist Ye Not That
Your Father and
I Sought Thee
Sorrowing?," 1865

Albumen print
GIFT OF EASTMAN
KODAK COMPANY,
EX-COLLECTION
GABRIEL CROMER
81:1121:0027

The community of artistic photographers in Britain was a small one; Rejlander and Carroll are believed to have instructed Julia Margaret Cameron in photography to some degree. Both men had photographed Cameron, her family, and her home, Dimbola, at Freshwater on the Isle of Wight. Born in India and raised in France and England, Cameron came to photography somewhat late in life at age 49. Literature, Renaissance and pre-Raphaelite painting, and the Bible were primary influences on Cameron's work. In a letter to Sir John Herschel, Cameron plainly stated her intention to align photography with the High Art movement: "My aspirations are to ennoble Photography and to secure for it the character and uses of High Art by combining the real & Ideal sacrificing nothing of Truth by all possible devotion to Poetry & beauty." Sir John Herschel was a family friend and mentor, and it was he who

Julia Margaret Cameron

Henry Taylor, 1865

Albumen print
GIFT OF EASTMAN
KODAK COMPANY,
EX-COLLECTION
GABRIEL CROMER
81:1119:0001

kept Cameron abreast of photographic developments long before she took it up as an avocation.

"Wist Ye Not That Your Father and I Sought Thee Sorrowing?" (alternately titled "The Return after Three Days") is loosely based on the New Testament story of Christ's visit at age 12 to the temple. Evocative rather than illustrative, Cameron's image is a metaphorical representation of spirituality.

The poet Sir Henry Taylor was one of Cameron's most frequent male sitters; he posed as Kings Lear, David, and Ahasuerus, and even as Rembrandt, whose paintings Cameron occasionally emulated. Ten Taylor portraits are in the Eastman House collection. Here Cameron depicts the poet as Prospero, the duke of Milan from Shakespeare's *The Tempest*. He is a wise sage, brow deeply furrowed in thought, his unruly beard suggesting that he had no time for such trivial concerns as grooming.

Like many Victorian ladies, Cameron was an avid maker of photographic albums, which she sent to friends, mentors, and family.

Julia Margaret Cameron
English, b. India, 1815–1879

Mary Hillier, Elizabeth
and Kate Kuhn, 1864

Albumen print
GIFT OF AN ANONYMOUS DONOR
71:0109:0031

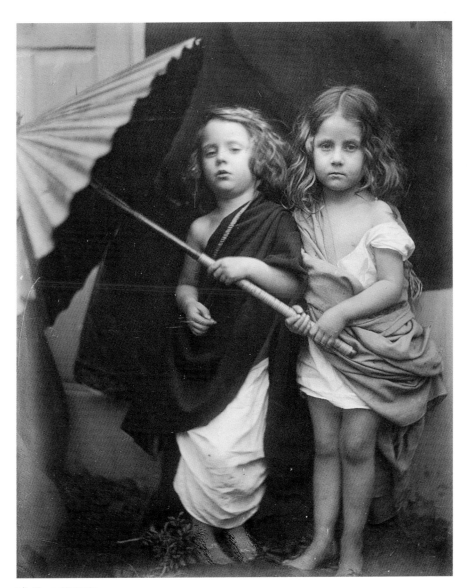

Julia Margaret Cameron
Paul and Virginia, 1864

Albumen print
GIFT OF AN ANONYMOUS DONOR
71:0109:0035

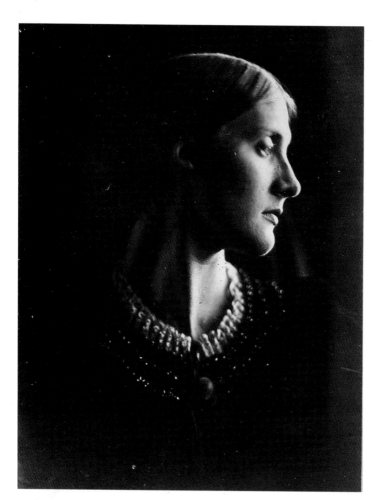

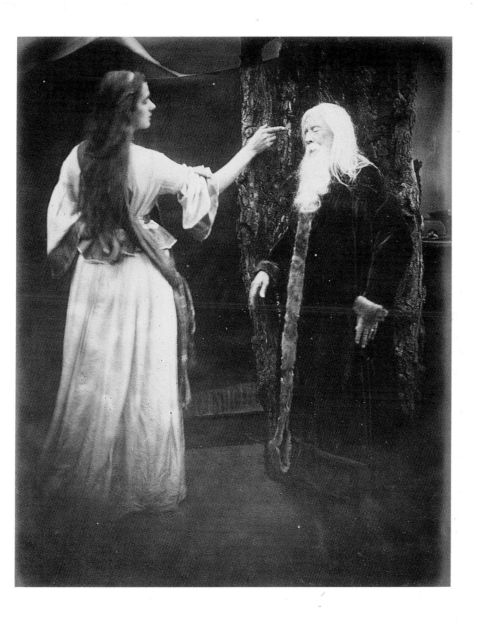

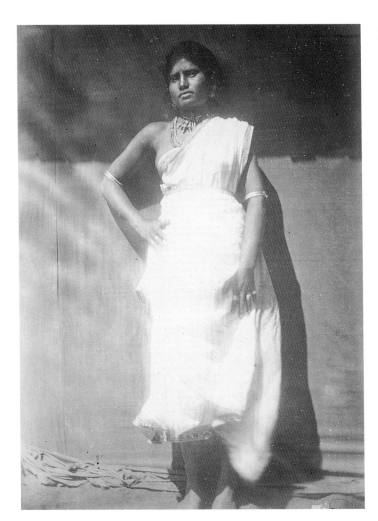

The Eastman House collection includes more than 150 images by Cameron, including the album of photographs that she presented to her mentor, the painter George Frederick Watts, which is one of the earliest known Cameron presentation albums. Cameron's maid, Mary Hillier, whom she called "one of the most beautiful and constant of my models," and Elizabeth and Kate Kuhn, daughters of the island's fortkeeper, are transformed into a Madonna and children for one portrait (page 366); she included this grouping in the Watts album. Cameron even painted the halo around Hillier's head directly onto the negative to imbue the scene with a sense of holiness.

"Paul and Virginia" (page 367), posed with Freddie Gould, a fisherman's son, and Elizabeth Kuhn, takes its inspiration from Jacques-Henri Bernardin de Saint-Pierre's 1787 romantic morality tale about two children, *Paul et Virginie*, which was highly popular among Victorian audiences. The pivotal scene in the drama is a shipwreck off the coast of the French colony of Mauritius, in which Virginia dies because, in her modesty, she refuses to remove her clothing to be rescued. This is one of Cameron's more literal if not entirely factual interpretations, with the oriental-style umbrella and scattered vegetation on the floor meant to suggest the tropical setting of the novel.

"Mrs. Herbert Duckworth as Julia Jackson" (page 368) is a striking portrait of Cameron's beloved niece and her most frequent subject. This portrait was made shortly before Jackson's marriage to Herbert Duckworth, a lawyer. Jackson would later become the mother of writer Virginia Woolf and artist Vanessa Bell from a second marriage. The significance that Cameron places upon Jackson's imminent marital status is evident from the title that already identifies the woman in relation to her husband.

"Vivien and Merlin" (page 369), with Cameron's husband Charles playing the role of Merlin and Miss Agnes as Vivien, is an illustration for Alfred, Lord Tennyson's epic poem *Idylls of the King*. Cameron had undertaken the illustrations of the highly popular work as a source of income. Tennyson was another family friend at Freshwater whom Cameron frequently photographed. Following a reversal of fortune, her family returned to Ceylon in 1875. There Cameron photographed only sporadically. Her work included a series of portraits of native people, mostly servants and plantation workers, that included this seemingly ethnographic study of a Sinhalese woman standing against a plain fabric backdrop.

**Peter Henry
Emerson**
English, b. Cuba,
1856–1936

Setting the Bow-Net,
ca. 1885

Platinum print
GIFT OF WILLIAM
C. EMERSON
79:4338:0037

Peter Henry Emerson was born in Cuba, raised in the United States, and went to England to school at age 13. A gentleman photographer, Emerson burst onto the scene as an outspoken critic of Robinson's *Pictorial Effect in Photography*, Rejlander's contrived images, and Cameron's "out-of-focus" work. He believed that photography did not need to emulate painting and painterly effects in order to be considered an art form. Rather, he believed that the inherent strengths of the medium should be utilized to their maximum potential. The Eastman House collection includes 340 images by Emerson, who was inarguably the most vocal proponent of photography as an art form in the 19th century. One of his main tenets was that of differential focus, meaning that photography should imitate ocular vision. That is, that a photograph should be in sharp focus where the eye directs its attention and have less sharpness around the edges to simulate peripheral vision. In 1889 he published *Naturalistic Photography*, which set forth the causes of truth and realism that could be achieved only through "pure" photography.

The Norfolk Broads, according to one historian, were regarded "[f]rom the 1840s at least ... as a primitive paradise, teeming with game, vivid with fragrant flowers, and the home of the last free men in England." By the time Emerson photographed there, the Broads had become a popular holiday resort for tourists. His 1887 publication *Life and*

Landscape on the Norfolk Broads was, in part, an attempt to photographically preserve a way of life threatened by encroaching modernization and urbanization. Luxuriously illustrated with platinum prints, it was the first of several books that he would produce on life in East Anglia.

Emerson, as a member of what he termed "an anthropological aristocracy," focused his camera upon the "natives," the peasant fishermen and local landowners of the region. Purporting to depict an authentic way of life, Emerson was not above asking subjects to "change and equip themselves in less pretentious manner" of dress when their fashion did not suit his own ethnographic vision. He usually offered beer or a couple of coins to induce his subjects to pose. Both "Setting the Bow-Net," an image of a man and woman readying their net for the water, and "Ricking the Reed," in which men pile stacks of reeds onto boats to be transported, emphasize the handicraft of labor, directly refuting the industrialization that was rapidly transforming the region.

Peter Henry Emerson

Ricking the Reed, ca. 1885

Platinum print
GIFT OF WILLIAM
C. EMERSON
79:4338:0011

"The Clay-Mill" is a scene from *Pictures of East Anglian Life*, which was published in 1888 with photogravure illustrations. In this volume, Emerson "endeavoured in the plates to express sympathetically various phases of peasant and fisherfolk life and landscape which have appealed to [him] in nature by their sentiment or poetry." "East Coast Fishermen" is a posed portrait of three seafaring men: ruddy, proud, and, as dramatized in the photograph, carrying on the tradition of their forefathers.

By January 1891 Emerson had become frustrated with the medium, particularly after discovering that his naturalistic views had no basis in science. He refuted his prior claims to art in an article "To All Photographers," which he later expanded into a pamphlet titled *The Death of Naturalistic Photography,* which firmly positioned photography as a science rather than an art form.

In 1892 Emerson's old rival H. P. Robinson became a cofounder of the Linked Ring Brotherhood, a group of photographers whose pro-art philosophy, which benefited from Emerson's dramatic reversal of opinion, led them to break away from the Royal Photographic Society and form their own photographic coalition. Emerson's early writings had already deeply influenced the aesthetics of many photographers, in particular the American Alfred Stieglitz, who founded the Photo-Secession movement in the United States in 1902.

Peter Henry
Emerson
English, b. Cuba,
1856–1936

The Clay-Mill,
ca. 1886

Photogravure print
GIFT OF ALDEN
SCOTT BOYER
81:1295:0026

(right)
**Peter Henry
Emerson**

East Coast
Fishermen, ca. 1886

Platinum print
GIFT OF WILLIAM
C. EMERSON
82:2532:0047

Frederick H. Evans
English, 1853–1943

Kelmscott Manor:
Attics, ca. 1897

Platinum print
MUSEUM PURCHASE,
EX-COLLECTION
GORDON CONN
81:1198:0005

(right)
Frederick H. Evans

Lincoln Cathedral
from the Castle, 1898

Platinum print
MUSEUM PURCHASE,
EX-COLLECTION
GORDON CONN
81:1198:0100

A bookseller by trade, Frederick Evans started to photograph around 1882. A proponent of "pure" photography and devotee of the platinum process, he modestly stated: "I have not been courageous enough as yet to try anything (if there is anything) beyond platinotype [platinum print]... I am more interested ... in making plain, simple, straightforward photography render, at its best and easiest, the effects of light and shade that so fascinate me. ..." Architecture was his primary subject. "Kelmscott Manor: Attics," made in William Morris's birthplace shortly after his death, is a study in light, shadow, and angle. "Lincoln Cathedral from the Castle" is a very different approach, remarkable for the way in which the cathedral rises above the foreground buildings with a muted tonality that makes it appear almost otherworldly. Evans was renowned for such images. In 1901 he was elected a Fellow of the Linked Ring. In an essay for *Amateur Photographer* three years later, Evans offered this advice to photographers: "... try for a record of an emotion rather than a piece of topography. Wait till the building makes

you feel intensely. ... Try and try again, until you find that your print shall give not only yourself, but others who have not your own intimate knowledge of the original, some measure of the feeling it originally inspired in you. ... This will be 'cathedral picturemaking,' something beyond mere photography. ..."

Lesser-known but no less successful were Evans' first photographic investigations using photomicrographic techniques, as evidenced by his "Tr. Sec. Spine of Echinus" of a specimen magnified 40 times. This image won the Royal Photographic Society Medal for photomicrography in 1887. In its perfection of form, it resembles a cathedral stained glass window, perhaps setting the stage for Evans' later, more famous work.

In 1889 the bookseller (Evans did not retire until 1898) met the young illustrator Aubrey Beardsley, with whom he traded books for drawings. Evans was responsible for securing Beardsley's first assignment, illustrating *Morte d'Arthur*. In turn, Beardsley sat for Evans, who made two successful exposures during a rather laborious sitting. The drawings of satyrs that border the mounted photograph are Beardsley's handiwork.

In November 1944, a year and a half after Evans's death, Alvin Langdon Coburn praised his predecessor's contributions during a symposium on Evans' work. "Evans laboured in the dawn of pictorial photography's fight for recognition as a means of personal expression. The fight is won now, but whenever and wherever the tale is told ... the name of Evans will be remembered as one of the champions of the purity of photography who worthily contributed to the final victory." In 1963 the Royal Photographic Society (RPS) and Eastman House jointly organized a major retrospective of Evans' work curated by then Eastman House director and RPS Fellow Beaumont Newhall. There are over 200 works by Evans in the collection.

Catherine Weed
Barnes Ward
American, 1851–1913

Dale Abbey
Hermitage,
ca. 1891–1912

*From a gelatin
on glass negative*
GIFT OF MEMORIAL
ART GALLERY
81:2291:1355

(right)
Catherine Weed
Barnes Ward

Fox Talbot's Cameras Lacock Abbey,
ca. 1891–1912

*From a gelatin
on glass negative*
GIFT OF MEMORIAL
ART GALLERY
81:2291:1716

Julia Margaret Cameron was not the only woman to excel at photography in the 19th century. American Catherine Weed Barnes Ward took up photography at age 35, setting up a darkroom in the attic of her family home. In 1890 she became an editor for *The American Amateur Photographer,* having written a column titled "Women's Work." A vocal advocate for women photographers, Ward used her editorial position to further her cause, declaring: "Good work is good work whether it be by a man or a woman, and poor is poor by the same rule." In the next decade, Ward's advocacy would be realized as an astounding number of women entered the photographic profession. The Eastman House has more than 2,000 negatives and lantern slides by this pioneering photographer, most of which were made during trips to England and Scotland. Among them are "Dale Abbey Hermitage," a delightful view enlivened by the gaggle of young boys peeking around the edge at left and maneuvering themselves into the frame. She also photographed an assemblage of Talbot's cameras on the grounds of Lacock Abbey, gathered together like curiously static performers in an unnamed play.

"It is not in man, even in f/64 man, to overlook the unnaturalness of joinings in photographic pictures, and the too visible drawing-room drapery air about attractive ladies playing at haymaking and fishwives," wrote George Davison, deriding the artificiality of art photography. Davison was a founding secretary of the London Camera Club and initially an avid proponent of Emerson's naturalistic philosophy. He soon developed his own theories; in a paper delivered to the Royal Academy of Arts, he suggested that diffusion rather than selective focus was the ideal means to convey impressionistic effects. His first diffused photograph was "The Onion Field," which he made using a pinhole camera and exhibited in 1890 at the Annual Exhibition of the Royal Photographic Society, where it was awarded a medal. Davison's method eliminated any point of sharp focus in the entire image, which greatly disheartened Emerson. He publicly renounced Davison's paper, referring to him derisively as an "audit clerk," Davison's former profession. However, in 1892 Davison was, along with Robinson, one of 15 founder-members of the Linked Ring.

George Davison
English, 1854–1930

The Onion Field, 1889

Photogravure print
GIFT OF ALVIN
LANGDON COBURN
67:0080:0006

Robert Demachy was a wealthy French banker who was passionate about music, painting, cars, and photography. By 1880 photography had become his avocation; he joined the Société Française de photographie and two years later founded the Photo-Club de Paris. He was elected a member of the Linked Ring and made an honorary member of the Royal Photographic Society and later became a member of the Photo-Secession. An advocate of the gum bichromate process, Demachy was the leading pictorialist photographer in France and author of *Pure Photography Is Not an Art,* rejecting Evans' approach. "We cannot do better than to take as a guide the effects of etching and water colors, freshness, strength, boldness and delicacy combined," he wrote. "In the Fields, Plumarch. A Breton Landscape" is an oil print, a technique Demachy took up around 1910.

Heinrich Kühn was a student of botany and medicine before devoting himself to photography around 1888. His initial foray was in photomicrography. Working in Vienna, Kühn began to make portraits and conduct research on the gum bichromate process, all the while developing his

Robert Demachy
French, 1859–1936

In the Fields, Plumarch. A Breton Landscape, ca. 1910

Oil print
GIFT OF C.J. CRARY
81:1146:0001

(right)
Heinrich Kühn
Austrian, b. Germany,
1866–1944

Tonwertstudie (Tonal
Value Study), 1929

Photogravure print
MUSEUM PURCHASE
78:0565:0003

Heinrich Kühn

Alfred Stieglitz,
MCMIV, 1904

Oil transfer print?
MUSEUM PURCHASE
78:0565:0006

pictorialist style. He was an active experimenter who wrote frequently about non-silver processes. In 1897, he and several Vienna Camera Club colleagues formed the Cloverleaf (or Trifolium) group, specializing in gum prints. This work attracted the attention of Alfred Stieglitz, who published their images in *Camera Work* and whom Kühn, in turn, photographed. Like Demachy, Kühn was elected to the Linked Ring Brotherhood.

His subject matter remained personal: "Tonwertstudie" (right) is a sensuous back view of a woman, her wide-brimmed hat and full-sleeved dress framed in the center of the composition like fluid architecture against the shadowy background. The subject is "Miss Mary" Warner, his children's English nanny. "Dame mit Pfingstrosen (Emma Kühn-Katsung – Wife)" (page 386) is a portrait study of the artist's wife, incorporating elements of his still-life work into the subtle composition. By comparison, "Gummibaum" (page 387), a still life of a potted rubber tree nestled in a warm shaft of light, is formal yet mysterious and evocative in its isolation, and more than hints at modernist concerns. In its simplicity and directness, the humble house plant is a portrait of calm

domesticity. Kühn's statement that "the apparatus, the soulless machine, must be subservient, the personality and its demands must dominate. The craftsman becomes an artist..." clearly identifies his belief in the art of photography.

In describing the sophisticated lighting involved in making "Tête de Gorgone," Émile Joachim Constant Puyo said: "As [an] example of localized lighting,... (the model's head was stuck through a rough paper), I wanted to have the orbits plunged in shade, the forehead and nose well-lighted, and altogether a strong light making the osseous frame stick out. A lamp enclosed in a screen and placed at a distance of fifty centimeters above the forehead

produced the effect; the dominant lights are well placed on the frontal bone and on the bridge of the nose. Try to obtain the same effect with only daylight." His choice of subjects was part of the "decadent imagination," which he shared with other artists of the 1890s. A French pictorialist, Puyo cofounded the Photo-Club de Paris with Demachy.

Baron Wilhelm von Gloeden, a German-born photographer who worked primarily in Taormina, Sicily, was a devotee of classical antiquity and the male nude. He began photographing the male nude around 1890, and no one was more successful at making these images acceptable than the baron. His iconographic alignment with a time-honored tradition was a sanctioned means through which to explore eroticism in art, and von Gloeden met with great financial success with this work. "Two Boys with Vases of Roses" includes vaguely Roman costuming, bronzed young flesh, and overripe flowers to connote a sensual abandon that recalled the works of popular painters like Sir Lawrence Alma-Tadema.

Émile Joachim Constant Puyo
French, 1857–1933

Tête de Gorgone (Gorgon's Head), ca. 1898

Gum bichromate print
MUSEUM PURCHASE
83:2344:0001

Baron Wilhelm von Gloeden
German, 1856–1931

Two Boys with Vases of Roses, 1913

Albumen print
GIFT OF J.J. CONMEY
67:0027:0001

An Art of Its Own

Despite the best efforts of Le Gray, Cameron, Emerson, and countless other photographers, by the 1890s photography had still not achieved the level of artistic acceptance that was granted to painting. Museums did not regularly collect or exhibit it.

In 1887 Emerson had been the judge of *Amateur Photographer*'s Holiday Work competition. He awarded the prize to an American photographer studying in Germany: Alfred Stieglitz. Upon Stieglitz's return to the United States three years later, he found a thriving amateur community, but nothing that compared with the European devotion to the medium as a fine art. He joined the Society of Amateur Photographers of New York, at whose gallery he exhibited photographs such as "The Terminal" (right), made using a hand-held camera during a New York City snowstorm. Up until then, artistic photography had been associated with soft-focus, pictorialist work, which resembled painting and drawing. Stieglitz's work offered a more everyday realism in its innovative subject matter and approach.

In 1893 he became the editor of *American Amateur Photographer*. When the Society of Amateur Photographers and the New York Camera Club merged in 1897, Stieglitz became the chairman of the publication committee. He started *Camera Notes*, "the official organ of the Camera Club," a quarterly journal illustrated with hand-pulled photogravures.

Edward J. Steichen
American, b. Luxembourg, 1879–1973

"Photo-Secession," 1905

Painting on board
80:0297:0001

This journal brought Stieglitz into contact with photographers Gertrude Käsebier, Edward Steichen, Eva Watson-Schütze, and Clarence White. In March 1902 Stieglitz organized an exhibition of pictorial photographs for the National Arts Club in New York, which he titled *American Pictorial Photography, Arranged by "The Photo-Secession."* The name derived from his desire to secede from the dominant amateur communities of the camera clubs and to align with photographic art splinter groups such as the British Linked Ring Brotherhood. With the early writings of Emerson as an unofficial guide, the Photo-Secessionist movement was born. In 1902 Stieglitz resigned from *Camera Notes*, and in December of that year he published the first issue of *Camera Work*, one of the most influential publications in the history of photography.

Alfred Stieglitz
American,
1864–1946

The Terminal
(New York), 1893

*Transparency,
gelatin on glass
(lantern slide)*
PART PURCHASE AND
PART GIFT OF AN
AMERICAN PLACE,
EX-COLLECTION
GEORGIA O'KEEFFE
83:0660:0018

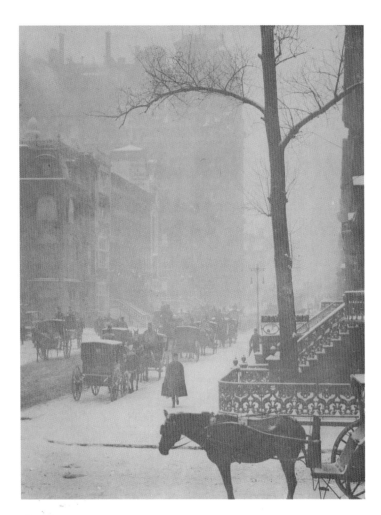

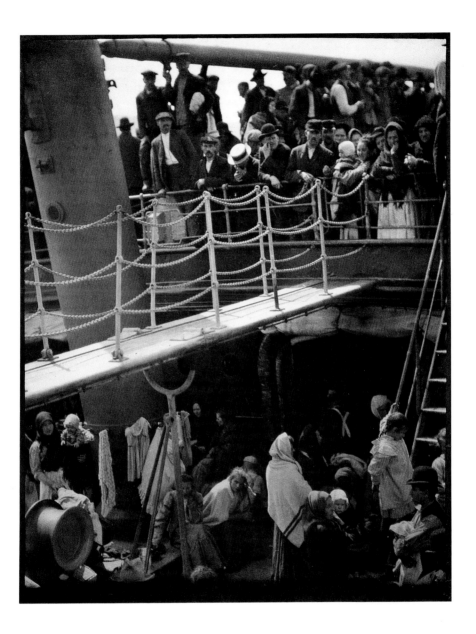

The Eastman House collection includes nearly 200 photographs by Stieglitz. "The Street – Design for a Poster" (page 392) is a wintry scene anchored by the verticality of the bare tree at right, a harbinger of the influence Japanese prints would soon have on his work. His most famous image, "The Steerage" (page 393), made on board a ship traveling from New York to Europe, was published in both *Camera Work* and *291*. About it Stieglitz wrote: "The scene fascinated me ... I saw shapes related to one another – a picture of shapes, and underlying it, a new vision that held me: simple people, the feeling of ship, ocean, sky, a sense of release that I was away from the mob called 'rich.' Rembrandt came into my mind and I wondered would he have felt as I did."

Edward Steichen, a painter and self-taught photographer who has been called "the acknowledged standard-bearer of the Photo-Secession," was the most frequently published and discussed photographer in *Camera Work*. At his urging, in 1905 Stieglitz opened the Little Galleries of the Photo-Secession at 291 Fifth Avenue, eventually simply called "291," as a forum for the Photo-Secessionists' work. There Stieglitz also exhibited modern European painting, drawing, and sculpture. Steichen's Photo-Secession painting (page 390) for Stieglitz's Little Galleries fittingly shows Stieglitz holding his camera before him, stepping toward greatness. Steichen's "Self-Portrait," of him wearing an

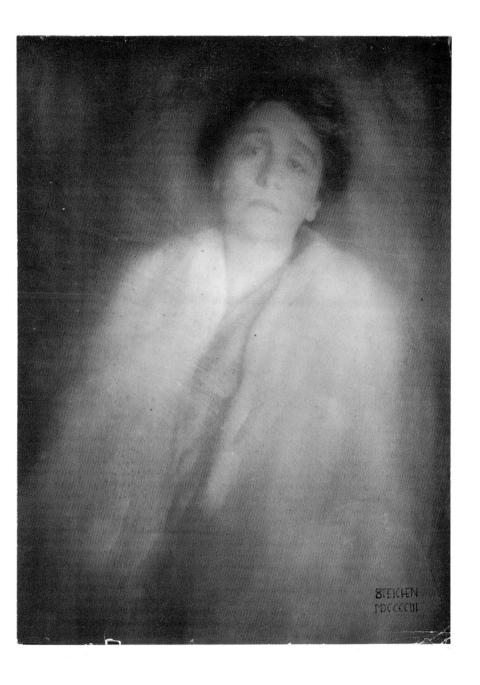

artist's smock and holding a palette and brush, is a bold declaration of his role in carrying forth the tradition of high art through the new medium. His portrait of Eleanora Duse, the Italian actress (page 395), is an atmospheric rendering in hushed tones, a whispered likeness. The museum holds more than 4,000 photographs by Steichen, spanning his entire career but primarily representative of his work for the publisher Condé Nast.

One of the most respected and talented members of the pictorialist movement was the Massachusetts bibliophile and publisher Frederick Holland Day. Through his firm, Copeland and Day, he published works by the infamous Irish writer Oscar Wilde and English artist Aubrey Beardsley. An avid advocate of photography as an art form, Day wrote about fine art photography for *Camera Notes*, *The Photogram*, and *Amateur Photographer*. He was elected to the Linked Ring in 1895.

Alvin Langdon Coburn reminisced on how Frederick Evans came to make Day's portrait of him dressed in an Algerian costume: "Holland Day had been to Algiers to make some 'native' photographs, and he

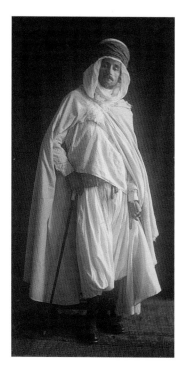

Frederick H. Evans
English, 1853–1943

F. Holland Day in Algerian Costume, 1901

Platinum print
MUSEUM PURCHASE,
EX-COLLECTION
GORDON CONN
81:1198:0083

returned with a number of Arabic costumes, and so one evening we dressed up in some of them, and went to call on Evans. ... Evans' housekeeper nearly fainted away when she opened the door and beheld us. Evans, however, rose to the occasion and did the obvious and entirely correct thing – he photographed us!"

Day's "Nubian Chief," published in Stieglitz's *Camera Notes* in 1897 with the title "An Ethiopian Chief," was not one of his Algiers "native" photographs but rather one of the *Nubian* series portraits of black men that he had made several years earlier in Massachusetts. Day was passionately interested in the colonial conflicts in Ethiopia and Algeria, and his sympathy for his subject –

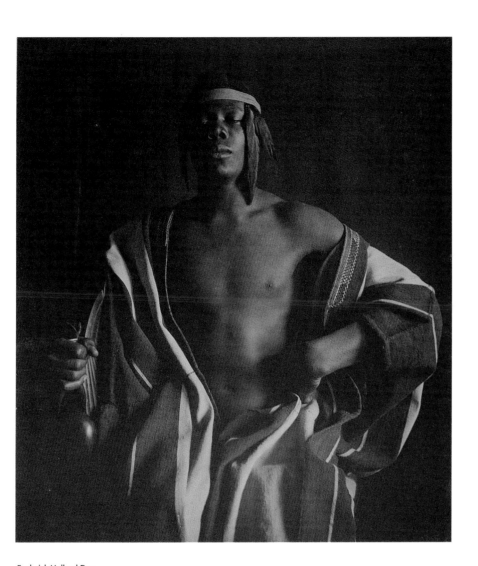

Frederick Holland Day
American, 1864–1933

Nubian Chief, 1897

Platinum print
GIFT OF 3M COMPANY,
EX-COLLECTION LOUIS
WALTON SIPLEY
77:0211:0001

F. Holland Day
American, 1864–1933

The Seven Last Words
1898

*Prints made in 1912
by Frederick H. Evans
Platinum prints*
MUSEUM PURCHASE

"Father, Forgive
Them, They Know
Not What They Do,"
73:0027:0001

"To-Day Shall
Thou Be with Me
in Paradise"
73:0027:0002

"Woman, Behold
Thy Son; Son, Thy
Mother"
73:0027:0003

"My God, My God,
Why Hast Thou
Forsaken Me?"
73:0027:0004

"I thirst"
73:0027:0005

"Into Thy Hands
I Commend My
Spirit"
73:0027:0006

"It Is Finished!"
73:0027:0007

however inaccurately rendered – is evident. Photographed from below, the anonymous sitter gazes imperiously at the viewer, commanding respect and attention through his bearing and Day's pictorially effective use of costume, even if the striped North African robe and headdress of black pigeon feathers were not authentic to the subject.

Day frequently made self-portraits as well, taking his inspiration from literary sources including the Bible. Rarely did he present himself as himself, preferring instead to assume guises and ethnicities that were not his own. Day's most ambitious and controversial work was *The Seven Last Words*, in which he depicted himself as Jesus Christ crucified on the cross. He had begun collecting reproductions of religious art following a trip to Europe in 1890; at the Prado in Madrid he found "the best of Van Dyck's sacred things ... Rubens' religious pieces, too. And Ribera and Murillo and Velázquez til one's eyes watered with admiration." He wanted to address in photographs what artists had long explored in paint – sacred subject matter. Nothing if not a perfectionist, Day starved himself for weeks to achieve the look of the emaciated body

of Christ during his final days. Focusing only on his tortured face topped by a crown of thorns, the images are an emotional and psychological approximation of Christ's ultimate trial. Each of the images is titled with Christ's plaintive words as he spoke to God about his imminent fate. As Day's friend Frederick Evans explained it, Day had "a mirror attached to the camera so that he could see his expression at the time of exposure; he made the exposure himself, so the whole effort was a purely personal one. ... It was a unique effort, inspired by the utmost reverence and carried out with extraordinary success."

Although Day was aware of the potential problem of presenting a sacred subject as mere mortal flesh, he exhibited the series in 1898 in Boston and again at the Philadelphia Salon. Meeting with criticism both from the public and his colleagues in the art world, Day's images suggested his own "artistic martyrdom" for venturing into such taboo territory. To his critics he wrote: "There will always be narrow minds to question the rights of portraying sacred subjects in any medium: to them the less said the better; but to those who criticise only the photographers' right to these subjects, I can advise but patience – give us time to get out of our drill work, to get into man's estate, so to speak, with our new theme, and then speak your harshest."

Although Stieglitz had initially published and supported Day's work, they became bitter rivals when Stieglitz would not lend his support to Day's idea of establishing an "American Association of Pictorial Photographers." In response, Day mounted his *New School of American Photography* exhibition in London and Paris, showing his own work along with that of the leading pictorialist photographers of the day.

Originally an accountant in Ohio, Clarence H. White began to photograph in 1893. Completely self-taught, White received almost immediate recognition when his work was exhibited in the first Philadelphia Photographic Salon (1898), where he met Day and Gertrude Käsebier. He also organized exhibits for his Newark (Ohio) camera club, showing the work of Steichen and Robert Demachy. He was elected to the Linked Ring in 1900, and two years later White became one of the co-founders of the Photo-Secession, with Stieglitz, Coburn, and Käsebier. Light, and the absence of it, were hallmarks of White's work. He explained: "My photographs were less sharp than others and I do not think it was because of the lens so much as the conditions under which the photographs were made – never in the studio, always in the home or in the

open, and when out of doors at a time of day rarely selected for photography." Two images, "Morning" and "Girl with Mirror," directly bear out this claim.

White's greatest legacy beyond his photographs was his teaching. He moved to New York in 1906 and started teaching the following year at Columbia University Teachers College, where he taught its first courses in photography. After opening a summer school in Maine, in 1914 he founded the Clarence H. White School of Photography in New York. There his students included Margaret Bourke-White, Paul Outerbridge, Ralph Steiner, and Doris Ulmann. In 1916, along with Käsebier and Coburn, he cofounded the Pictorial Photographers of America.

Eva Watson, later Watson-Schütze, had studied painting and modeling at the Pennsylvania Academy of the Fine Arts with Thomas Eakins before opening her own studio. Although she was a professional photographer, her six photographs submitted to the Philadelphia Photographic Salon of 1898 introduced her to Stieglitz; two years later

Clarence H. White
American, 1871–1925

Morning, 1908

Photogravure print
78:0708:0003

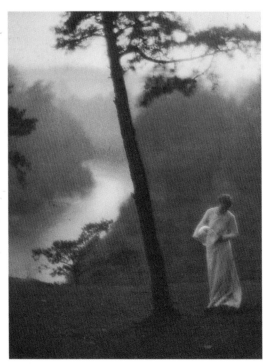

Clarence H. White

Girl with Mirror,
1898

*Varnished platinum
print*
79:4378:0001

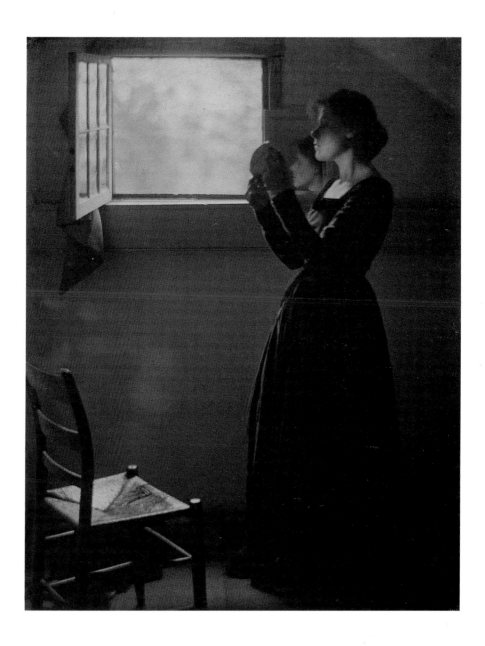

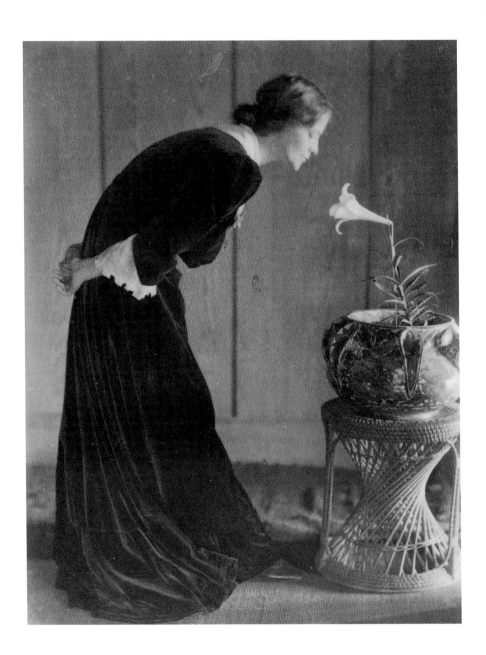

(left)
Eva Watson-Schütze
American, 1867–1935

Woman with Lily,
ca. 1903

Platinum print
GIFT OF FRIEDA
SCHÜTZE
81:1786:0046

George H. Seeley
American, 1880–1955

The Firefly, ca. 1907

Photogravure print
78:0708:0008

she served as a juror. She, too, was elected to the Linked Ring and the
Photo-Secession. Reminiscent of White's work, her "Woman with Lily"
is a romantic portrayal of universal womanhood and the sacredness of
the domestic realm.

George H. Seeley of Stockbridge, Massachusetts, was influenced by
both Day and White. Having exhibited 14 prints in the First American
Photographic Salon at New York, which was organized in opposition to
Stieglitz and the Photo-Secession, he nevertheless received Stieglitz's
attention. Stieglitz invited him to join the Photo-Secession, reproduced
his images in *Camera Work*, and exhibited his prints at 291. "The Firefly"
is one of his most famous and delicate compositions. In 1910 the
Albright Art Gallery in Buffalo, New York, hosted the International
Exhibition of Pictorial Photography, which became the highlight of
both the Photo-Secession's goals and Seeley's career.

Gertrude Käsebier
American, 1852–1934

Road to Rome, 1903

Gum bichromate print
GIFT OF MINA TURNER
70:0058:0016

After raising her three children, Gertrude Käsebier took up photography. She studied painting and photography in Brooklyn, New York, and opened a photographic portrait studio on Fifth Avenue near 32d Street. Stieglitz, White, and Evans were among her sitters. In 1900 Käsebier was the first woman elected to the Linked Ring Brotherhood; two years later she became a cofounder of the Photo-Secession when, at the opening of the first Photo-Secession exhibition at the National Arts Club in 1902, she and Stieglitz had the now often-repeated exchange: "What's this Photo-Secession? Am I a photo-secessionist?" He asked in return, "Do you feel you are?" "I do." "Well, that's all there is to it." Fourteen of her prints were included in the exhibition.

The first issue of *Camera Work* was devoted to Käsebier's work, yet her images were also widely published in the popular press. "Road to Rome," posed by her grandson Charles, was derived from the story *The Roman Road* by Kenneth Grahame. In it the protagonist reminisces about a country road in an English town that he and the other children

Gertrude Käsebier

The Heritage of Motherhood,
ca. 1904/print 1916

Gum bichromate print
GIFT OF HERMINE TURNER
71:0042:0033

often wandered: "'All roads lead to Rome,' I had once heard someone say; and I had taken the remark very seriously, of course, and puzzled over it many days. There must have been some mistake, I concluded at last; but of one road at least I intuitively felt it to be true." Of its allegorical meaning regarding the imaginations of artists and children Käsebier once explained that in the picture the boy sees "a wild rose. There is also a lamb tethered to a bush, and a duck floats idly on the water." Such interpretation of symbolic meaning beyond what is visible in the picture would become the essence of many photographers' work in this period.

Käsebier also produced various photographic "cycles." One was devoted to the theme of motherhood. The photographer Joseph Keiley called "The Heritage of Motherhood" (page 405) "one of the strongest things that she has ever done, and one of the saddest and most touching I have ever seen." Made while visiting Day at his summer home in Maine, it is a moody and melancholy portrait, full of solemnity and the weight of responsibility that hung over Käsebier's personal life at the time. "Lollipops" (page 409), made several years later, is its emotional counterpart.

When Käsebier photographed the sculptor Auguste Rodin in his studio in 1906, he was the world's most famous living artist, having

(above)
Gertrude Käsebier
American, 1852–1934

Newfoundland, 1912

Platinum print
GIFT OF HERMINE
TURNER
74:0060:0017

Gertrude Käsebier

Child on Dock, 1912

Platinum print
GIFT OF HERMINE
TURNER
74:0060:0010

Gertrude Käsebier

Lollipops, 1910

*Modern gelatin silver
print from original
gelatin on glass
negative*
GIFT OF MINA
TURNER
72:0019:0057MP

created masterpieces such as *The Kiss* and *The Thinker*. She later re-
vealed that "Rodin was a terrible man when it came to photographs.
When he knew he was going to be photographed, he'd stiffen into the
most grotesque and absurd postures ... [but] I caught him in one of his
moments. He was relaxed and brooding. He didn't know he had been
photographed until it was all over."

Coburn reminisced that "The Latin Quarter [in Paris] was at that peri-
od a place of romance. You could dine at little restaurants where artists,
afterwards famous, paid for their meals by painting mural decorations
on the walls!" Käsebier's "Gargoyle in Latin Quarter" (page 407) is
a playful image of a woman leaning over a parapet, overseeing and

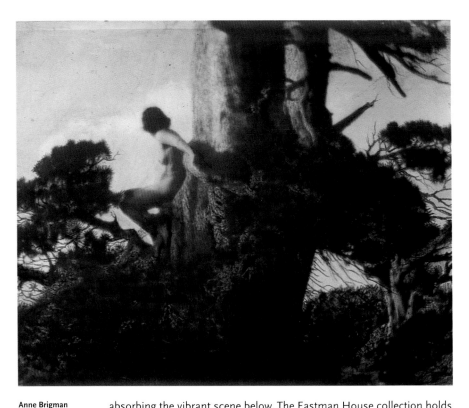

Anne Brigman
American, b. Hawaii,
1869–1950

The Pine Sprite, 1911

*Gelatin silver film
interpositive reworked
from earlier negative,
ca. 1940*
GIFT OF WILLARD
M. NOTT
76:0055:0008

absorbing the vibrant scene below. The Eastman House collection holds 124 photographs and 75 negatives by Käsebier, most of which came to the museum from her family.

By 1902 Ann Brigman was exhibiting and publishing her photography, merely a year after taking up the medium. Upon receiving a copy of the first issue of *Camera Work*, she promptly wrote to Stieglitz to proclaim her enthusiasm, and thus began a lifelong friendship with him. She became a Fellow of the Photo-Secession in 1906, the only photographer living west of the Mississippi to earn that distinction. Her work was published regularly in *Camera Work* and shown at 291.

During an eight-month visit to New York in 1910, Brigman attended Clarence White's first summer class in photography in Maine, receiving special instruction in landscape photography. Back west, her primary studio was the Sierra Nevada mountains, where she photographed herself, her family, and friends in the landscape. A pioneer of photographing

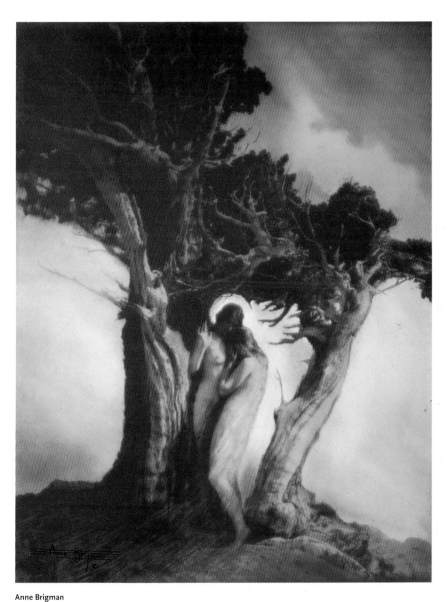

Anne Brigman

The Heart of the Storm, 1902

Gelatin silver print
GIFT OF WILLARD M. NOTT
81:1013:0035

the female nude in the landscape, Brigman conveyed the power of the relationship of humans communing with nature. At times mystical and symbolic, images such as "The Pine Sprite" (page 410) embody Brigman's ideal. "The Heart of the Storm" (page 411) made early in her career, depicts a guardian angel figure giving comfort to a woman within a stand of California western juniper trees. Working directly on the negative, Brigman added a halo around the head of one figure, and wispy strokes to suggest a diaphanous, wind-swept gown on the other. This image is likely a metaphor for the personal and professional challenges that Brigman was facing, suggesting that an inner muse would be her protector and guide.

A self-portrait in the studio reveals the artist in her element. From her original negatives, Brigman made interpositives that she reworked by hand, and from these created another negative from which she would print. She freely manipulated the medium to achieve her desired effect. "My etching tool is one of my closest allies. With it, all that is useless is etched away," she stated, unapologetic in the face of purist criticism. "I've swung far from the straight and narrow path of straight photography. ... I've done some hokus pokus that would make the shadow of Daguerre haunt me for a heretic."

"The Cleft of the Rock" shows a slender sylph emerging from a crevice, her white body like a shaft of light against the rocks. The museum

Anne Brigman
American, b. Hawaii, 1869–1950

A. B. in Studio, ca. 1915

From a gelatin on nitrocellulose sheet film negative
GIFT OF WILLARD
M. NOTT
76:0055:0213

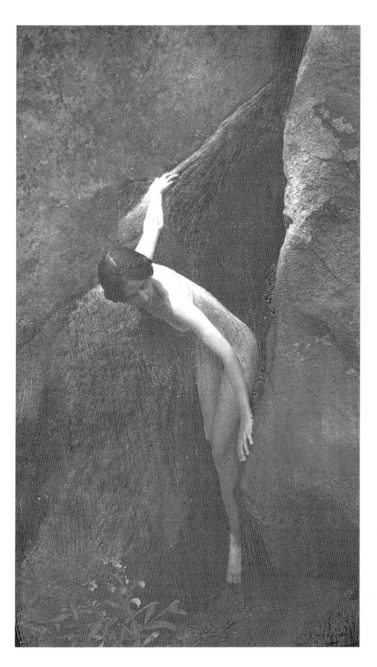

Anne Brigman

The Cleft of the
Rock, 1912

*Gelatin silver glass
interpositive reworked
from earlier negative,
ca. 1940*
GIFT OF WILLARD
M. NOTT
76:0055:0032

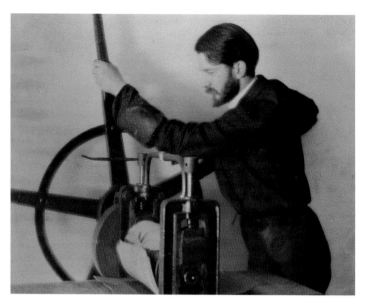

(right)
Alvin Langdon Coburn

Wapping, 1904

Gum platinum print
GIFT OF ALVIN
LANGDON COBURN
67:0146:0183

Alvin Langdon Coburn
British, b. United
States, 1882–1966

The Copper Plate
Press, 1908

Gum platinum print
GIFT OF ALVIN
LANGDON COBURN
67:0155:0092

holds more than 900 negatives, interpositives, and prints by Brigman.

In 1898 Alvin Langdon Coburn met Frederick Holland Day, a distant cousin. Day then instructed him and encouraged him to pursue a photographic career. Coburn, in turn, taught Day how to print, later describing the "dim red glow of a dark-room [as something] which Dante would have revelled in as a bit of local colour for his best-known poem ...". Despite his wicked humor about the darkroom experience, Coburn was a meticulous printer in the media of platinum, gum, and gravure. He selected as the frontispiece for his 1966 autobiography his self-portrait working the copper plate press, clearly identifying his affinity for and mastery of the photogravure process.

Along with Steichen, Coburn assisted Day in organizing the *New School of American Photography* exhibition in London in 1900 and later worked in Käsebier's studio. Breaking with his influential mentor, Coburn became the youngest of the founding Photo-Secessionists in 1902. Showing the influence of Japanese art, "Wapping" is a delicately balanced photograph, which he made in London and published in his 1909 book, *London*. "One of the conditions of harmony in architecture, as in life, is to avoid the monotony of regularity and excessive repetition. Exact equality of division lacks mystery. A rhythm that may not be

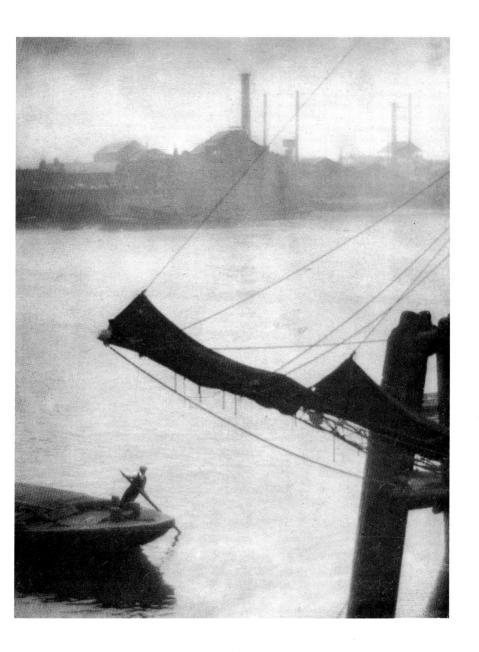

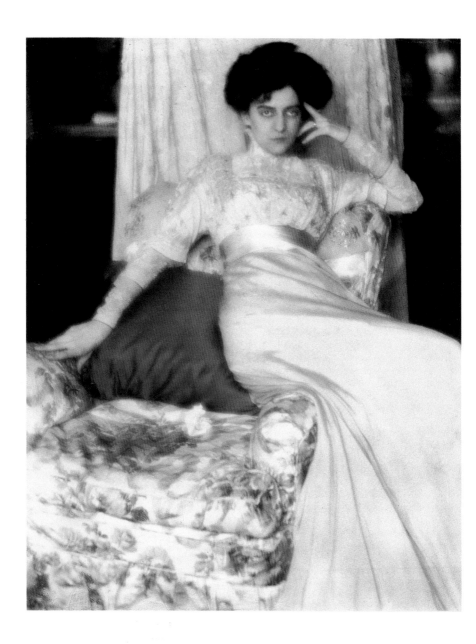

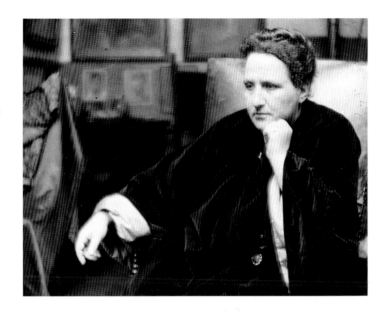

completely fathomed, a beauty that eludes the mind's grasp yet is manifestly of exquisite proportions, this is the secret of the marvellous power of the progression of the Golden-mean," wrote Coburn in 1941.

His subject matter was diverse; it included portraiture, as in this image of a seductively posed Miss Anderson, who is seated on the arm of a chair, her right arm extended, invitingly open. The writer Gertrude Stein also sat for Coburn in 1913; her portrait reflects a more mature style compared with the earlier work. The Flat Iron Building, called "a new Parthenon" for its aesthetic popularity with photographers, was also photographed by Steichen and Stieglitz, whom Coburn acknowledges emulating. In Coburn's view (page 418), made in the late evening, the foreground is punctuated by men walking along the street, their silhouetted forms framed by the spidery winter trees. The building itself anchors the composition in the distance. "Grand Canyon" (page 419) is a landscape infused with wonder and spectacle, as though a divine light is shining down from the heavens. Coburn photographed in the American West in 1911 and 1912.

"In the spring of 1904 I had a very memorable and fruitful interview with Perriton Maxwell, editor of *Metropolitan Magazine,* New York. I was an ambitious young man on the point of sailing for my second visit to

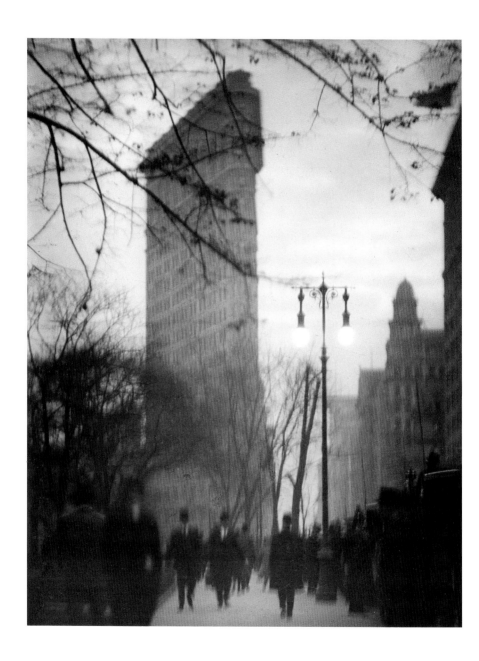

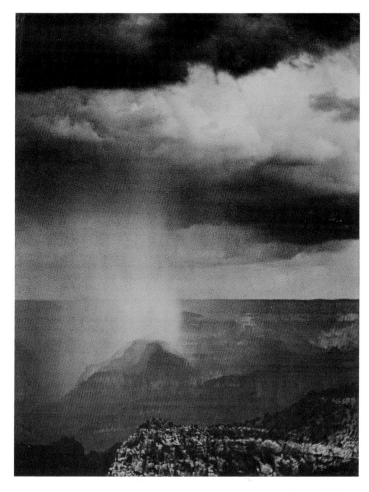

London, and I asked Maxwell to let me have a list of English authors and artists to photograph during my sojourn to the greatest city in the world," Coburn wrote in his autobiography. George Bernard Shaw, the first to be photographed, was the model for "Le Penseur," a direct homage to Auguste Rodin's sculpture of the same title that was completed in 1906. It was unusual that a famed author such as Shaw would pose in the nude, though he himself was an avid photographer, and the pose was his suggestion. The image generated considerable commentary in the press, but the immodest Shaw did not mind, saying waggishly: "[T]hough we have hundreds of photographs of [Charles] Dickens and [Richard] Wagner, we see nothing of them except their suits of clothes with their heads sticking out; and what is the use of that?"

The novelist Henry James, like Coburn an American expatriate, was a major influence on Coburn. He photographed James several times beginning in 1905, including this pensive profile, which Coburn included in *Men of Mark*, published in 1913. He eventually published a second volume, *More Men of Mark*. These publications owed a thematic debt to

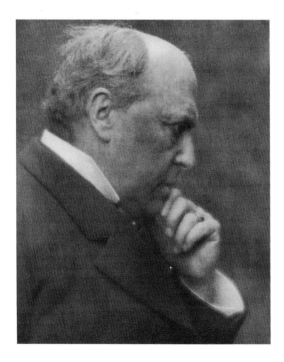

Cameron's series of *Famous Men*, which were inspired by Thomas Carlyle as well as a prevailing public fascination with noteworthy individuals. At James' invitation, Coburn also provided the frontispieces for 24 volumes of the collected edition of James' works.

Coburn emigrated to England in 1912, eventually becoming a British citizen. His work became increasingly "straight," that is, characterized by unmanipulated, crisp prints. In 1913 he wrote: "I wish to state very emphatically that I do not believe in any sort of handwork or manipulation on a photographic negative or print." In the complexity of overlapping shadows and

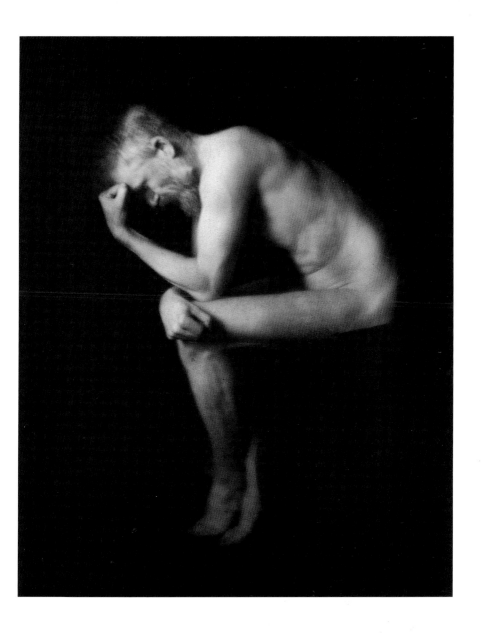

reflections, "The Octopus, New York," perhaps Coburn's most famous image, resembles a combination print, but it is not. He was inspired by his work in the Grand Canyon to ascend the heights of Manhattan's skyscrapers to obtain this view. Recognizing his achievement, Coburn described the work as "a composition or exercise in filling a rectangular space with curves and masses. Depending as it does more upon pattern than upon subject matter, this photograph was revolutionary in 1912."

Coburn's work became increasingly abstract as he became influenced by the symbolist movement. He also became involved with a group of artists known as Vorticists led by the poet Ezra Pound. His "Vortograph of Ezra Pound" (page 425) was achieved by placing the lens inside of three facing mirrors. "Liverpool Cathedral under Construction" (page 424) is a complex riot of intersecting angles, reveling in the texture of materials as well as the dynamism of the viewpoint.

Coburn was one of the few leading pictorialists who was able to shift his focus to the more modern approach that emerged following the demise of the Photo-Secession. As the repository of the Coburn archive,

Alvin Langdon Coburn
British, b. United States, 1882–1966

Station Roofs, Pittsburgh, 1910

Gelatin silver print
GIFT OF ALVIN LANGDON COBURN
67:0147:0001

(left)
Alvin Langdon Coburn

The Octopus, New York, 1912

Platinum print
GIFT OF ALVIN LANGDON COBURN
67:0144:0289

(left)
Alvin Langdon Coburn
British, b. United States, 1882–1966

Liverpool Cathedral under Construction, 1919

Gelatin silver print
GIFT OF ALVIN LANGDON COBURN
67:0160:0003

Alvin Langdon Coburn

Vortograph of Ezra Pound, 1917

Gelatin silver print
GIFT OF ALVIN LANGDON COBURN
67:0098:0021

the Eastman House collection includes more than 1,000 photographs, as well as 17,000 negatives, illustrated books, and personal papers.

Elias Goldensky was a Russian-born photographer who settled in Philadelphia with his family in 1891. He learned the medium from his father, who had a studio in Russia. Goldensky's first job was as a retoucher in a photography studio; within a year, he went to work for Frederick Gutekunst as a retoucher and printer. He was also an actor, founding a Russian dramatic society in Philadelphia that performed

until at least 1905. As a studio photographer, Goldensky photographed Philadelphia notables and visiting celebrities, including this provocative portrait of author Maxim Gorki, earning him the moniker "the photographers' photographer." He was active in professional photographic associations, which enabled him to socialize and share ideas with other photographers. He participated in at least five professional and amateur camera organizations, which brought him into contact with photographers such as Gertrude Käsebier. In *Camera Notes*, the critic Sadakichi Hartmann likened Goldensky's work to that of Day and Stieglitz, the two leading pictorialists of the time. His "Male Nude" is a sensuous, sinuous modeling of the subject rendered in deep, muted browns.

Paul Lewis Anderson, an engineer, took up photography in 1907 after seeing copies of *Camera Work*. Within three years, he had quit his job and opened a portrait studio. Although his photographs never made it to the pages of *Camera Work*, Anderson became part of a small but active post-Secession movement to carry on the pictorialist tradition.

Pictorial photography, according to Anderson, was defined as "opening the eyes of the average individual to the beauties of art – making it an everyday affair instead of the privilege of the exceptionally favored ones – and arousing an interest in natural beauty, together with a

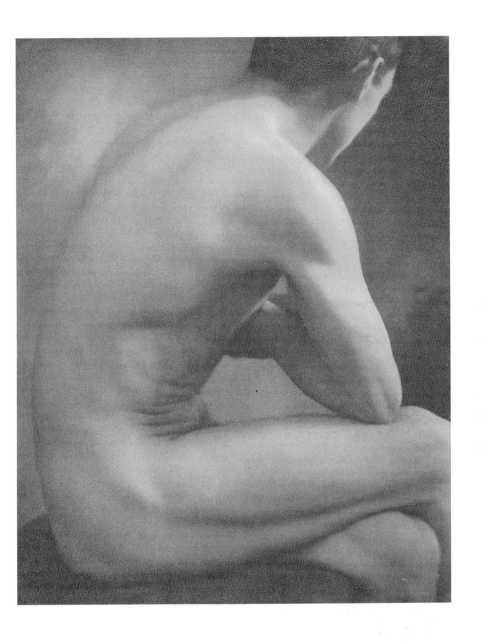

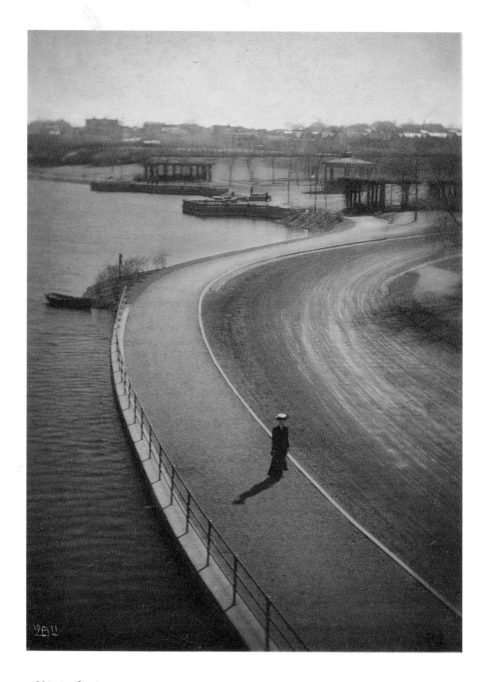

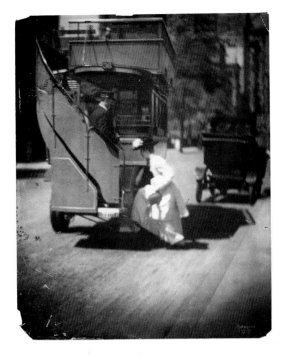

sensitiveness to design and to values which cannot fail to aid in the intellectual and moral progress of the race." Beginning in 1914 he taught at Clarence White's School of Photography and authored several photographic books. The museum's collection contains over 500 photographs by this master of the Pictorialist print. "Branch Brook Park" and "Woman Boarding Double-Decker Bus" are two of Anderson's works, both redolent with solitude and quiet. Anderson is said to have maintained that the test of a good picture is to hold it upside down to see if the composition remains strong. A simple test of his theory applied to his own images reveals a sophisticated symmetry that is not as apparent when viewed in its correct orientation.

Doris Ulmann was a native of New York City and studied teacher training with Lewis Hine at the Ethical Culture School. She also studied photography with Clarence White at his school. Ulmann soon joined the Pictorial Photographers of America and became a professional portrait photographer in New York. Her passion was to photograph the folk cultures of the American South, particularly in the Appalachian Mountains

and the predominantly black southeast coastal communities of Georgia and South Carolina known as Gullah. "Group at Church Meeting" captures a congregation's choir in a moment of rapturous prayer, revealing to a larger public an intimate moment not customarily shared with outsiders. "South Carolina," a portrait of an elderly black woman standing in a window, is as sympathetic as it is romantic. As Ulmann explained: "A face that has the marks of having lived intensely, that expresses ... some dominant quality or intellectual power, constitutes for me an interesting face."

The distinctive properties of the platinum prints that Ulmann favored were a gentle complement to her subjects. Although her work was marked by a pictorialist atmosphere, Ulmann's approach to her subject was documentary, a distinction that positions her work on the ever-widening gulf between the past and the present, pictorialism and modernism. There are 147 Ulmann photographs in the Eastman House collection.

In a similar vein, Edward Curtis's photographs of what he termed "the vanishing races" of North American Indians west of the Mississippi owe their painterly, romantic style to pictorialism and the Photo-Secessionists, but,

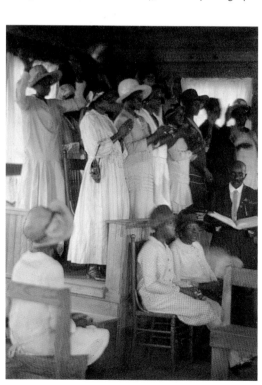

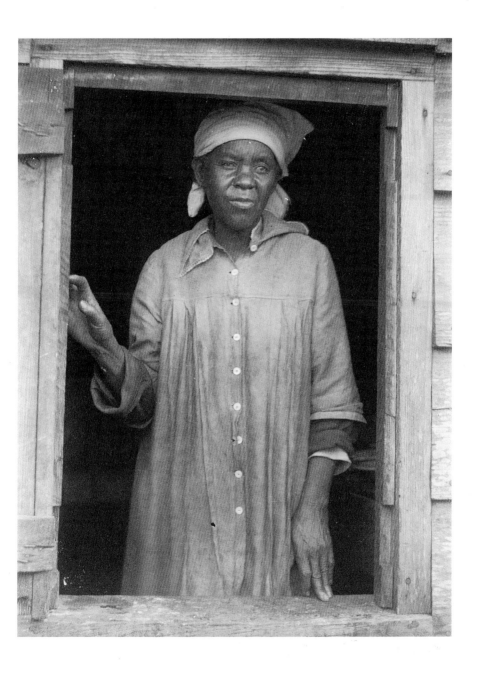

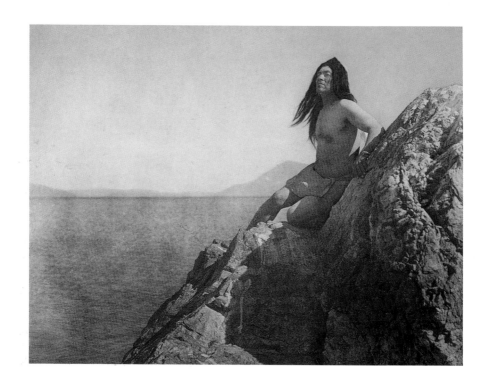

Edward S. Curtis
American, 1868–1952

On the Shores of
Clear Lake, ca. 1924

Photogravure print
MUSEUM PURCHASE
72:0001:0001

like Ulmann's, his intent was largely documentary. Curtis began his photographic career in a commercial studio in Seattle, Washington. His interest in Native American culture developed around 1896, and until 1927 he traveled the country making images for his monumental, 20-volume study, *The North American Indian*. With accompanying portfolios for each volume, the series included 2,222 photogravures, of which the Eastman House holds nearly 100. While an image like "Washo Baskets" is a straightforward still life of extraordinary handicrafts rendered with the modernist clarity of detail that the subject demanded, Curtis did not always rely on veracity to preserve a likeness of a culture. "On the Shores of Clear Lake" and "Bow River – Blackfoot" are highly contrived images of Native American life, which, for the most part, no longer existed when Curtis set about to photograph it. Nevertheless, his images are beautifully rendered, if fictional, portraits that represent a romantic recreation of America's past.

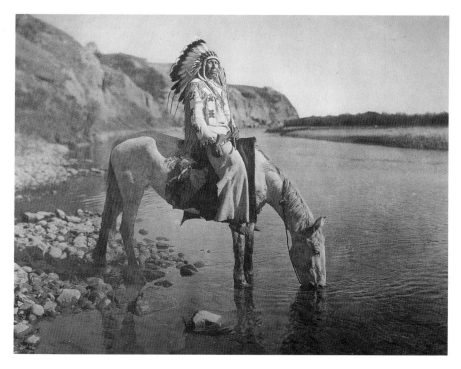

Edward S. Curtis

Bow River –
Blackfoot, ca. 1926

Photogravure print
74:0033:0029

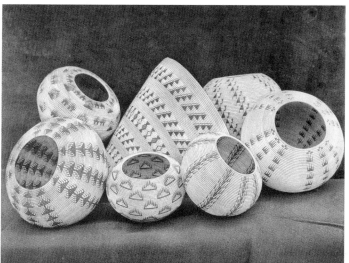

Edward S. Curtis

Washo Baskets,
ca. 1924

Photogravure print
MUSEUM PURCHASE
72:0001:0032

Our Modern World

By the 1890s faster films, better lenses, hand cameras, and the availability of commercial developing and printing services not only made it much easier to make photographs, but to make photographs that captured a wider range of the events of everyday life. This fueled another huge explosion in photographic practice; first by significantly expanding the number of amateur photographers and then by irrevocably altering and expanding the nature and practices of professional photography. A greatly expanded world of images – very different in concept and in form – suddenly became an inextricable part of the visual world. Boundaries that previously had distinguished photographic practices from one another simply fell away under this overwhelming flood of new imagery. Simultaneously, a changed and often startling world greeted photographers. Skyscrapers, public street lights, telephones, automobiles, and airplanes had not existed a generation earlier. It was a world in radical

**William M.
Van der Weyde**
American,
1871?–1929

Elaine Golding,
Swimmer, ca. 1900

*From a gelatin on
glass negative*
GIFT OF NEW YORK
PUBLIC LIBRARY
74:0056:1079

**William M.
Van der Weyde**

Matty McIntyre,
Baseball Player, 1904

*From a gelatin on
glass negative*
GIFT OF NEW YORK
PUBLIC LIBRARY
74:0056:0660

transformation, and speed, movement, and energy appeared at the heart
of the age.

William Van der Weyde, working as a professional photographer in New
York at the turn of the century, made news with his pioneering experiments
in the new genre of picturesque urban night photography. The images on
pages 434 to 437 are just five selected from the 1,461 gelatin on glass nega-
tives in the museum's collection. They show his willingness to photograph
anything and everything from baseball players to executions, and to forgo

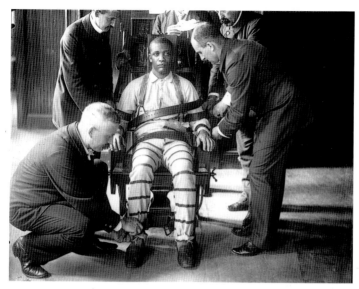

**William M.
Van der Weyde**
American,
1871?–1929

Electric Chair at Sing
Sing, ca. 1900

*From a gelatin on
glass negative*
GIFT OF NEW YORK
PUBLIC LIBRARY
74:0056:0386

**William M.
Van der Weyde**

Harrison NY,
RR Wreck,
ca. 1900

*From a gelatin on
glass negative*
GIFT OF NEW YORK
PUBLIC LIBRARY
74:0056:0086

(far left)
**William M.
Van der Weyde**
Dog Training,
ca. 1900

*From a gelatin on
glass negative*
GIFT OF NEW YORK
PUBLIC LIBRARY
74:0056:0316

traditional ideas of composition, content, and style in order to get the most descriptive picture in the hopes that his photograph would be published in one of the illustrated magazines of the day.

After obtaining a doctorate in classical philology at the University of Jena, Arnold Genthe visited America in 1895, traveling as a tutor for a wealthy German family who owned land in San Francisco. Falling in love with the "... energy, [and] freedom of thought and action ..." that he found in America, Genthe stayed on after his employer returned to Germany. After reading in a guidebook about San Francisco's Chinese quarter named Tangrenbu, Genthe, like other non-Chinese, was drawn to what was considered the mysterious world of Chinatown. He first tried sketching its inhabitants, but then turned to photography in order to capture his reluctant subjects. "An Unsuspecting Victim" presents a romantic view of Genthe's activities there. The dandified figure of

Arnold Genthe
American,
b. Germany,
1869–1942

An Unsuspecting
Victim, ca. 1899

Gelatin silver print
MUSEUM COLLEC-
TION, BY EXCHANGE
72:0044:0013

Genthe, embraced by light and clasping in his hands a box camera, assumes center stage while a bearded acquaintance looks on. The "unsuspecting victims" are the Chinese child and elderly man who are disappearing into the picture's dark and mood-filled background. In his autobiography, Genthe noted that the reclusive residents of Chinatown were frightened of being photographed and that he had to sneak photographs with a hand camera. Although he was a regular visitor to Chinatown – he took some 200 images there, mostly during holidays – Genthe surreptitiously recorded his subjects with a voyeuristic eye for the exotic and the novel. He went on to pursue portrait photography as a profession and gained admittance to San Francisco's cultured social

and arts communities. His elegant pictorial style of photography, evident from his early picturesque work in Chinatown, earned him numerous accolades and commissions.

In 1906 Genthe produced some of his most candid and documentary photographs. On April 18 of that year, San Francisco was devastated by an earthquake and fire that destroyed the city and left the majority of its inhabitants homeless. With the exception of Genthe's Chinatown negatives, which were locked up in a bank vault, the earthquake destroyed his studio, equipment, and five years of accumulated work. Undaunted, he obtained an inexpensive hand camera and joined the four newspaper photographers and the half dozen others who spent the next few days photographing the devastated city. In addition to his autobiography, Genthe produced several illustrated books, including *Pictures of Old Chinatown* (1909). The museum's collection holds 29 photographs and almost a dozen books written or illustrated by Genthe.

Arnold Genthe

San Francisco
Earthquake and
Fire, 1906

*Print by Ansel
Adams, 1956*
Gelatin silver print
GIFT OF CALIFORNIA
LEGION OF HONOR
73:0043:0001

Charles C. Zoller
American, 1854–1934

Child and Nurse,
ca. 1920

*Color plate, screen
(Autochrome) process*
GIFT OF MR. &
MRS. LUCIUS A.
DICKERSON
82:2047:0072

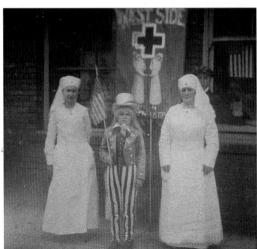

Charles C. Zoller

*World War I Support
Parade,* ca. 1917

*Color plate, screen
(Autochrome) process*
GIFT OF MR. &
MRS. LUCIUS A.
DICKERSON
82:2033:0025

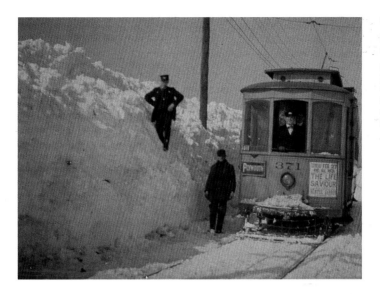

Charles C. Zoller

Street Car in Winter,
ca. 1931

*Color plate, screen
(Autochrome) process*
GIFT OF MR. &
MRS. LUCIUS A.
DICKERSON
82:2059:0087

Color was one of the numerous improvements made in photography at the turn of the century. Awkward and complicated by today's standards, several workable systems of color photography were available to the rare professional and dedicated amateur willing to cope with the attendant difficulties. The Autochrome process, perfected by the Lumière brothers in France in 1907, attracted attention from both amateurs and professionals. Heinrich Kühn and Jean Tournassoud in Europe and Arnold Genthe, Edward Steichen, and Alfred Stieglitz in America all worked with the process.

In Rochester, New York, Charles Zoller, a former furniture dealer who had turned to selling lantern slides, learned the Autochrome process around 1908 and began making Autochromes abroad and then in his hometown. In 1915 he began giving lectures to civic and professional groups, illustrated with the many Autochrome slides he had made. The illustrated lecture played a large role in public education and entertainment during this period, and professional lecturers often made a good living on the lecture circuit. Zoller also photographed Rochester's activities, events, celebrations, and the many gardens of "The Flower City." The museum's Zoller collection contains almost 3,900 Autochromes, 450 lantern slides, and 4,000 negatives.

Floyd W. Gunnison was a commercial photographer who lived and worked in the town of Canandaigua, in upstate New York, from 1908 until at least the mid-1920s. He was known for "... making a specialty of home portraiture and interior and exterior commercial work." This pragmatic extension of commercial photographic practice was commonplace. Gunnison's work is similar to that of other photographers working in small towns: photographs of local commercial enterprises; records of celebrations, ceremonial events, and weddings; and portraiture. His photographic style portrayed as much of the subject with as little subjective interpretation by the photographer as possible. Thus, the compositions are frontal, direct, static, and balanced. The subjects are normally centered and surrounded with enough space so that essential forms (whether a bathroom interior or a community band standing in front of a theater) are easily discerned and understood. However, Gunnison would at times deviate from his usual approach to elicit a more interesting perspective, as seen in his "Store Front," with its oblique angle of view. Gunnison worked in a distilled form of documentary photography, conveying clear, straightforward messages. He, like other small-town commercial practitioners, created an unprecedented catalogue of America's vernacular landscape, which today is prized by scholars and public alike for its cultural and historical information. But such acknowledgment was long in coming. Consequently, only a small percentage of work by these previously unsung practitioners was collected or preserved. In Gunnison's case, the museum holds 124 glass plate negatives and has made a set of modern gelatin silver prints from them.

By 1900 nearly every city, large and small, and even many towns,

Floyd W. Gunnison
American, 1882–1943

Interior of Bathroom,
ca. 1915

Modern gelatin silver print from the original gelatin on glass negative
GIFT OF CHARLES CARRUTH
67:0126:0025MP

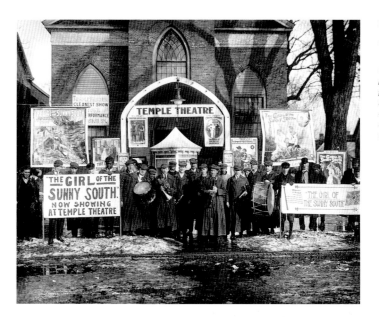

Floyd W. Gunnison

Band outside Temple Theater, ca. 1915

Modern gelatin silver print from the original gelatin on glass negative
GIFT OF CHARLES CARRUTH
67:0126:0038MP

Floyd W. Gunnison

Store Front, ca. 1915

Modern gelatin silver print from the original gelatin on glass negative
GIFT OF CHARLES CARRUTH
67:0126:0035MP

had established libraries, museums, local historical societies, civic booster organizations, or preservation groups, all interested in compiling or maintaining visual archives of events or buildings of local historical significance. In 1875 an organization called the Society for Photographing Relics of Old London was formed in London, which took as its mission the task of documenting and publishing photographic records of endangered and architecturally significant buildings. For 12 years the society commissioned a photographer to document these structures and then, on subscription, published carbon prints of this work at a rate of six (later 12) per year, for a total of 120 prints. Carefully researched captions were included with the photographs in later editions. Between 1875 and 1878 the partnership of Alfred and John Boole made the photographs, and from 1879 to 1886 the work was completed by Henry Dixon with his son Thomas. The museum holds this two-volume portfolio.

Paris, the beautiful "city of lights," had a long and storied tradition of visual documentation, with many publications, organizations, and institutions providing a base of support for this type of commercial photography. During the 1880s and 1890s, large, well-organized picture agencies such as Neurdien or Albert Hautecoeur

Henry Dixon
English, 1820–1893

Great Saint Helen's, London, 1882

Carbon print
MUSEUM PURCHASE
76:0048:0111

Eugène Atget
French, 1857–1927

Impasse des Bourdonnais
(1e Arr), 1908

Albumen print
MUSEUM PURCHASE
81:0951:0014

provided, at a reasonable price, both tourists and private and public in-
stitutions with very professional, well-printed, and detailed topographic
views of almost any recognized building. At the turn of the century one
photographer who made a modest living working on the margins of this
field of endeavor was an ex-actor named Eugène Atget. He worked as an
independent entrepreneur, taking occasional small assignments from
the Bibliothèque Nationale, the Archives Photographiques du Palais-
Royal, the Société d'Iconographie Parisienne, and other organizations
wanting to fill in the gaps of their picture collections. Atget also sold
prints door to door to decorators, shop owners, and artists in need
of source material. Atget's resources were limited, and his technique
was thought to be antiquated and awkward even when he began in the
1890s. Atget found little financial success amid the host of more profes-
sionally run firms of topographic photographers that Paris supported.

Forced by economics and perhaps by his own nature, Atget concen-
trated his attention on the unspectacular, the overlooked, the previously
disregarded features of daily life. He photographed the edges and cor-
ners of Paris diligently and incessantly until his death in 1927. Atget
worked out a private photographic approach and visual style that drew
from both the documentary and pictorial photography traditions he had

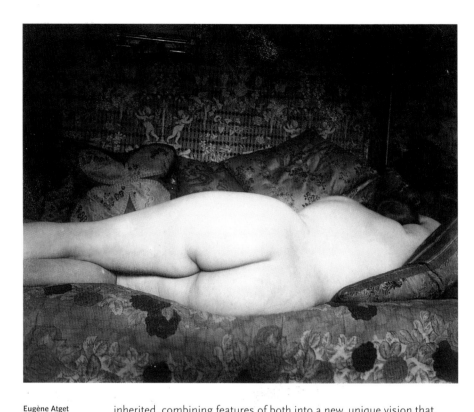

Eugène Atget
French, 1857–1927

Femme, 1925–1926

Matte albumen print
MUSEUM PURCHASE,
EX-COLLECTION
MAN RAY
76:0118:0006

(right)
Eugène Atget

Versailles, Coin de
parc, 1902

Albumen print
MUSEUM PURCHASE,
EX-COLLECTION
MME. LOUETTE,
VIA KODAK PATHÉ
78:1628:0040

inherited, combining features of both into a new, unique vision that changed the possibilities of visual expression for several generations of photographers. His prints, filled with halation flares, distorted perspectives, blocked vistas, and overlapping images, are simultaneously incompetently realized topographical photographs and transformative, brilliant art. Atget could infuse a sense of drama and brooding mystery equally into his views of the ancient, decayed gardens of a deposed king or into an indigenous storefront tableau arranged to commemorate a circus giant. Late in his life, a postwar generation of artists and writers attracted to new studies of man's unconscious mind took up Atget's mysterious and haunting images with extraordinary enthusiasm. Known as surrealists, these individuals recognized in Atget an untethered vision similar to their own and pronounced his work a precursor to their own. The museum holds nearly 500 images by Atget, ranging from the informational to the poetic, from the mundane to the extraordinary.

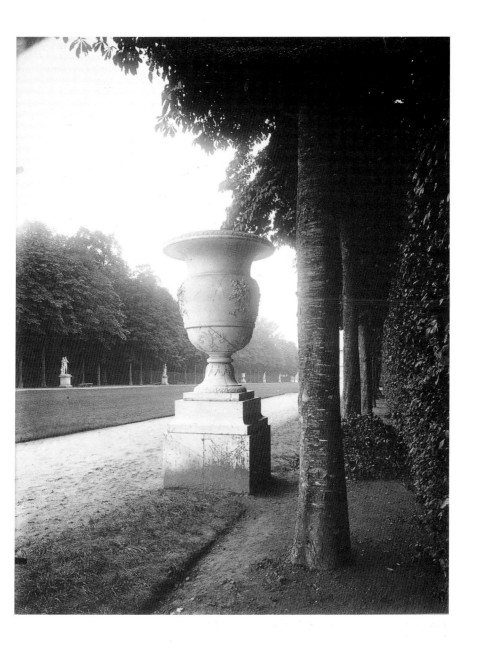

An album of 148 snapshots taken around 1910 of airplanes, airplane races and wrecks, and airplane models built and tested by the photographer, a French teenager named Jacques-Henri Lartigue, is held by the museum. Lartigue's interests mirrored the trends of the world around him. He loved the speed and drama of the new cars and airplanes and the exuberant, playful life of his large and active family. He loved to photograph all of these things. The son of a wealthy and indulgent banker, Lartigue had been given a camera in 1901 when he was seven years old and was encouraged to use it. With his youthful curiosity for recording the flux of activities around him and with a child's disregard for any "acceptable" standards of photographic practice, Lartigue made photographs that were banal, outrageous, funny, and, far more frequently than one would expect, simply wonderful.

Jacques-Henri Lartigue
French, 1894–1986

Mon plus petit model (9 cm. envergure) Il a bien marché (My Smallest Model [9cm. Wingspan] It Worked Well), 1910

Gelatin silver print
MUSEUM PURCHASE
76:0044:0105

As soon as photography became cheap and easy to use and making photographs came into the hands of thousands of visually and artistically untrained individuals, the possibilities of the medium exploded. Along with the millions of prosaic images made at this time, there are thousands of interesting and, extraordinary images depicting all sorts of unusual and bizarre objects, events, and activities that were a part of the human experience previously not thought worthy of the labor and cost of photographing. By 1910 a 16-year-old with a camera could show his model airplanes, demonstrate his love of flight, even convey his passion for life. It was another step, and an important one, in the democratization of information and the growing role of photography in communication.

Jacques-Henri Lartigue

Lalihan et Vachlin
sur Antoinelli
(Lalihan and Vachlin
on Antoinelli), 1910

Gelatin silver print
MUSEUM PURCHASE
76:0044:0066

Jacques-Henri Lartigue

Vols
*Model Airplane in
Flight*, 1910

Gelatin silver print
MUSEUM PURCHASE
76:0044:0102

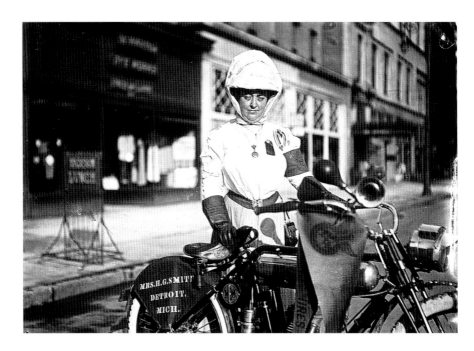

Nathan Lazarnick
American, b. Russia,
1879–1955

*Mrs. H. G. Smith
Detroit, Mich.,*
ca. 1916

*From a gelatin on
nitrocellulose sheet
film negative*
GIFT OF GEORGE
LAZARNICK
81:3051:0748

At the turn of the century the automobile was big news. Auto trade fairs, cross-country endurance trips, and speed races were all followed in the mass media and photographed avidly by professionals and amateurs. George Eastman House has over 1,800 gelatin on glass negatives from the files of Nathan Lazarnick, most of which depict automobiles being raced, tested, or displayed. Lazarnick was working as a professional photojournalist in 1899. This was the age of speed, and photojournalism was a profession that had to keep up with the world it was recording. Content was more important than form. The ability to capture the subject was more important than compositional skill. Traditional canons of composition, style, even printing quality were expanded or ignored by the imperatives of photojournalistic practice. As a result, a new body of imagery came into being, depicting blurred, truncated shapes and blocked forms of hastily seen things in granular and poorly printed images. But the excitement and drama of these events seemed heightened with these new forms of presentation. Later generations of photographers and artists responded to these innovative photographic practices and incorporated them into their own work.

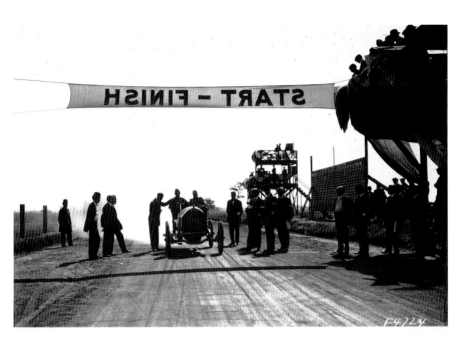

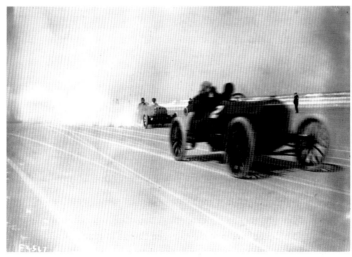

Nathan Lazarnick

*Thomas Derhart and
J. B. Lorimer,* 1908

*From a gelatin on
nitrocellulose sheet
film negative*
GIFT OF GEORGE
LAZARNICK
81:3051:0848

(left)
Nathan Lazarnick

*Autos Racing
on Beach,* ca. 1916

*From a gelatin on
nitrocellulose sheet
film negative*
GIFT OF GEORGE
LAZARNICK
81:3051:0754

Frederick W. Brehm
American,
1871/2–1950

*Police Officers with
Horses, Motorcycles,
and Police Van,*
ca. 1915

Gelatin silver print
77:0619:0047

This frieze of policemen superbly equipped to chase down any potential lawbreakers on horseback, by motorcycle, or by motorcoach was taken with a Cirkut panoramic camera by Frederick W. Brehm. Brehm trained as a cabinetmaker in the 1890s. He began to photograph in 1892 and by 1900 was working as a special designer for camera companies. In the ensuing years, Brehm came to specialize in the development of the panoramic camera, in particular the Cirkut, the most widely used panoramic camera of its day.

In 1917 Brehm joined Eastman Kodak Company and worked there until his retirement in 1945, serving as manager of several divisions of the company. He also pioneered the development of photographic instruction at several colleges in New York State. The museum holds 70

large panoramas by Brehm in its collections. These prints range from 2 to 10 feet in length and include views of the Genesee River and downtown Rochester and large groups of people at employee picnics or trade meetings. The museum also holds a 19-foot-long, 360-degree panoramic view of Washington, D.C., taken about 1910. Approximately 50 smaller panoramas (8 to 12 inches long), 40 other hand-colored photographs made in Scotland in 1909, 60 gelatin silver prints of flowers and gardens taken in the 1930s, and 600 glass negatives and positives constitute the remainder of the Brehm collection. The museum's technology collection holds two Cirkut cameras from this era, as well as eleven others made between 1907 and World War II. Brehm's innovative design would pioneer systems used in high-speed aerial cameras for decades to come.

Ch. Chusseau-Flaviens
French?, active
1890s–1910s

Russie celeb. Mme.
Kropinsky (Russian
celebrity, Madam
Kropinsky),
ca. 1900–1919

*From a gelatin
on glass negative*
GIFT OF KODAK
PATHÉ
75:0112:1633

George Eastman House has a collection of more than 10,800 original gelatin on glass negatives by Ch. Chusseau-Flaviens, which it received from Kodak Pathé in France. While little is known about this vast collection of work, its diversity suggests it may be a picture file gathered from the work of more than one individual. In the early years of the 20th century, large caches of images were being accumulated by nascent photo agencies such as Underwood & Underwood, Paul Thompson, and others to meet the demands of an emerging picture press. America, France, England, Germany, Portugal, Hungary, and other countries each had an active and flourishing press, which published illustrated weekly or monthly magazines. Almost all of these magazines had an illustrated section given some generic name such as "The World in Pictures," which showed celebrity, society, or political figures, or depicted celebratory events including gala balls, races, or more serious news. These publications demanded an immense quantity of "news" photographs each week and fostered the

Ch. Chusseau-Flaviens

Angleterre suffragette
(English Suffragette),
ca. 1900–1919

From a gelatin on glass negative
GIFT OF KODAK PATHÉ
75:0112:2134

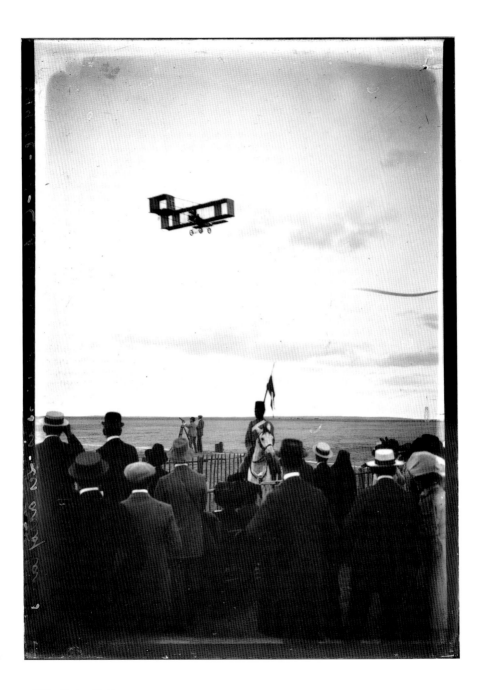

Ch. Chusseau-Flaviens
French?, active
1890s–1910s

Espagne Artillerie
(Spanish Artillery),
ca. 1900–1919

*From a gelatin on
glass negative*
GIFT OF KODAK
PATHÉ
75:0112:2511

growth of picture agencies that could quickly deliver a wide choice of photographs.

These images represent the work of one or more photojournalists working from the 1890s until just before World War I, depicting social and political figures and events throughout Europe and the colonial empires in the Near East and the Far East. Featured subjects included activities of the leisured classes or "society," political unrest in Spain and England, and the prewar buildup of European military forces. Events such as these no longer had to be staged for the photographer, which led to the notion that the camera could act as an unobtrusive witness to real events taking place in the world. This reliance on the camera as eyewitness would gain momentum in the decades ahead, helping to shape in thought and practice the developing fields of photojournalism and mass media.

Photographers had documented the aftermath of warfare as early as 1846, but World War I was the first war in which photography had an

Ch. Chusseau-Flaviens

Serbie Prince son Professor/Serbie
(Serbian Prince and His Professor),
ca. 1900–1919

From a gelatin on glass negative
GIFT OF KODAK PATHÉ
75:0112:0283

important strategic function. Aerial photographs of enemy fortifications were used to help form battle plans. Beyond that important direct use, the unprecedented scale and length of this war required a larger measure of public support, and every belligerent nation developed an apparatus to control the nature and direction of public information about the conflict. Though this ca. 1915 heroic charge of a headless officer fabricated from a collage of disparate images stands in sharp contrast to the scenes of war by Rudolf Tauskey, both images serve a similar function. The gallant cavalryman, able to don the head of anyone appropriate to the occasion, is designed to inspire public pride in a nation's military might. In it, a modern airplane is juxtaposed against the officer's "inaccurately" charging stallion (Muybridge's studies of the 1870s showed that horses simply don't run like this), while Tauskey's images depict American troops in the mud and under fire in the trenches at the front lines. Just two from a group of seventeen 8 x 10-inch positive images on glass, these were probably designed for public display and would have been used to garner public support for the war.

During World War I, propaganda was used with an intensity and thoroughness never seen before, and photography played an important part of this informational/propaganda effort. Every country established a corps of "official" military photographers, and the scale of coverage

Unidentified artist
French?, active
ca. 1910s

Military Montage,
ca. 1915

*Gelatin silver print
with applied color,
combination print*
78:0842:0001

(right)
Rudolf Tauskey
American?, active
1910s

*Soldiers in Trench,
World War I,* ca. 1916

*Transparency, gelatin
on glass*
GIFT OF MRS.
RUDOLF TAUSKEY
89:0154:0011

(above)
Rudolf Tauskey

*Explosion at Night,
World War I*, ca. 1916

*Transparency, gelatin
on glass*
GIFT OF MRS.
RUDOLF TAUSKEY
89:0154:0016

was unprecedented. The American Expeditionary Forces came to France very late and were only a small part of this conflict, yet the United States Signal Corps made over 75,000 photographs and shot "miles of motion picture film." There were also dozens of accredited and unaccredited photojournalists, such as Jimmy Hare and Donald Thompson, who managed to photograph in spite of heavy censorship. All the established organs of mass media were reconfigured to support the "war effort." Hundreds of carefully selected photographs appeared in the many illustrated weekly magazines, multivolume illustrated histories of the war were published while it was still being fought (or soon thereafter), and the new genre as well as the older field of stereography was employed for propagandistic ends.

George Eastman House holds an album of 65 photographs depicting the activities of the U. S. A. School of Aerial Photography at the Eastman Kodak Company in Rochester, which trained almost 2,000 soldiers

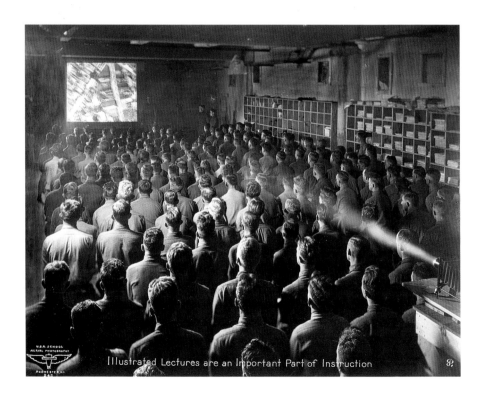

Illustrated Lectures are an Important Part of Instruction

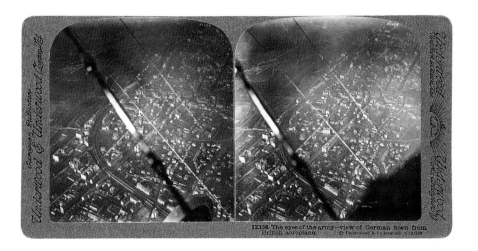

12336-The eyes of the army—view of German town from British aeroplane. © Underwood & Underwood. (U-13162)

between March 1918 and the end of the war. The museum also holds approximately 800 stereo views depicting the events of World War I. These are from various series titled "European War," "War of the Nations," or "World War," issued by Underwood & Underwood and the Keystone View Company.

By the early 1880s stereos were considered old-fashioned, and their popularity had sharply declined. Elmer and Bert Underwood, working in Ottawa, Kansas, began selling stereo views door to door through commissioned salesmen. This worked so well that by 1894 the company had grown into an immense international business, with four factories producing ten million photographs a year from their huge file of negatives. These images had been acquired by wholesale purchases of earlier stereomakers' stocks or were made by the company's hired photographers. The firm pioneered the concept of issuing boxed sets about specific topics or events, some containing up to 300 photographs. These sets contained extensive and well-written information and commentary on the stereo views' subjects, and by the beginning of the 20th century the stereo had become an important tool in public education and a vital contributor to the growth of mass media.

Oskar Weitzman served in the Austro-Hungarian army during World War I. The museum holds 76 of his photographs depicting a variety of military aircraft, including zeppelins and balloons.

Burden & Salisbury's "Mabel Pays by Check" (page 468) and Irving

Underwood & Underwood
American, active 1882–1923

The Eyes of the Army – View of German Town from British Aeroplane, ca. 1914

Gelatin silver print stereograph
GIFT OF THE UNIVERSITY OF ROCHESTER
83:1795:0336

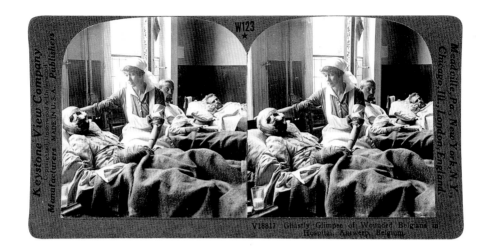

Keystone View Company
American, active
1892–1970

Ghastly Glimpse of
Wounded Belgians
in Hospital, Antwerp,
Belgium, ca. 1916

*Gelatin silver print
stereograph*
76:0147:0123

(below)
Keystone View Company

Repairing Field
Telephone Lines
during a Gas Attack
at the Front, ca. 1916

*Gelatin silver print
stereograph*
76:0147:0243

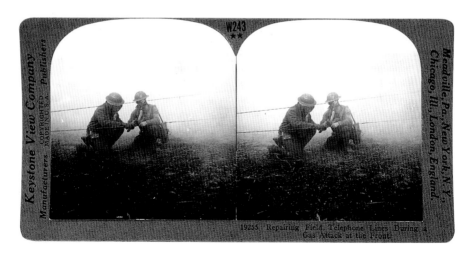

Oskar Weitzman
Austrian, 1898–1947

*Parachute Jump/
Portrait of Soldier,*
ca. 1916

*Gelatin silver print
postal card*
GIFT OF MRS. OWENS
83:1542:0061

Burden & Salisbury
American, active
1900s–1920s

Mabel Pays by
Check, 1923

*Transparency, gelatin
on glass (lantern
slide) with applied
color*
97:1949:0015

Underhill's extraordinary images of commonplace objects are examples
of yet another permutation in commercial photographic practice: adver-
tising photographs, made in the context of the explosion of mass media.
While not a completely new idea (canny businessmen had hired photog-
raphers to promote everything from machine guns to canned goods in
the 19th century), the tremendous growth in number and circulation of
popular illustrated magazines supported by advertising revenues put a
new and different emphasis on this type of imagery. "Mabel's" financial
practices were brought to the Rochester, New York, public as lantern
slides in a little series of 19 narrative episodes, each containing image
and text. These were shown in a story form familiar to an audience that
by now was experienced at going to "the movies."

(right)
Irving S. Underhill
American,
1872–1960

*Accountants Hand-
book, ca. 1915*

*Modern gelatin silver
print from original
gelatin on glass
negative*
GIFT OF FRED
LOWENFELS
79:1994:0217MP

Irving Underhill's photographs seem to a contemporary eye to have
a hyperreal insistence on the medium's factuality and a postmodern
sensibility of visual staging and incongruous juxtaposition. However,
this effect is accidental. Having worked at a commercial studio in New
York since 1896, Underhill sold news photographs to illustrate feature
articles in magazines, including *World's Work*, while also making studio
photographs for the advertisements found in the same magazines.
Backgrounds and any other "unnecessary information" in his pho-
tographs would have been blocked out by a retoucher to create
space for the advertisement's text.

(left)
Irving S. Underhill
American,
1872–1960

Wrenches, ca. 1915

Modern gelatin silver print from original gelatin on glass negative
GIFT OF FRED LOWENFELS
79:1994:0313MP

Irving S. Underhill

Metal Object – Machine Part, ca. 1915

Modern gelatin silver print from original gelatin on glass negative
GIFT OF FRED LOWENFELS
79:1994:0291MP

"Refrigerator" (page 472) depicts a seemingly affable but decidedly strange conjunction of two cultures. The young lady showing the ice cube tray to unidentified Bornese men is Osa Leighty Johnson, who was something of a self-made celebrity in the 1920s and 1930s. In 1940 Osa Johnson released the film *I Married Adventure,* honoring her husband Martin, who was accidentally killed in 1937. The film was essentially a

compilation of scenes from the ten adventure/exploration entertainment feature films and innumerable educational films depicting their travels to exotic areas of the world, including *Among the Cannibals of the South Pacific* (1918) and *Trailing African Wild Animals* (1923). More than a film title, *I Married Adventure* was the theme of the Johnsons' lives; they made their living by establishing themselves as celebrity adventurers through their prodigious works.

One function of a celebrity is to publicly experience and share the unusual and interesting features of existence as a surrogate for the average person. The three images shown here of this engaging young woman so clearly enjoying her work while playing directly to the camera's gaze and the audience beyond may help explain just why the Johnsons were so admired by the public. In the early 1920s they went to East Africa, where they organized safaris to find and photograph wild animals. In 1924 they visited Rochester, New York, and successfully approached George Eastman to gain his support for a major photographic and film expedition. They returned to Africa with a battery of still and motion picture cameras. After three years, they returned to the United States in 1927 to present a popular and profitable series of lectures and film showings, from which they made over $100,000. In 1932 the Johnsons bought two private planes, which allowed them even greater mobility to conduct their animal filming in Africa. The museum holds over 9,500 glass negatives, largely documents of these trips. A copy of the film *Chronicles of an African Trip* (1927), about George Eastman's visit to the Johnsons in Africa, is held in the museum's motion picture collection.

Osa & Martin Johnson
Americans, active 1917–1937

Refrigerator, ca. 1920

From a gelatin on glass negative
85:1263:0053

(above)
Osa & Martin Johnson

Osa and Airplane,
ca. 1918–1936

*From a gelatin on
glass negative*
85:1268:0010

Osa & Martin Johnson

Champagne,
ca. 1921–1927

*From a gelatin on
glass negative*
85:1262:0567

The Object Photographed

In the final two issues of *Camera Work*, Alfred Stieglitz published 17 pictures by the American photographer Paul Strand. "The White Fence, Port Kent, New York" was made in 1916, a crucial year for Strand, who made the startling transition from what he called "Whistlering" (after the painter James Abbott McNeil Whistler) to modernism. Strand's photogravure stands between the two traditions, at once focusing on the graphic symmetry of the white fence against the dark grass, yet playing against the vaguely picturesque buildings in the background. The medium was being redefined by a new approach to picture-making, suggested by Stieglitz's description of Strand's work as "[d]evoid of flim-flam; devoid of trickery and any 'ism'; devoid of any attempt to mystify an ignorant public, including the photographers themselves. These photographs are the direct expression of today."

Charles Sheeler

Bucks County Barn,
ca. 1916

Gelatin silver print
MUSEUM PURCHASE
81:1758:0021

Charles Sheeler
American, 1883–1965

Ship Funnel, 1927

Gelatin silver print
MUSEUM PURCHASE
81:1757:0002

Following the landmark *International Exhibition of Pictorial Photography* at the Albright Art Gallery in Buffalo, New York, the Photo-Secession movement soon dissipated, partly due to numerous fallings-out between Stieglitz and the other photographers, but primarily because the painterly, romantic imagery of pictorialism was being supplanted by a newer, more aggressive aesthetic. Modernism triumphed clarity of detail over atmospheric renderings, and unfettered reality over fabrication. Strand, who had studied with Lewis Hine at the Ethical Culture School, had been heavily influenced by the modern art that Stieglitz increasingly exhibited at his 291 Gallery. "The Lathe" (page 475) a close-up view of heavy machinery, is nearly abstract in its subversion of scale and focus on form, surface, and light.

Charles Sheeler, primarily a painter, collaborated with Strand on the film *Manhatta* in 1921. He photographed a ship's funnel (page 476), transforming the mechanism of the machine into cubist lines and

Alfred Stieglitz
American,
1864–1946

Paula, Berlin, 1889

Gelatin silver print
PART PURCHASE AND
PART GIFT OF AN
AMERICAN PLACE,
EX-COLLECTION
GEORGIA O'KEEFFE
74:0052:0040

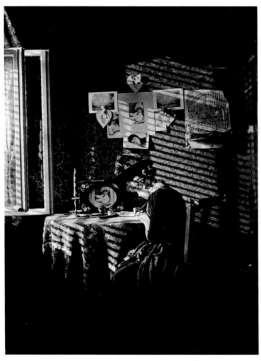

Alfred Stieglitz

Grape Leaves and
House, Lake George,
1934

Gelatin silver print
PART PURCHASE AND
PART GIFT OF AN
AMERICAN PLACE,
EX-COLLECTION
GEORGIA O'KEEFFE
74:0052:0097

Alfred Stieglitz
American,
1864–1946

Lake George
Ellen Koeniger,
Lake George, 1916

Gelatin silver print
PART PURCHASE AND
PART GIFT OF AN
AMERICAN PLACE,
EX-COLLECTION
GEORGIA O'KEEFFE
74:0052:0042

(right)
Alfred Stieglitz

New York Series,
Spring, 1935

Gelatin silver print
MUSEUM PURCHASE,
EX-COLLECTION
GEORGIA O'KEEFFE
81:2162:0001

circles. Similarly, his "Bucks County Barn" (page 477) transcends its vernacular subject to become a formal study in texture, line, and the subtle tonal range of whites that photography is capable of rendering.

Alfred Stieglitz's "Paula, Berlin" (page 478) was made early in his career, during the same year that he saw, for the first time, works by Louis-Jacques-Mandé Daguerre, William Henry Fox Talbot, and Julia Margaret Cameron in the Jubilee exhibition in Vienna, a celebration of the 50th anniversary of the public announcement of photography. The geometric striations of light and shadow that infiltrate the romantic, pictorialist-style portrait presage Stieglitz's later, more modernist style evidenced in "Grape Leaves and House, Lake George" (page 479). Clapboard siding on the summer cottage echoes the horizontal patterning in "Paula," while opposing porch pillars anchor the composition at either side with a sophisticated sense of framing and symmetry that can only be achieved through the precision of the photographic instrument.

Alfred Stieglitz
American,
1864–1946

Portrait of R.
Rebecca Strand, 1923

Gelatin silver print
PART PURCHASE AND
PART GIFT OF AN
AMERICAN PLACE,
EX-COLLECTION
GEORGIA O'KEEFFE
74:0052:0087

In 1916, during a summer visit to Oaklawn, the family summer home at Lake George, Stieglitz made a series of photographs of Ellen Koeniger, photographer Frank Eugene's niece (see page 480). Clad in a clinging, wet swimming costume, Koeniger is an ebullient, athletic muse. Stieglitz's sharp-focus image made in brilliant sunlight couples warmth and spontaneity with formal investigation and libidinous longing. Several years later, he neatly bisected the Manhattan skyline in "Spring" from the *New York* series (page 481). The bottom half of the composition is cast in deep shadow; rising up in crisp, delineated sunlight, the city's skyscrapers exert a forceful balance and energy that is almost the visual opposite of Koeniger's bathing form.

A portrait of Rebecca Strand (wife of Paul Strand) holding her breast in the water is a textural wonder. The top half of her body is so finely drawn that every goose bump on her flesh is rendered with sensuous precision, while the submerged half dissipates in waves of muted

Alfred Stieglitz

Georgia O'Keeffe,
1933

Gelatin silver print
PART PURCHASE AND
PART GIFT OF AN
AMERICAN PLACE,
EX-COLLECTION
GEORGIA O'KEEFFE
74:0052:0065

abstraction from the light-filled water that gently surrounds her. No
trace of the photographer's earlier soft-focus pictorialism is present
in these images.

The portraits of Strand and Koeniger anticipate the direction of
Stieglitz's series of photographs of his wife and greatest muse, the
painter Georgia O'Keeffe. Stieglitz met O'Keeffe in 1916 at 291
Gallery; he first photographed her the following year. O'Keeffe's
highly expressive hands represent both her artistry and her passion.
The physicality of these women is more direct and sexually charged

Alfred Stieglitz

Equivalent, 1929

Gelatin silver print
PART PURCHASE AND
PART GIFT OF AN
AMERICAN PLACE,
EX-COLLECTION
GEORGIA O'KEEFFE
74:0052:0020

than any in his previous work. Photographed in close-up to emphasize
details over the whole, their portraits convey an aspect rather than
a likeness.

 Believing that the object photographed had to be understood before
it could be successfully rendered, Stieglitz embarked in 1923 on a series
of cloud studies that he called "Equivalents." He wrote: "I had told Miss
O'Keeffe I wanted a series of photographs which when seen by [com-
poser] Ernest Bloch he would exclaim: 'Music! music! Man, why that
is music!'" This image of a mackerel sky equates the riotous natural

formations with the photographer's emotional state and transcends the abstract formality of the composition. "Clouds, Music No. 1, Lake George" (page 484) was part of a series of ten cloud photographs that he directly identified as visual music. While not an "Equivalent" per se, Stieglitz's landscape "Hedge and Grasses, Lake George" (page 484) finds formal communion with this very personal body of work.

In 1911 Johan Hagemeyer emigrated from Holland with a degree in pomology (the science and practice of fruit growing). He had been an avid snapshot photographer in Holland and was introduced to the artistic potential of photography through copies of *Camera Work* he saw at the Library of Congress. Hagemeyer then traveled to New York to meet Stieglitz. Suitably encouraged by his visit to pursue photography, in 1917 Hagemeyer moved to Los Angeles, where he met Edward Weston. Through their friendship, Hagemeyer was introduced to some of the leading photographic artists in the region. Although Hagemeyer's initial work was pictorialist in style, he, too, evolved toward a more modernist

Johan Hagemeyer
American,
b. Holland,
1884–1962

Modern American
Lyric – (Gasoline
Station), 1924

Gelatin silver print
GIFT OF DAVID
HAGEMEYER
81:1301:0076

style. Along with Weston, he was keenly aware of carrying forth the artistic legacy that Stieglitz had established. "[P]hotography has certain inherent qualities which are only possible with photography – one being the delineation of detail ... why limit yourself to what your eyes see when you have such an opportunity to extend your vision?" wrote Weston about a conversation with Hagemeyer that he recorded in his journal in 1923. The two had been struggling to define the essence and direction of the medium.

By 1924 Hagemeyer, who had established a studio in Carmel-by-the-Sea in northern California, had clearly absorbed Weston's perspective from the previous year. Less a gasoline station than

a sweeping arc of gray against black punctuated by a row of graphic white fence, Hagemeyer's image "Modern American Lyric – (Gasoline Station)," made from a startling bird's-eye vantage point, transformed the commonplace subject into extraordinary pattern and design. As he explained, "I am interested in everything contemporary and believe that we should live in our own time – seeing the beauty of today instead of worshipping the past."

From as early as 1921, Weston had begun evolving his modernist approach; five years earlier he plainly stated his preference for the previsualization of straight photography: "Get your lighting and exposure correct at the start and both developing and printing can be practically automatic." His 1921 "Attic, Glendale, California" is nearly pure geometry and tone, defining space completely through light and form. Even the figure of the woman on the right forms a black triangle against the wall; her upraised, bent hand forms another triangle in front of her.

Edward Weston
American, 1886–1958

Attic, Glendale,
California, 1921

Platinum print
MUSEUM PURCHASE,
EX-COLLECTION
BRETT WESTON
66:0070:0052

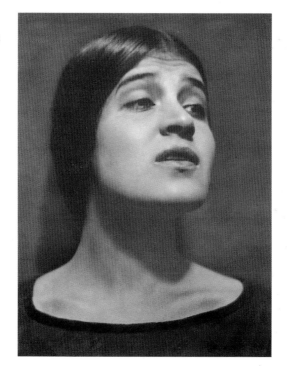

Weston was born in Highland Park, Illinois, and received his first camera from his father at age 16. From his very first roll of film, Weston approached photography seriously, and by the age of 20 had already published his work. In 1906 he went on a vacation to California to visit his sister and remained there. Almost immediately after his arrival, he settled on photography as a profession. In 1911 he established "The Little Studio" in Tropico (now Glendale). In 1922 Weston photographed his young son Neil in the nude. This is not the irrepressibly cute children of his commercial work; rather it is an exploration of form that recalls nothing less than classical sculpture. Although he met Stieglitz in New York that November and called their meeting "an important contact at a moment of my life …," the already successful Weston seems not to have been directly influenced by the established master of the medium.

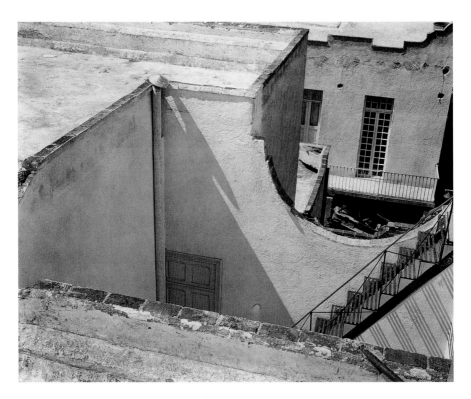

Edward Weston
American, 1886–1958

Mexico, 1924

Platinum print
MUSEUM PURCHASE,
EX-COLLECTION
BRETT WESTON
74:0061:0009

Tina Modotti was Weston's muse and lover; they met in late 1921 when she was an actress in Los Angeles, married to the artist Roubaix de l'Abrie Richey (Robo). By 1923 Weston had set sail for Mexico with his eldest son Chandler, with Tina at his side; Robo had died of smallpox some months before. "Tina Modotti Reciting Poetry" (page 489) is one of three dozen photographs Weston made of Modotti while she recited, emphasizing the sensual expressiveness of her slightly open mouth and raised eyebrows.

In Mexico with Modotti, Weston flourished, expanding his subject matter beyond what he had previously explored. An architectural study of the rooftops of town photographed "from the azotea" (roof) flattens the space into a two-dimensional drawing of light and texture. "Excusado" is a close-up of a porcelain commode. Filling the frame, Weston monumentalized the mundane, describing it as "Modern Classicism." Though all of these prints are platinum, the favored medium of

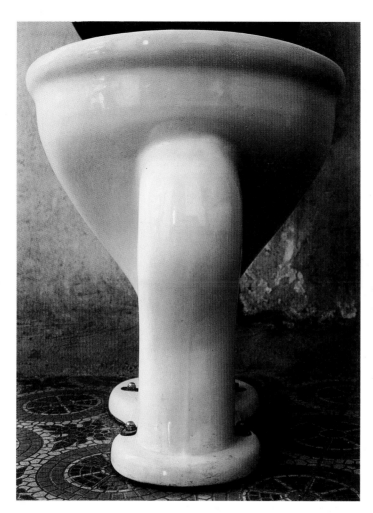

Edward Weston

Excusado, 1925

Platinum print
MUSEUM PURCHASE,
EX-COLLECTION
BRETT WESTON
74:0061:0064

pictorialism, in Weston's hands it is employed for its capacity for clarity and its wide range of tonality. In his photographs of Armco Steel (see page 492), he clearly recognized the extraordinary modernity of his industrial subject matter and brought to it a modernist eye, which reduces the architecture to elemental lines and forms.

In late 1929 Weston began his celebrated series of abstract compositions of eggplants, cabbages, peppers, and whatever else could be employed first as art and then as supper. "Pepper No. 30" (page 493)

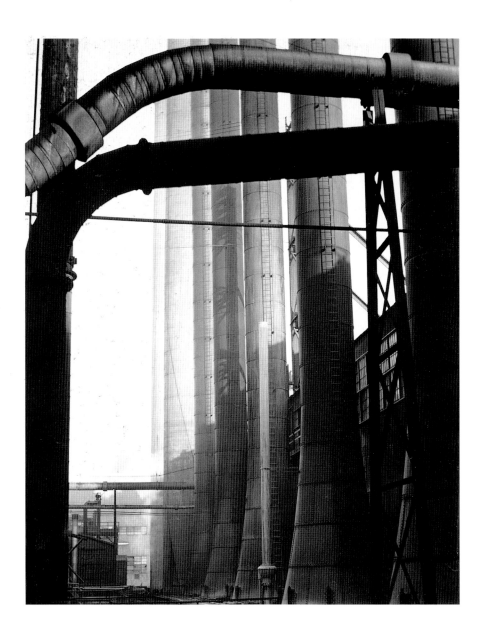

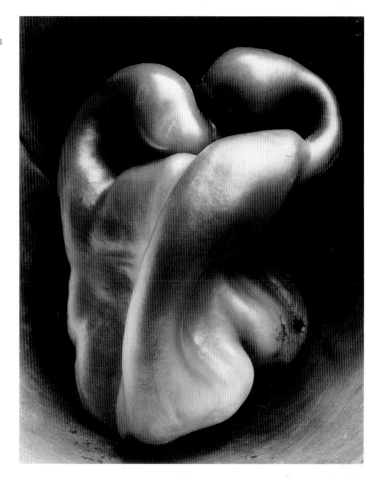

Edward Weston

Pepper No. 30, 1930

Gelatin silver print
MUSEUM PURCHASE
74:0061:0024

wrestles against itself inside a tin funnel that Weston used as a back-drop; the tension captured in the natural form has been isolated and enhanced by Weston's careful framing. Altogether, he made at least 30 negatives of the peppers over a four-day period.

After nine of Weston's photographs were hung in the *Group f/64* exhibition at San Francisco's de Young Memorial Museum in 1932, Weston was crowned the leader of the Group f/64. Sharp-focus negatives from a large-format camera, contact printed onto high-gloss paper, and record-ing optimum tone and detail was the preferred aesthetic of the f/64 photographers, who included Ansel Adams, Imogen Cunningham,

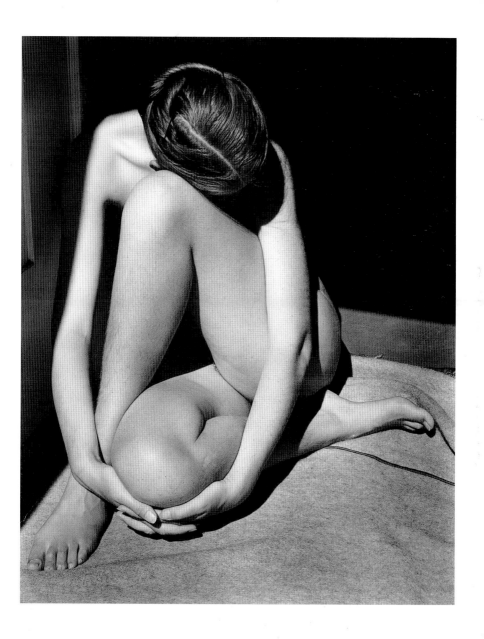

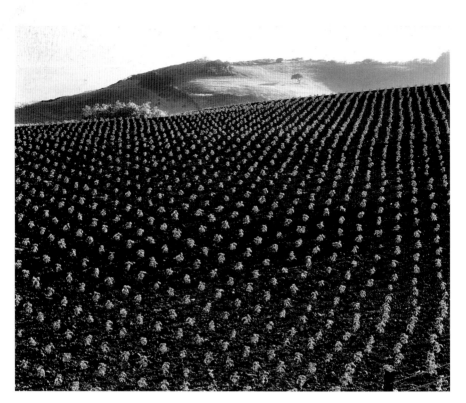

Edward Weston
American, 1886–1958

Tomato Field, 1937

Print made in 1953
by Brett Weston
Gelatin silver print
MUSEUM PURCHASE
74:0061:0072

and Weston's son Brett. Their name derived from the smallest lens aperture, which produces the greatest depth of field and detail.

In 1934 Weston met the 20-year-old Charis Wilson, the daughter of his neighbor, at a Carmel concert. "Perhaps C will be remembered as the great love of my life. Already I have achieved certain heights reached with no other love," wrote Weston of Charis, who would become his second wife and most frequent subject. In her 1998 memoir, Wilson described how the now-iconic image (page 495) came about, giving a rare glimpse at the perspective from the other side of the camera, and somewhat demystifying the process: "I think it was Edward's suggestion that I try sitting just inside the bedroom doorway. He was probably tired of the old gray army blanket I insisted upon lying on if I was out in the full sun. He saw what he wanted right away, but in the narrow section of sun deck outside the door it was difficult to set up the eight by ten to fit all of me in the picture and at the same time have the camera placed

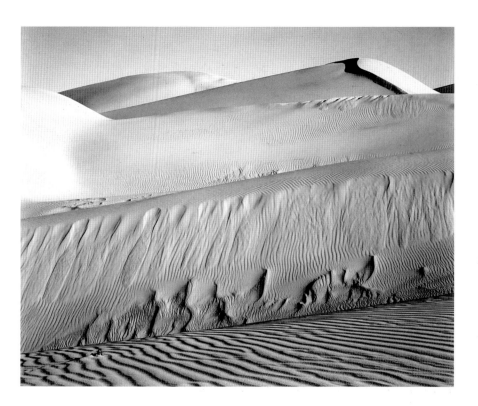

where he could operate it. In the end, he had to compromise and put up with the heavy shadow on the right arm; it was that or lose the picture. When I ducked my head because the sun was blinding me, Edward said, 'Hold it!' and made the exposure."

In 1937 Weston became the first photographer to be awarded a John Simon Guggenheim Memorial Fellowship. His proposal was to complete "The Making of a Series of Photographic Documents of the West," as his project was eventually called. "It seems so utterly naïve that landscape – not that of the pictorial school – is not considered of 'social significance' when it has far more important bearing on the human race of a given locale than the excrescences called cities. By landscape, I mean every physical aspect of a given region – weather, soil, wildflowers, mountain peaks – and its effect on the psyche and physical appearance of the people," Weston wrote the following year. He made three visits to the "Tomato Field" in Big Sur, California, before making this exposure,

Edward Weston

Dunes, Oceano,
1936

Gelatin silver print
MUSEUM PURCHASE
74:0061:0053

so that the light would render each individual plant distinct against the dark soil. It was the most difficult print Weston made during the two Guggenheim years. Another photograph, of the sand dunes at Oceano (page 497), reveals a palette of textures ranging from smooth stillness in the distance to variegated markings drawn by the wind, one layered on top of the other in a two-dimensional plane that recalls sedimentary rock. The museum holds more than 250 images by Weston.

The museum also owns 28 prints by Weston's muse, assistant, and sometime collaborator, Tina Modotti. An accomplished photographer in her own right, Modotti was born in Italy but immigrated to America with her family in 1913. They settled in San Francisco, where she worked in a textile factory and as a dressmaker before her marriage to Robo, who introduced her to the artistic community. Modotti met Weston in 1921 and learned photography from him; she decided to pursue it seriously when the two of them moved to Mexico in 1923. Through Weston, Modotti met Hagemeyer, Dorothea Lange, Imogen Cunningham, and Roi Partridge (Cunningham's husband). Though influenced by these artists, Modotti's style developed with more of a social concern.

Actively engaged in politics, she was involved with the Mexican Revolutionary Party and was a member of the Communist Party. Her sympathy for workers was frequently expressed through her portraits of the men and women who labor. Modotti was also keenly aware of the potential of labor to usurp the individual, which she depicted in a portrait of two men with enormous bundles strapped to their backs. Their loads are so heavy

Tina Modotti
American, b. Italy, 1896–1942

Woman of Tehuantepec, ca. 1929

Gelatin silver print
74:0061:0159

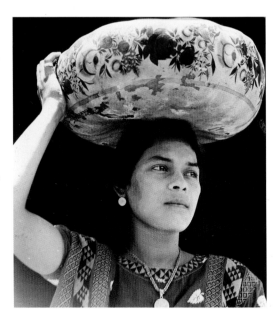

Tina Modotti

Two Men Carrying Large Loads on Backs, ca. 1927–1929

Gelatin silver print
74:0061:0164

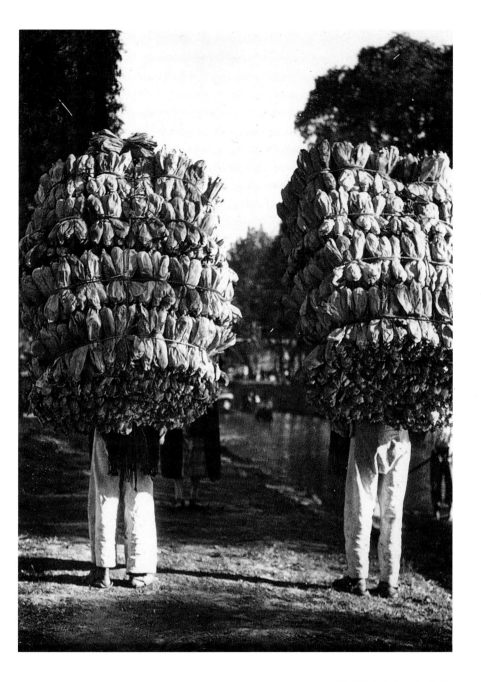

that they are stooped over, their faces obscured; the bundles not only envelop them but also dominate the frame. Through Modotti's eye, "Woman of Tehuantepec" (page 498), photographed from slightly below, is bestowed with an almost regal air, the large bowl suggesting not so much a vessel of transport as an elaborately patterned crown. A matriarchal society, the community of Tehuantepec must have been especially compelling for the fiercely independent Modotti. The images she made there represent the last significant burst of photographic energy in her career. "In my case life is always struggling to predominate and art naturally suffers ... I put too much art in my life ... and consequently I have not much left to give to art," Modotti wrote to Weston.

Modotti's photographic career was brief; after being deported from Mexico for her political activities, she made her way to Moscow between 1931 and 1934, and it was there that she gave up photography. In her only published statement on photography, Modotti concluded: "Photography, precisely because it can only be produced in the present, and because it is based on what exists objectively before the camera, takes its place as the most satisfactory medium for registering objective life in all its aspects, and from this comes its documental value. If to this is added sensibility and understanding and, above all, a clear orientation as to the place it should have in the field of historical development, I believe that the result is something worthy of a place in social production, to which we should all contribute."

A close friend of Weston and acquaintance of Modotti, Imogen Cunningham bought her first camera in 1901 at the suggestion of Gertrude Käsebier, whose Photo-Secessionist work had

Imogen Cunningham
American, 1883–1976

Designer and Design
(Roi Partridge), 1915

Platinum print
MUSEUM PURCHASE
77:0760:0043

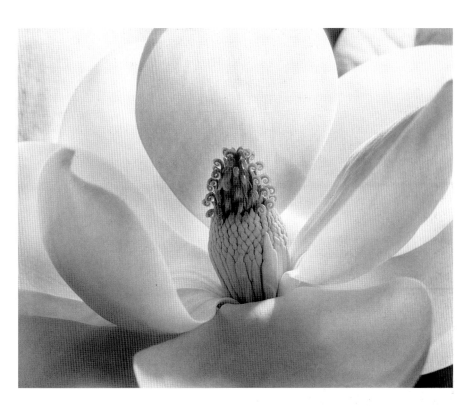

greatly influenced Cunningham. With a degree in chemistry and after a two-year stint as a printer in Edward Curtis's Seattle studio, she set up her own portrait studio, specializing in romantic, pictorial-style portraits and figure studies. Her nudes of her husband, the etcher Roi Partridge, were among the first nudes taken of a male in the landscape, for which she received both praise and prudish condemnation. "Designer and Design" is an early portrait of Partridge photographed against the backdrop of one of his designs influenced by the Arts and Crafts movement.

Throughout her career Cunningham made her living as a portrait photographer. Her sitters included the photographers Ansel Adams, August Sander, Stieglitz, and Weston. Although she joined a pictorialist photographer's group in 1923, 13 years later Cunningham would become a founding member of the Group f/64, and it was this sharp-focus, highly detailed style that defined her career. Between 1922 and 1929 Cunningham, an avid gardener, produced a series of plant and flower studies.

Imogen Cunningham

Magnolia Blossom, 1925

Gelatin silver print
MUSEUM PURCHASE
77:0760:0061

"If one decides upon the medium of photography, why attempt to soar in the realm of imagination?... There are plenty of the subtleties of life right on earth, which need delicate interpretation. ..." "Magnolia Blossom," Cunningham's son recalled, was brought home and sat in a vase for three days before his mother photographed it (page 501). She monumentalizes the flower, giving no reference or hint at its decorative purpose in the vase. Through her close-up vantage point, Cunningham reveals information about the flower that is not apparent to the casual eye. The stamen recalls human anatomy, its sensual curlicues resembling pubic hair. The eroticism and sexual metaphor in the flower images are subtle yet evident. "Magnolia Bud" and "Figures No. 1" show a striking similarity in the treatment of organic form. In each, Cunningham isolates the shape in order to reveal its essence. "Photography began for me with people and no matter what interest I have given plant life, I have never totally deserted the bigger significance in human life. As document or record of personality I feel that photography isn't surpassed by

any other graphic medium," Cunningham wrote. "The big discussion
as to whether it is an art or not was settled for me as well twenty years
ago." There are nearly 100 prints by Cunningham in the Eastman House
collection, most of which were acquired directly from the photographer.

For a brief period after the birth of her twin sons, Cunningham went
to work in the San Francisco studio of Francis Bruguière. Bruguière was
a student of music, painting, and poetry. Around 1905 he visited New
York City, where he met Stieglitz and began to study photography. Al-
most immediately, Bruguière became a member of the Photo-Secession,
but his work gradually began to develop a modernist inclination, first
through experiments with multiple exposures and abstraction.
Bruguière became the official photographer of the Theater Guild,
and this position influenced his dramatic use of light to create mood.
Around 1925 he began to experiment with cut-paper abstractions, which
he would then photograph. "Abstract Study # 7" revels in the play of
light and motion created by the precise cuts in the paper. While the cut
paper is the catalyst, the real actor in the image is the light itself, which
dances around the surface, reinventing spatial relationships. The image

Ralph Steiner
American,
1899–1986

Ham & Eggs, 1929

Gelatin silver print
MUSEUM PURCHASE,
CHARINA FOUNDA-
TION PURCHASE
FUND
96:0760:0001

of a woman with her arm raised against a wall (page 505) is radical in its selective focus; while her arm and the backdrop are finely delineated, the woman's dramatically out-of-focus face is a masklike distortion, thus transforming her likeness into an abstraction. More than 400 prints and negatives by Bruguière are in the Eastman House collection.

"The Ham and Eggs picture represents my revolt when a food editor of a women's magazine set before my camera a plate of raggedly trimmed ham and two runny eggs. I ran out to buy six dozen eggs, induced the editor to trim both ham and eggs into perfect Euclidean circles, and made my version of that classic dish," explained Ralph Steiner about this photograph. His statement reveals not only his originality and playful irreverence, but also the enormous precision, symmetry, and attention to detail that he brought to the photographic medium. An alumnus of the Clarence White School of Photography, Steiner made his living in advertising photography. Nevertheless, the rigorous sense

Paul Outerbridge
American, 1896–1958

Piano, 1924

Platinum print
GIFT OF THE
PHOTOGRAPHER
70:0375:0001

of graphic design that he used in his commercial work was also applied to his art, blurring the distinction between work for hire and work from the heart. Interestingly enough, the repetitive, fragile perfection of the egg became a potent image for many artists, figuring prominently into the work of Paul Outerbridge, who claimed to have made more than 4,000 images of the subject.

Paul Outerbridge began to focus on photography seriously as a student of Clarence White in 1921. He had worked as a painter and designer and brought these sensibilities to his photographic work. Taken from

an oblique angle, the piano that he practiced on as a child is considered two-dimensionally, as a flat plane of dynamically intersecting angles. The influence of cubism is strongly evident in the deceptively complex still-life image pictured on page 507.

Representing a photographic movement on the other side of the Atlantic, Albert Renger-Patzsch was a generation younger than – and worlds apart from – the pictorialist aesthetic in photography. He was a pioneer of modern German photography, occasionally being referred to as "the German Weston." Renger-Patzsch received a degree in chemistry but soon turned his efforts toward photography. Renger-Patzsch received his start as a professional photographer when he was asked to contribute photographs to the first two volumes of the series *Die Welt der Pflanze (The World of Plants)*. "Echeoeria," a close-up investigation of a succulent plant, is an example that calls to mind Cunningham's flower studies. Nature would become the dominant theme in his later work. In 1926 Renger-Patzsch contributed photographs to the book *Das Chorgestühl von Kappenberg (The Choir Pews of Cappenberg)*. "Gewölbe in Danziger Marien-kirche" is reminiscent of that body of work; the organic decoration in the chapel emulates his interpretation of the plant form in "Echeo-eria." Renger-Patzsch became Germany's leading photographer in the 1920s, and his book *Die Welt ist schön* an influential treatise on modernist photographic practice.

"Slaughterhouse" by Ch. Chusseau-Flaviens, whose work is discussed on page 456, displays a remarkably surreal sensibility in choice of subject matter. The presentation of the butcher standing amidst his gruesome work is framed by death on one side and a shadowy, mysterious figure on the other. It is, however, as a document of labor that Chusseau-Flaviens's work anticipates that of August Sander, who set about to make a document of the people of his native Westerwald, near Cologne, Germany.

"Man of the Twentieth Century" was the title Sander gave to his life-long photographic project. Sander divided the world into 45 "types" and photographed subjects from all walks of life, such as "Jungbauern, Westerwald" (page 512). "Nothing seemed to me more appropriate than to project an image of our time with absolute fidelity to nature by means of photography. ... Let me speak the truth in all honesty about our age and the people of our age," Sander wrote in an essay formally announcing the project. "Pastry Cook" is a forcefully honest representation of a proud working man, rendered without aggrandizement but with dignity and honor. Yet Sander's work was suppressed by the Nazi regime because his vision of the German people did not fit the Aryan mold. The 41 Sander prints in the museum's collection are from this same project, which occupied Sander until his death.

Ch. Chusseau-Flaviens
French?, active
1890s–1910s

Slaughterhouse,
ca. 1900–1919

*From a gelatin on
glass negative*
GIFT OF
KODAK PATHÉ
75:0111:0005

(right)
August Sander

German, 1876–1964

Konditor, Köln
(Pastry Cook,
Cologne), 1928

*Print by Gunther
Sander from the original
negative, ca. 1971
Gelatin silver print*
MUSEUM PURCHASE
71:0072:0005

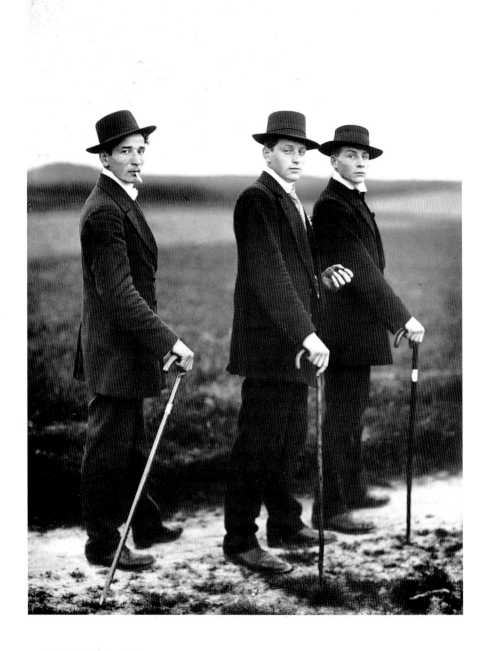

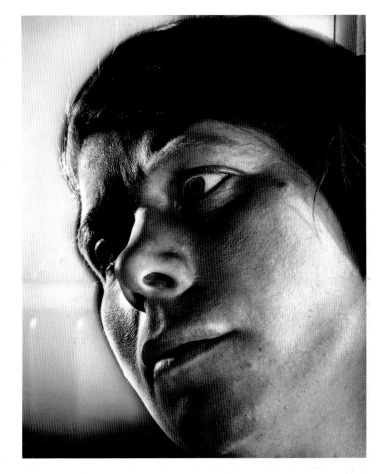

Helmar Lerski was a Swiss actor who did not take up photography
until age 40, and by accident – his wife was a photographer, and one
day he used her studio to photograph the members of his acting troupe.
His belief that "the modern portrait photographer should strive, with
the help of his own feeling for light, to express himself in a completely
personal manner, create his own style, and deliver with every portrait his
visiting card ... in order that he can be recognized in every one of his
pictures," is embodied in the monumentalized portrait heads that he
created. The dramatic directional lighting he employed suggests no
natural light source, but seems to emanate like heat from the subject.

Alexander Rodchenko was a Russian painter and graphic designer who became a leading constructivist artist in Moscow. He initially began to incorporate photography through photomontage; this montage made to illustrate the epic poem "Pro Eto" ("About This") by Vladimir Maiakovskii was constructed from photographs Rodchenko commissioned from Abram Shterenberg and other images taken from magazines. The unlikely combination of a dinosaur, a cityscape turned on its side to resemble a burst of sound, a man seated in a chair watching intently, a hausfrau, a klieg light, and the mysterious numbers "67-10" create a disjunctive narrative. Soon thereafter, Rodchenko began to make his own photographs, which were characterized by unusual vantage points, such as his view of a city street in Moscow.

Fellow Russian El Lissitzky was an architect, graphic artist, and photographer. Like Rodchenko, he also participated in the Constructivist movement, establishing a group in Düsseldorf, Germany. During a period in Berlin, Lissitzky became involved with artists at the Bauhaus School of Design, including Herbert Bayer. Lissitzky's work was overtly political in a way that was unprecedented in creative photography. Toward the end of his career, he received a commission to design Stalinist propaganda. The result was the book given to leading party members to commemorate the Seventh Congress of Soviets in 1935, *Industry of Socialism. Heavy Industry for the Seventh Congress of Soviets.* A cutout in a sea of Soviet workers frames a portrait of Lenin, and with a turn of the page, frames the head of Stalin as well.

Поддло
из шнура
скребущейся ремюсти
времен троглодитских тогдашнее чудище.

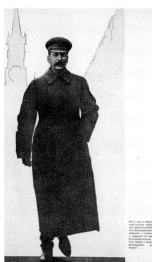

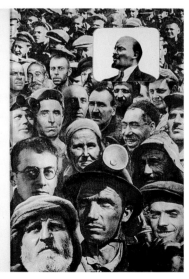

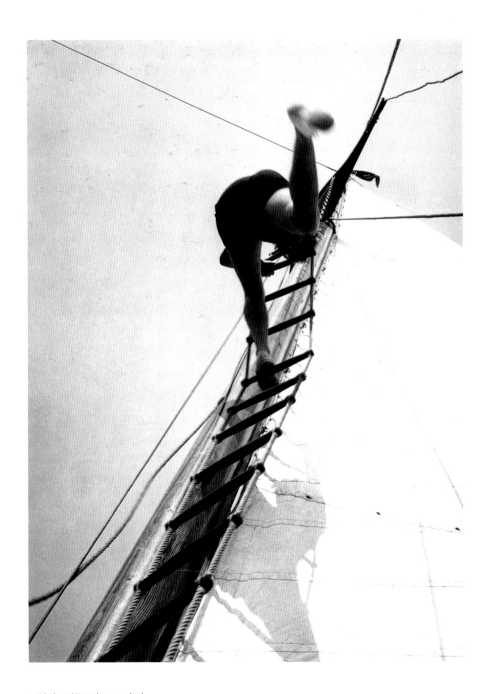

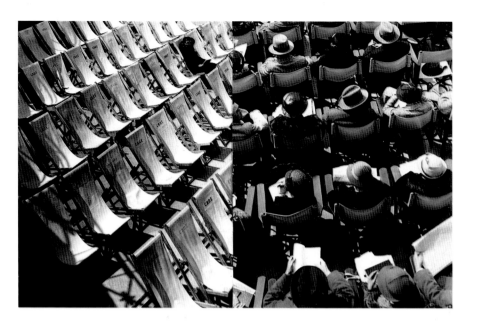

"The reality of our century is technology: the invention, construction, and maintenance of machines. To be a user of machines is to be of the spirit of this century. Machines have replaced the transcendental spiritualism of past eras." Although he was a sculptor, painter, graphic and stage designer, writer, and teacher, no other medium but photography would – or could – define the artistic philosophy of László Moholy-Nagy, the author of this quote. Influenced by the Russian constructivists, Moholy-Nagy did not believe that the art of the past was relevant to modern times, but through the use of machines man could forge a new language to represent his own day and age. Ironically, he never considered himself a photographer, but rather a painter. In Berlin he became acquainted with Lissitzky and accepted a position teaching at the Bauhaus, where he became founder and director of the photographic department. "Chairs at Margate" is both humorous and ponderous, playing with negative and positive space by juxtaposing empty chairs photographed on the diagonal with occupied seats in horizontal rows photographed from above and behind. "Sailing" defies logical perspective and shows a figure, photographed from below, perched on a ladder on a ship's mast, right foot precariously aloft as if the figure itself is about to set sail without the boat.

László Moholy-Nagy
American,
b. Hungary,
1895–1946

Chairs at Margate,
1935

Gelatin silver print
diptych
MUSEUM PURCHASE,
EX-COLLECTION
SYBIL MOHOLY-NAGY
81:2163:0006

(left)
László Moholy-Nagy

Sailing, 1926

Gelatin silver print
MUSEUM PURCHASE,
EX-COLLECTION
SYBIL MOHOLY-NAGY
81:2163:0046

László Moholy-Nagy
American,
b. Hungary,
1895–1946

Photogram, 1939

Gelatin silver print
MUSEUM PURCHASE,
EX-COLLECTION
SYBIL MOHOLY-NAGY
81:2163:0016

Moholy-Nagy called his photomontages "fotoplastiks," referring to what he viewed as the pliant nature of the medium. In "Massenpsychose" (page 518) the sense of unease is a reflection of the tumultuous political climate in Germany and the vulnerable status of the artist in relation to it. There is a flayed human figure stands, encroached upon by his own menacing shadow and threatened by a woman wielding a rifle; above his head another figure with a pool cue takes aim at a group of women, huddled together in the same manner as the tribal group below. Standing watch over the entire composition is a uniformed military guard.

"Eifersucht" (page 519) is one of his most famous fotoplastiks, in which a smiling, athletic woman in a swimsuit is shadowed by the artist himself. A crouching woman framed within the artist's silhouette takes aim with a rifle at the two figures' hearts. The standing woman's

László Moholy-Nagy

Photogram, ca. 1924

Gelatin silver print
MUSEUM PURCHASE,
EX-COLLECTION
SYBIL MOHOLY-NAGY
81:2163:0014

expression belies the underlying menace; through repetition of silhou-
ettes and figures and an economy of graphic design, Moholy-Nagy's
desire, coupled with jealous regard, is palpable.

Although the basic principle of the photogram process was employed
by some of photography's earliest practitioners such as William Henry
Fox Talbot and Anna Atkins, many consider that, along with El Lissitzky
and Man Ray, Moholy-Nagy was one of its inventors. "The organization
of light and shadow effects produce a new enrichment of vision," he
wrote about one of his photograms. Although certain visual elements
appear familiar, the overall effect is dynamic and completely abstract.
Advocating a "New Vision" in photography, Moholy-Nagy wrote: "... it
cannot be too plainly stated that it is quite unimportant whether pho-
tography produces 'art' or not. Its own basic laws, not the opinions of
art critics, will provide the only valid measure of its future worth."

The 80 works by Moholy-Nagy in the Eastman House collection are an important holding, most of them acquired from the artist's second wife, Sybil Moholy-Nagy.

A Bauhaus colleague of Moholy-Nagy, Herbert Bayer was initially interested in typography and graphic design. "Just as typography is human speech translated into what can be read, so photography is the translation of reality into a readable image," Bayer maintained. "Photography presents above all a document. It was false to overlook the new possibilities. We must adopt it, and put it to work, like pigment and brush. The control is not in the manipulation of the brush, but in the complete technical realization of what is seen." He took up photography, in part, to explore the geometry found in natural forms that could be recorded with the camera. He, too, experimented with photomontage and collage. "Legs in Sand" and "Riding a Bicycle" were both made during Bayer's Bauhaus tenure. The former radically crops the figure sitting in the sand just below the waist; the tanned legs disembodied are like found sculpture of another order. The bicycle handlebar and light, photographed from above and dramatically cropped, animate the vehicle as it seems to race along the road without its rider.

Germaine Krull studied photography in Munich before opening a portrait studio in Berlin. She also made photographs of architecture and industry; cranes, ships, machinery, and vertical lift bridges were her subject matter. She became acquainted with André Kertész and with Man Ray, who told her, "Germaine, you and I are

Herbert Bayer
American, b. Austria,
1900–1985

Legs in Sand, 1928

Modern gelatin silver print from the original negative
78:0071:0109MP

Herbert Bayer

Riding a Bicycle,
ca. 1925

*Modern gelatin silver
print from the original
negative*
78:0071:0133MP

the greatest photographers of our time, I in the old sense and you in the modern one." Having moved to Paris, fascinated by metal constructions and desiring to portray their power, strength, and precision, Krull photographed the Eiffel Tower as an assignment for *Vu* magazine. She published 64 of those images as the book *Métal* (page 524). Both the photograph of the tower and the graphic typography of *Métal*'s cover evoke the dynamic movement of steel harnessed and shaped into complex geometric art. As Florent Fels wrote in the book's preface, "From above, it appears that one disengages a bit from terrestrial contingencies. One glides in thought along the length of the tower right up to the point of her sister the shadow which lies like the stylus of a sundial." The museum's Menschel Library contains this and eight other books by Krull.

John Heartfield was a painter and cofounder of the subversive Dada movement in Berlin, Germany, which was born just before the end of World War I. Born Helmut Herzfeld, he adopted the Anglicized name to protest the rabid German nationalism and Anglophobia that devel-

oped following Germany's defeat in World War I. The Dada artists were closely tied to the revolutionary political struggle; "Use Photography as a Weapon!" was their slogan. Photomontage would become the means through which the Dadaists disseminated their messages as posters, book jackets, illustrations, and propaganda. It is they who are credited with coining the word *photomontage*. Heartfield taught himself, cutting up photographs and reassembling them to create images with highly charged political content. After joining the German Communist Party, Heartfield's imagery became more strident. "Diagnose," reproduced in the antifascist magazine *AIZ* (*Arbeiter Illustrierte Zeitung,* or *Worker's Illustrated Newspaper,* which also published Modotti's work), is a biting attack on those who, blindly following orders, made up the Nazi party; the text under the image reads: "How did the man get this curvature of the spine?" "That is the organic result of the endless 'Heil Hitler!'" Altogether, Heartfield published 237 relentlessly satirical photomontages in *AIZ* between 1930 and 1938.

Germaine Krull
French, 1897–1985

Cover of *Métal,*
ca. 1929

Photomechanical
reproduction
MUSEUM PURCHASE
LIBRARY COLLECTION

John Heartfield
(Helmut Herzfeld)
German, 1891–1968

Diagnose (Diagnosis), ca. 1935

Rotogravure print
MUSEUM PURCHASE,
EX-COLLECTION
BARBARA MORGAN
76:0076:0027

„Wodurch zog sich der Mann denn die Rückgratsverkrümmung zu?"
„Das sind die organischen Folgen des ewigen »Heil Hitler!«"

Fotomontage: John Heartfield

Frantisek Drtikol
Czechoslovakian,
b. Bohemia,
1883–1961

Nude Study, ca. 1929

Platinum print
MUSEUM PURCHASE
76:0136:0001

Frantisek Drtikol wanted to be a painter, but his father chose photography for his vocation. After working in various studios in Europe, Drtikol opened his own studio in 1907. He flourished as a landscape and portrait photographer influenced by the symbolist and Art Nouveau styles while employing pictorialist techniques and media. He began his nude studies around 1914, among the first ever made in Bohemia, developing a dynamic style relating the female form to purely geometric arcs drawn by light and shadows. Gradually, Drtikol approached a more modernist style. "Nude Study" equates the curves of a woman's slender body with the two arched forms that balance the right half of the composition. An earlier work, "The Bow," shows an elongated figure draped across an arc, the woman's body conforming to the shape and becoming a part of it. "Composition" is among the most dynamic; the posing figure activates the image, her forward thrust echoed by the sweeping lines of the background.

Frantisek Drtikol

The Bow, 1921

Pigment print
GIFT OF MRS.
ALEXANDER
LEVENTON
83:2424:0004

Frantisek Drtikol

Composition, 1929

Pigment print
GIFT OF DR. E. P.
WIGHTMAN
83:0454:0001

André Kertész
American,
b. Hungary,
1894–1985

Mondrian's Pipe and Glasses, Paris, 1926

Gelatin silver print
MUSEUM PURCHASE
80:0805:0002

Hungarian-born André Kertész moved to Paris in 1924. He met artist Piet Mondrian in 1926 and began a series of photographs of artists and their studios. "[I] instinctively tried to capture in my photographs the spirit of his paintings. He simplified, simplified, simplified," Kertész told a friend. He made a compelling portrait of Mondrian, photographing his pipe and two pairs of eyeglasses on a tabletop. In 1936 Kertész moved to New York, where he photographed from the window of his twelfth-floor apartment on Washington Square. He had adopted this high vantage point back in Hungary around 1913 or 1914. "July 9, 1978. No. 20" was made looking down on the rooftop of another building. The geometrically dynamic composition is punctuated by the figure of a woman lying on her stomach sunbathing below. These two photographs were made more than 50 years apart, evidence of Kertész's remarkable longevity and his continued ability to see things in a new way.

André Kertész

July 9, 1978. No. 20, 1979

Gelatin silver print
MUSEUM PURCHASE
80:0806:0002

Florence Henri
American, 1893–1982

Composition No. 10,
1928

Gelatin silver print
MUSEUM PURCHASE
73:0241:0001

In 1927 Florence Henri studied photography at the Bauhaus under Moholy-Nagy and became friends with Bayer and his wife, photographer Irene Bayer. Afterwards, Henri established a studio in Paris. Explaining her unapologetically formalist aesthetic, Henri said: "What I want above all in photography is to compose the image as I do with paintings. It is necessary that the volumes, lines, the shadows and light obey my will and say what I want them to say." Her still life "Composition No. 10" of a mirror, ring, and ball is compelling for the way in which shapes become doubled and redefined by intersecting with seams and bending with angles. Mirrors became an integral element in Henri's work. Reminiscent of Alvin Langdon Coburn's Vortographs (see page 425), she described her attraction to the device: "I use mirrors to introduce the same subject seen from different angles in a single photograph so as to give the same theme a variety of views that complete each other and are able to expound it better by interacting with each other."

Man Ray began his career as a commercial artist and painter in New York. There he visited Stieglitz's 291 Gallery, where he was exposed to

the cutting edge of modern European art. Under Stieglitz's guidance Man Ray taught himself photography and initially employed it because he could find no one to make satisfactory photographic reproductions of his paintings. After meeting Marcel Duchamp, who became his collaborator and lifelong friend, he moved to Paris, where he connected with the Dadaists. Man Ray set up a portrait studio and quickly made his name as the premier portrait photographer, especially of artists and intellectuals – the movers and shakers of Parisian intellectual life. Soon his circle of acquaintances and interests turned to surrealism. Man Ray's photograph "Typewriter" evidences the surrealist primacy of the object itself. "... I ask you, how can we ever get together on the question of beauty?... [T]he Artist, even when copying another, works under the illusion that he is covering new ground which he imagines no one has

**Man Ray
(Emmanuel
Rudnitzky)**
American,
1890–1976

Typewriter, ca. 1925

Gelatin silver print
MUSEUM PURCHASE
WITH NATIONAL
ENDOWMENT FOR
THE ARTS SUPPORT
74:0140:0001

covered before him. He is then necessarily discovering a new beauty which only he can appreciate, to begin with ... *the success with which the Artist is able to conceal the source of his inspiration, is the measure of his originality.*" Indeed, the typewriter, a tool of language, proved irresistible to Modotti and Steiner.

Not long after relocating to Paris, Man Ray began experimenting with the photogram. According to his autobiography, he discovered the technique by accident while working in the darkroom. Dadaist Tristan Tzara, a frequent collaborator, dubbed them "Rayographs" after him. As Tzara wrote: "When everything we call art has become thoroughly arthritic, a photographer ... invented a force that surpassed in importance all the constellations intended for our visual pleasure. ... It is a spiral of water or the tragic gleam of a revolver, an egg, a glistening arc or the floodgate of reason, a keen ear attuned to a mineral hiss, or a turbine of algebraic formulas?" Man Ray

Man Ray (Emmanuel Rudnitzky)
American, 1890–1976

Rayograph, 1950

Gelatin silver print photogram
MUSEUM PURCHASE
81:1662:0002

continued to make photograms throughout his career; this example (left) was made while the artist was living in Los Angeles. Although Man Ray believed the individual components used to create the image were irrelevant, the recognizable shape of binoculars utilized here was surely a sly reference to the distinctions between human and photographic vision.

The Sabattier effect was another photographic technique that Man Ray utilized and would become a signature of his work. Though often misidentified as solarization, the Sabattier effect occurs when a photographic print is exposed to light during the development process. This produces a partial reversal of tones, particularly in the highlight areas. This, too, Man Ray claimed to have come upon by accident in the darkroom. When applied to a portrait, the effect is to create a psychological landscape, essentially endowing the subject with a visible aura.

Man Ray (Emmanuel Rudnitzky)

Solarization, 1929

Solarized gelatin silver print
MUSEUM PURCHASE, EX-COLLECTION MAN RAY
81:1662:0001

**Brassaï
(Gyula Halasz)**
French, b. Hungary,
1899–1984

Streetwalker, Place
d'Italie, ca. 1932

Gelatin silver print
77:0749:0012

Brassaï, né Gyula Halasz, got his start in photography with Kertész's
assistance around 1930. In his 1976 publication *The Secret Paris of the
30's*, the Hungarian painter-writer turned photographer Brassaï wrote in
the chapter "Ladies of the Evening": "In the thirties, the rue Quincam-
poix had [a] specialty: it was full of fat girls. ... Contrary to the mobility
streetwalkers usually display, they waited, immobile and placid, along
the sidewalk like a row of caryatids. ... One day I took a room in a hotel
across the street and watched from my window these odalisques and
the men who would stroll past them ten or more times ... before stop-
ping in front of their choice." "Fille de joie Quartier les Halles" is one of
two views of a woman which Brassaï published alongside this text. The
image subverts the coquettish fantasy image of the prostitute, revealing
instead the slow banality of the profession. His portrait of the prostitute
supports his later statement: "I invent nothing, I imagine everything.
I have never looked for subjects that are exotic or sensational in them-
selves. Most of the time I have drawn my images from the daily life
around me. I think that is the most sincere and humble appreciation
of reality, the most everyday event leads to the extraordinary." "La
Maison que j'habite, ma vie, ce que j'écris," a photograph of crystal
formations, was published in André Breton's 1937 surrealist novel
L'Amour Fou.

**Brassaï
(Gyula Halasz)**

La maison que
j'habite, ma vie,
ce que j'écris (The
House Where I Live,
My Life, That Which
I Write), 1937

*Photomechanical
reproduction*
LIBRARY COLLECTION

Claude Cahun was an artist, writer, poet, and leftist activist involved with the surrealist movement in Paris. Much of her photographic work relies on photocollage; frequently she photographed herself, reconstructing her image through explorations of gender and identity both personal and political. Although little is known about her, her work is found in two publications. *Aveux non avenus* (*Unavowed Confessions*), published in 1930, is an illustrated literary work, and she also lent her photographs to *Le coeur de pic*, a book of poems by Lise Deharme. Both images here were included in *Aveux non avenus;* visually and thematically complex, both have a disturbing, fractured quality to them.

In "Cards, Chessboard, Hands" Cahun plays with notions of gender relationships through the metaphor of games. Serious card players know that spades, on which a masculinely dressed figure labeled Pallas (another name for Athena, the goddess of wisdom) appears, rank higher than hearts (a symbol of love), on which an androgynous female figure is superimposed. Conversely, the grinning chess "king" is shown falling off the board, shadowed by a cigar-smoking figure, presumably the "player," that presides over the proceedings. Finally, a female hand wearing a band on the ring finger stays a provocatively gloved hand that attempts to reveal the markings on the card lying face down on the chessboard. Cahun's image is heavily coded with subtext.

An ambiguous, ominous inscription in the upper left corner of "Portrait de Mademoiselle X" reads: "Here the executioner takes on the airs of a victim. But you know what to believe. Claude." She includes many images of herself: being strangled; behind prison bars on which there is a heart-shaped keyhole; her lips

Claude Cahun
(Lucy Schwob)

Portrait de Mademoiselle X, 1930

Photogravure print
MUSEUM PURCHASE
LIBRARY COLLECTION
85:1406:0006

superimposed on the petals of a flower that is, in fact, losing its petals, evoking the "she loves me, she loves me not" game. It also includes images that evoke the "hear no evil, see no evil, speak no evil" maxim. Given that the Nazis arrested Cahun and her female lover for "subversive" activities, it is reasonable to read this image as a commentary on their persecuted lesbian relationship. The Menschel Library is fortunate to have a copy of her important, evocative publication.

Cahun's provocative work is a counterbalance to the misogynistic overtones in Hans Bellmer's images of female doll bodies. A student of drawing and typography, Bellmer was largely self-taught in photography. He started the doll series around 1934, when these two images were made, in part as sculpture. Photography added another element to these explorations of psychology and form. In 1947 he published a book of 15 of the images, *Les jeux de la poupée*, with poems by Paul Eluard. Bellmer used dolls that could be taken apart and reassembled; as he described it: "As in a dream, the body can change the centre of gravity of its images. Inspired by a curious spirit of contradiction, it can add to one what it has taken from another: for instance, it can place the leg on top of the arm, the vulva in the armpit, in order to make 'compressions,' 'proofs of analogies,' 'ambiguities,' 'puns,' strange anatomical 'probability calculations.'" The photographs were hand-colored with

Hans Bellmer
French, 1902–1975

The Doll, ca. 1934

Gelatin silver print with applied color
MUSEUM PURCHASE, ALVIN LANGDON COBURN FUND
LIBRARY COLLECTION
82:1894:0006

lurid hues of green and pink. As dolls are the playthings of little girls, the suggestion of sexuality and violence directed at and coming from the subject is disturbing and never fully resolved in Bellmer's work.

In one image, the parts are assembled to suggest the doll is seated on a chair, facing the viewer. Its disheveled blond hair is lewdly suggestive; the face is almost swallowed up by the enormous, bulbous breasts, and the torso is defined by swollen labia that protrude from between the legs. There are no arms, and the

doll's only visible eye is a heavy-lidded blank space. Eluard's poem accompanying this image reads: "You never hear her talk of the country, of her parents. She is afraid of a negative reply, she fears the kiss of a silent mouth. Agile and liberated, gentle mother-child, she demolishes the cloaks of the walls which surround her and paints daylight in her own colours. She frightens animals and children. She turns cheeks paler and the grass a more cruel green." The implication through text and photograph is that the doll is the antagonist in a narrative; Bellmer is Humbert Humbert with a camera.

"Born with the photographic feeling" is how André Kertész described himself, Käsebier, Stieglitz, White, and Manuel Alvarez-Bravo. Alvarez-

Hans Bellmer

The Doll, ca. 1934

*Gelatin silver print
with applied color*
MUSEUM PURCHASE,
ALVIN LANGDON
COBURN FUND
LIBRARY COLLECTION
82:1894:0005

Manuel Alvarez-Bravo
Mexican, b. 1902

Gorrion, Claro
(Bright Sparrow),
ca. 1938–1940

Gelatin silver print
GIFT OF FREDERICK
MYERS
78:0637:0013

(right)
Manuel Alvarez-Bravo

El umbral (The
Threshold), 1947

Gelatin silver print
GIFT OF FREDERICK
MYERS
78:0637:0014

Bravo was born in Mexico City, the grandson of a photographer. He studied painting and music before taking up photography and was acquainted with Weston and Modotti. "Gorrion, Claro" is an image of a semi-nude young woman lying on a rooftop delineated by uneven lines of white paint. "El umbral" depicts a woman's feet as they hesitate, almost dancing, over puddles on the ground. Because of the deep, rich black tonality in the print, the identity of the liquid is not clear; it could be water, it could be urine, or it could be blood. The ambiguity adds an ominous element to the photograph, encouraging the viewer to construct his or her own meaning. Both images are like dream states, simultaneously representing the familiar and the unexpected. "The invisible is always contained and present in a work of art which recreates it. If the invisible cannot be seen in it, then the work of art does not exist," he explained. Alvarez-Bravo is the most famous Latin American photographer in the medium's history, his career spanning more than 70 years. The Eastman House collection includes 62 prints of his pioneering work.

Photography Sells

After World War I Edward Steichen returned to civilian life disheartened by the horrors of armed conflict. Unwilling to continue making art in his prewar manner, Steichen pursued ways to make photographs that could be expressive of the new age. From 1919 to 1921 he worked incessantly to increase his understanding of the physical and conceptual properties of the medium. Wanting to learn, as he said in *A Life in Photography*, "... a method of representing volume, scale, and a sense of weight," Steichen created images such as "Pears and an Apple" in which the straightforward presentation of the subject lifts the image into the realm of abstract form. He further reasoned that "... if it was possible to photograph objects in a way that makes them suggest something else entirely, perhaps it would be possible to give abstract meanings to very literal photographs." Thus he began to construct images using simple, everyday objects, which functioned as symbols representing abstract concepts such as Einstein's Theory of Relativity, about which he made the photograph "Space-Time Continuum." Ultimately, Steichen felt that he was less successful with this approach, but it led him to a close study of natural forms and patterns of growth that held his attention for the rest of his life. Many photographers,

Edward J. Steichen
American, b. Luxembourg, 1879–1973

Pears and an Apple, 1920

Gelatin silver print
BEQUEST OF EDWARD STEICHEN BY DIRECTION OF JOANNA T. STEICHEN
79:2024:0006

Edward J. Steichen

Space-Time Continuum, 1920

Palladium and ferroprussiate print
BEQUEST OF EDWARD STEICHEN BY DIRECTION OF JOANNA T. STEICHEN
79:2487:0002

Edward J. Steichen
American, b. Luxem-
bourg, 1879–1973

Camel Cigarettes,
ca. 1927

Gelatin silver print
BEQUEST OF EDWARD
STEICHEN BY DIREC-
TION OF JOANNA
T. STEICHEN
79:2408:0001

particularly in Europe (e. g., the surrealists), would continue to create
similar experimental photographs over the next two decades.

In 1980 Joanna Steichen, widow of Edward Steichen, directed a be-
quest of the photographer to deposit a collection of his photographs
with the museum. More than 3,000 images made up this gift, which
augmented an existing collection of works by the photographer, as well
as 1,000 pictures taken during World War II when Steichen directed a
photographic team for the U. S. Navy. The museum's Menschel Library
holds copies of all books written or illustrated by Steichen including an
original set of *Camera Work* magazine, which contains many high-quality
photogravure reproductions of his early pictorialist work. Over 180 of
the prints in the bequest are advertising photographs.

In 1925 Steichen returned to New York City from Europe, where he
began working as a commercial photographer for Condé Nast publica-
tions and for the J. Walter Thompson advertising agency, whose clients

included the Eastman Kodak Company and the Steinway Piano Manu-
facturing Company. He established an identifiable personal style in his
commercial photography. Essentially, he did this through two related
strategies. First, he hardened his focus, immediately placing his imagery
in the camp of the modernists and rejecting the older pictorialist soft-
focus imagery that was dominating high-fashion photography at the
time. Then he attempted to lend an air of naturalism to the advertise-
ments by choosing models and depicting situations that seemed to be
based in the real world. Steichen's interest in formal values kept break-
ing through, and there are few photographs in which the compositional
relationship of light, pattern, and form is not meticulously considered.

In 1926 Steichen was invited to do a series of designs for silk fabrics.
He chose ordinary household items, such as thumbtacks and matches
(a radical choice at the time), as subjects for semiabstract photographs.
The later "Camel Cigarettes" advertisement (page 544) utilized the

Edward J. Steichen

*Steinway and Sons
Piano Advertisement,*
ca. 1936

Gelatin silver print
BEQUEST OF EDWARD
STEICHEN BY DIREC-
TION OF JOANNA
T. STEICHEN
79:2411:0002

Edward J. Steichen
American, b. Luxembourg,
1879–1973

Paul Robeson in
"The Emperor Jones," 1933

Gelatin silver print
BEQUEST OF EDWARD STEICHEN BY
DIRECTION OF JOANNA T. STEICHEN
79:2322:0001

(above)
Edward J. Steichen

Martha Graham, 1931

Gelatin silver print
BEQUEST OF EDWARD STEICHEN BY
DIRECTION OF JOANNA T. STEICHEN
79:2184:0003

Edward J. Steichen
American, b. Luxembourg, 1879–1973

Marlene Dietrich,
1932

Gelatin silver print
BEQUEST OF EDWARD
STEICHEN BY DIREC-
TION OF JOANNA
T. STEICHEN
79:2143:0001

same strategy, and the very look of the ad would have shouted "avant-garde sophistication" to its viewer in the late 1920s.

In 1925 Steichen was hired by Condé Nast to make celebrity portraits for *Vanity Fair* magazine and fashion photographs for *Vogue*. These two magazines held indisputable reign over the world of high fashion, high society, and the "smart set" from the 1910s until World War II. Society figures, theater and film actors, authors, noted artists, and even political figures all came to Steichen to be photographed for these magazines, until he closed his studio in 1938.

In 1925 Steichen also began photographing with electric studio lights for the first time, and, as the images reproduced here illustrate, he developed a more theatrically inspired approach. How far Steichen moved from his pictorialist past is evident when his bold portraits of Paul Robeson and Martha Graham (pages 546 and 547) are compared

with his reserved soft-focus portraits of himself and Eleanora Duse (pages 394 and 395). Driven by the commercial mandate to be timely and to make photographs with "impact" (the byword of 1920s advertising photography), Steichen's photographs assumed a more stylized presentation. He infused his commercial work with the progressive ideals of design drawn from the major art movements of the day, including the streamlined forms of Art Deco and the elemental constructions of cubism. Steichen was held in high regard by his contemporaries, his background and work, encompassing numerous photographic genres, brought a cachet to the medium, thus elevating the status of commercial photography and its practitioners. In a nation reeling from the horrors of the Great Depression, and where ironically the illusion of celebrity and style played an ever more dominant role, the photographer's reputation became increasingly important in selling photographs.

Edward J. Steichen
American, b. Luxembourg, 1879–1973

Steichen's Pond from the Porch of His House, 1957

Color print, chromogenic development process
BEQUEST OF EDWARD STEICHEN BY DIRECTION OF JOANNA T. STEICHEN
79:2497:0167

In 1910 Steichen began breeding delphiniums, an activity he continued on his estate in Connecticut throughout the 1930s. Flowers were a passionate interest of his, keeping him "... in contact with nature, and [his] hands in contact with the soil. ..." In 1936 Steichen exhibited his hybrid delphiniums at the Museum of Modern Art. During World War II, Steichen's ties with that museum strengthened as he directed several thematic exhibitions for the institution. After the war, at age 67 he was hired as director for the museum's department of photography, a position he held for the next 15 years.

In the mid-1950s Steichen decided to photograph again, limiting himself to what could be seen from the windows of his home in Redding, Connecticut. This soon turned into a self-assigned project of several years' duration. He compiled a series of photographs focused on a shadblow tree he had planted. This, in turn, transmuted into a motion picture film project, documenting the changing seasons, climates, and moods mirrored by this small tree set by a small pond. The museum owns 24 color prints of his delphiniums as well as over 350 negatives, snapshots, and prints from the shadblow tree group.

Edward J. Steichen

Delphiniums, 1940

Color print, dye imbibition process
BEQUEST OF EDWARD STEICHEN BY DIRECTION OF JOANNA T. STEICHEN
79:2474:0005

Cecil Beaton's images of an elegant and pampered upper class were taken in the 1930s, at a time when the world suffered the terrible dislocations of an economic depression and the lines of the British social order were being radically redrawn. Sir Cecil Beaton, born to a middle-class family in England, learned to sketch and paint at Harrow, then took up photography at St. John's College, Cambridge, before leaving without a degree in 1925. After some false starts in business, Beaton began a career as a portraitist, where he was "taken up" by Edith Sitwell and introduced to high society, and in the late 1920s, to the world of high fashion.

Beaton was first hired by the British *Vogue* magazine as a cartoonist, but soon began photographing for them as well as for the American and French editions of *Vogue* after 1928. Beaton was competing against already well-established fashion photographers such as Edward Steichen in New York City and George Hoyningen-Huene in Paris, but soon he developed an eccentric style of presentation that helped establish his own photographic identity. Readily admitting the influences of Man Ray and Francis Bruguière, Beaton's photographs were busy, cluttered, richly varied, filled with incongruities, and with enough visual references to surrealism to lend them an air of artistic seriousness. This brash pastiche seemed to fit the age; his inventive, witty, and very stylish

photographs caught on. Beaton himself would go on to become the most successful British society photographer, to write and illustrate almost 40 books, and to work in costume and set design for dozens of productions in both the theater and films, winning awards for *Gigi* and *My Fair Lady*. He received a knighthood in 1972, conferred on him by his most illustrious sitter, Queen Elizabeth II.

The museum holds nearly 25,000 images by Nickolas Muray in its collection, including photographic prints, negatives, transparencies, and advertising tear sheets. Most of the prints are black-and-white studio portraits of celebrities from the 1920s, when Muray maintained a studio in New York City's Greenwich Village. These are supplemented by approximately 60 color prints of film stars from the 1940s and 1950s, and about 300 color prints from advertising projects by Muray, including approximately 70 prints from when he worked for *McCalls Magazine* beginning in 1939. This collection provides the opportunity to look into the changing styles and techniques of a major American illustrative and advertising photographer who was working from the 1920s to the 1960s.

Nickolas Muray learned lithography, photoengraving, and photographic chemistry at a graphic arts school in Hungary before immigrating to New York City in 1913, where he quickly obtained a job as a

Nickolas Muray
American,
b. Hungary,
1892–1965

Nick and Eva
LeGallienne, ca. 1927

Gelatin silver print
GIFT OF MRS.
NICKOLAS MURAY
83:2160:0001

(right)
Nickolas Muray

Gloria Swanson,
ca. 1922

Gelatin silver print
GIFT OF MRS.
NICKOLAS MURAY
77:0188:2809

(right)
Nickolas Muray

Babe Ruth, ca. 1927

Gelatin silver print
GIFT OF MRS.
NICKOLAS MURAY
77:0188:2448A

Nickolas Muray
American,
b. Hungary,
1892–1965

Babe Ruth
Holding Baseball,
ca. 1927

Gelatin silver print
GIFT OF MRS.
NICKOLAS MURAY
77:0188:2449

photoengraver for Condé Nast, the publisher of *Vogue* and *Harper's Bazaar* magazines. In 1920 he opened a portrait studio in his home in Greenwich Village while continuing to work as a photoengraver. In 1921 *Harper's Bazaar* asked him to do a celebrity portrait, and soon his portraits were being published in every issue of the magazine and his fashion and product photographs in a host of others. By 1925 Muray was an established celebrity photographer with a growing reputation. His early portraits, such as "Gloria Swanson" ca. 1922 (page 555), were photographed in a pictorialist style, with a softened focus that placed emphasis on form over line, balanced masses over depiction of detail, mood over information. Muray also learned the Carbro color process in the 1920s and became one of the first professionals to employ color in fashion and advertising photographs in the 1930s.

At a time when the nation was steeped in economic depression, and then war, advertising photography was used to sell the "American way of life." From the 1930s to the 1950s, advertising photography in the United States responded to nationalistic values that often went beyond the selling of a specific product, as in Muray's "McCalls Magazine,

Nickolas Muray
American,
b. Hungary,
1892–1965

*Woman in Cell,
Playing Solitaire,*
ca. 1950

*Color transparency,
chromogenic develop-
ment (Kodachrome)
process*
GIFT OF MRS.
NICKOLAS MURAY
83:0567:0151

(right)
Nickolas Muray

McCalls Magazine,
Homemaking Cover,
1939

*Color print, assembly
(Carbro) process*
GIFT OF MRS.
NICKOLAS MURAY
71:0050:0038

Homemaking Cover" (page 559). In this photograph, the idealized realm of middle-class domesticity is touted in a sharply focused, Carbro color tableau. This kind of presentation was a testament to the growing power of mass media to shape cultural attitudes.

For more than four decades, Victor Keppler was one of the United States' best-known advertising photographers. Largely self-taught in photography, he began his career in advertising in 1926 as a freelancer known to be able to tackle the most difficult commercial assignment. In fact, Keppler's trademark slogan, conferred upon him by an advertising agency, was "It *can* be done – call Keppler." One of the secrets to Keppler's success was his ability to adopt a modernist propensity for experimentation in order to create new looking, alluring images. His photograph of Martha Scott drinking coffee in an ad for Nescafe is a photomontage of sequenced vignettes with a narrative flow and constructed action similar to that found in motion pictures.

In the 1930s Keppler carved out a reputation as an innovator in color advertising photography, specifically the eye-riveting Carbro process. His "Woman in Convertible" is a spectacular achievement in which a

Victor Keppler
American,
1904–1987

Camel Cigarette Advertisement – Woman in Convertible, 1951

Color print, assembly (Carbro) process
GIFT OF 3M COMPANY, EX-COLLECTION LOUIS WALTON SIPLEY
77:0292:0027

(left)
Victor Keppler

Actress Martha Scott, Ad for Nescafe, 1946

Gelatin silver print
GIFT OF THE PHOTOGRAPHER
76:0241:0145

Victor Keppler
American,
1904–1987

Carter Corsets, 1938

Gelatin silver print
GIFT OF THE
PHOTOGRAPHER
76:0241:0209

(right)
Victor Keppler

Housewife in Kitchen, ca. 1940

*Color print, assembly (Carbro)
process*
GIFT OF 3M COMPANY,
EX-COLLECTION LOUIS
WALTON SIPLEY
77:0292:0011

dominant color and its corresponding hues playfully dazzle the viewer's eye while enticingly conveying the commercial message. The museum holds 1,300 black-and-white and color photographs, 12,000 proof prints and negatives by Keppler, as well as his studio account books.

In 1923 Australian-born Anton Bruehl viewed an exhibition of photographs by students of Clarence White. This chance encounter proved to be life-altering for him. Bruehl began studying with White, and by the decade's end, he, along with other students of White (including Ralph Steiner and Paul Outerbridge), were prominent New York advertising photographers. Like his contemporaries, Bruehl took many of White's teachings to heart, including releasing commercial illustration from the constraints of older pictorial conventions. This is evidenced in "Top Hats," an advertisement for Weber and Heilbroner, a men's apparel chain, in which modernist, clear-edged forms and a streamlined perspective set the stage for a fanciful and dynamic assembly line of elegant attire. The year this photograph was made, 1929, proved pivotal in Bruehl's career; not only did "Top Hats" win an elite advertising award, but his work was featured in the landmark *Film and Foto* exhibition in Stuttgart, Germany.

In the 1930s Condé Nast hired Bruehl as its chief color photographer, and in 1935 they published a

Anton Bruehl
American,
b. Australia,
1900–1982

Top Hats
*Ad for Weber and
Heilbroner,* 1929

*Modern gelatin silver
print from the original
negative*
76:0095:0016MP

Anton Bruehl

Dance from a Night-
club Act, ca. 1943

*Color print, dye
imbibition (Kodak
Dye Transfer) process*
MUSEUM PURCHASE
WITH NATIONAL
ENDOWMENT FOR
THE ARTS SUPPORT
75:0146:0001

brochure of his photographs with the almost embarrassingly frank title *Color Sells*. In fact, Bruehl's mastery of advanced color processes, as reproduced here in "Dance from a Nightclub Act" (page 565) a tableau for *Esquire* magazine, set his work apart from other color practitioners of his day, leading his editors to opine that "color is like dynamite – dangerous, unless you know how to use it."

Lejaren à Hiller started photographing in 1899, but wanted to be an artist. He studied at the Art Institute of Chicago and stated that "... photography paid most of the expenses during these years though I was fairly successful as an illustrator for American magazines." Hiller drew or painted more than 1,000 covers for *Munsey's Magazine* and scores of other popular illustrated magazines from about 1904 to 1914. By 1900 Hiller was attempting to convince magazine editors to let him make illustrations photographically rather than by hand, and eventually he was allowed to try. By 1915 his photographic illustrations had appeared in dozens of magazines from *Cosmopolitan* to the *Saturday Evening Post,* and he was widely credited with establishing what "... amounts to an entirely new field in picturemaking, to wit: Photographic Illustration."

The museum holds 390 items, including prints, 144 negatives, some lantern slides, and tear sheets by Hiller.

"Ambroise Paré" is one of 23 of Hiller's prints held by the museum from a series called *Surgery Through the Ages*. Consisting of approximately 200 images, this

series was created for the pharmaceutical company Davis and Geck from 1927 through 1950. These tableaux illustrate accomplishments or activities of personalities throughout the history of medicine. Used first in advertisements, on posters displayed in drugstores, and in well-printed gift portfolios for clients, 70 of the images were also published in a book in 1944. The poster design for the war bonds campaign was a departure for Hiller, not because his studio patriotically turned their publicity skills to war preparedness work during World War II (for every major studio did that), but because it is a photomontage. Almost all of Hiller's other incredibly complex images are carefully constructed studio tableaux.

The glamorous portrait of movie star Jean Harlow and the shocking character study "Human Relations, 1932" were taken by William Mortensen just a few years apart. From 1921 to 1930 Mortensen worked in Los Angeles, where he operated a portrait studio located at the Western Costume Company. There he worked as a still photographer for several film studios, photographing movie actors and extras in their film costumes and making publicity portraits. In 1932 he left this work to open the Mortensen School of Photography, teaching more than 3,000 students over the next 30 years. He also wrote nine books and numerous articles on photographic practice, technique, and theory, and became an influential spokesman for the

William Mortensen
American, 1897–1965

Jean Harlow, ca. 1927

Modern gelatin silver print from the original negative
GIFT OF 3M COMPA-
NY, EX-COLLECTION
LOUIS WALTON
SIPLEY
78:1643:0027MP

William Mortensen

Human Relations,
1932

Gelatin silver print
GIFT OF DR.
C. E. K. MEES
80:0479:0024

HUMAN·RELATIONS·1932

Arnold Newman
American, b. 1918

Kuniyoshi, 1942

Gelatin silver print
GIFT OF HAROLD
KAYE
80:0529:0014

(right)
Arnold Newman

George Grosz, 1942

Gelatin silver print
MUSEUM PURCHASE
73:0039:0005

late-pictorialist aesthetic. In his style, approach, and conception of the medium's uses and values, Mortensen stood in almost direct opposition to every tenet advocated by modernist photographers after 1920. In his own creative photography, Mortensen focused on "character studies." He presented basic human concepts by portraying them in elaborately costumed metaphorical or allegorical genre scenes, which he created by posing and photographing professional models, then manipulating his negatives or prints at will to achieve the graphic image he desired. The museum holds two portfolios comprising a total of 45 prints and 55 negatives by Mortensen from which the museum has made 43 prints.

These portraits of the Japanese-American still-life painter Yasuo Kuniyoshi and the expatriate German artist George Grosz were taken by Arnold Newman in 1942, during a period of intense creativity for this young artist still uncertain about choosing photography as a profession. Yet these early portraits reveal what would become the hallmark of

Arnold Newman
American, b. 1918

Dr. J. Robert
Oppenheimer, 1948

Gelatin silver print
GIFT OF HAROLD
KAYE
80:0529:0001

Newman's approach to portraiture: beautiful composition, an inclina-
tion for formal, clear-eyed perspectives, and an intuitive ability to elicit a
sitter's personality. As was his habit, Newman located his sitters in their
own living or work spaces, which added a degree of psychological depth
to his portraits. The personalities of Kuniyoshi and Grosz, and even a
sense of each man's artistic style, are intimated in the ways in which
Newman has related the pose of the figures to the character of their inti-
mate surroundings. This kind of presentation, and Newman's work in
particular, led to the coining of the term "environmental portraiture."

Newman acknowledges as early influences the photographs he saw in *Vanity Fair* and the work of the Farm Security Administration (FSA) photographers, particularly Walker Evans. For a celebrity photographer to study earlier work from *Vanity Fair* was to learn about historical precedents, but Newman's interest in the FSA photographers led him to infuse his work with a quiet humanity. Throughout the 1930s and 1940s the FSA photographers were the most visible and clearly defined practitioners of socially committed documentary photography in America. Their purpose was to present a more human picture of social problems in the hope of bringing about social and political change. Newman's work displays a similar seriousness of purpose – a respect for the dignity of the sitter. Eschewing the conventional presentation of celebrity fixed on glamour and fame, Newman prized the portrait that presented not the fleeting illusions of celebrity, but the enduring and defining features of an individual's character and life. Since the 1940s Newman has been recognized as one of the world's leading portraitists. The museum holds 222 photographs by Arnold Newman, with more than a third drawn from the first decade of his career.

Arnold Newman

Igor Stravinsky at Rehearsal, New York City, 1966

Gelatin silver print
GIFT OF THE
PHOTOGRAPHER
92:1036:0027

Public Record

Lewis Wickes Hine
American,
1874–1940

Young Russian
Jewess, Ellis Island,
1905

Gelatin silver print
GIFT OF THE PHOTO
LEAGUE, NEW YORK,
EX-COLLECTION
LEWIS WICKES HINE
77:0177:0148

"Young Russian Jewess" and "Italian Family on Ferry Boat" are photographs of immigrants at Ellis Island, the entry port into the United States for millions of immigrants at the turn of the century. In 1904 Lewis Wickes Hine, a teacher at the progressive Ethical Culture School in New York City, began to make photographs of immigrants as part of the school's teaching program. He continued to photograph at Ellis Island until 1909 and returned there after he became a professional photographer. The museum holds over 100 images of Ellis Island immigrants in its collection. These are among its collection of 3,800 negatives and over 6,000 prints by Hine.

At the turn of the century, the United States was experiencing a period of Progressive social reform that permeated almost every layer of educated thought in the country, ranging from social and educational theory to political reform in all levels of government. Hundreds of public and private agencies and organizations were established to confront the social problems arising from the new industrialized urban environment. This new social activism found its voice in pursuits as diverse as putting flower pots in tenement windows to the work of international organizations such as the Red Cross and the Salvation Army. Through exhibitions and publications, reform issues became a major focus in hundreds of illustrated magazines that were flourishing at this time. Educators, agencies, and organizations wanted to document their charitable and social activities, and the popular press provided an active market for socially concerned documentary photographs.

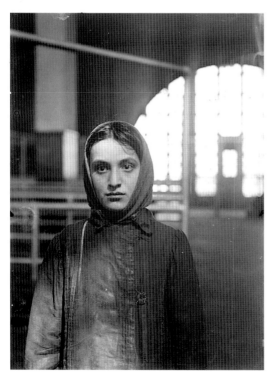

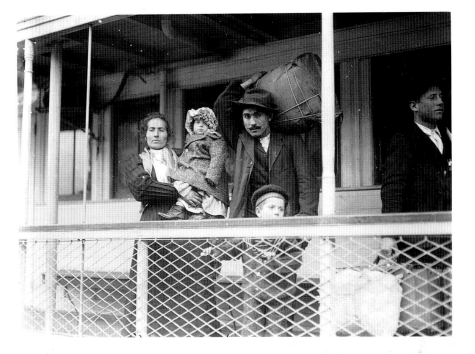

Lewis Wickes Hine

Italian Family on Ferry Boat, Leaving Ellis Island, 1905

Gelatin silver print
GIFT OF THE PHOTO LEAGUE, NEW YORK, EX-COLLECTION LEWIS WICKES HINE
77:0177:0169

Encouraged by fellow educators and sociologists, Lewis Hine, who had obtained a degree in Education from New York University in 1905, gave up the relative security of a teaching position for the life of a documentary photographer. His work at Ellis Island, followed by studies of tenement life in New York City, earned Hine high regard from social activist groups eager for photographic illustrations to support their causes.

In 1906 Hine began working for the *Charities and the Commons* magazine as well as for the National Child Labor Committee (NCLC) and other social organizations. From 1908 to 1918, he made many photographic trips on behalf of the NCLC, documenting children at work on farms and in factories, textile mills, and mines. He would then furnish his images for exhibitions, lectures, and a wide variety of publications. Hine instinctively understood the persuasive power of photographs as illustrative documents that, when united with explanatory text, provided in his words, a "... lever... for the social uplift."

In 1918 Hine left the National Child Labor Committee and was hired

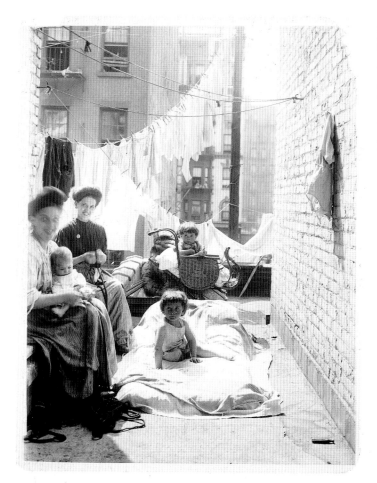

(right)
Lewis Wickes Hine

Street Play in the
Early Days – N.Y.,
1910

Gelatin silver print
GIFT OF THE PHOTO
LEAGUE, NEW YORK,
EX-COLLECTION
LEWIS WICKES HINE
78:1027:0047

(right)
Lewis Wickes Hine

Playground in Mill
Village, 1909

Gelatin silver print
GIFT OF THE PHOTO
LEAGUE, NEW YORK,
EX-COLLECTION
LEWIS WICKES HINE
78:1028:0060

Lewis Wickes Hine
American, 1874–1940

N.Y. Tenement Family
Gets Fresh Air on
a Hot Day, ca. 1910

Gelatin silver print
GIFT OF THE PHOTO
LEAGUE, NEW YORK,
EX-COLLECTION LEWIS
WICKES HINE
78:1026:0002

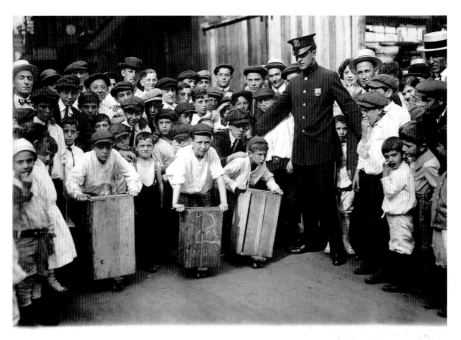

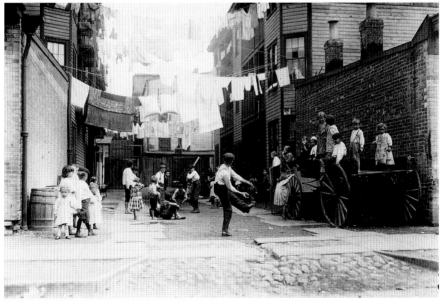

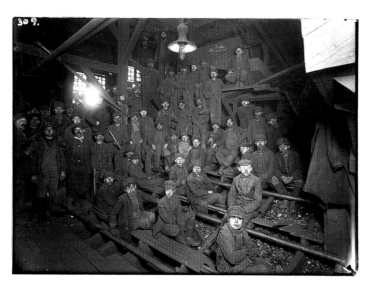

Lewis Wickes Hine
American,
1874–1940

Breaker Boys in
Coal Chute, South
Pittston, Penn-
sylvania, 1911

*From a gelatin on
glass negative*
GIFT OF THE PHOTO
LEAGUE, NEW YORK,
EX-COLLECTION
LEWIS WICKES HINE
85:0081:0021

Lewis Wickes Hine

Spinner Girl,
ca. 1908

*From a gelatin
on glass negative*
GIFT OF THE PHOTO
LEAGUE, NEW YORK,
EX-COLLECTION
LEWIS WICKES HINE
85:0079:0021

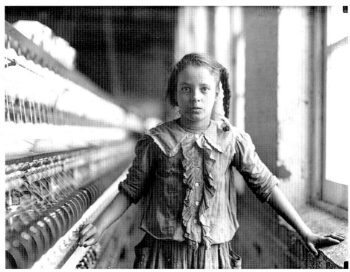

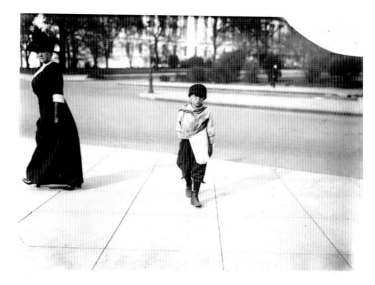

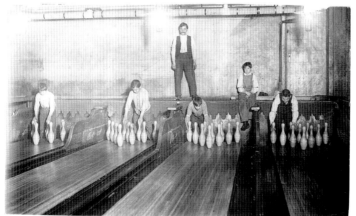

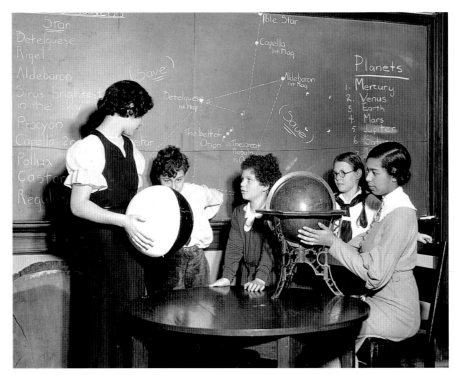

Lewis Wickes Hine
American, 1874–1940

Finding Out What
Caused That Recent
Eclipse, Ethical Culture
Schools, ca. 1935
Gelatin silver print
GIFT OF THE PHOTO
LEAGUE, NEW YORK,
EX-COLLECTION LEWIS
WICKES HINE
78:1016:0001

Lewis Wickes Hine

Health. Children
under Sunlamps,
ca. 1925
Gelatin silver print
GIFT OF THE PHOTO
LEAGUE, NEW YORK,
EX-COLLECTION
LEWIS WICKES HINE
78:1042:0117

by the American Red Cross (ARC) to photograph the devastation caused by World War I in Europe. For two years, Hine documented the ARC relief efforts, providing promotional images for their activities abroad. Following his work in Europe and for the next two decades, Hine obtained smaller assignments from a variety of educational and social agencies.

From 1904 to 1920, Hine's photography focused on the human predicament in the industrialized world, which gave his work a deeply humanistic cast based on social reform. In later years, Hine's photography underwent a substantial change, in large part due to the nature of his clients whose assignments had more to do with promotional documentation of an agency's programs than revealing social ills. For example, in "Finding Out What Caused That Recent Eclipse ..." and "Student Hairdressers, Bordentown School," (page 582) Hine created photographs that illustrated the organizations' activities and accomplishments, depicting the children as clients, there to receive services.

It is abundantly clear from his writings, his personal history, and his

Lewis Wickes Hine
American,
1874–1940

Kindergarten
Students with
Hammers, ca. 1930

Gelatin silver print
GIFT OF THE PHOTO
LEAGUE, NEW YORK,
EX-COLLECTION
LEWIS WICKES HINE
78:1021:0030

Lewis Wickes Hine

Student Hair-
dressers, Borden-
town School,
ca. 1935

Gelatin silver print
GIFT OF THE PHOTO
LEAGUE, NEW YORK,
EX-COLLECTION
LEWIS WICKES HINE
78:1020:0020

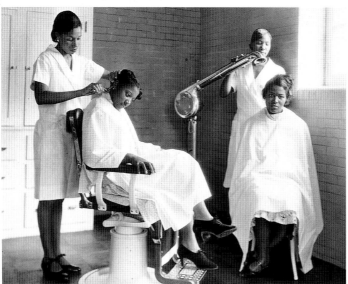

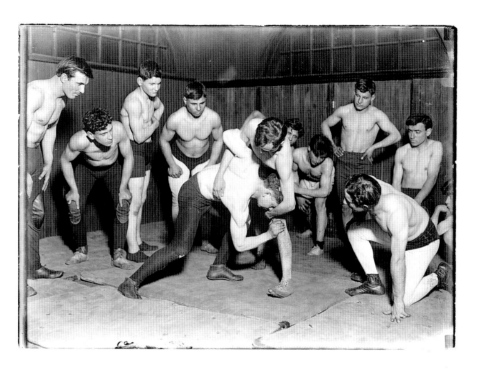

Lewis Wickes Hine

A "Wrestling-Club"
in a Social Settle-
ment in One of Our
Large Cities, 1910

Gelatin silver print
GIFT OF THE PHOTO
LEAGUE, NEW YORK,
EX-COLLECTION
LEWIS WICKES HINE
78:1023:0070

choice of profession that Hine deeply believed his work could provide change in a world in desperate need of social reform. It is equally clear that he was morally outraged about the conditions he photographed, that the sight of five-year-old children working 12-hour days in unsafe and unsanitary factories offended him and roused his sympathy. Hine never presented the subjects of his photographs as victims. The weary children are always allowed their dignity, allowed to face the camera on their own terms, to present their own sense of self, no matter what the circumstances. Throughout his career, Hine's photographs were affirming images, even when he photographed dehumanizing situations.

After World War I, Hine foresaw that there would be fewer commissions for social documentary photographs and he began to define himself as an interpretive photographer and redirected his consuming interest in the theme of labor to meet the progressive values of a new era.

In the years between the two world wars, a movement developed in the visual arts that portrayed the benefits of the United States' thriving industrial capitalism while focusing on the worker immersed in a new

machine age. Artists such as Joseph Pennell, John Sloan, and Joseph Stella took up this dynamic theme for a time, and photographers, including Margaret Bourke-White and Peter Stackpole, built their careers by following a similar course. As for Hine, he had photographed industrial workers as early as 1907 when he worked on Paul Kellogg's groundbreaking sociological study, "Pittsburgh Survey." His decision "to portray the human side of industry" met with public and financial success. Hine undoubtedly felt that he was still contributing to social betterment by positively portraying the role of the worker. His decision kept him current with the times, and the change was immediately recognized by astute observers. He received commissions from labor unions and industry alike. His eye-catching portraits of master mechanics working amid the bold forms and dramatic surroundings of heavy industry won him prizes and awards, and his work was exhibited in art clubs and reviewed in art magazines – new artistic and public venues for him. However, the stock market crash of 1929 and the onset of the Great Depression severely cut into his income, and he began to experience financial difficulties.

In May 1930 Hine was offered a commission to photograph the construction of the Empire State Building. It is likely that the commission came through the auspices of one of his neighbors, Richard Shreve, a principal in the architectural firm that designed

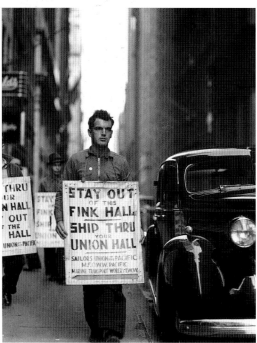

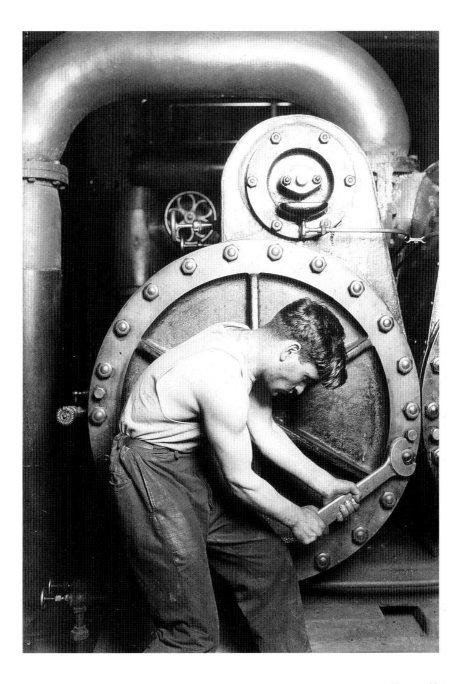

the building. Hine photographed construction workers, following them up into the sky as the building rose to its height of 102 stories, the tallest building ever erected up to that time. As in years past, his photographs seemed exceptionally modern to his audience. The strong graphic forms of the girders and struts of the building's framework and the sharply oblique perspectives forced upon Hine by necessity as he photographed his subjects from above and below, all appeared to voice an exciting new photographic vision. Since the construction of the Empire State Building was a particularly newsworthy event, Hine's photographs were seen and discussed by a wide audience. They were published in European art magazines, where they were featured as an expression of the American avant-garde. Photographers who were aligned with the new objectivist and constructivist movements in art were especially attracted to this work. In 1932 the Empire State photographs were gathered together in the critically acclaimed book *Men at Work*. The museum holds approximately 500 images from this series.

Lewis Wickes Hine
American,
1874–1940

Riveters Working
on Mooring Mast,
Empire State
Building, 1931

Gelatin silver print
GIFT OF THE PHOTO
LEAGUE, NEW YORK,
EX-COLLECTION
LEWIS WICKES HINE
77:0158:0007

Lewis Wickes Hine

*Man on Girders,
Mooring Mast,
Empire State
Building*, ca. 1931

Gelatin silver print
GIFT OF THE PHOTO
LEAGUE, NEW YORK,
EX-COLLECTION
LEWIS WICKES HINE
77:0161:0038

Margaret Bourke-White began her career as an advertising and industrial photographer in Cleveland in 1927. She developed a modernist approach, with dramatic use of perspective, light, and shadow on hard-edged industrial shapes, to create photographs that merged fact with the potent language of abstraction. In contrast to many American photographers who documented the world of industry, Bourke-White infused a grandeur into her industrial images, forging a personal style that was wholly contemporary and dramatic. Her photographs, born of an aesthetic appreciation for machinery that led her to claim that "a dynamo is as beautiful as a vase," lent a sense of power, authority, and glamour to structures previously viewed as unsightly or destructive. This work was immediately appreciated among her clientele of corporate industrialists. When Henry Luce started a magazine for business leaders in 1930 titled *Fortune*, Bourke-White was the first photographer he hired.

From 1929 to 1936, Bourke-White worked in New York City jointly as an advertising photographer and as a photographer for *Fortune*. In November of 1936 Henry Luce, encouraged by the success of his earlier magazines *Time* and *Fortune*, introduced a photographically illustrated weekly magazine named *LIFE*. The first issue's cover and lead story were by his ace photographer, Margaret Bourke-White, who had transferred from its sister journal to become one of the first four staff photographers for *LIFE*. The lead story for the inaugural issue was to be about the building of the Fort Peck Dam in Montana, but Bourke-White confounded expectations. The magazine's editors thought she would produce a group of "... construction pictures as only Bourke-White could take them. What the Editors got was a human document of American frontier life which, to them at least, was a revelation." The first issue of *LIFE* exceeded even the most hopeful expectations; the magazine became a publishing phenomenon. Before the advent of television, *LIFE* reached an unparalleled status in American society as a source of information

and entertainment – a position it held until the 1960s. For the next 33 years, Bourke-White was regarded as one of the most famous and well-respected *LIFE* photojournalists at a time when working for the magazine was considered the pinnacle of the photojournalistic profession. The Menschel Library holds all of her books, and the photography collection holds 335 photographs and the 1934 photogravure portfolio *U. S. S. R. Photographs*. Approximately 50 of

Margaret Bourke-White
American, 1904–1971

March of the Dynamos, 1928

Gelatin silver print
71:0155:0114

Margaret Bourke-White

Steel Liner, Fort Peck Dam, Montana, 1936

Gelatin silver print
71:0155:0074

the collection's prints date the time from before she worked for *LIFE*, and 11 prints are from the first *LIFE* essay on the Fort Peck Dam.

In addition to being a prolific photographer, Bourke-White was also a writer, a special bonus in the eyes of many a publisher and editor. She wrote or co-authored ten books from her many assignments to far-ranging places or politically troubled regions throughout the world. Significant among these are her works on Germany and the Soviet Union during the tumultuous 1930s; her pictures taken as a World War II combat photographer in Italy; and her firsthand account of India's struggle for independence in the late 1940s. Due to her exalted position in the pantheon of photojournalism, Bourke-White has, in turn, been the subject of a half-dozen monographs, a scholarly biography, and a not-so-scholarly movie starring Farrah Fawcett.

In the mid-1930s, Bourke-White adapted her style to changes in photojournalistic practices and thought, working in a more socially committed documentary mode. She replaced the heroic grandeur found in her

WORLD'S HIGHEST STANDARD OF LIVING

There's no way like the American Way

Margaret Bourke-White
American, 1904–1971

At the Time of the Louisville Flood, 1937

Gelatin silver print
66:0079:0008

(right)
Margaret Bourke-White

Khadeeja Feroze Ud-din, a Deputy Directress of Education, Veils Face and Hands in the Presence of Men, ca. 1947

Gelatin silver print
81:1002:0012

earlier images of booming industrial power with a candidness born of her contact with the homeless and poor during the Great Depression. For example, in the *LIFE* photograph "At the Time of the Louisville Flood, 1937," Bourke-White depicts with great irony a line of hungry, displaced people waiting for food in front of a billboard pronouncing the United States' status as having the "world's highest standard of living."

Throughout her career, Margaret Bourke-White was an integral force in the rising tide of photojournalism as it defined its role as both a specialized discipline and a legitimate form of mass communication. Her photographic acumen enabled her to keep step with her time, adapting her visual skills to meet the demands of her audience and subject, as in this late portrait of Khadeeja Feroze Ud-din. Featured in the book *Halfway to Freedom*, this portrait of Pakistan's new deputy directress of education demonstrates Bourke-White's skills at magnifying, through light and pyramidal form, a dramatic and mysterious portrayal of a woman veiled and gloved in accordance with the beliefs of her Muslim faith.

After experimenting with urban abstractions in the late 1920s, Walker Evans brought a strengthened vision to bear on American vernacular architecture. He photographed with a dispassionate, formalist large-camera precision and an austere classic vision so powerful that it forced the photographic community to reevaluate the virtues of both his subject matter and his photographic practice. In "View of Morgantown, West Virginia, 1935" and "Furniture Store Sign, Birmingham, Alabama, 1936," he transformed the mundane, the overlooked, and even the disdained objects of the world into coherent, expressive, even beautiful images. At the same time, he made candid 35mm photographs of ordinary people he found in the street walking or standing around doing very little. These photographs were not about any specific event, activity, or ceremonial function, but they referred instead to the ordinary people themselves and the ways people relate to their immediate surroundings. By making powerful and moving art out of ordinary and everyday objects, Evans helped to effectively change American creative photographic practice in the 1930s.

An austere man, suspicious of social or political groups and slogans, Evans was a key figure in effecting a transformation from the

Walker Evans
American, 1903–1975

View of Morgantown, West Virginia, 1935

Gelatin silver print
MUSEUM COLLECTION, BY EXCHANGE,
EX-COLLECTION
ROY STRYKER
73:0013:0041

Walker Evans

Furniture Store
Sign, Birmingham,
Alabama, 1936

Gelatin silver print
MUSEUM PURCHASE
71:0006:0001

domination of modernist abstraction to the rise of socially committed documentary photography. When Roy Stryker, chief of the Historical Section for the Farm Security Administration (FSA), developed an idea to create a pictorial record that would capture the effects of the Depression on American life, he turned to Evans to help him discover what photography's role could be in this project. Equally drawn to the visual strength of Walker Evans' work and to the compassionate humanity of Dorothea Lange's photographs, Stryker felt that both photographers' approaches were critical to the success of his project, and so he hired both to work for his fledgling organization.

Evans worked for the FSA for only 18 months; his association with Stryker ended due to personal differences. His photographic output was limited, but the photographs themselves exerted an extraordinary influence on both his colleagues and subsequent generations of

Walker Evans
American, 1903–1975

Burroughs Family,
Hale County,
Alabama, 1936

*Print by James Dow,
ca. 1971
Gelatin silver print*
MUSEUM PURCHASE
72:0017:0011

Walker Evans

A Miner's Home,
Vicinity Morgan-
town, West Virginia,
1935

*Print by James Dow,
ca. 1971
Gelatin silver print*
GIFT OF JAMES DOW
76:0191:0010

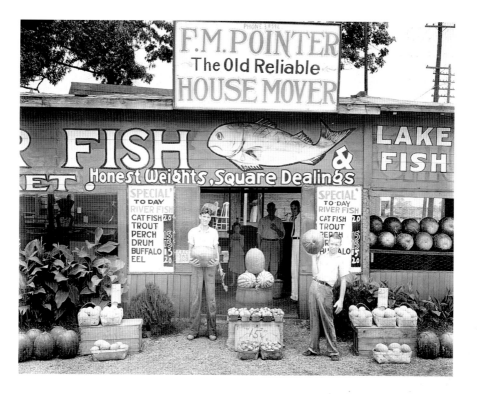

Walker Evans

Roadside Stand,
Vicinity Birmingham,
Alabama, 1936

Print by James Dow,
ca. 1971
Gelatin silver print
GIFT OF JAMES DOW
76:0191:0032

photographers. Evans' influence was particularly felt with his two books, *American Photographs*, published in 1938, and *Let Us Now Praise Famous Men*, published in 1941. *Let Us Now Praise Famous Men* began as a magazine assignment in 1936 about a family of tenant farmers in the South. When it was published, accompanied with text by James Agee, it received a puzzled critical response. Gradually, however, the combination of Agee's fervid, poetic prose and Evans' lucid and painfully acute photographs began to be recognized as a creative work of great power. Both books are now considered classics, models of the art of photographic book illustration.

In the early 1930s Dorothea Lange ran a small portrait studio situated on a busy street in San Francisco. She said that as the Depression deepened she could see the tide of homeless, jobless men as they aimlessly drifted by her windows. Like many other artists of the time, Lange began to shift her art-making practices in response to the hardships

overwhelming the country. Dorothea Lange was soon working out in the streets, photographing the homeless, as seen in her photograph "White Angel Bread Line ...". In 1935 Paul S. Taylor, an economics professor at the University of California, was asked by the State of California to create a report of the state's pressing migratory labor problem. He hired Lange to make visual records to support the field studies his team was conducting. She was placed on the payroll as a typist, since there was no provision for a project photographer. Together, Taylor and Lange compiled a scientifically directed study on this social problem, complete with statistical figures and analyses, quotes from the migrants, and moving, powerful, and convincing photographs depicting the difficulties that many migratory workers were experiencing. This new amalgam tying together scientific records and humanistic, expressive photographs that "put a human face on the statistics" proved to be the model for future practices of the Farm Security Administration photography unit and a great many other documentary efforts for decades to come.

Dorothea Lange
American, 1895–1965

White Angel Bread
Line, San Francisco,
1933

Gelatin silver print
MUSEUM COLLEC-
TION, BY EXCHANGE
74:0024:0017

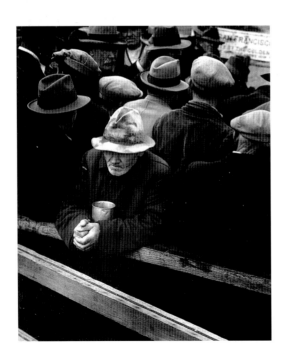

Dorothea Lange

Migrant Mother,
Nipomo, California,
1936

Gelatin silver print
GIFT OF AN ANONY-
MOUS DONOR
73:0095:0001

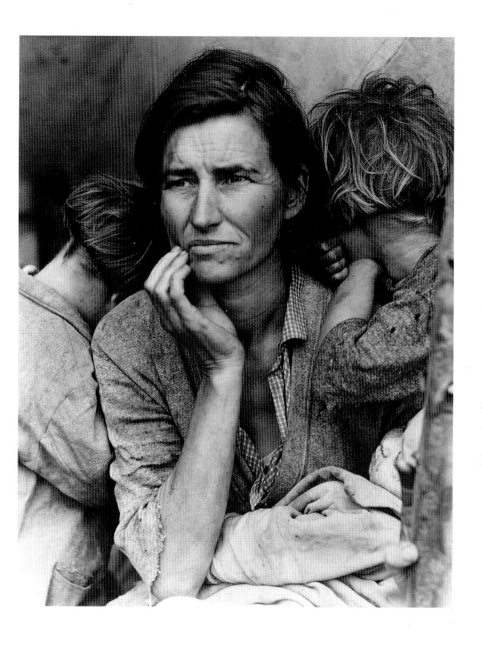

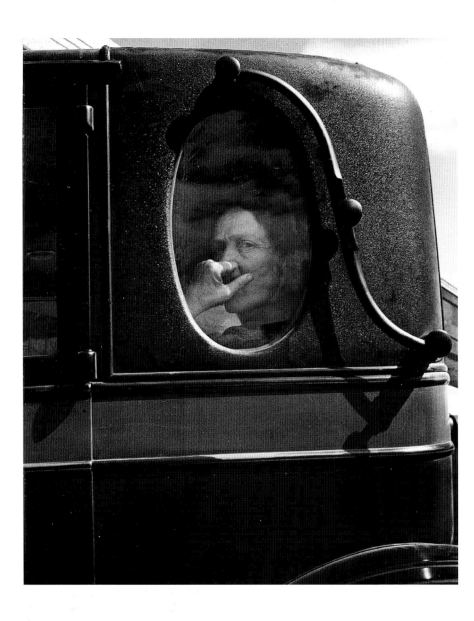

The museum holds more than 60 photographs by Dorothea Lange, approximately half of which are drawn from the FSA years and the others taken in the 1950s. A small woman with a limp from a childhood bout with polio, Dorothea Lange could walk right up to an individual from a proud, reserved people, stick a rather large and awkward camera in their face, and photograph them from an extraordinarily intimate distance. The results were photographs that were simply more powerful and humane than anyone else was making. Knowing that her best photograph would be the one that made the most powerful human statement, Lange would take many photographs in any promising situation and work until the best-possible image was made. She worked very hard on her composition and framing, and, when she could, on the quality of her printmaking. None of these things are prerequisites to traditional documentary practice. All of them, however, are concerns of a working artist.

Dorothea Lange
American, 1895–1965

Plantation Owner
and His Field Hands
near Clarksdale,
Mississippi, 1936

Gelatin silver print
GIFT OF THE
PHOTOGRAPHER
80:0751:0003

The photograph reproduced here was taken by Lange in 1936, during an extended trip through the South while she was employed by the Farm Security Administration. Lange composed the image so that its informational content as detailed in the title "Plantation Owner and His Field Hands near Clarksdale, Mississippi" is suffused with an emotional charge derived from the instinctual reading of body language and spatial clues. She took this photograph from a low angle and composed it so that everything fit into a shallow, enclosed, and confined space, with all visual sight lines leading to the figure of the dominating white man, surrounded by, yet separated from, the subsidiary figures of the black field hands. The owner, shown with his hand confidently on his knee, possessively leaning on his automobile – a symbol of wealth and prestige – dominates the picture, just as he dominated the world he inhabited.

Arthur Rothstein
American, 1915–1985

Cattle Skull, Bad
Lands, South
Dakota, 1936

Gelatin silver print
GIFT OF THE
PHOTOGRAPHER
76:0137:0002

Arthur Rothstein, a former student of Roy Stryker's, was the first photographer hired by Stryker to work for the FSA. Rothstein's initial tasks were to copy documents and photograph agency events while Stryker puzzled out the development of the agency's photographic project. Rothstein became a valuable member of the FSA, quickly learning to make the kind of images that Stryker wanted: images that were both informative and symbolic of general conditions throughout the devastated country. His "Cattle Skull, Bad Lands, South Dakota, 1936" popularly symbolized the disaster gripping rural America, embodying the drought and dust storms that drove so many farmers off their land and into migratory labor.

(right)
Arthur Rothstein

Colored Balcony,
Birmingham,
Alabama, 1940

Gelatin silver print
GIFT OF GRACE
ROTHSTEIN
89:1475:0018

Arthur Rothstein
American, 1915–1985

Saturday Night,
Birmingham,
Alabama, 1940

Gelatin silver print
GIFT OF THE
PHOTOGRAPHER
76:0137:0025

In 1940 Rothstein left the FSA and began a distinguished career as a photojournalist, first on assignment for *Look* magazine, in which the two images reproduced here were featured. *Look*, *Friday*, *PM*, *LIFE*, and a host of other illustrated magazines in the late 1930s drew many of their photographers from the FSA and the Photo League, at the same time absorbing many of the humanistic principles that drove the documentary approach in American photography. The museum's collection holds approximately 150 photographs by Rothstein, many of them taken between 1938 and 1948.

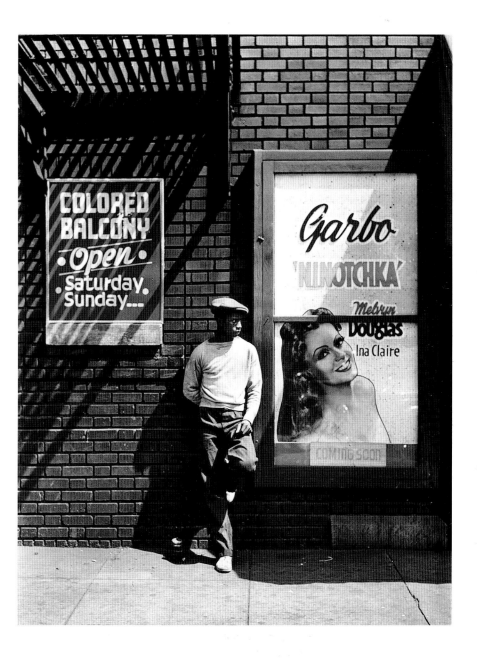

Esther Bubley
American, 1921–1998

Esso Research Center, Linden, New Jersey. Mechanic Oils Mechanism in a Micromax Recorder Which Is Used with the Infra-Red Gas Analyzer, ca. 1945

Gelatin silver print
GIFT OF STANDARD OIL OF NEW JERSEY
80:0209:0004

Harold Corsini
American, b. 1919

Shoe Repair Shop, Cushing, Oklahoma, ca. 1950

Gelatin silver print
GIFT OF STANDARD OIL OF NEW JERSEY
81:2930:0011

Esther Bubley

Entomology Labora-
tory Assistant Sprays
Insecticide into a Fly
Chamber. Bayway
Refinery, Linden,
New Jersey, ca. 1940

Gelatin silver print
GIFT OF STANDARD
OIL OF NEW JERSEY
80:0536:0010

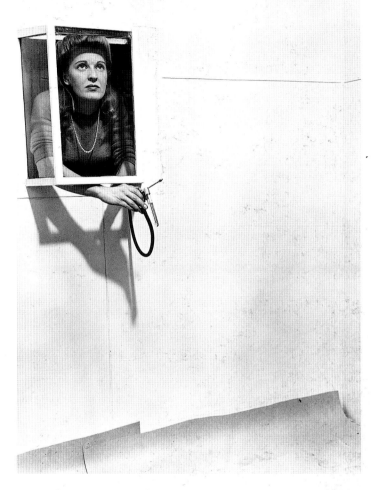

Following his government work with the FSA and the Office of
War Information, Roy Stryker found corporate support from Stan-
dard Oil of New Jersey to continue his work providing a photograph-
ic documentation of contemporary America. He hired a group of
young photographers, fed them economic and social information,
and assigned them particular subjects. The Standard Oil Project
lasted until 1950, employing up to 20 photographers who took an
astonishing 67,000 photographs. The museum holds 129 pictures

by 19 of these project photographers including Esther Bubley and Harold Corsini.

During the 1960s, the photographer Aaron Siskind donated to the museum approximately 140 photographs by six members of the Feature Group, a circle of advanced photographers that Siskind organized under the auspices of the Photo League of New York during the 1930s and 1940s. He also gave 300 negatives and 600 of his own photographs from this period to the museum.

The Photo League was a unique and influential organization of amateur and professional photographers primarily interested in producing documentary photography of social significance. Equipped with rudimentary darkroom facilities, it also offered classes in both introductory and intermediate photography, as well as upper-level workshops, feature groups, and production groups designed to work on long-term documentary projects for exhibition or publication. Most of the League's membership comprised New Yorkers born on the Lower East side of Manhattan, in Brooklyn, or the Bronx; most were first-generation Americans, Jewish, and poor. Funds to support the League came from membership dues, class fees, and proceeds from parties that were organized

Lucy Ashjian
American, active
ca. 1930s

*Group in Front of
Ambulance,* ca. 1935

Gelatin silver print
GIFT OF AARON
SISKIND
73:0079:0002

throughout the year. At its height, membership in the Photo League numbered from 80 to 200 persons.

In the late 1930s, this improbable organization became a leading center of photographic activity in America, with lectures, exhibitions, and activities that exerted an impact far greater than could ever have been anticipated. An extraordinary number of individuals who started at the League went on to exceptional careers in photography. In 1936 Siskind gathered several younger League photographers together into a group to produce visual documentary projects on various social topics. The largest of these was the "Harlem Document" project. Each week the group, consisting of photographers Lucy Ashjian, Harold Corsini, Morris Engle, Sol Fabricant, Beatrice Koslofsky, Richard Lyon, Jack Manning, and Siskind, met with Michael Carter, a black sociologist, who offered background information and introductions in Harlem. The group would photograph during the week, meet and critique their

Jack Manning
(Jack Mendelsohn)
American, b. 1920

Harlem Street Scene,
1937
Gelatin silver print
GIFT OF AARON
SISKIND
73:0081:0023

(left)
Harold Corsini
American, b. 1919

Playing Football,
ca. 1935

Gelatin silver print
GIFT OF AARON
SISKIND
69:0073:0012

Aaron Siskind
American, 1903–1991

Savoy Dancers,
Harlem, ca. 1937

*Modern gelatin silver
print from original
gelatin on safety base
sheet film negative*
GIFT OF THE
PHOTOGRAPHER
81:0751:0031MP

efforts, then return to Harlem again. The final "Harlem Document" was exhibited in 1940 in Harlem and elsewhere in New York City.

Andreas Feininger, the son of German painter Lionel Feininger, taught himself photography while practicing architecture in the early 1930s. Feininger worked for the Dephot photo agency in Germany. Fleeing the Nazis, he moved back to France and then to Sweden before finally immigrating to the United States, where he went to work for the Black Star photo agency. "When not on assignment, I roamed the streets of New York with my camera, trying to document every aspect of what to me was the greatest, the most exciting city on earth," Feininger wrote of his approach to photographing in his newly adopted home. His crowded, exuberant photograph of Times Square reflects the social energy of the era with an undercurrent of the political turmoil that had brought him there. A later image of a parade on lower Broadway dominated by an American flag displays a breathtaking patriotic fervor. By the early 1940s much of American photojournalism became involved in what was called "war preparedness work," and virtually all social documentary practice was subsumed into this patriotic effort. Feininger also worked for the Office of War Information, and from 1943 to 1962 as a *LIFE* magazine photographer. "I am a maker of picture books since I hardly ever take single pictures," Feininger wrote. He published more than 50 books, and the museum holds more than 675 of his photographs spanning his entire career.

Andreas Feininger
American, b. France, 1906–1999

Corner Times Square and 42nd Street, Midtown Manhattan, 1940

Gelatin silver print
GIFT OF THE PHOTOGRAPHER
78:0606:0298

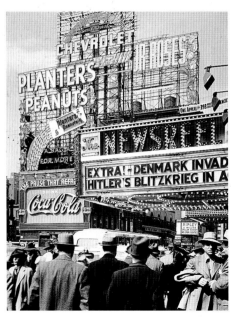

Andreas Feininger

Parade on Lower Broadway, 1952

Gelatin silver print
GIFT OF THE PHOTOGRAPHER
78:0606:0099

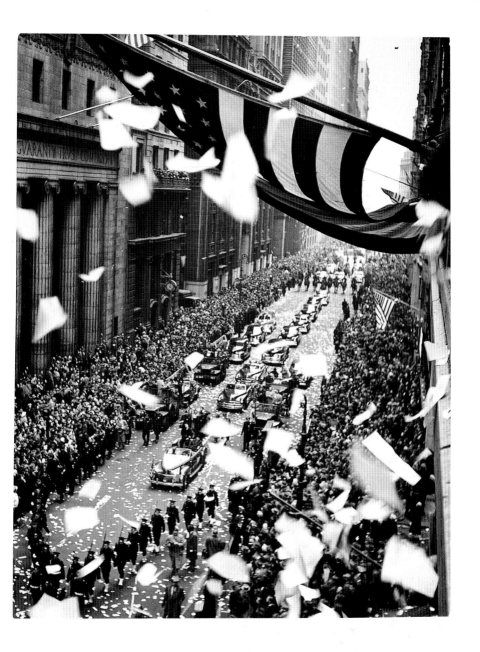

The photographic career of Berenice Abbott was long and prodigious. It measured the scope and breadth of many 20th-century photographic movements, with its preoccupation with documentary realism, surrealist evocation, commercial portraiture, and scientific documentation. But no matter the subject she portrayed, Abbott believed in her role as a privileged eyewitness to a rapidly changing modern world. For her, the fidelity of the camera marked its particular ability to seize upon the moment at hand, gathering within its gaze the traces of larger cultural appearances and concerns.

Born in the United States, Abbott moved to Paris in the early 1920s during the height of an artistic and literary resurgence. There she worked as a studio assistant for another American expatriate, Man Ray, absorbing a heady atmosphere primed with surrealist thought. At the same time, Abbott met the elderly and destitute Eugène Atget, saving his photographic archive from ruin and, thus, single-handedly saving his reputation from obscurity.

Berenice Abbott
American, 1898–1991

Horse in Lincoln
Square, 1930

Gelatin silver print
MUSEUM PURCHASE
67:0006:0001

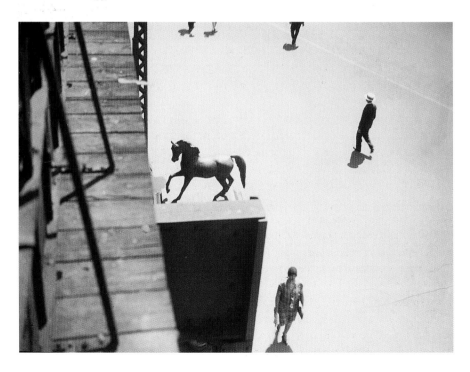

In 1929 Abbott returned to the United States, deciding to settle in New York City. For the next two decades, she prowled the city she described as "the truest phenomenon of the twentieth century." In images like "Horse in Lincoln Square," Abbott betrays the avant-garde sensibilities she learned abroad, choosing a bird's-eye view and disjunctive form and space to suggest both the mystery and the exceptional that are contained within mundane, everyday appearances.

In 1935 Abbott was appointed head of the Changing New York unit of the Federal Art Project, a relief agency formed to benefit artists. This project provided Abbott with a measure of institutional support, allowing her to expand and formalize her evolving documentary approach. In "Greyhound Bus Terminal," she continued to incorporate a high viewpoint as an active compositional element, but the earlier mysterious sense of the unforeseen has been replaced with a strong informational content, giving weight to the documentary purpose of the image.

Berenice Abbott

Greyhound Bus
Terminal,
July 14, 1936

Gelatin silver print
MUSEUM PURCHASE
71:0021:0014

Helen Levitt
American, b. 1918

New York, 1939

Gelatin silver print
MUSEUM PURCHASE,
CHARINA FOUNDA-
TION PURCHASE
FUND
93:0519:0001

During the 1940s, Helen Levitt walked around the streets of New York on self-imposed "assignments," photographing children at play and children's drawings, as seen in the two images reproduced here. Inspired by Henri Cartier-Bresson, and with advice and help from Walker Evans, Levitt used an unobtrusive 35mm camera that allowed her to respond to fleeting moments without altering the essential nature and spirit of the activity she observed. While Levitt's work shared the same subjects and a similar style of directness and candor found in documentary photography, her images are more personal, lyrical, and poetic in their approach.

In the 1940s Levitt collaborated with writer James Agee on a book of her photographs titled *A Way of Seeing*, which was finally published in 1965, ten years after Agee's death. Influenced by Agee, who gained renown as a film critic, Levitt turned to documentary filmmaking, collaborating with Agee and Janice Loeb on the motion picture *In the Street*. In 1949, she participated in the filming of *The Quiet One*, considered a classic of documentary filmmaking.

Helen Levitt

New York City, 1938

Gelatin silver print
MUSEUM PURCHASE,
CHARINA FOUNDA-
TION PURCHASE
FUND
93:0522:0001

(right)
**Weegee
(Arthur H. Fellig)**

Booked on Suspicion of Killing a Policeman, 1939

Gelatin silver print
MUSEUM PURCHASE,
INTREPID FUND
84:0157:0003

**Weegee
(Arthur H. Fellig)**
American, b. Poland,
1899–1968

Tenement Penthouse, ca. 1940

Gelatin silver print
81:2076:0001

Arthur Fellig, better known by his pseudonym "Weegee" or "Weegee the Famous," as he frequently described himself, was the son of an immigrant pushcart vendor. He worked as a dishwasher, then as a darkroom technician at Acme News for 12 years before becoming a freelance news photographer in 1935 at age 36. He kept police radios in his car and apartment, and his car trunk was always full of camera equipment. This allowed him to respond quickly to police calls, and he often arrived at the scene before the police. Fellig epitomized the stereotype of the hardnosed, cigar-smoking police reporter, dispassionately documenting murders, fires, and domestic tragedies with his 4 x 5 Speed Graphic and on-camera flashgun. "Many photographers live in a dream world of beautiful backgrounds. It wouldn't hurt them to get a taste of reality to wake them up," Fellig once said. Indeed his harshly lighted and hastily composed photographs certainly do have "a taste of reality." Sometimes they go beyond the customary bounds of news reportage photography to display the overlooked, but unforgettable, moments of human existence.

(left)
Lisette Model
American, b. Austria,
1901–1983

Sailor & Girl,
Sammy's Bar,
New York, 1940

Gelatin silver print
MUSEUM PURCHASE
80:0470:0003

 Berenice Abbott once wrote: "It is a large order to look at life unblink-
ingly in the midst of general confusion. [Only a few do this well.] I be-
lieve Lisette Model's seeing to be in the foreground of this elite group."
Escaping the Nazis, Lisette Model left her native Austria for France, then
immigrated to the United States in 1937. She took up photography to
make a living, setting aside her earlier training in classical music. Model
worked as a freelance magazine photographer and taught photography
in New York City. Recognized for her monumental street portraits,
Model's approach displays her direct, ironic, and compelling gaze.

Lisette Model

Lower East Side,
N.Y., ca. 1955

Gelatin silver print
GIFT OF ANSEL
ADAMS
81:1502:0001

Will Connell
American, 1898–1961

Hands and Baby,
ca. 1937

Gelatin silver print
GIFT OF THOMAS
J. MALONEY
79:4227:0001

(right)
Edward Farber
American, 1915–1982

The Flag Is Passing
By. Citizens Day Rally,
Milwaukee, 1941

Gelatin silver print
GIFT OF THOMAS
J. MALONEY
89:0423:0002

From the late 1930s to the 1950s Tom Maloney's populist publications *U. S. Camera* and *U. S. Camera Annual* were the most important and influential magazines on photography in the United States, providing a showplace for all aspects of photographic practice and thought, from advertising to art, newspaper journalism to scientific research. The pure eclecticism of his publications demonstrated the enormous vitality, diversity, and importance of photography during this period. The photographs seen here, by Will Connell, a professional photographer and teacher of photography in California, and Edward Farber, a photographer for the *Milwaukee Journal* during the 1940s, illustrate the emphasis on humanistic values and affirmative democratic ideology that were staples of America's self-definition during the war years. In 1974 Maloney donated to George Eastman House 250 photographs by more than 100 photographers who had been featured in his magazines.

In 1939 Lou Stouman studied at the Photo League with Sid Grossman, crediting his mentor with inspiring his passionate, lifelong interest in photography. A documentarian, Stouman early on described his work as "street photography," as seen in a work drawn from his Times Square project of the 1940s. In contrast to contemporary documentary practice and thought, Stouman eschewed political content in his work, focusing instead on appearances and the immediacy of the scene at hand.

Stouman was not alone in his decision to work in a non-political, documentary style. He was joined by others, including Larry Silver, who demonstrated a humanistic intent and populist leanings in his work. Born in the Bronx, Silver moved to Los Angeles as a student in 1954. The world he found there provided new subjects unlike those photographed by Photo League professionals, which had earlier impressed him. Immersing himself in West Coast culture, Silver created a photographic series about Southern California bodybuilders at Muscle Beach, whose way of life was little known outside their own community.

Candid Witness

This news photograph of Charles Lindbergh standing in front of his airplane, *The Spirit of St. Louis*, at the end of the first solo transatlantic flight is notable for being an early form of transmitted photographic imagery. Popularly known as wire photos, photographs transmitted over telegraph or telephone lines from a news agency to newspapers around the world were first introduced in 1907. It was not until the 1920s that the system became commercially feasible. The Bartlane system, founded by Harry Bartholomew, head of the art department for the London *Daily Mirror*, and Robert McFarlane, an English research engineer, was an early transatlantic system that translated photographs into patterns of perforations on a paper tape for telegraph transmission. The technology was discontinued at the beginning of World War II as other systems were perfected. And while many of them are still in use, they are rapidly being eclipsed by digital technologies.

Transmitted photographs were among the many new technologies emerging throughout the 1920s to improve the speed and scope of photographic reportage. They were just one part of the complex equation that helped to create the global phenomenon of print mass media. With the help of new cameras and the emergence of news associations, illustrated magazines, and newspapers, the photograph surpassed the written word as the primary means of mass communication.

**Bartlane
(Bartholomew &
McFarlane)**
English, active
1920s–1930s

Lindbergh and Plane,
May 20–21, 1927

*Gelatin silver print,
transmitted image*
GIFT OF MAYNARD
MCFARLANE
68:0323:0042G

Born to a wealthy family, Dr. Erich Salomon obtained a doctorate in law from the University of Berlin before World War I. He struggled to make a living in the inflation-driven chaos of Weimar Germany, finding a position with a publishing house. In 1926 he bought an Ermanox, an unobtrusive hand camera, and began to photograph political functions that were considered off-limits to the press. Salomon's elegant bearing and social graces gained him access to diplomatic meetings, as depicted here in "Summit Meeting ...". It also awarded him the respect and acceptance of his subjects, who came to depend on Salomon's pictures as a public record of their work. More than any other photographer of his day, Salomon defined a new style of reportage that prized the spontaneous and the direct. His work was called "candid" photography and was eagerly sought by a host of illustrated weekly magazines.

Although Salomon became a celebrity in his own right, he did not escape the terrors of World War II. Interned at Auschwitz, he, his wife, and a son were killed there in 1944.

Erich Salomon
German, 1886–1944

Summit Meeting in 1928. The Architects of Franco-German Rapprochement, Aristide Briand and Dr. Gustav Stresemann, Meet in the Hotel Splendide in Lugano with British Foreign Minister, Sir Austen Chamberlain. From left to right: Zaleski, Poland; Chamberlain; Briand; Scialoia, Italy, 1928

Gelatin silver print
MUSEUM PURCHASE
81:1926:0001

The figure of Robert Capa, née Andréi Friedmann, looms large in the history of photojournalism. He is remembered as the quintessential war photographer, having traversed the historical tides of civil revolution in Spain and the large-scale combat of World War II. Through pictorial magazines such as *LIFE*, his unparalleled work showed with great sensitivity the human drama of combat, its agonies, and its triumphs.

Capa came to photography as a young man, politically attuned to the civil discord then raging throughout the European continent and his homeland of Hungary. Working as a darkroom assistant in Berlin in 1931, he was given his first photojournalistic break – to photograph a political gathering in Copenhagen where Leon Trotsky was to speak. Robert Capa had to slip into the meeting, which was closed to press photographers, and, like Erich Salomon before him, surreptitiously get his photograph. Carrying the new Leica 35mm camera, Capa seized upon a portrait of Trotsky as the spellbinding orator, caught up in the fervor of a highly charged political moment. This portrait, reproduced below, became Capa's first published work, printed in the popular German illustrated weekly *Berliner Illustrierte Zeitung*.

**Robert Capa
(Andréi Friedmann)**
American, b.
Hungary, 1913–1954

Leon Trotsky,
Copenhagen, 1931

Gelatin silver print
66:0080:0005

When the United States entered the war in 1941, Edward Steichen, then 62 years old, approached the Department of the Navy for permission to form a small special unit of photographers to document the role of Naval aviation. Aware of the value that positive propaganda would have at home, the Navy took the unusual step of accepting Steichen's offer. This unit, consisting of Horace Bristol, Paul Dorsey, Barrett Gallagher, Fenno Jacobs, Victor Jorgensen, Charles Kerlee, Wayne Miller, John Swopes, and Steichen himself, was for the most part handpicked by Steichen from professional photographers, who were then commissioned into the Navy. The unit worked independent from all official naval photographic services. Steichen went aboard the U.S.S. *Lexington* as it joined the strike force supporting the attack on Kwajalein Island in the South Pacific in 1943. This dramatic photograph, playing the hulking mass of the aircraft carrier's superstructure against the intent figures of the sailors preparing for the air strike, imparts both the sense of massive military power and intense, concentrated human purpose.

Edward J. Steichen
American, b.
Luxembourg,
1879–1973

Aboard the U.S.S.
Lexington: Preparing
for the Strike on
Kwajalein, 1943

Gelatin silver print
GIFT OF JOANNA
T. STEICHEN
74:0025:0732

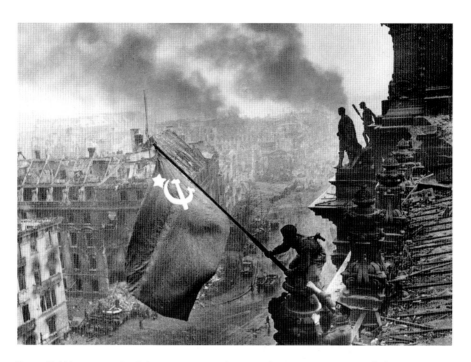

Yevgeny Khaldei
Russian, 1917–1997

Berlin, 1945

Gelatin silver print
MUSEUM PURCHASE,
FORD MOTOR
COMPANY FUND
96:0359:0004

(left)
Joe Rosenthal
American, b. 1911

Old Glory Goes up
on Mt. Suribachi,
Iwo Jima, 1945

Gelatin silver print
GIFT OF THE
ASSOCIATED PRESS
81:1678:0001

On February 19, 1945, the United States Marines invaded Iwo Jima, a tiny, critically strategic island in the South Pacific. By the fifth day of the invasion, the marines had swept the Japanese defenders from the beach and its commanding volcanic cone. While fighting continued for another month, the Battle for Iwo Jima had been won. A group of soldiers was detailed to replace the first small flag placed on the mountain with a larger, more visible one. Joe Rosenthal, an Associated Press photographer, came ashore with the group and photographed them as they raised the new flag. His photograph immediately became a national icon, transmitted around the world as the quintessential symbol of American victory.

In Europe, Yevgeny Khaldei, a member of the Soviet news agency TASS, saw Rosenthal's photograph and drew on it to make an equally dramatic image of Soviet triumph. During the fall of Berlin, Khaldei and several combat soldiers made their way to the Reichstag roof where he

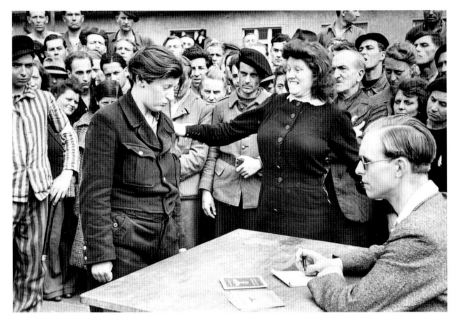

Henri Cartier-
Bresson
French, b. 1908

Dessau: Exposing a
Gestapo Informer,
1945

Gelatin silver print
MUSEUM COLLEC-
TION, BY EXCHANGE
73:0057:0002

(right)
**Unidentified
Associated Press
photographer**
American?, active
1950s

Army Troops See
Atomic Blast, 1951

Gelatin silver print
GIFT OF THE
ASSOCIATED PRESS
92:0902:0012

found "a good angle," gave his homemade flag to a soldier to wave, and created this memorable photograph.

In the years immediately following World War II, photojournalism played a greater role in the mass media, defining the dawn of a perilous age born of unprecedented human conflict and scientific invention, as seen in Henri Cartier-Bresson's "Dessau" and an unidentified photographer's "Army Troops See Atomic Blast." Though the images on these two pages are separated by geography, nationalistic concerns, and time, both communicate the consequences of a war that shook the foundation of modern civilization and its rationalist underpinnings.

A renowned photographer and filmmaker, Henri Cartier-Bresson was 36 years old when he took the "Dessau" photograph. He had spent much of the war as a prisoner before escaping and joining the French Resistance movement. Shaped by his war experiences, Cartier-Bresson took up a more socially involved photography, seizing upon the telling gesture or, what was termed the "decisive moment," rendering the dark and haunting narrative of betrayal and retribution.

Perhaps more than any other press image of its time, the towering inferno of an atomic blast epitomized a new world order – the United

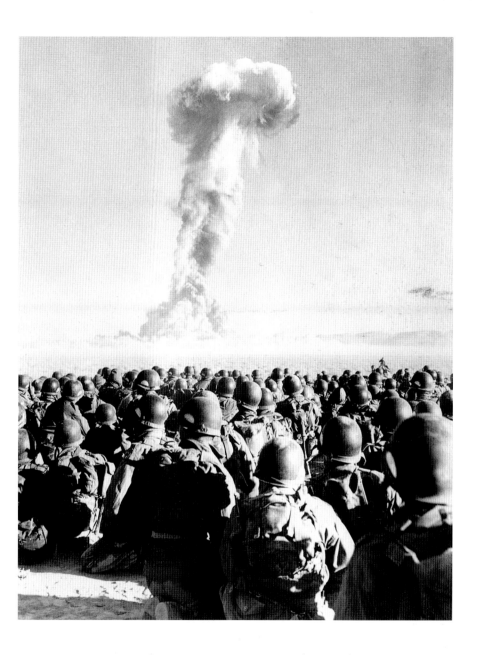

States' new global power, the Cold War, and the frightening specter of nuclear war.

In 1962 Edward Steichen, then the most powerful taste-maker in American photography, wrote about W. Eugene Smith's "The Thread Maker": "This image of a woman weaving in a Spanish village has some of the splendor and grandeur of Spanish painting – of Velasquez, Goya and El Greco." Steichen's statement expressed a view that many in reportage photography held: Photojournalism in addition to being a tool of news-gathering could also be a creative practice resonant with the qualities of fine art. More than any other photographer of his generation, W. Eugene Smith attempted to realize this goal, through classically rendered works of technical virtuosity and emotional intensity.

W. Eugene Smith
American, 1918–1978

The Thread Maker, 1951

Gelatin silver print
80:0338:0001

Smith's genius at making photographs that were both dramatic and artistic kept his reputation aloft, but for him the more important photographic format was the narrative essay, the combination of images and text to illuminate a specific topic.

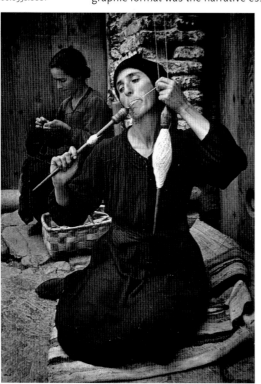

He believed that the more developed photographic essay was capable of providing a larger understanding of the human story. His skill at crafting essays that were intellectually stimulating and emotionally moving defined the high points of photojournalistic practice during the 1940s and 1950s.

Firmly believing that the photographer should maintain editorial control, Smith left *LIFE* magazine in 1954 when he reached an impasse with the picture editors over the presentation of his essay on Dr. Albert Schweitzer. In later years, Smith served as a mentor to a new generation of photographers who developed their work outside the framework of institutionalized photojournalism.

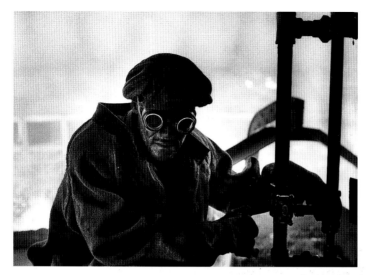

W. Eugene Smith

Pittsburgh Steel
Worker, 1955

Gelatin silver print
MUSEUM PURCHASE
WITH EASTMAN
KODAK COMPANY
FUNDS
81:1935:0001

W. Eugene Smith

Lambarene, French
Equatorial Africa,
1954

Gelatin silver print
MUSEUM PURCHASE
66:0023:0013

Bill Brandt
English, b. Germany,
1904–1983

Parlour Maids,
London, ca. 1936

Gelatin silver print
MUSEUM PURCHASE
77:0745:0011

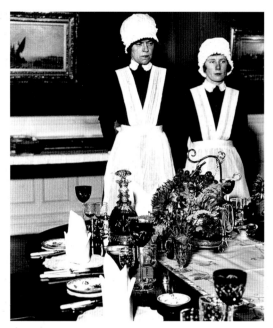

(right)
Bill Brandt

Belgravia, London,
1951

Gelatin silver print
MUSEUM PURCHASE
77:0745:0018

During the 1920s Bill Brandt's formative years in photography were largely shaped by a circle of friends who were part of the surrealist movement in France. He spent a few months in the studio of Man Ray, producing little, but taking in the intellectual life that flourished around him. In 1931 Brandt settled in England and there began his prodigious career, first as a photojournalist, and later as a fine art photographer. Unlike other photojournalists of the day, Brandt prized the square format of the Rolleiflex camera over the rectangular format of the popular 35mm camera. His "Parlour Maids, London," a variant of which is published in the book *The English at Home*, introduces a spirited irony into Brandt's look at the British class system. After World War II, Brandt re-dedicated his photographic career to investigating themes that portrayed the poetic sensibilities then displayed in contemporary art photography. Building on his surrealist roots, Brandt's "Belgravia, London" revels in the turbulent distortion of form and space, transforming and invigorating the time-honored, universal subject of the female nude.

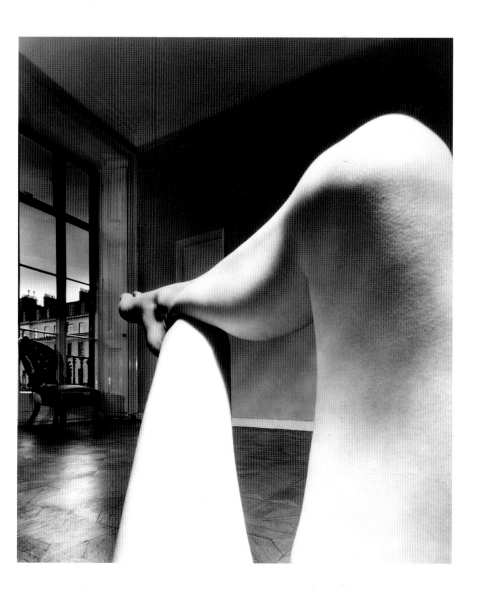

The Visual Mind

Minor White
American,
1908–1976

Lake Road,
Rochester, 1957

Gelatin silver print
77:0369:0095

Once photography had become accepted as a viable art medium, photographers began to push the boundaries of perception beyond the merely "seeable." The most influential photographer who advocated this pursuit in both word and image was Minor White. After receiving a degree in botany from the University of Minnesota, White was appointed "creative photographer" with the Works Progress Administration. In 1955, after he began studying comparative religions, a profound sense of spirituality permeated White's work. The Eastman House collection holds 155 prints by White, including a 117-image, autobiographical sequence titled *Sequence 13: Return to the Bud* (originally titled *Ashes Are for Burning*). The narrative sequencing of images, which White called a "cinema of stills," was his preferred method of presenting photographs. "Lake Road, Rochester" is an image of two construction tarpaulins

Minor White

Mission District,
San Francisco, 1949

Gelatin silver print
77:0369:0025

Minor White
American,
1908–1976

The Three Thirds,
1957

Gelatin silver print
72:0250:0001

draped in front of a cement wall; a ladder extends upward between them. The movement of the fabric is both animated and elegiac, like the rapid, nervous flapping of a trapped hummingbird.

The thin, vertical format of "Mission District, San Francisco" (page 639) demonstrates the artist's ability to select the essential element from his larger negative in order to convey the desired feeling. The radical cropping also suggests that, in White's view, the only thing that should not be manipulated in the creation of a successful photograph is the artist's vision. Both images were part of *Sequence 13*. "I always photograph found objects; excepting portraits, all of my photographs are of found objects … the best of them have always been photographs that found themselves," he wrote in 1957, the year that *Sequence 13* was first exhibited at Eastman House. "When I look at pictures I have made, I have forgotten what I saw in front of the camera and respond only to what I am seeing in the photographs." According to White, there are two ways to be creative: "… the first is accomplished by *photographing the subject itself in such a way that its character is revealed;* the second is accomplished by *choosing a subject to photograph which will illustrate an idea heretofore existing only in the mind of the photographer.*"

Minor White

Sun & Rock, 1948

Gelatin silver print
73:0063:0009

"The Three Thirds" can be read as a literal title, referring to the three distinct formal elements in the print: clouds reflected in a window, plaster oozing through a boarded up opening, and a jaggedly broken window pane. By titling the work "The Three Thirds," White implies that the image is to be understood as the sum of its parts, therefore representing a whole. Throughout his life, White would return to the tripartite form that held spiritual as well as formal significance for him. "Sun & Rock" is an image from the sequence *Song without Words*, which White created to reflect the turmoil he was feeling regarding his homosexuality. At one time curator of exhibitions at George Eastman House and editor of its journal *Image*, White was an extremely important photographer, publisher, and educator, referred to by a contemporary as "the very archetype of the artist-as-guru ... enclosed in a mysterious penumbra of spirituality." Alfred Stieglitz, Edward Weston, and Ansel Adams had been his mentors; Carl Chiarenza and Paul Caponigro became his students. In 1952, along with Ansel Adams, Dorothea Lange, Barbara

Morgan, and Beaumont and Nancy Newhall, White founded the influential *Aperture* magazine and was its editor for 23 years.

Born in San Francisco, Ansel Adams trained as a concert pianist. His first photographs were made using a Kodak Brownie camera during a visit to Yosemite Valley with his parents in 1916, which he described as "a culmination of experience so intense as to be almost painful. Since that day ... my life has been colored and modulated by the great earth gesture of the Sierra." He returned every summer, becoming a mountaineer and, more important, conservationist – which is ironic, perhaps, in that Adams' grand images have inspired increased tourism in the National Parks. In 1927 Adams made one of his most famous images, "Monolith, the Face of Half Dome" (page 645). The image is part of an Adams portfolio in the Eastman House collection, which the Sierra Club published in 1959.

In 1930, after meeting Paul Strand and finding his negatives to be a revelation, Adams decided to pursue photography as a career. Probably

Ansel Adams
American,
1902–1984

Lake Cliffs, Kaweah
Gap, Sierra Nevada,
ca. 1932

Gelatin silver print
72:0065:0074

surprising to many people, Adams's earliest images were pictorialist
in style, soft-focus and romantic. Then, in 1931, he wrote in his diary:
"Awoke in a kind of vision. It was like the Annunciation! Suddenly I saw
what photography could be ... a tremendously potent pure art form,"
and Adams abandoned his pictorialist style. The following year, he be-
came a founding member of the Group f/64, advocating the expressive
potential of straight photography. "Lake Cliffs, Kaweah Gap, Sierra
Nevada" demonstrates the full range of the medium's potential in tonal
range and clarity of detail. In 1940 Adams became one of the founders
of the department of photography at New York City's Museum of Mod-
ern Art – the first museum ever to have a department dedicated to the
medium as a fine art. The following year, he made "Moonrise, Hernan-
dez, New Mexico" a signature Adams image. This print reveals that
Adams's art was as calculated as that of the most ardent technician.
Rather than evoke the day's-end melancholy of "sunset," Adams titled

Ansel Adams

Moonrise,
Hernandez,
New Mexico, 1941

Gelatin silver print
74:0082:0001

Ansel Adams
American,
1902–1984

Surf Sequence III,
California Coast,
ca. 1940

Gelatin silver print
72:0065:0020

(right)
Ansel Adams

Monolith, the Face
of Half Dome, 1927

Gelatin silver print
MUSEUM PURCHASE
81:1018:0001

the image "Moonrise." Likewise, he printed two versions of the image: one in which the sky is rendered a dusky gray, closer to how it appeared at twilight, and this more famous version in which Adams printed the sky much darker. This helps create a dramatic, almost otherworldly contrast that highlights every cross in the tiny cemetery seen at the lower edge of the picture.

A photograph such as "Surf Sequence III, California Coast" reveals Adams's musical background. As he himself explained about the importance both of pre-visualization and darkroom technique: "The negative is the score, the print is the performance." In its layers of almost pure white to black with every nuance of gray in between, the sea veritably resonates with a full scale of sound. Of his work, Adams wrote: "Who can define the moods of the wild places, the meanings of nature in domains beyond those of material use? Here are the worlds of experience beyond the world of the aggressive man, beyond history, and beyond

Harry Callahan
American,
1912–1999

Eleanor, Chicago,
1953

Gelatin silver print
81:1135:0002

science. The moods and qualities of nature and the revelations of great art are equally difficult to define; we can grasp them only in the depths of our perceptive spirit." Eastman House has nearly 300 photographs by Adams, indisputably America's best-known photographer.

Harry Callahan's work is represented in the Eastman House collection by almost 100 images. Callahan was an engineer for Chrysler Corporation and became interested in photography as a hobby. Then, during a couple of weekend sessions at the Detroit Photo Guild, he saw Ansel Adams's work, which made him realize the potential of the medium. In 1945 Callahan spent six months in New York concentrating on his newly chosen profession; the following year, László Moholy-Nagy appointed him instructor at the Institute of Design in Chicago. Callahan's photographs of his wife Eleanor are among the most personal, lyrical, and poignant portraits in the history of the medium.

Harry Callahan

Detroit, ca. 1947

Gelatin silver print
MUSEUM PURCHASE
81:1131:0001

He photographed her from the beginning of their marriage in 1936. In his image of Eleanor, made in Chicago, she stands in perfect alignment with the telephone pole in the exact center of the composition. The cars and architecture are slightly off-balance, intentionally preventing this from being a perfectly symmetrical composition. An image of a pencil-fine branch against pure snow simply titled "Detroit" belies its urban name and is a triumph of abstract minimalism. "[I]t's the subject

Frederick Sommer
American, b. Italy,
1905–1999

Eight Young
Roosters, 1938

Gelatin silver print
MUSEUM PURCHASE
71:0112:0002

(right)
Frederick Sommer

Moon Culmination,
1951

Gelatin silver print
MUSEUM PURCHASE
72:0006:0001

matter that counts. I'm interested in revealing the subject in a new way to intensify it. A photo is able to capture a moment that people can't always see." Callahan's explanations were like his photographs – succinct and elegant.

In 1935, for health reasons, Italian-born landscape architect Frederick Sommer settled in Arizona, and in the 1930s his encounters with Alfred Stieglitz and Edward Weston encouraged him to pursue photography more seriously. Sommer's early imagery had strong Surrealist overtones; although he was never part of any acknowledged art movement, he did work with Man Ray and Max Ernst, photographing the latter on a trip to Arizona. The anatomy of chickens proved to be a recurring subject for Sommer; "Eight Young Roosters" is an anatomical grid of eviscerated parts, displayed not so much for their shock value as for their strange, repellent beauty. "Moon Culmination" shows a torn and weathered picture of a dancing couple that time and nature has blended into

Aaron Siskind
American,
1903–1991

Martha's Vineyard
107, 1954

Gelatin silver print
MUSEUM PURCHASE
81:2343:0020

Aaron Siskind

Chicago, 56, 1960

Gelatin silver print
MUSEUM PURCHASE
81:2343:0007

rock. Through such an unlikely juxtaposition, Sommer finds commonalities of poetic and universal form in vastly disparate objects.

"I have brought to my picturemaking, qualities of expression that come out of my experience of music and literature. My belief in the meaning of abstract expression came from my love of music," Aaron Siskind told an interviewer. His photographs of rocks at Martha's Vineyard and graffiti on a wall in Chicago appear a world apart from his previous documentary work, yet they share his extraordinary sense for the telling gesture and poised balance. Throughout a prodigious career that led him from documentary to abstract photography, Siskind remained an influential presence on the American art scene, first at the Photo League and later as an instructor at the Institute of Design in Chicago through an invitation from Harry Callahan. For further discussion on Siskind, see page 608.

The metaphorical relationship between music and photography

Wynn Bullock
American,
1902–1975

The Tide Pool, 1958

Gelatin silver print
MUSEUM PURCHASE
81:1072:0018

Carl Chiarenza
American, b. 1935

Untitled # 32, 1962

Gelatin silver print
MUSEUM PURCHASE
80:0339:0005

that Ansel Adams and Aaron Siskind found was also sensed by Wynn Bullock, Carl Chiarenza, and Paul Caponigro. Wynn Bullock worked as a professional singer before studying photography at the Los Angeles Art Center. His images have been hailed as evocative and almost mystical. One such photograph (page 651) challenges the viewer's understanding of the subject through its abstract ambiguity in which formations in a tidal pool are transformed into a celestial landscape.

Carl Chiarenza said of his own images: "The landscapes that appear in my photographs are about ideas about the land through time; they are, for me, landscapes of the mind ... as mysterious and as full of unknown forces as [they have been] through history." Abandoning recognizable subject matter early on to photograph crystalline structures, Chiarenza showed the spiritual influence of his teacher, Minor White, in his work. Visually, his photographs find communion with Siskind's abstract images. (Siskind's influence was so important that Chiarenza

wrote a biography about him in 1982.) "Untitled # 32" transcends the
specificity of the thing photographed, going beyond mere surface to
reveal what cannot be seen. The deep, rich blacks in Chiarenza's prints
represent not the absence of light, but rather, a spiritual presence.

Just as Chiarenza's passion for music, especially Beethoven, has in-
formed his photographic work, so too did Paul Caponigro's early music
studies influence his own sense of rhythm and movement in pho-
tographs. Also a student of Minor White, Caponigro cites Weston, too,
as an important inspiration. "West Hartford, Connecticut" is a land-
scape of delicate balance. "To listen is to be brought to oneness/To
listen is to awaken the greater love/And gently part the barriers to true
seeing/The eye of truth providing the wedge/For the barriers to break
and the inner ear to listen," wrote Caponigro. These photographers
expanded the notion of what a photograph can mean, challenging the
viewer to read beyond the surface of the object depicted and investigate
the possibilities of the medium revealing more than the thing itself.
Although visually very different, this work laid the conceptual ground-
work for the experimental work of the 1970s and beyond.

America Seen

After World War II, a growing number of photographers began to seek ways to achieve a personal vision. Many went into the streets with 35mm cameras and used an approach that became defined as "available-light photography." Prints with more pronounced photographic grain, harsher contrast, and out-of-focus, truncated forms helped to impart a sense of immediacy to an image. Louis Faurer made his living as a fashion photographer from 1947 to 1969, working for *Harper's Bazaar* and other magazines in New York City. During the late 1940s and 1950s Faurer, like his friend Robert Frank, spent much of his free time photographing the ever-changing streets of New York City, seeking poetic images from the flux of urban living.

Roy DeCarava worked in New York City as a commercial artist and illustrator from 1944 to 1958, and after that as a freelance photographer. On his own time he photographed in the streets of Harlem, where he lived, gradually building an oeuvre of often melancholic, but always evocative, humane images. His 1955 book *The Sweet Flypaper of Life*, with text by Langston Hughes, provided a rare and early opportunity for an African-American artist to find a public voice in America.

William Klein
American, b. 1928

Gun 2, near the
Bowery, New York,
1955

Gelatin silver print
MUSEUM PURCHASE,
LILA ACHESON
WALLACE FUND
85:1058:0003

Demobilized in Paris in 1948, William Klein studied art, meeting the
painters Fernand Léger, Bill Max, and expatriate Americans Ellsworth
Kelly and Jack Youngerman. In the early 1950s Klein began to experi-
ment with hard-edged, abstract painting. Although visually different,
this work would influence his gritty, no-nonsense approach to street
photography. In 1954 he returned briefly to New York City where he pho-
tographed extensively in the streets. An image of three children grinning
for the photographer as an adult points a toy gun at one child's head in-
timates the undercurrent of violence and loss of innocence that Klein
found in his wanderings through the city. The subject of children and
guns was one to which Klein returned many times, clearly drawn to the
jarring juxtaposition of violence and play. His description of the city as
"... this mixture of beauty, tenderness, idiotic brutality and incompre-
hensible menace" is also embodied in this image, which shatters the
illusion of idyllic childhood. Klein's book *New York,* published in 1956,
combined a radical, almost visceral layout with a harsh inking of Klein's
high-contrast, light-flared, granular prints. Klein has published 15 other
photographic books of his own design and directed more than 20 films.

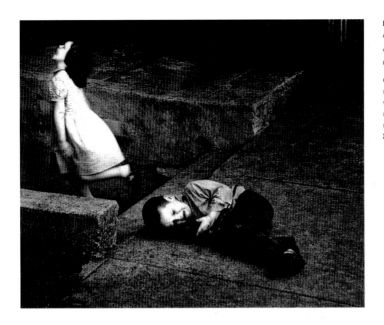

David Heath
American, b. 1931

Vengeful Sister,
Chicago, 1956

Gelatin silver print
MUSEUM PURCHASE
WITH EASTMAN
KODAK COMPANY
FUNDS
80:0366:0001

In 1947, at age 16, David Heath saw Ralph Crane's *Bad Boy's Story*, a classic photo essay about a child in an orphanage in *LIFE* magazine. Heath himself had spent his childhood in a series of orphanages and foster homes. Consequently, this photo essay would prove to have a commanding influence on his decision to become a photographer. Like Crane, Heath worked in terms of narrative groups of images. As his primary subject, he chose to address the impact that the powerful forces of isolation and community had on the human spirit, as seen in the haunting image "Vengeful Sister, Chicago." Throughout his career, Heath's work has been strongly autobiographical. His approach was very much in step with the time when the turbulent voice of the subjective "I" took center stage in the visual and literary arts. "For me," Heath wrote, "the act of photographing is no more than making notes, diaristic notes...." Profoundly moved by Robert Frank's *Les Américans*, Heath recognized that the book format provided the proper structure for his photographic art. His book, *A Dialogue with Solitude*, which he finished in 1961 but wasn't printed by an independent publisher until 1965, pushed the extended photographic essay form into a personal and poetic dimension that was unusual at that time and is still rarely seen today.

Lee Friedlander described his photographic practice in the early 1960s as documenting "the American social landscape and its conditions." This statement was only partially true; more accurately, his photographs are about a dialogue between the observer and the American social landscape and its conditions, as seen in "New York City," an image from Friedlander's self-portrait series. This series, in which the photographer's shadow or reflection intrudes into the image, contains a device reminiscent of certain literary conventions found in modern fiction since the time of Molière. It is an autobiographical device that allows the "author" to introduce personal commentary into the very heart of the narrative. Friedlander frequently employed this device to assert his presence into images that might otherwise be read as documentary records. As he once noted: "... I was finding myself at times in the landscape of my photography. I might call myself an intruder. At any rate [my photographs] came about slowly and not with plan but more as another discovery each time. ..." In the end, Friedlander's photographs are as much about personal observation as they are about the medium itself. Like his friend and fellow photographer Garry Winogrand, Friedlander worked to understand what the world looks like when photographed;

Lee Friedlander
American, b. 1934

Galax, Virginia, 1962

Gelatin silver print
MUSEUM PURCHASE
WITH NATIONAL
ENDOWMENT FOR
THE ARTS SUPPORT
81:0303:0002

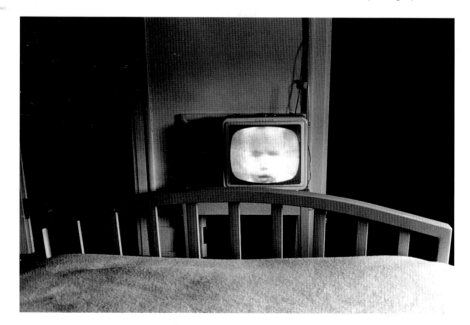

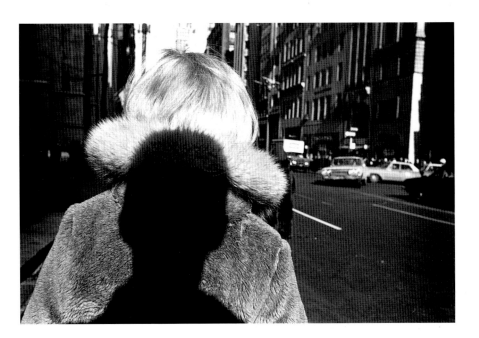

in other words, how reality is transformed through the medium of
photography into something else – something that will always be a
picture and may occasionally become art.

 Throughout his career, Friedlander's approach to picture-making
involved taking numerous photographs and putting them together
in groups. From within these distinct groups, a theme would slowly
emerge. Thus, Friedlander seeks photographic content and meaning
not in a single image, but as they evolve from the discoveries made
during the act of photographing and subsequently compiling images.
While this dialectic of question and response was familiar to painters
as they worked and reworked sketches for their paintings, it was far
from common in photographic practice before the 1960s. In earlier
photographic practice, the photographer simply sought to find the
single "best" image. As the potential of books and museum exhibitions
developed in the 1960s as venues of artistic communication, Fried-
lander and others could more readily think about finding their answers
within the process of building an extended body of work rather than by
defining themselves with single, iconic images.

Lee Friedlander

New York City, 1966

Gelatin silver print
MUSEUM PURCHASE
84:0837:0004

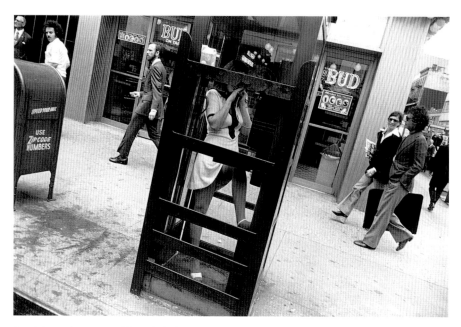

Garry Winogrand
American,
1928–1984

New York City, 1972

Gelatin silver print
GIFT OF ARTHUR
GOLDBERG
83:0151:0050

Although he began to photograph in 1948, Garry Winogrand didn't begin to develop serious ambitions for his work until the early 1960s. He would become the most existential photographer of his generation, creating a vision that stressed the authenticity of the fleeting moment, and the clarity of purpose that could emerge from within that moment. For him, the very act of taking photographs was the essence of experience, as he sought the extraordinary in the commonplace. But it was also a gamble; a gamble based on producing a huge number of photographs from which a successful image or a thematic body of work might emerge. Winogrand photographed prodigiously, even obsessively, as evidenced in his later years. At the time of his death in 1984, Winogrand had more than 2,500 rolls of exposed but undeveloped film in his possession, 6,500 rolls of developed but unproofed film, and 3,000 additional rolls with apparently unedited contact sheets. In other words, during his final five or six years, he made over a third of a million pictures that he never bothered to study after making the exposure. The photography collection holds 129 photographs by Garry Winogrand, including a set of 85 prints from the *Women Are Beautiful* series made in the 1960s.

Garry Winogrand

Coney Island,
ca. 1960

Gelatin silver print
MUSEUM PURCHASE
WITH EASTMAN
KODAK COMPANY
FUNDS
81:2077:0001

(left)
Garry Winogrand

San Marcos,
Texas, 1964

Gelatin silver print
MUSEUM PURCHASE
66:0058:0006

Bruce Davidson
American, b. 1933

Two Youths, Coney
Island, 1958–1959

Gelatin silver print
MUSEUM PURCHASE
80:0244:0032

Bruce Davidson's "Two Youths, Coney Island" is from a photographic essay on a Brooklyn youth gang that he worked on nearly every day for 11 months between 1958 and 1959. Davidson knew he wanted to be a photographer from the age of ten. Talented and lucky, his first photo essay was published in *LIFE* while he was still in college, and he was elected to the prestigious Magnum photo agency before the age of 25. His early influences were W. Eugene Smith, Henri Cartier-Bresson, and Robert Frank. His aspirations were to be an editorial photojournalist like Smith, and, like Smith, his practice was in his words, "... to work intensively with one group of people for one small period of time. ..." This in-depth concentration allowed Davidson to become more familiar with his subject and, in turn, for his subject to become more comfortable in front of his camera. From Cartier-Bresson, Davidson took a deep and basically positive humanistic stance. And, like Robert Frank, Davidson brought a poetic sensibility to an available-light style of granular, unfocused, harshly blocked tones, in order to depict outlaw or fringe elements in American society. The museum holds 67 photographs made by Davidson from 1958 to 1966.

Like Bruce Davidson, Danny Lyon has concentrated much of his attention on marginalized persons in American society. While still at the University of Chicago, he began photographing civil rights activities in the South for the Student Nonviolent Coordinating Committee, then in 1964 he returned to Chicago and began a four-year project to photograph a motorcycle gang, which was published in the book *The Bikeriders* in 1968. Between 1968 and 1991 he published several additional books and made films that he wrote, filmed, and edited. During 1967 and 1968 he photographed inside Texas prisons, ultimately producing the revelatory book *Conversations with the Dead: Photographs of Prison Life, with the Letters and Drawings of Billy McCune #122054*. In subsequent years, Lyon has been drawn to homeless children in South America, the poor in Haiti, the working class in the American Southwest, and to documenting his own family. He has always been an advocate for the people he photographs. His choice of social topics, his working practices, the direction of his career, and even the public venues he has chosen have always functioned as an alternative to standard, "establishment" media practice.

Danny Lyon
American, b. 1942

Cal, Elkhorn,
Wisconsin,
ca. 1965–1966

Gelatin silver print
MUSEUM PURCHASE,
CHARINA FOUNDA-
TION FUND AND
FUNDS PROVIDED
BY MR. & MRS.
ROBERT A. TAUB
90:0003:0043

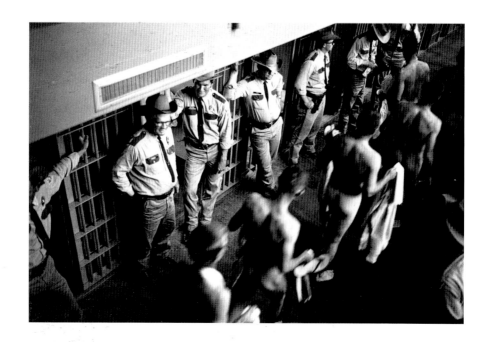

Danny Lyon
American, b. 1942

Building Shakedown,
ca. 1967–1968

Gelatin silver print
MUSEUM PURCHASE
71:0160:0003

While Danny Lyon documented his subjects from a sympathetic position, attempting to depict aspects of their lives with compassion and clarity, Larry Clark's view of nonconformity is more extreme.

A self-acknowledged drug addict, Clark photographed his own hermetic world of teenage drug addiction in his hometown of Tulsa, Oklahoma. His book *Tulsa*, published in 1971 by an independent publisher, was clearly autobiographical, and the photographs were direct and unsentimental without any moralizing or journalistic flourishes as seen here in "Man with Baby." It was a somber, powerful look into a previously unexplored world that was seemingly hidden from view.

The book caused a sensation within the photographic community, prompting many in the field to explore autobiography as the primary orientation for their work. Clark became an important member of a generation of photographers who worked to cast light on their particular lifestyle considered by mainstream America to be in opposition to traditional cultural values. He continues this approach in his current work as a filmmaker. The museum's holdings include a complete set of the 50 prints that were used to make *Tulsa*.

Larry Clark
American, b. 1943

Man with Baby,
ca. 1965

Gelatin silver print
MUSEUM PURCHASE
72:0136:0039

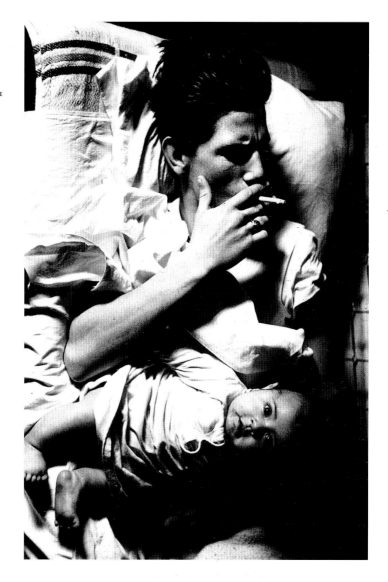

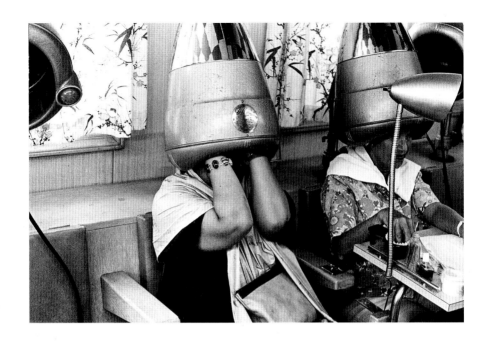

Joel Meyerowitz
American, b. 1938

*Women under
Hairdryers*, ca. 1964

Gelatin silver print
GIFT OF THE
PHOTOGRAPHER
78:0851:0020

Joel Meyerowitz studied painting in college and was working as an art director in New York City in 1962 when, inspired by Robert Frank's work, he began to make photographs. In 1966 he stated, "I find it strangely beautiful that the camera with its inherent clarity of object and detail can produce images that in spite of themselves offer possibilities to be more than they are ... a photograph of nothing very important at all, nothing but an intuition, a response, a twitch from the photographer's experience." Throughout the 1960s Meyerowitz, working in black and white with a 35mm camera, exercised his intuition along city streets and public spaces to find instances of the extraordinary, the bizarre, and the surreal in everyday life. In the 1970s, Meyerowitz took up color, larger cameras, and a more formalized style, helping advance two new photographic movements, "New Topographics" and "New Color," that flourished during the decade. He later said, "...[the small camera] taught me energy and decisiveness and immediacy ... The large camera taught me reverence, patience, and meditation." The photography collection holds 34 of Meyerowitz's early black-and-white photographs.

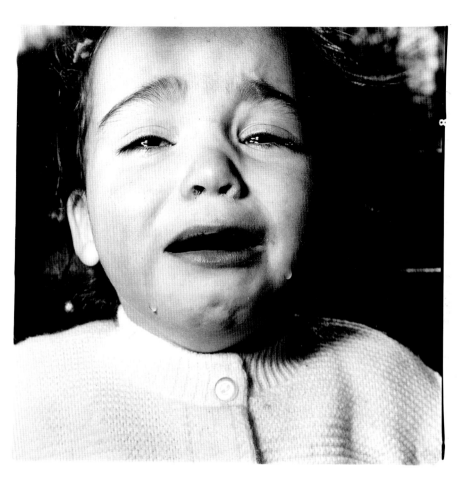

"A photograph is a secret about a secret. The more it tells you the less you know," Diane Arbus once noted. Arbus's uncanny ability to empathize with her subjects and thus extract startling moments of honesty from them produced some of the most confrontational and compelling portraits in the history of the medium. This extreme close-up of a child provides no visual escape or relief for either subject or viewer. In its stark frontal exposition, the photograph challenges the comfortable notion of blissful childhood to reveal its real terrors and fears, forcing the viewer not merely to look, but to see. As a photographer, Arbus was utterly daring, challenging herself to unveil the hidden realm of the human psyche.

Diane Arbus
American, 1923–1971

A Child Crying,
New Jersey, 1967

*Print 1988, by
Neil Selkirk.
Gelatin silver print*
MUSEUM PURCHASE,
CHARINA FOUNDA-
TION FUND
89:0358:0001

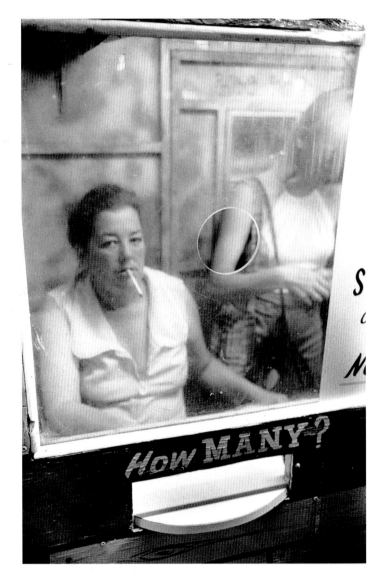

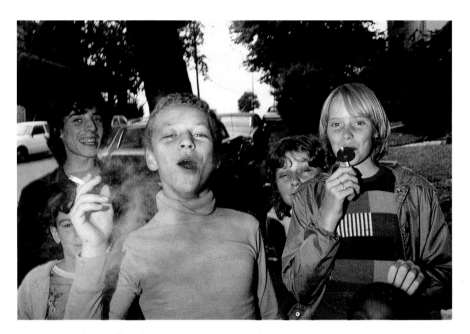

In a sense, both Bill Burke's "How Many?... " and Mark Cohen's "Group of Children" exemplify the logical end of several conceptual ideas that were fueling the "Street Photography" movement that was flourishing after World War II and the earlier documentary practice that preceded it. If photography is the most democratic of art forms, the one most tied to the very structure of democratic ideals, then it makes perfect sense to make photographs of "the people." The subject common to both Burke's and Cohen's art is the ordinary person involved in unexceptional, everyday events. By the early 1970s Mark Cohen, who ran a portrait studio in Wilkes-Barre, Pennsylvania, had become a street photographer of the vernacular who mined the mundane for photographs of mystery and beauty. The museum holds 127 of Cohen's images.

Bill Burke has also spent his career photographing the average citizen, the common face in the crowd. However, he has traveled to uncommon places to do this; the backwoods of Kentucky and West Virginia, the countryside of Brazil, and later the embattled land of Cambodia. But in each of these seemingly exotic places, he has always sought out the common citizen engaged in the daily activities, whether ordinary or notable, that give definition to the vast realm of human experience.

Mark Cohen
American, b. 1943

Group of Children,
ca. 1977–1978

Color print, chromo-genic development (Ektacolor) process
MUSEUM COMMIS-
SION WITH SUPPORT
FROM THE EASTMAN
KODAK COMPANY
78:0641:0034

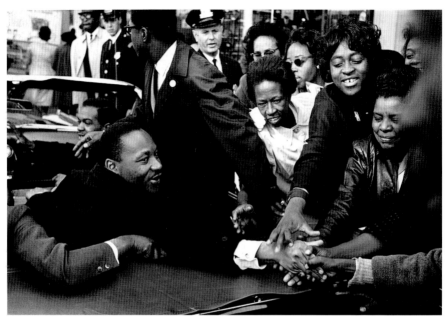

Leonard Freed
American, b. 1929

Dr. Martin Luther
King, Jr. Greeting
His Supporters after
He Received the
Nobel Peace Prize
in 1964, Baltimore,
MD, 1964

Gelatin silver print
GIFT OF THE
PHOTOGRAPHER/
MAGNUM PHOTOS,
INC.
88:0459:0003

The World Beat

In his 1991 book *Powerful Days*, Charles Moore stated that "Pictures can and do make a difference. Strong images of historical events do have an impact on society. ... The cry for freedom is heard from South Africa to the Soviet Republics. We must not give up our own struggles in this great country for increasing democracy and equality for all people." This social perspective has fueled Moore's work as well as the work of others featured in this chapter. These photographers directed their talents toward the "hot" end of photojournalism, into the line of fire. Leonard Freed, Charles Moore, and Flip Schulke each began to photograph the Civil Rights movement in the American South in the 1960s as routine assignments. Leonard Freed, a Magnum photojournalist, was gathering materials for his book *Black in White America*. Flip Schulke was sent to photograph Martin Luther King, Jr., for *Jet* magazine. A Montgomery, Alabama, newspaper sent Moore to report on King's civil rights campaign. For each of these photographers, their assignments turned into a mission and an extended commitment to photograph the political and social changes that were dividing American society.

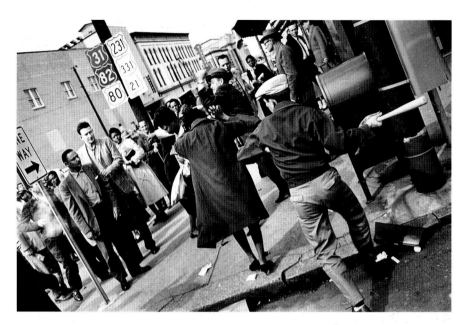

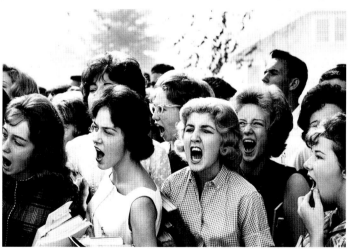

Charles Moore
American, b. 1931

Man Swinging Club
at Black Woman on
Montgomery, Alabama Street Corner,
ca. 1960–1961

Gelatin silver print
MUSEUM PURCHASE,
CHARINA FOUNDA-
TION FUND
88:0463:0002

(left)
Flip Schulke
American, b. 1930

White Students
in Birmingham
Demonstrate against
Integration in Their
High School,
September 1963

Gelatin silver print
GIFT OF THE
PHOTOGRAPHER
88:0397:0001

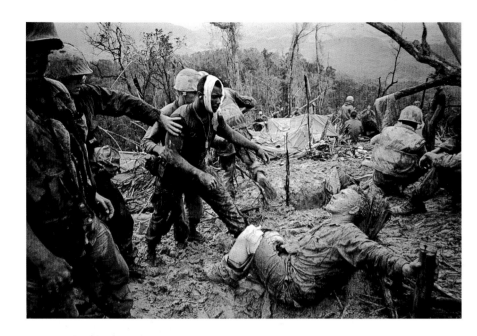

Larry Burrows
English, 1926–1971

Reaching Out, The
DMZ (During the
Aftermath of the
Taking of Hill 484,
South Vietnam),
1966

Print by F. Tartaro,
1987. Color print, dye
imbibition (Kodak
Dye Transfer) process
MUSEUM PURCHASE,
FORD MOTOR
COMPANY FUND
87:0390:0001

"Reaching Out, The DMZ ..." by Larry Burrows and "Khe Sanh ..." by Robert Ellison show the extraordinary immediacy and intimacy that photojournalists were able to achieve in their coverage of the Vietnam War. By the 1960s, 35mm cameras and color film had replaced the larger press cameras and black-and-white film to become the standard for magazine photojournalists. Photojournalists also began to put themselves in harm's way much more often than in the past. During World War II, Robert Capa and W. Eugene Smith's working in the midst of actual combat was considered to be beyond journalistic practice, but in ensuing years, many photographers routinely exposed themselves to dangerous situations, none greater than Vietnam. Burrows photographed the Vietnam War from 1962 until he was killed there in 1971. His photographic essay *Yankee Papa 13* (*LIFE*, April 16, 1965) is considered a hallmark of photojournalism, as is his color image "Reaching Out ...". Robert Ellison joined the Black Star photo agency and went to Vietnam, where he photographed the North Vietnamese Tet Offensive in Khe Sanh in 1968, before being killed two weeks later.

Robert Ellison
American,
1945–1968

Khe Sanh, Vietnam
War, 1968

*Print 1988. Color
print, chromogenic
development (Ekta-
color) process*
MUSEUM PURCHASE,
CHARINA FOUNDA-
TION FUND
88:0463:0001

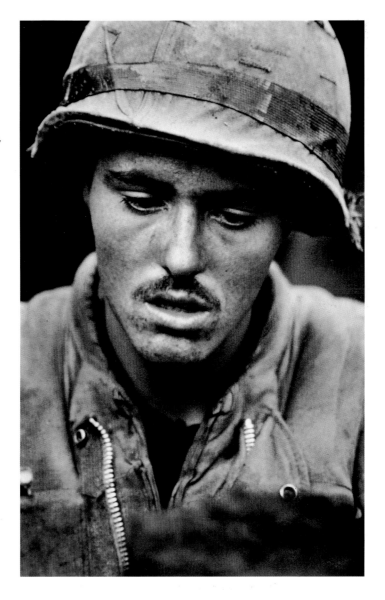

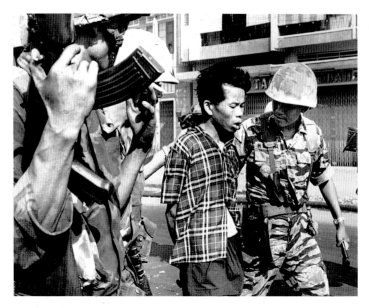

(right)
Benedict J. Fernandez
American, b. 1936

Dissenters, United Nations Plaza, New York City, April 1967

Gelatin silver print
GIFT OF THE PHOTOGRAPHER
88:0460:0001

Eddie Adams
American, b. 1933

Vietcong Arrested, 1968, print 1988

Gelatin silver print
GIFT OF THE ASSOCIATED PRESS
88:0398:0026

The photographs of Larry Burrows and Robert Ellison, among others, brought the agony and insanity of war home to the American people with a new immediacy and graphic power. In a guerrilla war with no fixed battle lines, neither the Vietnamese nor the American governments were able to exercise the degree of censorship imposed in earlier conflicts. This was certainly the case with Eddie Adams's 1968 "Vietcong Arrested," part of a series of photographs of a roadside execution. The series was made after a fire fight in the An Quang Pagoda in Saigon. The prisoner, supposedly a Vietcong lieutenant captured in the battle, was led to Brigadier General Nguyen Ngoc Loan, Vietnamese chief of police, who, without warning, pulled out a pistol and shot him in the head. The climactic image, also included in the museum's collection, became a universal symbol of the vicious nature of the war. As a result, it served to polarize public opinion about America's participation and its foreign policies.

Back in America, the national debate over the Vietnam War spilled into the streets, as depicted in Benedict J. Fernandez's photographs of anti-war protesters and pro-war supporters demonstrating in New York City. Fernandez captured the rallies, protests, and leaders that dominated the social landscape of the 1960s. The museum holds 114

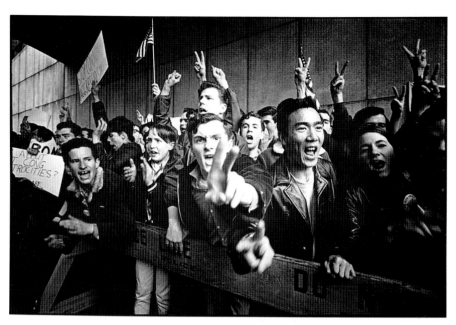

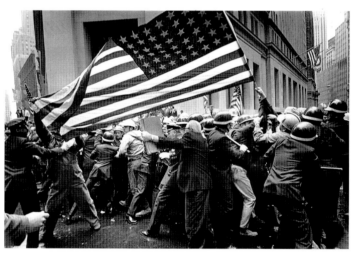

(left)
**Benedict J.
Fernandez**

Pro-Vietnam-War
Demonstration,
New York, 1970

Gelatin silver print
GIFT OF THE
PHOTOGRAPHER
96:0350:0014

photographs by Fernandez, including more than 50 photographs relating to Dr. Martin Luther King's life.

These two photographs by Don McCullin, "Cyprus" and "British Soldiers … Londonderry" portray the violence of two of the many factional conflicts that have raged throughout the world since World War II. McCullin worked his way out of a London slum to become one of the most highly regarded photographers in Great Britain. He was introduced to a wider world and to photography while serving in the Royal Air Force in the 1950s. Back in England and working as a laborer, McCullin began to photograph his friends in a London youth gang. When a murder made the gang newsworthy, McCullin showed his "snaps" to a newspaper editor who was perceptive enough to publish them and to hire him as a stringer. In 1964 McCullin was sent on assignment by the London *Observer* to cover the civil war in Cyprus. His photographs, taken in the midst of the bitter house-to-house fighting and showing the suffering of the war's victims, won awards and international recognition for McCullin. He was hired by the London *Sunday Times* in 1967 and worked as a photojournalist for the next 20 years, photographing poverty in England and famine

Don McCullin
English, b. 1935

Cyprus, 1964

Gelatin silver print
MUSEUM PURCHASE,
FORD MOTOR
COMPANY FUND
88:0273:0001

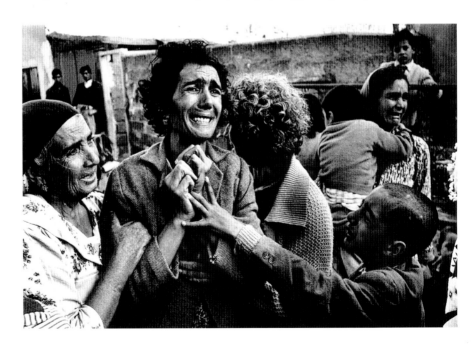

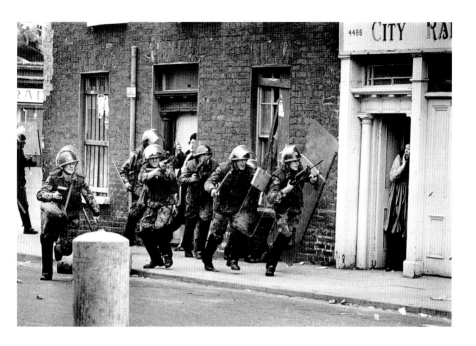

and warfare in the Congo, South Vietnam, Cambodia, Biafra, India, Pakistan, the Sahara, Northern Ireland, Beirut, and elsewhere.

In 1989 McCullin summarized his work: "I don't believe you can see what's beyond the edge unless you put your head over it; I've many times been right up to the precipice, not even a foot or an inch away. That's the only place to be if you're going to see and show what suffering really means. ... I've spent fourteen years getting on and off aeroplanes and photographing other people's conflicts. I will never get on another aeroplane and go photograph another country's war." In spite of this promise, in the early 1990s McCullin went to war again, photographing Saddam Hussein's attacks on the Iraqi Kurds. McCullin, in seeking a larger audience, has published many books of his work throughout his career. *The Destruction Business* (1971), *Is Anyone Taking Notice?* (1973), *The Homecoming* (1979), *Hearts of Darkness* (1980), *The Palestinians* (1981), *Beirut: A City in Crisis* (1983), and *Don McCullin: Sleeping with Ghosts* (1996) are representative of his efforts.

Raymond Depardon's "Christian Phalangist Militiaman ..." (page 678) and Gilles Peress' "Pro-Shariatmadari Demonstration ..." (page 679)

Don McCullin

British Soldiers Dressed Like Samurais Charge Stone-Throwing Youths, Londonderry, 1970

Gelatin silver print
MUSEUM PURCHASE,
FORD MOTOR
COMPANY FUND
88:0273:0002

were both taken during the political turmoil wracking the Middle East in the late 1970s. Both men were top-ranking French photojournalists working for independent photo agencies. Each utilized the faster, better 35mm cameras and lenses available by the 1970s to place themselves in the middle of the tumultuous events they were photographing. Being at the heart of a conflict had become standard photojournalistic practice. Moreover, it was encouraged by many of the fighting factions, who hoped to air their cause in the world press.

Both photographs were taken with wide-angle lenses, allowing a greater depth of field at faster shutter speeds. As the name implies, the wide-angle lens encloses an expanse of space that is broader than normal human vision, exaggerating spatial perspective. It also renders very close and very distant objects in focus simultaneously. This allows the photographer to dramatically heighten, in both composition and mood, the startling action occurring in front of the camera. The result can be clearly seen in "Militiaman ..." in which Depardon has visually merged the rifleman in the foreground of his photograph with the source of enemy fire coming from a distant building.

Peress uses similar compositional strategies in his photograph to

Raymond Depardon
French, b. 1942

Christian Phalangist Militiaman Fires to Cover Himself as He Races for a New Position in the Shattered Streets of Beirut, 1978

Gelatin silver print
MUSEUM PURCHASE, FORD MOTOR COMPANY FUND
88:0459:0001

collapse the spatial structure of the image into one dynamic field of view. The almost abstract shapes of the truncated heads in the bottom foreground space are balanced against the cropped head of the ayatollah on the poster; these are counterbalanced against the middle and distant groups of men, some armed. This composition presents a complex and tense image, metaphorically suggesting the complexity and uncertainty of the political situation in Iran following the Shah's abdication and the American hostage crisis.

Depardon and Peress have both published several books and directed various documentary films. Peress's book, *Telex: Iran: In the Name of Revolution*, features 100 photographs with captions derived from his telegrams to his photo agency to present his sense of alienation as he watched and waited through the long days of the political crisis. More than simple reportage, this publication extends its message to encompass compelling personal commentary.

Mary Ellen Mark and Donna Ferrato documented social issues afflicting America in the 1980s. While both began their careers as general magazine photographers, each was drawn to addressing complex social

Gilles Peress
French, b. 1946

Pro-Shariatmadari
Demonstration,
Tabriz, Iran,
ca. 1979–1980

Gelatin silver print
MUSEUM PURCHASE,
FORD MOTOR
COMPANY FUND
85:0760:0001

Donna Ferrato
American, b. 1949

First Night in
Shelter, February,
1987

Gelatin silver print
GIFT OF THE
PHOTOGRAPHER
88:0461:0001

themes that had previously not found a voice in print mass media.
Ferrato wrote in the preface to her 1991 book *Living with the Enemy* that
she began to photograph domestic violence in 1981, but could not find
a magazine editor willing to print anything about the topic until after
1986. Mary Ellen Mark was faced with a similar obstacle. Her unprece-
dented book on the harrowing lives of homeless children, entitled
Streetwise, was published in 1988, five years after the start of the project.
For both Ferrato and Mark, photojournalism involves not only a com-
mitment to revealing social problems, but engaging and altering pre-
vailing public opinion.

In 1979, at age 32, Susan Meiselas became only the second woman
to win the coveted Robert Capa Prize for photojournalism with a break-
through body of work documenting the Nicaraguan revolution. In

Susan Meiselas
American, b. 1948

Awaiting Counter-
Attack by the Guard
in Matagalpa,
ca. 1978–1979

*Color print, chromo-
genic development
(Ektacolor) process*
GIFT OF THE
PHOTOGRAPHER/
MAGNUM PHOTOS,
INC.
88:0459:0009

color-saturated photographs such as "Awaiting Counter-Attack by the Guard in Matagalpa," she emphasizes the psychological and physical suspense that accompanies the pause before an impending battle. Meiselas went to Nicaragua without an assignment and with little understanding of the language or the civil crisis there. What she did know was that it was a story largely ignored by the international press. When recognition did occur, her photographs served to define Nicaragua's upended political scene and shape the world's knowledge of it.

Unlike other photojournalists, past or present, Meiselas never hides her sympathy or allegiance to a specific cause or group when photographing in highly charged situations, as in her depictions of Nicaraguan rebels. She has always been aware of the photograph's power to elicit strong emotions and to sway public opinion. In ensuing years, Meiselas has made the political and social landscape of Latin and Central America a personal pursuit, including coordinating the efforts of photographers in El Salvador and gaining for them greater international exposure.

The development of faster color printing technologies for magazines and newspapers made color photojournalism a practical endeavor in

the 1970s. Since then, color photographs have gradually replaced black-and-white in most illustrated magazines and in many newspapers. A young photographer practiced in the psychological power of color photography is the Chinese photojournalist Liu Heung Shing, who was on assignment for The Associated Press during the student demonstration at Beijing's Tiananmen Square, and its subsequent suppression by Chinese authorities.

Born in China in 1951, Heung Shing studied journalism and political science at Hunter College in the United States. By the mid-1970s he was covering political hot zones for *Time* magazine. Like many of his contemporaries, including several cited in this publication, Heung Shing's use of color photography helps to collapse the psychological distance between the subject photographed and the viewer. This, coupled with the dramatic authenticity of color, not only integrates the overall composition of the photograph, but ensures the emotional scope and depth of the action at hand, as seen in Heung Shing's "Rescue Bullet Wounded ...". His use of color accentuates the violent context of the scene, thus creating a memorable emblem of civil strife.

Liu Heung Shing
American, b. Hong Kong, 1951

Rescue Bullet Wounded – A Rickshaw Driver Fiercely Paddled [*sic*] the Wounded People with the Help of Bystanders to a Nearby Hospital Sunday. P. L. A. Soldiers Again Fired Hundreds of Rounds towards Angry Crowds Gathered outside Tiananmen Square at Noon, June 1989

Color print, chromogenic development (Ektacolor) process
GIFT OF THE
ASSOCIATED PRESS
90:0466:0026

Peers and Predecessors

By the late 1960s the battle had been waged and (mostly) won over photography's status as a fine art. The medium had successfully imitated painting, and it had also come into its own, exploring its unique capabilities. Universities had established photography departments and programs; the Museum of Modern Art established a department of photography in 1940, and Eastman House opened its doors to the public in 1949. Several of the photographers discussed in this chapter, Thomas Barrow, Robert Fichter, and Joe Deal, worked at Eastman House at some point, which provided them access to the extraordinary wealth and scope of photographic history housed there. Others, such as Paul Berger, Betty Hahn, Les Krims, Joan Lyons, Bea Nettles, and Jerry Uelsmann, attended school, taught, or lived in Rochester, benefiting directly from the vibrant photographic community, including Visual Studies Workshop and the Rochester Institute of Technology.

With photography having made significant inroads into the academy of High Art, photographers began to use the medium to address what

Robert Heinecken
American, b. 1931

Mansmag, 1969

Offset lithographs in form of a booklet
GIFT OF THE
PHOTOGRAPHER
79:4389:0001

Thomas F. Barrow
American, b. 1938

*Television Image
Montage*, 1969

*Toned gelatin
silver print*
MUSEUM PURCHASE
70:0167:0002

museums and universities traditionally did not: popular media. After all, most people experienced photographs every day through television, newspapers, and magazines and were unfamiliar or unconcerned with the academic debate over whether or not this medium with such practical applications was capable of the same expressive qualities as painting. Informing this generation was also the precedent set by John Heartfield, László Moholy-Nagy, and Alexander Rodchenko, who used found images, text, and graphic design to convey political and personal messages through work that was not necessarily conceived as fine art.

Common to all of this work was dependence on the notion that people believe what they see in a photograph. "Because I was never in a school situation where someone said 'This is the way a photograph is supposed to look,' I was completely free to cut them up, combine them, or do anything. ... Some of my enthusiasm for the photograph was based on the fact that there was some residual illusion of reality in it always, no matter what I did to it," wrote Robert Heinecken, who was trained as a printmaker. "Mansmag" is part photomontage, part subversive performance. Using stock images from softcore pornographic houses and pages from women's fashion magazines, Heinecken montaged the porn images through the offset printing process and rendered the images as negatives. He thus blurred the distinctions between different types of cultural representation, leaving the viewer to contemplate the conflicted visual messages that the media feed women versus those they feed men.

Thomas F. Barrow's early work was also a commentary on popular media, in this instance on television, or "cathode ray canvas," as it has been called. Like Heinecken, Barrow used pornographic images, in this

Robert W. Fichter
American, b. 1939

Astronaut Still Life,
ca. 1974

*Cyanotype and gum
bichromate print*
MUSEUM PURCHASE
WITH NATIONAL
ENDOWMENT FOR
THE ARTS SUPPORT
74:0222:0004

instance placed over a TV screen tuned to a soap opera. With the light produced by the TV, he rephotographed the montaged relationships – and meanings – that were newly created. The hypnotic layering of images that occurs on a TV screen in the split second when one frame changes to another also informs the work.

Robert Fichter's "Astronaut Still Life" uses the iconography of boy's toys and war games to construct an image of alienation and obliteration. A student of Jerry Uelsmann, Fichter stated, "I am a student of photography – not a photographer," referring to his use of the medium only as a means to an end. The clashing, acidic colors of the print send a chilling message of America's persuasive might expanding into new frontiers.

Fichter, Bea Nettles, and Betty Hahn used some of the older photographic processes – cyanotype, Van Dyke, and gum bichromate – to communicate their contemporary messages. The techniques imbue the work with a deliberate nostalgia, while also denoting the hand of the

Betty Hahn
American, b. 1940

Broccoli, 1972

*Gum bichromate on
fabric with applied
stitching*
MUSEUM PURCHASE
73:0044:0002

maker. Nettles created "Floating Fish Fantasy," (page 687) a densely
layered image that transforms elements of landscape into an imaginary
dreamscape. The subtle hand-coloring on the rich Van dyke print adds
an autographic dimension.

Nettles' imagery has been categorized as so-called "women's work,"
which emerged around this time to expand the acceptable limits of
media. Paper photographs stitched together, photographs on fabric –
these were some of the methods she and others employed. In a propi-
tious coincidence, Nettles' first camera was one that her grandmother
received from having bought a sewing machine.

Betty Hahn's "Broccoli," from her *Gum Bichromates on Fabric* series,
is a witty variation on the more traditionally defined "floral" images
in the history of art as well as those revered vegetables portrayed by
Edward Weston. A gum bichromate print on fabric, the image has been
embellished with embroidery thread, a craft that is traditionally associat-
ed with women. By combining these various media, Hahn claims each
of them as a valid means of expression, creating an object with no
precedent in art but with a rich history.

Although artists have always made self-portraits, the work of
Joan Lyons revels in the plasticity of the medium, utilizing alternative

Jerry N. Uelsmann
American, b. 1934

Hands with Round Object in Mountainscape, 1970

Gelatin silver print
MUSEUM PURCHASE
73:0051:0002

imaging machines. As she defines it, her work exemplifies the "difference between autobiographical and personal and ideas that seem universal and common ... experiences that will be understood. ..." Lyons does not consider her series of portraits done on an early-model photocopier to be self-portraits. "The machine does funny things and I could make portraits of myself on that machine that make me look sixteen years old or make me look eighty-three. It's a different person each time."

For Jerry Uelsmann, the darkroom is a laboratory of technical and psychological exploration. Uelsmann credits Minor White as being one of his "photographic godfathers." His montaged images are as seamless as they are fabricated, challenging the viewer's beliefs about the veracity of the photographic image.

About his own portrait in his *Photo-Transformations* series, Lucas Samaras wrote: "Each click of the shutter suggests an emotional and

visual involvement and contains the potential of establishing greater rapport with some quintessential aspect of the subject and my feelings toward it, both conscious and preconscious." Samaras utilized the popular Polaroid SX-70 camera that produces a small, square instant image, a one-of-a-kind color photograph. Most commonly used for snapshots, the expressive possibilities of the Polaroid print are transformed through Samaras's use of homemade filters that radically alter color and his manipulation of the emulsion during development to produce the figurative distortions.

Lucas Samaras
American, b. Greece, 1936

Photo-Transformation, 1976

Color print, internal dye diffusion transfer (Polaroid SX-70) process
ALVIN LANGDON COBURN MEMORIAL FUND BY EXCHANGE 83:0617:0002

Les Krims
American, b. 1943

*Pregnant Woman
Making Large Soap
Bubble,* 1969

*Toned gelatin silver
(Kodalith) print*
78:0516:0022

The bizarre humor of Les Krims is an anomaly in the photographic canon. The incongruous and unexpected elements of "Pregnant Woman Making a Large Soap Bubble" make sense from a formal perspective: the huge, elongated bubble that the woman creates echoes the form of her belly. The subject elements conjure up different images from photographic history: the mask recalls Pierre-Louis Pierson's portrait of the Countess de Castiglione; the fluid orb recalls the delicate balance of Anne Brigman's "The Bubble." However, what is most compelling is Krims' art of the setup, the complete staging of a scene that defies both logic and necessity. The absurdity of the wearing of a mask, the subject's gesture, the mundane functionality of the underwear that suggests undress rather than academic nudity, and even the decision to locate the action next to a pipe running vertically down the wall contribute to an overall sense of reality being tampered with for the sake of the photograph.

Masks take on a different meaning in the work of Lexington, Kentucky, optician Ralph Eugene Meatyard. He, too, set up scenes for the camera. An image of his children and wife sitting in bored postures on

bleachers assumes another dimension of reality when they don Halloween fright masks, so jarring compared with their casual poses. Particularly poignant is the way in which these grotesque masks, worn by children, reveal their own father's intense look at his mortality. The title, "Romance (N) from Ambrose Bierce, No. 3," lends a literary allusion to this image. What could have been a simple snapshot of Meatyard's children and wife becomes a meditation on persona and collective memory. Bierce defined romance as "fiction that owes no allegiance to the God of things as They Are," and Meatyard's fictional "romances" pay their own allegiance to the power of memory and imagination.

Ralph Eugene Meatyard
American, 1925–1972

Romance (N) from Ambrose Bierce, No. 3, 1962

Gelatin silver print
MUSEUM PURCHASE WITH EASTMAN KODAK COMPANY FUNDS
80:0467:0001

Eikoh Hosoe
Japanese, b. 1933

Ordeal by Roses,
1962

Gelatin silver print
MUSEUM PURCHASE
75:0119:0003

(right)
Ralph Gibson
American, b. 1939

*Snake around Man's
Neck*, 1972

Gelatin silver print
MUSEUM PURCHASE,
CHARINA FOUNDA-
TION PURCHASE
FUND
90:0701:0014

In 1962 Japanese photographer Eikoh Hosoe created "Ordeal by Roses" from the series *Killed by Roses*, with the celebrated Japanese author Yukio Mishima as his model. Hosoe defined the project as "an effort at destruction of iconoclasm ... it also involved great respect for my subject. Destruction should be followed by reconstruction, and the project actually grew into a subjective documentary of Mishima based on my own imagination and vision of truth." A portrait of Mishima holding a rose up to his nose and staring piercingly at the viewer is less a likeness than a state of mind. Mishima described the experience of being photographed: "The world to which I was abducted under the spell of his lens was abnormal, warped, sarcastic, grotesque, savage, and promiscuous ... yet there was a clear undercurrent of lyricism murmuring gently through its unseen conduits."

A similar world of unseen meaning permeates Ralph Gibson's "Snake around Man's Neck," from the series *Days at Sea*. (This series was published as a book, the third in a trilogy of books by Gibson.) For its radical use of perspective, the image owes a debt to Rodchenko and Moholy-Nagy. The figure is deliberately rendered as an uneasy abstract pattern.

Robert Adams
American, b. 1937

Tract House, Westminster, Colorado, 1974

Gelatin silver print
GIFT OF THE
PHOTOGRAPHER
77:0149:0006

In the early 1970s a particular aesthetic developed among photographers traveling in the West and Southwest. Theirs was an industrial and suburban landscape of architecture and land reorganization that redefined the mythical, heroic Western landscape as a contemporary reality. Robert Adams wrote that his hope as a photographer was "to discover a tension so exact that it is at peace." "Tract House, Westminster, Colorado" is not critical of its subject but rather seeks to find beauty in what is before the photographer, even the cookie-cutter, vernacular architecture of late-20th-century suburban sprawl. In 1975 the *New Topographics* exhibition at George Eastman House introduced this aesthetic, and even more lasting, the label that was aptly applied to this body of work that examined the new American landscape. The Eastman House exhibition featured, among others, the work of Robert Adams, Lewis Baltz, Joe Deal, Frank Gohlke, and Stephen Shore.

Gohlke was a student of Paul Caponigro; he wrote: "The best landscape images, whatever their medium and whatever other emotions

Frank Gohlke
American, b. 1942

Landscape,
Albuquerque,
New Mexico, 1974

Gelatin silver print
MUSEUM PURCHASE
WITH NATIONAL
ENDOWMENT FOR
THE ARTS SUPPORT
77:0055:0004

Joe Deal
American, b. 1947

Untitled View
(Albuquerque), 1974

Gelatin silver print
GIFT OF THE
PHOTOGRAPHER
77:0118:0001

they may evoke ... propose the possibility of an intimate connection with a world to which we have access only through our eyes, a promise containing its own denial." His landscape of Albuquerque, New Mexico, is all concrete and sky, which dwarf the noisier signs of civilization that line the horizon. What unifies all of these photographers' work is the conspicuous absence of humans coupled with the palpable force of human presence in these deeply inhabited worlds.

Joe Deal credits his time working at the Eastman House, first as a security guard and later as director of exhibitions, with changing his perception about the possibilities of photographs through the vast range of images that passed before his eyes. Of his landscapes, including the untitled view overlooking Albuquerque (page 697), Deal explained: "I ... wanted to deal with more ordinary, contemporary structures that weren't special and see what could be done. ... My problem was to find a different way of photographing this new subject matter that wouldn't satirize it. It was more of an accident that I was up on a hill and looked down and could see the houses in the context of the landscape rather

Lewis Baltz
American, b. 1945

South Corner, Riccar America Company, 3184 Pullman, Costa Mesa, 1974

Gelatin silver print
GIFT OF THE PHOTOGRAPHER
78:0515:0017

than just singling out the details of the architecture. I could get more distance and there was a feeling of greater objectivity in that."

Like Deal, Lewis Baltz steadfastly maintains a cool distance from personal expression or emotion throughout his work. In images such as "South Corner, Riccar America Company, 3184 Pullman, Costa Mesa," even the title, so precise as to be almost clinical, echoes the detached objectivity of the image.

Stephen Shore was largely self-taught in photography, although he studied at one time with Minor White. Shore's work has virtually always been distinguished by his use of saturated color, which makes images such as "Holden St., North Adams, Massachusetts" instantly recognizable, but equally as important, also makes them formal constructs of photographic color and detail.

John Pfahl puts a particular spin on the landscape photograph. "Shed with Blue Dotted Lines, Penland, North Carolina," from the series

Stephen Shore
American, b. 1947

Holden St., North Adams, Massachusetts, July 13, 1974

Color print, chromogenic development (Ektacolor) process
GIFT OF BARNABAS MCHENRY
85:1240:0001

John Pfahl
American, b. 1939

Shed with Blue
Dotted Lines,
Penland, North
Carolina, June, 1975

*Color print, chromo-
genic development
(Ektacolor) process*
MUSEUM PURCHASE
77:0119:0001

Altered Landscapes is both a visual pun and a reinvestigation of the two-dimensional picture plane. The dotted lines are actually placed in the landscape, not added later to the print, as might be assumed. He further explains: "Locations for the photographs were chosen for their 'picturesque' qualities, their formal structure, and their referential possibilities. The added elements suggest numerous markmaking devices associated with photographs, maps, plans, and diagrams. On different occasions, they may pointedly repeat a strong formal element in the landscape, they may fill in information or utilize information suggested by the scene, or they may be only arbitrarily related to the scene but refer instead to the process of making a photograph."

"Kaanapali Coast, Maui, Hawaii" from the series *Picture Windows* investigates the devices we use to interpret, rather than experience, nature from the window that frames a spectacular view to the photograph itself, which frames them both. "Bethlehem # 16, Lackawanna, New York" from the series *Smoke*, presents the awful beauty of industrial waste and pollution; Pfahl seduces the viewer with Turneresque color but is careful to include just enough of the smokestack to remind the viewer of beauty's subjectivity. Eastman House is fortunate to have been chosen by the artist as the repository for his life's work.

John Pfahl

Bethlehem # 16,
Lackawanna, N.Y.,
1988

*Color print, chromo-
genic development
(Ektacolor) process*
MUSEUM PURCHASE,
CHARINA FOUNDA-
TION FUND AND
MATCHING FUNDS
90:0066:0001

John Pfahl

Kaanapali Coast,
Maui, Hawaii,
March 1978

*Color print, chromo-
genic development
(Fktacolor) process*
GIFT OF THE
PHOTOGRAPHER
95:1562:0001

Emmet Gowin
American, b. 1941

Copper Ore Tailing,
Globe, Arizona, 1988

*Split-toned gelatin
silver print*
MUSEUM PURCHASE,
CHARINA FOUNDA-
TION FUND AND
MATCHING FUNDS
90:0012:0001

The seductive beauty of industrial waste has also been examined by
Emmet Gowin. Gowin was a student of Harry Callahan at the Rhode
Island School of Design, whose work appealed to Gowin because of
"a poetry of feeling and intimacy and the revelation of a secret, un-
recognized dimension in the commonplace." A meticulous printer,
Gowin infuses a disturbing image such as "Copper Ore Tailing, Globe,
Arizona" with a rare luminosity. These aerial photographs began as a
study of the nuclear landscape. "Even if we could turn back the nuclear
clock, the attitude that humankind has had toward nature is based

Emmet Gowin

Siena, Italy, 1978

Gelatin silver print
MUSEUM COLLEC-
TION, BY EXCHANGE
85:0519:0002

largely on dominance, ownership, and a concept of right founded on a misunderstanding. We have believed that we could do as we wished with the earth without substantially affecting ourselves," Gowin wrote.

An earlier work, "Siena, Italy," owes a debt to Frederick Sommer, whom he met in 1967 and whose horizonless landscapes were another major influence on Gowin's work. "Don't let anyone talk you out of physical splendor," Sommer once counseled, and Gowin's imagery is the artistic manifestation of the mentor's admonishment. Gowin has long exhibited a respect for the natural world and those who investigate it: "I find that I'm in harmony with the physicists, the scientists. I find them to be the most poetic people of our age. ... I feel the most tender language is coming from them. ... I require a non-aggressive approach to positive solutions that have as their subject the unity of life."

Like Tom Barrow and Robert Fichter, John Baldessari is an artist who

John Baldessari
American, b. 1931

Embed Series: Cigar
Dreams (Seeing Is
Believing), October,
1974

*Retouched gelatin
silver print*
MUSEUM PURCHASE
76:0185:0001

uses photographs but does not see himself as a photographer. His work belongs to the world of conceptual art that emerged in the late 1960s. It owed its roots to Symbolism and its successors, Dada and Surrealism. Photography is an appealing medium to Baldessari because of its ubiquity and ordinariness. "I just want to challenge the boundaries set up by each convention. The irony comes through as a by-product. I don't consciously set out to be ironic. And I have enough appreciation of the traditions to preserve them. But I don't consciously work for beauty," he wrote. The *Embed Series*, which he began in 1974, is a comment on the coding of consumer messages in advertising. According to Baldessari, the series deals with "the embedding of words, and occasional images, within the photographic image. A variety of means were employed – airbrushing, brush, double-exposure, etc. ... Another motivation was to test the idea of subliminal motivation. Can I really get one to believe the messages I have hidden about imagining, dreaming, fantasy, wish, and hope?" Embedded in the triptych "Cigar Dreams" are the words "seeing is believing," which also function as an ironic comment on photography itself.

John Baldessari

Embed Series: Cigar
Dreams (Seeing Is
Believing), October,
1974

*Retouched gelatin
silver print*
MUSEUM PURCHASE
76:0185:0002

John Baldessari

Embed Series: Cigar
Dreams (Seeing Is
Believing), October,
1974

*Retouched gelatin
silver print*
MUSEUM PURCHASE
76:0185:0003

Paul Berger's work utilizes sequential narrative and the format of popular news magazines to challenge the assumption of truth not only in photographs but also in captions. "Seattle Subtext – Photography" mimics the layout of *Time* magazine. The text under his vaguely ominous park view reads: "Untitled no. 237 – 'Let's see ... it's a park ... in France ... no, in Italy ... yeah, I think it's in Italy. ...'" French text below it repeats the comment in the third person. Using appropriated language and images from video and television, family photographs, his own still photography, and printouts of his computer cataloging system, Berger assembled a cacophony of images that call to mind the daily barrage of disparate messages that are connected through their visual proximity to one another and the recipient's layered reception of them. As Berger explained: "I would feel aligned with Constructivism in that photographs are so context-bound – in our daily encounter with them, a lot of the content we get from them is from where we see them and how we see them. A coherent photographic work is possible only when the art activity is correlating those parts into a new context that is clear, or definite."

Paul Berger
American, b. 1948

Seattle Subtext –
Photography, 1981

Gelatin silver print
MUSEUM PURCHASE
84:0837:0008

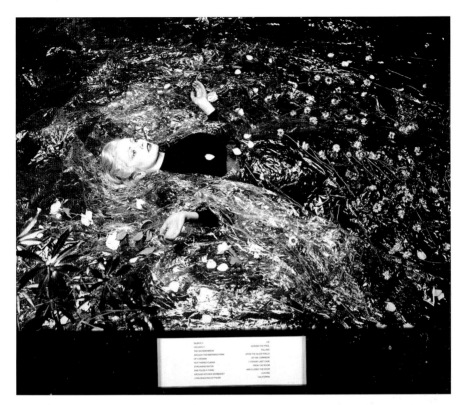

Englishman Victor Burgin's work concerns itself with the construction of meaning not only through the evidence of the image – in this case, found in art historical referents and Hollywood cinema – but also through the way in which images are discussed and evaluated in the museum context. "The Bridge – Venus Perdica" is a photograph based on Sir John Everett Millais's 1852 painting of the drowned Ophelia from William Shakespeare's *Hamlet*, and the character of Madeleine from Alfred Hitchcock's film *Vertigo*. "The history of representations in the West is flooded with watery images of women. This image by Millais ...'Susanna Bathing'... The question is not so much one of relations between men and women. ... The question ... is ... how men and women are constructed in difference." Burgin further explains his choice of appropriation: "The gallery has been the site of the production of images of relations between men and women. The gallery can be a site of

Victor Burgin
English, b. 1941

The Bridge – Venus
Perdica, 1984

Gelatin silver print
MUSEUM PURCHASE,
INTREPID FUND
85:0516:0001

Dieter Appelt
German, b. 1935

Die Befreiung der
Finger (Liberation of
the Fingers), 1979

Gelatin silver print
MUSEUM PURCHASE,
FORD MOTOR
COMPANY FUND
85:0675:0006

interrogation of those same images. The images which belong to the history of art, to the history of cinema, to the history of photography, become trapped, like flies in amber, in meanings given to them by the institutionalized forms of discourse: art history, photography history, and art criticism. We can return to these images and we can reopen them, we can 'reopen the case.'"

"Making time visible and thus comprehending time" are the primary foci of the German artist Dieter Appelt's photographic work. "Die Befreiung der Finger" is from the series titled *Erinnerungsspur (Memory's Trace)*. "A snapshot steals life that it cannot return. A long exposure [creates] a form that never existed," Appelt wrote; his images are layered fragments of thousands of exposures of manual time-lapse photography taking hours to complete. The photograph is thus revealed to be not only an instantaneous, split-second capture, but also capable of expressing stasis and permanence in a single frame.

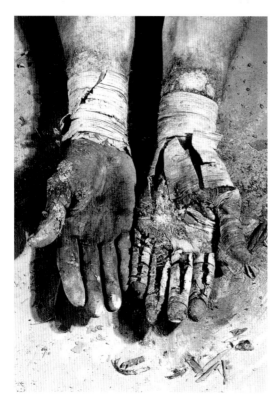

Hiromi Tsuchida is a Japanese photographer a generation younger than Eikoh Hosoe. His *Hiroshima* series documents the objects found after the devastation of the nuclear bombing in 1945 by the United States. Beginning in 1975, Tsuchida interviewed and photographed "hibakusha," the survivors; in 1978 and 1979 he photographed the relics of the landscape within a three-kilometer radius of the bomb site; and in 1980 he photographed the documents in the Hiroshima Peace Memorial Museum. "Lunch Box" is from this last work. The emotional impact of the deformed object as still life silently bespeaks the horrors visited upon the human victims.

On the other end of the spectrum, Jan Groover's formalist

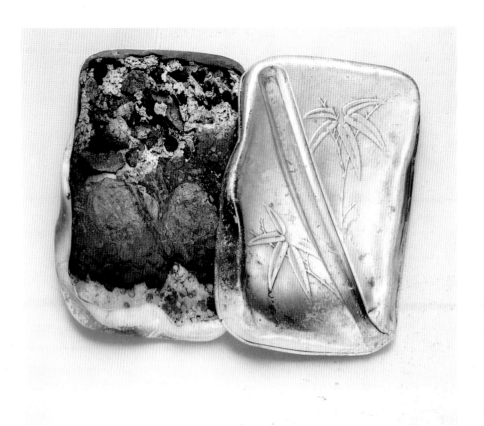

Lunch box

Reiko Watanabe (15 at the time) was doing fire prevention work under the Student Mobilization Order, at a place 500 meters from the hypocenter. Her lunch box was found by school authorities under a fallen mud wall. Its contents of boiled peas and rice, a rare feast at the time, were completely carbonized. Her body was not found.

Hiromi Tsuchida
Japanese, b. 1939

Lunch Box, 1982

Gelatin silver print
GIFT OF THE
PHOTOGRAPHER
90:0700:0005

Jan Groover
American, b. 1943

Untitled, # 78.4,
1978

Color print, chromo-
genic development
(Ektacolor) process
MUSEUM PURCHASE,
MARGARET T. MOR-
RIS FOUNDATION
FUND, IN MEMORY
OF DR. WESLEY T.
"BUNNY" HANSEN,
WITH NATIONAL
ENDOWMENT FOR
THE ARTS FUNDS
89:0355:0001

(right)
Anne Turyn
American, b. 1954

Untitled, 1984

Color print, chromo-
genic development
(Ektacolor) process
GIFT OF THE
PHOTOGRAPHER
89:1119:0003

 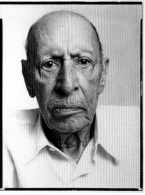

Richard Avedon
American, b. 1923

Igor Stravinsky,
Composer, New York
City, November 2,
1969

*Gelatin silver print
(triptych)*
MUSEUM PURCHASE
WITH NATIONAL
ENDOWMENT FOR
THE ARTS SUPPORT
76:0046:0001

still-life composition (page 410) is an update of Edward Weston and Paul Strand's early formalist images. Distorting scale and ignoring functionality, Groover reinvents these familiar forms with intense colors that heighten the reality of the objects photographed.

An admirer of Baldessari's work, Anne Turyn uses narrative in her photographs like a storyteller. "Untitled" from the series *Illustrated Memories* (page 711) shows a bureau top with a ghost image on a turned-off TV and a gleaming photograph of an unidentified man. Was the photograph left behind? Is this someone's home or a motel room? By photographing absence and constructing fiction, Turyn deliberately and provocatively presents unanswerable questions.

"A photographic portrait is a picture of someone who knows he's being photographed, and what he does with this knowledge is as much a part of the photograph as what he's wearing or how he looks. He's implicated in what's happened, and he has a certain real power over the result," wrote Richard Avedon. Avedon creates portraits that are raw and confrontational, compelling in the physical information they reveal about the subject. Photographed in the studio against a white backdrop, the triptych of composer Igor Stravinsky presents a striking visage of old age and the physical accumulation of life. The subtle transformation that occurs from frame to frame suggests the slow, deliberate passage of time and the camera's ability to capture such evocative, often fleeting nuances of human character. On the other hand, Avedon's portrait of pianist Oscar Levant is an animated, energetic explosion of raw emotion revealed before the photographer's unerring lens.

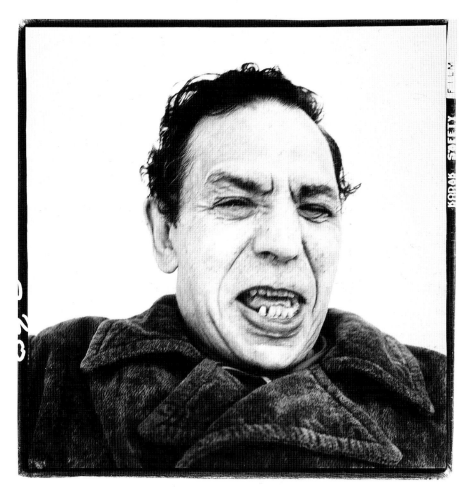

Avedon uses no filter or mask to soften the penetrating gaze of the camera. His uncompromising portraits reveal both likeness and psychology, but the tension lies in discovering whose psychology is on display, the subject's, the photographer's, or the viewer's. Therein lies the power of Avedon's portraits. The element of celebrity and the automatic familiarity that the average viewer brings to Avedon's photographs adds another dimension. Unlike those portrayed in Galerie Contemporaine or in Alvin Langdon Coburn's book *Men of Mark* (see page 420), the late-20th-century celebrity is not only photographed and collected because

Richard Avedon

Oscar Levant, Pianist, Beverly Hills, California, April 9, 1972

Gelatin silver print
GIFT OF THE
PHOTOGRAPHER
76:0047:0002

Chuck Close
American, b. 1940

Working Photograph
for Phil, 1969

*Gelatin silver print
with applied ink and
masking tape*
MUSEUM PURCHASE,
LILA ACHESON
WALLACE FUND
85:1376:0001

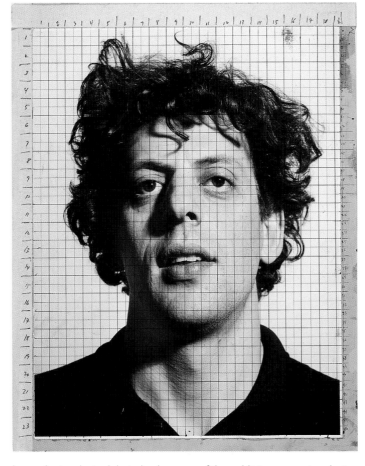

he or she is admired, but also because of the public's consuming desire to see something about a person that he or she might not necessarily have wanted the viewer to see.

Avedon's portraiture influenced the younger artist Chuck Close, who worked in a similar, large format with the same unrelenting pursuit of detail and stark isolation of a subject against a white background. "Working Photograph for Phil" is a photograph of composer Philip Glass. Contrary to convention, Close presents the portrait as a gridded image rather than what might be perceived as a more complete, finished work, emphasizing the degree to which the portrait is broken

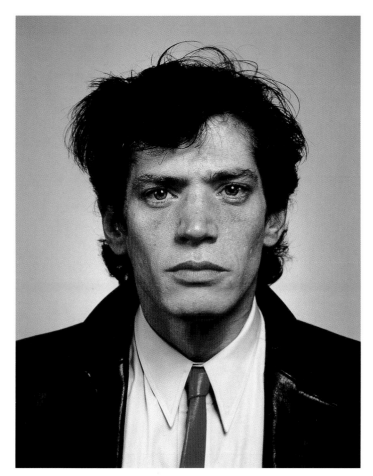

Neil Winokur
American, b. 1945

Robert Mapple-
thorpe, 1982

*Color print, chromo-
genic development
(Ektacolor) process*
GIFT OF THE
PHOTOGRAPHER
83:2325:0002

down and segmented into consumable and comprehensible parts. By deliberately showing as the finished work what would ordinarily be regarded as a preparatory study, Close suggests that what the viewer gleans from a portrait is not a whole picture but rather many smaller parts that he or she, not the photographer, then constructs into a whole.

Neil Winokur's vivid color, straightforward, life-sized, head-and-shoulders portrait of photographer Robert Mapplethorpe relies in part on Mapplethorpe's notoriety and self-constructed photographic persona for its power and resonance. Aligning himself outside the artistic canon, Winokur states: "The graduation headshot or the police mugshot or my

photos – they're all the same thing. It's basically, this is what the person looks like. I will tell you nothing about them. You can make up your own story about this person, because that's all the information you really have." Winokur supplies the viewer with the necessary visual information – and then leaves it to the beholder to create his or her personal meaning.

Robert Mapplethorpe's own photographs, in turn, have been compared to the stark formalism of Edward Weston's images. Flowers and the human form are his primary subjects. His diptych of Ajitto seated atop a draped pedestal like some piece of ebony sculpture unabashedly

Robert Mapplethorpe

Ajitto, 1981

Gelatin silver print
MUSEUM PURCHASE,
INTREPID FUND
83:2336:0002

proclaims this male form to be a work of art ordained both by pose and photographic enshrinement. Mappelthorpe updates the genre of the nude study by using the black male body, a subject rarely seen, much less celebrated, over the course of the history of photography. Ajitto's pose is reminiscent of other nude studies by F. Holland Day; here the mirroring effect of the diptych pairing diminishes the sitter's individuality and emphasizes his role as an iconographic type. Furthermore, the deliberate inclusion of the black man's genitalia transforms Mapplethorpe's work from classicism to fetishism, treading the fine line

between celebration and exploitation. Given the stereotype of hyper-sexuality attributed to black subjects, Mapplethorpe's image is loaded with cultural as well as personal associations.

"Ralph Eugene Meatyard was one of only a few photographers who had any sort of influence on my 'photographic' roots. ... I believed in his bizarre, fictional world," wrote Cindy Sherman. Sherman emerged as one of the most important artists of the 1980s for her ongoing investigations using her own body as a catalyst for cultural commentary, but her staged narratives also owe a debt to Les Krims' fictional narratives constructed for the camera. Like Baldessari, Sherman prefers to think of herself as an artist who uses photography rather than as a photographer. In an early

Cindy Sherman
American, b. 1954

Untitled #85, 1981

*Color print, chromo-
genic development
process*
MUSEUM PURCHASE,
L.A.W. FUND
83:1576:0001

untitled work, she is seated on a kitchen floor in her gingham dress that, with its puffed sleeves and smocked bodice, brings to mind the small-town innocence of Dorothy in the film *The Wizard of Oz*, yet an expression of blank bewilderment is frozen on her face. While there is no actual story being illustrated, Sherman's work relies on the viewer's cultural literacy to supply the narrative. Her posture, expression, and costume are codified and recognizable to contemporary viewers: The implication of threat and the woman's vulnerability are obvious and compressed into heightened melodrama like a two-hour made-for-television movie.

Nan Goldin's *Ballad of Sexual Dependency*, a project she termed her "public diary," documents the intimate lives of the photographer and

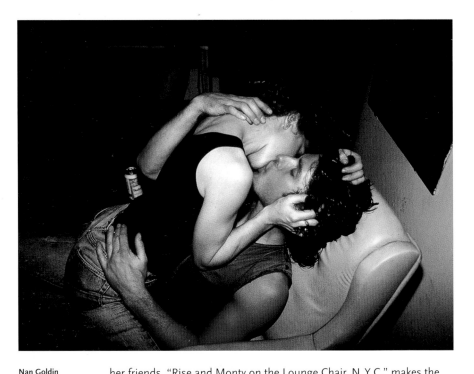

Nan Goldin
American, b. 1953

Rise and Monty on
the Lounge Chair,
N.Y.C., 1988

*Color print, silver dye
bleach (Cibachrome)
process*
MUSEUM PURCHASE,
CHARINA FOUNDA-
TION FUND
88:0615:0002

her friends. "Rise and Monty on the Lounge Chair, N.Y.C." makes the private public. The complete disregard for the camera's presence indicates its complete saturation in their lives; the subjects neither notice nor seem to care that through a friend a viewer has been invited into their moment. Goldin's images are remarkable for their candid honesty, providing glimpses into her world and that of her friends that universally resonate. Like Larry Clark, Goldin defines her life as art through the act of photographing. "... I hope it transcends the specific world in which it was made and applies to the whole nature of the relationships between men and women," wrote Goldin of her *Ballad*, which in its various presentations encompassed still photographs, slide shows, and soundtracks.

Lorna Simpson's coolly detached and deliberately impersonal image "Counting" references African-American history and the legacy of slavery, labor, and the toll that both take on the black female body. Segments of time that recall work shifts are listed alongside a woman's silent mouth and neck, emphasizing both her value as a worker (how, indeed,

she "counts") and her lack of voice. An accounting of the materials of labor both personal and economic and a chronology of enslavement are juxtaposed with images of a smokehouse and a neatly coiled braid of hair. Unlike captions, the words in "Counting" do not define the images, but they carry double meanings that refer to the subjects. "Twists," "Locks," and "Bricks" not only represent the physical objects in the photographs but also evoke the obstacles that have traditionally faced black women in the United States as well as the strength that was required to endure them.

Japanese photographer Michiko Kon's "Cuttlefish and Sneaker" is a construction at once fascinating and grotesque. The sneaker is not made of canvas but of fish; the laces are squid tentacles. The most immediate referent in art history is the work of Giuseppe Arcimboldo, the 18th-century Italian painter who constructed portraits out of vegetables and animal parts. Conveniently, Kon's studio in Tokyo is near the fish market; she has carefully laid the fish skin over the basic structure of the high-top athletic shoe. The photograph is essential to the object's meaning, proof of its strange reality. Kon's images challenge us as viewers to look carefully, to pay attention to the distinction between what we see and what we believe we see. The persistent belief in photography's

Michiko Kon
Japanese, b. 1955

Cuttlefish and
Sneaker, 1990

Gelatin silver print
MUSEUM PURCHASE,
FORD MOTOR
COMPANY FUND
92:0386:0003

truth is at the crux of these images. They are also meant to confuse the senses: although we experience photographs visually, we experience fresh fish primarily through touch and smell. That these senses are strongly triggered by her photographic image challenges our assumptions about how we experience the world – through actual encounter or our memories of it.

"I want to express myself and keep sensitive by implementing all the bodily senses such as taste, touch, hearing, sight and smell," Kon states without claiming primacy for any. On the other hand, Zeke Berman is primarily "interested in how we see, how we apprehend the world through our eyes." "I originally made sculpture, but became attracted to placing a camera between myself and what I make. The result is a kind of distancing that transforms a physical construction into an optical one." Optics and perception are Berman's tools: "You have a subject, you use a lens, you make an image. This is an obvious and powerful schema for a procedure that generates images." Like Kon, Berman is interested in the relationship between vision and knowledge: how we see, and how the camera and the photograph inform that act of seeing.

Zeke Berman
American, b. 1951

Inversion, 1991

Gelatin silver print
MUSEUM PURCHASE,
CHARINA FOUNDA-
TION FUND
92:1039:0001

"Inversion" takes the mundane and recognizable image of cup and saucer and literally turns it on its head.

Suzanne Bloom and Ed Hill began working together as MANUAL in 1974. "Lore/Lure" takes a 1940s advertising image from *LIFE* magazine as its basis to construct a commentary on consumerism and gender marketing. Advertising "lures" the consumer, while what is sold is "lore," the equivalent of wives' tales or falsehoods. In doubling the image, the woman is enlarged, but computer pixellation has rendered her out of focus, literally blurring her identity. Using a computer, MANUAL digitally superimposes an outline of the model home, conspicuously without doors or windows, strongly implying that there is no way out of this particular domestic trap.

Similarly, Barbara Kruger's "Untitled" image takes a stock image of a man placing a wedding band on a woman's finger and overlays the statement: "You are a captive audience" as a critique on the unquestioning acceptance of the patriarchal order, especially when it promises jewelry. The bracelet on the woman's wrist suggests that she has already been co-opted; the ring is icing on the wedding cake. Kruger's text also indicts the viewer, who also buys into the narrative, anxious to find out what happens next. Kruger's background as an editor for women's

MANUAL
(Suzanne Bloom & Ed Hill)
American, b. 1943 & American, b. 1935

Lore/Lure, 1987

Color print, chromogenic development (Ektacolor) process
MUSEUM PURCHASE, CHARINA FOUNDA-TION FUND
88:0264:0003

Barbara Kruger
American, b. 1945

Untitled, 1992

Photo-silkscreen print
MUSEUM PURCHASE,
CHARINA FOUNDA-
TION PURCHASE
FUND
92:0379:0001

(right)
Bill Jacobson
American, b. 1955

Songs of Sentient
Beings, # 1530, 1995

Gelatin silver print
MUSEUM PURCHASE,
CHARINA FOUNDA-
TION PURCHASE
FUND
97:0643:0001

Joyce Neimanas
American, b. 1944

Face Lift, 1993

*Computer-generated
color ink-jet (Iris) print*
MUSEUM PURCHASE,
WARREN AND
MARGOT COVILLE
FUND
93:1506:0003

fashion magazines informs her design and layout and how effectively a simple, strong graphic and a bold written statement together communicate a message. Graphically, her work is reminiscent of Rodchenko and Heartfield – Kruger creates feminist, postmodern propaganda that strikes at cultural icons.

Joyce Neimanas is a mixed-media artist and alumna of the Art Institute of Chicago, where she teaches today. "Face Lift," from the series *Legends of the Powerless*, layers images of women taken from different eras and imposes on them a looking-glass or portrait oval of - reflection. The text that the image "speaks" – "Were you talking to me" – derives, in part, from dialogue in the motion picture *Taxi Driver*, in which taxi driver Travis Bickle faces the mirror and gives his famous one-sentence soliloquy, "You talkin' to me?" over and over again, growing more agitated, aggressive, and dangerous. Adapted here in the past tense, Neimanas' words suggest that through the agency of the woman remaking herself in her own image, the implied threat no longer exists.

Bill Jacobson describes his haunting images as "statement[s] about personal desire and collective loss,... drawing on feelings around the tentativeness and vulnerability of life in the age of AIDS. ... I hope to create floating, fragile objects that evoke ghosts and spirits of a rapidly disappearing segment of the population." Their painterly quality calls to mind the work of the pictorialist photographers of the turn of the 20th century. "Songs of Sentient Beings, # 1530" shows the slender form of a man from the back, quietly retreating into the background. "I believe their faded quality is a reflection of how the mind works – struggling to hold onto memories as they dim," he

explains. In their hushed eloquence, Jacobson's images affirm the emotional impact of the photograph and illuminate that which was invisible.

Photographs affirm who we are in many ways; one of the most basic is by merely depicting our likenesses, individually as well as collectively. "Who defines beauty?" Joan Myers asks. Approaching 50, Myers looked around and wondered where her likeness was. The aging female body is virtually never depicted in popular culture, and being a member of a group that never sees its likeness is an oddly disorienting experience. Anne Noggle and Imogen Cunningham created series of portraits of older men and women. Myers, whose previous work consisted largely of landscapes, joined their company with the series "Women of a Certain Age." She photographed the women nude, removing the specificities of culture and class that clothing carries. While "June" obviously agreed to pose nude, she carefully covers her softly aging flesh, a gesture that reminds the viewer of the personal difficulty of transcending barriers and breaking taboos while the hint of a defiant smile begins to form at her

Joan Myers
American, b. 1944

June, 1993

Platinum-palladium print with watercolor wash
MUSEUM PURCHASE, CHARINA FOUNDATION PURCHASE FUND
94:1231:0005

lips. "I use my camera to explore possibilities, the messages and histories expressed in other women's bodies. I wish less to define than to reveal," says Myers.

For all the technical and artistic advances photography has achieved since 1839, in this era of digital and electronic imagery the work of Abelardo Morell leaves photography where it began, making images using the camera obscura. Instead of a box, Morell transforms entire rooms into receptacles of light images; his aperture is a 3/8-inch opening in a covered window. "Camera Obscura Image of Houses across the Street in Our Bedroom" reveals the process at its most rudimentary; an upside-down, inverted image appears in the camera

obscura projection, and this is what Morell photographs using a large format view camera on a tripod; the exposures take about eight hours. "[T]he very basics of photography could be potent and strange," Morell explained how he came to use the oldest principle of photography itself. "So why not make pictures about the medium itself?"

Some 160 years later, photographers have both returned to the medium's roots and expanded its possibilities beyond Daguerre's and Talbot's wildest dreams, claiming every application in between as rich and exciting means to discovery and creation. Indeed, photography itself has proven to be the most experimental, compelling, accessible, and complex of any artistic medium; its applications are far-reaching and personal, instantly familiar and spectacularly new. For 50 years, Eastman House has gathered together the medium's masterpieces as well as its anonymous gems, preserving the past and promoting the future of images that record and interpret the world and our dreams of it.

Abelardo Morell
American, b. Cuba, 1948

Camera Obscura
Image of Houses
across the Street in
Our Bedroom, 1991

Gelatin silver print
MUSEUM PURCHASE,
FORD MOTOR
COMPANY FUND
95:2068:0001

Appendix

Glossary

Additive color *See* Color, additive

Albumen print Albumen prints are the most common type of photographs from the 19th century and were the first photographic prints in which the image was suspended on the surface of the paper instead of being embedded in the fibers of the paper. The process involves coating a sheet of paper with albumen (egg white), which gives the paper a glossy, smooth surface. The albumenized paper is sensitized with a solution of silver nitrate, then exposed in contact with a negative, generally a **collodion on glass negative.** Albumen prints are **"printed-out,"** meaning that the image is created solely by the action of light on the sensitized paper without any chemical development. The printing-out process requires long exposures and results in prints that are susceptible to fading. Despite these problems, the ability to capture fine detail and the relative ease of producing many prints from a single negative helped hasten the replacement of direct-positive processes, such as **daguerreotypes** and **ambrotypes,** by negative-positive processes. Albumen prints, which were invented in 1850 by Louis-Desiré Blanquart-Evrard, replaced **salted paper prints** as the dominant type of photograph; they were, in turn, replaced by **gelatin silver prints** in the 1890s.

Ambrotype Ambrotypes are sharply detailed, one-of-a-kind photographs on glass, packaged in protective cases similar to those used for **daguerreotypes.** An ambrotype is essentially a **collodion on glass negative** that is intentionally underexposed so that the negative image appears as a positive image when viewed against a dark background. The process for making ambrotypes was patented in the United States in 1854 by James Ambrose Cutting. Ambrotypes (and the closely related **tintypes**) soon replaced the more expensive daguerreotypes as the favored process for portrait photography. The process has the additional benefit of being non-reflective, making ambrotypes easier to view than daguerreotypes. The popularity of ambrotypes was short-lived, however, and the process was soon displaced by the growing popularity of the negative-positive process of collodion on glass negatives and **albumen prints.**

Bichromated colloid	A bichromated colloid is any one of a number of viscous substances, such as gelatin or albumen, that has been made light-sensitive by the addition of a bichromate, most commonly potassium bichromate ($K_2Cr_2O_7$). Bichromated colloids harden when exposed to light and become insoluble in water; this is the principle behind many of the non-silver-based photographic processes, such as **carbon prints** and **gum bichromate prints,** and most **photomechanical** processes. The effect of light on bichromates was discovered by Mungo Ponton in Scotland in 1839, and the hardening effect of light on bichromated colloids was first described by Alphonse Poitevin in France in 1855.
Cabinet card	The cabinet card – a popular format for 19th-century photographs – is a photograph mounted on heavy card stock and measures approximately 6-1/2 x 4-1/4 inches. Cabinet cards are usually studio portraits, and cabinet cards of celebrities, a favorite subject, were widely collected in the last quarter of the 19th century. The format was introduced in 1866 and soon surpassed the smaller **carte-de-visite** format in popularity. Cabinet cards lost much of their popularity after 1900 and largely disappeared by the end of World War I.
Calotype negative	The calotype negative is a paper negative and was the first negative to rely on the chemical development of a latent image. The process was patented in England in 1841 by William Henry Fox Talbot. It was an advancement on Talbot's first paper negatives, called photogenic drawings, that were produced solely by the effect of light on light-sensitive paper. The chemical development process meant that calotype negatives required much less exposure time than photogenic drawings. One calotype negative could be used to make many prints (at the time, **salted paper prints**), and this negative-positive process was the direct antecedent to modern photography. The longer exposure time and the lack of precise image details made calotypes less popular than **daguerreotypes** for portraiture, but calotype negatives and salted paper prints were popular during the 1840s for many other photographic practices, such as architectural and view photography. Calotype negatives were largely replaced by **collodion on glass negatives** in the mid-1850s.

Carbon print A carbon print is a **pigment print** that relies on the use of a **bichromated colloid** mixed with a pigment (usually carbon black) for the formation of the print image. Carbon prints are noted for their permanence and their rich and glossy dark tones. To make a carbon print a sheet of paper is coated with bichromated gelatin mixed with carbon black. The paper is exposed in contact with a negative; the gelatin hardens in proportion to the amount of light received. After exposure, the paper is pressed in contact with a second sheet of paper that has been coated with an insoluble gelatin layer. When the two sheets are soaked together in water, the first sheet floats free and the unhardened gelatin washes away, with the carbon image transferred in relief to the second sheet. The carbon print process was patented in France in 1855 by Alphonse Louis Poitevin, and reached the height of its popularity between 1870 and 1910.

Carbro print A Carbro print is an assembly of three bichromated gelatin tissues, each pigmented with one of the primary **subtractive colors,** cyan, magenta, or yellow. The image on each tissue is formed as a result of a chemical reaction that occurs when the bichromated gelatin tissue is placed in contact with a silver bromide print. The silver bromide prints, each made from a black-and-white separation negative (see **Color, additive**) cause the tissues' gelatin to harden in proportion to the density of the print. The unhardened gelatin is then washed away. When these tissues are placed in exact register onto a paper support, they combine to produce a full-color (tricolor) photograph. The Carbro process, patented in 1905 as the Ozobrome, was adapted from **carbon printing** techniques developed in the 1850s. Though monochromatic Carbro prints were made, this process is best known through its vivid three-color images. Carbro prints are also noted for their image permanence.

Carte-de-visite The carte-de-visite – a paper photograph mounted on card stock measuring approximately 4 x 2-1/2 inches – was the most popular format for portrait photography in the 19th century. A carte-de-visite was roughly the same size as the visiting cards that gave the format its name. Cartes-de-visite were often exchanged between friends and family members and were collected in specially made albums. The format became popular in the late 1850s when a technique was developed for making multiple negatives on a single glass plate (thereby reducing the cost of portrait photography), and it remained popular through the 1860s. The

larger **cabinet card** format gradually eclipsed the popularity of the carte-de-visite.

Chromogenic development process *See* Color transparency, chromogenic development process

Cibachrome *See* Color, silver dye bleach print

Collodion *See* Negative, collodion on glass

Collotype *See* Photomechanical, collotype print

Color, additive The principle of additive color demonstrates that all the colors of light can be made by combining different proportions of the three primary colors of light: blue, green, and red. (These colors are the complementary colors of the primary **subtractive colors**: yellow, magenta, and cyan.) When the three additive primary colors are mixed equally, the result is white light. **Autochrome plates** and color television images depend on this principle. When white light passes through a filter colored one of the primary additive colors, the filter transmits only that color of light and absorbs the other colors. Black-and-white photographic negatives exposed through such filters are called "separation negatives." Separation negatives are required in color photographic processes such as **Carbro** and **dye imbibition.**

Color, Autochrome plate Autochromes are color transparencies on glass plates that are viewed either in special viewers called diascopes or projected onto a screen. The first practical color process, Autochromes were one of the few commercially successful **additive color** processes. Autochromes were made by coating a glass plate with a mosaic of minute potato starch grains dyed to approximate the primary additive colors of light. This was then coated with a panchromatic silver emulsion. Exposed in a camera so that the color mosaic filtered the light before it reached the emulsion layer, the plate was processed to create a black-and-white positive. This, in combination with the color mosaic, created the illusion of a full-color positive image. Autochrome plates were manufactured from 1907 to the 1930s by the

Lumière brothers, who also figure prominently in the early history of motion pictures.

Color, chromogenic development print

A chromogenic development print is made on photographic paper that has three silver emulsion layers sensitized to the primary **additive colors** of light. During development, dye couplers bond with the exposed and developed silver halides to produce complementary **subtractive color** dyes. The silver is bleached away, leaving a full-color positive image. Due to chemical impurities in the dyes, chromogenic prints are not as stable as prints made with other techniques.

Color, dye imbibition print

A dye imbibition print is a color print made of dyes transferred from three gelatin matrices onto a sheet of paper coated with gelatin. To make a dye imbibition print, three separation negatives are made (see **Color, additive**). From these negatives, gelatin matrices are created that are capable of absorbing and releasing dyes of the primary **subtractive colors.** When placed in exact registration on the paper, the transferred dyes create a full-color image. The process was favored for the high degree of control over the final print image that it offered photographers. Dye imbibition prints are noted for their permanence, and the black-and-white matrix film used in the process is more stable than chromogenic color film so that new dye imbibition prints could be made many years after the original print was made.

Color, internal dye diffusion transfer print

An internal dye diffusion transfer print is a one-of-a-kind, "instant" color photograph most commonly marketed by the Polaroid Corporation. The process uses a multi-layered film pack that includes an image-receiving layer, a reagent-collecting layer, and layers sensitized to the primary **additive colors** alternating with layers of primary **subtractive color** dyes. The film pack is ejected from the camera immediately after exposure, breaking open a pod of reagent that starts the development process. The exposed silver in the additive color layers blocks the diffusion of the complementary subtractive colors upward to the image-receiving layer, while the reagent-collecting layer turns opaque, masking the residual silver and dyes that did not diffuse to the image-receiving layer. Dye diffusion prints are favored for the instant results they provide and for particular image manipulation techniques that are possible during the development process.

Color, silver dye bleach print	A silver dye bleach print, such as a Cibachrome print, is made on paper containing three emulsion layers, each sensitized to one of the primary **additive colors** of light, and each containing a full density of the complementary **subtractive color** dye. During development, the silver and the unnecessary dyes are selectively bleached away, leaving a final positive print. The process is used for making prints from color transparencies and is noted for its stability, image clarity, and color saturation. Interest in the process dates to the early years of the 20th century, but it wasn't until the introduction of Cibachrome materials in 1963 that the process became widely available.
Color, subtractive	The principle of subtractive color concerns the creation of any color by subtracting (in varying proportions) one or more of the primary subtractive colors – yellow, magenta, and cyan – from white light. The primary subtractive colors are the complementary colors of the three primary **additive colors** – blue, green, and red. Most modern color photography processes rely on the principle of subtractive color.
Color transparency, chromogenic development process	A chromogenic color transparency is a positive image made on glass or film in which three silver emulsion layers sensitized to the primary **additive colors** are exposed to light. During the developing process, dye couplers bond to the exposed silver halides to produce complementary **subtractive color** dyes. The silver is bleached away, leaving a full-color positive image. The chromogenic development process is the most common contemporary color photography process and is used for negatives, transparencies, and prints. Due to chemical impurities in the dyes, chromogenic prints are not as stable as other color printing techniques.
Cyanotype	A cyanotype is a photographic print distinguished by its bright blue color. Cyanotype images are embedded in the fibers of a paper support, instead of being suspended on top as in **albumen prints** or **gelatin silver prints.** Like albumen prints and **salted paper prints,** cyanotypes are **"printed-out,"** meaning that the image is created by the action of light alone on light-sensitive paper, without the use of chemical developers. The process involves soaking a sheet of paper in a solution of iron salts, then exposing the paper in contact with a negative. The part of the paper exposed to light turns blue, while the unexposed areas remain

white. The image is fixed by washing the paper in water, which rinses off unexposed chemicals and intensifies the blue color. The process was invented in 1842 by Sir John Herschel.

Daguerreotype Daguerreotypes are sharply defined, highly reflective, one-of-a-kind photographs on silver-coated copper plates, packaged behind glass and kept in protective cases. Introduced in 1839 by Louis-Jacques-Mandé Daguerre, the daguerreotype process was the first commercially successful photographic process and is distinguished by a remarkable clarity of pictorial detail. Although early daguerreotypes required exposures of several minutes, advances in the process quickly reduced exposure times, to the relief of many sitters. Daguerreotypes were popular through the 1840s and into the 1850s, especially for portrait photography; they were primarily replaced by less-expensive and more easily viewed **ambrotypes** and **tintypes,** as well as by the improved negative-positive techniques of **collodion on glass negatives** and **albumen prints.**

Developed-out *See* Gelatin silver print

Dye imbibition print *See* Color, dye imbibition print

Gelatin silver print A gelatin silver print is produced on paper coated with a gelatin emulsion containing light-sensitive silver salts. Like **albumen prints,** gelatin silver print images are suspended on a paper's surface as opposed to being embedded in its fibers. Unlike albumen prints, however, gelatin silver prints are "developed-out" instead of "printed-out"; the paper registers a latent image that becomes visible only when developed in a chemical bath. The developing-out procedure allows for much shorter exposure times than printing out and results in an image less susceptible to fading. Developed at the end of the 19th century, gelatin silver printing has been the dominant black-and-white photographic process of the 20th century.

Gelatin silver glass interpositive A gelatin silver glass interpositive is a positive image that is made from a negative and printed on a glass plate. It serves as an intermediate stage that gives the photographer who wishes to retouch the photograph a positive image on which to work. The interpositive can be drawn on, scratched, or otherwise manipulated, then used to make another negative. The final print is made from the second negative.

Gum bichromate print A gum bichromate print is a **pigment print** often characterized by broad tones and a lack of precise pictorial detail. The process relies on the principle of **bichromated colloids** hardening on exposure to light. It calls for coating a sheet of paper with sensitized and pigmented gum arabic, then exposing the paper in contact with a negative, whereupon the gum hardens in proportion to the amount of light received. After exposure, the paper is soaked in water to dissolve the unhardened gum, leaving a positive image on the paper. The technique was invented in the 1850s but was largely forgotten until the 1890s when it was adopted by many pictorialist photographers who reveled in their artistic control over the final image, often working the surface of the print with brushes in a painterly fashion. Like other pigment prints, gum bichromate prints have no light-sensitive metals susceptible to deterioration and are thus noted for their image stability and permanence.

Gum platinum print A gum platinum print combines the fine tonal gradations found in the platinum process with the deep shadow areas possible in **gum bichromate prints.** To make a gum platinum print, a lightly exposed and fully developed **platinum print** is coated with sensitized and pigmented gum arabic and re-exposed under the same negative used to make the platinum print. The pigmented gum hardens in proportion to the amount of light it receives during exposure. The process flourished in the early part of the 20th century when many photographers engaged in complex processes that required hand-rendered manipulations in order to bolster their claims of photography's artistic properties.

Kodak snapshot The term "Kodak snapshot" applies to photographs taken with Kodak snapshot cameras introduced by the Eastman Dry Plate and Film Company (later named the Eastman Kodak Company) in 1888. These cameras had a fixed focus lens and a set shutter speed and were preloaded with roll film for 100 exposures. All that was required of photographers

was to expose and advance the film. The snapshot cameras were marketed to a new and growing amateur photography market with the slogan, "You press the button, we do the rest." Indeed, once all exposures were made, the photographer sent the camera back to the factory where the pictures were printed and the camera reloaded. Both prints and camera were then returned to the photographer. The term "snapshot" was first applied to photography by Sir John Herschel in 1860 to describe "the possibility ... of securing a picture in a tenth of a second of time."

Lantern slide *See* Transparency, gelatin on glass

Mechanical lantern slide *See* Transparency, gelatin on glass

Negative, collodion on glass Collodion on glass negatives – the dominant type of negative for much of the 19th century – are noted for greater image detail and shorter exposure times than **calotype** negatives. The clarity and reproducibility of collodion negatives coupled with **albumen prints** helped spell the demise of the **daguerreotype** and **ambrotype** as the favored processes for portrait photography. First described by Frederick Scott Archer in 1851, the process revolutionized photography in the second half of the 19th century and remained popular until about 1880, when collodion negatives were displaced by **gelatin on glass negatives**. Collodion on glass negatives were made by coating glass plates with collodion, a sticky substance to which light-sensitive silver salts could adhere. The sensitized plates were exposed in a camera, then developed in chemical baths. The majority of collodion on glass negatives were "wet-plate" negatives; the plate had to be coated and sensitized immediately prior to exposure and then developed shortly after exposure, before the plate could dry. This required view photographers to carry all of their chemicals and equipment with them in the field. Although ways to slow the drying time of the collodion were developed, thereby allowing the plates to be prepared farther in advance of their use, these so-called "dry-plate" collodion negatives produced inconsistent results and required longer exposure times than wet-plate negatives, hampering efforts to commercially produce and market such plates.

Negative, calotype *See* Calotype negative

Negative, gelatin on glass Gelatin on glass negatives are produced by coating glass plates with an emulsion of gelatin mixed with light-sensitive silver salts. Introduced in 1871 by Richard Leach Maddox, the process was an advancement on the collodion process, as gelatin negatives were up to ten times more sensitive to light than **collodion on glass negatives**. Even more important, gelatin on glass negative plates could be made well in advance of actual use, meaning that for the first time negative materials could be manufactured rather than having to be prepared by the photographer. Commercially available glass plates were first manufactured in 1875, and gelatin soon displaced collodion as the dominant negative process. The convenience and availability of gelatin on glass negatives helped create the large amateur photography market in the 1880s.

Negative, gelatin on nitrocellulose sheet film Nitrocellulose negatives are created using sheets of nitrocellulose film as a support for a light-sensitive gelatin emulsion. Efforts to find a flexible and transparent medium on which to make negatives led to the introduction of nitrocellulose roll film by the Eastman Dry Plate and Film Company in 1889. (The process was actually developed by the Reverend Hannibal Goodwin in 1887, though he didn't receive credit for his invention until 1914.) The portability of nitrocellulose roll film compared to the cumbersome glass plates made photography increasingly convenient to amateurs. For the professional, improvements in manufacturing techniques in the early 1900s led to larger film sizes and the introduction of nitrocellulose sheet film in 1913. Because nitrocellulose is highly flammable and subject to deterioration, it was no longer used as a support material after 1950.

Oil print An oil print is produced on a sheet of paper coated with an unpigmented **bichromated colloid**. After contact printing, the paper is soaked in water so that the unexposed areas absorb water and swell. The areas of the unexposed colloid that have absorbed water (the highlights) reject the application of a greasy ink that is daubed on the paper with a brush. The exposed, hardened areas of the colloid (the shadows and midtones) accept the ink, creating the final image. The process was developed in

1904 by G. E. H. Rawlins. It was used by photographers seeking greater control over the final print image than was offered by conventional photographic techniques.

Palladium print A palladium print is similar in appearance to a **platinum print** with its matte surface and subtle tonal gradations. Like platinum prints, palladium print images are embedded in the fibers of the paper support, not suspended on its surface as in **albumen prints** or **gelatin silver prints**. To make a palladium print, a sheet of paper sensitized with iron salts is exposed in contact with a negative until a faint image is formed. In development, the iron salts are replaced with palladium, and the image becomes more pronounced. Commercially made palladium papers were introduced in 1916 in response to the rising cost of platinum during World War I, but the cost of palladium rose to prohibitive levels in the 1920s, and the manufacture of palladium papers ceased. Like platinum prints, palladium prints are noted for having greater stability than silver-based prints.

Photogenic drawings *See* Calotype negative

Photogram The most elemental of photographic techniques, the photogram is made without the aid of camera or lens. It is produced by placing objects in contact with the surface of sensitized paper or film and then exposing it to light. The resultant image, after processing, reveals a photographic tracing of the object's form, with dark tonality in areas exposed to light, and light tonality in unexposed areas. Made by early practitioners such as Anna Atkins and William Henry Fox Talbot and modernists such as Man Ray and László Moholy-Nagy, the photogram has proved to be an enduring method of discovery and transformation.

Photogravure *See* Photomechanical, photogravure print

Photomechanical, collotype print The collotype relies on the effect of light on **bichromated colloids** and the mutual repulsion of water and oil-based ink. To make a collotype, a printing plate is first coated with bichromated gelatin. After exposing the plate under a negative, the plate is washed in water, causing the gelatin to swell into the reticulated pattern that is the hallmark of

collotypes. When the damp plate is inked, the unhardened gelatin (which forms the highlights) repels the ink, while the hardened gelatin (which forms the shadows) accepts it. The inked plate is then printed on paper. The fine reticulation of the gelatin allows for subtle midtones, often making collotypes difficult to distinguish from silver-based photographs except under magnification. The development of the collotype and other photomechanical processes in the second half of the 19th century was an important technical achievement that allowed for the distribution of photographic reproductions in books.

Photo-mechanical, photogravure print

Photogravure printing is a form of intaglio printing, in which a photographic image is chemically etched into a copper plate. When the plate is inked, then wiped clean, the ink remains in the pits of the plate and is transferred to a sheet of paper during the printing process. In the photogravure process, the printing plate is first dusted with a resin, creating a random dot structure that allows for the continuous tones of the original photograph to be reproduced. The plate is then coated with bichromated gelatin and exposed in contact with a positive photographic transparency. The printing plate is etched in those areas where the gelatin remains unhardened (forming the shadows), but not in those areas where the hardened gelatin acts as a resist (forming the highlights). William Henry Fox Talbot experimented with photogravure as early as 1852, but the process was not widely used until the 1870s, when Karl Klic developed a way of satisfactorily dusting the plates with resinous powder. Around the turn of the 20th century, photogravure was embraced by pictorialist photographers who admired the beautiful reproductions the process allowed. Perhaps the ultimate achievement of photogravure printing is to be found in the pages of *Camera Work,* published by the photographer Alfred Stieglitz from 1903 to 1917.

Photo-mechanical, Woodburytype

Woodburytypes are distinguished from other photomechanical processes by the fact that they are continuous-tone images. The process involves exposing unpigmented bichromated gelatin in contact with a negative. The gelatin hardens in proportion to the amount of light received. When the gelatin is washed, the unexposed portion dissolves, leaving a very fine and hard relief of the image. Under extremely high pressure, this relief is pressed into a sheet of soft lead, producing a mold of the image. This mold is then filled with pigmented gelatin and

transferred to paper during printing. The process was invented in 1864 by Walter Woodbury and achieved acclaim for its exquisite rendering of pictorial detail and its permanency.

Physionotrace engraving

A physionotrace is made by the use of a mechanical system that scratches a profile onto a copper plate as the operator traces a sitter's profile cast on a sheet of glass. After tracing the profile, features can be added to the plate, which is then inked and printed. Invented in 1786 by Gilles-Louis Chrétien, the process was the first mechanical means for making multiple prints of a portrait.

Pigment print

A pigment print involves any one of a number of photographic processes (such as **carbon prints** and **gum bichromate prints**) that utilize pigments and **bichromated colloids** rather than metal salts in the creation of print images. Pigment printing processes were first developed in the 1850s and were popular because they were more permanent than metal-based processes. They also allowed for a greater control of the appearance of the final print image.

Platinum/ palladium print

A platinum/palladium print combines platinum and palladium solutions in order to conserve the amount of the more expensive platinum used to make the print. See **platinum print** for more information.

Platinum print

A platinum print is distinguished by its matte surface and subtle tonal gradations. Like **salted paper prints**, platinum print images are embedded in the fibers of the paper, not suspended on the surface of the paper support. To make a platinum print, a sheet of paper sensitized with iron salts is exposed in contact with a negative until a faint image is formed. In development, the iron salts are replaced with platinum, and the image becomes more pronounced. Because of the tonal range and surface quality of platinum prints, many fine art photographers of the late 19th and early 20th century preferred the process over **gelatin silver prints**. The platinum printing process was developed in the 1870s, and commercially made platinum papers were available until the rising costs of platinum during World War I made the process prohibitively expensive. Platinum prints were replaced by the similar, but less-expensive, **palladium prints.** Platinum prints are the most stable of all the metal-based prints.

Polaroid print *See* Color, internal dye diffusion transfer print

Printing-out *See* Albumen print, Cyanotype, or Salted paper print

Salted paper print Salted paper prints were the earliest photographic prints on paper. They are often distinguished by their lack of precise image details and matte surface. Salted paper print images are embedded in the fibers of the paper, instead of being suspended on the surface of the paper, as in the later **albumen prints** and **gelatin silver prints.** Salted paper prints were "printed-out" in contact with paper negatives; the image was formed solely by the action of light on metal salts, without chemical developers. The **printing-out process** required long exposure times for producing a positive print. The process for making salted paper prints was developed by William Henry Fox Talbot in the 1830s, and salted paper prints were common until the mid-1850s, when they were eclipsed in popularity by albumen prints.

Silver dye bleach print *See* Color, silver dye bleach print

Stereograph A stereograph comprises two nearly identical photographic prints that have been recorded with a specially designed camera that has two lenses eye-width apart. Stereograph negatives are exposed simultaneously and later printed on heavy card stock. When a stereograph is viewed through a special viewer called a stereoscope, the viewer sees the image with a third dimension, giving a sense of depth and "reality" to the scene. They were a popular form of entertainment from the 1850s to the 1920s. In the 20th century stereography found renewed popularity in the form of Viewmaster reels and viewers.

Subtractive color *See* Color, subtractive

Tintype A tintype is a non-reflective, one-of-a-kind photograph on a sheet of iron coated with a dark enamel. Its most common use was for portrait photography. Like **ambrotypes**, tintypes rely on the principle that underexposed collodion negatives appear as positive images when viewed against a dark background. Less expensive and more durable than

either ambrotypes or **daguerreotypes**, tintypes did not require protective cases and were often kept in simple paper frames or folders. Tintypes first appeared in the United States in 1856 and remained popular well into the 20th century.

Transparency, gelatin on glass (lantern slide)

A lantern slide is a gelatin silver positive image on a glass plate that is projected onto a screen with the use of a slide projector, or "magic lantern." Before photography, lantern slide images were either stenciled or drawn, but in the 1850s, photographic lantern slides with albumen positive images became available. Beginning in the 1870s, gelatin silver lantern slides were commercially produced to meet the ever-increasing public demand. Lantern slides were used for popular entertainment, education, scientific study, and travelogues.

Transparency, gelatin on glass (mechanical lantern slide)

A mechanical lantern slide is two or more separate lantern slides in one holder or frame. The movement of one slide over a second slide produces motion or the appearance of motion when projected onto a screen.

Woodburytype

See Photomechanical, Woodburytype

Alternative Image II: Photography on Nonconventional Supports.
Sheboygan, Wis.: John Michael Kohler Arts Center, 1984.

Arnold, Harry John Philip. *William Henry Fox Talbot: Pioneer of Photography and Man of Science.* London: Hutchinson, 1977.

Auer, Michèle, and Michel Auer. *Encyclopèdie internationale des photographes de 1830 à nos jours.* Hermance, Switzerland: Editions Camera Obscura, 1985.

Baldwin, Gordon. *Looking at Photographs: A Guide to Technical Terms.* Malibu, Cal.: John Paul Getty Museum in association with British Museum Press, 1991.

Becchetti, Piero. *Fotografi e fotografia in Italia 1839–1880.* Roma: Edizioni Quasar, 1978.

—. *La fotografia a Roma dalle origini al 1915.* Roma: Colombo, 1983.

Brettell, Richard R., Roy Flukinger, Nancy Keeler, and Sydney Mallett Kilgore. *Paper and Light: The Calotype in France and Great Britain, 1839–1870.* Boston: D.R. Godine in association with The Museum of Fine Arts, Houston and the Art Institute of Chicago, 1984.

Browne, Turner, and Elaine Partnow. *Macmillan Biographical Encyclopedia of Photographic Artists and Innovators.* New York: Macmillan, 1983.

Bruce, Chris, and Andy Grundberg. *After Art: Rethinking 150 Years of Photography; Selections from the Joseph and Elaine Monsen Collection.* Seattle: Henry Art Gallery; distributed by University of Washington Press, 1984.

Bruce, Roger R., ed. *Seeing the Unseen: Dr. Harold Edgerton and the Wonders of Strobe Alley.* Essays by James Enyeart, Douglas Collins, and Joyce E. Bedi. Rochester, N.Y.: International Museum of Photography at George Eastman House; Cambridge, Mass.: distributed by Massachusetts Institute of Technology Press, 1994.

Buerger, Janet E. *The Era of the French Calotype.* Rochester, N.Y.: International Museum of Photography at George Eastman House, 1982.

—. *French Daguerreotypes.* Chicago: University of Chicago Press, 1989.

Bunnell, Peter C., Maria B. Pellarano, and Joseph B. Rauch. *Minor White: The Eye That Shapes.* Princeton, N.J.: The Art Museum, Princeton University in association with Bulfinch Press and Little, Brown & Co., 1989.

Bunnell, Peter C., ed. *A Photographic Vision: Pictorial Photography, 1893–1923*. Salt Lake City: Peregrine Smith, 1980.

Carlebach, Michael L. *The Origins of Photojournalism in America*. Washington, D.C.: Smithsonian Institution Press, 1992.

Coburn, Alvin Langdon. *Alvin Langdon Coburn, Photographer; An Autobiography*. Edited by Helmut Gernsheim and Alison Gernsheim. New York: Dover Publications, 1978.

Coe, Brian. *The Birth of Photography: The Story of the Formative Years 1800–1900*. London: Ash & Grant, 1976.

——. *Colour Photography: The First Hundred Years, 1840–1940*. London: Ash & Grant, 1978.

Coe, Brian, and Paul Gates. *The Snapshot Photograph: The Rise of Popular Photography, 1888–1939*. London: Ash & Grant, 1977.

Coke, Van Deren. *Avant-Garde Photography in Germany, 1919–1939*. New York: Pantheon Books, 1982.

Collins, Douglas. *The Story of Kodak*. New York: Harry N. Abrams, 1990.

Conger, Amy. *Edward Weston: Photographs from the Collection of the Center for Creative Photography*. Tucson: Center for Creative Photography, University of Arizona, 1992.

Daniel, Malcolm. *The Photographs of Édouard Baldus*. New York: Metropolitan Museum of Art; Montreal: Canadian Centre for Architecture; distributed by Harry N. Abrams, 1994.

Darrah, William Culp. *Cartes de Visite in Nin[e]teenth Century Photography*. Gettysburg, Pa.: W. C. Darrah, 1981.

——. *The World of Stereographs*. Gettysburg, Pa.: W. C. Darrah, 1977.

Davis, Keith F. *Désiré Charnay, Expeditionary Photographer*. Albuquerque: University of New Mexico Press, 1981.

Dixon, Penelope. *Photographers of the Farm Security Administration: An Annotated Bibliography, 1930–1980*. New York: Garland, 1983.

Doherty, Jonathan L. *Lewis Wickes Hine's Interpretive Photography, The Six Early Projects*. Chicago: University of Chicago Press, 1978.

Doherty, Jonathan L., ed. *Women at Work, 153 Photographs by Lewis W. Hine*. Rochester, N. Y.: George Eastman House; New York: Dover Publications, 1981.

Earle, Edward, ed. *Points of View, The Stereograph in America: A Cultural History*. Essays by Howard S. Becker, Thomas Southall, and Harvey Green. Rochester, N. Y.: Visual Studies Workshop Press in collaboration with the Gallery Association of New York State, 1979.

Eauclaire, Sally. *The New Color Photography*. New York: Abbeville Press, 1981.

Eder, Josef Maria. *History of Photography*. Translated by Edward Epstean. Originally published 1932. New York: Dover Publications, 1978.

Ehrens, Susan. *A Poetic Vision: The Photographs of Anne Brigman*. Santa Barbara, Cal.: Santa Barbara Museum of Art, 1995.

Elliott, David, ed. *Photography in Russia, 1840–1940*. London: Thames and Hudson, 1992.

Enyeart, James. *Brugière: His Photographs and His Life*. New York: Alfred A. Knopf, 1977.

Evans, Martin Matrix, and Amanda Hopkinson, eds. *Contemporary Photographers*. 3rd ed. New York: St. James Press, 1995.

The Extended Document. Rochester, N.Y.: International Museum of Photography at George Eastman House, 1975.

Fabian, Rainer, and Hans-Christian Adam. *Masters of Early Travel Photography*. New York: Vendome Press, 1983.

Fielder, Jeannine, ed. *Photography at the Bauhaus*. Cambridge, Mass.: Massachusetts Institute of Technology Press, 1990.

Finkel, Kenneth. *Nineteenth Century Photography in Philadelphia: 250 Historic Prints from the Library Company of Philadelphia*. New York: Dover Publications, 1980.

Fleming, Paula Richardson, and Judith Luskey. *The North American Indians in Early Photographs*. New York: Harper & Row, 1986.

Flukinger, Roy. *The Formative Decades: Photography in Great Britain, 1839–1920*. Austin: University of Texas Press in cooperation with the Harry Ransom Humanities Research Center and the Archer M. Huntington Art Gallery, 1985.

Frank, Robert, and Alain Bosquet. *Les Américains*. Paris: R. Delpire, 1958.

French Primitive Photography. Introduction by Minor White; commentaries by André Jammes and Robert Sobieszek. Millerton, N.Y.: Aperture, 1969.

Fuller, Patricia Gleason. *Alternative Image: An Aesthetic and Technical Exploration of Non-conventional Photographic Printing Processes*. Sheboygan, Wis.: John Michael Kohler Arts Center, 1983.

Fulton, Marianne. *Eyes of Time: Photojournalism in America*. Essays by Estelle Jussim, Colin Osman, Sandra S. Phillips, and William Stapp. Boston: New York Graphic Society and Little, Brown & Co. in

association with International Museum of Photography at George Eastman House, 1988.

—. *Mary Ellen Mark, 25 Years.* Boston: Little, Brown & Co. in association with International Museum of Photography at George Eastman House, 1991.

Fulton, Marianne, ed. *Pictorialism into Modernism: The Clarence H. White School of Photography.* Texts by Bonnie Yochelson and Kathleen A. Erwin. New York: Rizzoli International Publications; George Eastman House in association with The Detroit Institute of Arts, 1996.

Gardner, Alexander. *Gardner's Photographic Sketchbook of the Civil War.* Unabridged republication. New York: Dover Publications, 1959.

Gee, Helen. *Photography of the Fifties: The American Perspective.* Tucson: Center for Creative Photography, University of Arizona, ca. 1980.

George Eastman House: International Museum of Photography and Film, Rochester N. Y. Photographers Biography File.

Gernsheim, Helmut. *The Origins of Photography.* New York: Thames and Hudson, 1982.

—. *The Rise of Photography, 1850–1880: The Age of Collodion.* Revised 3rd ed. New York: Thames and Hudson, 1988.

Gernsheim, Helmut, and Alison Gernsheim. *L. J. M. Daguerre: The History of the Diorama and the Daguerreotype.* New York: Dover Publications, 1968.

Goldschmidt, Lucien, and Weston J. Naef. *The Truthful Lens: A Survey of the Photographically Illustrated Book, 1844–1914.* 1st ed. New York: Grolier Club, 1980.

Green, Jonathan. *American Photography: A Critical History, 1945 to the Present.* New York: Harry N. Abrams, 1984.

Green, Jonathan, ed. *Camera Work: A Critical Anthology.* Millerton, N. Y.: Aperture, 1973.

Greenhill, Gillian. "The Jersey Years: Photography in the Circle of Victor Hugo." *History of Photography* 4, no. 2 (April 1980): 113–120.

Greenough, Sarah, and Juan Hamilton. *Alfred Stieglitz, Photographs and Writings.* 1st ed. Washington, D. C.: National Gallery of Art, 1983.

Grundberg, Andy, and Kathleen McCarthy Gauss. *Photography and Art: Interactions Since 1946.* Fort Lauderdale, Fl.: Fort Lauderdale Museum of Art; New York: Abbeville Press, 1987.

Gutman, Judith Mara. *Through Indian Eyes.* New York: Oxford University Press; International Center for Photography, 1982.

Haas, Robert Bartlett. *Muybridge: Man in Motion*. Berkeley: University of California Press, 1976.

Hager, Michael, Rick McKee Hock, and Ruth Rosenberg-Naparsteck. "A Portrait of Rochester: Through the Lens of Charles Zoller." *Rochester History* 50, no. 1 (January 1988).

Hales, Peter B. *William Henry Jackson and the Transformation of the American Landscape*. Philadelphia: Temple University Press, 1988.

Hambourg, Maria Morris, Françoise Helibrun, and Philippe Néagu, et al. *Nadar*. New York: Metropolitan Museum of Art; distributed by Harry N. Abrams, 1995.

Hambourg, Maria Morris, and Christopher Phillips. *The New Vision: Photography Between the World Wars*. New York: Metropolitan Museum of Art; distributed by Harry N. Abrams, 1989.

Hannavy, John. *Roger Fenton of Crimble Hall*. London: Gordon Fraser, 1975.

Harker, Margaret F. *Henry Peach Robinson: Master of Photographic Art, 1830–1901*. New York: B. Blackwell, 1988.

—. *The Linked Ring: The Secession Movement in Photography in Britain, 1892–1910*. London: Heinemann, 1979.

Haworth-Booth, Mark. *The Golden Age of British Photography, 1839–1900: Photographs from the Victoria and Albert Museum* ... Millerton, N.Y.: Aperture in association with the Philadelphia Museum of Art; distributed in U.S. by Viking Penguin, 1984.

Hine, Lewis. *Men at Work, Photographic Studies of Modern Men and Machines*. 1932. Reprint. New York: Dover Publications; Rochester, N.Y.: International Museum of Photography at George Eastman House, 1977.

Hirsch, Julia. *Family Photographs: Content, Meaning, and Effect*. New York: Oxford University Press, 1981.

Homer, William Innes. *Alfred Stieglitz and the Photo-Secession*. Boston: Little, Brown & Co. and New York Graphic Society, 1983.

Hurley, Forrest Jack, and Robert J. Doherty, eds. *Portrait of a Decade: Roy Stryker and the Development of Documentary Photography in the Thirties*. Baton Rouge: Louisiana State University Press, 1972.

Jammes, André, and Eugenia Parry Janis. *The Art of French Calotype, With a Critical Dictionary of Photographers, 1845–1870*. Princeton, N.J.: Princeton University Press, 1983.

Jenkins, William. *New Topographics: Photographs of a Man-Altered*

Landscape. Rochester, N. Y.: International Museum of Photography at George Eastman House, 1975.

Johnson, Osa Helen. *I Married Adventure: The Lives of Martin and Osa Johnson.* Garden City, N. Y.: Garden City Publishing Company, 1940.

Johnson, William S. *Nineteenth-Century Photography: An Annotated Bibliography, 1839–1879.* Boston: G. K. Hall, 1990.

Jussim, Estelle, and Cheryl Brutvan. *A Distanced Land: The Photography of John Pfahl.* Albuquerque: University of New Mexico Press in association with Albright-Knox Art Gallery, 1990.

Johnston, Patricia. *Real Fantasies: Edward Steichen's Advertising Photography.* Berkeley: University of California Press, 1997.

Keppler, Victor. *A Life of Color Photography: The Eighth Art.* New York: W. Morrow & Co., 1938.

Kraus, Rosalind, and Jane Livingston. *L'Amour Fou: Photography and Surrealism.* Washington, D. C.: Corcoran Gallery of Art; New York: Abbeville Press, 1985.

Knapp, Ulrich. *Kühn: Photographien.* Salzburg: Residenz Verlag, 1988.

Lahs-Gonzalez, Olivia, and Lucy Lippard. *Defining Eyes: Women Photographers of the Twentieth Century.* St. Louis, Mo.: St. Louis Art Museum, 1997.

LéCuyer, Raymond. *Histoire de la Photographie.* Paris: Baschet, 1945.

Lemagny, Jean-Claude, and André Rouillé. *A History of Photography: Social and Cultural Perspectives.* Translated by Janet Lloyd. New York: Cambridge University Press, 1987.

Lewinski, Jorge. *The Camera at War: A History of War Photography from 1848 to the Present Day.* New York: Simon and Schuster, 1980.

Livingston, Jane. *The New York School: Photographs, 1936–1960.* New York: Stewart, Tabori and Chang and Professional Imaging, Eastman Kodak Company, 1992.

Lloyd, Valerie. *Roger Fenton, Photographer of the 1850s.* London: South Board Bank, 1988.

Lorenz, Richard. *Imogen Cunningham: Ideas without End, A Life in Photographs.* San Francisco: Chronicle Books, 1993.

Lukitsh, Joanne. *Cameron, Her Work and Career.* Rochester, N. Y.: International Museum of Photography at George Eastman House, 1986.

Lyons, Nathan. *Photography in the Twentieth Century.* New York: Horizon Press in collaboration with George Eastman House, 1966.

—. *Towards a Social Landscape*. New York: Horizon Press in collaboration with George Eastman House, 1967.

—. *Vision and Expression*. New York: Horizon Press in collaboration with George Eastman House, 1969.

Maddow, Ben. *Faces: A Narrative History of the Portrait in Photography*. Photographs compiled and edited by Constance Sullivan. Boston: New York Graphic Society, 1977.

Manchester, William. *In Our Time: The World as Seen by Magnum Photographers*. New York: American Federation of Arts in association with Norton, 1989.

Marbot, Bernard. *After Daguerre: Masterworks of French Photography, 1848–1920, from the Bibliothèque Nationale, Musée de Petit Palais*. New York: The Metropolitan Museum of Art, 1980.

Margolis, Marianne Fulton. *Camera Work: A Pictorial Guide with Reproductions of All 559 Illustrations and Plates. Fully Indexed [from the original magazine edited by] Alfred Stieglitz*. New York: Dover Publications; Rochester, N.Y.: International Museum of Photography at George Eastman House, 1978.

—. *Muray's Celebrity Portraits of the Twenties and Thirties: 135 Photographs by Nickolas Muray*. New York: Dover Publications; Rochester, N.Y.: International Museum of Photography at George Eastman House, 1978.

Martin, Rupert. *Floods of Light: Flash Photography, 1851–1981*. London: The Photographers' Gallery, 1982.

McCauley, Elizabeth Anne. *Industrial Madness: Commercial Photography in Paris, 1848–1871*. New Haven: Yale University Press, 1994.

Michaels, Barbara L. *Gertrude Käsebier: The Photographer and Her Photographs*. New York: Harry N. Abrams, 1992.

Mulligan, Therese, Eugenia Parry Janis, April Watson, and Joanne Lukitsh. *For My Best Beloved Sister Mia: An Album of Photography by Julia Margaret Cameron: An Exhibition of Works from the Hochberg-Mattis Collection*. Albuquerque: University of New Mexico Art Museum, 1994.

Muybridge, Eadweard. *Muybridge's Complete Human and Animal Locomotion: All 781 Plates from the 1887 Animal Locomotion*. Introduction by Anita Ventura Mozley. New York: Dover Publications, 1979.

Nadeau, Luis. *Encyclopedia of Printing, Photographic, and Photomechanical Processes: Containing Invaluable Information on Over 1500 Processes*. Fredericton, New Brunswick, Canada: Atelier L. Nadeau, 1994.

Naef, Weston J., and James N. Wood. *Era of Exploration: The Rise of*

Landscape Photography in the American West, 1860–1885. Boston: New York Graphic Society, 1975.

Naylor, Colin, ed. *Contemporary Photographers.* 2nd ed. Chicago: St. James Press, 1988.

Neubauer, Hendrik. *Black Star: 60 Years of Photojournalism.* Köln: Köneman, 1997.

Newhall, Beaumont. *The Daguerreotype in America.* 3rd ed. New York: Dover Publications, 1976.

—. *Frederick H. Evans.* Rochester, N. Y.: George Eastman House, 1964.

—. *The History of Photography from 1839 to the Present.* Revised ed. New York: Metropolitan Museum of Art; distributed by New York Graphic Society, 1982.

Newhall, Nancy. *This Is the Photo League.* New York: The Photo League, 1949.

Newhall, Nancy Wynne. *Peter Henry Emerson: The Fight for Photography as a Fine Art.* New York: Aperture, 1975.

Nir, Yeshayahu. *The Bible and the Image: The History of Photography in the Holy Land, 1839–1899.* Philadelphia: University of Pennsylvania Press, 1985.

O'Neal, Hank. *A Vision Shared; A Classic Portrait of America and Its People, 1935–1943.* New York: St. Martin's Press, 1976.

Onne, Eyal. *Photographic Heritage of the Holy Land, 1839–1914.* Manchester, England: Institute of Advanced Studies, Manchester Polytechnic, 1980.

Ostroff, Eugene. *Western Views and Eastern Visions.* Washington: Smithsonian Institution Traveling Exhibition Service with the cooperation of the U. S. Geological Survey, 1981.

Panzer, Mary. *Philadelphia Naturalistic Photography, 1865–1906.* New Haven: Yale University Art Gallery, 1982.

Perez, Nissan N. *Focus East: Early Photography in the Near East, 1839–1885.* New York: Harry N. Abrams in association with the Domino Press, Jerusalem, and the Israel Museum, Jerusalem, 1988.

Peterson, Christian A. *After the Photo-Secession: American Pictorial Photography, 1910–1955.* New York: The Minneapolis Institute of Arts in association with W. W. Norton and Company, 1997.

Plattner, Steven W. *Roy Stryker: U. S. A., 1943–1950; The Standard Oil (New Jersey) Photography Project.* Austin, Tx.: University of Texas Press, 1983.

Points of Entry: A Nation of Strangers. Essays by Vicki Goldberg and Arthur Ollman. San Diego: Museum of Photographic Art, 1995.

Points of Entry: Reframing America. Essays by Andrei Codrescu and Terrence Pitts. Tucson: Center for Creative Photography, 1995.

Points of Entry: Tracing Cultures. Essays by Rebecca Solnit and Ronald Takaki. San Francisco: Friends of Photography, 1995.

Rinhart, Floyd, and Marion Rinhart. *The American Daguerreotype.* Athens, Ga.: University of Georgia, 1981.

Ritter, Dorothea. *Venise: Photographies Anciennes, 1841–1920.* Translation by Anne-Marie Mourot. London: Calmann & King, 1994.

Rosenblum, Naomi. *A History of Women Photographers.* 1st ed. New York: Abbeville Press, 1994.

— . *A World History of Photography.* New York: Abbeville Press, 1984.

Rosenblum, Naomi, Walter Rosenblum, and Alan Trachtenberg. *America and Lewis Hine: Photographs, 1904–1940.* New York: Aperture, 1977.

Sandweiss, Martha A. *Photography in Nineteenth-Century America.* Essays by Alan Trachtenberg, et al. New York: Harry N. Abrams, 1991.

Schaaf, Larry J. *Out of the Shadows: Herschel, Talbot and the Invention of Photography.* New Haven: Yale University Press, 1992.

Seiberling, Grace, and Carolyn Bloore in association with the International Museum of Photography at George Eastman House. *Amateurs, Photography, and the Mid-Victorian Imagination.* Chicago: University of Chicago Press, 1986.

Silverman, Jonathan. *For the World to See: The Life of Margaret Bourke-White.* New York: Viking Press, 1983.

Sipley, Louis Walton. *A Half-Century of Color.* New York: Macmillan, 1951.

Snyder, Joel. *American Frontiers: The Photographs of Timothy H. O'Sullivan, 1867–1874.* Millerton, N.Y.: Aperture, 1981.

Snyder, Joel and Doug Munson. *The Documentary Photograph as a Work of Art: American Photographs, 1860–1876.* Chicago: The David and Alfred Smart Gallery, The University of Chicago, 1976.

Sobieszek, Robert A. "An American Century of Photography, 1840–1940: Selections from the Sipley/3M Collection." *Camera* 57, no. 6 (June 1978).

—. *The Art of Persuasion: A History of Advertising Photography.* New York: Harry N. Abrams, 1988.

—. *Masterpieces of Photography from the George Eastman House Collections.* New York: Abbeville Press, 1985.

Sobieszek, Robert, and Odette M. Appel. *The Spirit of Fact: The Daguerreotypes of Southworth and Hawes, 1843–1862.* Boston: D. R. Godine, 1976.

Stapp, William F. "Souvenirs of Asia: Photography in the Far East, 1840–1920." *Image* 37, nos. 3–4 (fall/winter 1994): 2–53.

Steichen, Edward. *A Life in Photography.* Published in collaboration with Museum of Modern Art. Garden City, N.Y.: Doubleday, 1963.

Steinorth, Karl, ed. *Internationale Ausstellung des Deutschen Werkbundes: Film und Foto Stuttgart 1929.* Introduction by Karl Steinorth, foreword by Manfred Rommel. Stuttgart: Deutsche Verlags-Anstalt GmbH, 1979.

—. *Lewis Hine, Passionate Journey, Photographs, 1905–1937.* Texts by Anthony Bannon and Marianne Fulton. Zurich: Edition Stemmle in association with International Museum of Photography at George Eastman House, Rochester, New York, 1996.

Stevenson, Sara. *David Octavius Hill and Robert Adamson: A Catalogue of their Calotypes Taken Between 1843 and 1847 in the Collection of the Scotland National Portrait Gallery.* Edinburgh: National Galleries of Scotland, 1981.

Stuhlman, Rachel. "It Isn't Sanity, But It Sure Is Fun." *Image* 34, nos. 1–2 (spring/summer 1991): 22–28.

Sweetman, Alex. *Photographic Book to Photobookwork: 140 Years of Photography in Publication. CMP Bulletin* 5, no. 2, Riverside, Cal.: California Museum of Photography, University of California, 1986.

Szarkowski, John. *Photography until Now.* New York: Museum of Modern Art, 1989.

Szarkowski, John, and Maria Morris Hambourg. *The Work of Atget.* New York: Museum of Modern Art; Boston: New York Graphic Society, 1981.

Taft, Robert. *Photography and the American Scene: A Social History, 1839–1889.* New York: Macmillan, 1938.

Teitelbaum, Matthew, ed. *Montage and Modern Life: 1919–1942.* Cambridge, Mass.: Massachusetts Institute of Technology Press, 1992.

Thomas, Alan. *Time in a Frame: Photography and the Nineteenth-Century Mind.* New York: Schocken Books, 1977.

Thomas, Anne. *Beauty of Another Order: Photography in Science.* Essays by Marta Braun, et al. New Haven: Yale University Press in association with the National Gallery of Canada, 1997.

Thomas, Dr. G. *History of Photography, India, 1840–1980.* [Hyderabad]: Andhra Pradesh State Akademi of Photography, 1981.

Traub, Charles, ed. *New Vision: Forty Years of Photography at the Institute of Design*. Essay by John Grimes. Millerton, N.Y.: Aperture, 1982.

Treadwell, T.K., and William C. Darrah. *Stereographers of the World*. vols. 1–2. N.p.: National Stereoscopic Association, 1994.

Tucker, Anne. *Photographic Crossroads: The Photo League*. Ottawa: National Gallery of Canada for the Corporation of National Museums of Canada, 1978.

Van Haaften, Julia, and Jon E. Manchip White. *Egypt and the Holy Land in Historic Photographs: 77 Views by Francis Frith*. New York: Dover Publications, 1980.

Voignier, J.M. *Répertoire des Photographes de France au Dix-Neuvième Siècle*. Chevilly-Larue: Le Pont de Pierre, 1993.

Weinberg, Adam D., Eugenia Parry Janis and Max Kozloff. *Vanishing Presence*. Minneapolis: Walker Arts Center; New York: Rizzoli, 1989.

Welling, William. *Photography in America: The Formative Years, 1839–1900*. New York: Thomas Y. Crowell Co., 1978.

Weston, Edward. *The Daybooks of Edward Weston*. Edited by Nancy Newhall, foreword by Beaumont Newhall. 2nd ed. New York: Aperture, 1990.

White, Stephen. *John Thomson: A Window to the Orient*. New York: Thames and Hudson, 1986.

Wood, John. *The Art of the Autochrome: The Birth of Color Photography*. Foreword by Merry A. Foresta. Iowa City: University of Iowa Press, 1993.

—. *The Scenic Daguerreotype: Romanticism and Early Photography*. Iowa City: University of Iowa Press, 1995.

Wood, John, ed. *The Daguerreotype: A Sesquicentennial Celebration*. Iowa City: University of Iowa Press, 1989.

Worswick, Clark, ed. *Japan: Photographs, 1854–1905*. New York: Alfred A. Knopf, A Penwick Book, 1979.

Zannier, Italo. *Le Grand Tour: dans les Photographies des Voyageurs de XIXe Siècle*. Venise: Canal and Stamperia, 1997.

Photographers' Credits

The editors wish to thank copyright holders who greatly assisted in this publication, including photographers or their representatives, estates, agencies, foundations, and collecting institutions. Every effort was made to identify and contact individual copyright holders; omissions are unintentional. The following are credits for copyrighted material, listed by the photographer's last name.

Abbott: © Commerce Graphics, Inc., East Rutherford | **Adams**: © The Ansel Adams Publishing Rights Trust, Carmel | **Adams**: © The Associated Press, New York | **Adams**: © Robert Adams, Astoria | **Alvarez-Bravo**: © Manuel Alvarez-Bravo, Coyoacan | **Appelt**: © Dieter Appelt, Courtesy of Galerie Rudolf Kicken, Cologne | **Arbus**: Copyright © 1972 The Estate of Diane Arbus, New York | **Avedon**: © Richard Avedon Studio, New York | **Baldessari**: © John Baldessari, Santa Monica | **Baltz**: © Lewis Baltz and Stephen Wirtz Gallery, San Francisco | **Barrow**: © Thomas F. Barrow, Albuquerque | **Bayer**: © Mr. Javan Bayer, Denver | **Berger**: © Paul Berger, Seattle | **Berman**: © Zeke Berman, New York | **Bourke-White**: © Estate of Margaret Bourke-White, Jonathan B. White, East Lansing; © Time Life Syndication, New York |.**Brandt**: Bill Brandt © Bill Brandt Archive Ltd., London | **Brassaï**: © Gilberte Brassaï, Paris | **Brigman**: © The Oakland Museum of California, City of Oakland | **Bruehl**: © Estate of Anton Bruehl, Courtesy of Howard Greenberg Gallery, New York | **Bubley:** © Photographic Archives. Ekstrom Library, Universitiy of Louisville, Louisville | **Bullock**: © The Bullock Photography Trust, Carmel | **Burke**: © Bill Burke, Dorchester | **Burrows**: Courtesy Laurence Miller Gallery, New York | **Callahan**: Courtesy of PaceWildensteinMacGill, New York | **Capa**: © Cornell Capa, New York | **Cartier-Bresson**: © Helen Wright, New York | **Chiarenza**: © Carl Chiarenza, Rochester | **Close**: © Chuck Close, New York | **Cohen**: © Mark Cohen, Wilkes-Barre | **Corsini**: © Harold Corsini, Pittsburgh | **Cunningham**: © The Imogen Cunningham Trust, Berkeley | **Davidson:** © Bruce Davidson and Magnum Photos, Inc., New York | **Deal**: © Joe Deal, St. Louis | **DeCarava**: © Roy DeCarava, Brooklyn | **Depardon**: © Raymond Depardon and Magnum Photos, Inc., New York | **Drtikol**: © Ervina Boková-Drtikolová, Podebrady | **Edgerton**: © Harold and Esther Edgerton Foundation, 1998, Courtesy of Palm Press, Inc., Concord | **Ellison**: © Paul Stephanus, Wayne; Black Star, New York | **Evans**: © Evan Evans, Epsom Surrey | **Evans**: Library of Congress, Prints and Photographs Division, FSA/OWI Collection, LCUSF3 428 253A; LC-USF342–8091A; LC-USF342–894A; LC-USF342–890A, Washington, D.C.; © The Walker Evans Archive. The Metropolitan Museum of Art, New York | **Faurer**: © Louis Faurer, Howard Greenberg Gallery and Ferber, Chan & Essner, LLP., New York | **Feininger**: Photo by Andreas Feininger, *LIFE Magazine* © Time Inc., New York | **Fernandez**: © Benedict Fernandez, North Bergen | **Ferrato**: Courtesy of

Domestic Abuse Awareness Inc., New York | **Fichter**: © Robert Fichter, Tallahassee | **Freed**: © Leonard Freed and Magnum Photos, Inc., New York | **Friedlander**: © Lee Friedlander, New City | **Gibson**: © Ralph Gibson, New York | **Gohlke**: © Frank Gohlke, Southborough | **Goldin**: © Nan Goldin, New York | **Gowin**: © Emmet Gowin, Newtown | **Groover**: © Jan Groover, Montpon-Menesterol | **Hahn**: © Betty Hahn, Albuquerque | **Heath**: © David Heath, Toronto | **Heinecken**: © Robert Heinecken, Chicago | **Henri**: © Galleria Martini & Ronchetti, Genoa, Italy | **Hiller**: © Visual Studies Workshop, Rochester | **Hosoe**: © Eikoh Hosoe, Tokyo | **Jacobsen**: © Bill Jacobsen, Courtesy of Julie Saul Gallery, New York | **Keppler**: © Herbert Keppler, New York | **Kertész**: Photo André Kertész © Ministère de la Culture-France, Mission du Patrimonie Photographique, Paris | **Khaldei**: © Anna Khaldei-Bibicheva and Leonid Khaldei, Moscow | **Klein**: © William Klein, Paris | **Kon**: Courtesy of Photo Gallery International/Sata Corporation, Tokyo; © Michiko Kon, Courtesy: Robert Mann Gallery, New York | **Krims**: © Les Krims, Buffalo | **Kruger**: © Barbara Kruger, Courtesy of Mary Boone Gallery, New York | **Krull**: © Fotografische Sammlung, Museum Folkwang, Essen | **Kühn**: © Kühn-Nachlaß, Birgitz | **Lange**: Library of Congress, Prints and Photographs Division, FSA/OWI Collection, LCUSF349 058C; LC-USF34–9599C, Washington, D.C.; © The Dorothea Lange Collection, The Oakland Museum of California, City of Oakland. Gift of Paul S. Taylor, Oakland | **Lartigue**: Photographie J.H. Lartigue © Ministère de la Culture-France A.A.J.H.L., Paris | **Lazarnick**: Courtesy of the Detroit Public Library, National Automotive History Collection, Detroit | **Lerski**: © Fotografische Sammlung, Museum Folkwang, Essen | **Levitt**: © Helen Levitt, New York | **Lissitzky**: © 1998 Artists Rights Society (ARS), New York/VG Bild-Kunst, Bonn | **Lyon**: Courtesy of Danny Lyon and Edwynn Houk Gallery, Clintondale | **Lyons**: © Joan Lyons, Rochester | **Man Ray**: 1998 Man Ray Trust/Artists Rights Society, NY/ADAGP, Paris | **Manning**: © Jack Manning, Pearl River | **MANUAL**: © Suzanne Bloom and Ed Hill, Houston | **Mapplethorpe**: © The Estate of Robert Mapplethorpe. Used by permission. New York | **Mark**: © Mary Ellen Mark, Falkland Road, Inc., New York | **McCullin**: © Don McCullin, Somerset | **Meatyard**: © Christopher Meatyard, Lexington | **Meiselas**: © Susan Meiselas and Magnum Photos, Inc., New York | **Meyerowitz**: © Joel Meyerowitz, New York | **Model**: © Lisette Model Foundation, New York | **Moholy-Nagy**: © 1999 Artists Rights Society (ARS), New York/VG Bild-Kunst, Bonn | **Moore**: © Charles Moore, Shelbourne Falls | **Morell**: © Abelardo Morell, Brookline | **Myers**: © Joan Myers, Tesuque | **Neimanas**: © Joyce Neimanas, Chicago | **Nettles**: © Bea Nettles, Urbana | **Newman**: All photographs copyrighted by Arnold Newman, New York | **Outerbridge**: © Courtesy of G. Ray Hawkins Gallery, Santa Monica | **Peress**: © Gilles Peress and Magnum Photos, Inc., New York | **Pfahl**: © John Pfahl, Buffalo | **Renger-Patzsch**: © 1998 Artists Rights Society (ARS), New York/VG Bild-Kunst, Bonn | **Rodchenko**: © Howard Schickler on behalf of Rodchenko/Stepanova Archives, New York | **Rosenthal**: © The Associated Press, New York | **Rothstein**: © Photograph by Arthur Rothstein, New Rochelle | **Salomon**: © Peter Hunter, The Hague | **Samaras**: © PaceWildensteinMacGill, New York | **Sander**: © Die Fotografische Sammlung/SK Stiftung Kultur—August

Index of Photographers

Further praise for

POMPEII

'Blazingly exciting . . . Harris evokes the milieu soon to be engulfed by the volcano with confident expertise . . . What makes this novel all but unputdownable, though, is the bravura fictional flair that crackles throughout . . . Harris, as Vesuvius explodes, gives full vent to his genius for thrilling narrative. Fast-paced twists and turns alternate with nightmarish slow-motion scenes. Harris's unleashing of the furnace ferocities of the eruption's terminal phase turns his book's closing sequences into pulse-rate-speeding masterpieces of suffocating suspense and searing action. It is hard to imagine a more thoroughly enjoyable thriller read' Peter Kemp, *Sunday Times*

'*Pompeii* by Robert Harris was another triumph . . . put together with the skill of a craftsman' David Robson, 'Books of the Year', *Sunday Telegraph*

'Apart from its thriller content – breakneck pace, constant jeopardy and subtle twists of plot – what distinguishes *Pompeii* is its vivid recreation of a former world . . . The depth of the research in the book is staggering . . . *Pompeii* is indeed a blazing blockbuster' Simon Brett, *Daily Mail*

'Harris's skill lies in disturbing the splendidly drawn luxury of Neapolitan life with premonitory intimations of catastrophe . . . Readers must hope that Robert Harris will want to return soon to the classical warm south' Robert McCrum, *Observer*

'Britain's leading thriller writer . . . The key to the tension, which Harris expertly cranks up, is that while the characters in the novel have no idea that Vesuvius is about to blow, the reader does . . . The scenes of violence and doom that Harris portrays with such relish are given added piquancy by the fact that the tourist who has visited Pompeii or Herculaneum will recognise many of them. The long drawn-out death agony of the two cities is brilliantly done. Explosive stuff, indeed – and yes, it goes with a bang' Tom Holland, *Daily Telegraph*

'Harris has done a tremendous job of evoking life in ancient Italy . . . When Vesuvius finally blows its top, you can almost taste the pumice. You can feel the ash in your hair . . . Harris had me imaginatively surrounded. I am lost in admiration at his energy and skill' Boris Johnson, *Mail on Sunday*

'The ability to disguise the outcome is held to be a vital part of the thriller writer's art. Robert Harris though, has built a major career in open defiance of this rule . . . Harris is equally successful in making us flinch and fear for characters who are going to a doom which we know before them . . . In the post-eruption sequences – chillingly, viscerally described – the novelist makes explicit implied connection with September 11 . . . Readers will be reminded here not of their school history books but of newspaper front pages just two years old' Mark Lawson, *Guardian*

'[Harris] eschews lavish dramatic irony in favour of fast-paced narrative. He judges every element of his craft with perfect professionalism – the page-turning pace, the easy-to-read but

informative background-painting . . . Harris's Pompeii seems just around the corner – a Pompeii for our times' Felipe Fernández-Armesto, *The Times*

'The inspired aqueduct angle on events, the lively interaction of characters real and fictional and the time bomb in the shape of Vesuvius places Harris's novel in a distinguished tradition that successfully creates great fiction in an authentically imagined other world' Peter Jones, *Evening Standard*

A whole community, buried in volcanic ash 2000 years ago, has been brought to life . . . Stirring and absorbing' David Robson, *Sunday Telegraph*

'Harris has cleverly glossed and expanded on ancient sources, retelling the story very effectively . . . A master craftsman . . . Harris is a writer of integrity who does not seek refuge in postmodern nonsense. There are no temporal dislocations, 'unearthed diaries' or other hocus-pocus. He knows how to tell a story and achieves page-turning readability without effort' Frank McLynn, *Daily Express*

'Genuinely thrilling' *Literary Review*

'Harris triumphs . . . a skilled writer on top form . . . The pitfalls that come with this territory are skilfully avoided by Harris, who engages with material ancient and modern in a thoughtful way . . . A sophisticated thriller that takes in its stride the conventions of the historical novel, *Pompeii* deserves the place it will undoubtedly have at the top of the bestseller lists' *Times Literary Supplement*

'A supremely good piece of storytelling, most impressively researched' Diana Athill, *Guardian*

'As a writer, Mr Harris is as thought-provoking as he is entertaining. Thanks to his minute attention to detail, his handling of the eruption and his competence as a historian, the novel works both as an engaging thriller and as a believable portrayal of life in ancient Rome, with no small lesson for our own time' *The Economist*

'A gripping novel that carries the reader smoothly along as in a litter borne by several muscular Nubian slaves . . . Harris proves, if proof were needed, that he is a writer who, unfashionably, never loses sight of his obligation towards the reader's welfare and enjoyment . . . this expert piece of storytelling' Philip Kerr, *New Statesman*

'Harris is a knowing capable writer who understands better than anyone how to keep readers gripped. Never less than tremendous fun, *Pompeii* scores highly for quality of research and technical detail' *Time Out*

'Fast, fact filled, and quite fun. A blast, really' *Kirkus Reviews* (Starred Review)

'Harris colourfully evokes the sights and sounds of the ancient world' Christopher Hart, *Independent on Sunday*

'Beautifully crafted . . . gripping and illuminating' Nicholas Coleridge, *Irish Examiner*

'Quite simply a wonderful novel . . . Harris has excelled yet again. His characters leap off the pages . . . It is beautifully written, meticulously researched and comes across as solidly true to the era. But don't take my word, read it and believe' Paul Carson, *Irish News*

'Harris has astounded millions with his ability to tell a captivating tale. Particularly adept at revealing the shocking ties between our past failures and their reverberating effects, this latest promises no less . . . We see the corruption and arrogance of a dying era amid the delicious intrigue and cool precision we expect from Harris' *The Good Book Guide*

'Deeply researched, faithful to the evidence, and gloriously successful in evoking a plausible picture of what the world of first-century Italy might have been like . . . A gripping taste of the contradictions of a real Roman world' Professor Andrew Wallace-Hadrill, *The Art Newspaper*

'Terrific and prodigiously researched . . . Attilius' scientific curiosity – and knowledge – places him squarely within the tradition of the best literary detectives, such as Sherlock Holmes and Hercule Poirot . . . The author has clearly done a herculean study of Roman civil engineering and waterworks, which *Pompeii* smoothly incorporates without ever feeling pedantic . . . It's a testament to the tightly wound structure and entertaining detail that Harris has built into his idiosyncratic historical-volcanological mystery that, even though you know how his story ends, you still can't put it down as the inevitable comes closer . . . Harris's latest thriller

is so cunningly devised that, however unsurprising its denouement is, it still manages to end with a bang' Daniel Mendelsohn, *The New York Times*

'Harris is terrific in describing the grandeur of the aqueducts, inviting the reader inside' *People Magazine*

'Another winner . . . Packed with fascinating historical details, Harris's yarn brings Pompeii to life even as it faces death' *Newsweek*

'Harris vividly brings to life the ancient world on the brink of disaster' *Booklist*

'*Pompeii* proves once again that a talented writer can make anything interesting . . . Vivid atmosphere, rich characterizations and awesome descriptions of nature's fury that show Harris working at the top of his game' *Time Out New York*

About the author

Robert Harris was born in Nottingham in 1957 and is a graduate of Cambridge University. He has been a reporter on the BBC's Newsnight and Panorama programmes, Political Editor on the *Observer*, and a columnist on the *Sunday Times* and the *Daily Telegraph*. In 2003 he was named Columnist of the Year in the British Press Awards. He is the author of *Fatherland*, *Enigma*, *Archangel*, *Pompeii* and *Imperium*, as well as five non-fiction books. He lives in Berkshire with his wife and four children.

BY THE SAME AUTHOR

fiction
Fatherland
Enigma
Archangel
Imperium

non-fiction
A Higher Form of Killing
(*with Jeremy Paxman*)
Gotcha!
The Making of Neil Kinnock
Selling Hitler
Good and Faithful Servant

POMPEII

ROBERT HARRIS

arrow books

Published in 2004 by Arrow Books

11 13 15 17 19 20 18 16 14 12

Map of Aqua Augusta by Reginald Piggott

First published in 2003 by Hutchinson

Hutchinson
The Random House Group Limited
20 Vauxhall Bridge Road, London SW1V 2SA

www.randomhouse.co.uk

Addresses for companies within The Random House Group
Limited can be found at: www.randomhouse.co.uk/offices.htm

The Random House Group Limited Reg. No. 954009

A CIP catalogue record for this book
is available from the British Library

ISBN 9780099282617

The Random House Group Limited makes every effort to ensure
that the papers used in its books are made from trees that have
been legally sourced from well-managed and credibly certified
forests. Our paper procurement policy can be found at:
www.randomhouse.co.uk/paper.htm

Typeset by Palimpsest Book Production Limited
Polmont, Stirlingshire

Printed and bound in Great Britain by
Bookmarque Ltd, Croydon, Surrey

To Gill

Author's note

The Romans divided the day into twelve hours. The first, *hora prima*, began at sunrise. The last, *hora duodecima*, ended at sunset.

The night was divided into eight watches – *Vespera, Prima fax, Concubia* and *Intempesta* before midnight; *Inclinatio, Gallicinium, Conticinium* and *Diluculum* after it.

The days of the week were Moon, Mars, Mercury, Jupiter, Venus, Saturn and Sun.

Pompeii takes place over four days.

Sunrise on the Bay of Naples in the fourth week of August AD 79 was at approximately 06:20 hours.

'American superiority in all matters of science, economics, industry, politics, business, medicine, engineering, social life, social justice, and of course, the military was total and indisputable. Even Europeans suffering the pangs of wounded chauvinism looked on with awe at the brilliant example the United States had set for the world as the third millennium began.'

Tom Wolfe, *Hooking Up*

'In the whole world, wherever the vault of heaven turns, there is no land so well adorned with all that wins Nature's crown as Italy, the ruler and second mother of the world, with her men and women, her generals and soldiers, her slaves, her pre-eminence in arts and crafts, her wealth of brilliant talent . . .'

Pliny, *Natural History*

'How can we withhold our respect from a water system that, in the first century AD, supplied the city of Rome with substantially more water than was supplied in 1985 to New York City?'

A. Trevor Hodge, author,
Roman Aqueducts & Water Supply

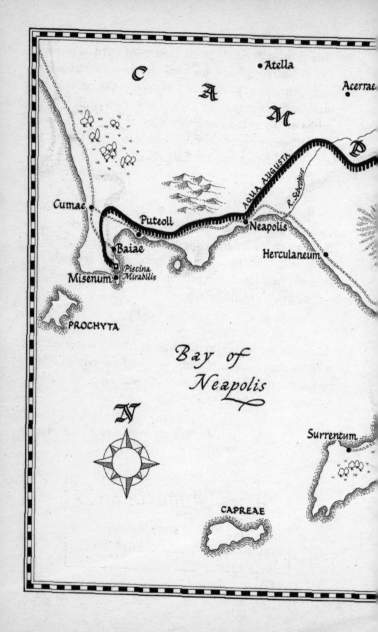

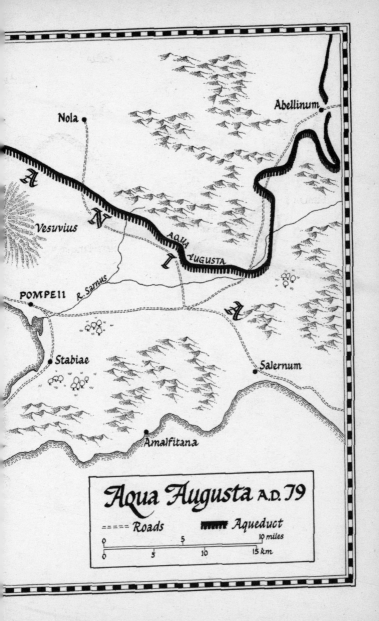

Nola

Abellinum

Vesuvius

AQUA

AUGUSTA

R. Sarnus

POMPEII

Stabiae

Salernum

Amalfitana

Aqua Augusta A.D. 79

===== Roads ▬▬▬ Aqueduct

0 5 10 miles
0 5 10 15 km

MARS

22 August

Two days before the eruption

Conticinium

'A strong correlation has been found between the magnitude of eruptions and the length of the preceding interval of repose. Almost all very large, historic eruptions have come from volcanoes that have been dormant for centuries.'
Jacques-Marie Bardintzeff, Alexander R. McBirney,
Volcanology *(second edition)*

They left the aqueduct two hours before dawn, climbing by moonlight into the hills overlooking the port – six men in single file, the engineer leading. He had turfed them out of their beds himself – all stiff limbs and sullen, bleary faces – and now he could hear them complaining about him behind his back, their voices carrying louder than they realised in the warm, still air.

'A fool's errand,' somebody muttered.

'Boys should stick to their books,' said another.

3

He lengthened his stride.

Let them prattle, he thought.

Already he could feel the heat of the morning beginning to build, the promise of another day without rain. He was younger than most of his work gang, and shorter than any of them: a compact, muscled figure with cropped brown hair. The shafts of the tools he carried slung across his shoulder – a heavy, bronze-headed axe and a wooden shovel – chafed against his sunburnt neck. Still, he forced himself to stretch his bare legs as far as they would reach, mounting swiftly from foothold to foothold, and only when he was high above Misenum, at a place where the track forked, did he set down his burdens and wait for the others to catch up.

He wiped the sweat from his eyes on the sleeve of his tunic. Such shimmering, feverish heavens they had here in the south! Even this close to daybreak, a great hemisphere of stars swept down to the horizon. He could see the horns of Taurus, and the belt and sword of the Hunter; there was Saturn, and also the Bear, and the constellation they called the Vintager, which always rose for Caesar on the twenty-second day of August, following the Festival of Vinalia, and signalled that it was time to harvest the wine. Tomorrow night the moon would be full. He raised his hand to the sky, his blunt-tipped fingers black and sharp against the glittering constellations – spread them, clenched them, spread them again – and for a moment it seemed to him that he was the shadow, the nothing; the light was the substance.

4

From down in the harbour came the splash of oars as the night watch rowed between the moored triremes. The yellow lanterns of a couple of fishing boats winked across the bay. A dog barked and another answered. And then the voices of the labourers slowly climbing the path beneath him: the harsh local accent of Corax the overseer – *'Look, our new aquarius is waving at the stars!'* – and the slaves and the free men, equals for once in their resentment if nothing else, panting for breath and sniggering.

The engineer dropped his hand. 'At least,' he said, 'with such a sky, we have no need of torches.' Suddenly he was vigorous again, stooping to collect his tools, hoisting them back on to his shoulder. 'We must keep moving.' He frowned into the darkness. One path would take them westwards, skirting the edge of the naval base. The other led north, towards the seaside resort of Baiae. 'I think this is where we turn.'

'He thinks,' sneered Corax.

The engineer had decided the previous day that the best way to treat the overseer was to ignore him. Without a word he put his back to the sea and the stars, and began ascending the black mass of the hillside. What was leadership, after all, but the blind choice of one route over another and the confident pretence that the decision was based on reason?

The path here was steeper. He had to scramble up it sideways, sometimes using his free hand to pull himself along, his feet skidding, sending showers of loose stones rattling away in the darkness. People stared

5

at these brown hills, scorched by summer brushfires, and thought they were as dry as deserts, but the engineer knew differently. Even so, he felt his earlier assurance beginning to weaken, and he tried to remember how the path had appeared in the glare of yesterday afternoon, when he had first reconnoitred it. The twisting track, barely wide enough for a mule. The swathes of scorched grass. And then, at a place where the ground levelled out, flecks of pale green in the blackness – signs of life that turned out to be shoots of ivy reaching towards a boulder.

After going halfway up an incline and then coming down again, he stopped and turned slowly in a full circle. Either his eyes were getting used to it, or dawn was close now, in which case they were almost out of time. The others had halted behind him. He could hear their heavy breathing. Here was another story for them to take back to Misenum – how their new young aquarius had dragged them from their beds and marched them into the hills in the middle of the night, and all *on a fool's errand*. There was a taste of ash in his mouth.

'Are we lost, pretty boy?'

Corax's mocking voice again.

He made the mistake of rising to the bait: 'I'm looking for a rock.'

This time they did not even try to hide their laughter.

'He's running around like a mouse in a pisspot!'

'I know it's here somewhere. I marked it with chalk.'

More laughter – and at that he wheeled on them: the squat and broad-shouldered Corax; Becco, the long-

nose, who was a plasterer; the chubby one, Musa, whose skill was laying bricks; and the two slaves, Polites and Corvinus. Even their indistinct shapes seemed to mock him. 'Laugh. Good. But I promise you this: either we find it before dawn or we shall all be back here tomorrow night. Including you, Gavius Corax. Only next time make sure you're sober.'

Silence. Then Corax spat and took a half-step forward and the engineer braced himself for a fight. They had been building up to this for three days now, ever since he had arrived in Misenum. Not an hour had passed without Corax trying to undermine him in front of the men.

And if we fight, thought the engineer, he will win – it's five against one – and they will throw my body over the cliff and say I slipped in the darkness. But how will that go down in Rome – if a second aquarius of the Aqua Augusta is lost in less than a fortnight?

For a long instant they faced one another, no more than a pace between them, so close that the engineer could smell the stale wine on the older man's breath. But then one of the others – it was Becco – gave an excited shout and pointed.

Just visible behind Corax's shoulder was a rock, marked neatly in its centre by a thick white cross.

Attilius was the engineer's name – Marcus Attilius Primus, to lay it out in full, but plain Attilius would have satisfied him. A practical man, he had never

had much time for all these fancy handles his fellow countrymen went in for. ('Lupus', 'Panthera', 'Pulcher' – 'Wolf', 'Leopard', 'Beauty' – who in hell did they think they were kidding?) Besides, what name was more honourable in the history of his profession than that of the *gens* Attilia, aqueduct engineers for four generations? His great-grandfather had been recruited by Marcus Agrippa from the ballista section of Legion XII 'Fulminata' and set to work building the Aqua Julia. His grandfather had planned the Anio Novus. His father had completed the Aqua Claudia, bringing her into the Esquiline Hill over seven miles of arches, and laying her, on the day of her dedication, like a silver carpet at the feet of the Emperor. Now he, at twenty-seven, had been sent south to Campania and given command of the Aqua Augusta.

A dynasty built on water!

He squinted into the darkness. Oh, but she was a mighty piece of work, the Augusta – one of the greatest feats of engineering ever accomplished. It was going to be an honour to command her. Somewhere far out there, on the opposite side of the bay, high in the pine-forested mountains of the Appenninus, the aqueduct captured the springs of the Serinus and bore the water westwards – channelled it along sinuous underground passages, carried it over ravines on top of tiered arcades, forced it across valleys through massive syphons – all the way down to the plains of Campania, then around the far side of Mount Vesuvius, then south to the coast at Neapolis, and finally along the spine of the Misenum

peninsula to the dusty naval town, a distance of some sixty miles, with a mean drop along her entire length of just two inches every one hundred yards. She was the longest aqueduct in the world, longer even than the great aqueducts of Rome and far more complex, for whereas her sisters in the north fed one city only, the Augusta's serpentine conduit – the matrix, as they called it: the motherline – suckled no fewer than nine towns around the Bay of Neapolis: Pompeii first, at the end of a long spur, then Nola, Acerrae, Atella, Neapolis, Puteoli, Cumae, Baiae and finally Misenum.

And this was the problem, in the engineer's opinion. She had to do too much. Rome, after all, had more than half a dozen aqueducts: if one failed the others could make up the deficit. But there was no reserve supply down here, especially not in this drought, now dragging into its third month. Wells that had provided water for generations had turned into tubes of dust. Streams had dried up. River beds had become tracks for farmers to drive their beasts along to market. Even the Augusta was showing signs of exhaustion, the level of her enormous reservoir dropping hourly, and it was this which had brought him out on to the hillside in the time before dawn when he ought to have been in bed.

From the leather pouch on his belt Attilius withdrew a small block of polished cedar with a chin rest carved into one side of it. The grain of the wood had been rubbed smooth and bright by the skin of his ancestors. His great-grandfather was said to have been given it as

9

a talisman by Vitruvius, architect to the Divine Augustus, and the old man had maintained that the spirit of Neptune, god of water, lived within it. Attilius had no time for gods – boys with wings on their feet, women riding dolphins, greybeards hurling bolts of lightning off the tops of mountains in fits of temper – these were stories for children, not men. He placed his faith instead in stones and water, and in the daily miracle that came from mixing two parts of slaked lime to five parts of puteolanum – the local red sand – conjuring up a substance that would set underwater with a consistency harder than rock.

But still – it was a fool who denied the existence of luck, and if this family heirloom could bring him that . . . He ran his finger around its edge. He would try anything once.

He had left his rolls of Vitruvius behind in Rome. Not that it mattered. They had been hammered into him since childhood, as other boys learnt their Virgil. He could still recite entire passages by heart.

'These are the growing things to be found which are signs of water: slender rushes, wild willow, alder, chaste berry, ivy, and other things of this sort, which cannot occur on their own without moisture . . .'

'Corax over there,' ordered Attilius. 'Corvinus there. Becco, take the pole and mark the place I tell you. You two: keep your eyes open.'

Corax gave him a look as he passed.

'Later,' said Attilius. The overseer stank of resentment almost as strongly as he reeked of wine, but there

would be time enough to settle their quarrel when they got back to Misenum. For now they would have to hurry.

A grey gauze had filtered out the stars. The moon had dipped. Fifteen miles to the east, at the mid-point of the bay, the forested pyramid of Mount Vesuvius was becoming visible. The sun would rise behind it.

'This is how to test for water: lie face down, before sunrise, in the places where the search is to be made, and with your chin set on the ground and propped, survey these regions. In this way the line of sight will not wander higher than it should, because the chin will be motionless . . .'

Attilius knelt on the singed grass, leant forward, and arranged the block in line with the chalk cross, fifty paces distant. Then he set his chin on the rest and spread his arms. The ground was still warm from yesterday. Particles of ash wafted into his face as he stretched out. No dew. Seventy-eight days without rain. The world was burning up. At the fringe of his eyeline he saw Corax make an obscene gesture, thrusting out his groin – 'Our aquarius has no wife, so he tries to fuck Mother Earth instead!' – and then, away to his right, Vesuvius darkened and light shot from the edge of it. A shaft of heat struck Attilius's cheek. He had to bring up his hand to shield his face from the dazzle as he squinted across the hillside.

'In those places where moisture can be seen curling and rising into the air, dig on the spot, because this sign cannot occur in a dry location . . .'

You saw it quickly, his father used to tell him, or you

11

did not see it at all. He tried to scan the ground rapidly and methodically, shifting his gaze from one section of the land to the next. But it all seemed to run together – parched browns and greys and streaks of reddish earth, already beginning to waver in the sun. His vision blurred. He raised himself on his elbows and wiped each eye with a forefinger and settled his chin again.

There!

As thin as a fishing line it was – not 'curling' or 'rising' as Vitruvius promised, but snagging, close to the ground, as if a hook were caught on a rock and someone were jerking it. It zig-zagged towards him. And vanished. He yelled and pointed – 'There, Becco, there!' – and the plasterer lumbered towards the spot. 'Back. Yes. There. Mark it.'

He scrambled to his feet and hurried towards them, brushing the red dirt and black ash from the front of his tunic, smiling, holding the magical block of cedar aloft. The three had gathered around the place and Becco was trying to jam the pole into the earth, but the ground was too hard to sink it far enough.

Attilius was triumphant. 'You saw it? You must have seen it. You were closer than I.'

They stared at him blankly.

'It was curious, did you notice? It rose like this.' He made a series of horizontal chops at the air with the flat of his hand. 'Like steam coming off a cauldron that's being shaken.'

He looked from one to another, his smile fixed at first, then shrinking.

Corax shook his head. 'Your eyes are playing tricks on you, pretty boy. There's no spring up here. I told you. I've known these hills for twenty years.'

'And I'm telling you I saw it.'

'Smoke.' Corax stamped his foot on the dry earth, raising a cloud of dust. 'A brush fire can burn underground for days.'

'I know smoke. I know vapour. This was vapour.'

They were shamming blindness. They had to be. Attilius dropped to his knees and patted the dry red earth. Then he started digging with his bare hands, working his fingers under the rocks and tossing them aside, tugging at a long, charred tuber which refused to come away. Something had emerged from here. He was sure of it. Why had the ivy come back to life so quickly if there was no spring?

He said, without turning round, 'Fetch the tools.'

'Aquarius –'

'Fetch the tools!'

They dug all morning, as the sun climbed slowly above the blue furnace of the bay, melting from yellow disc to gaseous white star. The ground creaked and tautened in the heat, like the bowstring of one of his great-grandfather's giant siege engines.

Once, a boy passed them, dragging an emaciated goat by a rope halter toward the town. He was the only person they saw. Misenum itself lay hidden from view just beyond the cliff edge. Occasionally its sounds

floated up to them – shouts of command from the military school, hammering and sawing from the shipyards.

Attilius, an old straw hat pulled low over his face, worked hardest of all. Even when the others crept off occasionally to sprawl in whatever patches of shade they could find, he continued to swing his axe. The shaft was slippery with his sweat and hard to grip. His palms blistered. His tunic stuck to him like a second skin. But he would not show weakness in front of the men. Even Corax shut up after a while.

The crater they eventually excavated was twice as deep as a man's height, and broad enough for two of them to work in. And there was a spring there, right enough, but it retreated whenever they came close. They would dig. The rusty soil at the bottom of the hole would turn damp. And then it would bake dry again in the sunlight. They would excavate another layer and the same process would recur.

Only at the tenth hour, when the sun had passed its zenith, did Attilius at last acknowledge defeat. He watched a final stain of water dwindle and evaporate, then flung his axe over the lip of the pit and hauled himself after it. He pulled off his hat and fanned his burning cheeks. Corax sat on a rock and watched him. For the first time Attilius noticed he was bare-headed.

He said, 'You'll boil your brains in this heat.' He uncorked his waterskin and tipped a little into his hand, splashed it on to his face and the back of his neck, then drank. It was hot – as unrefreshing as swallowing blood.

'I was born here. Heat doesn't bother me. In

Campania we call this cool.' Corax hawked and spat. He tilted his broad chin towards the hole. 'What do we do with this?'

Attilius glanced at it – an ugly gash in the hillside, great mounds of earth heaped all around it. His monument. His folly. 'We'll leave it as it is,' he said. 'Have it covered with planks. When it rains, the spring will rise. You'll see.'

'When it rains, we won't need a spring.'

A fair point, Attilius had to concede.

'We could run a pipe from it,' he said thoughtfully. He was a romantic when it came to water. In his imagination, a whole pastoral idyll suddenly began to take shape. 'We could irrigate this entire hillside. There could be lemon groves up here. Olives. It could be terraced. Vines –'

'Vines!' Corax shook his head. 'So now we're farmers! Listen to me, young expert from Rome. Let me tell you something. The Aqua Augusta hasn't failed in more than a century. And she isn't going to fail now. Not even with you in charge.'

'We hope.' The engineer finished the last of his water. He could feel himself blushing scarlet with humiliation, but the heat hid his shame. He planted his straw hat firmly on his head and pulled down the brim to protect his face. 'All right, Corax, get the men together. We've done here for the day.'

He collected his tools and set off without waiting for the others. They could find their own way back.

He had to watch where he put his feet. Each step

sent a scattering of lizards rustling away into the dry undergrowth. It was more Africa than Italy, he thought, and when he reached the coastal path, Misenum appeared beneath him, shimmering in the haze of heat like an oasis town, pulsing – or so it seemed to him – in time with the cicadas.

The headquarters of the western imperial fleet was a triumph of Man over Nature, for by rights no town should exist here. There was no river to support her, few wells or springs. Yet the Divine Augustus had decreed that the Empire needed a port from which to control the Mediterranean, and here she was, the embodiment of Roman power: the glittering silver discs of her inner and outer harbours, the golden beaks and fan-tail sterns of fifty warships glinting in the late afternoon sun, the dusty brown parade ground of the military school, the red-tiled roofs and the whitewashed walls of the civilian town rising above the spiky forest of masts in the shipyard.

Ten thousand sailors and another ten thousand citizens were crammed into a narrow strip of land with no fresh water to speak of. Only the aqueduct had made Misenum possible.

He thought again of the curious motion of the vapour, and the way the spring had seemed to run back into the rock. A strange country, this. He looked ruefully at his blistered hands.

A fool's errand –'

He shook his head, blinking his eyes to clear them of sweat, and resumed his weary trudge down to the town.

16

Hora undecima

[17:42 hours]

'A question of practical importance to forecasting is how much time elapses between an injection of new magma and an ensuing eruption. In many volcanoes, this time interval may be measured in weeks or months, but in others it seems to be much shorter, possibly days or hours.'

Volcanology *(second edition)*

A t the Villa Hortensia, the great coastal residence on the northern outskirts of Misenum, they were preparing to put a slave to death. They were going to feed him to the eels.

It was not an unknown practice in that part of Italy, where so many of the huge houses around the Bay of Neapolis had their own elaborate fish farms. The new owner of the Villa Hortensia, the millionaire Numerius Popidius Ampliatus, had first heard the story as a boy – of how the Augustan aristocrat, Vedius Pollio, would

hurl clumsy servants into his eel pond as a punishment for breaking dishes – and he often referred to it admiringly as the perfect illustration of what it was to have power. Power, and imagination, and wit, and a certain *style*.

So when, many years later, Ampliatus, too, came to possess a fishery – just a few miles down the coast from Vedius Pollio's old place at Pausilypon – and when one of his slaves also destroyed something of rare value, the precedent naturally came back into his mind. Ampliatus had been born a slave himself; this was how he thought an aristocrat ought to behave.

The man was duly stripped to his loincloth, had his hands tied behind his back and was marched down to the edge of the sea. A knife was run down both of his calves, to draw an attractive amount of blood, and he was also doused with vinegar, which was said to drive the eels mad.

It was late afternoon, very hot.

The eels had their own large pen, built well away from the other fish ponds to keep them segregated, reached by a narrow concrete gangway extending out into the bay. These eels were morays, notorious for their aggression, their bodies as long as a man's and as wide as a human trunk, with flat heads, wide snouts and razor teeth. The villa's fishery was a hundred and fifty years old and nobody knew how many lurked in the labyrinth of tunnels and in the shady areas built into the bottom of the pond. Scores, certainly; probably hundreds. The more ancient eels were monsters and

several wore jewellery. One, which had a gold earring fitted to its pectoral fin, was said to have been a favourite of the Emperor Nero.

The morays were a particular terror to this slave because – Ampliatus savoured the irony – it had long been his responsibility to feed them, and he was shouting and struggling even before he was forced on to the gangway. He had seen the eels in action every morning when he threw in their meal of fish heads and chicken entrails – the way the surface of the water flickered, then roiled as they sensed the arrival of the blood, and the way they came darting out of their hiding-places to fight over their food, tearing it to pieces.

At the eleventh hour, despite the sweltering heat, Ampliatus himself promenaded down from the villa to watch, attended by his teenaged son, Celsinus, together with his household steward, Scutarius, a few of his business clients (who had followed him from Pompeii and had been hanging around since dawn in the hope of dinner), and a crowd of about a hundred of his other male slaves who he had decided would profit by witnessing the spectacle. His wife and daughter he had ordered to remain indoors: this was not a sight for women. A large chair was set up for him, with smaller ones for his guests. He did not even know the errant slave's name. He had come as part of a job lot with the fish ponds when Ampliatus had bought the villa, for a cool ten million, earlier in the year.

All manner of fish were kept, at vast expense, along the shoreline of the house – sea bass, with their woolly-

white flesh; grey mullet, that required high walls around their pond to prevent them leaping to freedom; flatfish and parrot fish and giltheads; lampreys and congers and hake.

But by far the most expensive of Ampliatus's aquatic treasures – he trembled to think how much he had paid for them, and he did not even much like fish – were the red mullet, the delicate and whiskered goatfish, notoriously difficult to keep, whose colours ran from pale pink to orange. And it was these that the slave had killed. Whether by malice or incompetence, Ampliatus did not know, nor care, but there they were: clustered together in death as they had been in life, a multi-hued carpet floating on the surface of their pond, discovered earlier that afternoon. A few had still been alive when Ampliatus was shown the scene, but they had died even as he watched, turning like leaves in the depths of the pool and rising to join the others. Poisoned, every one. They would have fetched six thousand apiece at current market prices – one mullet being worth five times as much as the miserable slave who was supposed to look after them – and now they were fit only for the fire. Ampliatus had pronounced sentence immediately: 'Throw him to the eels!'

The slave was screaming as they dragged and prodded him towards the edge of the pool. It was not his fault, he was shouting. It was not the food. It was the water. They should fetch the aquarius.

The aquarius!

Ampliatus screwed up his eyes against the glare of

the sea. It was hard to make out the shapes of the writhing slave and of the two others holding him, or of the fourth, who held a boat-hook like a lance and was jabbing it into the doomed man's back – mere stick-figures, all of them, in the haze of the heat and the sparkling waves. He raised his arm in the manner of an emperor, his fist clenched, his thumb parallel with the ground. He felt godlike in his power, yet full of simple human curiosity. For a moment he waited, tasting the sensation, then abruptly he twisted his wrist and jammed his thumb upward. Let him have it!

The piercing cries of the slave teetering on the edge of the eel-pond carried up from the seafront, across the terraces, over the swimming pool and into the silent house where the women were hiding.

Corelia Ampliata had run to her bedroom, thrown herself down on the mattress, and pulled her pillow over her head, but there was no escaping the sound. Unlike her father, she knew the slave's name – Hipponax, a Greek – and also the name of his mother, Atia, who worked in the kitchens, and whose lamentations, once they started, were even more terrible than his. Unable to bear the screams for more than a few moments, she sprang up again and ran through the deserted villa to find the wailing woman, who had sunk against a column in the cloistered garden.

Seeing Corelia, Atia clutched at her young mistress's hem and began weeping at her slippered feet, repeating

over and over that her son was innocent, that he had shouted to her as he was being carried away – it was the water, the water, there was something wrong with the water. Why would nobody listen to him?

Corelia stroked Atia's grey hair and tried to make such soothing noises as she could. There was little else that she could do. Useless to appeal to her father for clemency – she knew that. He listened to nobody, least of all to a woman, and least of all women to his daughter, from whom he expected an unquestioning obedience – an intervention from her would only make the death of the slave doubly certain. To Atia's pleas she could only reply that there was nothing she could do.

At this, the old woman – in truth she was in her forties, but Corelia thought of slave years as being like dog years, and she appeared at least sixty – suddenly broke away and roughly dried her eyes on her arm.

'I must find help.'

'Atia, Atia,' said Corelia gently, 'who will give it?'

'He shouted for the aquarius. Didn't you hear him? I shall fetch the aquarius.'

'And where is he?'

'He may be at the aqueduct down the hill, where the watermen work.'

She was on her feet now, trembling but determined, looking around her wildly. Her eyes were red, her dress and hair disordered. She looked like a madwoman and Corelia saw at once that no one would pay her any attention. They would laugh at her, or drive her off with stones.

'I'll come with you,' she said, and as another terrible scream rose from the waterfront Corelia gathered up her skirts with one hand, grabbed the old woman's wrist with the other and together they fled through the garden, past the empty porter's stool, out of the side door, and into the dazzling heat of the public road.

The terminus of the Aqua Augusta was a vast underground reservoir, a few hundred paces south of the Villa Hortensia, hewn into the slope overlooking the port and known, for as long as anyone could remember, as the Piscina Mirabilis – The Pool of Wonders.

Viewed from the outside, there was nothing particularly wonderful about her and most of the citizens of Misenum passed her without a second glance. She appeared on the surface as a low, flat-roofed building of red brick, festooned with pale-green ivy, a city block long and half a block wide, surrounded by shops and storerooms, bars and apartments, hidden away in the dusty back streets above the naval base.

Only at night, when the noise of the traffic and the shouts of the tradesmen had fallen silent, was it possible to hear the low, subterranean thunder of falling water, and only if you went into the yard, unlocked the narrow wooden door and descended a few steps into the Piscina itself was it possible to appreciate the reservoir's full glory. The vaulted roof was supported by forty-eight pillars, each more than fifty feet high – although most of their length was submerged by the waters of

the reservoir – and the echo of the aqueduct hammering into the surface was enough to shake your bones.

The engineer could stand here, listening and lost in thought, for hours. The percussion of the Augusta sounded in his ears not as a dull and continuous roar but as the notes of a gigantic water-organ: the music of civilisation. There were air shafts in the Piscina's roof, and in the afternoons, when the foaming spray leapt in the sunlight and rainbows danced between the pillars – or in the evenings, when he locked up for the night and the flame of his torch shone across the smooth black surface like gold splashed on ebony – in those moments, he felt himself to be not in a reservoir at all, but in a temple dedicated to the only god worth believing in.

Attilius's first impulse on coming down from the hills and into the yard at the end of that afternoon was to check the level of the reservoir. It had become his obsession. But when he tried the door he found it was locked and then he remembered that Corax was carrying the key on his belt. He was so tired that for once he thought no more about it. He could hear the distant rumble of the Augusta – she was running: that was all that counted – and later, when he came to analyse his actions, he decided he could not really reproach himself for any dereliction of duty. There was nothing he could have done. Events would have worked out differently for him personally, that was true – but that hardly mattered in the larger context of the crisis.

So he turned away from the Piscina and glanced

around the deserted yard. The previous evening he had ordered that the space be tidied and swept while he was away, and he was pleased to see that this had been done. There was something reassuring to him about a well-ordered yard. The neat stacks of lead sheets, the amphorae of lime, the sacks of puteolanum, the ruddy lengths of terracotta pipe – these were the sights of his childhood. The smells, too – the sharpness of the lime; the dustiness of fired clay left out all day in the sun.

He went into the stores, dropped his tools on the earth floor and rotated his aching shoulder, then wiped his face on the sleeve of his tunic and re-entered the yard just as the others trooped in. They headed straight for the drinking fountain without bothering to acknowledge him, taking turns to gulp the water and splash their heads and bodies – Corax, then Musa, then Becco. The two slaves squatted patiently in the shade, waiting until the free men had finished. Attilius knew he had lost face during the course of the day. But still, he could live with their hostility. He had lived with worse things.

He shouted to Corax that the men could finish work for the day, and was rewarded with a mocking bow, then started to climb the narrow wooden staircase to his living quarters.

The yard was a quadrangle. Its northern side was taken up by the wall of the Piscina Mirabilis. To the west and south were storerooms and the administrative offices of the aqueduct. To the east was the living accommodation: a barracks for the slaves on the ground floor, and an apartment for the aquarius above it. Corax

and the other free men lived in the town with their families.

Attilius, who had left his mother and sister behind in Rome, thought that in due course he would probably move them down to Misenum as well and rent a house, which his mother could keep for him. But for the time being he was sleeping in the cramped bachelor accommodation of his predecessor, Exomnius, whose few possessions he had had moved into the small spare room at the end of the passage.

What had happened to Exomnius? Naturally, that had been Attilius's first question when he arrived in the port. But nobody had had an answer, or, if they had, they weren't about to pass it on to him. His enquiries were met by sullen silence. It seemed that old Exomnius, a Sicilian who had run the Augusta for nearly twenty years, had simply walked out one morning more than two weeks ago and had not been heard of since.

Ordinarily, the department of the Curator Aquarum in Rome which administered the aqueducts in regions one and two (Latium and Campania) would have been willing to let matters lie for a while. But given the drought, and the strategic importance of the Augusta, and the fact that the Senate had risen for its summer recess in the third week of July and half its members were at their holiday villas around the bay, it had been thought prudent to dispatch an immediate replacement. Attilius had received the summons on the Ides of August, at dusk, just as he was finishing off some routine maintenance work on the Anio Novus. Conducted into

the presence of the Curator Aquarum himself, Acilius Aviola, at his official residence on the Palatine Hill, he had been offered the commission. Attilius was bright, energetic, dedicated – the senator knew how to flatter a man when he wanted something – with no wife or children to detain him in Rome. Could he leave the next day? And, of course, Attilius had accepted at once, for this was a great opportunity to advance his career. He had said farewell to his family and had caught the daily ferry from Ostia.

He had started to write a letter to them. It lay on the nightstand next to the hard wooden bed. He was not very good at letters. Routine information – *I have arrived, the journey was good, the weather is hot* – written out in his schoolboy's hand was the best he could manage. It gave no hint of the turmoil he felt within: the pressing sense of responsibility, his fears about the water shortage, the isolation of his position. But they were women – what did they know? – and besides, he had been taught to live his life according to the Stoic school: to waste no time on nonsense, to do one's job without whining, to be the same in all circumstances – intense pain, bereavement, illness – and to keep one's lifestyle simple: the camp-bed and the cloak.

He sat on the edge of the mattress. His household slave, Phylo, had put out a jug of water and a basin, some fruit, a loaf, a pitcher of wine and a slice of hard white cheese. He washed himself carefully, ate all the food, mixed some wine into the water and drank. Then, too exhausted even to remove his shoes and tunic, he

lay down on the bed, closed his eyes and slipped at once into that hinterland between sleeping and waking which his dead wife endlessly roamed, her voice calling out to him – pleading, urgent: 'Aquarius! Aquarius!'

His wife had been just twenty-two when he watched her body consigned to the flames of her funeral pyre. This woman was younger – eighteen, perhaps. Still, there was enough of the dream that lingered in his mind, and enough of Sabina about the girl in the yard for his heart to jump. The same darkness of hair. The same whiteness of skin. The same voluptuousness of figure. She was standing beneath his window and shouting up.

'Aquarius!'

The sound of raised voices had drawn some of the men from the shadows and by the time he reached the bottom of the stairs they had formed a gawping half-circle around her. She was wearing a loose white tunica, open wide at the neck and sleeves – a dress to be worn in private, which showed a little more of the milky plumpness of her bare white arms and breasts than a respectable lady would have risked in public. He saw now that she was not alone. A slave attended her – a skinny, trembling, elderly woman, whose thin grey hair was half pinned up, half tumbling down her back.

She was breathless, gabbling – something about a pool of red mullet that had died that afternoon in her

father's fish ponds, and poison in the water, and a man who was being fed to the eels, and how he must come at once. It was hard to catch all her words.

He held up his hand to interrupt her and asked her name.

'I am Corelia Ampliata, daughter of Numerius Popidius Ampliatus, of the Villa Hortensia.' She announced herself impatiently and, at the mention of her father, Attilius noticed Corax and some of the men exchange looks. 'Are you the aquarius?'

Corax said, 'The aquarius isn't here.'

The engineer waved him away. 'I am in charge of the aqueduct, yes.'

'Then come with me.'

She began walking towards the gate and seemed surprised when Attilius did not immediately follow. The men were starting to laugh at her now. Musa did an impersonation of her swaying hips, tossing his head grandly: '"Oh aquarius, come with me . . . !"'

She turned, with tears of frustration glinting in her eyes.

'Corelia Ampliata,' said Attilius patiently and not unkindly, 'I may not be able to afford to eat red mullet, but I believe them to be sea-water fish. And I have no responsibility for the sea.'

Corax grinned and pointed. 'Do you hear that? She thinks you're Neptune!'

There was more laughter. Attilius told them sharply to be quiet.

'My father is putting a man to death. The slave was

29

screaming for the aquarius. That is all I know. You are his only hope. Will you come or not?'

'Wait,' said Attilius. He nodded towards the older woman, who had her hands pressed to her face and was crying, her head bowed. 'Who is this?'

'She's his mother.'

The men were quiet now.

'Do you see?' Corelia reached out and touched his arm. 'Come,' she said quietly. 'Please.'

'Does your father know where you are?'

'No.'

'Don't interfere,' said Corax. 'That's my advice.'

And wise advice, thought Attilius, for if a man were to take a hand every time he heard of a slave being cruelly treated, he would have no time to eat or sleep. A sea-water pool full of dead mullet? That was nothing to do with him. He looked at Corelia. But then again, if the poor wretch was actually *asking* for him.

Omens, portents, auspices –

Vapour that jerked like a fishing line. Springs that ran backward into the earth. An aquarius who vanished into the hot air. On the pastured lower slopes of Mount Vesuvius, shepherds had reported seeing giants. In Herculaneum, according to the men, a woman had given birth to a baby with fins instead of feet. And now an entire pool of red mullet had died in Misenum, in the space of a single afternoon, of no apparent cause.

A man must make such sense of it as he could.

He scratched his ear. 'How far away is this villa?'

'Please. A few hundred paces. No distance at all.' She

tugged at his arm, and he allowed himself to be pulled along. She was not an easy woman to resist, this Corelia Ampliata. Perhaps he ought at least to walk her back to her family? It was hardly safe for a woman of her age and class to be out in the streets of a naval town. He shouted over his shoulder to Corax to follow, but Corax shrugged – 'Don't interfere!' he repeated – and then Attilius, almost before he realised what was happening, was out of the gate and into the street, and the others were lost from sight.

It was that time of day, an hour or so before dusk, when the people of the Mediterranean begin emerging from their houses. Not that the town had lost much of its heat. The stones were like bricks from a kiln. Old women sat on stools beside their porches, fanning themselves, while the men stood at the bars, drinking and talking. Thickly bearded Bessians and Dalmatians, Egyptians with gold rings in their ears, red-headed Germans, olive-skinned Greeks and Cilicians, great muscled Nubians as black as charcoal and with eyes bloodshot by wine – men from every country of the Empire, all of them desperate enough, or ambitious enough, or stupid enough, to be willing to trade twenty-five years of their lives at the oars in return for Roman citizenship. From somewhere down in the town, near the harbour front, came the piping notes of a water organ.

Corelia was mounting the steps quickly, her skirts

gathered up in either hand, her slippers soft and soundless on the stone, the slave woman running on ahead. Attilius loped behind them. '"A few hundred paces,"' he muttered to himself, '"no distance at all" – aye, but every foot of the way uphill!' His tunic was glued to his back by sweat.

They came at last to level ground and before them was a long high wall, dun-coloured, with an arched gate set into it, surmounted by two wrought-iron dolphins leaping to exchange a kiss. The women hurried through the unguarded entrance, and Attilius, after a glance around, followed – plunging at once from noisy, dusty reality into a silent world of blue that knocked away his breath. Turquoise, lapis lazuli, indigo, sapphire – every jewelled blue that Mother Nature had ever bestowed – rose in layers before him, from crystal shallows, to deep water, to sharp horizon, to sky. The villa itself sprawled below on a series of terraces, its back to the hillside, its face to the bay, built solely for this sublime panorama. Moored to a jetty was a twenty-oared luxury cruiser, painted crimson and gold, with a carpeted deck to match.

He had little time to register much else, apart from this engulfing blueness, before they were off again, Corelia in front now, leading him down, past statues, fountains, watered lawns, across a mosaic floor inlaid with a design of sea creatures and out on to a terrace with a swimming pool, also blue, framed in marble, projecting towards the sea. An inflatable ball turned gently against the tiled surround, as if abandoned in

mid-game. He was suddenly struck by how deserted the great house seemed and when Corelia gestured to the balustrade, and he laid his hands cautiously on the stone parapet and leaned over, he saw why. Most of the household was gathered along the seashore.

It took a while for his mind to assemble all the elements of the scene. The setting was a fishery, as he had expected, but much bigger than he had imagined – and old, by the look of it, presumably built in the decadent last years of the Republic when keeping fish had first become the fashion – a series of concrete walls, extending out from the rocks, enclosing rectangular pools. Dead fish dappled the surface of one. Around the most distant, a group of men was staring at something in the water, an object which one of them was prodding with a boat-hook – Attilius had to shield his eyes to make them out – and as he studied them more closely he felt his stomach hollow. It reminded him of the moment of the kill at the amphitheatre – the stillness of it – the erotic complicity between crowd and victim.

Behind him, the old woman started making a noise – a soft ululation of grief and despair. He took a step backwards and turned towards Corelia, shaking his head. He wanted to escape from this place. He longed to return to the decent, simple practicalities of his profession. There was nothing he could do here.

But she was in his way, standing very close. 'Please,' she said. 'Help her.'

Her eyes were blue, bluer even than Sabina's had

been. They seemed to collect the blueness of the bay and fire it back at him. He hesitated, set his jaw, then turned and reluctantly looked out to sea again.

He forced his gaze down from the horizon, deliberately skirting what was happening at the pool, let it travel back towards the shore, tried to appraise the whole thing with a professional eye. He saw wooden sluice-gates. Iron handles to raise them. Metal lattices over some of the ponds to keep the fish from escaping. Gangways. Pipes. *Pipes.*

He paused, then swung round again to squint at the hillside. The rising and falling of the waves would wash through metal grilles, set into the concrete sides of the fish pools, beneath the surface, to prevent the pens becoming stagnant. That much he knew. But *pipes* — he cocked his head, beginning to understand — the pipes must carry fresh water down from the land, to mix with the sea water, to make it brackish. As in a lagoon. An artificial lagoon. The perfect conditions for rearing fish. And the most sensitive of fish to rear, a delicacy reserved only for the very rich, were red mullet.

He said quietly, 'Where does the aqueduct connect to the house?'

Corelia shook her head. 'I don't know.'

It would have to be big, he thought. *A place this size —*

He knelt beside the swimming pool, scooped up a palmful of the warm water, tasted it, frowning, swilled it round in his mouth like a connoisseur of wine. It was clean, as far as he could judge. But then again, that

might mean nothing. He tried to remember when he had last checked the outflow of the aqueduct. Not since the previous evening, before he went to bed.

'At what time did the fish die?'

Corelia glanced at the slave woman, but she was lost to their world. 'I don't know. Perhaps two hours ago?'

Two hours!

He vaulted over the balustrade on to the lower terrace beneath and started to stride towards the shore.

Down at the water's edge, the entertainment had not lived up to its promise. But then nowadays, what did? Ampliatus felt increasingly that he had reached some point – age, was it, or wealth? – when the arousal of anticipation was invariably more exquisite than the emptiness of relief. The voice of the victim cries out, the blood spurts and then – what? Just another death.

The best part had been the beginning: the slow preparation, followed by the long period when the slave had merely floated, his face just above the surface – very quiet now, not wanting to attract any attention from what was beneath him, concentrating, treading water. Amusing. Even so, time had dragged in the heat, and Ampliatus had started to think that this whole business with eels was overrated and that Vedius Pollio was not quite as stylish as he had imagined. But no: you could always rely on the aristocracy! Just as he was preparing to abandon proceedings, the water had begun to twitch

and then – plop! – the face had disappeared, like a fisherman's plunging float, only to bob up again for an instant, wearing a look of comical surprise and then vanish altogether. That expression, in retrospect, had been the climax. After that, it had all become rather boring and uncomfortable to watch in the heat of the sinking afternoon sun.

Ampliatus took off his straw hat, fanned his face, looked around at his son. Celsinus at first appeared to be staring straight ahead, but when you looked again you saw his eyes were closed, which was typical of the boy. He always seemed to be doing what you wanted. But then you realised he was only obeying mechanically, with his body: his attention was elsewhere. Ampliatus gave him a poke in the ribs with his finger and Celsinus's eyes jerked open.

What was in his mind? Some Eastern rubbish, presumably. He blamed himself. When the boy was six – this was twelve years ago – Ampliatus had built a temple in Pompeii, at his own expense, dedicated to the cult of Isis. As a former slave, he would not have been encouraged to build a temple to Jupiter, Best and Greatest, or to Mother Venus, or to any of the other most sacred guardian deities. But Isis was Egyptian, a goddess suitable for women, hairdressers, actors, perfume-makers and the like. He had presented the building in Celsinus's name, with the aim of getting the boy on to Pompeii's ruling council. And it had worked. What he had not anticipated was that Celsinus would take it seriously. But he did and that was what he

would be brooding about now, no doubt – about Osiris, the Sun God, husband to Isis, who is slain each evening at sundown by his treacherous brother, Set, the bringer of darkness. And how all men, when they die, are judged by the Ruler of the Kingdom of the Dead, and if found worthy are granted eternal life, to rise again in the morning like Horus, heir of Osiris, the avenging new sun, bringer of light. Did Celsinus really believe all this girlish twaddle? Did he really think that this half-eaten slave, for example, might return from his death at sundown to wreak his revenge at dawn?

Ampliatus was turning to ask him exactly that when he was distracted by a shout from behind him. There was a stir among the assembled slaves and Ampliatus shifted further round in his chair. A man whom he did not recognise was striding down the steps from the villa waving his arm above his head and calling out.

The principles of engineering were simple, universal, impersonal – in Rome, in Gaul, in Campania – which was what Attilius liked about them. Even as he ran, he was envisaging what he could not see. The main line of the aqueduct would be up in that hill at the back of the villa, buried a yard beneath the surface, running on an axis north-to-south, from Baiae down to the Piscina Mirabilis. And whoever had owned the villa when the Aqua Augusta was built, more than a century ago, would almost certainly have run two spurs off it. One would disgorge into a big cistern to feed the house, the

swimming pool, the garden fountains: if there was contamination on the matrix, it might take as long as a day for it to work through the system, depending on the size of the tank. But the other spur would channel a share of the Augusta's water directly down to the fishery to wash through the various ponds: any problem with the aqueduct and the impact there would be immediate.

Ahead of him, the tableau of the kill was beginning to assume an equally clear shape: the master of the household – Ampliatus, presumably – rising in astonishment from his chair, the spectators now with their backs turned to the pool, all eyes on him as he sprinted down the final flight of steps. He ran on to the concrete ramp of the fishery, slowing as he approached Ampliatus but not stopping.

'Pull him out!' he said as he ran past him.

Ampliatus, his thin face livid, shouted something at his back and Attilius turned, still running, trotting backwards now, holding up his palms: 'Please. Just pull him out.'

Ampliatus's mouth gaped open, but then, still staring intently at Attilius, he slowly raised his hand – an enigmatic gesture, which nevertheless set off a chain of activity, as though everyone had been waiting for exactly such a signal. The steward of the household put two fingers to his mouth and whistled at the slave with the boat-hook, and made an upwards motion with his hand, at which the slave swung round and flung the end of his pole towards the surface of the eel pond, hooked something and began to drag it in.

Attilius was almost at the pipes. Closer to, they were larger than they had looked from the terrace. Terracotta. A pair. More than a foot in diameter. They emerged from the slope, traversed the ramp together, parted company at the edge of the water, then ran in opposite directions along the side of the fishery. A crude inspection plate was set into each – a loose piece of pipe, two feet long, cut crossways – and as he reached them he could see that one had been disturbed and not replaced properly. A chisel lay nearby, as if whoever had been using it had been disturbed.

Attilius knelt and jammed the tool into the gap, working it up and down until it had penetrated most of the way, then twisted it, so that the flat edge gave him enough space to fit his fingers underneath the cover and lever it off. He lifted it away and pushed it over, not caring how heavily it fell. His face was directly over the running water and he smelt it at once. Released from the confined space of the pipe, it was strong enough to make him want to retch. An unmistakable smell of rottenness. Of rotten eggs.

The breath of Hades.

Sulphur.

The slave was dead. That much was obvious, even from a distance. Attilius, crouching beside the open pipe, saw the remains hauled out of the eel pond and covered with a sack. He saw the audience disperse and begin traipsing back up to the villa, at the same time

as the grey-haired slave woman threaded her way between them, heading in the opposite direction, down towards the sea. The others avoided looking at her, left a space around her, as if she had some virulent disease. As she reached the dead man she flung up her hands to the sky and began rocking silently from side to side. Ampliatus did not notice her. He was walking purposefully towards Attilius. Corelia was behind him and a young man who looked just like her – her brother, presumably – and a few others. A couple of the men had knives at their belts.

The engineer returned his attention to the water. Was it his imagination or was the pressure slackening? The smell was certainly much less obvious now that the surface was open to the air. He plunged his hands into the flow, frowning, trying to gauge the strength of it, as it twisted and flexed beneath his fingers, like a muscle, like a living thing. Once, when he was a boy, he had seen an elephant killed at the Games – hunted down by archers and by spearmen dressed in leopard skins. But what he remembered chiefly was not the hunt but rather the way the elephant's trainer, who had presumably accompanied the giant beast from Africa, had crouched at its ear as it lay dying in the dust, whispering to it. That was how he felt now. The aqueduct, the immense Aqua Augusta, seemed to be dying in his hands.

A voice said, 'You are on my property.'

He looked up to find Ampliatus staring down at him. The villa's owner was in his middle fifties. Short, but

40

broad-shouldered and powerful. 'My property,' Ampliatus repeated.

'Your property, yes. But the Emperor's water.' Attilius stood, wiping his hands on his tunic. The waste of so much precious liquid, in the middle of a drought, to pamper a rich man's fish, made him angry. 'You need to close the sluices to the aqueduct. There's sulphur in the matrix and red mullet abominate all impurities. *That –*' he emphasised the word '– is what killed your precious fish.'

Ampliatus tilted his head back slightly, sniffing the insult. He had a fine, rather handsome face. His eyes were the same shade of blue as his daughter's. 'And you are who, exactly?'

'Marcus Attilius. Aquarius of the Aqua Augusta.'

'Attilius?' The millionaire frowned. 'What happened to Exomnius?'

'I wish I knew.'

'But surely Exomnius is still the aquarius?'

'No. As I said, I am now the aquarius.' The engineer was in no mood to pay his respects. Contemptible, stupid, cruel – on another occasion, perhaps, he would be delighted to pass on his compliments, but for now he did not have the time. 'I must get back to Misenum. We have an emergency on the aqueduct.'

'What sort of emergency? Is it an omen?'

'You could say that.'

He made to go, but Ampliatus moved swiftly to one side, blocking his way. 'You insult me,' he said. 'On my property. In front of my family. And now you try to

leave without offering any apology?' He brought his face so close to Attilius's that the engineer could see the sweat beading above his thinning hairline. He smelled sweetly of crocus oil, the most expensive unguent. 'Who gave you permission to come here?'

'If I have in any way offended you –' began Attilius. But then he remembered the wretched bundle in its shroud of sacking and the apology choked in his throat. 'Get out of my way.'

He tried to push his way past, but Ampliatus grabbed his arm and someone drew a knife. Another instant, he realised – a single thrust – and it would all be over.

'He came because of me, father. I invited him.'

'What?'

Ampliatus wheeled round on Corelia. What he might have done, whether he would have struck her, Attilius would never know, for at that instant a terrible screaming started. Advancing along the ramp came the grey-headed woman. She had smeared her face, her arms, her dress with her son's blood and her hand was pointing straight ahead, the first and last of her bony brown fingers rigidly extended. She was shouting in a language Attilius did not understand. But then he did not need to: a curse is a curse in any tongue, and this one was directed straight at Ampliatus.

He let go of Attilius's arm and turned to face her, absorbing the full force of it, with an expression of indifference. And then, as the torrent of words began to slacken, he laughed. There was silence for a moment, then the others began to laugh as well. Attilius glanced

at Corelia, who gave an almost imperceptible nod and gestured with her eyes to the villa – *I shall be all right*, she seemed to be saying, *go* – and that was the last that he saw or heard, as he turned his back on the scene and started mounting the path up to the house – two steps, three steps at a time – running on legs of lead, like a man escaping in a dream.

Hora duodecima

[18:48 hours]

> *'Immediately before an eruption, there may be a marked increase in the ratios S/C, SO2/CO2, S/Cl, as well as the total amount of HCl A marked increase in the proportions of mantle components is often a sign that magma has risen into a dormant volcano and that an eruption may be expected.'*

<div align="right">

Volcanology *(second edition)*

</div>

An aqueduct was a work of Man, but it obeyed the laws of Nature. The engineers might trap a spring and divert it from its intended course, but once it had begun to flow, it ran, ineluctable, remorseless, at an average speed of two and a half miles per hour, and Attilius was powerless to prevent it polluting Misenum's water.

He still carried one faint hope: that somehow the sulphur was confined to the Villa Hortensia; that the

leak was in the pipework beneath the house; and that Ampliatus's property was merely an isolated pocket of foulness on the beautiful curve of the bay.

That hope lasted for as long as it took him to sprint down the hill to the Piscina Mirabilis, to roust Corax from the barracks where he was playing a game of bones with Musa and Becco, to explain what had happened, and to wait impatiently while the overseer unlocked the door to the reservoir – at which moment it evaporated completely, wafted away by the same rank smell that he had detected in the pipe at the fishery.

'Dog's breath!' Corax blew out his cheeks in disgust. 'This must have been building up for hours.'

'Two hours.'

'Two hours?' The overseer could not quite disguise his satisfaction. 'When you had us up in the hills on your fool's errand?'

'And if we had been here? What difference could we have made?'

Attilius descended a couple of the steps, the back of his hand pressed to his nose. The light was fading. Out of sight, beyond the pillars, he could hear the aqueduct disgorging into the reservoir, but with nothing like its normal percussive force. It was as he had suspected at the fishery: the pressure was dropping, fast.

He called up to the Greek slave, Polites, who was waiting at the top of the steps, that he wanted a few things fetched – a torch, a plan of the aqueduct's main line and one of the stoppered bottles from the store-room, which they used for taking water samples. Polites

trotted off obediently and Attilius peered into the gloom, glad that the overseer could not see his expression, for a man was his face; the face the man.

'How long have you worked on the Augusta, Corax?'

'Twenty years.'

'Anything like this ever happened before?'

'Never. You've brought us all bad luck.'

Keeping one hand on the wall, Attilius made his way cautiously down the remaining steps to the reservoir's edge. The splash of water falling from the mouth of the Augusta, together with the smell and the melancholy light of the day's last hour, made him feel as if he were descending into hell. There was even a rowing boat moored at his feet: a suitable ferry to carry him across the Styx.

He tried to make a joke of it, to disguise the panic that was fastening hold of him. 'You can be my Charon,' he said to Corax, 'but I don't have a coin to pay you.'

'Well, then – you are doomed to wander in hell for ever.'

That was funny. Attilius tapped his fist against his chest, his habit when thinking, then shouted back up towards the yard, 'Polites! Get a move on!'

'Coming, aquarius!'

The slim outline of the slave appeared in the doorway, holding a taper and a torch. He ran down and handed them to Attilius, who touched the glowing tip to the mass of tow and pitch. It ignited with a *wumph* and a gust of oily heat. Their shadows danced on the concrete walls.

Attilius stepped carefully into the boat, holding the torch aloft, then turned to collect the rolled-up plans and the glass bottle. The boat was light and shallow-bottomed, used for maintenance work in the reservoir, and when Corax climbed aboard it dipped low in the water.

I must fight my panic, thought Attilius. I must be the master.

'If this had happened when Exomnius was here, what would he have done?'

'I don't know. But I tell you one thing. He knew this water better than any man alive. He would have seen this coming.'

'Perhaps he did, and that was why he ran away.'

'Exomnius was no coward. He didn't run anywhere.'

'Then where is he, Corax?'

'I've told you, pretty boy, a hundred times: I don't know.'

The overseer leaned across, untied the rope from its mooring ring and pushed them away from the steps, then turned to sit facing Attilius and took up the oars. His face in the torchlight was swarthy, guileful, older than his forty years. He had a wife and a brood of children crammed into an apartment across the street from the reservoir. Attilius wondered why Corax hated him so much. Was it simply that he had coveted the post of aquarius for himself and resented the arrival of a younger man from Rome? Or was there something more?

He told Corax to row them towards the centre of

the Piscina and when they reached it he handed him the torch, uncorked the bottle and rolled up the sleeves of his tunic. How often had he seen his father do this, in the subterranean reservoir of the Claudia and the Anio Novus on the Esquiline Hill? The old man had shown him how each of the matrices had its own flavour, as distinct from another as different vintages of wine. The Aqua Marcia was the sweetest-tasting, drawn from the three clear springs of the River Anio; the Aqua Alsietina the foulest, a gritty lakewater, fit only for irrigating gardens; the Aqua Julia, soft and tepid; and so on. A good aquarius, his father had said, should know more than just the solid laws of architecture and hydraulics – he should have a taste, a nose, a feel for water, and for the rocks and soils through which it had passed on its journey to the surface. Lives might depend on this skill.

An image of his father flashed into his mind. Killed before he was fifty by the lead he had worked with all his life, leaving Attilius, a teenager, as head of the family. There had not been much left of him by the end. Just a thin shroud of white skin stretched taut over sharp bone.

His father would have known what to do.

Holding the bottle so that its top was face down to the water, Attilius stretched over the side and plunged it in as far as he could, then slowly turned it underwater, letting the air escape in a stream of bubbles. He recorked it and withdrew it.

Settled back in the boat, he opened the bottle again

and passed it back and forth beneath his nose. He took a mouthful, gargled and swallowed. Bitter, but drinkable, just about. He passed it to Corax who swapped it for the torch and gulped the whole lot down in one go. He wiped his mouth with the back of his hand. 'It'll do,' he said, 'if you mix it with enough wine.'

The boat bumped against a pillar and Attilius noticed the widening line between the dry and damp concrete – sharply defined, already a foot above the surface of the reservoir. She was draining away faster than the Augusta could fill her.

Panic again. *Fight it.*

'What's the capacity of the Piscina?'

'Two hundred and eighty quinariae.'

Attilius raised the torch towards the roof, which disappeared into the shadows about fifteen feet above them. So that meant the water was perhaps thirty-five feet deep, the reservoir two-thirds full. Suppose it now held two hundred quinariae. At Rome, they worked on the basis that one quinaria was roughly the daily requirement of two hundred people. The naval garrison at Misenum was ten thousand strong, plus, say, another ten thousand civilians.

A simple enough calculation.

They had water for two days. Assuming they could ration the flow to perhaps an hour at dawn and another at dusk. And assuming the concentration of sulphur at the bottom of the Piscina was as weak as it was at the top. He tried to think. Sulphur in a natural spring was warm, and therefore rose to the surface. But sulphur

when it had cooled to the same temperature as the surrounding water – what did that do? Did it disperse? Or float? Or sink?

Attilius glanced towards the northern end of the reservoir, where the Augusta emerged. 'We should check the pressure.'

Corax began to row with powerful strokes, steering them expertly around the labyrinth of pillars towards the falling water. Attilius held the torch in one hand and with the other he unrolled the plans, flattening them out across his knees with his forearm.

The whole of the western end of the bay, from Neapolis to Cumae, was sulphurous – he knew that much. Green translucent lumps of sulphur were dug from the mines in the Leucogaei Hills, two miles north of the aqueduct's main line. Then there were the hot sulphur springs around Baiae, to which convalescents came from across the Empire. There was a pool called Posidian, named after a freedman of Claudius, that was hot enough to cook meat. Even the sea at Baiae occasionally steamed with sulphur, the sick wallowing in its shallows in the hope of relief. It must be somewhere in this smouldering region – where the Sibyl had her cave and the burning holes gave access to the Underworld – that the Augusta had become polluted.

They had reached the aqueduct's tunnel. Corax let the boat glide for a moment, then rowed a few deft strokes in the opposite direction, bringing them to halt precisely beside a pillar. Attilius laid aside the plans and raised the torch. It flashed on an emerald sheen of green

mould, then lit the giant head of Neptune, carved in stone, from whose mouth the Augusta normally gushed in a jet-black torrent. But even in the time it had taken to row from the steps the flow had dwindled. It was scarcely more than a trickle.

Corax gave a soft whistle. 'I never thought I'd live to see the Augusta dry. You were right to be worried, pretty boy.' He looked at Attilius and for the first time there was a flash of fear across his face. 'So what stars were you born under, that you've brought this down on us?'

The engineer was finding it difficult to breathe. He pressed his hand to his nose again and moved the torch above the surface of the reservoir. The reflection of the light on the still black water suggested a fire in the depths.

It was not possible, he thought. Aqueducts did not just fail – not like this, not in a matter of hours. The matrices were walled with brick, rendered with water-proof cement, and surrounded by a concrete casing a foot and a half thick. The usual problems – structural flaws, leaks, lime deposits that narrowed the channel – all these needed months, even years to develop. It had taken the Claudia a full decade gradually to close down.

He was interrupted by a shout from the slave, Polites: 'Aquarius!'

He half turned his head. He could not see the steps for the pillars, which seemed to rise like petrified oaks from some dark and foul-smelling swamp. 'What is it?'

'There's a rider in the yard, aquarius! He has a message that the aqueduct has failed!'

Corax muttered, 'We can see that for ourselves, you Greek fool.'

Attilius reached for the plans again. 'Which town has he come from?' He expected the slave to shout back Baiae or Cumae. Puteoli at the very worst. Neapolis would be a disaster.

But the reply was like a punch in the stomach: 'Nola!'

The messenger was so rimed with dust he looked more ghost than man. And even as he told his story – of how the water had failed in Nola's reservoir at dawn and of how the failure had been preceded by a sharp smell of sulphur that had started in the middle of the night – a fresh sound of hooves was heard in the road outside and a second horse trotted into the yard.

The rider dismounted smartly and offered a rolled papyrus. A message from the city fathers at Neapolis. The Augusta had gone down there at noon.

Attilius read it carefully, managing to keep his face expressionless. There was quite a crowd in the yard by now. Two horses, a pair of riders, surrounded by the gang of aqueduct workers who had abandoned their evening meal to listen to what was happening. The commotion was beginning to attract the attention of passers-by in the street, as well as some of the local shopkeepers. 'Hey, waterman!' shouted the owner of the snack bar opposite. 'What's going on?'

It would not take much, thought Attilius – merely the slightest breath of wind – for panic to take hold

like a hillside fire. He could feel a fresh spark of it within himself. He called to a couple of slaves to close the gates to the yard and told Polites to see to it that the two messengers were given food and drink. 'Musa, Becco – get hold of a cart and start loading it. Quicklime, puteolanum, tools – everything we might need to repair the matrix. As much as a couple of oxen can pull.'

The two men looked at one another. 'But we don't know what the damage is,' objected Musa. 'One cartload may not be enough.'

'Then we'll pick up extra material as we pass through Nola.'

He strode towards the aqueduct's office, the messenger from Nola at his heels.

'But what am I to tell the aediles?' The rider was scarcely more than a boy. The hollows of his eyes were the only part of his face not caked with dirt, the soft pink discs emphasising his fearful look. 'The priests want to sacrifice to Neptune. They say the sulphur is a terrible omen.'

'Tell them we are aware of the problem.' Attilius gestured vaguely with the plans. 'Tell them we are organising repairs.'

He ducked through the low entrance into the small cubicle. Exomnius had left the Augusta's records in chaos. Bills of sale, receipts and invoices, promissory notes, legal stipulations and opinions, engineers' reports and storeroom inventories, letters from the department of the Curator Aquarum and orders from the naval

commander in Misenum – some of them twenty or thirty years old – spilled out of chests, across a table and over the concrete floor. Attilius swept the table clear with his elbow and unrolled the plans.

Nola! How was this possible? Nola was a big town, thirty miles to the east of Misenum, and nowhere near the sulphur fields. He used his thumb to mark out the distances. With a cart and oxen it would take them the best part of two days merely to reach it. The map showed him as clearly as a painting how the calamity must have spread, the matrix emptying with mathematical precision. He traced it with his finger, his lips moving silently. Two and a half miles per hour! If Nola had gone down at dawn, then Acerrae and Atella would have followed in the middle of the morning. If Neapolis, twelve miles round the coast from Misenum, had lost its supply at noon, then Puteoli's must have gone at the eighth hour, Cumae's at the ninth, Baiae's at the tenth. And now, at last, inevitably, at the twelfth, it was their turn.

Eight towns down. Only Pompeii, a few miles upstream from Nola, so far unaccounted for. But even without it: more than two hundred thousand people without water.

He was aware of the entrance behind him darkening, of Corax coming up and leaning against the door frame, watching him.

He rolled up the map and tucked it under his arm. 'Give me the key to the sluices.'

'Why?'

'Isn't it obvious? I'm going to shut off the reservoir.'

'But that's the Navy's water. You can't do that. Not without the authority of the admiral.'

'Then why don't you get the authority of the admiral? I'm closing those sluices.' For the second time that day, their faces were barely a hand's breadth apart. 'Listen to me, Corax. The Piscina Mirabilis is a strategic reserve. Understand? That's what it's there for – to be shut off in an emergency – and every moment we waste arguing we lose more water. Now give me the key, or you'll answer for it in Rome.'

'Very well. Have it your way, pretty boy.' Without taking his eyes from Attilius's face, he removed the key from the ring on his belt. 'I'll go and see the admiral all right. I'll tell him what's been going on. And then we'll see who answers for what.'

Attilius grabbed the key and pushed sideways past him, out into the yard. He shouted to the nearest slave, 'Close the gates after me, Polites. No one is to be let in without my permission.'

'Yes, aquarius.'

There was still a crowd of curious onlookers in the street but they cleared a path to let him through. He took no notice of their questions. He turned left, then left again, down a steep flight of steps. The water organ was still piping away in the distance. Washing hung above his head, strung between the walls. People turned to stare at him as he jostled them out of his way. A girl prostitute in a saffron dress, ten years old at most, clutched at his arm and wouldn't let go until he dug into the pouch on his belt and gave her a couple of

copper coins. He saw her dart through the crowd and hand them to a fat Cappadocian – her owner, obviously – and as he hurried on he cursed his gullibility.

The building that housed the sluice-gate was a small redbrick cube, barely taller than a man. A statue of Egeria, goddess of the water-spring, was set in a niche beside the door. At her feet lay a few stems of withered flowers and some mouldy lumps of bread and fruit – offerings left by pregnant women who believed that Egeria, consort of Numa, the Prince of Peace, would ease their delivery when their time came. Another worthless superstition. A waste of food.

He turned the key in the lock and tugged angrily at the heavy wooden door.

He was level now with the floor of the Piscina Mirabilis. Water from the reservoir poured under pressure down a tunnel in the wall, through a bronze grille, swirled in the open conduit at his feet, and then was channelled into three pipes that fanned out and disappeared under the flagstones behind him, carrying the supply down to the port and town of Misenum. The flow was controlled by a sluice-gate, set flush with the wall, worked by a wooden handle attached to an iron wheel. It was stiff from lack of use. He had to pound it with the heel of his hand to loosen it, but when he put his back into it, it began to turn. He wound the handle as fast as he could. The gate descended, rattling like a portcullis, gradually choking off the flow of water until at last it ceased altogether, leaving a smell of moist dust.

Only a puddle remained in the stone channel, evaporating so rapidly in the heat he could see it shrinking. He bent down and dabbed his fingers in the wet patch, then touched them to his tongue. No taste of sulphur.

He had done it now, he thought. Deprived the Navy of its water, in a drought, without authority, three days into his first command. Men had been stripped of their rank and sent to the treadmills for lesser crimes. It occurred to him that he had been a fool to let Corax be the first to get to the admiral. There was certain to be a court of inquiry. Even now the overseer would be making sure who got the blame.

Locking the door to the sluice chamber, he glanced up and down the busy street. Nobody was paying him any attention. They did not know what was about to happen. He felt himself to be in possession of some immense secret and the knowledge made him furtive. He headed down a narrow alley towards the harbour, keeping close to the wall, eyes on the gutter, avoiding people's gaze.

The admiral's villa was on the far side of Misenum and to reach it the engineer had to travel the best part of half a mile – walking, mostly, with occasional panicky bursts of running – across the narrow causeway and over the revolving wooden bridge which separated the two natural harbours of the naval base.

He had been warned about the admiral before he left Rome. 'The commander-in-chief is Gaius Plinius,'

said the Curator Aquarum. 'Pliny. You'll come across him sooner or later. He thinks he knows everything about everything. Perhaps he does. He will need careful stroking. You should take a look at his latest book. The *Natural History*. Every known fact about Mother Nature in thirty-seven volumes.'

There was a copy in the public library at the Porticus of Octavia. The engineer had time to read no further than the table of contents.

'The world, its shape, its motion. Eclipses, solar and lunar. Thunderbolts. Music from the stars. Sky portents, recorded instances. Sky-beams, sky-yawning, colours of the sky, sky-flames, sky-wreaths, sudden rings. Eclipses. Showers of stones . . .'

There were other books by Pliny in the library. Six volumes on oratory. Eight on grammar. Twenty volumes on the war in Germany, in which he had commanded a cavalry unit. Thirty volumes on the recent history of the Empire, which he had served as procurator in Spain and Belgian Gaul. Attilius wondered how he managed to write so much and rise so high in the imperial administration at the same time. The Curator said, 'Because he doesn't have a wife.' He laughed at his own joke. 'And he doesn't sleep, either. You watch he doesn't catch you out.'

The sky was red with the setting sun and the large lagoon to his right, where the warships were built and repaired, was deserted for the evening; a few seabirds called mournfully among the reeds. To his left, in the outer harbour, a passenger ferry was approaching

through the golden glow, her sails furled, a dozen oars on either side dipping slowly in unison as she steered between the anchored triremes of the imperial fleet. She was too late to be the nightly arrival from Ostia, which meant she was probably a local service. The weight of the passengers crammed on her open deck was pressing her low to the surface.

'Showers of milk, of blood, of flesh, of iron, of wool, of bricks. Portents. The earth at the centre of the world. Earthquakes. Chasms. Air-holes. Combined marvels of fire and water: mineral pitch; naptha; regions constantly glowing. Harmonic principle of the world . . .'

He was moving more quickly than the water pipes were emptying and when he passed through the triumphal arch that marked the entrance to the port he could see that the big public fountain at the crossroads was still flowing. Around it was grouped the usual twilight crowd – sailors dousing their befuddled heads, ragged children shrieking and splashing, a line of women and slaves with earthenware pots at their hips and on their shoulders, waiting to collect their water for the night. A marble statue of the Divine Augustus, carefully positioned beside the busy intersection to remind the citizens who was responsible for this blessing, gazed coldly above them, frozen in perpetual youth.

The overloaded ferry had come alongside the quay. Her gangplanks, fore and aft, had been thrown down and the timber was already bowing under the weight of passengers scrambling ashore. Luggage was tossed from hand to hand. A taxi owner, surprised by the speed

of the exodus, was running around kicking his bearers to get them on their feet. Attilius called across the street to ask where the ferry was from, and the taxi owner shouted back over his shoulder, 'Neapolis, my friend – and before that, Pompeii.'

Pompeii.

Attilius, on the point of moving off, suddenly checked his stride. Odd, he thought. Odd that they had heard no word from Pompeii, the first town on the matrix. He hesitated, swung round and stepped into the path of the oncoming crowd. 'Any of you from Pompeii?' He waved the rolled-up plans of the Augusta to attract attention. 'Was anyone in Pompeii this morning?' But nobody took any notice. They were thirsty after the voyage – and, of course, they would be, he realised, if they had come from Neapolis, where the water had failed at noon. Most passed to either side of him in their eagerness to reach the fountain, all except for one, an elderly holy man, with the conical cap and curved staff of an augur, who was walking slowly, scanning the sky.

'I was in Neapolis this afternoon,' he said, when Attilius stopped him, 'but this morning I was in Pompeii. Why? Is there something I can do to help you, my son?' His rheumy eyes took on a crafty look, his voice dropped. 'No need to be shy. I am practised in the interpretation of all the usual phenomena – thunderbolts, entrails, bird omens, unnatural manifestations. My rates are reasonable.'

'May I ask, holy father,' said the engineer, 'when you left Pompeii?'

'At first light.'

'And were the fountains playing? Was there water?'

So much rested on his answer, Attilius was almost afraid to hear it.

'Yes, there was water.' The augur frowned and raised his staff to the fading light. 'But when I arrived in Neapolis the streets were dry and in the baths I smelled sulphur. That is why I decided to return to the ferry and to come on here.' He squinted again at the sky, searching for birds. 'Sulphur is a terrible omen.'

'True enough,' agreed Attilius. 'But are you certain? And are you sure the water was running?'

'Yes, my son. I'm sure.'

There was a commotion around the fountain and both men turned to look. It was nothing much to start with, just some pushing and shoving, but quickly punches were being thrown. The crowd seemed to contract, to rush in on itself and become denser, and from the centre of the melee a large earthenware pot went sailing into the air, turned slowly and landed on the quayside, smashing into fragments. A woman screamed. Wriggling between the backs at the edge of the mob, a man in a Greek tunic emerged, clutching a waterskin tightly to his chest. Blood was pouring from a gash in his temple. He sprawled, picked himself up and stumbled forwards, disappearing into an alleyway.

And so it starts, thought the engineer. First this fountain, and then the others all around the port, and then the big basin in the forum. And then the public baths, and then the taps in the military school, and in the big

61

villas – nothing emerging from the empty pipes except the clank of shuddering lead and the whistle of rushing air –

The distant water organ had become stuck on a note and died with a long moan.

Someone was yelling that the bastard from Neapolis had pushed to the front and stolen the last of the water, and, like a beast with a single brain and impulse, the crowd turned and began to pour down the narrow lane in pursuit. And suddenly, as abruptly as it had begun, the riot was over, leaving behind a scene of smashed and abandoned pots, and a couple of women crouched in the dust, their hands pressed over their heads for protection, close to the edge of the silent fountain.

Vespera

[20:07 hours]

> *'Earthquakes may occur in swarms at areas of
> stress concentrations – such as nearby faults – and
> in the immediate vicinity of magma where pressure
> changes are occurring.'*
>
> Haraldur Sigurdsson (editor),
> Encyclopaedia of Volcanoes

The admiral's official residence was set high on the hillside overlooking the harbour and by the time Attilius reached it and was conducted on to the terrace it was dusk. All around the bay, in the seaside villas, torches, oil lamps and braziers were being lit, so that gradually a broken thread of yellow light had begun to emerge, wavering for mile after mile, picking out the curve of the coast, before vanishing in the purple haze towards Capri.

A marine centurion in full uniform of breastplate and crested helmet, with a sword swinging at his belt,

was hurrying away as the engineer arrived. The remains of a large meal were being cleared from a stone table beneath a trellised pergola. At first he did not see the admiral, but the instant the slave announced him – 'Marcus Attilius Primus, aquarius of the Aqua Augusta!' – a stocky man in his middle fifties at the far end of the terrace turned on his heel and came waddling towards him, trailed by what Attilius assumed were the guests of his abandoned dinner party: four men sweating in togas, at least one of whom, judging by the purple stripe on his formal dress, was a senator. Behind them – obsequious, malevolent, inescapable – came Corax.

Attilius had for some reason imagined that the famous scholar would be thin, but Pliny was fat, his belly protruding sharply, like the ramming post of one of his warships. He was dabbing at his forehead with his napkin.

'Shall I arrest you now, aquarius? I could, you know, that's already clear enough.' He had a fat man's voice: a high-pitched wheeze, which became even hoarser as he counted off the charges on his pudgy fingers. 'Incompetence to start with – who can doubt that? Negligence – where were you when the sulphur infected the water? Insubordination – on what authority did you shut off our supply? Treason – yes, I could make a charge of treason stick. What about fomenting rebellion in the imperial dockyards? I've had to order out a century of marines – fifty to break some heads in the town and try to restore public order, the other fifty to the reservoir, to guard whatever water's left. Treason –'

He broke off, short of breath. With his puffed-out cheeks, pursed lips and sparse grey curls plastered down with perspiration, he had the appearance of an elderly, furious cherub, fallen from some painted, peeling ceiling. The youngest of his guests – a pimply lad in his late teens – stepped forward to support his arm, but Pliny shrugged him away. At the back of the group Corax grinned, showing a mouthful of dark teeth. He had been even more effective at spreading poison than Attilius had expected. What a politician. He could probably show the senator a trick or two.

He noticed that a star had come out above Vesuvius. He had never really looked properly at the mountain before, certainly not from this angle. The sky was dark but the mountain was darker, almost black, rising massively above the bay to a pointed summit. And there was the source of the trouble, he thought. Somewhere there, on the mountain. Not on the seaward side, but round to landward, on the north-eastern slope.

'Who are you anyway?' Pliny eventually managed to rasp out. 'I don't know you. You're far too young. What's happened to the proper aquarius? What was his name?'

'Exomnius,' said Corax.

'Exomnius, precisely. Where's he? And what does Acilius Aviola think he's playing at, sending us boys to do men's work? Well? Speak up! What have you to say for yourself?'

Behind the admiral Vesuvius formed a perfect natural pyramid, with just that little crust of light from the waterfront villas running around its base. In a couple

of places the line bulged slightly and those, the engineer guessed, must be towns. He recognised them from the map. The nearer would be Herculaneum; the more distant, Pompeii.

Attilius straightened his back. 'I need,' he said, 'to borrow a ship.'

He spread out his map on the table in Pliny's library, weighing down either side with a couple of pieces of magnetite which he took from a display cabinet. An elderly slave shuffled behind the admiral's back, lighting an elaborate bronze candelabrum. The walls were lined with cedarwood cabinets, packed with rolls of papyri stacked end-on, in dusty honeycombs, and even with the doors to the terrace pushed wide open, no breeze came off the sea to dispel the heat. The oily black strands of smoke from the candles rose undisturbed. Attilius could feel the sweat trickling down the sides of his belly, irritating him, like a crawling insect.

'Tell the ladies we shall rejoin them directly,' said the admiral. He turned away from the slave and nodded at the engineer. 'All right. Let's hear it.'

Attilius glanced around at the faces of his audience, intent in the candlelight. He had been told their names before they sat down and he wanted to make sure he remembered them: Pedius Cascus, a senior senator who, he dimly recalled, had been a consul years ago and who owned a big villa along the coast at Herculaneum; Pomponianus, an old Army comrade of Pliny, rowed

over for dinner from his villa at Stabiae; and Antius, captain of the imperial flagship, the *Victoria*. The pimply youth was Pliny's nephew, Gaius Plinius Caecilius Secundus.

He put his finger on the map and they all leant forward, even Corax.

'This is where I thought originally that the break must be, admiral – here, in the burning fields around Cumae. That would explain the sulphur. But then we learnt that the supply had gone down in Nola as well – over here, to the east. That was at dawn. The timing is crucial, because according to a witness who was in Pompeii at first light, the fountains there were still running this morning. As you can see, Pompeii is some distance back up the matrix from Nola, so logically the Augusta should have failed there in the middle of the night. The fact that it didn't can only mean one thing. The break has to be here' – he circled the spot – 'somewhere here, on this five-mile stretch, where she runs close to Vesuvius.'

Pliny frowned at the map. 'And the ship? Where does that come in?'

'I believe we have two days' worth of water left. If we set off overland from Misenum to discover what's happened it will take us at least that long simply to find where the break has occurred. But if we go by sea to Pompeii – if we travel light and pick up most of what we need in the town – we should be able to start repairs tomorrow.'

In the ensuing silence, the engineer could hear the

67

steady drip of the water clock beside the doors. Some of the gnats whirling around the candles had become encrusted in the wax.

Pliny said, 'How many men do you have?'

'Fifty altogether, but most of those are spread out along the length of the matrix, maintaining the settling tanks and the reservoirs in the towns. I have a dozen altogether in Misenum. I'd take half of those with me. Any other labour we need, I'd hire locally in Pompeii.'

'We could let him have a liburnian, admiral,' said Antius. 'If he left at first light he could be in Pompeii by the middle of the morning.'

Corax seemed to be panicked by the mere suggestion. 'But with respect, this is just more of his moonshine, admiral. I wouldn't pay much attention to any of this. For a start, I'd like to know how he's so sure the water's still running in Pompeii.'

'I met a man on the quayside, admiral, on my way here. An augur. The local ferry had just docked. He told me he was in Pompeii this morning.'

'An augur!' mocked Corax. 'Then it's a pity he didn't see this whole thing coming! But all right – let's say he's telling the truth. Let's say this is where the break is. I know this part of the matrix better than anyone – five miles long and every foot of her underground. It will take us more than a day just to find out where she's gone down.'

'That's not true,' objected Attilius. 'With that much water escaping from the matrix, a blind man could find the break.'

'With that much water backed up in the tunnel, how do we get inside it to make the repairs?'

'Listen,' said the engineer. 'When we get to Pompeii, we split into three groups.' He had not really thought this through. He was having to make it up as he went along. But he could sense that Antius was with him and the admiral had yet to take his eyes from the map. 'The first group goes out to the Augusta – follows the spur from Pompeii to its junction with the matrix and then works westwards. I can assure you, finding where the break is will not be a great problem. The second group stays in Pompeii and puts together enough men and materials to carry out the repairs. A third group rides into the mountains, to the springs at Abellinum, with instructions to shut off the Augusta.'

The senator looked up sharply. 'Can that be done? In Rome, when an aqueduct has to be closed for repairs, it stays shut down for weeks.'

'According to the drawings, senator, yes – it can be done.' Attilius had only just noticed it himself, but he was inspired now. The whole operation was taking shape in his mind even as he described it. 'I have never seen the springs of the Serinus myself, but it appears from this plan that they flow into a basin with two channels. Most of the water comes west, to us. But a smaller channel runs north, to feed Beneventum. If we send all the water north, and let the western channel drain off, we can get inside to repair it. The point is, we don't have to dam it and build a temporary diversion, which is what we have to do with the aqueducts of Rome,

before we can even start on the maintenance. We can work much more quickly.'

The senator transferred his drooping eyes to Corax. 'Is this true, overseer?'

'Maybe,' conceded Corax grudgingly. He seemed to sense he was beaten, but he would not give up without a fight. 'However, I still maintain he's talking moonshine, admiral, if he thinks we can get all this done in a day or two. Like I said, I know this stretch. We had problems here nearly twenty years ago, at the time of the great earthquake. Exomnius was the aquarius, new in the job. He'd just arrived from Rome, his first command, and we worked on it together. All right – it didn't block the matrix completely, I grant you that – but it still took us weeks to render all the cracks in the tunnel.'

'What great earthquake?' Attilius had never heard mention of it.

'Actually, it was seventeen years ago.' Pliny's nephew piped up for the first time. 'The earthquake took place on the Nones of February, during the consulship of Regulus and Verginius. Emperor Nero was in Neapolis, performing on stage at the time. Seneca describes the incident. You must have read it, uncle? The relevant passage is in *Natural Questions*. Book six.'

'Yes, Gaius, thank you,' said the admiral sharply. 'I have read it, although obviously I'm obliged for the reference.' He stared at the map and puffed out his cheeks. 'I wonder –' he muttered. He shifted round in his chair and shouted at the slave. 'Dromo! Bring me my glass of wine. Quickly!'

'Are you ill, uncle?'

'No, no.' Pliny propped his chin on his fists and returned his attention to the map. 'So is this what has damaged the Augusta? An earthquake?'

'Then surely we would have felt it?' objected Antius. 'That last quake brought down a good part of Pompeii. They're still rebuilding. Half the town is a building site. We've had no reports of anything on that scale.'

'And yet,' continued Pliny, almost to himself, 'this is certainly earthquake weather. A flat sea. A sky so breathless the birds can scarcely fly. In normal times we would anticipate a storm. But when Saturn, Jupiter and Mars are in conjunction with the sun, instead of occurring in the air, the thunder is sometimes unleashed by Nature underground. That is the definition of an earthquake, in my opinion – a thunderbolt hurled from the interior of the world.'

The slave had shuffled up beside him, carrying a tray, in the centre of which stood a large goblet of clear glass, three-quarters full. Pliny grunted and lifted the wine to the candlelight.

'A Caecuban,' whispered Pomponianus, in awe. 'Forty years old and still drinking beautifully.' He ran his tongue round his fat lips. 'I wouldn't mind another glass myself, Pliny.'

'In a moment. Watch.' Pliny waved the wine back and forth in front of them. It was thick and syrupy, the colour of honey. Attilius caught the sweet mustiness of its scent as it passed beneath his nose. 'And now watch more closely.' He set the glass carefully on the table.

At first, the engineer did not see what point he was trying to make, but as he studied the glass more closely he saw that the surface of the wine was vibrating slightly. Tiny ripples radiated out from the centre, like the quivering of a plucked string. Pliny picked up the glass and the movement ceased; he replaced it and the motion resumed.

'I noticed it during dinner. I have trained myself to be alert to things in Nature, which other men might miss. The shaking is not continuous. See now – the wine is still.'

'That's really remarkable, Pliny,' said Pomponianus. 'I congratulate you. I'm afraid once I have a glass in my hand, I don't tend to put it down until it's empty.'

The senator was less impressed. He folded his arms and pushed himself back in the chair, as if he had somehow made himself look a fool by watching a childish trick. 'I don't know what's significant about that. So the table trembles? It could be anything. The wind –'

'There is no wind.'

'– heavy footsteps somewhere. Or perhaps Pomponianus, here, was stroking one of the ladies under the table.'

Laughter broke the tension. Only Pliny did not smile. 'We know that this world we stand on, which seems to us so still, is in fact revolving eternally, at an indescribable velocity. And it may be that this mass hurtling through space produces a sound of such volume that it is beyond the capacity of our human ears to detect. The stars out there, for example, might be tinkling like wind

chimes, if only we could hear them. Could it be that the patterns in this wineglass are the physical expression of that same heavenly harmony?'

'Then why does it stop and start?'

'I have no answer, Cascus. Perhaps at one moment the earth glides silently, and at another it encounters resistance. There is a school which holds that winds are caused by the earth travelling in one direction and the stars in the other. Aquarius – what do you think?'

'I'm an engineer, admiral,' said Attilius tactfully, 'not a philosopher.' In his view, they were wasting time. He thought of mentioning the strange behaviour of the vapour on the hillside that morning, but decided against it. Tinkling stars! His foot was tapping with impatience. 'All I can tell you is that the matrix of an aqueduct is built to withstand the most extreme forces. Where the Augusta runs underground, which is most of the way, she's six feet high and three feet wide, and she rests on a base of concrete one and a half feet thick, with walls of the same dimensions. Whatever force breached that must have been powerful.'

'More powerful than the force which shakes my wine?' The admiral looked at the senator. 'Unless we are not dealing with a phenomenon of nature at all. In which case, what is it? A deliberate act of sabotage, perhaps, to strike at the fleet? But who would dare? We haven't had a foreign enemy set foot in this part of Italy since Hannibal.'

'And sabotage would hardly explain the presence of sulphur.'

'Sulphur,' said Pomponianus suddenly. 'That's the stuff in thunderbolts, isn't it? And who throws thunderbolts?' He looked around excitedly. 'Jupiter! We should sacrifice a white bull to Jupiter, as a deity of the upper air, and have the haruspices inspect the entrails. They'll tell us what to do.'

The engineer laughed.

'What's so funny about that?' demanded Pomponianus. 'It's not so funny as the idea that the world is flying through space – which, if I may say so, Pliny, rather begs the question of why we don't all fall off.'

'It's an excellent suggestion, my friend,' said Pliny soothingly. 'And, as admiral, I also happen to be the chief priest of Misenum, and I assure you, if I had a white bull to hand I would kill it on the spot. But for the time being, a more practical solution may be needed.' He sat back in his chair and wiped his napkin across his face, then unfolded and inspected it, as if it might contain some vital clue. 'Very well, aquarius. I shall give you your ship.' He turned to the captain. 'Antius – which is the fastest liburnian in the fleet?'

'That would be the *Minerva*, admiral. Torquatus's ship. Just back from Ravenna.'

'Have her made ready to sail at first light.'

'Yes, admiral.'

'And I want notices posted on every fountain telling the citizens that rationing is now in force. Water will only be allowed to flow twice each day, for one hour exactly, at dawn and dusk.'

Antius winced. 'Aren't you forgetting that tomorrow is a public holiday, admiral? It's Vulcanalia, if you recall?'

'I'm perfectly aware it's Vulcanalia.'

And so it is, thought Attilius. In the rush of leaving Rome and fretting about the aqueduct he had completely lost track of the calendar. The twenty-third of August, Vulcan's day, when live fish were thrown on to bonfires, as a sacrifice, to appease the god of fire.

'But what about the public baths?' persisted Antius.

'Closed until further notice.'

'They won't like that, admiral.'

'Well, it can't be helped. We've all grown far too soft, in any case.' He glanced briefly at Pomponianus. 'The Empire wasn't built by men who lazed around the baths all day. It will do some people good to have a taste of how life used to be. Gaius – draft a letter for me to sign to the aediles of Pompeii, asking them to provide whatever men and materials may be necessary for the repair of the aqueduct. You know the kind of thing. "In the name of the Emperor Titus Caesar Vespasianus Augustus, and in accordance with the power vested in me by the Senate and People of Rome, blah blah" – something to make them jump. Corax – it's clear that you know the terrain around Vesuvius better than anyone else. You should be the one to ride out and locate the fault, while the aquarius assembles the main expedition in Pompeii.'

The overseer's mouth flapped open in dismay.

'What's the matter? Do you disagree?'

'No, admiral.' Corax hid his anxiety quickly, but

Attilius had noticed it. 'I don't mind looking for the break. Even so, would it not make more sense for one of us to remain at the reservoir to supervise the rationing –'

Pliny cut him off impatiently. 'Rationing will be the Navy's responsibility. It's primarily a question of public order.'

For a moment Corax looked as if he might be on the point of arguing, but then he bowed his head, frowning.

From the terrace came the sound of female voices and a peal of laughter.

He doesn't want me to go to Pompeii, thought Attilius, suddenly. This whole performance tonight – it's been to keep me away from Pompeii.

A woman's elaborately coiffeured head appeared at the doorway. She must have been about sixty. The pearls at her throat were the largest Attilius had ever seen. She crooked her finger at the senator. 'Cascus, darling, how much longer are you planning to keep us waiting?'

'Forgive us, Rectina,' said Pliny. 'We've almost finished. Does anyone have anything else to add?' He glanced at each of them in turn. 'No? In that case, I for one propose to finish my dinner.'

He pushed back his chair and everyone stood. The ballast of his belly made it hard for him to rise. Gaius offered his arm, but the admiral waved him away. He had to rock forwards several times and the strain of finally pushing himself up on to his feet left him breathless. With one hand he clutched at the table, with the

other he reached for his glass, then stopped, his outstretched fingers hovering in mid-air.

The wine had resumed its barely perceptible trembling.

He blew out his cheeks. 'I think perhaps I shall sacrifice that white bull after all, Pomponianus. And you,' he said to Attilius, 'will give me back my water within two days.' He picked up the glass and took a sip. 'Or – believe me – we shall all have need of Jupiter's protection.'

Nocte intempesta

[23:22 hours]

*'Magma movement may also disturb the local
water table, and changes in flow and temperature
of groundwater may be detected.'*

Encyclopaedia of Volcanoes

Two hours later – sleepless, naked, stretched out
on his narrow wooden bed – the engineer lay
waiting for the dawn. The familiar, hammer-
ing lullaby of the aqueduct had gone and in its place
crowded all the tiny noises of the night – the creak
of the sentries' boots in the street outside, the rustle of
mice in the rafters, the hacking cough of one of the
slaves downstairs in the barracks. He closed his eyes,
only to open them again almost immediately. In the
panic of the crisis he had managed to forget the sight
of the corpse, dragged from the pool of eels, but in the
darkness he found himself replaying the whole scene –
the concentrated silence at the water's edge; the body

hooked and dragged ashore; the blood; the screams of the woman; the anxious face and the pale white limbs of the girl.

Too exhausted to rest, he swung his bare feet on to the warm floor. A small oil lamp flickered on the night-stand. His uncompleted letter home lay beside it. There was no point now, he thought, in finishing it. Either he would repair the Augusta, in which case his mother and sister would hear from him on his return. Or they would hear *of* him, when he was shipped back to Rome, in disgrace, to face a court of inquiry – a dishonour to the family name.

He picked up the lamp and took it to the shelf at the foot of the bed, setting it down among the little shrine of figures that represented the spirits of his ances-tors. Kneeling, he reached across and plucked out the effigy of his great-grandfather. Could the old man have been one of the original engineers on the Augusta? It was not impossible. The records of the Curator Aquarum showed that Agrippa had shipped in a work-force of forty thousand, slaves and legionaries, and had built her in eighteen months. That was six years after he built the Aqua Julia in Rome and seven years before he built the Virgo, and his great-grandfather had certainly worked on both of those. It pleased him to imagine that an earlier Attilius might have come south to this sweltering land – might even have sat on this very spot as the slaves dug out the Piscina Mirabilis. He felt his courage strengthening. Men had built the Augusta; men would fix her. *He* would fix her.

79

And then his father.

He replaced one figure and took up another, running his thumb tenderly over the smooth head.

Your father was a brave man; make sure you are, too.

He had been a baby when his father had finished the Aqua Claudia, but so often had he been told the story of the day of its dedication – of how, at four months old, he had been passed over the shoulders of the engineers in the great crowd on the Esquiline Hill – that it sometimes seemed to him he could remember it all at first hand: the elderly Claudius, twitching and stammering as he sacrificed to Neptune, and then the water appearing in the channel, as if by magic, at the exact moment that he raised his hands to the sky. But that had had nothing to do with the intervention of the gods, despite the gasps of those present. That was because his father had known the laws of engineering and had opened the sluices at the head of the aqueduct exactly eighteen hours before the ceremony was due to reach its climax, and had ridden back into the city faster than the water could chase him.

He contemplated the piece of clay in his palm.

And you, father? Did you ever come to Misenum? Did you know Exomnius? The aquarii of Rome were always a family – as close as a cohort, you used to say. Was Exomnius one of those engineers on the Esquiline on your day of triumph? Did he swing me in his arms with the rest?

He stared at the figure for a while, then kissed it and put it carefully with the others.

He sat back on his haunches.

First the aquarius disappears and then the water. Th.
more he considered it, the more convinced he was that
these must be connected. But how? He glanced around
the roughly plastered walls. No clue here, that was for
sure. No trace of any man's character left behind in this
plain cell. And yet, according to Corax, Exomnius had
run the Augusta for twenty years.

He retrieved the lamp and went out into the passage,
shielding the flame with his hand. Drawing back the
curtain opposite, he shone the light into the cubicle
where Exomnius's possessions were stored. A couple of
wooden chests, a pair of bronze candelabra, a cloak,
sandals, a pisspot. It was not much to show for a life-
time. Neither of the chests was locked, he noticed.

He glanced towards the staircase, but the only sound
coming from below was snoring. Still holding the lamp,
he lifted the lid of the nearest chest and began to
rummage through it with his free hand. Clothes – old
clothes mostly – which, as he disturbed them, released
a strong smell of stale sweat. Two tunics, loincloths, a
toga, neatly folded. He closed the lid quietly and raised
the other. Not much in this chest, either. A skin scraper
for removing oil in the baths. A jokey figure of Priapus
with a vastly extended penis. A clay beaker for throw-
ing dice, with more penises inlaid around its rim. The
dice themselves. A few glass jars containing various herbs
and unguents. A couple of plates. A small bronze goblet,
badly tarnished.

He rolled the dice as gently as he could in the beaker

and threw them. His luck was in. Four sixes – the Venus throw. He tried again and threw another Venus. The third Venus settled it. Loaded dice.

He put away the dice and picked up the goblet. Was it really bronze? Now he examined it more closely, he was not so sure. He weighed it in his hand, turned it over, breathed on it and rubbed the bottom with his thumb. A smear of gold appeared and part of an engraved letter *P.* He rubbed again, gradually increasing the radius of gleaming metal, until he could make out all the initials.

N. P. N. l. A.

The *l* stood for *libertus* and showed it to be the property of a freed slave.

A slave who had been freed by an owner whose family name began with a *P,* and who was rich enough, and vulgar enough, to drink his wine from a gold cup.

Her voice was suddenly as clear in his mind as if she had been standing beside him.

'My name is Corelia Ampliata, daughter of Numerius Popidius Ampliatus, owner of the Villa Hortensia . . .'

The moonlight shone on the smooth black stones of the narrow street and silhouetted the lines of the flat roofs. It felt almost as hot as it had been in the late afternoon; the moon as bright as the sun. As he mounted the steps between the shuttered, silent houses, he could picture her darting before him – the movement of her hips beneath the plain white dress.

'*A few hundred paces — aye, but every one of them uphill!*'

He came again to the level ground and to the high wall of the great villa. A grey cat ran along it and disappeared over the other side. The glinting metal dolphins leapt and kissed above the chained gate. He could hear the sea in the distance, moving against the shore, and the throb of the cicadas in the garden. He rattled the iron bars and pressed his face to the warm metal. The porter's room was shuttered and barred. There was not a light to be seen.

He was remembering Ampliatus's reaction when he turned up on the seashore: '*What's happened to Exomnius? But surely Exomnius is still the aquarius?*' There had been surprise in his voice and, now he came to think about it, possibly something more: alarm.

'Corelia!' He called her name softly. 'Corelia Ampliata!'

No response. And then a whisper in the darkness, so low he almost missed it: 'Gone.'

A woman's voice. It came from somewhere to his left. He stepped back from the gate and peered into the shadows. He could make out nothing except a small mound of rags piled in a drift against the wall. He moved closer and saw that the shreds of cloth were moving slightly. A skinny foot protruded, like a bone. It was the mother of the dead slave. He went down on one knee and cautiously touched the rough fabric of her dress. She shivered, then groaned and muttered something. He withdrew his hand. His fingers were sticky with blood.

'Can you stand?'

'Gone,' she repeated.

He lifted her carefully until she was sitting, propped against the wall. Her swollen head dropped forward and he saw that her matted hair had left a damp mark on the stone. She had been whipped and badly beaten, and thrown out of the household to die.

N. P. N. l. A: Numerius Popidius Numerii libertus Ampliatus. Granted his freedom by the family Popidii. It was a fact of life that there was no crueller master than an ex-slave.

He pressed his fingers lightly to her neck to make sure she was still alive. Then he threaded one arm under the crook of her knees and with the other grasped her round her shoulders. It cost him no effort to rise. She was mere rags and bones. Somewhere, in the streets close to the harbour, the nightwatchman was calling the fifth division of the darkness: 'Media noctis inclinatio' – midnight.

The engineer straightened his back and set off down the hill as the day of Mars turned into the day of Mercury.

MERCURY

23 August

The day before the eruption

Diluculum

[06:00 hours]

'Prior to AD 79, a reservoir of magma had
accumulated beneath the volcano. It is not possible
to say when this magma chamber began to form,
but it had a volume of at least 3.6 cubic kilo-
metres, was about 3 km below the surface, and
was compositionally stratified, with volatile-rich
alkalic magma (55 percent SiO2 and almost
10 per cent K2O) overlying slightly denser, more
mafic magma.'

Peter Francis, Volcanoes: A Planetary Perspective

At the top of the great stone lighthouse, hidden beyond the ridge of the southern headland, the slaves were dousing the fires to greet the dawn. It was supposed to be a sacred place. According to Virgil, this was the spot where Misenus, the herald of the Trojans, slain by the sea god Triton, lay buried with his oars and trumpet.

Attilius watched the red glow fade beyond the tree-crested promontory, while in the harbour the outlines of the warships took shape against the pearl-grey sky.

He turned and walked back along the quay to where the others were waiting. He could make out their faces at last – Musa, Becco, Corvinus, Polites – they were becoming as familiar to him as family. No sign yet of Corax.

'Nine brothels!' Musa was saying. 'Believe me, if you want to get laid, Pompeii's the place. Even Becco can give his hand a rest for a change. Hey, aquarius!' he shouted, as Attilius drew closer. 'Tell Becco he can get himself laid!'

The dockside stank of shit and gutted fish. Attilius could see a putrid melon and the bloated, whitened carcass of a rat lapping at his feet between the pillars of the wharf. So much for poets! He had a sudden yearning for one of those cold, northern seas he had heard about – the Atlantic, perhaps, or the Germanicum – a land where a deep tide daily swept the sand and rocks; some place healthier than this tepid Roman lake.

He said, 'As long as we fix the Augusta, Becco can screw every girl in Italy for all I care.'

'There you go, Becco. Your prick will soon be as long as your nose –'

The ship the admiral had promised was moored before them: the *Minerva*, named for the goddess of wisdom, with an owl, the symbol of her deity, carved into her prow. A liburnian. Smaller than the big triremes. Built for speed. Her high sternpost reared out

behind her, then curled across her low deck like the sting of a scorpion preparing to strike. She was deserted.

'– Cuculla and Zmyrina. And then there's this red-haired Jewess, Martha. And a little Greek girl, if you like that kind of thing – her mother's barely twenty –'

'What use is a ship without a crew?' muttered Attilius. He was fretting already. He could not afford to waste an hour. 'Polites – run to the barracks, there's a good lad, and find out what's happening.'

'– Aegle and Maria –'

The young slave got to his feet.

'No need,' said Corvinus, and gestured with his head towards the entrance to the port. 'Here they come.'

Attilius said, 'Your ears must be sharper than mine –' but then he heard them, too. A hundred pairs of feet, doubling along the road from the military school. As the marchers crossed the wooden bridge of the causeway, the sharp rhythm became a continuous thunder of leather on wood, then a couple of torches appeared and the unit swung into the street leading to the harbour front. They came on, five abreast, three officers wearing body armour and crested helmets in the lead. At a first shout of command the column halted; at a second, it broke and the sailors moved towards the ship. None spoke. Attilius drew back to let them pass. In their sleeveless tunics, the misshapen shoulders and hugely muscled arms of the oarsmen appeared grotesquely out of proportion to their lower bodies.

'Look at them,' drawled the tallest of the officers. 'The cream of the Navy: human oxen.' He turned to

Attilius and raised his fist in salute. 'Torquatus, captain of the *Minerva*.'

'Marcus Attilius. Engineer. Let's go.'

I t did not take long to load the ship. Attilius had seen no point in dragging the heavy amphorae of quick-lime and sacks of puteolanum down from the reservoir and ferrying them across the bay. If Pompeii was, as they described her, swarming with builders, he would use the admiral's letter to commandeer what he needed. Tools, though, were a different matter. A man should always use his own tools.

He arranged a chain to pass them on board, hand-ing each in turn to Musa, who threw them on to Corvinus – axes, sledgehammers, saws, picks and shov-els, wooden trays to hold the fresh cement, hoes to mix it, and the heavy flat-irons they used to pound it into place – until eventually it had all reached Becco, stand-ing on the deck of the *Minerva*. They worked swiftly, without exchanging a word, and by the time they had finished it was light and the ship was making ready to sail.

Attilius walked up the gangplank and jumped down to the deck. A line of marines with boathooks was wait-ing to push her away from the quay. From his platform beneath the sternpost, next to the helmsman, Torquatus shouted down, 'Are you ready, engineer?' and Attilius called back that he was. The sooner they left, the better.

'But Corax isn't here,' objected Becco.

To hell with him, thought Attilius. It was almost a relief. He would manage the job alone. 'That's Corax's look-out.'

The mooring ropes were cast off. The boathooks dropped like lances and connected with the dock. Beneath his feet, Attilius felt the deck shake as the oars were unshipped and the *Minerva* began to move. He looked back towards the shore. A crowd had gathered around the public fountain, waiting for the water to appear. He wondered if he should have stayed at the reservoir long enough to supervise the opening of the sluices. But he had left six slaves behind to run the Piscina and the building was ringed by Pliny's marines.

'There he is!' shouted Becco. 'Look! It's Corax!' He started waving his arms above his head. 'Corax! Over here!' He gave Attilius an accusing look. 'You see! You should have waited!'

The overseer had been slouching past the fountain, a bag across his shoulder, seemingly deep in thought. But now he looked up, saw them, and started to run. He moved fast for a man in his forties. The gap between the ship and the quay was widening quickly – three feet, four feet – and it seemed to Attilius impossible that he could make it, but when he reached the edge he threw his bag and then leapt after it, and a couple of the marines stretched out and caught his arms and hauled him aboard. He landed upright, close to the stern, glared at Attilius and jerked his middle finger at him. The engineer turned away.

The *Minerva* was swinging out from the harbour,

prow first, and sprouting oars, two dozen on either side of her narrow hull. A drum sounded below deck, and the blades dipped. It sounded again and they splashed the surface, two men pulling on each shaft. The ship glided forwards – imperceptibly to begin with, but picking up speed as the tempo of the drum beats quickened. The pilot, leaning out above the ramming post and staring straight ahead, pointed to the right, Torquatus called out an order, and the helmsman swung hard on the huge oar that served as a rudder, steering a course between two anchored triremes. For the first time in four days, Attilius felt a slight breeze on his face.

'You have an audience, engineer!' shouted Torquatus, and gestured towards the hill above the port. Attilius recognised the long white terrace of the admiral's villa set amid the myrtle groves, and, leaning against the balustrade, the corpulent figure of Pliny himself. He wondered what was going through the old man's mind. Hesitantly, he raised his arm. A moment later Pliny responded. Then the *Minerva* passed between the two great warships, the *Concordia* and the *Neptune*, and when he looked again the terrace was deserted.

In the distance, behind Vesuvius, the sun was starting to appear.

Pliny watched the liburnian gather speed as she headed towards open water. Against the grey, her oars stroked vivid flashes of white, stirring somewhere

a long-forgotten memory of the leaden Rhine at daybreak – at Vetera, this must have been, thirty years ago – and the troop-ferry of Legion V 'The Larks' taking his cavalry to the far bank. Such times! What he would not give to embark again on a voyage at first light, or better still to command the fleet in action, a thing he had never done in his two years as admiral. But the effort of simply coming out of his library and on to the terrace to see the *Minerva* go – of rising from his chair and taking a few short steps – had left him breathless, and when he lifted his arm to acknowledge the wave of the engineer he felt as if he were hoisting an exercise weight.

'Nature has granted man no better gift than the shortness of life. The senses grow dull, the limbs are numb, sight, hearing, gait, even the teeth and alimentary organs die before we do, and yet this period is reckoned a portion of life.'

Brave words. Easy to write when one was young and death was still skulking over a distant hill somewhere; less easy when one was fifty-six and the enemy was advancing in full view across the plain.

He leaned his fat belly against the balustrade, hoping that neither of his secretaries had noticed his weakness, then pushed himself away and shuffled back inside.

He had always had a fondness for young men of Attilius's kind. Not in the filthy Greek way, of course – he had never had time for any of that malarkey, although he had seen plenty of it in the Army – but rather spiritually, as the embodiment of the muscular

93

Roman virtues. Senators might dream of empires; soldiers might conquer them; but it was the engineers, the fellows who laid down the roads and dug out the aqueducts, who actually *built* them, and who gave to Rome her global reach. He promised himself that when the aquarius returned he would summon him to dinner and pick his brains to discover exactly what had happened to the Augusta. And then together they would consult some of the texts in the admiral's library and he would teach him a few of the mysteries of Nature, whose surprises were never-ending. These intermittent, harmonic tremors, for example – what were these? He should record the phenomenon and include it in the next edition of the *Natural History*. Every month he discovered something new that required explanation.

His two Greek slaves stood waiting patiently beside the table – Alcman for reading aloud, Alexion for dictation. They had been in attendance since soon after midnight, for the admiral had long ago disciplined himself to function without much rest. 'To be awake is to be alive,' that was his motto. The only man he had ever known who could get by on less sleep was the late Emperor, Vespasian. They used to meet in Rome in the middle of the night to transact their official business. That was why Vespasian had put him in charge of the fleet: 'My ever-vigilant Pliny,' he had called him, in that country bumpkin's accent of his, and had pinched his cheek.

He glanced around the room at the treasures accumulated during his journeys across the Empire. One

hundred and sixty notebooks, in which he had recorded every interesting fact he had ever read or heard (Larcius Licinius, the governor of Hispania Tarraconensis, had offered him four hundred thousand sesterces for the lot, but he had not been tempted). Two pieces of magnetite, mined in Dacia, and locked together by their mysterious magic. A lump of shiny grey rock from Macedonia, reputed to have fallen from the stars. Some German amber with an ancient mosquito imprisoned inside its translucent cell. A piece of concave glass, picked up in Africa, which gathered together the sun's rays and aimed them to a point of such concentrated heat it would cause the hardest wood to darken and smoulder. And his water clock, the most accurate in Rome, built according to the specifications of Ctesibius of Alexandria, inventor of the water organ, its apertures bored through gold and gems to prevent corrosion and plugging.

The clock was what he needed. It was said that clocks were like philosophers: you could never find two that agreed. But a clock by Ctesibius was the Plato of timepieces.

'Alcman, fetch me a bowl of water. No –' He changed his mind when the slave was halfway to the door, for had not the geographer, Strabo, described the luxurious Bay of Neapolis as 'the wine bowl'? 'On second thoughts, wine would be more appropriate. But something cheap. A Surrentum, perhaps.' He sat down heavily. 'All right, Alexion – where were we?'

'Drafting a signal to the Emperor, admiral.'

'Ah yes. Just so.'

Now that it was light, he would have to send a dispatch by flash to the new emperor, Titus, to alert him to the problem on the aqueduct. It would shoot, from signal tower to signal tower, all the way up to Rome, and be in the Emperor's hands by noon. And what would the new Master of the World make of that, he wondered?

'We shall signal the Emperor, and after we have done that, I think we shall start a new notebook, and record some scientific observations. Would that interest you?'

'Yes, admiral.' The slave picked up his stylus and wax tablet, struggling to suppress a yawn. Pliny pretended not to see it. He tapped his finger against his lips. He knew Titus well. They had served in Germania together. Charming, cultivated, clever – and completely ruthless. News that a quarter of a million people were without water could easily tip him over the edge into one of his lethal rages. This would require some careful phrasing.

'To His Most Eminent Highness, the Emperor Titus, from the Commander-in-Chief, Misenum,' he began. 'Greetings!'

The *Minerva* passed between the great concrete moles that protected the entrance to the harbour and out into the expanse of the bay. The lemony light of early morning glittered on the water. Beyond the thicket of poles that marked the oyster beds, where the seagulls swooped and cried, Attilius could see the fishery of the Villa Hortensia. He got to his feet for a better

view, bracing himself against the motion of the boat. The terraces, the garden paths, the slope where Ampliatus had set up his chair to watch the execution, the ramps along the shoreline, the gantries between the fish-pens, the big eel pond set away from the rest – all deserted. The villa's crimson-and-gold cruiser was no longer moored at the end of the jetty.

It was exactly as Atia had said: they had gone.

The old woman had still not recovered her senses when he left the reservoir before dawn. He had lain her on a straw mattress in one of the rooms beside the kitchen, and had told the domestic slave, Phylo, to summon a doctor and to see that she was cared for. Phylo had made a face, but Attilius had told him gruffly to do as he was told. If she died – well, that might be a merciful release. If she recovered – then, as far as he was concerned, she could stay. He would have to buy another slave in any case, to look after his food and clothes. His needs were few; the work would be light. He had never paid much attention to such matters. Sabina had looked after the household when he was married; after she had gone, his mother had taken over.

The great villa looked dark and shuttered, as though for a funeral; the screams of the gulls were like the cries of mourners.

Musa said, 'I hear he paid ten million for it.'

Attilius acknowledged the remark with a grunt, without taking his eyes off the house. 'Well, he's not there now.'

'Ampliatus? Of course he's not. He never is. He has

houses everywhere, that one. Mostly, he's in Pompeii.'

'Pompeii?'

Now the engineer looked round. Musa was sitting cross-legged, his back propped against the tools, eating a fig. He always seemed to be eating. His wife sent him to work each day with enough food to feed half a dozen. He stuffed the last of the fruit into his mouth and sucked his fingers. 'That's where he comes from. Pompeii's where he made his money.'

'And yet he was born a slave.'

'So it goes these days,' said Musa bitterly. 'Your slave dines off silver plate, while your honest, free-born citizen works from dawn till nightfall for a pittance.'

The other men were sitting towards the stern, gathered around Corax, who had his head hunched forwards and was talking quietly – telling some story that required a lot of emphatic hand gestures and much heavy shaking of his head. Attilius guessed he was describing the previous night's meeting with Pliny.

Musa uncorked his waterskin and took a swig then wiped the top and offered it up to Attilius. The engineer took it and squatted beside him. The water had a vaguely bitter taste. Sulphur. He swallowed a little, more to be friendly than because he was thirsty, wiped it in return and handed it back.

'You're right, Musa,' he said carefully. 'How old is Ampliatus? Not even fifty. Yet he's gone from slave to master of the Villa Hortensia in the time it would take you or I to scrape together enough to buy some bug-infested apartment. How could any man do that honestly?'

'An honest millionaire? As rare as hen's teeth! The way I hear it,' said Musa, looking over his shoulder and lowering his voice, 'he really started coining it just after the earthquake. He'd been left his freedom in old man Popidius's will. He was a good-looking lad, Ampliatus, and there was nothing he wouldn't do for his master. The old man was a lecher – I don't think he'd leave the dog alone. And Ampliatus looked after his wife for him, too, if you know what I mean.' Musa winked. 'Anyway, Ampliatus got his freedom, and a bit of money from somewhere, and then Jupiter decided to shake things up a bit. This was back in Nero's time. It was a very bad quake – the worst anyone could remember. I was in Nola, and I thought my days were up, I can tell you.' He kissed his lucky amulet – a prick and balls, made of bronze, which hung from a leather thong around his neck. 'But you know what they say: one man's loss is another's gain. Pompeii caught it worst of all. But while everyone else was getting out, talking about the town being finished, Ampliatus was going round, buying up the ruins. Got hold of some of those big villas for next to nothing, fixed them up, divided them into three or four, then sold them off for a fortune.'

'Nothing illegal about that, though.'

'Maybe not. But did he really own them when he sold them? That's the thing.' Musa tapped the side of his nose. 'Owners dead. Owners missing. Legal heirs on the other side of the Empire. Half the town was rubble, don't forget. The Emperor sent a commissioner

down from Rome to sort out who owned what. Suedius Clemens was his name.'

'And Ampliatus bribed him?'

'Let's just say Suedius left a richer man than he arrived. Or so they say.'

'And what about Exomnius? He was the aquarius at the time of the earthquake – he must have known Ampliatus.'

Attilius could see at once that he had made a mistake. The eager light of gossip was immediately extinguished in Musa's eyes. 'I don't know anything about that,' he muttered, and busied himself with his bag of food. 'He was a fine man, Exomnius. He was good to work for.'

Was, thought Attilius. *Was* a fine man. *Was* good to work for. He tried to make a joke of it. 'You mean he didn't keep dragging you out of bed before dawn?'

'No. I mean he was straight and would never try to trick an honest man into saying more than he ought.'

'Hey, Musa!' shouted Corax. 'What are you going on about over there? You gossip like a woman! Come and have a drink!'

Musa was on his feet at once, swaying down the deck to join the others. As Corax threw him the wineskin, Torquatus jumped down from the stern and made his way towards the centre of the deck, where the mast and sails were stowed.

'We'll have no need of those, I fear.' He was a big man. Arms akimbo he scanned the sky. The fresh, sharp sun glinted on his breastplate; already it was hot. 'Right,

engineer. Let's see what my oxen can do.' He swung his feet on to the ladder and descended down the hatch to the lower deck. A moment later, the tempo of the drum increased and Attilius felt the ship lurch slightly. The oars flashed. The silent Villa Hortensia dwindled further in the distance behind them.

The *Minerva* pushed on steadily as the heat of the morning settled over the bay. For two hours the oarsmen kept up the same remorseless pace. Clouds of steam curled from the terraces of the open-air baths in Baiae. In the hills above Puteoli, the fires of the sulphur mines burned pale green.

The engineer sat apart, his hands clasped around his knees, his hat pulled low to shield his eyes, watching the coast slide by, searching the landscape for some clue as to what had happened on the Augusta.

Everything about this part of Italy was strange, he thought. Even the rust-red soil around Puteoli possessed some quality of magic, so that when it was mixed with lime and flung into the sea it turned to rock. This puteolanum, as they called it, in honour of its birthplace, was the discovery that had transformed Rome. And it had also given his family their profession, for what had once needed laborious construction in stone and brick could now be thrown up overnight. With shuttering and cement Agrippa had sunk the great wharves of Misenum, and had irrigated the Empire with aqueducts – the Augusta here in Campania, the Julia and the Virgo

in Rome, the Nemausus in southern Gaul. The world had been remade.

But nowhere had this hydraulic cement been used to greater effect than in the land where it was discovered. Piers and jetties, terraces and embankments, breakwaters and fish-farms had transformed the Bay of Neapolis. Whole villas seemed to thrust themselves up from the waves and to float offshore. What had once been the realm of the super-rich – Caesar, Crassus, Pompey – had been flooded by a new class of millionaires, men like Ampliatus. Attilius wondered how many of the owners, relaxed and torpid as this sweltering August stretched and yawned and settled itself into its fourth week, would be aware by now of the failure of the aqueduct. Not many, he would guess. Water was something that was carried in by slaves, or which appeared miraculously from the nozzle of one of Sergius Orata's shower-baths. But they would know soon enough. They would know once they had to start drinking their swimming pools.

The further east they rowed, the more Vesuvius dominated the bay. Her lower slopes were a mosaic of cultivated fields and villas, but from her halfway point rose dark green, virgin forest. A few wisps of cloud hung motionless around her tapering peak. Torquatus declared that the hunting up there was excellent – boar, deer, hare. He had been out many times with his dogs and net, and also with his bow. But one had to look out for the wolves. In winter, the top was snow-capped. Squatting next to Attilius he took off his helmet and

wiped his forehead. 'Hard to imagine,' he said, 'snow in this heat.'

'And is she easy to climb?'

'Not too hard. Easier than she looks. The top's fairly flat when you get up there. Spartacus made it the camp for his rebel army. Some natural fortress that must have been. No wonder the scum were able to hold off the legions for so long. When the skies are clear you can see for fifty miles.'

They had passed the city of Neapolis and were parallel with a smaller town which Torquatus said was Herculaneum, although the coast was such a continuous ribbon of development – ochre walls and red roofs, occasionally pierced by the dark green spear-thrusts of cypresses – that it was not always possible to tell where one town ended and another began. Herculaneum looked stately and well-pleased with herself at the foot of the luxuriant mountain, her windows facing out to sea. Brightly coloured pleasure-craft, some shaped like sea-creatures, bobbed in the shallows. There were parasols on the beaches, people casting fishing lines from the jetties. Music, and the shouts of children playing ball, wafted across the placid water.

'Now that's the greatest villa on the Bay,' said Torquatus. He nodded towards an immense colonnaded property that sprawled along the shoreline and rose in terraces above the sea. 'That's the Villa Calpurnia. I had the honour to take the new Emperor there last month, on a visit to the former consul, Pedius Cascus.'

'Cascus?' Attilius pictured the lizard-like senator from

the previous evening, swaddled in his purple-striped toga. 'I had no idea he was so rich.'

'Inherited through his wife, Rectina. She had some connection with the Piso clan. The admiral comes here often, to use the library. Do you see that group of figures, reading in the shade beside the pool? They are philosophers.' Torquatus found this very funny. 'Some men breed birds as a pastime, others have dogs. The senator keeps philosophers!'

'And what species are these philosophers?'

'Followers of Epicurus. According to Cascus, they hold that man is mortal, the gods are indifferent to his fate, and therefore the only thing to do in life is enjoy oneself.'

'I could have told him that for nothing.'

Torquatus laughed again then put on his helmet and tightened the chin-strap. 'Not long to Pompeii now, engineer. Another half-hour should do it.'

He walked back towards the stern.

Attilius shielded his eyes and contemplated the villa. He had never had much use for philosophy. Why one human being should inherit such a palace, and another be torn apart by eels, and a third break his back in the stifling darkness rowing a liburnian – a man could go mad trying to reason why the world was so arranged. Why had he had to watch his wife die in front of him when she was barely older than a girl? Show him the philosophers who could answer that and he would start to see the point of them.

She had always wanted to come on holiday to the

Bay of Neapolis, and he had always put her off, saying he was too busy. And now it was too late. Grief at what he had lost and regret at what he had failed to do, his twin assailants, caught him unawares again, and hollowed him, as they always did. He felt a physical emptiness in the pit of his stomach. Looking at the coast he remembered the letter a friend had shown him on the day of Sabina's funeral; he had learnt it off by heart. The jurist, Servius Sulpicus, more than a century earlier, had been sailing back from Asia to Rome, lost in grief, when he found himself contemplating the Mediterranean shore. Afterwards he described his feelings to Cicero, who had also just lost his daughter: 'There behind me was Aegina, in front of me Megara, to the right Piraeus, to the left Corinth; once flourishing towns, now lying low in ruins before one's eyes, and I began to think to myself: "How can we complain if one of us dies or is killed, ephemeral creatures as we are, when the corpses of so many towns lie abandoned in a single spot. Check yourself, Servius, and remember that you were born a mortal man. Can you be so greatly moved by the loss of one poor little woman's frail spirit?"'

To which, for Attilius, the answer still remained, more than two years later: yes.

He let the warmth soak his body and face for a while, and despite himself he must have floated off to sleep, for when he next opened his eyes, the town

had gone, and there was yet another huge villa slumbering beneath the shade of its giant umbrella pines, with slaves watering the lawn and scooping leaves from the surface of the swimming pool. He shook his head to clear his mind, and reached for the leather sack in which he carried what he needed – Pliny's letter to the aediles of Pompeii, a small bag of gold coins and the map of the Augusta.

Work was always his consolation. He unrolled the plan, resting it against his knees, and felt a sudden stir of anxiety. The proportions of the sketch, he realised, were not at all accurate. It failed to convey the immensity of Vesuvius, which still they had not passed, and which must surely, now he looked at it, be seven or eight miles across. What had seemed a mere thumb's-width on the map was in reality half a morning's dusty trek in the boiling heat of the sun. He reproached himself for his naivety – boasting to a client, in the comfort of his library, of what could be done, without first checking the actual lie of the land. The rookie's classic error.

He pushed himself to his feet and made his way over to the men, who were crouched in a circle, playing dice. Corax had his hand cupped over the beaker and was shaking it hard. He did not look up as Attilius's shadow fell across him. 'Come on, Fortuna, you old whore,' he muttered and rolled the dice. He threw all aces – a dog – and groaned. Becco gave a cry of joy and scooped up the pile of copper coins.

'My luck was good,' said Corax, 'until he appeared.' He jabbed his finger at Attilius. 'He's worse than a raven,

lads. You mark my words – he'll lead us all to our deaths.'

'Not like Exomnius,' said the engineer, squatting beside them. 'I bet he always won.' He picked up the dice. 'Whose are these?'

'Mine,' said Musa.

'I'll tell you what. Let's play a different game. When we get to Pompeii, Corax is going out first to the far side of Vesuvius, to find the break on the Augusta. Someone must go with him. Why don't you throw for the privilege?'

'Whoever wins goes with Corax!' exclaimed Musa.

'No,' said Attilius. 'Whoever loses.'

Everyone laughed, except Corax.

'Whoever loses!' repeated Becco. 'That's a good one!'

They took it in turns to roll the dice, each man clasping his hands around the cup as he shook it, each whispering his own particular prayer for luck.

Musa went last, and threw a dog. He looked crestfallen.

'You lose!' chanted Becco. 'Musa the loser!'

'All right,' said Attilius, 'the dice settle it. Corax and Musa will locate the fault.'

'And what about the others?' grumbled Musa.

'Becco and Corvinus will ride to Abellinum and close the sluices.'

'I don't see why it takes two of them to go to Abellinum. And what's Polites going to do?'

'Polites stays with me in Pompeii and organises the tools and transport.'

'Oh, that's fair!' said Musa, bitterly. 'The free man sweats out his guts on the mountain, while the slave gets to screw the whores in Pompeii!' He snatched up his dice and hurled them into the sea. 'That's what I think of my luck!'

From the pilot at the front of the ship came a warning shout – 'Pompeii ahead!' – and six heads turned as one to face her.

She came into view slowly from behind a headland, and she was not at all what the engineer had expected – no sprawling resort like Baiae or Neapolis, strung out along the coastline of the bay, but a fortress-city, built to withstand a siege, set back a quarter of a mile from the sea, on higher ground, her port spread out beneath her.

It was only as they drew closer that Attilius saw that her walls were no longer continuous – that the long years of the Roman peace had persuaded the city fathers to drop their guard. Houses had been allowed to emerge above the ramparts, and to spill, in widening, palm-shaded terraces, down towards the docks. Dominating the line of flat roofs was a temple, looking out to sea. Gleaming marble pillars were surmounted by what at first appeared to be a frieze of ebony figures. But the frieze, he realised, was alive. Craftsmen, almost naked and blackened by the sun, were moving back and forth against the white stone – working, even though it was a public holiday. The ring of chisels on stone and the rasp of saws carried clear in the warm air.

Activity everywhere. People walking along the top of the wall and working in the gardens that looked out to sea. People swarming along the road in front of the town – on foot, on horseback, in chariots and on the backs of wagons – throwing up a haze of dust and clogging the steep paths that led up from the port to the two big city gates. As the *Minerva* turned in to the narrow entrance of the harbour the din of the crowd grew louder – a holiday crowd, by the look of it, coming into town from the countryside to celebrate the festival of Vulcan. Attilius scanned the dockside for fountains but could see none.

The men were all silent, standing in line, each with his own thoughts.

He turned to Corax. 'Where does the water come into the town?'

'On the other side of the city,' said Corax, staring intently at the town. 'Beside the Vesuvius Gate. *If –*' he gave heavy emphasis to the word '– it's still flowing.'

That would be a joke, thought Attilius, if it turned out the water was not running after all and he had brought them all this way merely on the word of some old fool of an augur.

'Who works there?'

'Just some town slave. You won't find him much help.'

'Why not?'

Corax grinned and shook his head. He would not say. A private joke.

'All right. Then the Vesuvius Gate is where we'll start

from.' Attilius clapped his hands. 'Come on, lads. You've seen a town before. The cruise is over.'

They were inside the harbour now. Warehouses and cranes crowded against the water's edge. Beyond them was a river – the Sarnus, according to Attilius's map – choked with barges waiting to be unloaded. Torquatus, shouting orders, strode down the length of the ship. The drumbeats slowed and ceased. The oars were shipped. The helmsman turned the rudder slightly and they glided alongside the wharf at walking-pace, no more than a foot of clear water between the deck and the quay. Two groups of sailors carrying mooring cables jumped ashore and wound them quickly around the stone posts. A moment later the ropes snapped taut and, with a jerk that almost knocked Attilius off his feet, the *Minerva* came to rest.

He saw it as he was recovering his balance. A big, plain stone plinth with a head of Neptune gushing water from his mouth into a bowl that was shaped like an oyster-shell, and the bowl *overflowing* – this was what he would never forget – cascading down to rinse the cobbles, and wash, unregarded, into the sea. Nobody was queuing to drink. Nobody was paying it any attention. Why should they? It was just an ordinary miracle. He vaulted over the low side of the warship and swayed towards it, feeling the strange solidity of the ground after the voyage across the bay. He dropped his sack and put his hands into the clear arc of water, cupped them, raised them to his lips. It tasted sweet and pure and he almost laughed aloud with pleasure and relief,

then plunged his head beneath the pipe, and let the water run everywhere – into his mouth and nostrils, his ears, down the back of his neck – heedless of the people staring at him as if he had gone insane.

Hora quarta

[09:48 hours]

*'Isotope studies of Neapolitan volcanic magma
show signs of significant mixing with the
surrounding rock, suggesting that the reservoir isn't
one continuous molten body. Instead, the reservoir
might look more like a sponge, with the magma
seeping through numerous fractures in the rock.
The massive magma layer may feed into several
smaller reservoirs that are closer to the surface and
too small to identify with seismic techniques . . .'*

American Association for the Advancement of Science,
news bulletin, 'Massive Magma Layer feeds Mt.
Vesuvius', November 16 2001

A man could buy anything he needed in the harbour of Pompeii. Indian parrots, Nubian slaves, nitrum salt from the pools near Cairo, Chinese cinnamon, African monkeys, Oriental slave-girls famed for their sexual tricks . . . Horses were as

easy to come by as flies. Half a dozen dealers hung around outside the customs shed. The nearest sat on a stool beneath a crudely drawn sign of the winged Pegasus, bearing the slogan 'Baculus: Horses Swift Enough for the Gods'.

'I need five,' Attilius told the dealer. 'And none of your clapped-out nags. I want good, strong beasts, capable of working all day. And I need them now.'

'That's no problem, citizen.' Baculus was a small, bald man, with the brick-red face and glassy eyes of a heavy drinker. He wore an iron ring too large for his finger, which he twisted nervously, round and round. 'Nothing's a problem in Pompeii, provided you've the money. Mind you, I'll require a deposit. One of my horses was stolen the other week.'

'And I also want oxen. Two teams and two wagons.'

'On a public holiday?' He clicked his tongue. 'That, I think, will take longer.'

'How long?'

'Let me see.' Baculus squinted at the sun. The more difficult he made it sound, the more he could charge. 'Two hours. Maybe three.'

'Agreed.'

They haggled over the price, the dealer demanding an outrageous sum which Attilius immediately divided by ten. Even so, when eventually they shook hands, he was sure he had been swindled and it irritated him, as any kind of waste always did. But he had no time to seek out a better bargain. He told the dealer to bring round four of the horses immediately to the Vesuvius

Gate and then pushed his way back through the traders towards the *Minerva*.

By now the crew had been allowed up on deck. Most had peeled off their sodden tunics and the stench of sweat from the sprawled bodies was strong enough to compete with the stink of the nearby fish-sauce factory, where liquefying offal was decomposing in vats in the sunshine. Corvinus and Becco were picking their way between the oarsmen, carrying the tools, throwing them over the side to Musa and Polites. Corax stood with his back to the boat, peering towards the town, occasionally rising on tiptoe to see over the heads of the crowd.

He noticed Attilius and stopped. 'So the water runs,' he said, and folded his arms. There was something almost heroic about his stubbornness, his unwillingness to concede he had been wrong. It was then that Attilius knew, beyond question, that once all this was over he would have to get rid of him.

'Yes, she runs,' he agreed. He waved to the others to stop what they were doing and to gather round. It was agreed that they would leave Polites to finish the unloading and to guard the tools on the dockside; Attilius would send word to him about where to meet up later. Then the remaining five set off towards the nearest gate, Corax trailing behind, and whenever Attilius looked back it seemed that he was searching for someone, his head craning from side to side.

The engineer led them up the ramp from the harbour towards the city wall, beneath the half-finished temple of Venus and into the dark tunnel of the gate. A customs

official gave them a cursory glance to check they were not carrying anything they might sell, then nodded them into the town.

The street beyond the gate was not as steep as the ramp outside, or as slippery, but it was narrower, so that they were almost crushed by the weight of bodies surging into Pompeii. Attilius found himself borne along past shops and another big temple – this one dedicated to Apollo – and into the blinding open space and swarming activity of the forum.

It was imposing for a provincial town: basilica, covered market, more temples, a public library – all brilliantly coloured and shimmering in the sunlight; three or four dozen statues of emperors and local worthies high up on their pedestals. Not all of it was finished. A webwork of wooden scaffolding covered some of the large buildings. The high walls acted to trap the noise of the crowd and reflect it back at them – the flutes and drums of the buskers, the cries of the beggars and hawkers, the sizzle of cooking food. Fruit-sellers were offering green figs and pink slices of melon. Wine merchants crouched beside rows of red amphorae propped in nests of yellow straw. At the foot of a nearby statue a snake-charmer sat cross-legged, playing a pipe, a grey serpent rising groggily from the mat in front of him, another draped round his neck. Small pieces of fish were frying on an open range. Slaves, bowed under the weight of bundles of wood, were hurrying in relays to pile them on to the big bonfire being built in the centre of the forum for the evening sacrifice to Vulcan.

A barber advertised himself as an expert in pulling teeth and had a foot-high pile of grey and black stumps to prove it.

The engineer took off his hat and wiped his forehead. Already there was something about the place he did not much like. A hustler's town, he thought. Full of people on the make. She would welcome a visitor for exactly as long as it took to fleece him. He beckoned to Corax to ask him where he would find the aediles – he had to cup his hand to the man's ear to make himself heard – and the overseer pointed towards a row of three small offices lining the southern edge of the square, all closed for the holiday. A long notice-board was covered in proclamations, evidence of a thriving bureaucracy. Attilius cursed to himself. Nothing was ever easy.

'You know the way to the Vesuvius Gate,' he shouted to Corax. 'You lead.'

Water was pumping through the city. As they fought their way towards the far end of the forum he could hear it washing clear the big public latrine beside the Temple of Jupiter and bubbling in the streets beyond. He kept in close behind Corax, and once or twice he found himself splashing through the little torrents that were running in the gutters, bearing away the dust and rubbish down the slope towards the sea. He counted seven fountains, all overflowing. The Augusta's loss was clearly Pompeii's gain. The whole force of the aqueduct had nowhere to run except here. So while the other towns around the bay were baking dry in the heat, the children of Pompeii paddled in the streets.

It was hard work, toiling up the hill. The press of people was mainly moving in the opposite direction, down towards the attractions of the forum, and by the time they reached the big northern gate Baculus was already waiting for them with their horses. He had hitched them to a post beside a small building that backed on to the city wall. Attilius said, 'The castellum aquae?' and Corax nodded.

The engineer took it in at a glance – the same redbrick construction as the Piscina Mirabilis, the same muffled sound of rushing water. It looked to be the highest point in the town and that made sense: invariably an aqueduct entered beneath a city's walls where the elevation was greatest. Gazing back down the hill he could see the water towers which regulated the pressure of the flow. He sent Musa inside the castellum to fetch out the water-slave while he turned his attention to the horses. They did not appear too bad. You would not want to enter them for a race at the Circus Maximus, but they would do the job. He counted out a small pile of gold coins and gave them to Baculus, who tested each one with his teeth. 'And the oxen?'

These, Baculus promised, with much solemn pressing of his hands to his heart and rolling of his eyes to heaven, would be ready by the seventh hour. He would attend to it immediately. He wished them all the blessings of Mercury on their journey, and took his leave – but only as far, Attilius noticed, as the bar across the street.

He assigned the horses on the basis of their strength.

The best he gave to Becco and Corvinus, on the grounds that they would have the most riding to do, and he was still explaining his reasons to an aggrieved Corax when Musa reappeared to announce that the castellum aquae was deserted.

'What?' Attilius wheeled round. 'Nobody there at all?'

'It's Vulcanalia, remember?'

Corax said, 'I told you he'd be no help.'

'Public holidays!' Attilius could have punched the brickwork in frustration. 'Somewhere in this town there had better be people willing to work.' He regarded his puny expedition uneasily, and thought again how unwise he had been in the admiral's library, mistaking what was theoretically possible with what actually could be achieved. But there was nothing else for it now. He cleared his throat. 'All right. You all know what you have to do? Becco, Corvinus – have either of you ever been up to Abellinum before?'

'I have,' said Becco.

'What's the set-up?'

'The springs rise beneath a temple dedicated to the water-goddesses, and flow into a basin within the nymphaeum. The aquarius in charge is Probus, who also serves as priest.'

'An aquarius as priest!' Attilius laughed bitterly and shook his head. 'Well, you can tell this heavenly engineer, whoever he is, that the goddesses, in their celestial wisdom, require him to close his main sluice and divert all his water to Beneventum. Make sure it's done

118

the moment you arrive. Becco – you are to remain behind in Abellinum and see it stays closed for twelve hours. Then you open it again. Twelve hours – as near exact as you can make it. Have you got that?'

Becco nodded.

'And if, by any remote chance, we can't make the repairs in twelve hours,' said Corax sarcastically, 'what then?'

'I've thought of that. As soon as the water is closed off, Corvinus leaves Becco at the basin and follows the course of the Augusta back down the mountains until he reaches the rest of us north-east of Vesuvius. By that time it will be clear how much work needs to be done. If we can't fix the problem in twelve hours, he can take word back to Becco to keep the sluice-gate closed until we've finished. That's a lot of riding, Corvinus. Are you up to it?'

'Yes, aquarius.'

'Good man.'

'Twelve hours!' repeated Corax, shaking his head. 'That's going to mean working through the night.'

'What's the matter, Corax? Scared of the dark?' Once again, he managed to coax a laugh from the other men. 'When you locate the problem, make an assessment of how much material we'll need for the repair job, and how much labour. You stay there and send Musa back with a report. I'll make sure I requisition enough torches along with everything else we need from the aediles. Once I've loaded up the wagons, I'll wait here at the castellum aquae to hear from you.'

'And what if I don't locate the problem?'

It occurred to Attilius that the overseer, in his bitterness, might even try to sabotage the entire mission. 'Then we'll set out anyway, and get to you before nightfall.' He smiled. 'So don't try to screw me around.'

'I'm sure there are plenty who'd like to screw you, pretty boy, but I'm not one of them.' Corax leered back at him. 'You're a long way from home, young Marcus Attilius. Take my advice. In this town – watch your back. If you know what I mean.'

And he thrust his groin back and forth in the same obscene gesture he had made out on the hillside the previous day, when Attilius had been prospecting for the spring.

He saw them off from the pomoerium, the sacred boundary just beyond the Vesuvius Gate, kept clear of buildings in honour of the city's guardian deities.

The road ran around the town like a racetrack, passing beside a bronze works and through a big cemetery. As the men mounted their horses Attilius felt he ought to say something – some speech like Caesar's, on the eve of battle – but he could never find those kinds of words. 'When this is done, I'll buy wine for everyone. In the finest place in Pompeii,' he added lamely.

'And a woman,' said Musa, pointing at him. 'Don't forget the women, aquarius!'

'The women you can pay for yourself.'

'If he can find a whore who'll have him!'

'Screw you, Becco. See you later, cocksuckers!'

And before Attilius could think of anything else to say they were kicking their heels into the sides of their horses and wheeling away through the crowds thronging into the city – Corax and Musa to the left, to pick up the trail to Nola; Becco and Corvinus right, towards Nuceria and Abellinum. As they trotted into the necropolis, only Corax looked back – not at Attilius, but over his head, towards the walls of the city. His glance swept along the ramparts and watchtowers for a final time, then he planted himself more firmly in the saddle and turned in the direction of Vesuvius.

The engineer followed the progress of the riders as they disappeared behind the tombs, leaving only a blur of brown dust above the white sarcophagi to show where they had passed. He stood for a few moments – he barely knew them, yet so many of his hopes, so much of his future went with them! – then he retraced his steps towards the city gate.

It was only as he joined the line of pedestrians queuing at the gate that he noticed the slight hump in the ground where the tunnel of the aqueduct passed beneath the city wall. He stopped and swivelled, following the line of it towards the nearest manhole, and saw to his surprise that its course pointed directly at the summit of Vesuvius. Through the haze of dust and heat the mountain loomed even more massively over the countryside than it had above the sea, but less distinctly; more bluish-grey than green. It was impossible that the spur should actually run all the way on to Vesuvius itself. He

guessed it must swerve off to the east at the edge of the lower slopes and travel inland to join up with the Augusta's main line. He wondered where exactly. He wished he knew the shape of the land, the quality of rock and soil. But Campania was a mystery to him.

He went back through the shadowy gate and into the glare of the small square, acutely aware suddenly of being alone in a strange town. What did Pompeii know or care of the crisis beyond its walls? The heedless activity of the place seemed deliberately to mock him. He walked around the side of the castellum aquae and along the short alley that led to its entrance. 'Is anyone there?'

No answer. He could hear the rush of the aqueduct much more clearly here, and when he pushed open the low wooden door he was hit at once by the drenching spray and that sharp, coarse, sweet smell – the smell that had pursued him all his life – of fresh water on warm stone.

He went inside. Fingers of light from two small windows set high above his head pierced the cool darkness. But he did not need light to know how the castellum was arranged for he had seen dozens of them over the years – all identical, all laid out according to the principles of Vitruvius. The tunnel of the Pompeii spur was smaller than the Augusta's main matrix, but still big enough for a man to squeeze along it to make repairs. The water jetted from its mouth through a bronze mesh screen into a shallow concrete reservoir divided by wooden gates, which in turn fed a set of three big lead pipes. The central conduit would carry the supply for

the drinking fountains; that to its left would be for private houses; that to its right for the public baths and theatres. What was unusual was the force of the flow. It was not only drenching the walls. It had also swept a mass of debris along the tunnel, trapping it against the metal screen. He could make out leaves and twigs and even a few small rocks. Slovenly maintenance. No wonder Corax had said the water-slave was useless.

He swung one leg over the concrete wall of the reservoir and then the other, and lowered himself into the swirling pool. The water came up almost to his waist. It was like stepping into warm silk. He waded the few paces to the grille and ran his hands underwater, around the edge of the mesh frame, feeling for its fastenings. When he found them, he unscrewed them. There were two more at the top. He undid those as well, lifted away the grille, and stood aside to let the rubbish swirl past him.

'Is somebody there?'

The voice startled him. A young man stood in the doorway. 'Of course there's somebody here, you fool. What does it look like?'

'What are you doing?'

'You're the water-slave? Then I'm doing your fucking job for you – that's what I'm doing. Wait there.' Attilius swung the grille back into place and refastened it, waded over to the side of the reservoir and hauled himself out. 'I'm Marcus Attilius. The new aquarius of the Augusta. And what do they call you, apart from a lazy idiot?'

'Tiro, aquarius.' The boy's eyes were open wide in

alarm, his pupils darting from side to side. 'Forgive me.'
He dropped to his knees. 'The public holiday, aquar-
ius – I slept late – I –'

'All right. Never mind that.' The boy was only about
sixteen – a scrap of humanity, as thin as a stray dog –
and Attilius regretted his roughness. 'Come on. Get up
off the floor. I need you to take me to the magistrates.'
He held out his hand but the slave ignored it, his eyes
still flickering wildly back and forth. Attilius waved his
palm in front of Tiro's face. 'You're blind?'

'Yes, aquarius.'

A blind guide. No wonder Corax had smiled when
Attilius had asked about him. A blind guide in an
unfriendly city! 'But how do you perform your duties
if you can't see?'

'I can hear better than any man.' Despite his nerv-
ousness, Tiro spoke with a trace of pride. 'I can tell by
the sound of the water how well it flows and if it's
obstructed. I can smell it. I can taste it for impurities.'
He lifted his head, sniffing the air. 'This morning there's
no need for me to adjust the gates. I've never heard the
flow so strong.'

'That's true.' The engineer nodded: he had underes-
timated the boy. 'The main line is blocked somewhere
between here and Nola. That's why I've come, to get
help to repair it. You're the property of the town?' Tiro
nodded. 'Who are the magistrates?'

'Marcus Holconius and Quintus Brittius,' said Tiro
promptly. 'The aediles are Lucius Popidius and Gaius
Cuspius.'

'Which is in charge of the water supply?'

'Popidius.'

'Where will I find him?'

'It's a holiday –'

'Where's his house then?'

'Straight down the hill, aquarius, towards the Stabian Gate. On the left. Just past the big crossroads.' Tiro scrambled to his feet eagerly. 'I can show you if you like.'

'Surely I can find it by myself?'

'No, no.' Tiro was already in the alley, anxious to prove himself. 'I can take you there. You'll see.'

They descended into the town together. It tumbled away below them, a jumble of terracotta roofs sloping down to a sparkling sea. Framing the view to the left was the blue ridge of the Surrentum peninsula; to the right was the tree-covered flank of Vesuvius. Attilius found it hard to imagine a more perfect spot in which to build a city, high enough above the bay to be wafted by the occasional breeze, close enough to the shore to enjoy the benefits of the Mediterranean trade. No wonder it had risen again so quickly after the earthquake.

The street was lined with houses, not the sprawling apartment blocks of Rome, but narrow-fronted, windowless dwellings that seemed to have turned their backs on the crowded traffic and to be looking inwards upon themselves. Open doors revealed an occasional

flash of what lay beyond – cool mosaic hallways, a sunny garden, a fountain – but apart from these glimpses, the only relief from the monotony of the drab walls were election slogans daubed in red paint.

'THE ENTIRE MASS HAVE APPROVED THE CANDIDACY OF CUSPIUS FOR THE OFFICE OF AEDILE.'

'THE FRUIT DEALERS TOGETHER WITH HELVIUS VESTALIS UNANIMOUSLY URGE THE ELECTION OF MARCUS HOLCONIUS PRISCUS AS MAGISTRATE WITH JUDICIAL POWER.'

'THE WORSHIPPERS OF ISIS UNANIMOUSLY URGE THE ELECTION OF LUCIUS POPIDIUS SECUNDUS AS AEDILE.'

'Your whole town appears to be obsessed with elections, Tiro. It's worse than Rome.'

'The free men vote for the new magistrates each March, aquarius.'

They were walking quickly, Tiro keeping a little ahead of Attilius, threading along the crowded pavement, occasionally stepping into the gutter to splash through the running stream. The engineer had to ask him to slow down. Tiro apologised. He had been blind from birth, he said cheerfully: had been dumped on the refuse tip outside the city walls and left to die. But someone had picked him up and he'd lived by running errands for the town since he was six years old. He knew his way by instinct.

'This aedile, Popidius,' said Attilius, as they passed his name for the third time, 'his must have been the family which once had Ampliatus as a slave.'

But Tiro, despite the keenness of his ears, seemed for once not to have heard.

They came to a big crossroads, dominated by an enormous triumphal arch, resting on four marble pillars. A team of four horses, frozen in stone, plunged and reared against the brilliant blue sky, hauling the figure of Victory in her golden chariot. The monument was dedicated to yet another Holconius – Marcus Holconius Rufus, dead these past sixty years – and Attilius paused long enough to read the inscription: military tribune, priest of Augustus, five times magistrate, patron of the town.

Always the same few names, he thought. Holconius, Popidius, Cuspius . . . The ordinary citizens might put on their togas every spring, turn out to listen to the speeches, throw their tablets into the urns and elect a new set of magistrates. But still the familiar faces came round again and again. The engineer had almost as little time for politicians as he had for the gods.

He was about to put his foot down to cross the street when he suddenly pulled it back. It appeared to him that the large stepping stones were rippling slightly. A great dry wave was passing through the town. An instant later he lurched, as he had done when the *Minerva* was moored, and he had to grab at Tiro's arm to stop himself falling. A few people screamed; a horse shied. On the opposite corner of the crossroads a tile slid down a steep-pitched roof and shattered on the pavement. For a few moments the centre of Pompeii was almost silent. And then, gradually, activity began again. Breath was exhaled. Conversations resumed. The driver flicked his whip over the back of his frantic horse and the cart jumped forwards.

Tiro took advantage of the lull in the traffic to dart across to the opposite side and, after a brief hesitation, Attilius followed, half-expecting the big raised stones to give way again beneath his leather soles. The sensation made him jumpier than he cared to admit. If you couldn't trust the ground you trod on, what could you trust?

The slave waited for him. His blank eyes, endlessly searching for what he could not see, gave him a look of constant unease. 'Don't worry, aquarius. It happens all the time this summer. Five times, ten times, even, in the past two days. The ground is complaining of the heat!'

He offered his hand but Attilius ignored it – he found it demeaning, the blind man reassuring the sighted – and mounted the high pavement unaided. He said irritably, 'Where's this bloody house?' and Tiro gestured vaguely to a doorway across the street, a little way down.

It did not look much. The usual blank walls. A bakery on one side, with a queue of customers waiting to enter a confectionery shop. A stink of urine from the laundry opposite, with pots left on the pavement for passers-by to piss in (nothing cleaned clothes as well as human piss). Next to the laundry, a theatre. Above the big door of the house was another of the ubiquitous, red-painted slogans: 'HIS NEIGHBOURS URGE THE ELECTION OF LUCIUS POPIDIUS AS AEDILE. HE WILL PROVE WORTHY.' Attilius would never have found the place on his own.

'Aquarius, may I ask you something?'

'What?'

'Where is Exomnius?'

'Nobody knows, Tiro. He's vanished.'

The slave absorbed this, nodding slowly. 'Exomnius was like you. He could not get used to the shaking, either. He said it reminded him of the time before the big earthquake, many years ago. The year I was born.'

He seemed to be on the edge of tears. Attilius put a hand on his shoulder and studied him intently. 'Exomnius was in Pompeii recently?'

'Of course. He lived here.'

Attilius tightened his grip. 'He lived *here*? In Pompeii?'

He felt bewildered and yet he also grasped immediately that it must be true. It explained why Exomnius's quarters at Misenum had been so devoid of personal possessions, why Corax had not wanted him to come here, and why the overseer had behaved so strangely in Pompeii – all that looking around, searching the crowds for a familiar face.

'He had rooms at Africanus's place,' said Tiro. 'He was not here all the time. But often.'

'And how long ago did you speak to him?'

'I can't remember.' The youth really was beginning to seem frightened now. He turned his head as though trying to look at Attilius's hand on his shoulder. The engineer quickly released him and patted his arm reassuringly.

'Try to remember, Tiro. It could be important.'

'I don't know.'

'After the Festival of Neptune or before?' Neptunalia was on the twenty-third day of July: the most sacred date in the calendar for the men of the aqueducts.

'After. Definitely. Perhaps two weeks ago.'

'Two weeks? Then you must have been one of the last to talk to him. And he was worried about the tremors?' Tiro nodded again. 'And Ampliatus? He was a great friend of Ampliatus, was he not? Were they often together?'

The slave gestured to his eyes. 'I cannot see —'

No, thought Attilius, but I bet you heard them: not much escapes those ears of yours. He glanced across the street at the house of Popidius. 'All right, Tiro. You can go back to the castellum. Do your day's work. I'm grateful for your help.'

'Thank you, aquarius.' Tiro gave a little bow and took Attilius's hand and kissed it. Then he turned and began climbing back up the hill towards the Vesuvius Gate, dancing from side to side through the holiday crowd.

Hora quinta

[11:07 hours]

*'Injections of new magma can also trigger
eruptions by upsetting the thermal, chemical, or
mechanical equilibrium of older magma in a
shallow reservoir. New magmas coming from
deeper, hotter sources can suddenly raise the
temperature of the cooler resident magma causing
it to convect and vesiculate.'*

Volcanology *(second edition)*

T he house had a double door – heavy-studded,
bronze-hinged, firmly closed. Attilius hammered
on it a couple of times with his fist. The noise
he made seemed too feeble to be heard above the racket
of the street. But almost at once it opened slightly and
the porter appeared – a Nubian, immensely tall and broad
in a sleeveless crimson tunic. His thick black arms and
neck, as solid as tree trunks, glistened with oil, like some
polished African hardwood.

131

Attilius said lightly, 'A keeper worthy of his gate, I see.'

The porter did not smile. 'State your business.'

'Marcus Attilius, aquarius of the Aqua Augusta, wishes to present his compliments to Lucius Popidius Secundus.'

'It's a public holiday. He's not at home.'

Attilius put his foot against the door. 'He is now.' He opened his bag, and pulled out the admiral's letter. 'Do you see this seal? Give it to him. Tell him it's from the commander-in-chief at Misenum. Tell him I need to see him on the Emperor's business.'

The porter looked down at Attilius's foot. If he had slammed the door he would have snapped it like a twig. A man's voice behind him cut in: 'The Emperor's business, did he just say, Massavo? You had better let him in.' The Nubian hesitated – Massavo: that was the right name for him, thought Attilius – then stepped backwards, and the engineer slipped quickly through the opening. The door was closed and locked behind him; the sounds of the city were extinguished.

The man who had spoken wore the same crimson uniform as the porter. He had a bunch of keys attached to his belt – the household steward, presumably. He took the letter and ran his thumb across the seal, checking to see if it was broken. Satisfied, he studied Attilius. 'Lucius Popidius is entertaining guests for Vulcanalia. But I shall see that he receives it.'

'No,' said Attilius. 'I shall give it to him myself. Immediately.'

He held out his hand. The steward tapped the cylinder of papyrus against his teeth, trying to decide what to do. 'Very well.' He gave Attilius the letter. 'Follow me.'

He led the way down the narrow corridor of the vestibule towards a sunlit atrium, and for the first time Attilius began to appreciate the immensity of the old house. The narrow façade was an illusion. He could see beyond the shoulder of the steward straight through into the interior, a hundred and fifty feet or more, successive vistas of light and colour – the shaded passageway with its black and white mosaic floor; the dazzling brilliance of the atrium with its marble fountain; a tablinum for receiving visitors, guarded by two bronze busts; and then a colonnaded swimming pool, its pillars wrapped with vines. He could hear finches chirruping in an aviary somewhere, and women's voices, laughing.

They came into the atrium and the steward said, brusquely, 'Wait here,' before disappearing to the left, behind a curtain that screened a narrow passageway. Attilius glanced around. Here was money, old money, used to buy absolute privacy in the middle of the busy town. The sun was almost directly overhead, shining through the square aperture in the atrium's roof, and the air was warm and sweet with the scent of roses. From this position he could see most of the swimming pool. Elaborate bronze statues decorated the steps at the nearest end – a wild boar, a lion, a snake rising from its coils, and Apollo playing the cithara. At the far end,

four women reclined on couches, fanning themselves, each with her own maid standing behind her. They noticed Attilius staring and there was a little flutter of laughter from behind their fans. He felt himself redden with embarrassment and he quickly turned his back on them, just as the curtain parted and the steward reappeared, beckoning.

Attilius knew at once, by the humidity and by the smell of oil, that he was being shown into the house's private baths. And of course, he thought, it was bound to have its own suite, for with money such as this, why mix with the common herd? The steward took him into the changing room and told him to remove his shoes then they went back out into the passageway and into the tepidarium, where an immensely fat old man lay face down, naked, on a table, being worked on by a young masseur. His white buttocks vibrated as the masseur made chopping motions up and down his spine. He turned his head slightly as Attilius passed by, regarded him with a single, bloodshot grey eye, then closed it again.

The steward slid open a door, releasing a billow of fragrant vapour from the dim interior, then stood aside to let the engineer pass through.

It was hard at first to see very much in the caldarium. The only light came from a couple of torches mounted on the wall and from the glowing coals of a brazier, the source of the steam which filled the room. Gradually Attilius made out a large sunken bath with three dark heads of hair, seemingly disembodied,

floating in the greyness. There was a ripple of water as one of the heads moved and a splash as a hand was raised and gently waved.

'Over here, aquarius,' said a languid voice. 'You have a message for me, I believe, from the Emperor? I don't know these Flavians. Descended from a tax-collector, I believe. But Nero was a great friend of mine.'

Another head was stirring. 'Fetch us a torch!' it commanded. 'Let us at least see who disturbs us on a feast day.'

A slave in the corner of the room, who Attilius had not noticed, took down one of the torches from the wall and held it close to the engineer's face so that he could be inspected. All three heads were now turned towards him. Attilius could feel the pores of his skin opening, the sweat running freely down his body. The mosaic floor was baking hot beneath his bare feet – a hypocaust, he realised. Luxury was certainly piled upon luxury in the house of the Popidii. He wondered if Ampliatus, in the days when he was a slave here, had ever been made to sweat over the furnace in mid-summer.

The heat of the torch on his cheek was unbearable. 'This is no place to conduct the Emperor's business,' he said and pushed the slave's arm away. 'To whom am I speaking?'

'He's certainly a rude enough fellow,' declared the third head.

'I am Lucius Popidius,' said the languid voice, 'and these gentlemen are Gaius Cuspius and Marcus

Holconius. And our esteemed friend in the tepidarium is Quintus Brittius. Now do you know who we are?'

'You're the four elected magistrates of Pompeii.'

'Correct,' said Popidius. 'And this is our town, aquarius, so guard your tongue.'

Attilius knew how the system worked. As aediles, Popidius and Cuspius would hand out the licences for all the businesses, from the brothels to the baths; they were responsible for keeping the streets clean, the water flowing, the temples open. Holconius and Brittius were the duoviri – the commission of two men – who presided over the court in the basilica and dispensed the Emperor's justice: a flogging here, a crucifixion there, and no doubt a fine to fill the city's coffers whenever possible. He would not be able to accomplish much without them so he forced himself to stand quietly, waiting for them to speak. Time, he thought: I am losing so much time.

'Well,' said Popidius after a while. 'I suppose I have cooked for long enough.' He sighed and stood, a ghostly figure in the steam, and held out his hand for a towel. The slave replaced the torch in its holder, knelt before his master and wrapped a cloth around his waist. 'All right. Where's this letter?' He took it and padded into the adjoining room. Attilius followed.

Brittius was on his back and the young slave had obviously been giving him more than a massage for his penis was red and engorged and pointing hard against the fat slope of his belly. The old man batted away the slave's hands, and reached for a towel. His face was

scarlet. He scowled at Attilius. 'Who's this then, Popi?'

'The new aquarius of the Augusta. Exomnius's replacement. He's come from Misenum.' Popidius broke open the seal and unrolled the letter. He was in his early forties, delicately handsome. The dark hair slicked back over his small ears emphasised his aquiline profile as he bent forwards to read; the skin of his body was white, smooth, hairless. He has had it plucked, thought Attilius with disgust.

The others were now coming in from the caldarium, curious to find out what was happening, slopping water over the black and white floor. Around the walls ran a fresco of a garden, enclosed inside a wooden fence. In an alcove, on a pedestal carved to resemble a water nymph, stood a circular marble basin.

Brittius propped himself up on his elbow. 'Read it out, Popi. What's it say?'

A frown creased Popidius's smooth skin. 'It's from Pliny. "In the name of the Emperor Titus Caesar Vespasianus Augustus, and in accordance with the power vested in me by the Senate and People of Rome –"'

'Skip the blather!' said Brittius. 'Get to the meat of it.' He rubbed his thumb and middle finger together, counting money. 'What's he after?'

'It seems the aqueduct has failed somewhere near Vesuvius. All the towns from Nola westwards are dry. He says he wants us – "orders" us, he says – to "provide immediately sufficient men and materials from the colony of Pompeii to effect repairs to the Aqua Augusta, under the command of Marcus Attilius Primus,

engineer, of the Department of the Curator Aquarum, Rome".'

'Does he indeed? And who foots the bill, might I ask?'

'He doesn't say.'

Attilius cut in: 'Money is not an issue. I can assure your honours that the Curator Aquarum will reimburse any costs.'

'Really? You have the authority to make that promise, do you?'

Attilius hesitated. 'You have my word.'

'Your word? Your word won't put gold back in our treasury once it's gone.'

'And look at this,' said one of the other men. He was in his middle-twenties, well-muscled, but with a small head: Attilius guessed he must be the second junior magistrate, the aedile, Cuspius. He turned the tap above the circular basin and water gushed out. 'There's no drought here – d'you see? So I say this: what's it to do with us? You want men and materials? Go to one of these towns that has no water. Go to Nola. We're swimming in it! Look!' And to make his point he opened the tap wider and left it running.

'Besides,' said Brittius craftily, 'it's good for business. Anybody on the bay who wants a bath, or a drink for that matter – he has to come to Pompeii. And on a public holiday, too. What do you say, Holconius?'

The oldest magistrate adjusted his towel around him like a toga. 'It's offensive to the priests to see men working on a holy day,' he announced judiciously. 'People

should do as we are doing – they should gather with their friends and families to observe the religious rites. I vote we tell this young fellow, with all due respect to Admiral Pliny, to fuck off out of here.'

Brittius roared with laughter, banging on the side of the table in approval. Popidius smiled and rolled up the papyrus. 'I think you have our answer, aquarius. Why don't you come back tomorrow and we'll see what we can do?'

He tried to hand the letter back but Attilius reached past him and firmly closed the tap. What a picture they looked, the three of them, dripping with water – *his* water – and Brittius, with his puny hard-on, now lost in the flabby folds of his lap. The sickly scented heat was unbearable. He wiped his face on the sleeve of his tunic.

'Now listen to me, your honours. From midnight tonight, Pompeii will also lose her water. The whole supply is being diverted to Beneventum, so we can get inside the tunnel of the aqueduct to repair it. I've already sent my men into the mountains to close the sluices.' There was a mutter of anger. He held up his hand. 'Surely it's in the interests of all citizens on the bay to co-operate?' He looked at Cuspius. 'Yes, all right – I could go to Nola for assistance. But at the cost of at least a day. And that's an extra day you'll be without water, as well as they.'

'Yes, but with one difference,' said Cuspius. 'We'll have some notice. How about this for an idea, Popidius? We could issue a proclamation, telling our citizens to

fill every container they possess and in that way ours will still be the only town on the bay with a reserve of water.'

'We could even sell it,' said Brittius. 'And the longer the drought goes on, the better the price we could get for it.'

'It's not yours to sell!' Attilius was finding it hard to keep his temper. 'If you refuse to help me, I swear that the first thing I'll do after the main line is repaired is to see to it that the spur to Pompeii is closed.' He had no authority to issue such a threat, but he swept on anyway, jabbing his finger in Cuspius's chest. 'And I'll send to Rome for a commissioner to come down and investigate the abuse of the imperial aqueduct. I'll make you pay for every extra cupful you've taken beyond your proper share!'

'Such insolence!' shouted Brittius.

'He touched me!' said Cuspius, outraged. 'You all saw that? This piece of scum actually laid his filthy hand on me!' He stuck out his chin and stepped up close to Attilius, ready for a fight, and the engineer might have retaliated, which would have been disastrous – for him, for his mission – if the curtain had not been swished aside to reveal another man, who had obviously been standing in the passageway listening to their conversation.

Attilius had only met him once, but he was not about to forget him in a hurry: Numerius Popidius Ampliatus.

* * *

140

What most astonished Attilius, once he had recovered from the shock of seeing him again, was how much they all deferred to him. Even Brittius swung his plump legs over the side of the table and straightened his back, as if it was somehow disrespectful to be caught lying down in the presence of this former slave. Ampliatus put a restraining hand on Cuspius's shoulder, whispered a few words in his ear, winked, tousled his hair, and all the while he kept his eyes on Attilius.

The engineer remembered the bloody remains of the slave in the eel pool, the lacerated back of the slave-woman.

'So what's all this, gentlemen?' Ampliatus suddenly grinned and pointed at Attilius. 'Arguing in the baths? On a religious festival? That's unseemly. Where were you all brought up?'

Popidius said, 'This is the new aquarius of the aqueduct.'

'I know Marcus Attilius. We've met, haven't we, aquarius? May I see that?' He took Pliny's letter from Popidius and scanned it quickly, then glanced at Attilius. He was wearing a tunic bordered in gold, his hair was glossy, and there was the same smell of expensive unguents that the engineer had noticed the previous day.

'What is your plan?'

'To follow the spur from Pompeii back to its junction with the Augusta, then to work my way along the main line towards Nola until I find the break.'

'And what is it you need?'

'I don't know yet exactly.' Attilius hesitated. The appearance of Ampliatus had disconcerted him. 'Quicklime. Puteolanum. Bricks. Timber. Torches. Men.'

'How much of each?'

'Perhaps six amphorae of lime to start with. A dozen baskets of puteolanum. Fifty paces of timber and five hundred bricks. As many torches as you can spare. Ten strong pairs of hands. I may need less, I may need more. It depends how badly the aqueduct is damaged.'

'How soon will you know?'

'One of my men will report back this afternoon.'

Ampliatus nodded. 'Well, if you want my opinion, your honours, I think we should do all in our power to help. Never let it be said that the ancient colony of Pompeii turned its back on an appeal from the Emperor. Besides, I have a fishery in Misenum that drinks water like Brittius here drinks wine. I want that aqueduct running again as soon as possible. What do you say?'

The magistrates exchanged uneasy glances. Eventually Popidius said, 'It may be that we were over-hasty.'

Only Cuspius risked a show of defiance. 'I still think this ought to be Nola's responsibility –'

Ampliatus cut him off. 'That's settled then. I can let you have all you need, Marcus Attilius, if you'll just be so good as to wait outside.' He shouted over his shoulder to the steward. 'Scutarius! Give the aquarius his shoes!'

None of the others spoke to Attilius or looked at him. They were like naughty schoolboys discovered fighting by their master.

The engineer collected his shoes and walked out of the tepidarium, into the gloomy passageway. The curtain was quickly drawn behind him. He leaned against the wall to pull on his shoes, trying to listen to what was being said, but he could make out nothing. From the direction of the atrium he heard a splash as someone dived into the swimming pool. This reminder that the house was busy for the holiday made up his mind for him. He dared not risk being caught eavesdropping. He opened the second curtain and stepped back out into the dazzling sunlight. Across the atrium, beyond the tablinum, the surface of the pool was rocking from the impact of the dive. The wives of the magistrates were still gossiping at the other end, where they had been joined by a dowdy middle-aged matron who sat demurely apart, her hands folded in her lap. A couple of slaves carrying trays laden with dishes passed behind them. There was a smell of cooking. A huge feast was clearly in preparation.

His eye was caught by a flash of darkness beneath the glittering water and an instant later the swimmer broke the surface.

'Corelia Ampliata!'

He said her name aloud, unintentionally. She did not hear him. She shook her head, and stroked her black hair away from her closed eyes, gathering it behind her with both hands. Her elbows were spread wide, her

pale face tilted towards the sun, oblivious to his watching her.

'Corelia!' He whispered it, not wanting to attract the attention of the other women, and this time she turned. It took a moment for her to search him out against the glare of the atrium, but when she found him she began wading towards him. She was wearing a shift of thin material that came down almost to her knees and as her body emerged from the water she placed one dripping arm across her breasts and the other between her thighs, like some modest Venus arising from the waves. He stepped into the tablinum and walked towards the pool, past the funeral masks of the Popidii clan. Red ribbons linked the images of the dead, showing who was related to whom, in a criss-cross pattern of power stretching back for generations.

'Aquarius,' she hissed, 'you must leave this place!' She was standing on the circular steps that led out of the pool. 'Get out! Go! My father is here, and if he sees you –'

'Too late for that. We've met.' But he drew back slightly, so that he was hidden from the view of the women at the other end of the pool. I ought to look away, he thought. It would be the honourable thing to do. But he could not take his eyes off her. 'What are you doing here?'

'What am I doing here?' She regarded him as if he were an idiot and leaned toward him. 'Where else should I be? *My father owns this house.*'

At first he did not fully take in what she was saying.

'But I was told that Lucius Popidius lived here –'

'He does.'

He was still confused. 'Then – ?'

'We are to be married.' She said it flatly and shrugged, and there was something terrible in the gesture, an utter hopelessness, and suddenly all was clear to him – the reason for Ampliatus's unannounced appearance, Popidius's deference to him, the way the others had followed his lead. Somehow Ampliatus had contrived to buy the roof from over Popidius's head and now he was going to extend his ownership completely, by marrying off his daughter to his former master. The thought of that ageing playboy, with his plucked and hairless body, sharing a bed with Corelia filled him with an unexpected anger, even though he told himself it was none of his business.

'But surely a man as old as Popidius is already married?'

'He was. He's been forced to divorce.'

'And what does Popidius think of such an arrangement?'

'He thinks it is contemptible, of course, to make a match so far beneath him – as you do, clearly.'

'Not at all, Corelia,' he said quickly. He saw that she had tears in her eyes. 'On the contrary. I should say you were worth a hundred Popidii. A thousand.'

'I hate him,' she said. But whether she meant Popidius or her father he could not tell.

From the passage came the sound of rapid footsteps and Ampliatus's voice, yelling, 'Aquarius!'

She shuddered. 'Please leave, I beg you. You were a good man to have tried to help me yesterday. But don't let him trap you, as he's trapped the rest of us.'

Attilius said stiffly, 'I am a freeborn Roman citizen, on the staff of the Curator Aquarum, in the service of the Emperor, here on official business to repair the imperial aqueduct – not some slave, to be fed to his eels. Or an elderly woman, for that matter, to be beaten half to death.'

It was her turn to be shocked. She put her hands to her mouth. 'Atia?'

'Atia, yes – is that her name? Last night I found her lying in the street and took her back to my quarters. She had been whipped senseless and left out to die like an old dog.'

'Monster!' Corelia stepped backwards, her hands still pressed to her face, and sank into the water.

'You take advantage of my good nature, aquarius!' said Ampliatus. He was advancing across the tablinum. 'I told you to wait for me, that was all.' He glared at Corelia – 'You should know better, after what I told you yesterday!' – then shouted across the pool – 'Celsia!' – and the mousy woman Attilius had noticed earlier jerked up in her chair. 'Get our daughter out of the pool! It's unseemly for her to show her tits in public!' He turned to Attilius. 'Look at them over there, like a lot of fat hens on their nests!' He flapped his arms at them, emitting a series of squawks – *cluuuuck, cluck-cluck-cluck!* – and the women raised their fans in distaste. 'They won't fly, though. Oh no. One thing I've learned

about our Roman aristocrat – he'll go anywhere for a free meal. And his women are even worse.' He called out: 'I'll be back in an hour! Don't dish up without me!' And with a gesture to Attilius that he should fall in behind him, the new master of the House of the Popidii turned on his heel and strode towards the door.

As they passed through the atrium, Attilius glanced back at the pool where Corelia was still submerged, as if she thought that by completely immersing herself she could wash away what was happening.

Hora sexta

[12:00 hours]

'As magma rises from depth, it undergoes a large pressure decrease. At a 10-kilometre depth, for example, pressures are about 300 megapascals (MPa), or 3000 times the atmospheric pressure. Such a large pressure change has many consequences for the physical properties and flow of magma.'

Encyclopaedia of Volcanoes

Ampliatus had a litter and eight slaves waiting outside on the pavement, dressed in the same crimson livery as the porter and steward. They scrambled to attention as their master appeared but he walked straight past them, just as he ignored the small crowd of petitioners squatting in the shade of the wall across the street, despite the public holiday, who called out his name in a ragged chorus.

'We'll walk,' he said, and set off up the slope towards

148

the crossroads, maintaining the same fast pace as he had in the house. Attilius followed at his shoulder. It was noon, the air scalding, the roads quiet. The few pedestrians who were about mostly hopped into the gutter as Ampliatus approached or drew back into the shop doorways. He hummed to himself as he walked, nodding an occasional greeting, and when the engineer looked back he saw that they were trailing a retinue that would have done credit to a senator – first, at a discreet distance, the slaves with the litter, and behind them the little straggle of supplicants: men with the dejected, exhausted look that came from dancing attendance on a great man since before dawn and knowing themselves doomed to disappointment.

About halfway up the hill to the Vesuvius Gate – the engineer counted three city blocks – Ampliatus turned right, crossed the street, and opened a little wooden door set into a wall. He put his hand on Attilius's shoulder to usher him inside and Attilius felt his flesh recoil at the millionaire's touch.

'Don't let him trap you, as he's trapped the rest of us.'

He eased himself clear of the grasping fingers. Ampliatus closed the door behind them and he found himself standing in a big, deserted space, a building site, occupying the best part of the entire block. To the left was a brick wall surmounted by a sloping, red-tiled roof – the back of a row of shops – with a pair of high wooden gates set into the middle; to the right, a complex of new buildings, very nearly finished, with large modern windows looking out across the expanse of

scrub and rubble. A rectangular tank was being excavated directly beneath the windows.

Ampliatus had his hands on his hips and was studying the engineer's reaction. 'So then. What do you think I'm building? I'll give you one guess.'

'Baths.'

'That's it. What do you think?'

'It's impressive,' said Attilius. And it was, he thought. At least as good as anything he had seen under construction in Rome in the past ten years. The brickwork and the columns were beautifully finished. There was a sense of tranquillity – of space, and peace, and light. The high windows faced south-west to take advantage of the afternoon sun, which was just beginning to flood into the interior. 'I congratulate you.'

'We had to demolish almost the whole block to make way for it,' said Ampliatus, 'and that was unpopular. But it will be worth it. It will be the finest baths outside Rome. And more modern than anything you've got up there.' He looked around, proudly. 'We provincials, you know, when we put our minds to it, we can still show you big city men from Rome a thing or two.' He cupped his hands to his mouth and bellowed, 'Januarius!'

From the other side of the yard came an answering shout, and a tall man appeared at the top of a flight of stairs. He recognised his master and ran down the steps and across the yard, wiping his hands on his tunic, bobbing his head in a series of bows as he came closer.

'Januarius – this is my friend, the aquarius of the Augusta. He works for the Emperor!'

'Honoured,' said Januarius, and gave Attilius another bow.

'Januarius is one of my foremen. Where are the lads?'

'In the barracks, sir.' He looked terrified, as if he had been caught idling. 'It's the holiday –'

'Forget the holiday! We need them here now. Ten did you say you needed, aquarius? Better make it a dozen. Januarius, send for a dozen of the strongest men we have. Brebix's gang. Tell them they're to bring food and drink for a day. What else was it you needed?'

'Quicklime,' began Attilius, 'puteolanum –'

'That's it. All that stuff. Timber. Bricks. Torches – don't forget torches. He's to have everything he needs. And you'll require transport, won't you? A couple of teams of oxen?'

'I've already hired them.'

'But you'll have mine – I insist.'

'No.' Ampliatus's generosity was starting to make the engineer uneasy. First would come the gift, then the gift would turn out to be a loan, and then the loan would prove a debt impossible to pay back. That was no doubt how Popidius had ended up losing his house. *A hustler's town.* He glanced at the sky. 'It's noon. The oxen should be arriving down at the harbour by now. I have a slave waiting there with our tools.'

'Who did you hire from?'

'Baculus.'

'Baculus! That drunken thief! My oxen would be better. At least let me have a word with him. I'll get you a fat discount.'

Attilius shrugged. 'If you insist.'

'I do. Fetch the men from the barracks, Januarius, and send a boy to the docks to have the aquarius's wagons brought here for loading. I'll show you around while we're waiting, aquarius.' And again his hand fell upon the engineer's shoulder. 'Come.'

Baths were not a luxury. Baths were the foundation of civilisation. Baths were what raised even the meanest citizen of Rome above the level of the wealthiest hairy-arsed barbarian. Baths instilled the triple disciplines of cleanliness, healthfulness and strict routine. Was it not to feed the baths that the aqueducts had been invented in the first place? Had not the baths spread the Roman ethos across Europe, Africa and Asia as effectively as the legions, so that in whatever town in this far-flung empire a man might find himself, he could at least be sure of finding this one precious piece of home?

Such was the essence of Ampliatus's lecture as he conducted Attilius around the empty shell of his dream. The rooms were unfurnished and smelled strongly of fresh paint and stucco and their footsteps echoed as they passed through the cubicles and exercise rooms into the main part of the building. Here, the frescoes were already in place. Views of the green Nile, studded with basking crocodiles, flowed into scenes from the lives of the gods. Triton swam beside the Argonauts and led them back to safety. Neptune transformed his son

into a swan. Perseus saved Andromeda from the sea-monster sent to attack the Ethiopians. The pool in the caldarium was built to take twenty-eight paying customers at a time, and as the bathers lay on their backs they would gaze up at a sapphire ceiling, lit by five hundred lamps and swimming with every species of marine life, and believe themselves to be floating in an undersea grotto.

To attain the luxury he demanded, Ampliatus was employing the most modern techniques, the best materials, the most skilful craftsmen in Italy. There were Neapolitan glass windows in the dome of the laconium – the sweating-room – as thick as a man's finger. The floors and the walls and the ceilings were hollow, the furnace that heated the cavities so powerful that even if snow lay on the ground, the air inside would be sweltering enough to melt a man's flesh. It was built to withstand an earthquake. All the main fittings – pipes, drains, grills, vents, taps, stop-cocks, shower-nozzles, even the handles to flush the latrines – were of brass. The lavatory seats were Phrygian marble, with elbow rests carved in the shape of dolphins and chimeras. Hot and cold running water throughout. *Civilisation.*

Attilius had to admire the vision of the man. Ampliatus took so much pride in showing him everything it was almost as if he was soliciting an investment. And the truth was that if the engineer had had any money – if most of his salary had not already been sent back home to his mother and sister – he might well have given him every last coin, for he had never

encountered a more persuasive salesman than Numerius Popidius Ampliatus.

'How soon before you're finished?'

'I should say a month. I need to bring in the carpenters. I want some shelves, a few cupboards. I thought of putting down sprung wood floors in the changing room. I was considering pine.'

'No,' said Attilius. 'Use alder.'

'Alder? Why?'

'It won't rot in contact with water. I'd use pine – or perhaps a cypress – for the shutters. But it would need to be something from the lowlands, where the sun shines. Don't touch pine from the mountains. Not for a building of this quality.'

'Any other advice?'

'Always use timber cut in the autumn, not the spring. Trees are pregnant in the spring and the wood is weaker. For clamping, use olive wood, scorched – it will last for a century. But you probably know all that.'

'Not at all. I've built a lot, it's true, but I've never understood much about wood and stone. It's money I understand. And the great thing about money is that it doesn't matter when you harvest it. It's an all-year crop.' He laughed at his own joke and turned to look at the engineer. There was something unnerving about the intensity of his gaze, which was not steady, but which shifted, as if he were constantly measuring different aspects of whomever he addressed, and Attilius thought, No, it's not money you understand, it's men – their strengths and their weaknesses; when to flatter,

when to frighten. 'And you, aquarius?' Ampliatus said quietly. 'What is it that you know?'

'Water.'

'Well, that's an important thing to know. Water is at least as valuable as money.'

'Is it? Then why aren't I a rich man?'

'Perhaps you could be.' He made the remark lightly, left it floating for a moment beneath the massive dome, and then went on: 'Do you ever stop to think how curiously the world is ordered, aquarius? When this place is open, I shall make another fortune. And then I shall use that fortune to make another, and another. But without your aqueduct, I could not build my baths. That's a thought, is it not? Without Attilius: no Ampliatus.'

'Except that it's not my aqueduct. I didn't build it – the Emperor did.'

'True. And at a cost of two million a mile! "The late lamented Augustus" – was ever a man more justly proclaimed a deity? Give me the Divine Augustus over Jupiter any time. I say my prayers to him every day.' He sniffed the air. 'This wet paint makes my head ache. Let me show you my plans for the grounds.'

He led them back the way they had come. The sun was shining fully now through the large open windows. The gods on the opposite walls seemed alive with colour. Yet there was something haunted about the empty rooms – the drowsy stillness, the dust floating in the shafts of light, the cooing of the pigeons in the builders' yard. One bird must have flown into the laconium and

become trapped. The sudden flapping of its wings against the dome made the engineer's heart jump.

Outside, the luminous air felt almost solid with the heat, like melted glass, but Ampliatus did not appear to feel it. He climbed the open staircase easily and stepped on to the small sun deck. From here he had a commanding view of his little kingdom. That would be the exercise yard, he said. He would plant plane trees around it for shade. He was experimenting with a method of heating the water in the outdoor pool. He patted the stone parapet. 'This was the site of my first property. Seventeen years ago I bought it. If I told you how little I paid for it, you wouldn't believe me. Mark you, there was not much left of it after the earthquake. No roof, just the walls. I was twenty-eight. Never been so happy, before or since. Repaired it, rented it out, bought another, rented that. Some of these big old houses from the time of the Republic were huge. I split them up and fitted ten families into them. I've gone on doing it ever since. Here's a piece of advice for you, my friend: there's no safer investment than property in Pompeii.'

He swatted a fly on the back of his neck and inspected its pulpy corpse between his fingers. He flicked it away. Attilius could imagine him as a young man – brutal, energetic, remorseless. 'You had been freed by the Popidii by then?'

Ampliatus shot him a look. However hard he tries to be affable, thought Attilius, those eyes will always betray him.

156

'If that was meant as an insult, aquarius, forget it. Everyone knows Numerius Popidius Ampliatus was born a slave and he's not ashamed of it. Yes, I was free. I was manumitted in my master's will when I was twenty. Lucius, his son – the one you just met – made me his household steward. Then I did some debt-collecting for an old money-lender called Jucundus, and he taught me a lot. But I never would have been rich if it hadn't been for the earthquake.' He looked fondly towards Vesuvius. His voice softened. 'It came down from the mountain one morning in February like a wind beneath the earth. I watched it coming, the trees bowing as it passed, and by the time it had finished this town was rubble. It didn't matter then who had been born a free man and who had been born a slave. The place was empty. You could walk the streets for an hour and meet no one except for the dead.'

'Who was in charge of rebuilding the town?'

'Nobody! That was the disgrace of it. All the richest families ran away to their country estates. They were all convinced there was going to be another earthquake.'

'Including Popidius?'

'Especially Popidius!' He wrung his hands, and whined, '"Oh, Ampliatus, the gods have forsaken us! Oh, Ampliatus, the gods are punishing us!" The gods! I ask you! As if the gods could care less who or what we fuck or how we live. As if earthquakes aren't as much a part of living in Campania as hot springs and summer droughts! They came creeping back, of course, once they saw it was safe, but by then things had started to change.

157

Salve lucrum! "Hail profit!" That's the motto of the new Pompeii. You'll see it all over the town. *Lucrum gaudium!* "Profit is joy!" Not money, mark you – any fool can inherit money. Profit. That takes skill.' He spat over the low wall into the street below. 'Lucius Popidius! What skill does he have? He can drink in cold water and piss out hot, and that's about the limit of it. Whereas you –' and again Attilius felt himself being sized up '– you, I think, are a man of some ability. I see myself in you, when I was your age. I could use a fellow like you.'

'Use me?'

'Here, for a start. These baths could do with a man who understands water. In return for your advice, I could cut you in. A share of the profits.'

Attilius shook his head, smiling. 'I don't think so.'

Ampliatus smiled back. 'Ah, you drive a hard bargain! I admire that in a man. Very well – a share of the owner-ship, too.'

'No. Thank you. I'm flattered. But my family has worked the imperial aqueducts for a century. I was born to be an engineer on the matrices, and I shall die doing it.'

'Why not do both?'

'What?'

'Run the aqueduct, and advise me as well. No one need ever know.'

Attilius looked at him closely, at his crafty, eager face. Beneath the money, the violence and the lust for power, he was really nothing bigger than a small-town crook. 'No,' he said coldly, 'that would be impossible.'

The contempt must have shown in his face because Ampliatus retreated at once. 'You're right,' he said, nodding. 'Forget I even mentioned it. I'm a rough fellow sometimes. I have these ideas without always thinking them through.'

'Like executing a slave before finding out if he's telling the truth?'

Ampliatus grinned and pointed at Attilius. 'Very good! That's right. But how can you expect a man like me to know how to behave? You can have all the money in the Empire but it doesn't make you a gentleman, right? You may think you're copying the aristocracy, showing a bit of class, but then it turns out you're a monster. Isn't that what Corelia called me? A monster?'

'And Exomnius?' Attilius blurted out the question. 'Did you have an arrangement with him that nobody ever knew about?'

Ampliatus's smile did not waver. From down in the street came a rumble of heavy wooden wheels on stone. 'Listen – I think I can hear your wagons coming. We'd better go down and let them in.'

The conversation might never have happened. Humming to himself again, Ampliatus dodged across the rubble-strewn yard. He swung open the heavy gates and as Polites led the first team of oxen into the site he made a formal bow. A man Attilius did not recognise was leading the second team; a couple more sat on the back of the empty cart, their legs dangling

over the side. They jumped down immediately when they noticed Ampliatus and stood looking respectfully at the ground.

'Well done, lads,' said Ampliatus. 'I'll see you're rewarded for working a holiday. But it's an emergency and we've all got to rally round and help fix the aqueduct. For the common good – isn't that right, aquarius?' He pinched the cheek of the nearest man. 'You're under his command now. Serve him well. Aquarius: take as much as you want. It's all in the yard. Torches are inside in the storeroom. Is there anything more I can do for you?' He was obviously eager to go.

'I shall make an inventory of what we use,' said Attilius formally. 'You will be compensated.'

'There's no need. But as you wish. I wouldn't want to be accused of trying to corrupt you!' He laughed, and pointed again. 'I'd stay and help you load myself – nobody ever said that Numerius Popidius Ampliatus was afraid of getting his hands dirty! – but you know how it is. We're dining early because of the festival and I mustn't show my low birth by keeping all those fine gentlemen and their ladies waiting.' He held out his hand. 'So! I wish you luck, aquarius.'

Attilius took it. The grip was dry and firm; the palm and fingers, like his own, callused by hard work. He nodded. 'Thank you.'

Ampliatus grunted and turned away. Outside in the quiet street his litter was waiting for him and this time he clambered straight into it. The slaves ran around to take up their positions, four men on either side.

Ampliatus clicked his fingers and they hoisted the bronze-capped poles – first to waist height, and then, grimacing with the strain, up on to their shoulders. Their master settled himself back on his cushions, staring straight ahead – unseeing, brooding. He reached behind his shoulder, unfastened the curtain and let it fall. Attilius stood in the gateway and watched him go, the crimson canopy swaying as it moved off down the hill, the little crowd of weary petitioners trudging after it.

He went back into the yard.

It was all there, as Ampliatus had promised, and for a while Attilius was able to lose himself in the simple effort of physical work. It was comforting to handle the materials of his craft again – the weighty, sharp-edged bricks, just big enough to fit a man's grasp, and their familiar brittle clink as they were stacked on the back of the cart; the baskets of powdery red puteolanum, always heavier and denser than you expected, sliding across the rough boards of the wagon; the feel of the timber, warm and smooth against his cheek as he carried it across the yard; and finally the quicklime, in its bulbous clay amphorae – difficult to grasp and heave up on to the cart.

He worked steadily with the other men and had a sense at last that he was making progress. Ampliatus was undeniably cruel and ruthless and the gods alone knew what else besides, but his stuff was good and in

honest hands it would serve a better purpose. He had asked for six amphorae of lime but when it came to it he decided to take a dozen and increased the amount of puteolanum in proportion, to twenty baskets. He did not want to come back to Ampliatus to ask for more; what he did not use he could return.

He went into the bath-house to look for the torches and found them in the largest storeroom. Even these were of a superior sort – tightly wadded flax and resin impregnated with tar; good, solid wooden handles bound with rope. Next to them lay open wooden crates of oil lamps, mostly terracotta, but some of brass, and candles enough to light a temple. Quality, as Ampliatus said: you couldn't beat it. Clearly, this was going to be a most luxurious establishment.

'It will be the finest baths outside Rome . . .'

He was suddenly curious and with his arms full of torches he looked into some of the other storerooms. Piles of towels in one, jars of scented massage-oil in another, lead exercise weights, coils of rope and leather balls in a third. Everything ready and waiting for use; everything here except chattering, sweating humanity to bring it all to life. And water, of course. He peered through the open door into the succession of rooms. It would use a lot of water, this place. Four or five pools, showers, flush-latrines, a steam-room . . . Only public facilities, such as the fountains, were connected to the aqueduct free of charge, as the gift of the Emperor. But private baths like these would cost a small fortune in water-taxes. And if Ampliatus had made his

money by buying big properties, subdividing them, and renting them out, then his overall consumption of water must be huge. He wondered how much he was paying for it. Presumably he could find out once he returned to Misenum and tried to bring some order to the chaos in which Exomnius had left the Augusta's records.

Perhaps he wasn't paying anything at all.

He stood there in the sunlight, in the echoing bathhouse, listening to the cooing pigeons, turning the possibility over in his mind. The aqueducts had always been wide open to corruption. Farmers tapped into the main lines where they crossed their land. Citizens ran an extra pipe or two and paid the water inspectors to look the other way. Public work was awarded to private contractors and bills were paid for jobs that were never done. Materials went missing. Attilius suspected that the rottenness went right to the top – even Acilius Aviola, the Curator Aquarum himself, was rumoured to insist on a percentage of the take. The engineer had never had anything to do with it. But an honest man was a rare man in Rome; an honest man was a fool.

The weight of the torches was making his arms ache. He went outside and stacked them on one of the wagons, then leaned against it, thinking. More of Ampliatus's men had arrived. The loading had finished and they were sprawled in the shade, waiting for orders. The oxen stood placidly, flicking their tails, their heads in clouds of swarming flies.

If the Augusta's accounts, back at the Piscina

Mirabilis, were in such a mess, might it be because they had been tampered with?

He glanced up at the cloudless sky. The sun had passed its zenith. Becco and Corvinus should have reached Abellinum by now. The sluice-gates might already be closed, the Augusta starting to drain dry. He felt the pressure of time again. Nevertheless, he made up his mind and beckoned to Polites. 'Go into the baths,' he ordered, 'and fetch another dozen torches, a dozen lamps and a jar of olive oil. And a coil of rope, while you're at it. But no more, mind. Then, when you've finished here, take the wagons and the men up to the castellum aquae, next to the Vesuvius Gate, and wait for me. Corax should be coming back soon. And while you're at it, see if you can buy some food for us.' He gave the slave his bag. 'There's money in there. Look after it for me. I shan't be long.'

He brushed the residue of brick dust and puteolanum from the front of his tunic and walked out of the open gate.

Hora septa

[14:10 hours]

'If magma is ready to be tapped in a high-level
reservoir, even a small change of regional stress,
usually associated with an earthquake, can disturb
the stability of the system and bring about an
eruption.'

Volcanology *(second edition)*

Ampliatus's banquet was just entering its second
hour, and of the twelve guests reclining around
the table only one showed signs of truly enjoy-
ing it, and that was Ampliatus himself.

It was stiflingly hot for a start, even with one wall
of the dining room entirely open to the air, and with
three slaves in their crimson livery stationed around the
table waving fans of peacock feathers. A harpist beside
the swimming pool plucked mournfully at some form-
less tune.

And four diners to each couch! This was at least one

too many, in the judgement of Lucius Popidius, who groaned to himself as each fresh course was set before them. He held to the rule of Varro, that the number of guests at a dinner party ought not to be less than that of the Graces (three), nor to exceed that of the Muses (nine). It meant that one was too close to one's fellow diners. Popidius, for example, reclined between Ampliatus's dreary wife, Celsia, and his own mother, Taedia Secunda – close enough to feel the heat of their bodies. Disgusting. And when he propped himself on his left elbow and reached out with his right hand to take some food from the table, the back of his head would brush Celsia's shallow bosom and – worse – his ring occasionally become entangled with his mother's blonde hairpiece, shorn from the head of some German slave girl and now disguising the elderly lady's thin grey locks.

And the food! Did Ampliatus not understand that hot weather called for simple, cold dishes, and that all these sauces, all this elaboration, had gone out of fashion back in Claudius's time? The first of the hors d'oeuvres had not been too bad – oysters bred in Brundisium then shipped two hundred miles round the coast for fattening in the Lucrine Lake, so that the flavours of the two varieties could be tasted at once. Olives and sardines, and eggs seasoned with chopped anchovies – altogether acceptable. But then had come lobster, sea urchins and, finally, mice rolled in honey and poppy seeds. Popidius had felt obliged to swallow at least one mouse to please his host and

the crunch of those tiny bones had made him break out in a sweat of nausea.

Sow's udder stuffed with kidneys, with the sow's vulva served as a side dish, grinning up toothlessly at the diners. Roast wild boar filled with live thrushes that flapped helplessly across the table as the belly was carved open, shitting as they went. (Ampliatus had clapped his hands and roared with laughter at that.) Then the delicacies: the tongues of storks and flamingos (not too bad), but the tongue of a talking parrot had always looked to Popidius like nothing so much as a maggot and it had indeed tasted much as he imagined a maggot might taste if it had been doused in vinegar. Then a stew of nightingales' livers . . .

He glanced around at the flushed faces of his fellow guests. Even fat Brittius, who once boasted that he had eaten the entire trunk of an elephant, and whose motto was Seneca's – 'eat to vomit, vomit to eat' – was starting to look green. He caught Popidius's eye and mouthed something at him. Popidius could not quite make it out. He cupped his ear and Brittius repeated it, shielding his mouth from Ampliatus with his napkin and emphasising every syllable: 'Tri-mal-chi-o.'

Popidius almost burst out laughing. Trimalchio! Very good! The freed slave of monstrous wealth in the satire by Titus Petronius, who subjects his guests to exactly such a meal and cannot see how vulgar and ridiculous he is showing himself. Ha ha! Trimalchio! For a moment, Popidius slipped back twenty years to his time as a young aristocrat at Nero's court, when Petronius, that arbiter

167

of good taste, would keep the table amused for hours by his merciless lampooning of the nouveau riche.

He felt suddenly maudlin. Poor old Petronius. Too funny and stylish for his own good. In the end, Nero, suspecting his own imperial majesty was being subtly mocked, had eyed him for one last time through his emerald monocle and had ordered him to kill himself. But Petronius had succeeded in turning even that into a joke – opening his veins at the start of a dinner in his house at Cumae, then binding them to eat and to gossip with his friends, then opening them again, then binding them, and so on, as he gradually ebbed away. His last conscious act had been to break a fluorspar wine-dipper, worth three hundred thousand sesterces, which the Emperor had been expecting to inherit. *That* was style. *That* was taste.

And what would he have made of me, thought Popidius, bitterly. That I – a Popidius, who played and sang with the Master of the World – should have come to this, at the age of forty-five: the prisoner of Trimalchio!

He looked across at his former slave, presiding at the head of the table. He was still not entirely sure how it had happened. There had been the earthquake, of course. And then, a few years later, the death of Nero. Then civil war, a mule-dealer as Emperor, and Popidius's world had turned upside-down. Suddenly Ampliatus was everywhere – rebuilding the town, erecting a temple, worming his infant son on to the town council, controlling the elections, even buying the house next

door. Popidius had never had a head for figures, so when Ampliatus had told him he could make some money, too, he had signed the contracts without even reading them. And somehow the money had been lost, and then it turned out that the family house was surety, and his only escape from the humiliation of eviction was to marry Ampliatus's daughter. Imagine: his own ex-slave as his father-in-law! He thought the shame of it would kill his mother. She had barely spoken since, her face haggard with sleeplessness and worry.

Not that he would mind sharing a bed with Corelia. He watched her hungrily. She was stretched out with her back to Cuspius, whispering to her brother. He wouldn't mind screwing the boy, either. He felt his prick begin to stiffen. Perhaps he might suggest a threesome? No – she would never go for it. She was a cold bitch. But he would soon be warming her up. His gaze met Brittius's once more. What a funny fellow. He winked and gestured with his eyes to Ampliatus and mouthed in agreement, 'Trimalchio!'

'What's that you're saying, Popidius?'

Ampliatus's voice cut across the table like a whip. Popidius cringed.

'He was saying, "What a feast!"' Brittius raised his glass. 'That's what we're all saying, Ampliatus. What a magnificent feast.' A murmur of assent went round the table.

'And the best is yet to come,' said Ampliatus. He clapped his hands and one of the slaves hurried out of the dining room in the direction of the kitchen.

Popidius managed to force a smile. 'I for one have left room for dessert, Ampliatus.' In truth he felt like vomiting, and he would not have needed the usual cup of warm brine and mustard to do it, either. 'What is it to be then? A basket of plums from Mount Damascus? Or has that pastry chef of yours made a pie of Attican honey?' Ampliatus's cook was the great Gargilius, bought for a quarter of a million, recipe books and all. That was how it was along the Bay of Neapolis these days. The chefs were more celebrated than the people they fed. Prices had been pushed into the realms of insanity. The wrong sort of people had the money.

'Oh, it's not yet time for dessert, my dear Popidius. Or may I – if it's not too premature – call you "son"?' Ampliatus grinned and pointed and by a superhuman effort, Popidius succeeded in hiding his revulsion. O, Trimalchio, he thought, Trimalchio . . .

There was a sound of scuffling footsteps and then four slaves appeared, bearing on their shoulders a model trireme, as long as a man and cast in silver, surfing a sea of encrusted sapphires. The diners broke into applause. The slaves approached the table on their knees and with difficulty slid the trireme, prow first, across the table. It was entirely filled by an enormous eel. Its eyes had been removed and replaced by rubies. Its jaws were propped open and filled with ivory. Clipped to its dorsal fin was a thick gold ring.

Popidius was the first to speak. 'I say, Ampliatus – that's a whopper.'

'From my own fishery at Misenum,' said Ampliatus

proudly. 'A moray. It must be thirty years old if it's a day. I had it caught last night. You see the ring? I do believe, Popidius, that this is the creature your friend Nero used to sing to.' He picked up a large silver knife. 'Now who will have the first slice? You, Corelia – I think you should try it first.'

Now that was a nice gesture, thought Popidius. Up till this point, her father had conspicuously ignored her, and he had begun to suspect ill-feeling between them, but here was a mark of favour. So it was with some astonishment that he saw the girl flash a look of undiluted hatred at her father, throw down her napkin, rise from her couch, and run sobbing from the table.

The first couple of pedestrians Attilius approached swore they had never heard of Africanus's place. But at the crowded bar of Hercules, a little further down the street, the man behind the counter gave him a shifty look and then provided directions in a quiet voice – walk down the hill for another block, turn right, then first left, then ask again: 'But be careful who you talk to, citizen.'

Attilius could guess what that meant and sure enough, from the moment he left the main road, the street curved and narrowed, the houses became meaner and more crowded. Carved in stone beside several of the squalid entrances was the sign of the prick and balls. The brightly coloured dresses of the prostitutes bloomed in the gloom like blue and yellow flowers. So this was

where Exomnius had chosen to spend his time! Attilius's footsteps slowed. He wondered if he should turn back. Nothing could be allowed to jeopardise the main priority of the day. But then he thought again of his father, dying on his mattress in the corner of their little house – another honest fool, whose stubborn rectitude had left his widow poor – and he resumed his walk, but faster, angry now.

At the end of the street, a heavy first-floor balcony jutted over the pavement, reducing the road to scarcely more than a passageway. He shouldered his way past a group of loitering men, their faces flushed by heat and wine, through the nearest open door, and into a dingy vestibule. There was a sharp, almost feral stink of sweat and semen. Lupanars they called these places, after the howl of the lupa, the she-wolf, in heat. And lupa was the street-word for a harlot – a meretrix. The business sickened him. From upstairs came the sound of a flute, a thump on the floorboards, male laughter. On either side, from curtained cubicles, came the noises of the night – grunts, whispers, a child's whimper.

In the semi-darkness, a woman in a short green dress sat on a stool with her legs wide apart. She stood as she heard him enter and came towards him eagerly, arms outstretched in welcome, vermillion lips cracked into a smile. She had used antimony to blacken her eyebrows, stretching the lines so that they met across the bridge of her nose, a mark which some men prized as beauty, but which reminded Attilius of the death-masks of the

Popidii. She was ageless – fifteen or fifty, he could not tell in the weak light.

He said, 'Africanus?'

'Who?' She had a thick accent. Cilician, perhaps. 'Not here,' she said quickly.

'What about Exomnius?' At the mention of his name her painted mouth split wide. She tried to block his path, but he moved her out of his way, gently, his hands on her bare shoulders, and pulled back the curtain behind her. A naked man was squatting over an open latrine, his thighs bluish-white and bony in the darkness. He looked up, startled. 'Africanus?' asked Attilius. The man's expression was uncomprehending. 'Forgive me, citizen.' Attilius let the curtain fall and moved towards one of the cubicles on the opposite side of the vestibule, but the whore beat him to it, extending her arms to block his way.

'No,' she said. 'No trouble. He not here.'

'Where, then?'

She hesitated. 'Above.' She gestured with her chin towards the ceiling.

Attilius looked around. He could see no stairs.

'How do I get up there? Show me.'

She did not move so he lunged towards another curtain, but again she beat him to it. 'I show,' she said. 'This way.'

She ushered him towards a second door. From the cubicle beside it, a man cried out in ecstasy. Attilius stepped into the street. She followed. In the daylight he could see that her elaborately piled-up hair was

173

streaked with grey. Rivulets of sweat had carved furrows down her sunken, powdered cheeks. She would be lucky to earn a living here much longer. Her owner would throw her out and then she'd be living in the necropolis beyond the Vesuvius Gate, spreading her legs for the beggars behind the tombs.

She put her hand to her turkey-throat, as if she had guessed what was in his mind, and pointed to the staircase a few paces further on, then hurried back inside. As he started to mount the stone steps he heard her give a low whistle. I am like Theseus in the labyrinth, he thought, but without the ball of thread from Ariadne to guide me back to safety. If an attacker appeared above him and another blocked off his escape, he would not stand a chance. When he reached the top of the staircase he did not bother to knock but flung open the door.

His quarry was already halfway out of the window, presumably tipped off by the whistle from the elderly whore. But the engineer was across the room and had him by his belt before he could drop down to the flat roof below. He was light and scrawny and Attilius hauled him in as easily as an owner might drag a dog back by his collar. He deposited him on the carpet.

He had disturbed a party. Two men lay on couches. A negro boy was clutching a flute to his naked chest. An olive-skinned girl, no more than twelve or thirteen, and also naked, with silver-painted nipples, stood on a table, frozen in mid-dance. For a moment, nobody moved. Oil lamps flickered against crudely painted

erotic scenes – a woman astride a man, a man mounting a woman from behind, two men lying with their fingers on one another's cocks. One of the reclining clients began trailing his hand slowly beneath the couch, patting the floor, feeling towards a knife which lay beside a plate of peeled fruit. Attilius planted his foot firmly in the middle of Africanus's back, Africanus groaned, and the man quickly withdrew his hand.

'Good.' Attilius nodded. He smiled. He bent and grabbed Africanus by his belt again and dragged him out of the door.

'Teenage girls!' said Ampliatus, as the sound of Corelia's footsteps died away. 'It's all just nerves before her wedding. Frankly, I'll be glad, Popidius, when she's your responsibility and not mine.' He saw his wife rise to follow her. 'No, woman! Leave her!' Celsia lay down meekly, smiling apologetically to the other guests. Ampliatus frowned at her. He wished she would not do that. Why should she defer to her so-called betters? He could buy and sell them all!

He stuck his knife into the side of the eel and twisted it then gestured irritably to the nearest slave to take over the carving. The fish stared up at him with blank red eyes. The Emperor's pet, he thought: a prince in its own little pond. Not any more.

He dunked his bread in a bowl of vinegar and sucked it, watching the dextrous hand of the slave as he piled their plates with lumps of bony grey meat. Nobody

wanted to eat it yet nobody wanted to be the first to refuse. An atmosphere of dyspeptic dread descended, as heavy as the air around the table, hot and stale with the smell of food. Ampliatus allowed the silence to hang. Why should he set them at their ease? When he was a slave at table, he had been forbidden to speak in the dining room in the presence of guests.

He was served first but he waited until the others had all had their golden dishes set in front of them before reaching out and breaking off a piece of fish. He raised it to his lips, paused, and glanced around the table, until, one by one, beginning with Popidius, they reluctantly followed his example.

He had been anticipating this moment all day. Vedius Pollio had thrown his slaves to his eels not only to enjoy the novelty of seeing a man torn apart underwater rather than by beasts in the arena, but also because, as a gourmet, he maintained that human flesh gave the morays a more piquant flavour. Ampliatus chewed carefully yet he tasted nothing. The meat was bland and leathery – inedible – and he felt the same sense of disappointment that he had experienced the previous afternoon by the seashore. Once again, he had reached out for the ultimate experience and once more he had grasped – nothing.

He scooped the fish out of his mouth with his fingers and threw it back on his plate in disgust. He tried to make light of it – 'So then! It seems that eels, like women, taste best when young!' – and grabbed for his wine to wash away the taste. But there was no disguising the

fact that the pleasure had gone out of the afternoon. His guests were coughing politely into their napkins or picking the tiny bones out of their teeth and he knew they would all be laughing about him for days afterwards, just as soon as they could get away, especially Holconius and that fat pederast, Brittius.

'My dear fellow, have you heard the latest about Ampliatus? He thinks that fish, like wine, improves with age!'

He drank more wine, swilling it around in his mouth, and was just contemplating getting up to propose a toast – to the Emperor! to the Army! – when he noticed his steward approaching the dining room carrying a small box. Scutarius hesitated, clearly not wanting to disturb his master with a business matter during a meal, and Ampliatus would indeed have told him to go to blazes, but there was something about the man's expression . . .

He screwed up his napkin, got to his feet, nodded curtly to his guests, and beckoned to Scutarius to follow him into the tablinum. Once they were out of sight he flexed his fingers. 'What is it? Give it here.'

It was a *capsa*, a cheap beechwood document case, covered in rawhide, of the sort a schoolboy might use to carry his books around in. The lock had been broken. Ampliatus flipped open the lid. Inside were a dozen small rolls of papyri. He pulled out one at random. It was covered in columns of figures and for a moment Ampliatus squinted at it, baffled, but then the figures assumed a shape – he always did have a head for

177

numbers – and he understood. 'Where is the man who brought this?'

'Waiting in the vestibule, master.'

'Take him into the old garden. Have the kitchen serve dessert and tell my guests I shall return shortly.'

Ampliatus took the back route, behind the dining room and up the wide steps into the courtyard of his old house. This was the place he had bought ten years earlier, deliberately settling himself next door to the ancestral home of the Popidii. What a pleasure it had been to live on an equal footing with his former masters and to bide his time, knowing even then that one day, somehow, he would punch a hole in the thick garden wall and swarm through to the other side, like an avenging army capturing an enemy city.

He sat himself on the circular stone bench in the centre of the garden, beneath the shade of a rose-covered pergola. This was where he liked to conduct his most private business. He could always talk here undisturbed. No one could approach him without being seen. He opened the box again and took out each of the papyri then glanced up at the wide uncorrupted sky. He could hear Corelia's goldfinches, chirruping in their rooftop aviary and, beyond them, the drone of the city coming back to life after the long siesta. The inns and the eating-houses would be coining it now as people poured into the streets ready for the sacrifice to Vulcan.

Salve lucrum!
Lucrum gaudium!

He did not look up as he heard his visitor approach. 'So,' he said, 'it seems we have a problem.'

Corelia had been given the finches not long after the family had moved into the house, on her tenth birthday. She had fed them with scrupulous attention, tended them when they were sick, watched them hatch, mate, flourish, die, and now, whenever she wanted to be alone, it was to the aviary that she came. It occupied half of the small balcony outside her room, above the cloistered garden. The top of the cage was sheeted as protection against the sun.

She was sitting, drawn up tightly in the shady corner, her arms clasped around her legs, her chin resting on her knees, when she heard someone come into the courtyard. She edged forward on her bottom and peered over the low balustrade. Her father had settled himself on to the circular stone bench, a box beside him, and was reading through some papers. He laid the last one aside and stared at the sky, turning in her direction. She ducked her head back quickly. People said she resembled him: 'Oh, she's the image of her father!' And, as he was a handsome man, it used to make her proud.

She heard him say, 'So, it seems we have a problem.'

She had discovered as a child that the cloisters played a peculiar trick. The walls and pillars seemed to capture the sound of voices and funnel them upwards, so that even whispers, barely audible at

ground-level, were as distinct up here as speeches from the rostrum on election day. Naturally, this had only added to the magic of her secret place. Most of what she heard when she was growing up had meant nothing to her – contracts, boundaries, rates of interest – the thrill had simply been to have a private window on the adult world. She had never even told her brother what she knew, for it was only in the past few months that she had begun to decipher the mysterious language of her father's affairs. And it was here, a month ago, that she had heard her own future being bargained away by her father with Popidius: so much to be discounted on the announcement of the betrothal, the full debt to be discharged once the marriage was transacted, the property to revert in the event of a failure to produce issue, said issue to inherit fully on coming of age . . .

'My little Venus,' he had used to call her. 'My little brave Diana.'

. . . a premium payable on account of virginity, virginity attested by the surgeon, Pumponius Magonianus, payment waived on signing of contracts within the stipulated period . . .

'I always say,' her father had whispered, 'speaking man to man here, Popidius, and not to be too legal about it – you can't put a price on a good fuck.'

'*My little Venus . . .*'

'*It seems we have a problem . . .*'

A man's voice – harsh, not one she recognised – replied, 'Yes, we have a problem right enough.'

To which Ampliatus responded: 'And his name is Marcus Attilius . . .'

She leaned forward again so as not to miss a word.

Africanus wanted no trouble. Africanus was an honest man. Attilius marched him down the staircase, only half listening to his jabbering protests, glancing over his shoulder every few steps to make sure they were not being followed. 'I am an official here on the Emperor's business. I need to see where Exomnius lived. Quickly.' At the mention of the Emperor, Africanus launched into a fresh round of assurances of his good name. Attilius shook him. 'I haven't the time to listen to this. Take me to his room.'

'It's locked.'

'Where's the key?'

'Downstairs.'

'Get it.'

When they reached the street he pushed the brothelkeeper back into the gloomy hallway and stood guard as he fetched his cash-box from its hiding-place. The meretrix in the short green dress had returned to her stool: Zmyrina, Africanus called her – 'Zmyrina, which is the key to Exomnius's room?' – his hands shaking so much that when finally he managed to open the cash-box and take out the keys he dropped them and she had to stoop and retrieve them for him. She picked out a key from the bunch and held it up.

'What are you so scared about?' asked Attilius. 'Why

181

try to run away at the mention of a name?'

'I don't want any trouble,' repeated Africanus. He took the key and led the way to the bar next door. It was a cheap place, little more than a rough stone counter with holes cut into it for the jars of wine. There was no room to sit. Most of the drinkers were outside on the pavement, propped against the wall. Attilius supposed this was where the lupanar's customers waited their turn for a girl and then came afterwards to refresh themselves and boast about their prowess. It had the same fetid smell as the brothel and he thought that Exomnius must have fallen a long way – the corruption must have really entered his soul – for him to have ended up down here.

Africanus was small and nimble, his arms and legs hairy, like a monkey's. Perhaps that was where he had got his name – from the African monkeys in the forum, performing tricks at the ends of their chains to earn a few coins for their owners. He scuttled through the bar and up the rickety wooden staircase to the landing. He paused with the key in his hand, and cocked his head to one side, looking at Attilius. 'Who are you?' he said.

'Open it.'

'Nothing's been touched. I give you my word.'

'That's valuable. Now open it.'

The whore-monger turned towards the door with the key outstretched and then gave a little cry of surprise. He gestured to the lock and when Attilius stepped up next to him he saw that it was broken. The interior of the room was dark, the air stuffy with trapped smells

– bedding, leather, stale food. A thin grid of brilliant light on the opposite wall showed where the shutters were closed. Africanus went in first, stumbling against something in the blackness, and unfastened the window. The afternoon light flooded a shambles of strewn clothes and upended furniture. Africanus gazed around him in dismay. 'This was nothing to do with me – I swear it.'

Attilius took it all in at a glance. There had not been much in the room to start with – bed and thin mattress with a pillow and a coarse brown blanket, a washing-jug, a pisspot, a chest, a stool – but nothing had been left untouched. Even the mattress had been slashed; its stuffing of horsehair bulged out in tufts.

'I swear,' repeated Africanus.

'All right,' said Attilius. 'I believe you.' He did. Africanus would hardly have broken his own lock when he had a key, or left the room in such disorder. On a little three-legged table was a lump of white-green marble that turned out, on closer inspection, to be a half-eaten loaf of bread. A knife and a rotten apple lay beside it. There was a fresh smear of fingerprints in the dust. Attilius touched the surface of the table and inspected the blackened tip of his finger. This had been done recently, he thought. The dust had not had time to resettle. Perhaps it explained why Ampliatus had been so keen to show him every last detail of the new baths – to keep him occupied while the room was searched? What a fool he had been, holding forth about lowland pine and scorched olive wood! He said, 'How long had Exomnius rented this place?'

'Three years. Maybe four.'

'But he was not here all the time?'

'He came and went.'

Attilius realised he did not even know what Exomnius looked like. He was pursuing a phantom. 'He had no slave?'

'No.'

'When did you last see him?'

'Exomnius?' Africanus spread his hands. How was he supposed to remember? So many customers. So many faces.

'When did he pay his rent?'

'In advance. On the kalends of every month.'

'So he paid you at the beginning of August?' Africanus nodded. Then one thing was settled. Whatever else had happened to him, Exomnius had not planned to disappear. The man was obviously a miser. He would never have paid for a room he had no intention of using. 'Leave me,' he said. 'I'll straighten it up.'

Africanus seemed about to argue, but when Attilius took a step towards him he held up his hands in surrender and retreated to the landing. The engineer closed the broken door on him and listened to his footsteps descending to the bar.

He went around the room, reassembling it so that he could get an impression of how it had looked, as if by doing so he might conjure some clue as to what else it had held. He laid the eviscerated mattress back on the bed and placed the pillow – also slashed – at the head. He folded the thin blanket. He lay down. When

he turned his head he noticed a pattern of small black marks on the wall and he saw that they were made by squashed insects. He imagined Exomnius lying here in the heat, killing bed bugs, and wondered why, if he was taking bribes from Ampliatus, he had chosen to live like a pauper. Perhaps he had spent all his money on whores? But that did not seem possible. A tumble with one of Africanus's girls could not have cost more than a couple of copper coins.

A floorboard creaked.

He sat up very slowly and turned to look at the door. The moving shadows of a pair of feet showed clearly beneath the cheap wood and for a moment he was sure it must be Exomnius, come to demand an explanation from this stranger who had taken his job and invaded his property and was now lying on his bed in his ransacked room. 'Who's there?' he called, and when the door opened slowly and he saw it was only Zmyrina, he felt oddly disappointed. 'Yes?' he said. 'What do you want? I told your master to leave me alone.'

She stood on the threshold. Her dress was split, to show her long legs. She had a fading purple bruise the size of a fist on her thigh. She gazed around the room and put her hands to her mouth in horror. 'Who done this?'

'You tell me.'

'He said he take care for me.'

'What?'

She came further into the room. 'He said when come back he take care for me.'

185

'Who?'

'Aelianus. He said.'

It took him a beat to work out who she meant – Exomnius. Exomnius Aelianus. She was the first person he had met who had used the aquarius's given, rather than his family, name. That just about summed him up. His only intimate – a whore. 'Well he isn't coming back,' he said roughly, 'to take care for you. Or for anyone else.'

She passed the back of her hand under her nose a couple of times and he realised that she was crying. 'He dead?'

'You tell me.' Attilius softened his tone. 'The truth is, no one knows.'

'Buy me from Africanus. He said. No whore everyone. Special him. Understand?' She touched her chest and gestured to Attilius, then touched herself again.

'Yes, I understand.'

He looked at Zmyrina with new interest. It was not uncommon, he knew, especially in this part of Italy. The foreign sailors, when they left the Navy after their twenty-five years' service and were granted Roman citizenship – the first thing most of them did with their demob money was head for the nearest slave-market and buy themselves a wife. The prostitute was kneeling now, picking up the scattered clothes and folding them, putting them away in the chest. And perhaps it was a point in Exomnius's favour, he thought, that he should have decided to choose her, rather than someone younger or prettier. Or, then again, perhaps he was

just lying and never intended to come back for her. Either way, her future had more or less disappeared along with her principal client.

'He had the money, did he? Enough money to buy you? Only you wouldn't think it, to look at this place.'

'Not *here*.' She sat back on her heels and looked up at him with scorn. 'Not safe money *here*. Money hidden. Plenty money. Some place clever. Nobody find. He said. Nobody.'

'Somebody has tried –'

'Money not here.'

She was emphatic. No doubt she had searched for it often enough when he wasn't around. 'Did he ever tell you where this place was?'

She stared at him, her vermillion mouth wide open, and suddenly she bent her head. Her shoulders were shaking. He thought at first she was crying again but when she turned he saw that the glint in her eyes was from tears of laughter. 'No!' She started rocking again. She looked almost girlish in her delight. She clapped her hands. It was the funniest thing she had ever heard, and he had to agree – the idea of Exomnius confiding in a whore of Africanus where he had hidden his money – it *was* funny. He began laughing himself, then swung his feet to the floor.

There was no point in wasting any more time here.

On the landing he glanced back at her, still kneeling on her haunches in her split dress, one of Exomnius's tunics pressed to her face.

* * *

Attilius hurried back the way he had come, along the shadowy side street. He thought, This must have been Exomnius's route from the brothel to the castellum aquae. This must have been what he saw whenever he came here – the whores and drunks, the puddles of piss and patches of vomit baked to crusts in the gutter, the graffiti on the walls, the little effigies of Priapus beside the doorways, with his enormous jutting cock dangling bells at its tip to ward off evil. So what was in his head as he walked this way for the final time? Zmyrina? Ampliatus? The safety of his hidden money?

He looked back over his shoulder but no one was paying him any attention. Still, he was glad to reach the wide central thoroughfare and the safety of its glaring light.

The town remained much quieter than it had been in the morning, the heat of the sun keeping most people off the road, and he made quick progress up the hill towards the Vesuvius Gate. As he approached the small square in front of the castellum aquae he could see the oxen and the carts, now fully laden with tools and materials. A small crowd of men sprawled in the dirt outside a bar, laughing at something. The horse he had hired was tethered to its post. And here was Polites – faithful Polites, the most trustworthy member of the workgang – advancing to meet him.

'You were gone a long while, aquarius.'

Attilius ignored the tone of reproach. 'I'm here now. Where is Musa?'

'Still not here.'

188

'What?' He swore and cupped his hand to his eyes to check the position of the sun. It must be four hours – no, nearer five – since the others had ridden off. He had expected to receive some word by now. 'How many men do we have?'

'Twelve.' Polites rubbed his hands together uneasily.

'What's the matter with you?'

'They're a rough-looking lot, aquarius.'

'Are they? Their manners don't concern me. As long as they can work.'

'They've been drinking for an hour.'

'Then they'd better stop.'

Attilius crossed the square to the bar. Ampliatus had promised a dozen of his strongest slaves and once again he had more than kept his word. It looked as if he had supplied a troop of gladiators. A flagon of wine was being handed around, from one pair of tattooed arms to another, and to pass the time they had fetched Tiro from the castellum and were playing a game with him. One of them had snatched off the water-slave's felt cap and whenever he turned helplessly in the direction of whoever he thought was holding it, it would be tossed to someone else.

'Cut that out,' said the engineer. 'Leave the lad alone.' They ignored him. He spoke up more loudly. 'I am Marcus Attilius, aquarius of the Aqua Augusta, and you men are under my command now.' He snatched Tiro's cap and pressed it into his hand. 'Go back to the castellum, Tiro.' And then, to the slave gang: 'That's enough drinking. We're moving out.'

The man whose turn it was with the wine regarded Attilius with indifference. He raised the clay jar to his mouth, threw back his head and drank. Wine dribbled down his chin and on to his chest. There was an appreciative cheer and Attilius felt the anger ignite inside himself. To train so hard, to build and work, to pour so much skill and ingenuity into the aqueducts – and all to carry water to such brutes as these, and Africanus. They would be better left to wallow beside some mosquito-infested swamp. 'Who is the senior man among you?'

The drinker lowered the flagon. '"The senior man,"' he mocked. 'What is this? The fucking army?'

'You are drunk,' said Attilius quietly. 'But I am sober, and in a hurry. Now *move.*' He lashed out with his foot and caught the flagon, knocking it out of the drinker's hand. It spun away and landed on its side, where it lay, unbroken, emptying itself across the stones. For a moment, in the silence, the glug-glug of the wine was the only sound, and then there was a rush of activity – the men rising, shouting, the drinker lunging forward, with the apparent intention of sinking his teeth into Attilius's leg. Through all this commotion, one booming voice rang louder than the rest – 'Stop!' – and an enormous man, well over six feet tall, came running across the square and planted himself between Attilius and the others. He spread out his arms to keep them back.

'I am Brebix,' he said. 'A freed man.' He had a coarse red beard, trimmed, shovel-shaped. 'If anyone is senior, I am.'

'Brebix.' Attilius nodded. He would remember that name. This one, he saw, actually *was* a gladiator, or rather an ex-gladiator. He had the brand of his troop on his arm, a snake drawing back to strike. 'You should have been here an hour ago. Tell these men that if they have any complaints, they should take them to Ampliatus. Tell them that none has to come with me, but any who stay behind will have to answer for it to their master. Now get those wagons out through the gate. I'll meet you on the other side of the city wall.'

He turned, and the crowd of drinkers from the other bars, who had come thronging into the square in the hope of seeing a fight, stood aside to let him pass. He was trembling and he had to clench his fist in his palm to stop it showing. 'Polites!' he called.

'Yes?' The slave eased his way through the mob.

'Fetch me my horse. We've wasted long enough here.'

Polites looked anxiously towards Brebix, now leading the reluctant work gang over to the wagons. 'These men, aquarius – I don't trust them.'

'Neither do I. But what else can we do? Come on. Get my horse. We'll meet up with Musa on the road.'

As Polites hurried away, Attilius glanced down the hill. Pompeii was less like a seaside resort, more like a frontier garrison: a boom town. Ampliatus was rebuilding her in his own image. He would not be sorry if he never saw her again – apart from Corelia. He wondered what she was doing, but even as the image of her wading towards him through the glittering pool began to form in his mind he forced himself to banish it. Get out of

here, get to the Augusta, get the water running, and then get back to Misenum and check the aqueduct's records for evidence of what Exomnius had been up to. Those were his priorities. To think of anything else was foolish.

In the shadow of the castellum aquae Tiro crouched, and Attilius was on the point of raising his hand in farewell, until he saw those flickering, sightless eyes.

The public sundial showed it was well into the ninth hour when Attilius passed on horseback beneath the long vault of the Vesuvius Gate. The ring of hooves on stone echoed like a small detachment of cavalry. The customs official poked his head out of his booth to see what was happening, yawned and turned away.

The engineer had never been a natural rider. For once, though, he was glad to be mounted. It gave him height, and he needed every advantage he could get. When he trotted over to Brebix and the men they were obliged to squint up at him, screwing their eyes against the glare of the sky.

'We follow the line of the aqueduct towards Vesuvius,' he said. The horse wheeled and he had to shout over his shoulder. 'And no dawdling. I want us in position before dark.'

'In position where?' asked Brebix.

'I don't know yet. It should be obvious when we see it.'

His vagueness provoked an uneasy stir among the

men – and who could blame them? He would have liked to have known where he was going himself. Damn Musa! He brought his mount under control and turned it towards the open country. He raised himself from the saddle so that he could see the course of the road beyond the necropolis. It ran straight towards the mountain through neat, rectangular fields of olive trees and corn, separated by low stone walls and ditches – centuriated land, awarded to demobbed legionaries decades ago. There was not much traffic on the paved highway – a cart or two, a few pedestrians. No sign of any plume of dust that might be thrown up by a galloping horseman. Damn him, damn him . . .

Brebix said, 'Some of the lads aren't too keen on being out near Vesuvius after nightfall.'

'Why not?'

A man called out, 'The giants!'

'Giants?'

Brebix said, almost apologetically, 'Giants have been seen, aquarius, bigger than any man. Wandering over the earth by day and night. Sometimes journeying through the air. Their voices sound like claps of thunder.'

'Perhaps they *are* claps of thunder,' said Attilius. 'Have you considered that? There can be thunder without rain.'

'Aye, but this thunder is never in the air. It's on the ground. Or even under the ground.'

'So this is why you drink?' Attilius forced himself to laugh. 'Because you are scared to be outside the city

193

walls after dark? And you were a gladiator, Brebix? I'm
glad I never wagered money on you! Or did your troop
only ever fight blind boys?' Brebix began to swear, but
the engineer talked over his head, to the work gang. 'I
asked your master to lend me men, not women! We've
argued long enough! We have to go five miles before
dark. Perhaps ten. Now drive those oxen forward, and
follow me.'

He dug his heels into the flanks of his horse and it
started off at a slow trot. He passed along the avenue
between the tombs. Flowers and small offerings of food
had been left on some, to mark the Festival of Vulcan.
A few people were picnicking in the shade of the
cypresses. Small black lizards scattered across the stone
vaults like spreading cracks. He did not look back. The
men would follow, he was sure. He had goaded them
into it and they were scared of Ampliatus.

At the edge of the cemetery he drew on the reins
and waited until he heard the creak of the wagons
trundling over the stones. They were just crude farm
carts – the axle turned with the wheels, which were no
more than simple sections of tree-trunk, a foot thick.
Their rumble could be heard a mile away. First the oxen
passed him, heads down, each team led by a man with
a stick, and then the lumbering carts, and finally the
rest of the work gang. He counted them. They were all
there, including Brebix. Beside the road, the marker-
stones of the aqueduct, one every hundred paces,
dwindled into the distance. Neatly spaced between them
were the round stone inspection covers that provided

access to the tunnel. The regularity and precision of it gave the engineer a fleeting sense of confidence. If nothing else, he knew how this worked.

He spurred his horse.

An hour later, with the afternoon sun dipping towards the bay, they were halfway across the plain – the parched and narrow fields and bone-dry ditches spread out all around them, the ochre-coloured walls and watchtowers of Pompeii dissolving into the dust at their backs, the line of the aqueduct leading them remorselessly onwards, towards the blue-grey pyramid of Vesuvius, looming ever more massively ahead.

Hora duodecima

[18:47 hours]

> *'While rocks are extremely strong in compression,*
> *they are weak in tension (strengths of about 1.5 x*
> *10^7 bars). Thus, the strength of the rocks capping*
> *a cooling and vesiculating magma body is easily*
> *exceeded long before the magma is solid. Once this*
> *happens, an explosive eruption occurs.'*
>
> Volcanoes: A Planetary Perspective

Pliny had been monitoring the frequency of the trembling throughout the day – or, more accurately, his secretary, Alexion, had been doing it for him, seated at the table in the admiral's library, with the water clock on one side and the wine bowl on the other.

The fact that it was a public holiday had made no difference to the admiral's routine. He worked whatever day it was. He had broken off from his reading and dictation only once, in the middle of the morning,

to bid goodbye to his guests, and had insisted on accompanying them down to the harbour to see them aboard their boats. Lucius Pomponianus and Livia were bound for Stabiae, on the far side of the bay, and it had been arranged that they would take Rectina with them in their modest cruiser, as far as the Villa Calpurnia in Herculaneum. Pedius Cascus, without his wife, would take his own fully manned liburnian to Rome for a council meeting with the Emperor. Old, dear friends! He had embraced them warmly. Pomponianus could play the fool, it was true, but his father, the great Pomponianus Secundus, had been Pliny's patron, and he felt a debt of honour to the family. And as for Pedius and Rectina – their generosity to him had been without limit. It would have been hard for him to finish the *Natural History,* living outside Rome, without the use of their library.

Just before he boarded his ship, Pedius had taken him by the arm. 'I didn't like to mention it earlier, Pliny, but are you sure you're quite well?'

'Too fat,' wheezed Pliny, 'that's all.'

'What do your doctors say?'

'Doctors? I won't let those Greek tricksters anywhere near me. Only doctors can murder a man with impunity.'

'But look at you, man – your heart –'

'"In cardiac disease the one hope of relief lies undoubtedly in wine." You should read my book. And that, my dear Pedius, is a medicine I can administer myself.'

The senator looked at him, then said grimly, 'The Emperor is concerned about you.'

That gave Pliny a twinge in his heart, right enough. He was a member of the imperial council himself. Why had he not been invited to this meeting, to which Pedius was hurrying? 'What are you implying? That he thinks I'm past it?'

Pedius said nothing – a nothing that said everything. He suddenly opened his arms and Pliny leaned forwards and hugged him, patting the senator's stiff back with his pudgy hand. 'Take care, old friend.'

'And you.'

To his shame, when Pliny pulled back from the embrace, his cheek was wet. He stayed on the quayside, watching until the ships were out of sight. That was all he seemed to do these days: watch other people leave.

The conversation with Pedius had stayed with him all day, as he shuffled back and forth on the terrace, periodically wandering into the library to check Alexion's neat columns of figures. *The Emperor is concerned about you.* Like the pain in his side, it would not go away.

He took refuge, as always, in his observations. The number of *harmonic episodes,* as he had decided to call the tremors, had increased steadily. Five in the first hour, seven in the second, eight in the third, and so on. More striking still had been their lengthening duration. Too small to measure at the beginning of the day, as the afternoon went on, Alexion had been able to use the

accuracy of the water clock to estimate them – first at one-tenth part of the hour, and then one-fifth, until finally, for the whole eleventh hour, he had recorded one tremor only. The vibration of the wine was continuous.

'We must change our nomenclature,' muttered Pliny, leaning over his shoulder. 'To call such movements an *episode* will no longer suffice.'

And increasing in proportion with the movement of the earth, as if Man and Nature were bound by some invisible link, came reports of agitation in the town – a fight at the public fountains when the first hour's discharge had ended and not everyone had filled their pots; a riot outside the public baths when they had failed to open at the seventh hour; a woman stabbed to death for the sake of two amphorae of water – water! – by a drunk outside the Temple of Augustus; now it was said that armed gangs were hanging round the fountains, waiting for a fight.

Pliny had never had any difficulty issuing orders. It was the essence of command. He decreed that the evening's sacrifice to Vulcan should be cancelled and that the bonfire in the forum must be dismantled at once. A large public gathering at night was a recipe for trouble. It was unsafe, in any case, to light a fire of such a size in the centre of the town when the pipes and fountains were dry and the drought had rendered the houses as flammable as kindling.

'The priests won't like that,' said Antius.

The flagship captain had joined Pliny in the library.

The admiral's widowed sister, Julia, who kept house for him, was also in the room, holding a tray of oysters and a jug of wine for his supper.

'Tell the priests that we have no choice. I'm sure Vulcan in his mountain forge will forgive us, just this once.' Pliny massaged his arm irritably. It felt numb. 'Have all the men, apart from the sentry patrols, confined to their barracks from dusk. In fact, I want a curfew imposed across the whole of Misenum from vespera until dawn. Anyone found on the streets is to be imprisoned and fined. Understood?'

'Yes, admiral.'

'Have we opened the sluices in the reservoir yet?'

'It should be happening now, admiral.'

Pliny brooded. They could not afford another such day. Everything depended on how long the water would last. He made up his mind. 'I'm going to take a look.'

Julia came towards him anxiously with the tray. 'Is that wise, brother? You ought to eat and rest –'

'Don't nag, woman!' Her face crumpled and he regretted his tone at once. Life had knocked her about enough as it was – humiliated by her wastrel husband and his ghastly mistress, then left widowed with a boy to bring up. That gave him an idea. 'Gaius,' he said, in a gentler voice. 'Forgive me, Julia. I spoke too sharply. I'll take Gaius with me, if that will make you happier.'

On his way out, he called to his other secretary, Alcman, 'Have we had a signal back yet from Rome?'

'No, admiral.'

'The Emperor is concerned about you . . .'
He did not like this silence.

Pliny had grown too fat for a litter. He travelled instead by carriage, a two-seater, with Gaius wedged in next to him. Beside his red and corpulent uncle he looked as pale and insubstantial as a wraith. The admiral squeezed his knee fondly. He had made the boy his heir and had fixed him up with the finest tutors in Rome – Quintilian for literature and history; the Smyrnan, Nicetes Sacerdos, for rhetoric. It was costing him a fortune but they told him the lad was brilliant. He would never make a soldier, though. It would be a lawyer's life for him.

An escort of helmeted marines trotted on foot on either side of the carriage, clearing a path for them through the narrow streets. A couple of people jeered. Someone spat.

'What about our water, then?'

'Look at that fat bastard! I bet you he's not going thirsty!'

Gaius said, 'Shall I close the curtains, uncle?'

'No, boy. Never let them see that you're afraid.'

He knew there would be a lot of angry people on the streets tonight. Not just here, but in Neapolis and Nola and all the other towns, especially on a public festival. Perhaps Mother Nature is punishing us, he thought, for our greed and selfishness. We torture her at all hours by iron and wood, fire and stone. We dig

her up and dump her in the sea. We sink mineshafts into her and drag out her entrails – and all for a jewel to wear on a pretty finger. Who can blame her if she occasionally quivers with anger?

They passed along the harbour front. An immense line of people had formed, queuing for the drinking-fountain. Each had been allowed to bring one receptacle only and it was obvious to Pliny that an hour was never going to be sufficient for them all to receive their measure. Those who had been at the head of the line already had their ration and were hurrying away, cradling their pots and pans as if they were carrying gold. 'We shall have to extend the flow tonight,' he said, 'and trust to that young aquarius to carry out the repairs as he promised.'

'And if he doesn't, uncle?'

'Then half this town will be on fire tomorrow.'

Once they were free of the crowd and on to the cause-way the carriage picked up speed. It rattled over the wooden bridge then slowed again as they climbed the hill towards the Piscina Mirabilis. Jolting around in the back Pliny felt sure he was about to faint and perhaps he did. At any rate, he nodded off, and the next thing he knew they were drawing into the courtyard of the reservoir, past the flushed faces of half a dozen marines. He returned their salute and descended, unsteadily, on Gaius's arm. If the Emperor takes away my command, he thought, I shall die, as surely as if he orders one of his praetorian guard to strike my head from my shoulders. I shall never write another book. My life-force has gone. I am finished.

'Are you all right, uncle?'

'I am perfectly well, Gaius, thank you.'

Foolish man! he reproached himself. Stupid, trembling, credulous old man! One sentence from Pedius Cascus, one routine meeting of the imperial council to which you are not invited, and you fall to pieces. He insisted on going down the steps into the reservoir unaided. The light was fading and a slave went on ahead with a torch. It was years since he had last been down here. Then, the pillars had been mostly submerged, and the crashing of the Augusta had drowned out any attempt at conversation. Now it echoed like a tomb. The size of it was astonishing. The level of the water had fallen so far beneath his feet he could barely make it out, until the slave held his torch over the mirrored surface, and then he saw his own face staring back at him – querulous, broken. The reservoir was also vibrating slightly, he realised, just like the wine.

'How deep is it?'

'Fifteen feet, admiral,' said the slave.

Pliny contemplated his reflection. '"There has never been anything more remarkable in the whole world,"' he murmured.

'What was that, uncle?'

'"When we consider the abundant supplies of water in public buildings, baths, pools, open channels, private houses, gardens and country estates, and when we think of the distances traversed by the water before it arrives, the raising of arches, the tunnelling of mountains and the building of level routes across deep valleys, then we

203

shall readily admit that there has never been anything more remarkable than our aqueducts in the whole world." I quote myself, I fear. As usual.' He pulled back his head. 'Allow half the water to drain away tonight. We shall let the rest go in the morning.'

'And then what?'

'And then, my dear Gaius? And then we must hope for a better day tomorrow.'

In Pompeii, the fire for Vulcan was to be lit as soon as it was dark. Before that, there was to be the usual entertainment in the forum, supposedly paid for by Popidius, but in reality funded by Ampliatus – a bullfight, three pairs of skirmishing gladiators, some boxers in the Greek style. Nothing too elaborate, just an hour or so of diversion for the voters while they waited for the night to arrive, the sort of spectacle an aedile was expected to lay on in return for the privilege of office.

Corelia feigned sickness.

She lay on her bed, watching the lines of light from the closed shutters creep slowly up the wall as the sun sank, thinking about the conversation she had overheard, and about the engineer, Attilius. She had noticed the way he looked at her, both in Misenum yesterday, and this morning, when she was bathing. Lover, avenger, rescuer, tragic victim – in her imagination she pictured him briefly in all these parts, but always the fantasy dissolved into the same brutal coupling of facts: she had

brought him into the orbit of her father and now her father was planning to kill him. His death would be her fault.

She listened to the sounds of the others preparing to leave. She heard her mother calling for her, and then her footsteps on the stairs. Quickly she felt for the feather she had hidden under her pillow. She opened her mouth and tickled the back of her throat, vomited noisily, and when Celsia appeared she wiped her lips and gestured weakly to the contents of the bowl.

Her mother sat on the edge of the mattress and put her hand on Corelia's brow. 'Oh my poor child. You feel hot. I should send for the doctor.'

'No, don't trouble him.' A visit from Pumponius Magonianus, with his potions and purges, was enough to make anyone ill. 'Sleep is all I need. It was that endless, awful meal. I ate too much.'

'But my dear, you hardly ate a thing!'

'That's not true –'

'Hush!' Her mother held up a warning finger. Someone else was mounting the steps, with a heavier tread, and Corelia braced herself for a confrontation with her father. He would not be so easy to fool. But it was only her brother, in his long white robes as a priest of Isis. She could smell the incense on him.

'Hurry up, Corelia. He's shouting for us.'

No need to say who *he* was.

'She's ill.'

'Is she? Even so, she must still come. He won't be happy.'

Ampliatus bellowed from downstairs and they both jumped. They glanced towards the door.

'Yes, can't you make an effort, Corelia?' said her mother. 'For his sake?'

Once, the three of them had formed an alliance: had laughed about him behind his back – his moods, his rages, his obsessions. But lately that had stopped. Their domestic triumvirate had broken apart under his relentless fury. Individual strategies for survival had been adopted. Corelia had observed her mother become the perfect Roman matron, with a shrine to Livia in her dressing room, while her brother had subsumed himself in his Egyptian cult. And she? What was she supposed to do? Marry Popidius and take a second master? Become more of a slave in the household than Ampliatus had ever been?

She was too much her father's daughter not to fight.

'Run along, both of you,' she said bitterly. 'Take my bowl of vomit and show it to him, if you like. But I'm not going to his stupid spectacle.' She rolled on to her side and faced the wall. Another roar came from below.

Her mother breathed her martyr's sigh. 'Oh, very well. I'll tell him.'

It was exactly as the engineer had suspected. Having led them almost directly north towards the summit for a couple of miles, the aqueduct spur suddenly swung eastwards, just as the ground began to rise towards Vesuvius. The road turned with it and for the first

time they had their backs to the sea and were pointing inland, towards the distant foothills of the Appenninus.

The Pompeii spur wandered away from the road more often now, hugging the line of the terrain, weaving back and forth across their path. Attilius relished this subtlety of aqueducts. The great Roman roads went crashing through Nature in a straight line, brooking no opposition. But the aqueducts, which had to drop the width of a finger every hundred yards – any more and the flow would rupture the walls; any less and the water would lie stagnant – they were obliged to follow the contours of the ground. Their greatest glories, such as the triple-tiered bridge in southern Gaul, the highest in the world, that carried the aqueduct of Nemausus, were frequently far from human view. Sometimes it was only the eagles, soaring in the hot air above some lonely mountainscape, who could appreciate the true majesty of what men had wrought.

They had passed through the gridwork of centuriated fields and were entering into the wine-growing country, owned by the big estates. The ramshackle huts of the smallholders on the plain, with their tethered goats and their half-dozen ragged hens pecking in the dust, had given way to handsome farmhouses with red-tile roofs that dotted the lower slopes of the mountain.

Surveying the vineyards from his horse, Attilius felt almost dazed by the vision of such abundance, such astonishing fertility, even in the midst of a drought. He was in the wrong business. He should give up water and go into wine. The vines had escaped from ordinary

cultivation and had fastened themselves on to every available wall and tree, reaching to the top of the tallest branches, enveloping them in luxuriant cascades of green and purple. Small white faces of Bacchus, made of marble to ward off evil, with perforated eyes and mouths, hung motionless in the still air, peering from the foliage like ambushers ready to strike. It was harvest-time and the fields were full of slaves – slaves on ladders, slaves bent halfway to the ground by the weight of the baskets of grapes on their backs. But how, he wondered, could they possibly manage to gather it all in before it rotted?

They came to a large villa looking out across the plain to the bay and Brebix asked if they could stop for a rest.

'All right. But not for long.'

Attilius dismounted and stretched his legs. When he wiped his forehead the back of his hand came away grey with dust and when he tried to drink he found that his lips were caked. Polites had bought a couple of loaves and some greasy sausages and he ate hungrily. Astonishing, always, the effects of a bit of food in an empty stomach. He felt his spirits lift with each mouthful. This was always where he preferred to be – not in some filthy town, but out in the country, with the hidden veins of civilisation, beneath an honest sky. He noticed that Brebix was sitting alone and he went over and broke off half a loaf for him and held it out, along with a couple of sausages. A peace offering.

Brebix hesitated, nodded and took them. He was

naked to the waist, his sweating torso criss-crossed with scars.

'What class of fighter were you?'

'Guess.'

It was a long time since Attilius had been to the games. 'Not a retiarius,' he said eventually. 'I don't see you dancing around with a net and a trident.'

'You're right there.'

'So, a thrax, then. Or a murmillo, perhaps.' A thrax carried a small shield and a short, curved sword; a murmillo was a heavier fighter, armed like an infantry-man, with a gladius and a full rectangular shield. The muscles of Brebix's left arm – his shield arm, more likely than not – bulged as powerfully as his right. 'I'd say a murmillo.' Brebix nodded. 'How many fights?'

'Thirty.'

Attilius was impressed. Not many men survived thirty fights. That was eight or ten years of appearances in the arena. 'Whose troop were you with?'

'Alleius Nigidius. I fought all around the bay. Pompeii, mostly. Nuceria. Nola. After I won my free-dom I went to Ampliatus.'

'You didn't turn trainer?'

Brebix said quietly, 'I've seen enough killing, aquar-ius. Thanks for the bread.' He got to his feet lightly, in a single, fluid motion, and went over to the others. It took no effort to imagine him in the dust of the amphitheatre. Attilius could guess the mistake his oppo-nents had made. They would have thought he was massive, slow, clumsy. But he was as agile as a cat.

209

The engineer took another drink. He could see straight across the bay to the rocky islands off Misenum – little Prochyta and the high mountain of Aenaria – and for the first time he noticed that there was a swell on the water. Flecks of white foam had appeared among the tiny ships that were strewn like filings across the glaring, metallic sea. But none had hoisted a sail. And that was strange, he thought – that was odd – but it was a fact: *there was no wind.* Waves but no wind.

Another trick of nature for the admiral to ponder.

The sun was just beginning to dip behind Vesuvius. A hare eagle – small, black, powerful, famed for never emitting a cry – wheeled and soared in silence above the thick forest. They would soon be heading into shadow. Which was good, he thought, because it would be cooler, and also bad, because it meant there was not long till dusk.

He finished his water and called to the men to move on.

Silence also in the great house.

She could always tell when her father had gone. The whole place seemed to let out its breath. She slipped her cloak around her shoulders and listened again at the shutters before she opened them. Her room faced west. On the other side of the courtyard the sky was as red as the terracotta roof, the garden beneath her balcony in shadow. A sheet still lay across the top of the aviary and she pulled it back, to give the birds some

air, and then – on impulse: it had never occurred to her before that moment – she released the catch and opened the door at the side of the cage.

She drew back into the room.

The habits of captivity are hard to break. It took a while for the goldfinches to sense their opportunity. Eventually, one bird, bolder than the rest, edged along its perch and hopped on to the bottom of the door frame. It cocked its red-and-black-capped head at her and blinked one tiny bright eye then launched itself into the air. Its wings cracked. There was a flash of gold in the gloom. It swooped across the garden and came to rest on the ridge-tiles opposite. Another bird fluttered to the door and took off, and then another. She would have liked to stay and watch them all escape but instead she closed the shutters.

She had told her maid to go with the rest of the slaves to the forum. The passage outside her room was deserted, as were the stairs, as was the garden in which her father had held what he thought was his secret conversation. She crossed it quickly, keeping close to the pillars in case she encountered anyone. She passed through into the atrium of their old house and turned towards the tablinum. This was where her father still conducted his business affairs – rising to greet his clients at dawn, meeting them either singly or in groups until the law courts opened, whereupon he would sweep out into the street, followed by his usual anxious court of petitioners. It was a symbol of Ampliatus's power that the room contained not the usual one but three strong

boxes, made of heavy wood bonded with brass, attached by iron rods to the stone floor.

Corelia knew where the keys were kept because in happier days – or was it simply a device to convince his associates of what a charming fellow he was? – she had been allowed to creep in and sit at his feet while he was working. She opened the drawer of the small desk, and there they were.

The document case was in the second strong box. She did not bother to unroll the small papyri, but simply stuffed them into the pockets of her cloak, then locked the safe and replaced the key. The riskiest part was over and she allowed herself to relax a little. She had a story ready in case she was stopped – that she was recovered now, and had decided to join the others in the forum after all – but nobody was about. She walked across the courtyard and down the staircase, past the swimming pool with its gently running fountain, and the dining room in which she had endured that terrible meal, moving swiftly around the colonnade towards the red-painted drawing room of the Popidii. Soon she would be the mistress of all this: a ghastly thought.

A slave was lighting one of the brass candelabra but drew back respectfully against the wall to let her pass. Through a curtain. Another, narrower flight of stairs. And suddenly she was in a different world – low ceilings, roughly plastered walls, a smell of sweat: the slaves' quarters. She could hear a couple of men talking somewhere and a clang of iron pots and then, to her relief, the whinny of a horse.

The stables were at the end of the corridor, and it was as she had thought – her father had decided to take his guests by litter to the forum, leaving all the horses behind. She stroked the nose of her favourite, a bay mare, and whispered to her. Saddling her was a job for the slaves but she had watched them often enough to know how to do it. As she fastened the leather harness beneath the belly the horse shifted slightly and knocked against the wooden stall. She held her breath but no one came.

She whispered again: 'Easy, girl, it's only me, it's all right.'

The stable door opened directly on to the side street. Every sound seemed absurdly loud to her – the bang of the iron bar as she lifted it, the creak of the hinges, the clatter of the mare's hooves as she led her out into the road. A man was hurrying along the pavement opposite and he turned to look at her but he didn't stop – he was late, presumably, and on his way to the sacrifice. From the direction of the forum came the noise of music and then a low roar, like the breaking of a wave.

She swung herself up on to the horse. No decorous, feminine sideways mount for her tonight. She opened her legs and sat astride it like a man. The sense of limitless freedom almost overwhelmed her. This street – this utterly ordinary street, with its cobblers' shops and dressmakers, along which she had walked so many times – had become the edge of the world. She knew that if she hesitated any longer the panic would seize her

completely. She pressed her knees into the flanks of the horse and pulled hard left on the reins, heading away from the forum. At the first crossroads she turned left again. She stuck carefully to the empty back streets and only when she judged that she was far enough away from the house to be unlikely to meet anyone she knew did she join the main road. Another wave of applause carried from the forum.

Up the hill she went, past the deserted baths her father was building, past the castellum aquae and under the arch of the city gate. She bowed her head as she passed the customs post, pulling the hood of her cloak low, and then she was out of Pompeii and on the road to Vesuvius.

Vespera

[20:00 hours]

*'The arrival of magma into the near-surface swells
the reservoir and inflates the surface . . .'*

Encyclopaedia of Volcanoes

Attilius and his expedition reached the matrix of
the Aqua Augusta just as the day was ending.
One moment the engineer was watching the
sun vanish behind the great mountain, silhouetting it
against a red sky, making the trees look as though they
were on fire, and the next it had gone. Looking ahead,
he saw, rising out of the darkening plain, what appeared
to be gleaming heaps of pale sand. He squinted at them,
then spurred his horse and galloped ahead of the
wagons.

Four pyramids of gravel were grouped around a roof-
less, circular brick wall, about the height of a man's
waist. It was a settling tank. He knew there would be
at least a dozen of these along the length of the Augusta

215

– one every three or four miles was Vitruvius's recommendation – places where the water was deliberately slowed to collect impurities as they sank to the bottom. Masses of tiny pebbles, worn perfectly round and smooth as they were washed along the matrix, had to be dug out every few weeks and piled beside the aqueduct, to be carted away and either dumped or used for road-building.

A settling tank had always been a favourite place from which to run off a secondary line and as Attilius dismounted and strode across to it he saw that this was indeed the case here. The ground beneath his feet was spongy, the vegetation greener and more luxuriant, the soil singing with saturation. Water was bubbling over the carapace of the tank at every point, washing the brickwork with a shimmering, translucent film. The final manhole of the Pompeii spur lay directly in front of the wall.

He rested his hands on the lip and peered over the side. The tank was twenty feet across and, he would guess, at least fifteen deep. With the sun gone it was too dark to see all the way to the gravel floor but he knew there would be three tunnel mouths down there – one where the Augusta flowed in, one where it flowed out, and a third connecting Pompeii to the system. Water surged between his fingers. He wondered when Corvinus and Becco had shut off the sluices at Abellinum. With luck, the flow should be starting to ease very soon.

He heard feet squelching over the ground behind

him. Brebix and a couple of the other men were walking across from the wagons.

'So is this the place, aquarius?'

'No, Brebix. Not yet. But not far now. You see that? The way the water is gushing from below? That's because the main line is blocked somewhere further down its course.' He wiped his hands on his tunic. 'We need to get moving again.'

It was not a popular decision, and quickly became even less so when they discovered that the wagons were sinking up to their axles in the mud. There was an outbreak of cursing and it took all their strength – shoulders and backs applied first to one cart and then to the other – to heave them up on to firmer ground. Half a dozen of the men went sprawling and lay there refusing to move and Attilius had to go round offering his hand and pulling them up on to their feet. They were tired, superstitious, hungry – it was worse than driving a team of ill-tempered mules.

He hitched his horse to the back of one of the wagons and when Brebix asked him what he was doing he said, 'I'll walk with the rest of you.' He took the halter of the nearest ox and tugged it forwards. It was the same story as when they left Pompeii. At first nobody moved but then, grudgingly, they set off after him. The natural impulse of men is to follow, he thought, and whoever has the strongest sense of purpose will always dominate the rest. Ampliatus understood that better than anyone he'd met.

They were crossing a narrow plain between high

ground. Vesuvius was to their left; to their right, the distant cliffs of the Appenninus rose like a wall. The road had once again parted company with the aqueduct and they were following a track, plodding along beside the Augusta – marker-stone, manhole, marker-stone, manhole, on and on – through ancient groves of olives and lemons, as pools of darkness began to gather beneath the trees. There was little to hear above the rumble of the wheels except the occasional sound of goats' bells in the dusk.

Attilius kept glancing off to the line of the aqueduct. Water was bubbling around the edges of some of the manholes, and that was ominous. The aqueduct tunnel was six feet high. If the force of the water was sufficient to dislodge the heavy inspection covers, then the pressure must be immense, which in turn suggested that the obstruction in the matrix must be equally massive, otherwise it would have been swept away. Where were Corax and Musa?

An immense crash, like a peal of thunder, came from the direction of Vesuvius. It seemed to go rolling past them and echoed off the rock-face of the Appenninus with a flat boom. The ground heaved and the oxen shied, turning instinctively from the noise, dragging him with them. He dug his heels into the track and had just about managed to bring them to a halt when one of the men shrieked and pointed. 'The giants!' Huge white creatures, ghostly in the twilight, seemed to be issuing from beneath the earth ahead of them, as if the roof of Hades had split apart and the spirits of the dead

were flying into the sky. Even Attilius felt the hair stiffen on the back of his neck and it was Brebix in the end who laughed and said, 'They're only birds, you fools! Look!'

Birds – immense birds: flamingos, were they? – rose in their hundreds like some great white sheet that fluttered and dipped and then settled out of sight again. Flamingos, thought Attilius: water birds.

In the distance he saw two men, waving.

Nero himself, if he had spent a year on the task, could not have wished for a finer artificial lake than that which the Augusta had created in barely a day and a half. A shallow depression to the north of the matrix had filled to a depth of three or four feet. The surface was softly luminous in the dusk, broken here and there by clumpy islands formed by the dark foliage of half-submerged olive trees. Water-fowl scudded between them; flamingos lined the distant edge.

The men of Attilius's work-gang did not stop for permission. They tore off their tunics and ran naked towards it, their sun-burnt bodies and dancing, snow-white buttocks giving them the appearance of some exotic herd of antelope come down for an evening drink and a bathe. Whoops and splashes carried to where Attilius stood with Musa and Corvinus. He made no attempt to stop them. Let them enjoy it while they could. Besides, he had a fresh mystery to contend with.

Corax was missing.

219

According to Musa, he and the overseer had discovered the lake less than two hours after leaving Pompeii – around noon it must have been – and it was exactly as Attilius had predicted: how could anyone miss a flood of this size? After a brief inspection of the damage, Corax had remounted his horse and set off back to Pompeii to report on the scale of the problem, as agreed.

Attilius's jaw was set in anger. 'But that must have been seven or eight hours ago.' He did not believe it. 'Come on, Musa – what really happened?'

'I'm telling you the truth, aquarius. I swear it!' Musa's eyes were wide in apparently sincere alarm. 'I thought he would be coming back with you. Something must have happened to him!'

Beside the open manhole, Musa and Corvinus had lit a fire, not to keep themselves warm – the air was still sultry – but to ward off evil. The timber they had found was as dry as tinder, the flames bright in the darkness, spitting fountains of red sparks that rose whirling with the smoke. Huge white moths mingled with the flakes of ash.

'Perhaps we missed him on the road somehow.'

Attilius peered behind him into the encroaching gloom. But even as he said it he knew that it could not be right. And in any case, a man on horseback, even if he had taken a different route, would surely have had time to reach Pompeii, discover they had left and catch up with them. 'This makes no sense. Besides, I thought I made it clear that you were to bring us the message, not Corax.'

'You did.'

'Well?'

'He insisted on going to fetch you.'

He has run away, thought Attilius. It had to be the likeliest explanation. He and his friend Exomnius together – they had fled.

'This place,' said Musa, looking around. 'I'll be honest with you, Marcus Attilius – it gives me the creeps. That noise just now – did you hear it?'

'Of course we heard it. They must have heard it in Neapolis.'

'And just you wait till you see what's happened to the matrix.'

Attilius went over to one of the wagons and collected a torch. He returned and thrust it into the flames. It ignited immediately. The three of them gathered around the opening in the earth and once again he caught the whiff of sulphur rising from the darkness. 'Fetch me some rope,' he said to Musa. 'It's with the tools.' He glanced at Corvinus. 'And how did it go with you? Did you close the sluices?'

'Yes, aquarius. We had to argue with the priest but Becco convinced him.'

'What time did you shut it off?'

'The seventh hour.'

Attilius massaged his temples, trying to work it out. The level of water in the flooded tunnel would start to drop in a couple of hours. But unless he sent Corvinus back to Abellinum almost immediately, Becco would follow his instruction, wait twelve hours, and reopen

the sluices during the sixth watch of the night. It was all desperately tight. They would never manage it.

When Musa came back Attilius handed him the torch. He tied one end of the rope around his waist and sat on the edge of the open manhole. He muttered, 'Theseus in the labyrinth.'

'What?'

'Never mind. Just make sure you don't let go of the other end, there's a good fellow.'

Three feet of earth, thought Attilius, then two of masonry and then six of nothing from the top of the tunnel roof to the floor. Eleven feet in all. I had better land well. He turned and lowered himself into the narrow shaft, his fingers holding tight to the lip of the manhole, and hung there for a moment, suspended. How many times had he done this? And yet never in more than a decade had he lost the sense of panic at finding himself entombed beneath the earth. It was his secret dread, never confessed to anyone, not even to his father. Especially not to his father. He shut his eyes and let himself drop, bending his knees as he landed to absorb the shock. He crouched there for a moment, recovering his balance, the stink of sulphur in his nostrils, then cautiously felt outwards with his hands. The tunnel was only three feet wide. Dry cement beneath his fingers. Darkness when he opened his eyes – as dark as when they were closed. He stood, squeezed himself back a pace and shouted up to Musa, 'Throw down the torch!'

The flame guttered as it fell and for a moment he

feared it had gone out, but when he bent to take the handle it flared again, lighting the walls. The lower part was encrusted with lime deposited by the water over the years. Its roughened, bulging surface looked more like the wall of a cave than anything man-made and he thought how quickly Nature seized back what She had yielded – brickwork was crumbled by rain and frost, roads were buried under green drifts of weeds, aqueducts were clogged by the very water they were built to carry. Civilisation was a relentless war which Man was doomed to lose eventually. He picked at the lime with his thumbnail. Here was another example of Exomnius's idleness. The lime was almost as thick as his finger. It ought to have been scraped back every couple of years. No maintenance work had been done on this stretch for at least a decade.

He turned awkwardly in the confined space, holding the torch in front of him, and strained his eyes into the darkness. He could see nothing. He began to walk, counting each pace, and when he reached eighteen he gave a murmur of surprise. It was not simply that the tunnel was entirely blocked – he had expected that – but rather it seemed as if the floor had been driven upwards, pushed from below by some irresistible force. The thick concrete bed on which the channel rested had been sheared and a section of it sloped towards the roof. He heard Musa's muffled shout behind him: 'Can you see it?'

'Yes, I see it!'

The tunnel narrowed dramatically. He had to get

down on his knees and shuffle forwards. The fracturing of the base had, in turn, buckled the walls and collapsed the roof. Water was seeping through a compressed mass of bricks and earth and lumps of concrete. He scraped at it with his free hand, but the stench of sulphur was at its strongest here and the flames of his torch began to dwindle. He backed away quickly, reversing all the way to the shaft of the manhole. Looking up he could just make out the faces of Musa and Corvinus framed by the evening sky. He leaned his torch against the tunnel wall.

'Hold the rope fast. I'm coming out.' He untied it from around his waist and gave it a sharp pull. The faces of the men had vanished. 'Ready?'

'Yes!'

He tried not to think of what might happen if they let him fall. He grasped the rope with his right hand and hauled himself up, then grabbed it with his left and hauled again. The rope swung wildly. He got his head and shoulders into the inspection shaft and for a moment he thought his strength would let him down but another heave with each hand brought his knees into contact with the aperture and he was able to wedge his back against the side of the shaft. He decided it was easier to let go of the rope and to work himself up, pushing his body up with his knees and then with his back, until his arms were over the side of the manhole and he was able to eject himself into the fresh night air.

He lay on the ground, recovering his breath as Musa and Corvinus watched him. A full moon was rising.

'Well?' said Musa. 'What did you make of it?'

The engineer shook his head. 'I've never come across anything like it. I've seen roof falls and I've seen land slips on the sides of mountains. But this? This looks as though an entire section of the floor has just been shifted upwards. That's new to me.'

'Corax said exactly the same.'

Attilius got to his feet and peered down the shaft. His torch was still burning on the tunnel floor. 'This land,' he said bitterly. 'It looks solid enough. But it's no more firm than water.' He started walking, retracing his steps along the course of the Augusta. He counted off eighteen paces and stopped. Now that he studied the ground more closely he saw that it was bulging slightly. He scraped a mark with the edge of his foot and walked on, counting again. The swollen section did not seem very wide. Six yards, perhaps, or eight. It was difficult to be precise. He made another mark. Away to his left, Ampliatus's men were still clowning around in the lake.

He experienced a sudden rush of optimism. Actually, it wasn't too big, this blockage. The more he pondered it, the less likely it seemed to him to have been the work of an earthquake, which could easily have shaken the roof down along an entire section – now *that* would have been a disaster. But this was much more localised: more as if the land, for some strange reason, had risen a yard or two along a narrow line.

He turned in a full circle. Yes, he could see it now. The ground had heaved. The matrix had been

225

obstructed. At the same time the pressure of the movement had opened a crack in the tunnel wall. The water had escaped into the depression and formed a lake. But if they could clear the blockage and let the Augusta drain . . .

He decided at that moment that he would not send Corvinus back to Abellinum. He would try to fix the Augusta overnight. To confront the impossible: that was the Roman way! He cupped his hands to his mouth and shouted to the men. 'All right, gentlemen! The baths are closing! Let's get to work!'

Women did not often travel alone along the public highways of Campania and, as Corelia passed them, the peasants working in the dried-up, narrow fields turned to stare at her. Even some brawny farmer's wife, as broad as she was tall and armed with a stout hoe, might have hesitated to venture out unprotected at vespera. But an obviously rich young girl? On a fine-looking horse? How juicy a prize was that? Twice men stepped out into the road and attempted to block her path or grab at the reins, but each time she spurred her mount onwards and after a few hundred paces they gave up trying to chase her.

She knew the route the aquarius had taken from her eavesdropping that afternoon. But what had sounded a simple enough journey in a sunlit garden – following the line of the Pompeii aqueduct to the point where it joined the Augusta – was a terrifying undertaking when

actually attempted at dusk and by the time she reached the vineyards on the foothills of Vesuvius she was wishing she had never come. It was true what her father said of her – headstrong, disobedient, foolish, that she acted first and thought about it afterwards. These were the familiar charges he had flung at her the previous evening in Misenum, after the death of the slave, as they were embarking to return to Pompeii. But it was too late to turn back now.

Work was ending for the day and lines of exhausted, silent slaves, shackled together at the ankle, were shuffling beside the road in the twilight. The clank of their chains against the stones and the flick of the overseer's whip across their backs were the only sounds. She had heard about such wretches, crammed into the prison blocks attached to the larger farms and worked to death within a year or two: she had never actually seen them close up. Occasionally a slave found the energy to raise his eyes from the dirt and meet her glance; it was like staring through a hole into hell.

And yet she would not give in, even as nightfall emptied the road of traffic and the line of the aqueduct became harder to follow. The reassuring sight of the villas on the lower slopes of the mountain gradually dissolved, to be replaced by isolated points of torchlight and lamplight, winking in the darkness. Her horse slowed to a walk and she swayed in the saddle in time with its plodding motion.

It was hot. She was thirsty. (Naturally, she had forgotten to bring any water: that was something the slaves

always carried for her.) She was sore where her clothes chafed against her sweating skin. Only the thought of the aquarius and the danger he was in kept her moving. Perhaps she would be too late? Perhaps he had been murdered already? She was just beginning to wonder whether she would ever catch up with him when the heavy air seemed to turn solid and to hum around her, and an instant later, from deep inside the mountain to her left, came a loud crack. Her horse reared, pitching her backwards, and she was almost thrown, the reins snapping through her sweaty fingers, her damp legs failing to grip its heaving flanks. When it plunged forwards again and set off at a gallop she only saved herself by wrapping her fingers tightly in its thick mane and clinging for her life.

It must have charged for a mile or more and when at last it began to slow and she was able to raise her head she found that they had left the road and were cantering over open ground. She could hear water somewhere near and the horse must have heard it, too, or smelled it, because it turned and began walking towards the sound. Her cheek had been pressed close to the horse's neck, her eyes shut tight, but now, as she raised her head, she could make out white heaps of stone and a low brick wall that seemed to enclose an enormous well. The horse bent to drink. She whispered to it, and gently, so as not to alarm it, dismounted. She was trembling with shock.

Her feet sank into mud. Far in the distance she could see the lights of camp fires.

* * *

Attilius's first objective was to remove the debris from underground: no easy task. The tunnel was only wide enough for one man at a time to confront the obstruction, to swing a pick-axe and dig with a shovel, and once a basket was filled it had to be passed along the matrix from hand to hand until it reached the bottom of the inspection shaft, then attached to a rope and hauled to the surface, emptied, and sent back again, by which time a second basket had already been loaded and dispatched on its way.

Attilius, in his usual way, had taken the first turn with the pick. He tore a strip from his tunic and tied it round his mouth and nose to try to reduce the smell of the sulphur. Hacking away at the brick and earth and then shovelling it into the basket was bad enough. But trying to wield the axe in the cramped space and still find the force to smash the concrete into manageable lumps was a labour fit for Hercules. Some of the fragments took two men to carry and before long he had scraped his elbows raw against the walls of the tunnel. As for the heat, compounded by the sweltering night, the sweating bodies and the burning torches – that was worse than he imagined it could be even in the gold mines of Hispania. But still, Attilius had a sense of progress, and that gave him extra strength. He had found the spot where the Augusta was choked. All his problems would be overcome if he could clear these few narrow yards.

After a while, Brebix tapped him on the shoulder and offered to take over. Attilius gratefully handed him

the pick and watched in admiration as the big man, despite the fact that his bulk completely filled the tunnel, swung it as easily as if it were a toy. The engineer squeezed back along the line and the others shifted to make room for him. They were working as a team now, like a single body: the Roman way again. And whether it was the restorative effects of their bathe, or relief at having a specific task to occupy their thoughts, the mood of the men appeared transformed. He began to think that perhaps they were not such bad fellows after all. You could say what you liked about Ampliatus: at least he knew how to train a slave-gang. He took the heavy basket from the man beside him – the same man, he noticed, whose wine he had kicked away – turned and shuffled with it to the next in the line.

Gradually he lost track of time, his world restricted to this narrow few feet of tunnel, his sensations to the ache of his arms and back, the cuts on his hands from the sharp debris, the pain of his skinned elbows, the suffocating heat. He was so absorbed that at first he did not hear Brebix shouting to him.

'Aquarius! *Aquarius!*'

'Yes?' He flattened himself against the wall and edged past the men, aware for the first time that the water in the tunnel was up to his ankles. 'What is it?'

'Look for yourself.' Attilius took a torch from the man behind him and held it up close to the compacted mass of the blockage. At first glance it looked solid enough, but then he saw that it was seeping water everywhere. Tiny rivulets were running down the oozing

bulk, as if it had broken into a sweat. 'See what I mean?' Brebix prodded it with the axe. 'If this lot goes, we'll be drowned like rats in a sewer.'

Attilius was aware of the silence behind him. The slaves had all stopped work and were listening. Looking back he saw that they had already cleared four or five yards of debris. So what was left to hold back the weight of the Augusta? A few feet? He did not want to stop. But he did not want to kill them all, either.

'All right,' he said, reluctantly. 'Clear the tunnel.'

They needed no second telling, leaning the torches up against the walls, dropping their tools and baskets and lining up for the rope. No sooner had one man climbed it, his feet disappearing into the inspection shaft, than another had it in his hands and was hauling himself to safety. Attilius followed Brebix up the tunnel and by the time they reached the manhole they were the only ones left below ground.

Brebix offered him the rope. Attilius refused it. 'No. You go. I'll stay down and see what else can be done.' He realised Brebix was looking at him as if he were mad. 'I'll fasten the rope around me for safety. When you get to the top, untie it from the wagon and pay out enough for me to reach the end of the tunnel. Keep a firm hold.'

Brebix shrugged. 'Your choice.'

As he turned to climb, Attilius caught his arm. 'You are strong enough to hold me, Brebix?'

The gladiator grinned briefly. 'You – and your fucking mother!'

Despite his weight, Brebix ascended the rope as nimbly as a monkey, and then Attilius was alone. As he knotted the rope around his waist for a second time he thought that perhaps he *was* mad, but there seemed no alternative, for until the tunnel was drained they could not repair it, and he did not have the time to wait for all the water to seep through the obstruction. He tugged on the rope. 'All right, Brebix?'

'Ready!'

He picked up his torch and began moving back along the tunnel, the water above his ankles now, sloshing around his shins as he stepped over the abandoned tools and baskets. He moved slowly, so that Brebix could pay out the rope, and by the time he reached the debris he was sweating, from nerves as much as from the heat. He could sense the weight of the Augusta behind it. He transferred the torch into his left hand and with his right began pulling at the exposed end of a brick that was level with his face, working it up and down and from side to side. A small gap was what he needed: a controlled release of pressure from somewhere near the top. At first the brick wouldn't budge. Then water started to bubble around it and suddenly it shot through his fingers, propelled by a jet that fired it past his head, so close that it grazed his ear.

He cried out and backed away as the area around the leak bulged then sprang apart, peeling outwards and downwards in a V – all of this occurring in an instant, yet somehow slowly enough for him to register each individual stage of the collapse – before a wall of water

descended over him, smashing him backwards, knocking the torch out of his hand and submerging him in darkness. He hurtled underwater very fast – on his back, head-first – swept along the tunnel, scrabbling for a purchase on the smooth cement render of the matrix, but there was nothing he could grip. The surging current rolled him, flipped him over on to his stomach, and he felt a flash of pain as the rope snapped tight beneath his ribs, folding him and jerking him upwards, grazing his back against the roof. For a moment he thought he was saved, only for the rope to go slack again and for him to plunge to the bottom of the tunnel, the current sweeping him on – on like a leaf in a gutter – on into the darkness.

Nocte concubia

[22:07 hours]

*'Many observers have commented on the tendency
for eruptions to be initiated or become stronger at
times of full moon when the tidal stresses in the
crust are greatest.'*

Volcanology *(second edition)*

Ampliatus had never cared much for Vulcanalia.
The festival marked that point in the calendar
when nights fell noticeably earlier and morn-
ings had to start by candlelight: the end of the prom-
ise of summer and the start of the long, melancholy
decline into winter. And the ceremony itself was
distasteful. Vulcan dwelt in a cave beneath a mountain
and spread devouring fire across the earth. All creatures
went in fear of him, except for fish, and so – on the
principle that gods, like humans, desire most that which
is least attainable – he had to be appeased by a sacri-
fice of fish thrown alive on to a burning pyre.

It was not that Ampliatus was entirely lacking in religious feeling. He always liked to see a good-looking animal slaughtered – the placid manner of a bull, say, as it plodded towards the altar, and the way it stared at the priest so bemusedly; then the stunning and unexpected blow from the assistant's hammer and the flash of the knife as its throat was cut; the way it fell, as stiff as a table, with its legs sticking out; the crimson gouts of blood congealing in the dust and the yellow sac of guts boiling from its slit belly for inspection by the haruspices. Now *that* was religious. But to see hundreds of small fish tossed into the flames by the superstitious citizenry as they filed past the sacred fire, to watch the silvery bodies writhing and springing in the heat: there was nothing noble in it as far as he was concerned.

And it was particularly tedious this year because of the record numbers who wished to offer a sacrifice. The endless drought, the failure of springs and the drying of wells, the shaking of the ground, the apparitions seen and heard on the mountain – all this was held to be the work of Vulcan, and there was much apprehension in the town. Ampliatus could see it in the reddened, sweating faces of the crowd as they shuffled around the edge of the forum, staring into the fire. The fear in the air was palpable.

He did not have a very good position. The rulers of the town, as tradition demanded, were gathered on the steps of the Temple of Jupiter – the magistrates and the priests at the front, the members of the Ordo, including his own son, grouped behind, whereas Ampliatus,

as a freed slave, with no official recognition, was invariably banished by protocol to the back. Not that he minded. On the contrary. He relished the fact that power, *real* power, should be kept hidden: an invisible force that permitted the people these civic ceremonials while all the time jerking the participants as if they were marionettes. Besides, and this was what was truly exquisite, most people knew that it was actually he – that fellow standing third from the end in the tenth row – who really ran the town. Popidius and Cuspius, Holconius and Brittius – they knew it, and he felt that they squirmed, even as they acknowledged the tribute of the mob. And most of the mob knew it, too, and were all the more respectful towards him as a result. He could see them searching out his face, nudging and pointing.

'*That's Ampliatus,*' he imagined them saying, '*who rebuilt the town when the others ran away! Hail Ampliatus! Hail Ampliatus! Hail Ampliatus!*'

He slipped away before the end.

Once again, he decided he would walk rather than ride in his litter, passing down the steps of the temple between the ranks of the spectators – a nod bestowed here, an elbow squeezed there – along the shadowy side of the building, under the triumphal arch of Tiberius and into the empty street. His slaves carried his litter behind him, acting as a bodyguard, but he was not afraid of Pompeii after dark. He knew every stone of the town, every hump and hollow in the road, every storefront, every drain. The vast full moon and the

occasional streetlight – another of his innovations –
showed him the way home clearly enough. But it was
not just Pompeii's buildings he knew. It was its people,
and the mysterious workings of its soul, especially at
elections: five neighbourhood wards – Forenses,
Campanienses, Salinienses, Urbulanenses, Pagani – in
each of which he had an agent; and all the craft guilds
– the laundrymen, the bakers, the fishermen, the
perfume-makers, the goldsmiths and the rest – again,
he had them covered. He could even deliver half the
worshippers of Isis, his temple, as a block vote. And in
return for easing whichever booby he selected into
power he received those licences and permits, planning
permissions and favourable judgements in the Basilica
which were the invisible currency of power.

He turned down the hill towards his house – his
houses, he should say – and stopped for a moment to
savour the night air. He loved this town. In the early
morning the heat could feel oppressive, but usually,
from the direction of Capri, a line of dark blue rippling
waves would soon appear and by the fourth hour a
sea breeze would be sweeping over the city, rustling
the leaves, and for the rest of the day Pompeii would
smell as sweet as spring. True, when it was hot and
listless, as it was tonight, the grander people
complained that the town stank. But he almost
preferred it when the air was heavier – the dung of
the horses in the streets, the urine in the laundries,
the fish sauce factories down in the harbour, the sweat
of twenty thousand human bodies crammed within

the city walls. To Ampliatus this was the smell of life: of activity, money, profit.

He resumed his walk and when he reached his front door he stood beneath the lantern and knocked loudly. It was still a pleasure for him to come in through the entrance he had not been permitted to use as a slave and he rewarded the porter with a smile. He was in an excellent mood, so much so that he turned when he was halfway down the vestibule and said, 'Do you know the secret of a happy life, Massavo?'

The porter shook his immense head.

'To die.' Ampliatus gave him a playful punch in the stomach and winced; it was like striking wood. 'To die, and then to come back to life, and relish every day as a victory over the gods.'

He was afraid of nothing, no one. And the joke was, he was not nearly as rich as everyone assumed. The villa in Misenum – ten million sesterces, far too expensive, but he had simply had to have it! – that had only been bought by borrowing, chiefly on the strength of this house, which had itself been paid for through a mortgage on the baths, and they were not even finished. Yet Ampliatus kept it all running somehow by the force of his will, by cleverness and by public confidence, and if that fool Lucius Popidius thought he was getting his old family home back once he had married Corelia – well, sadly, he should have got himself a decent lawyer before he signed the settlement.

As he passed the swimming pool, lit by torches, he paused to study the fountain. The mist of the water

mingled with the scent of the roses, but even as he watched it seemed to him that it was beginning to lose its strength, and he thought of the solemn young aquarius, out in the darkness somewhere, trying to repair the aqueduct. He would not be coming back. It was a pity. They might have done business together. But he was honest, and Ampliatus's motto was always 'May the gods protect us from an honest man'. He might even be dead by now.

The flaccidity of the fountain began to perturb him. He thought of the silvery fish, springing and sizzling in the flames, and tried to imagine the reaction of the townspeople when they discovered the aqueduct was failing. Of course, he realised, they would blame it all on Vulcan, the superstitious fools. He had not considered that. In which case tomorrow might be an appropriate moment finally to produce the prophecy of Biria Onomastia, the sibyl of Pompeii, which he had taken the precaution of commissioning earlier in the summer. She lived in a house near the amphitheatre and at night, amid swathes of smoke, she communed with the ancient god, Sabazios, to whom she sacrificed snakes – a disgusting procedure – on an altar supporting two magical bronze hands. The whole ceremony had given him the creeps, but the sibyl had predicted an amazing future for Pompeii, and it would be useful to let word of it spread. He decided he would summon the magistrates in the morning. For now, while the others were still in the forum, he had more urgent business to attend to.

His prick began to harden even as he climbed the steps to the private apartments of the Popidii, a path he had trodden so many times, so long ago, when the old master had used him like a dog. What secret, frantic couplings these walls had witnessed over the years, what slobbering endearments they had overheard as Ampliatus had submitted to the probing fingers and had spread himself for the head of the household. Far younger than Celsinus he had been, younger even than Corelia – who was she to complain about marriage in the absence of love? Mind you, the master had always whispered that he loved him, and perhaps he had – after all, he had left him his freedom in his will. Everything that Ampliatus had grown to be had had its origin in the hot seed spilled up here. He had never forgotten it.

The bedroom door was unlocked and he went in without knocking. An oil lamp burned low on the dressing table. Moonlight spilled through the open shutters, and by its soft glow he saw Taedia Secunda lying prone upon her bed, like a corpse upon its bier. She turned her head as he appeared. She was naked; sixty if she was a day. Her wig was laid out on a dummy's head beside the lamp, a sightless spectator to what was to come. In the old days it was she who had always issued the commands – here, there, *there* – but now the roles were reversed, and he was not sure if she didn't enjoy it more, although she never uttered a word. Silently she turned and raised herself on her hands and knees, offering him her bony haunches, blue-sheened by the moon,

waiting, motionless, while her former slave – her master now – climbed up on to her bed.

Twice after the rope gave way Attilius managed to jam his knees and elbows against the narrow walls of the matrix in an effort to wedge himself fast and twice he succeeded only to be pummelled loose by the pressure of the water and propelled further along the tunnel. Limbs weakening, lungs bursting, he sensed he had one last chance and tried again, and this time he stuck, spread wide like a starfish. His head broke the surface and he choked and spluttered, gasping for breath.

In the darkness he had no idea where he was or how far he had been carried. He could see and hear nothing, feel nothing except the cement against his hands and knees and the pressure of the water up to his neck, hammering against his body. He had no idea how long he clung there but gradually he became aware that the pressure was slackening and that the level of the water was falling. When he felt the air on his shoulders he knew that the worst was over. Very soon after that his chest was clear of the surface. Cautiously he let go of the walls and stood. He swayed backward in the slow-moving current and then came upright, like a tree that had survived a flash-flood.

His mind was beginning to work again. The backed-up waters were draining away and because the sluices had been closed in Abellinum twelve hours earlier there

was nothing left to replenish them. What remained was being tamed and reduced by the infinitesimal gradient of the aqueduct. He felt something tugging at his waist. The rope was streaming out behind him. He fumbled for it in the darkness and hauled it in, coiling it around his arm. When he reached the end he ran his fingers over it. Smooth. Not frayed or hacked. Brebix must simply have let go of it. Why? Suddenly he was panicking, frantic to escape. He leaned forward and began to wade but it was like a nightmare – his hands stretched out invisible in front him feeling along the walls into the infinite dark, his legs unable to move faster than an old man's shuffle. He felt himself doubly imprisoned, by the earth pressing in all around him, by the weight of the water ahead. His ribs ached. His shoulder felt as if it had been branded by fire.

He heard a splash and then in the distance a pin-prick of yellow light dropped like a falling star. He stopped wading and listened, breathing hard. More shouts, followed by a second splash, and then another torch appeared. They were searching for him. He heard a faint shout – 'Aquarius!' – and tried to decide whether he should reply. He was scaring himself with shadows, surely? The wall of debris had given way so abruptly and with such force that no normal man would have had the strength to hold him. But Brebix was not a man of normal strength and what had happened was not unexpected: the gladiator was supposed to have been braced against it.

'Aquarius!'

He hesitated. There was no other way out of the tunnel, that was for certain. He would have to go on and face them. But his instinct told him to keep his suspicions to himself. He shouted back, 'I'm here!' and splashed on through the dwindling water towards the waving lights.

They greeted him with a mixture of wonder and respect – Brebix, Musa and young Polites all crowding forward to meet him – for it had seemed to them, they said, that nothing could have survived the flood. Brebix insisted that the rope had shot through his hands like a serpent and as proof he showed his palms. In the torchlight each was crossed by a vivid burn-mark. Perhaps he was telling the truth. He sounded contrite enough. But then any assassin would look shame-faced if his victim came back to life. 'As I recall it, Brebix, you said you could hold me and my mother.'

'Aye, well your mother's heavier than I thought.'

'You're favoured by the gods, aquarius,' declared Musa. 'They have some destiny in mind for you.'

'My destiny,' said Attilius, 'is to repair this fucking aqueduct and get back to Misenum.' He unfastened the rope from around his waist, took Polites's torch and edged past the men, shining the light along the tunnel.

How quickly the water was draining! It was already below his knees. He imagined the current swirling past him, on its way to Nola and the other towns. Eventually it would work its way all around the bay, across the

243

arcades north of Neapolis and over the great arch at Cumae, down the spine of the peninsula to Misenum. Soon this section would be drained entirely. There would be nothing more than puddles on the floor. Whatever happened, he had fulfilled his promise to the admiral. He had cleared the matrix.

The point where the tunnel had been blocked was still a mess but the force of the flood had done most of their work for them. Now it was a matter of clearing out the rest of the earth and rubble, smoothing the floor and walls, putting down a bed of concrete and a fresh lining of bricks, then a render of cement – nothing fancy: just temporary repairs until they could get back to do a proper job in the autumn. It was still a lot of work to get through in a night, before the first tongues of fresh water reached them from Abellinum, after Becco had reopened the sluices. He told them what he wanted and Musa started adding his own suggestions. If they brought down the bricks now, he said, they could stack them along the wall and have them ready to use when the water cleared. They could make a start on mixing the cement above ground immediately. It was the first time he had shown any desire to co-operate since Attilius had taken charge of the aqueduct. He seemed awed by the engineer's survival. *I should come back from the dead more often,* Attilius thought.

Brebix said, 'At least that stink has gone.'

Attilius had not noticed it before. He sniffed the air. It was true. The pervasive stench of sulphur seemed to have been washed away. He wondered what that had

244

all been about – where it had come from in the first place, why it should have evaporated – but he did not have time to consider it. He heard his name being called and he kicked his way back through the water to the inspection shaft. It was Corvinus's voice: 'Aquarius!'

'Yes?' The face of the slave was silhouetted by a red glow. 'What is it?'

'I think you ought to come and see.' His head disappeared abruptly.

Now what? Attilius took the rope and tested it carefully, then started climbing. In his bruised and exhausted state it was harder work than before. He ascended slowly – right hand, left hand, right hand, hauling himself into the narrow access shaft, working himself up, thrusting his arms over the lip of the manhole and levering himself out into the warm night.

In the time he had been underground the moon had risen – huge, full and red. It was like the stars in this part of the world – like everything, in fact – unnatural and overblown. There was quite an operation in progress on the surface by now: the heaps of spoil excavated from the tunnel, a couple of big bonfires spitting sparks at the harvest moon, torches planted in the ground to provide additional light, the wagons drawn up and mostly unloaded. He could see a thick rim of mud in the moonlight around the shallow lake, where it had already mostly drained. The slaves of Ampliatus's work-gang were leaning against the carts, waiting for orders. They watched him with curiosity as he hauled himself to his feet. He must look a sight, he realised,

drenched and dirty. He shouted into the tunnel for Musa to come up and set them back to work, then looked around for Corvinus. He was about thirty paces away, close to the oxen, with his back to the manhole. Attilius shouted to him impatiently.

'Well?'

Corvinus turned and by way of explanation stepped aside, revealing behind him a figure in a hooded cloak. Attilius set off towards them. It was only as he came closer and the stranger pulled back the hood that he recognised her. He could not have been more startled if Egeria herself, the goddess of the water-spring, had suddenly materialised in the moonlight. His first instinct was that she must have come with her father and he looked around for other riders, other horses. But there was only one horse, chewing placidly on the thin grass. She was alone and as he reached her he raised his hands in astonishment.

'Corelia – what is this?'

'She wouldn't tell me what she wants,' interrupted Corvinus. 'She says she'll only talk to you.'

'Corelia?'

She nodded suspiciously towards Corvinus, put her finger to her lips and shook her head.

'See what I mean? The moment she turned up yesterday I knew she was trouble –'

'All right, Corvinus. That's enough. Get back to work.'

'But –'

'*Work!*'

As the slave slouched away he examined her more closely. Cheeks smudged, hair dishevelled, cloak and dress spattered with mud. But it was her eyes, unnaturally wide and bright, that were most disturbing. He took her hand. 'This is no place for you,' he said gently. 'What are you doing here?'

'I wanted to bring you these,' she whispered and from the folds of her cloak she began producing small cylinders of papyrus.

The documents were of different ages and conditions. Six in total, small enough to fit into the cradle of one arm. Attilius took a torch and with Corelia beside him moved away from the activity around the aqueduct to a private spot behind one of the wagons, looking out over the flooded ground. Across what remained of the lake ran a wavering path of moonlight, as wide and straight as a Roman road. From the far side came the rustle of wings and the cries of the waterfowl.

He took her cloak from her shoulders and spread it out for her to sit on. Then he jammed the handle of the torch into the earth, squatted and unrolled the oldest of the documents. It was a plan of one section of the Augusta – this very section: Pompeii, Nola and Vesuvius were all marked in ink that had faded from black to pale grey. It was stamped with the imperial seal of the Divine Augustus as if it had been inspected and officially approved. A surveyor's drawing. Original. Drafted more than a century ago. Perhaps the great Marcus

Agrippa himself had once held it in his hands? He turned it over. Such a document could only have come from one of two places, either the archive of the Curator Aquarum in Rome, or the Piscina Mirabilis in Misenum. He rolled it carefully.

The next three papyri consisted mostly of columns of numerals and it took him a while to make much sense of them. One was headed *Colonia Veneria Pompeianorum* and was divided into years – DCCCXIV, DCCCXV and so on – going back nearly two decades, with further subdivisions of notations, figures and totals. The quantities increased annually until, by the year that had ended last December – Rome's eight hundred and thirty-third – they had doubled. The second document seemed at first glance to be identical until he studied it more closely and then he saw that the figures throughout were roughly half as large as in the first. For example, for the last year, the grand total of three hundred and fifty-two thousand recorded in the first papyrus had been reduced in the second to one hundred and seventy-eight thousand.

The third document was less formal. It looked like the monthly record of a man's income. Again there were almost two decades' worth of figures and again the sums gradually mounted until they had almost doubled. And a good income it was – perhaps fifty thousand sesterces in the last year alone, maybe a third of a million overall.

Corelia was sitting with her knees drawn up, watching him. 'Well? What do they mean?'

He took his time answering. He felt tainted: the shame of one man, the shame of them all. And who could tell how high the rot had spread? But then he thought, No, it would not have gone right the way up to Rome, because if Rome had been a part of it, Aviola would never have sent him south to Misenum. 'These look like the actual figures for the amount of water consumed in Pompeii.' He showed her the first papyrus. 'Three hundred and fifty thousand quinariae last year – that would be about right for a town of Pompeii's size. And this second set of records I presume is the one that my predecessor, Exomnius, officially submitted to Rome. They wouldn't know the difference, especially after the earthquake, unless they sent an inspector down to check. And this' – he did not try to hide his contempt as he flourished the third document – 'is what your father paid him to keep his mouth shut.' She looked at him, bewildered. 'Water is expensive,' he explained, 'especially if you're rebuilding half a town. "At least as valuable as money" – that's what your father said to me.' No doubt it would have made the difference between profit and loss. *Salve lucrum!*

He rolled up the papyri. They must have been stolen from the squalid room above the bar. He wondered why Exomnius would have run the risk of keeping such an incriminating record so close to hand. But then he supposed that incrimination was precisely what Exomnius would have had in mind. They would have given him a powerful hold over Ampliatus: *Don't ever think of trying to move against me – of silencing me, or*

cutting me out of the deal, or threatening me with exposure – because if I am ruined, I can ruin you with me.

Corelia said, 'What about those two?'

The final pair of documents were so different from the others it was as if they did not belong with them. They were much newer, for a start, and instead of figures they were covered in writing. The first was in Greek.

The summit itself is mostly flat, and entirely barren. The soil looks like ash, and there are cave-like pits of blackened rock, looking gnawed by fire. This area appears to have been on fire in the past and to have had craters of flame which were subsequently extinguished by a lack of fuel. No doubt this is the reason for the fertility of the surrounding area, as at Caetana, where they say that soil filled with the ash thrown up by Etna's flames makes the land particularly good for vines. The enriched soil contains both material that burns and material that fosters production. When it is over-charged with the enriching substance it is ready to burn, as is the case with all sulphurous substances, but when this has been exuded and the fire extinguished the soil becomes ash-like and suitable for produce.

Attilius had to read it through twice, holding it to the torchlight, before he was sure he had the sense of it. He passed it to Corelia. *The summit?* The summit of what? Of Vesuvius, presumably – that was the only summit round here. But had Exomnius – lazy, ageing,

hard-drinking, whore-loving Exomnius – really found the energy to climb all the way up to the top of Vesuvius, in a drought, to record his impressions in Greek? It defied belief. And the language – *'cave-like pits of blackened rock . . . fertility of the surrounding area'* – that didn't sound like the voice of an engineer. It was too literary, not at all the sort of phrases that would come naturally to a man like Exomnius, who was surely no more fluent in the tongue of the Hellenes than Attilius was himself. He must have copied it from somewhere. Or had it copied for him. By one of the scribes in that public library on Pompeii's forum, perhaps.

The final papyrus was longer, and in Latin. But the content was equally strange:

Lucilius, my good friend, I have just heard that Pompeii, the famous city in Campania, has been laid low by an earthquake which also disturbed all the adjacent districts. Also, part of the town of Herculaneum is in ruins and even the structures which are left standing are shaky. Neapolis also lost many private dwellings. To these calamities others were added: they say that a flock of hundreds of sheep were killed, statues were cracked, and some people were deranged and afterwards wandered about unable to help themselves.

I have said that a flock of hundreds of sheep were killed in the Pompeiian district. There is no reason you should think this happened to those sheep because of fear. For they say that a plague usually occurs after

a great earthquake, and this is not surprising. For many death-carrying elements lie hidden in the depths. The very atmosphere there, which is stagnant either from some flaw in the earth or from inactivity and the eternal darkness, is harmful to those breathing it. I am not surprised that sheep have been infected – sheep which have a delicate constitution – the closer they carried their heads to the ground, since they received the afflatus of the tainted air near to the ground itself. If the air had come out in greater quantity it would have harmed people too; but the abundance of pure air extinguished it before it rose high enough to be breathed by people.

Again, the language seemed too flowery to be the work of Exomnius, the execution of the script too professional. In any case, why would Exomnius have claimed to have *just heard* about an earthquake which had happened seventeen years earlier? And who was Lucilius? Corelia had leaned across to read the document over his shoulder. He could smell her perfume, feel her breath on his cheek, her breast pressed against his arm. He said, 'And you are sure these were with the other papyri? They could not have come from somewhere else?'

'They were in the same box. What do they mean?'

'And you didn't see the man who brought the box to your father?'

Corelia shook her head. 'I could only hear him. They talked about you. It was what they said that made me decide to find you.' She shifted fractionally closer to

him and lowered her voice. 'My father said he didn't want you to come back from this expedition alive.'

'Is that so?' He made an effort to laugh. 'And what did the other man say?'

'He said that it would not be a problem.'

Silence. He felt her hand touch his – her cool fingers on his raw cuts and scratches – and then she rested her head against his chest. She was exhausted. For a moment, for the first time in three years, he allowed himself to relish the sensation of having a woman's body close to his.

So this was what it was like to be alive, he thought. He had forgotten.

After a while she fell asleep. Carefully, so as not to wake her, he disengaged his arm. He left her and walked back over to the aqueduct.

The repair work had reached a decisive point. The slaves had stopped bringing debris up out of the tunnel and had started lowering bricks down into it. Attilius nodded warily to Brebix and Musa who were standing talking together. Both men fell silent as he approached and glanced beyond him to the place where Corelia was lying, but he ignored their curiosity.

His mind was in a turmoil. That Exomnius was corrupt was no surprise – he had been resigned to that. And he had assumed his dishonesty explained his disappearance. But these other documents, this piece of Greek and this extract from a letter, these cast the

mystery in a different light entirely. Now it seemed that Exomnius had been worried about the soil through which the Augusta passed – the sulphurous, tainted soil – at least three weeks before the aqueduct had been contaminated. Worried enough to look out a set of the original plans and to go researching in Pompeii's library.

Attilius stared distractedly down into the depths of the matrix. He was remembering his exchange with Corax in the Piscina Mirabilis the previous afternoon: Corax's sneer – *'He knew this water better than any man alive. He would have seen this coming'* – and his own, unthinking retort – *'Perhaps he did, and that was why he ran away.'* For the first time he had a presentiment of something terrible. He could not define it. But too much was happening that was out of the ordinary – the failure of the matrix, the trembling of the ground, springs running backwards into the earth, sulphur poisoning . . . Exomnius had sensed it, too.

The fire of the torches glowed in the tunnel.

'Musa?'

'Yes, aquarius?'

'Where was Exomnius from? Originally?'

'Sicily, aquarius.'

'Yes, yes, I know Sicily. Which part exactly?'

'I think the east.' Musa frowned. 'Caetana. Why?'

But the engineer, gazing across the narrow moonlit plain towards the shadowy mass of Vesuvius, did not reply.

JUPITER

24 August

The day of the eruption

Hora prima

[06:20 hours]

*'At some point, hot magma interacted with
ground-water seeping downwards through the
volcano, initiating the first event, the minor
phreato-magmatic eruption which showered fine-
grained grey tephra over the eastern flanks of the
volcano. This probably took place during the night
or on the morning of 24 August.'*

Volcanoes: A Planetary Perspective

He kept his increasing anxiety to himself all
through the sweltering night, as they worked
by torchlight to repair the matrix.

He helped Corvinus and Polites on the surface mix
the wooden troughs of cement, pouring in the quick-
lime and the powdery puteolanum and a tiny amount
of water – no more than a cupful, mind, because that
was the first secret of making a good cement: the drier
the mixture, the stronger it set – and then he helped the

slaves carry it down in baskets into the matrix and spread it out to form a new base for the conduit. He helped Brebix smash up the rubble they had dug out earlier and they added a couple of layers of that into the base, for strength. He helped saw the planks they used to shutter the walls and to crawl along over the wet cement. He passed bricks to Musa as he laid them. Finally he stood shoulder-to-shoulder with Corvinus to apply the thin coat of render. (And here was the second secret of perfect cement: to pound it as hard as possible, 'hew it as you would hew wood', to squeeze out every last bubble of water or air which might later be a source of weakness.)

By the time the sky above the manhole was turning grey he knew that they had probably done enough to bring the Augusta back into service. He would have to return to repair her properly. But for now, with a bit of luck, she would hold. He walked with his torch to the end of the patched-up section, inspecting every foot. The waterproof render would be setting even as the aqueduct started to flow again. By the end of the first day it would be hard; by the end of the third it would be stronger than rock.

If being stronger than rock means anything any more. But he kept the thought to himself.

'Cement that dries underwater,' he said to Musa when he came back. 'Now *that* is a miracle.'

He let the others climb up ahead of him. The breaking day showed that they had pitched their camp in rough pasture, littered with large stones, flanked by mountains. To the east were the steep cliffs of the

Appenninus, with a town – Nola, presumably – just becoming visible in the dawn light about five or six miles away. But the shock was to discover how close they were to Vesuvius. It lay directly to the west and the land started to rise almost immediately, within a few hundred paces of the aqueduct, steepening to a point so high the engineer had to tilt his head back to see the summit. And what was most unsettling, now that the shadows were lifting, were the streaks of greyish-white beginning to appear across one of its flanks. They stood out clearly against the surrounding forest, shaped like arrow-heads, pointing towards the summit. If it had not been August he would have sworn that they were made of snow. The others had noticed them as well.

'Ice?' said Brebix, gawping at the mountain. 'Ice in August?'

'Did you ever see such a thing, aquarius?' asked Musa.

Attilius shook his head. He was thinking of the description in the Greek papyri: *the ash thrown up by Etna's flames makes the land particularly good for vines*.

'Could it,' he said hesitantly, almost to himself, 'could it perhaps be *ash*?'

'But how can there be ash without fire?' objected Musa. 'And if there had been a fire that size in the darkness we would have seen it.'

'That's true.' Attilius glanced around at their exhausted, fearful faces. The evidence of their work was everywhere – heaps of rubble, empty amphorae, dead torches, scorched patches where the night's fires had been allowed to burn themselves out. The lake had gone,

and with it, he noticed, the birds. He had not heard them leave. Along the mountain ridge opposite Vesuvius the sun was beginning to appear. There was a strange stillness in the air. No birdsong of any sort, he realised. No dawn chorus. That would send the augurs into a frenzy. 'And you're sure it was not there yesterday, when you arrived with Corax?'

'Yes.' Musa was staring at Vesuvius transfixed. He wiped his hands uneasily on his filthy tunic. 'It must have happened last night. That crash which shook the ground, remember? That must have been it. The mountain has cracked and spewed.'

There was a general muttering of uneasiness among the men and someone cried out, 'That can only be the giants!'

Attilius wiped the sweat from his eyes. It was starting to feel hot already. Another scorching day in prospect. And something more than heat – a tautness, like a drumskin stretched too far. Was it his mind playing tricks, or did the ground seem to be vibrating slightly? A prickle of fear stirred the hair on the back of his scalp. Etna and Vesuvius – he was beginning to sense the same terrible connection that Exomnius must have recognised.

'All right,' he said briskly. 'Let's get away from this place.' He set off towards Corelia. 'Bring everything up out of the matrix,' he called over his shoulder. 'And look sharp about it. We've finished here.'

* * *

S he was still asleep, or at least he thought she was. She was lying beside the more distant of the two wagons, curled up on her side, her legs drawn up, her hands raised in front of her face and balled into fists. He stood looking down at her for a moment, marvelling at the incongruity of her beauty in this desolate spot – Egeria among the humdrum tools of his profession.

'I've been awake for hours.' She rolled on to her back and opened her eyes. 'Is the work finished?'

'Finished enough.' He knelt and began collecting together the papyri. 'The men are going back to Pompeii. I want you to go on ahead of them. I'll send an escort with you.'

She sat up quickly. 'No!'

He knew how she would react. He had spent half the night thinking about it. But what other choice did he have? He spoke quickly. 'You must return those documents to where you found them. If you set off now you should be back in Pompeii well before midday. With luck, he need never know you took them, or brought them out here to me.'

'But they are the proof of his corruption –'

'No.' He held up his hand to quiet her. 'No, they're not. On their own, they mean nothing. Proof would be Exomnius giving testimony before a magistrate. But I don't have him. I don't have the money your father paid him or even a single piece of evidence that he spent any of it. He's been very careful. As far as the world is concerned, Exomnius was as honest as Cato. Besides, this isn't as important as getting you away from here.

Something's happening to the mountain. I'm not sure what. Exomnius suspected it weeks ago. It's as if –' He broke off. He didn't know how to put it into words. 'It's as if it's – *coming alive*. You'll be safer in Pompeii.'

She was shaking her head. 'And what will you do?'

'Return to Misenum. Report to the admiral. If anyone can make sense of what is happening, he can.'

'Once you're alone they'll try to kill you.'

'I don't think so. If they'd wanted to do that, they had plenty of chances last night. If anything, I'll be safer. I have a horse. They're on foot. They couldn't catch me even if they tried.'

'I also have a horse. Take me with you.'

'That's impossible.'

'Why? I can ride.'

For a moment he played with the image of the two of them turning up in Misenum together. The daughter of the owner of the Villa Hortensia sharing his cramped quarters at the Piscina Mirabilis. Hiding her when Ampliatus came looking for her. How long would they get away with it? A day or two. And then what? The laws of society were as inflexible as the laws of engineering.

'Corelia, listen.' He took her hands. 'If I could do anything to help you, in return for what you've done for me, I would. But this is madness, to defy your father.'

'You don't understand.' Her grip on his fingers was ferocious. 'I can't go back. Don't make me go back. I can't bear to see him again, or to marry that man –'

'But you know the law. When it comes to marriage, you're as much your father's property as any one of those slaves over there.' What could he say? He hated the words even as he uttered them. 'It may not turn out to be as bad as you fear.' She groaned, pulled away her hands and buried her face. He blundered on. 'We can't escape our destiny. And, believe me, there are worse ones than marrying a rich man. You could be working in the fields and dead at twenty. Or a whore in the back streets of Pompeii. Accept what has to happen. Live with it. You'll survive. You'll see.'

She gave him a long, slow look – contempt, was it, or hatred? 'I swear to you, I sooner would be a whore.'

'And I swear you would not.' He spoke more sharply. 'You're young. What do you know of how people live?'

'I know I cannot be married to someone I despise. Could you?' She glared at him. 'Perhaps you could.'

He turned away. 'No, Corelia.'

'Are you married?'

'No.'

'But you *were* married?'

'Yes,' he said quietly, 'I was married. My wife is dead.'

That shut her up for a moment. 'And did you despise her?'

'Of course not.'

'Did she despise you?'

'Perhaps she did.'

She was briefly silent again. 'How did she die?'

He did not ever talk of it. He did not even think of it. And if, as sometimes happened, especially in the

wakeful hours before dawn, his mind ever started off down that miserable road, he had trained himself to haul it back and set it on a different course. But now – there was something about her: she had got under his skin. To his astonishment, he found himself telling her.

'She looked something like you. And she had a temper, too, like yours.' He laughed briefly, remembering. 'We were married three years.' It was madness; he could not stop himself. 'She was in childbirth. But it came from the womb feet first, like Agrippa. That's what the name means – Agrippa – aegre partus – "born with difficulty" – did you know that? I thought at first it was a fine omen for a future aquarius, to be born like the great Agrippa. I was sure it was a boy. But the day went on – it was June in Rome, and hot: almost as hot as down here – and even with a doctor and two women in attendance, the baby would not move. And then she began to bleed.' He closed his eyes. 'They came to me before nightfall. "Marcus Attilius, choose between your wife and your child!" I said that I chose both. But they told me that was not to be, so I said – of course I said – "My wife." I went into the room to be with her. She was very weak, but she disagreed. Arguing with me, even then! They had a pair of shears, you know – the sort that a gardener might use? And a knife. And a hook. They cut off one foot, and then the other, and used the knife to quarter the body, and then the hook to draw out the skull. But Sabina's bleeding didn't stop, and the next morning she also died.

So I don't know. Perhaps at the end she did despise me.'

He sent her back to Pompeii with Polites. Not because the Greek slave was the strongest escort available, or the best horseman, but because he was the only one Attilius trusted. He gave him Corvinus's mount and told him not to let her out of his sight until she was safely home.

She went meekly in the end, with barely another word, and he felt ashamed of what he had said. He had silenced her well enough, but in a coward's way – unmanly and self-pitying. Had ever an unctuous lawyer in Rome used a cheaper trick of rhetoric to sway a court than this ghastly parading of the ghosts of a dead wife and child? She swept her cloak around her and then flung her head back, flicking her long dark hair over her collar, and there was something impressive in the gesture: she would do as he asked but she would not accept that he was right. Never a glance in his direction as she swung herself easily into the saddle. She made a clicking sound with her tongue and tugged the reins and set off down the track behind Polites.

It took all his self-control not to run after her. A poor reward, he thought, for all the risks she ran for me. But what else did she expect of him? And as for fate – the subject of his pious little lecture – he *did* believe in fate. One was shackled to it from birth as to a moving wagon. The destination of the journey could

not be altered, only the manner in which one approached it – whether one chose to walk erect or to be dragged complaining through the dust.

Still, he felt sick as he watched her go, the sun brightening the landscape as the distance between them increased, so that he was able to watch her for a long time, until at last the horses passed behind a clump of olive trees, and she was gone.

I n Misenum, the admiral was lying on his mattress in his windowless bedroom, remembering.

He was remembering the flat, muddy forests of Upper Germany, and the great oak trees that grew along the shore of the northern sea – if one could speak of a shore in a place where the sea and the land barely knew a boundary – and the rain and the wind, and the way that in a storm the trees, with a terrible splintering, would sometimes detach themselves from the bank, vast islands of soil trapped within their roots, and drift upright, their foliage spread like rigging, bearing down on the fragile Roman galleys. He could still see in his mind the sheet lightning and the dark sky and the pale faces of the Chauci warriors amid the trees, the smell of the mud and the rain, the terror of the trees crashing into the ships at anchor, his men drowning in that filthy barbarian sea –

He shuddered and opened his eyes to the dim light, hauled himself up, and demanded to know where he was. His secretary, sitting beside the couch next to a

candle, his stylus poised, looked down at his wax tablet.

'We were with Domitius Corbulo, admiral,' said Alexion, 'when you were in the cavalry, fighting the Chauci.'

'Ah yes. Just so. The Chauci. I remember –'

But what did he remember? The admiral had been trying for months to write his memoirs – his final book, he was sure – and it was a welcome distraction from the crisis on the aqueduct to return to it. But what he had seen and done and what he had read or been told seemed nowadays to run together, in a kind of seamless dream. Such things he had witnessed! The empresses – Lollia Paulina, Caligula's wife, sparkling like a fountain in the candlelight at her betrothal banquet, cascading with forty million sesterces' worth of pearls and emeralds. And the Empress Agrippina, married to the drooling Claudius: he had seen her pass by in a cloak made entirely out of gold. And gold-mining he had watched, of course, when he was procurator in northern Spain – the miners cutting away at the mountainside, suspended by ropes, so that they looked, from a distance, like a species of giant bird pecking at the rockface. Such work, such danger – and to what end? Poor Agrippina, murdered here, in this very town, by Ancietus, his predecessor as admiral of the Misene Fleet, on the orders of her son, the Emperor Nero, who put his mother to sea in a boat that collapsed and then had her stabbed to death by sailors when she somehow struggled ashore. Stories! This was his problem. He had too many stories to fit into one book.

'The Chauci –' How old was he then? Twenty-four? It was his first campaign. He began again. 'The Chauci, I remember, dwelt on high wooden platforms to escape the treacherous tides of that region. They gathered mud with their bare hands, which they dried in the freezing north wind, and burnt for fuel. To drink they consumed only rainwater, which they collected in tanks at the front of their houses – a sure sign of their lack of civilisation. Miserable bloody bastards, the Chauci.' He paused. 'Leave that last bit out.'

The door opened briefly, admitting a shaft of brilliant white light. He heard the rustling of the Mediterranean, the hammering of the shipyards. So it was morning already. He must have been awake for hours. The door closed again. A slave tip-toed across to the secretary and whispered into his ear. Pliny rolled his fat body over on to one side to get a better view. 'What time is it?'

'The end of the first hour, admiral.'

'Have the sluices been opened at the reservoir?'

'Yes, admiral. We have a message that the last of the water has drained away.'

Pliny groaned and flopped back on to his pillow.

'And it seems, sir, that a most remarkable discovery has just been made.'

The work-gang had left about a half-hour after Corelia. There were no elaborate farewells: the contagion of fear had spread throughout the men to

infect Musa and Corvinus and all were eager to get back to the safety of Pompeii. Even Brebix, the former gladiator, the undefeated hero of thirty fights, kept turning his small, dark eyes nervously towards Vesuvius. They cleared the matrix and flung the tools, the unused bricks and the empty amphorae on to the backs of the wagons. Finally, a couple of the slaves shovelled earth across the remains of the night's fires and buried the grey scars left by the cement. By the time this was finished it was as if they had never been there.

Attilius stood warily beside the inspection shaft with his arms folded and watched them prepare to leave. This was his moment of greatest danger, now that the work was done. It would be typical of Ampliatus to make sure he extracted a final measure of use out of the engineer before dispensing with him. He was ready to fight, to sell himself dearly if he had to.

Musa had the only other horse and once he was in the saddle he called down to Attilius. 'Are you coming?'

'Not yet. I'll catch you up later.'

'Why not come now?'

'Because I'm going to go up on to the mountain.'

Musa looked at him, astonished. 'Why?'

A good question. *Because the answer to what has been happening down here must lie up there. Because it's my job to keep the water running. Because I am afraid.* The engineer shrugged. 'Curiosity. Don't worry. I haven't forgotten my promise, if that's what's bothering you. Here.' He threw Musa his leather purse. 'You've done well. Buy the men some food and wine.'

Musa opened the purse and inspected its contents. 'There's plenty here, aquarius. Enough for a woman as well.'

Attilius laughed. 'Go safely, Musa. I'll see you soon. Either in Pompeii or Misenum.'

Musa gave him a second glance and seemed about to say something, but changed his mind. He wheeled away and set off after the carts and Attilius was alone.

Again, he was struck by the peculiar stillness of the day, as if Nature were holding Her breath. The noise of the heavy wooden wheels slowly faded into the distance and all he could hear was the occasional tinkle of a goat's bell and the ubiquitous chafing of the cicadas. The sun was quite high now. He glanced around at the empty countryside, then lay on his stomach and peered into the matrix. The heat pressed heavily on his back and shoulders. He thought of Sabina and of Corelia and of the terrible image of his dead son. He wept. He did not try to stop himself but for once surrendered to it, choking and shaking with grief, gulping the tunnel air, inhaling the cold and bitter odour of the wet cement. He felt oddly apart from himself, as if he had divided into two people, one crying and the other watching him cry.

After a while he stopped and raised himself to wipe his face on the sleeve of his tunic and it was only when he looked down again that his eye was caught by something – by a glint of reflected light in the darkness. He drew his head back slightly to let the sun shine directly along the shaft and he saw very faintly that the floor

of the aqueduct was glistening. He rubbed his eyes and looked again. Even as he watched the quality of the light seemed to change and become more substantial, rippling and widening as the tunnel began to fill with water.

He whispered to himself, 'She runs!'

When he was satisfied that he was not mistaken and that the Augusta had indeed begun to flow again, he rolled the heavy manhole cover across to the shaft. He slowly lowered it, pulling his fingers back at the last instant to let it drop the final few inches. With a thud the tunnel was sealed.

He untethered his horse and climbed into the saddle. In the shimmering heat, the marker-stones of the aqueduct dwindled into the distance like a line of submerged rocks. He pulled on the reins and turned away from the Augusta to face Vesuvius. He spurred the horse and they moved off along the track that led towards the mountain, walking at first but quickening to a trot as the ground began to rise.

At the Piscina Mirabilis the last of the water had drained away and the great reservoir was empty – a rare sight. It had last been allowed to happen a decade ago and that had been for maintenance, so that the slaves could shovel out the sediment and check the walls for signs of cracking. The admiral listened attentively as the slave explained the workings of the system. He was always interested in technical matters.

'And how often is this supposed to be done?'

'Every ten years would be customary, admiral.'

'So this was going to be done again soon?'

'Yes, admiral.'

They were standing on the steps of the reservoir, about halfway down – Pliny, his nephew Gaius, his secretary Alexion, and the water-slave, Dromo. Pliny had issued orders that nothing was to be disturbed until he arrived and a marine guard had been posted at the door to prevent unauthorised access. Word of the discovery had got out, however, and there was the usual curious crowd in the courtyard.

The floor of the Piscina looked like a muddy beach after the tide had gone out. There were little pools here and there, where the sediment was slightly hollowed, and a litter of objects – rusted tools, stones, shoes – that had fallen into the water over the years and had sunk to the bottom, some of them entirely shrouded so that they appeared as nothing more than small humps on the smooth surface. The rowing boat was grounded. Several sets of footprints led out from the bottom of the steps towards the centre of the reservoir, where a larger object lay, and then returned. Dromo asked if the admiral would like him to fetch it.

'No,' said Pliny, 'I want to see it where it lies for myself. Oblige me, would you, Gaius.' He pointed to his shoes and his nephew knelt and unbuckled them while the admiral leaned on Alexion for support. He felt an almost childish anticipation and the sensation intensified as he descended the last of the steps and

cautiously lowered his feet into the sediment. Black slime oozed between his toes, deliciously cool, and immediately he was a boy again, back at the family home in Comum, in Transpadane Italy, playing on the shores of the lake, and the intervening years – nearly half a century of them – were as insubstantial as a dream. How many times did this occur each day? It never used to happen. But lately almost anything could set it off – a touch, a smell, a sound, a colour glimpsed – and immediately memories he did not know he still possessed came flooding back, as if there was nothing left of him any more but a breathless sack of remembered impressions.

He hoisted the folds of his toga and began stepping gingerly across the surface, his feet sinking deep into the mud, which then made a delightful sucking noise each time he lifted them. He heard Gaius shout behind him, 'Be careful, uncle!' but he shook his head, laughing. He kept away from the tracks the others had made: it was more enjoyable to rupture the crust of mud where it was still fresh and just beginning to harden in the warm air. The others followed at a respectful distance.

What an extraordinary construction it was, he thought, this underground vault, with its pillars each ten times higher than a man! What imagination had first envisioned it, what will and strength had driven it through to construction – and all to store water that had already been carried for sixty miles! He had never had any objection to deifying emperors. 'God is man helping man,' that was his philosophy. The Divine

Augustus deserved his place in the pantheon simply for commissioning the Campanian aqueduct and the Piscina Mirabilis. By the time he reached the centre of the reservoir he was breathless with the effort of repeatedly hoisting his feet out of the clinging sediment. He propped himself against a pillar as Gaius came up beside him. But he was glad that he had made the effort. The water-slave had been wise to send for him. This was something to see, right enough: a mystery of Nature had become also a mystery of Man.

The object in the mud was an amphora used for storing quicklime. It was wedged almost upright, the bottom part buried in the soft bed of the reservoir. A long, thin rope had been attached to its handles and this lay in a tangle around it. The lid, which had been sealed with wax, had been prised off. Scattered, gleaming in the mud, were perhaps a hundred small silver coins.

'Nothing has been removed, admiral,' said Dromo anxiously. 'I told them to leave it exactly as they found it.'

Pliny blew out his cheeks. 'How much is in there, Gaius, would you say?'

His nephew buried both hands into the amphora, cupped them, and showed them to the admiral. They brimmed with silver denarii. 'A fortune, uncle.'

'And an illegal one, we may be sure. It corrupts the honest mud.' Neither the earthenware vessel nor the rope had much of a coating of sediment, which meant, thought Pliny, that it could not have lain on the reservoir

274

floor for long – a month at most. He glanced up towards the vaulted ceiling. 'Someone must have rowed out,' he said, 'and lowered it over the side.'

'And then let go of the rope?' Gaius looked at him in wonder. 'But who would have done such a thing? How could he have hoped to retrieve it? No diver could swim down this deep!'

'True.' Pliny dipped his own hand into the coins and examined them in his plump palm, stroking them apart with his thumb. Vespasian's familiar, scowling profile decorated one side, the sacred implements of the augur occupied the other. The inscription round the edge – IMP CAES VESP AVG COS III – showed that they had been minted during the Emperor's third consul-ship, eight years earlier. 'Then we must assume that their owner didn't plan to retrieve them by diving, Gaius, but by draining the reservoir. And the only man with the authority to empty the piscina whenever he desired was our missing aquarius, Exomnius.'

Hora quarta

[10:37 hours]

*'Average magma ascent rates obtained in recent
studies suggest that magma in the chamber beneath
Vesuvius may have started rising at a velocity of
> 0.2 metres per second into the conduit of the
volcano some four hours before the eruption – that
is, at approximately 9 a.m. on the morning of
24 August.'*

Burkhard Müller-Ullrich (editor), Dynamics of
Volcanism

The quattuorviri – the Board of Four: the elected
magistrates of Pompeii – were meeting in emer-
gency session in the drawing room of Lucius
Popidius. The slaves had carried in a chair for each of
them, and a small table, around which they sat, mostly
silent, arms folded, waiting. Ampliatus, out of defer-
ence to the fact that he was not a magistrate, reclined
on a couch in the corner, eating a fig, watching them.

Through the open door he could see the swimming pool and its silent fountain, and also, in a corner of the tiled garden, a cat playing with a little bird. This ritual of extended death intrigued him. The Egyptians held the cat to be a sacred animal: of all creatures the nearest in intelligence to Man. And in the whole of Nature, only cats and men – that he could think of – derived an obvious pleasure from cruelty. Did that mean that cruelty and intelligence were inevitably entwined? Interesting.

He ate another fig. The noise of his slurping made Popidius wince. 'I must say, you seem supremely confident, Ampliatus.' There was an edge of irritation in his voice.

'I am supremely confident. You should relax.'

'That's easy enough for you to say. Your name is not on fifty notices spread around the city assuring everyone that the water will be flowing again by midday.'

'Public responsibility – the price of elected office, my dear Popidius.' He clicked his juicy fingers and a slave carried over a small silver bowl. He dunked his hands and dried them on the slave's tunic. 'Have faith in Roman engineering, your honours. All will be well.'

It was four hours since Pompeii had woken to another hot and cloudless day and to the discovery of the failure of its water supply. Ampliatus's instinct for what would happen next had proved correct. Coming on the morning after most of the town had turned out to sacrifice to Vulcan it was hard, even for the least superstitious, not to see this as further evidence of the god's

displeasure. Nervous groups had started forming on the street corners soon after dawn. Placards, signed by L. Popidius Secundus, posted in the forum and on the larger fountains, announced that repairs were being carried out on the aqueduct and that the supply would resume by the seventh hour. But it was not much reassurance for those who remembered the terrible earthquake of seventeen years ago – the water had failed on that occasion, too – and all morning there had been uneasiness across the town. Some shops had failed to open. A few people had left, with their possessions piled on carts, loudly proclaiming that Vulcan was about to destroy Pompeii for a second time. And now word had got out that the quattuorviri were meeting at the House of Popidius. A crowd had gathered in the street outside. Occasionally, in the comfortable drawing room, the noise of the mob could be heard: a growl, like the sound of the beasts in their cages in the tunnels of the amphitheatre, immediately before they were let loose to fight the gladiators.

Brittius shivered. 'I told you we should never have agreed to help that engineer.'

'That's right,' agreed Cuspius. 'I said so right at the start. Now look where it's got us.'

You could learn so much from a man's face, thought Ampliatus. How much he indulged himself in food and drink, what manner of work he did, his pride, his cowardice, his strength. Popidius, now: he was handsome and weak; Cuspius, like his father, brave, brutal, stupid; Brittius sagged with self-indulgence; Holconius

vinegary-sharp and shrewd – too many anchovies and too much garum sauce in *that* diet.

'Balls,' said Ampliatus amiably. 'Think about it. If we hadn't helped him, he would simply have gone to Nola for assistance and we would still have lost our water, only a day later – and how would that have looked when Rome got to hear of it? Besides, this way we know where he is. He's in our power.'

The others did not notice, but old Holconius turned round at once. 'And why is it so important that we know where he is?'

Ampliatus was momentarily lost for an answer. He laughed it off. 'Come on, Holconius! Isn't it always useful to know as much as possible? That's worth the price of lending him a few slaves and some wood and lime. Once a man is in your debt, isn't it easier to control him?'

'That's certainly true,' said Holconius drily and glanced across the table at Popidius.

Even Popidius was not stupid enough to miss the insult. He flushed scarlet. 'Meaning?' he demanded. He pushed back his chair.

'Listen!' commanded Ampliatus. He wanted to stop this conversation before it went any further. 'I want to tell you about a prophecy I commissioned in the summer, when the tremors started.'

'A prophecy?' Popidius sat down again. He was imme-diately interested. He loved all that stuff, Ampliatus knew: old Biria with her two magical bronze hands, covered in mystic symbols, her cage full of snakes, her

milky-white eyes that couldn't see a man's face but could stare into the future. 'You've consulted the sibyl? What did she say?'

Ampliatus arranged his features in a suitably solemn expression. 'She sacrificed serpents to Sabazius, and skinned them for their meaning. I was present throughout.' He remembered the flames on the altar, the smoke, the glittering hands, the incense, the sibyl's wavering voice: high-pitched, barely human – like the curse of that old woman whose son he had fed to the eels. He had been awed by the whole performance, despite himself. 'She saw a town – our town – many years from now. A thousand years distant, maybe more.' He let his voice fall to a whisper. 'She saw a city famed throughout the world. Our temples, our amphitheatre, our streets – thronging with people of every tongue. That was what she saw in the guts of the snakes. Long after the Caesars are dust and the Empire has passed away, what we have built here will endure.'

He sat back. He had half convinced himself. Popidius let out his breath. 'Biria Onomastia,' he said, 'is never wrong.'

'And she will repeat all this?' asked Holconius sceptically. 'She will let us use the prophecy?'

'She will,' Ampliatus affirmed. 'She'd better. I paid her plenty for it.' He thought he heard something. He rose from the couch and walked out into the sunshine of the garden. The fountain that fed the swimming pool was in the form of a nymph tipping a jug. As he came closer he heard it again, a faint gurgling, and then water

began to trickle from the vessel's lip. The flow stuttered, spurted, seemed to stop, but then it began to run more strongly. He felt suddenly overwhelmed by the mystic forces he had unleashed. He beckoned to the others to come and look. 'You see. I told you. The prophecy is correct!'

Amid the exclamations of pleasure and relief, even Holconius managed a thin smile. 'That's good.'

'Scutarius!' Ampliatus shouted to the steward. 'Bring the quattuorviri our best wine – the Caecuban, why not? Now, Popidius, shall I give the mob the news or will you?'

'You tell them, Ampliatus. I need a drink.'

Ampliatus swept across the atrium towards the great front door. He gestured to Massavo to open it and stepped out on to the threshold. Perhaps a hundred people – *his* people was how he liked to think of them – were crowded into the street. He held up his arms for silence. 'You all know who I am,' he shouted, when the murmur of voices had died away, 'and you all know you can trust me!'

'Why should we?' someone shouted from the back.

Ampliatus ignored him. 'The water is running again! If you don't believe me – like that insolent fellow there – go and look at the fountains and see for yourselves. The aqueduct is repaired! And later today, a wonderful prophecy, by the sibyl, Biria Onomastia, will be made public. It will take more than a few trembles in the ground and one hot summer to frighten the colony of Pompeii!'

281

A few people cheered. Ampliatus beamed and waved. 'Good day to you all, citizens! Let's get back to business. *Salve lucrum! Lucrum gaudium!*' He ducked back into the vestibule. 'Throw them some money, Scutarius,' he hissed, still smiling at the mob. 'Not too much, mind you. Enough for some wine for them all.'

He lingered long enough to hear the effects of his largesse, as the crowd struggled for the coins, then headed back towards the atrium, rubbing his hands with delight. The disappearance of Exomnius had jolted his equanimity, he would not deny it, but in less than a day he had dealt with the problem, the fountain looked to be running strongly, and if that young aquarius was not dead yet he would be soon. A cause for celebration! From the drawing room came the sound of laughter and the clink of crystal glass. He was about to walk around the pool to join them when, at his feet, he noticed the body of the bird he had watched being killed. He prodded it with his toe then stopped to pick it up. Its tiny body was still warm. A red cap, white cheeks, black and yellow wings. There was a bead of blood in its eye.

A goldfinch. Nothing to it but fluff and feathers. He weighed it in his hand for a moment, some dark thought moving in the back of his mind, then let it drop and quickly mounted the steps into the pillared garden of his old house. The cat saw him coming and darted out of sight behind a bush but Ampliatus was not interested in pursuing it. His eyes were fixed on the empty cage on Corelia's balcony and the darkened, shuttered

windows of her room. He bellowed, 'Celsia!' and his wife came running. 'Where's Corelia?'

'She was ill. I let her sleep –'

'Get her! Now!' He shoved her in the direction of the staircase, turned, and hurried towards his study.

It was not possible –

She would not dare –

He knew there was something wrong the moment he picked up the lamp and took it over to his desk. It was an old trick, learned from his former master – a hair in the drawer to tell him if a curious hand had been meddling in his affairs – but it worked well enough, and he had let it be understood that he would crucify the slave who could not be trusted.

There was no hair. And when he opened the strong box and took out the document case there were no papyri, either. He stood there like a fool, tipping up the empty *capsa* and shaking it like a magician who had forgotten the rest of his trick, then hurled it across the room where it splintered against the wall. He ran out to the courtyard. His wife had opened Corelia's shutters and was standing on the balcony, her hands pressed to her face.

Corelia had her back to the mountain as she came through the Vesuvius Gate and into the square beside the castellum aquae. The fountains had started to run again, but the flow was still weak and from this high vantage point it was possible to see that a dusty

pall had formed over Pompeii, thrown up by the traffic in the waterless streets. The noise of activity rose as a general hum above the red roofs.

She had taken her time on the journey home, never once spurring her horse above walking pace as she skirted Vesuvius and crossed the plain. She saw no reason to speed up now. As she descended the hill towards the big crossroads, Polites plodding faithfully behind her, the blank walls of the houses seemed to rise on either side to enclose her like a prison. Places she had relished since childhood – the hidden pools and the scented flower gardens, the shops with their trinkets and fabrics, the theatres and the noisy bath-houses – were as dead to her now as ash. She noticed the angry, frustrated faces of the people at the fountains, jostling to jam their pots beneath the dribble of water, and she thought again of the aquarius. She wondered where he was and what he was doing. His story of his wife and child had haunted her all the way back to Pompeii.

She knew that he was right. Her fate was inescapable. She felt neither angry nor afraid any more as she neared her father's house, merely dead to it all – exhausted, filthy, thirsty. Perhaps this would be her life from now on, her body going through the routine motions of existence and her soul elsewhere, watchful and separate? She could see a crowd in the street up ahead, bigger than the usual collection of hangers-on who waited for hours for a word with her father. As she watched they seemed to break into some outlandish, ritualistic dance, leaping into the air with their arms outstretched then

dropping to their knees to scrabble on the stones. It took her a moment to realise that they were having money thrown to them. That was typical of her father, she thought – the provincial Caesar, trying to buy the affection of the mob, believing himself to be acting like an aristocrat, never recognising his own puffed-up vulgarity.

Her contempt was suddenly greater than her hatred and it strengthened her courage. She led the way round to the back of the house, towards the stables, and at the sound of the hooves on the cobbles an elderly groom came out. He looked wide-eyed with surprise at her dishevelled appearance, but she took no notice. She jumped down from the saddle and handed him the reins. 'Thank you,' she said to Polites and then, to the groom, 'See that this man is given food and drink.'

She passed quickly out of the glare of the street and into the gloom of the house, climbing the stairs from the slaves' quarters. As she walked she drew the rolls of papyri from beneath her cloak. Marcus Attilius had told her to replace them in her father's study and hope their removal had not been noticed. But she would not do that. She would give them to him herself. Even better, she would tell him where she had been. He would know that she had discovered the truth and then he could do to her what he pleased. She did not care. What could be worse than the fate he had already planned? You cannot punish the dead.

It was with the exhilaration of rebellion that she emerged through the curtain into the House of Popidius

and walked towards the swimming pool that formed the heart of the villa. She heard voices to her right and saw in the drawing room her future husband and the magistrates of Pompeii. They turned to look at her at exactly the moment that her father, with her mother and brother behind him, appeared on the steps leading to their old home. Ampliatus saw what she was carrying and for one glorious instant she saw the panic in his face. He shouted at her – 'Corelia!' – and started towards her but she swerved away and ran into the drawing room, scattering his secrets across the table and over the carpet before he had a chance to stop her.

It seemed to the engineer that Vesuvius was playing a game with him, never coming any closer however hard he rode towards her. Only occasionally, when he looked back, shielding his eyes against the sun, did he realise how high he was climbing. Soon he had a clear view of Nola. The irrigated fields around it were like a clear green square, no larger than a doll's handkerchief lying unfolded on the brown Campanian plain. And Nola itself, an old Samnite fortress, appeared no more formidable than a scattering of tiny children's bricks dropped off the edge of the distant mountain range. The citizens would have their water running by now. The thought gave him fresh confidence.

He had deliberately aimed for the edge of the nearest white-grey streak and he reached it soon after the middle of the morning, at the point where the pastureland on

the lower slopes ended and the forest began. He passed no living creature, neither man nor animal. The occasional farmhouse beside the track was deserted. He guessed everyone must have fled, either in the night when they heard the explosion or at first light, when they woke to this ghostly shrouding of ash. It lay across the ground, like a powdery snow, quite still, for there was not a breath of wind to disturb it. When he jumped down from his horse he raised a cloud that clung to his sweating legs. He scooped up a handful. It was odourless, fine-grained, warm from the sun. In the distant trees it covered the foliage exactly as would a light fall of snow.

He put a little in his pocket, to take back to show the admiral, and drank some water, swilling the dry taste of the dust from his mouth. Looking down the slope he could see another rider, perhaps a mile away, also making steady progress towards this same spot, presumably led by a similar curiosity to discover what had happened. Attilius considered waiting for him, to exchange opinions, but decided against it. He wanted to press on. He spat out the water, remounted, and rode back across the flank of the mountain, away from the ash, to rejoin the track that led into the forest.

Once he was among the trees the woodland closed around him and quickly he lost all sense of his position. There was nothing for it but to follow the hunters' track as it wound through the trees, over the dried-up beds of streams, meandering from side to side but always leading him higher. He dismounted to take a piss. Lizards rustled away among the dead leaves. He saw

small red spiders and their fragile webs, hairy caterpillars the size of his forefinger. There were clumps of crimson berries that tasted sweet on his tongue. The vegetation was commonplace – alder, brambles, ivy. Torquatus, the captain of the liburnian, had been right, he thought: Vesuvius was easier to ascend than she looked, and when the streams were full there would be enough up here to eat and drink to sustain an army. He could readily imagine the Thracian gladiator, Spartacus, leading his followers along this very trail a century and a half before, climbing towards the sanctuary of the summit.

It took him perhaps another hour to pass through the forest. He had little sense of time. The sun was mostly hidden by the trees, falling in shafts through the thick canopy of leaves. The sky, broken into fragments by the foliage, formed a brilliant, shifting pattern of blue. The air was hot, fragrant with the scent of dried pine and herbs. Butterflies flitted among the trees. There was no noise except the occasional soft hooting of wood pigeons. Swaying in the saddle in the heat he felt drowsy. His head nodded. Once he thought he heard a larger animal moving along the track behind him but when he stopped to listen the sound had gone. Soon afterwards the forest began to thin. He came to a clearing.

And now it was as if Vesuvius had decided to play a different game. Having for hours never seemed to come any closer, suddenly the peak rose directly in front of him – a few hundred feet high, a steeper incline, mostly of rock, without sufficient soil to support much

in the way of vegetation except for straggly bushes and plants with small yellow flowers. And it was exactly as the Greek writer had described: a black cap, long ago scorched by fire. In places, the rock bulged outwards, almost as if it were being pushed up from beneath, sending small flurries of stones rattling down the slope. Further along the ridge, larger landslips had occurred. Huge boulders, the size of a man, had been sent crashing into the trees – and recently, by the look of them. Attilius remembered the reluctance of the men to leave Pompeii. *'Giants have journeyed through the air, their voices like claps of thunder . . .'* The sound must have carried for miles.

It was too steep a climb for his horse. He dismounted and found a shady spot where he could tie its reins to a tree. He scouted around for a stick and selected one about half as thick as his wrist – smooth, grey, long-dead – and with that to support his weight he set out to begin his final ascent.

The sun up here was merciless, the sky so bright it was almost white. He moved from rock to cindery rock in the suffocating heat and the air itself seemed to burn his lungs, a dry heat, like a blade withdrawn from a fire. No lizards underfoot here, no birds overhead – it was a climb directly into the sun. He could feel the heat through the soles of his shoes. He forced himself to press on, without looking back, until the ground ceased to rise and what was ahead of him was no longer black rock but blue sky. He clambered over the ridge and peered across the roof of the world.

The summit of Vesuvius was not the sharp peak that it had appeared from the base but a rough and circular plain, perhaps two hundred paces in diameter, a wilderness of black rock, with a few brownish patches of sickly vegetation that merely emphasised its deadness. Not only did it look to have been on fire in the past, as the Greek papyri had said, but to be burning now. In at least three places thin columns of grey vapour were rising, fluttering and hissing in the silence. There was the same sour stench of sulphur that there had been in the pipes of the Villa Hortensia. This is the place, thought Attilius. This is the heart of the evil. He could sense something huge and malevolent. One could call it Vulcan or give it whatever name one liked. One could worship it as a god. But it was a tangible presence. He shuddered.

He kept close to the edge of the summit and began working his way around it, mesmerised to begin with by the sulphurous clouds that were whispering from the ground and then by the astonishing panoramas beyond the rim. Away to his right the bare rock ran down to the edge of the forest, and then there was nothing but an undulating green blanket. Torquatus had said that you could see for fifty miles, but to Attilius it seemed that the whole of Italy was spread beneath him. As he moved from north to west the Bay of Neapolis came into his vision. He could easily make out the promontory of Misenum and the islands off its point, and the imperial retreat of Capri, and beyond them, as sharp as a razor-cut, the fine line where the deep blue of the sea

met the paler blue of the sky. The water was still flecked
by the waves he had noticed the night before – scud-
ding waves on a windless sea – although now he thought
about it perhaps there *was* a breeze beginning to get
up. He could feel it on his cheek: the one they called
Caurus, blowing from the north-west, towards Pompeii,
which appeared at his feet as no more than a sandy
smudge set back from the coast. He imagined Corelia
arriving there, utterly unreachable now, a dot within a
dot, lost to him forever.

It made him feel light-headed simply to look at it,
as if he were himself nothing but a speck of pollen that
might be lifted at any moment by the hot air and blown
into the blueness. He felt an overwhelming impulse to
surrender to it – a yearning for that perfect blue obliv-
ion so strong that he had to force himself to turn away.
Shaken, he began to pick his way directly across the
summit towards the other side, back to where he had
started, keeping clear of the plumes of sulphur which
seemed to be multiplying all around him. The ground
was shaking, bulging. He wanted to get away now, as
fast as he could. But the terrain was rough, with deep
depressions on either side of his path – *'cave-like pits of
blackened rock'*, as the Greek writer had said – and he
had to watch where he put his feet. And it was because
of this – because he had his head down – that he smelled
the body before he saw it.

It stopped him in his tracks – a sweet and cloying
stink that entered his mouth and nostrils and coated
them with a greasy film. The stench was emanating

from the large dust bowl straight ahead of him. It was perhaps six feet deep and thirty across, simmering like a cauldron in the haze of heat, and what was most awful, when he peered over the side, was that everything in it was dead: not just the man, who wore a white tunic and whose limbs were so purplish-black Attilius thought at first he was a Nubian, but other creatures – a snake, a large bird, a litter of small animals – all scattered in this pit of death. Even the vegetation was bleached and poisoned.

The corpse was lying at the bottom, on its side, with its arms flung out, a water-gourd and a straw hat just beyond its reach, as if it had died straining for them. It must have lain out here for at least two weeks, putrefying in the heat. Yet the wonder was how much of it remained. It had not been attacked by insects, or picked to the bone by birds and animals. No clouds of blow-flies swarmed across its half-baked meat. Rather, its burnt flesh appeared to have poisoned anything that had tried to feast on it.

He swallowed hard to keep back his vomit. He knew at once that it had to be Exomnius. He had been gone two weeks or more, and who else would have ventured up here in August? But how could he be sure? He had never met the man. Yet he was reluctant to venture down on to that carpet of death. He forced himself to squat close to the lip of the pit and squinted at the blackened face. He saw a row of grinning teeth, like pips in a burst fruit; a dull eye, half-closed, sighting along the length of the grasping arm. There was no sign

of any wound. But then the whole body was a wound, bruised and suppurating. What could have killed him? Perhaps he had succumbed to the heat. Perhaps his heart had given out. Attilius leaned down further and tried to poke at it with his stick and immediately he felt himself begin to faint. Bright lights wove and danced before him and he almost toppled forwards. He scrabbled with his hands in the dust and just managed to push himself back, gasping for breath.

'*The afflatus of the tainted air near to the ground itself* . . .'

His head was pounding. He threw up – bitter, vile-tasting fluid – and was still coughing and spitting mucus when he heard, in front of him, the crack of dry vegetation being broken by a step. He looked up groggily. On the other side of the pit, no more than fifty paces away, a man was moving across the summit towards him. He thought at first it must be part of the visions induced by the *tainted air* and he stood with an effort, swaying drunkenly, blinking the sweat out of his eyes, trying to focus, but still the figure came on, framed by the hissing jets of sulphur, with the glint in his hand of a knife.

It was Corax.

Attilius was in no condition to fight. He would have run. But he could barely raise his feet.

The overseer approached the pit cautiously – crouched low, his arms spread wide, shifting lightly from foot to foot, reluctant to take his eyes off the engineer, as if he suspected a trick. He darted a quick glance at

the body, frowned at Attilius, then looked back down again. He said softly, 'So what's all this then, pretty boy?' He sounded almost offended. He had planned his assault carefully, had travelled a long way to carry it out, had waited in the darkness for daylight and had followed his quarry at a distance – he must have been the horseman I saw behind me, thought Attilius – all the time relishing the prospect of revenge, only to have his plans thrown awry at the last moment. It was not fair, his expression said – another in the long series of obstacles that life had thrown in the way of Gavius Corax. 'I asked you: what's all this?'

Attilius tried to speak. His voice was thick and slurred. He wanted to say that Exomnius had not been wrong, that there was terrible danger here, but he could not pronounce the words. Corax was scowling at the corpse and shaking his head. 'The stupid old bastard, climbing up here at his age! Worrying about the mountain. And for what? For nothing! Nothing – except landing us with you.' He returned his attention to Attilius. 'Some clever young cunt from Rome, come to teach us all our jobs. Still fancy your chances, pretty boy? Nothing to say now, I notice. Well, why don't I cut you another mouth and we'll see what comes out of that?'

He hunched forwards, tossing his knife from hand to hand, his face set and ready for the kill. He began to circle the pit and it was all Attilius could do to stumble in the opposite direction. When the overseer stopped, Attilius stopped, and when he reversed his steps and started prowling the other way, Attilius

followed suit. This went on for a while, but the tactic obviously enraged Corax – 'Fuck this,' he yelled, 'I'm not playing your stupid games!' – and suddenly he made a rush at his prey. Red-faced, panting for breath in the heat, he ran down the side of the hollow and across it and had just reached the other slope when he stopped. He glanced down at his legs in surprise. With a terrible slowness he tried to wade forwards, opening and shutting his mouth like a landed fish. He dropped his knife and sank to his knees, batting feebly at the air in front of him, then he crashed forwards on to his face.

There was nothing that Attilius could do except to watch him drown in the dry heat. Corax made a couple of feeble attempts to move, each time seeming to stretch for something beyond his reach as Exomnius must have done. Then he gave up and quietly lay on his side. His breathing became more shallow then stopped, but long before it ceased altogether Attilius had left him – stumbling across the bulging, trembling summit of the mountain, through the thickening plumes of sulphur, now flattened by the gathering breeze and pointing in the direction of Pompeii.

Down in the town, the light wind, arriving during the hottest part of the day, had come as a welcome relief. The Caurus raised tiny swirls of dust along the streets as they emptied for the siesta, fluttering the coloured awnings of the bars and snack-houses, stirring the foliage of the big plane trees close to the

amphitheatre. In the House of Popidius it ruffled the surface of the swimming pool. The little masks of dancing fauns and bacchantes hanging between the pillars stirred and chimed. One of the papyri lying on the carpet was caught by the gust and rolled towards the table. Holconius put out his foot to stop it.

'What's going on?' he asked.

Ampliatus was tempted to strike Corelia there and then but checked himself, sensing that it would somehow be her victory if he was to be seen beating her in public. His mind moved quickly. He knew all there was to know about power. He knew that there were times when it was wisest to keep your secrets close: to possess your knowledge privately, like a favourite lover, to be shared with no one. He also knew that there were times when secrets, carefully revealed, could act like hoops of steel, binding others to you. In a flash of inspiration he saw that this was one of those occasions.

'Read them,' he said. 'I have nothing to hide from my friends.' He stooped and collected the papyri and piled them on the table.

'We should go,' said Brittius. He drained his glass of wine and began to rise to his feet.

'Read them!' commanded Ampliatus. The magistrate sat down sharply. 'Forgive me. Please. I insist.' He smiled. 'They come from the room of Exomnius. It's time you knew. Help yourself to more wine. I shall only be a moment. Corelia, you will come with me.' He seized her by the elbow and steered her towards the steps. She dragged her feet but he was too strong for

her. He was vaguely aware of his wife and son following. When they were out of sight, around the corner, in the pillared garden of their old house, he twisted her flesh between his fingers. 'Did you really think,' he hissed, 'that you could hurt me – a feeble girl like you?'

'No,' she said, wincing and wriggling to escape. 'But at least I thought I could try.'

Her composure disconcerted him. 'Oh?' He pulled her close to him. 'And how did you propose to do that?'

'By showing the documents to the aquarius. By showing them to everyone. So that they could all see you for what you are.'

'And what is that?' Her face was very close to his.

'A thief. A murderer. Lower than a *slave*.'

She spat out the last word and he drew back his hand and this time he would certainly have hit her but Celsinus grabbed his wrist from behind.

'No, father,' he said. 'We'll have no more of that.'

For a moment, Ampliatus was too astonished to speak. 'You?' he said. 'You as well?' He shook his hand free and glared at his son. 'Don't you have some religious rite to go to? And you?' He wheeled on his wife. 'Shouldn't you be praying to the holy matron, Livia, for guidance? Ach,' he spat, 'get out of my way, the pair of you.' He dragged Corelia along the path towards the staircase. The other two did not move. He turned and pushed her up the steps, along the passage, and into her room. She fell backwards on to her bed. 'Treacherous, ungrateful child!'

He looked around for something with which to

punish her but all he could see were feeble, feminine possessions, neatly arranged – an ivory comb, a silk shawl, a parasol, strings of beads – and a few old toys which had been saved to be offered to Venus before her wedding. Propped in a corner was a wooden doll with movable limbs he had bought her for her birthday years ago and the sight of it jolted him. What had happened to her? He had loved her so much – his little girl! – how had it come to hatred? He was suddenly baffled. Had he not done everything, built all of this, raised himself out of the muck, for the sake of her and her brother? He stood panting, defeated, as she glared at him from the bed. He did not know what to say. 'You'll stay in here,' he finished lamely, 'until I have decided what should be done with you.' He went out, locking the door behind him.

His wife and son had left the garden. Typical, feeble rebels, he thought, melting away when his back was turned. Corelia had always had more balls than the rest of them put together. His little girl! In the drawing room the magistrates were leaning forward across the table, muttering. They fell silent as he approached and turned to watch him as he headed towards the sideboard and poured himself some wine. The lip of the decanter rattled against the glass. Was his hand shaking? He examined it, front and back. This was not like him: it looked steady enough. He felt better after draining the glass. He poured himself another, fixed a smile and faced the magistrates.

'Well?'

It was Holconius who spoke first. 'Where did you get these?'

'Corax, the overseer on the Augusta, brought them round to me yesterday afternoon. He found them in Exomnius's room.'

'You mean he stole them?'

'Found, stole –' Ampliatus fluttered his hand.

'This should have been brought to our attention immediately.'

'And why's that, your honours?'

'Isn't it obvious?' cut in Popidius excitedly. 'Exomnius believed there was about to be another great earthquake!'

'Calm yourself, Popidius. You've been whining about earthquakes for seventeen years. I wouldn't take all that stuff seriously.'

'Exomnius took it seriously.'

'Exomnius!' Ampliatus looked at him with contempt. 'Exomnius always was a bag of nerves.'

'Maybe so. But why was he having documents copied? This in particular. What do you think he wanted with this?' He waved one of the papyri.

Ampliatus glanced at it and took another gulp of wine. 'It's in Greek. I don't read Greek. You forget, Popidius: I haven't had the benefit of your education.'

'Well I do read Greek, and I believe I recognise this. I think this is the work of Strabo, the geographer, who travelled these parts in the time of the Divine Augustus. He writes here of a summit that is flat and barren and has been on fire in the past. Surely that must be Vesuvius? He says the fertile soil around Pompeii

299

reminds him of Caetana, where the land is covered with ash thrown up by the flames of Etna.'

'So what?'

'Wasn't Exomnius a Sicilian?' demanded Holconius. 'What town was he from?'

Ampliatus waved his glass dismissively. 'I believe Caetana. But what of it?' He must learn the rudiments of Greek, he thought. If a fool like Popidius could master it, anyone could.

'As for this Latin document – this I certainly recognise,' continued Popidius. 'It's part of a book, and I know both the man who wrote it and the man to whom the passage is addressed. It's by Annaeus Seneca – Nero's mentor. Surely even *you* must have heard of him?'

Ampliatus flushed. 'My business is building, not books.' Why were they going on about all this stuff?

'The Lucilius to whom he refers is Lucilius Junior, a native of this very city. He had a house near the theatre. He was a procurator overseas – in Sicily, as I remember it. Seneca is describing the great Campanian earthquake. It's from his book, *Natural Questions*. I believe there is even a copy in our own library on the forum. It lays out the foundations of the Stoic philosophy.'

'"The Stoic philosophy!"' mocked Ampliatus. 'And what would old Exomnius have been doing with "the Stoic philosophy"?'

'Again,' repeated Popidius, with mounting exasperation, 'isn't it obvious?' He laid the two documents side by side. 'Exomnius believed there was a link, you see?' He gestured from one to the other. 'Etna and Vesuvius.

The fertility of the land around Caetana and the land around Pompeii. The terrible omens of seventeen years ago – the poisoning of the sheep – and the omens all around us this summer. He was from Sicily. He saw signs of danger. *And now he's disappeared.*'

Nobody spoke for a while. The effigies around the pool tinkled in the breeze.

Brittius said, 'I think these documents ought to be considered by a full meeting of the Ordo. As soon as possible.'

'No,' said Ampliatus.

'But the Ordo is the ruling council of the town! They have a right to be informed –'

'No!' Ampliatus was emphatic. 'How many citizens are members of the Ordo?'

'Eighty-five,' said Holconius.

'There you are. It will be all over the town within an hour. Do you want to start a panic, just as we're starting to get back on our feet? When we've got the prophecy of the sibyl to give them, to keep them sweet? Remember who voted for you, your honours – the traders. They won't thank you for scaring their business away. You saw what happened this morning, simply because the fountains stopped for a few hours. Besides, what does this add up to? So Exomnius was worried about earth tremors? So Campania has ashy soil like Sicily, and stinking fumaroles? So what? Fumaroles have been part of life on the bay since the days of Romulus.' He could see his words were striking home. 'Besides, this isn't the real problem.'

Holconius said, 'And what is the real problem?'

'The other documents – the ones that show how much Exomnius was paid to give this town cheap water.'

Holconius said quickly, 'Have a care, Ampliatus. Your little arrangements are no concern of ours.'

'*My* little arrangements!' Ampliatus laughed. 'That's a good one!' He set down his glass and lifted the decanter to pour himself another drink. Again, the heavy crystal rattled. He was becoming light-headed but he didn't care. 'Come now, your honours, don't pretend you didn't know! How do you think this town revived so quickly after the earthquake? I've saved you a fortune by my "little arrangements". Yes, and helped make myself one into the bargain – I don't deny it. But you wouldn't be here without me! Your precious baths, Popidius – where Brittius here likes to be wanked off by his little boys – how much do you pay for them? Nothing! And you, Cuspius, with your fountains. And you, Holconius, with your pool. And all the private baths and the watered gardens and the big public pool in the palaestra and the pipes in the new apartments! This town has been kept afloat for more than a decade by my "little arrangement" with Exomnius. And now some nosy bastard of an aquarius from Rome has got to hear about it. *That's* the real problem.'

'An outrage!' said Brittius, his voice quivering. 'An outrage – to be spoken to in such a way by this jumped-up slave.'

'Jumped up, am I? I wasn't so jumped up when I paid for the games that secured your election, Brittius.

302

"Cold steel, no quarter, and the slaughterhouse right in the middle where all the stands can see it" – that's what you asked for, and that was what I gave.'

Holconius raised his hands. 'All right, gentlemen. Let's keep ourselves calm.'

Cuspius said, 'But surely we can just cut a deal with this new aquarius, like the one you had with the other fellow?'

'It seems not. I dropped a hint yesterday but all he did was look at me as if I'd just put my hand on his cock. I felt insulted for my generosity. No, I'm afraid I recognise his type. He'll take this up in Rome, they'll check the accounts and we'll have an imperial commission down here before the year's end.'

'Then what are we to do?' said Popidius. 'If this comes out, it will look bad for all of us.'

Ampliatus smiled at him over the rim of his glass. 'Don't worry. I've sorted it out.'

'How?'

'Popidius!' cautioned Holconius quickly. 'Take care.'

Ampliatus paused. They did not want to know. They were the magistrates of the town, after all. The innocence of ignorance – that was what they craved. But why should they have peace of mind? He would dip their hands in the blood along with his own.

'He'll go to meet his ancestors.' He looked around. 'Before he gets back to Misenum. An accident out in the countryside. Does anyone disagree? Speak up if you do. Popidius? Holconius? Brittius? Cuspius?' He waited. It was all a charade. The aquarius would be dead by

303

now, whatever they said: Corax had been itching to slit his throat. 'I'll take that as agreement. Shall we drink to it?'

He reached for the decanter but stopped, his hand poised in mid-air. The heavy crystal glass was not merely shaking now: it was moving sideways along the polished wooden surface. He frowned at it stupidly. That could not be right. Even so, it reached the end of the sideboard and crashed to the floor. He glanced at the tiles. There was a vibration beneath his feet. It gradually built in strength and then a gust of hot air passed through the house, powerful enough to bang the shutters. An instant later, far away – but very distinctly, unlike anything he, or anyone else, had ever heard – came the sound of a double boom.

Hora sexta

[12:57 hours]

'The surface of the volcano ruptured shortly after noon allowing explosive decompression of the main magma body . . . The exit velocity of the magma was approximately 1,440 km. per hour (Mach 1). Convection carried incandescant gas and pumice clasts to a height of 28 km.

Overall, the thermal energy liberated during the course of the entire eruption may be calculated using the following formula:

$$Eth = V \cdot d \cdot T \cdot K$$

where Eth is in joules, V is the volume in cubic km., d is specific gravity (1.0), T is the temperature of the ejecta (500 degrees centigrade), and K a constant including the specific heat of the magma and the mechanical equivalent of heat (8.37×10^{14}).

Thus the thermal energy released during the A.D. 79 eruption would have been roughly

2 x 10^{18} joules – or about 100,000 times that of the Hiroshima atomic bomb.'

<div align="right">Dynamics of Volcanism</div>

A fterwards, whenever they compared their stories, the survivors would always wonder at how differently the moment had sounded to each of them. A hundred and twenty miles away in Rome it was heard as a thud, as if a heavy statue or a tree had toppled. Those who escaped from Pompeii, which was five miles downwind, always swore they had heard two sharp bangs, whereas in Capua, some twenty miles distant, the noise from the start was a continuous, tearing crack of thunder. But in Misenum, which was closer than Capua, there was no sound at all, only the sudden appearance of a narrow column of brown debris fountaining silently into the cloudless sky.

For Attilius, it was like a great, dry wave which came crashing over his head. He was roughly two miles clear of the summit, following an old hunting trail through the forest, descending fast on horseback along the mountain's western flank. The effects of the poisoning had shrunk to a small fist of pain hammering behind his eyes and in place of the drowsiness everything seemed oddly sharpened and heightened. He had no doubt of what was coming. His plan was to pick up the coastal road at Herculaneum and ride directly to Misenum to warn the admiral. He reckoned he would be there by mid-afternoon. The bay sparkled in the

sunlight between the trees, close enough for him to be able to make out individual lines of surf. He was noticing the glistening pattern of the spiders' webs hanging loosely in the foliage and a particular cloud of midges, swirling beneath a branch ahead of him, when suddenly they disappeared.

The shock of the blast struck him from behind and knocked him forward. Hot air, like the opening of a furnace door. Then something seemed to pop in his ears and the world became a soundless place of bending trees and whirling leaves. His horse stumbled and almost fell and he clung to its neck as they plunged down the path, both of them riding the crest of the scalding wave, and then abruptly it was gone. The trees sprang upright, the debris settled, the air became breathable again. He tried to talk to the horse but he had no voice and when he looked back towards the top of the mountain he saw that it had vanished and in its place a boiling stem of rock and earth was shooting upward.

From Pompeii it looked as if a sturdy brown arm had punched through the peak and was aiming to smash a hole in the roof of the sky – bang, bang: that double crack – and then a hard-edged rumble, unlike any other sound in Nature, that came rolling across the plain. Ampliatus ran outside with the magistrates. From the bakery next door and all the way up the street people were emerging to stare at Vesuvius, shielding their eyes, their faces turned towards this new dark sun rising in

the north on its thundering plinth of rock. There were a couple of screams but no general panic. It was still too early, the thing was too awesome – too strange and remote – for it to be perceived as an immediate threat.

It would stop at any moment, Ampliatus thought. He willed it to do so. *Let it subside now, and the situation will still be controllable.* He had the nerve, the force of character; it was all a question of presentation. He could handle even this: 'The gods have given us a sign, citizens! Let us heed their instruction! Let us build a great column, in imitation of this celestial inspiration! We live in a favoured spot!' But the thing did not stop. Up and up it went. A thousand heads tilted backward as one to follow its trajectory and gradually the isolated screams became more widespread. The pillar, narrow at its base, was broadening as it rose, its apex flattening out across the sky.

Someone shouted that the wind was carrying it their way.

That was the moment at which he knew he would lose them. The mob had a few simple instincts – greed, lust, cruelty – he could play them like the strings of a harp because he was of the mob and the mob was him. But shrill fear drowned out every other note. Still, he tried. He stepped into the centre of the street and held his arms out wide. 'Wait!' he shouted. 'Cuspius, Brittius – all of you – link hands with me! Set them an example!'

The cowards did not even look at him. Holconius broke first, jamming his bony elbows into the press of bodies to force his way down the hill. Brittius followed,

and then Cuspius. Popidius turned tail and darted back inside the house. Up ahead, the crowd had become a solid mass as people streamed from the sidestreets to join it. Its back was to the mountain now, its face was to the sea, its single impulse: flight. Ampliatus had a final glimpse of his wife's white face in the doorway and then he was engulfed by the stampeding crowd, spun like one of the revolving wooden models they used for practice in the gladiatorial school. He was thrown sideways, winded, and would have disappeared beneath their feet if Massavo had not seen him fall and scooped him up to safety on the step. He saw a mother drop her baby and heard its screams as it was trampled, saw an elderly matron slammed head first against the opposite wall then slip, unconscious, out of sight, as the mob swept on regardless. Some screamed. Some sobbed. Most were tight-mouthed, intent on saving their strength for the battle at the bottom of the hill, where they would have to fight their way through the Stabian Gate.

Ampliatus, leaning against the door-jamb, was aware of a wetness on his face and when he dabbed the back of his hand to his nose it came away smeared in blood. He looked above the heads of the crowd towards the mountain but already it had disappeared. A vast black wall of cloud was advancing towards the city, as dark as a storm. But it was not a storm, he realised, and it was not a cloud; it was a thundering waterfall of rock. He looked quickly in the other direction. He still had his gold-and-crimson cruiser moored down in the

harbour. They could put to sea, try to head to the villa in Misenum, seek shelter there. But the cram of bodies in the street leading to the gate was beginning to stretch back up the hill. He would never reach the port. And even if he did, the crew would be scrambling to save themselves.

His decision was made for him. And so be it, he thought. This was exactly how it had been seventeen years ago. The cowards had fled, he had stayed, and then they had all come crawling back again! He felt his old energy and confidence returning. Once more the former slave would give his masters a lesson in Roman courage. The sibyl was never wrong. He gave a final, contemptuous glance to the river of panic streaming past him, stepped back and ordered Massavo to close the door. Close it and bolt it. They would stay, and they would endure.

I n Misenum it looked like smoke. Pliny's sister, Julia, strolling on the terrace with her parasol, picking the last roses of summer for the dinner table, assumed it must be another of the hillside fires that had plagued the bay all summer. But the height of the cloud, its bulk and the speed of its ascent were like nothing she had ever seen. She decided she had better wake her brother, who was dozing over his books in the garden below.

Even in the heavy shade of the tree his face was as scarlet as the flowers in her basket. She hesitated to

disturb him, because of course he would immediately start to get excited. He reminded her of how their father had been in the days before his death – the same corpulence, the same shortness of breath, the same uncharacteristic irritability. But if she let him sleep he would no doubt be even more furious to have missed the peculiar smoke, so she stroked his hair and whispered, 'Brother, wake up. There is something you will want to see.'

He opened his eyes at once. 'The water – is it flowing?'

'No. Not the water. It looks like a great fire on the bay, coming from Vesuvius.'

'Vesuvius?' He blinked at her then shouted to a nearby slave. 'My shoes! Quickly!'

'Now, brother, don't exert yourself too much –'

He did not even wait for his shoes. Instead, for the second time that day, he set off barefoot, lumbering across the dry grass towards the terrace. By the time he reached it most of the household slaves were lining the balustrade, looking east across the bay towards what looked like a gigantic umbrella pine made of smoke growing over the coast. A thick brown trunk, with black and white blotches, was rolling miles into the air, sprouting at its crown a clump of feathery branches. These broad leaves seemed in turn to be dissolving along their lower edges, beginning to rain a fine, sand-coloured mist back down to earth.

It was an axiom of the admiral's, one which he was fond of repeating, that the more he observed Nature,

311

the less prone he was to consider any statement about
Her to be impossible. But surely this *was* impossible.
Nothing he had read of – and he had read everything
– came close to matching this spectacle. Perhaps Nature
was granting him the privilege of witnessing something
never before recorded in history? Those long years of
accumulating facts, the prayer with which he had ended
the *Natural History* – 'Hail Nature, mother of all
creation, and mindful that I alone of the men of Rome
have praised thee in all thy manifestations, be gracious
towards me' – was it all being rewarded at last? If he
had not been so fat he would have fallen to his knees.
'Thank you,' he whispered. 'Thank you.'

He must start work at once. *Umbrella pine . . . tall
stem . . . feathery branches . . .* He needed to get all this
down for posterity, while the images were still fresh in
his head. He shouted to Alexion to collect pen and
paper and to Julia to fetch Gaius.

'He's inside, working on the translation you set him.'

'Well, tell him to come out here at once. He won't
want to miss this.' It could not be smoke, he thought.
It was too thick. Besides, there was no sign of any fire
at the base. But if not smoke, what? 'Be quiet, damn
you!' He waved at the slaves to stop their jabbering.
Listening hard, it was just possible to make out a low
and ceaseless rumble carrying across the bay. If that was
how it sounded at a distance of fifteen miles, what must
it be like close to?

He beckoned to Alcman. 'Send a runner down to
the naval school to find the flagship captain. Tell him

I want a liburnian made ready and put at my disposal.'

'Brother – no!'

'Julia!' He held up his hand. 'You mean well, I know, but save your breath. This phenomenon, whatever it is, is a sign from Nature. This is *mine.*'

Corelia had thrown open her shutters and was standing on the balcony. To her right, above the flat roof of the atrium, a gigantic cloud was advancing, as black as ink, like a heavy curtain being drawn across the sky. The air was shaking with thunder. She could hear screams from the street. In the courtyard garden slaves ran back and forth, to no apparent purpose. They reminded her of dormice in a jar, before they were fished out for cooking. She felt somehow detached from the scene – a spectator in a box at the back of the theatre, watching an elaborate production. At any moment, a god would be lowered from the wings to whisk her off to safety. She shouted down – 'What's happening?' – but nobody paid her any attention. She tried again and realised she was forgotten.

The drumming of the cloud was getting louder. She ran to the door and tried to open it but the lock was too strong to break. She ran back on to the balcony but it was too high to jump. Below, and to the left, she saw Popidius coming up the steps from his part of the house, shepherding his elderly mother, Taedia Secunda, before him. A couple of their slaves, laden with bags, were following behind. She screamed at him –

ROBERT HARRIS

'Popidius!' – and at the sound of his name he stopped and glanced around. She waved to him. 'Help me! He's locked me in!'

He shook his head in despair. 'He's trying to lock us all in! He's gone mad!'

'Please – come up and open the door!'

He hesitated. He wanted to help her. And he would have done so. But even as he took half a pace towards her something hit the tiled roof behind him and bounced off into the garden. A light stone, the size of a child's fist. He saw it land. Another struck the pergola. And suddenly it was dusk and the air was full of missiles. He was being hit repeatedly on the head and shoulders. Frothy rocks, they looked to be: a whitish, petrified sponge. They weren't heavy but they stung. It was like being caught in a sudden hailstorm – a warm, dark, dry hailstorm, if such a thing were imaginable. He ran for the cover of the atrium, ignoring Corelia's cries, pushing his mother in front of him. The door ahead – Ampliatus's old entrance – was hanging open and he stumbled out into the street.

Corelia did not see him go. She ducked back into her room to escape the bombardment. She had one last impression of the world outside, shadowy in the dust, and then all light was extinguished and there was nothing in the pitch darkness, not even a scream, only the roaring waterfall of rock.

* * *

In Herculaneum life was peculiarly normal. The sun was shining, the sky and sea were a brilliant blue. As Attilius reached the coastal road he could even see fishermen out in their boats casting their nets. It was like some trick of the summer weather by which half of the bay was lost from view in a violent storm whilst the other half blessed its good fortune and continued to enjoy the day. Even the noise from the mountain seemed unthreatening – a background rumble, drifting with the veil of debris towards the peninsula of Surrentum.

Outside the town gates of Herculaneum a small crowd had gathered to watch the proceedings, and a couple of enterprising traders were setting up stalls to sell pastries and wine. A line of dusty travellers was already plodding down the road, mostly on foot and carrying luggage, some with carts piled high with their belongings. Children ran along behind them, enjoying the adventure, but the faces of their parents were rigid with fear. Attilius felt as if he were in a dream. A fat man, his mouth full of cake, sitting on a milestone, called out cheerfully to ask what it was like back there.

'As black as midnight in Oplontis,' someone replied, 'and Pompeii must be even worse.'

'Pompeii?' said Attilius sharply. That woke him up. 'What's happening in Pompeii?'

The traveller shook his head, drawing his finger across his throat, and Attilius recoiled, remembering Corelia. When he had forced her to leave the aqueduct he had thought he was sending her out of harm's way. But now, as his eye followed the curve of the road towards

315

Pompeii, to the point where it disappeared into the murk, he realised he had done the opposite. The outpouring of Vesuvius, caught by the wind, was blowing directly over the town.

'Don't go that way, citizen,' warned the man, 'there's no way through.'

But Attilius was already turning his horse to face the stream of refugees.

The further he went the more clogged the road became, and the more pitiful the state of the fleeing population. Most were coated in a thick grey dust, their hair frosted, their faces like death masks, spattered with blood. Some carried torches, still lit: a defeated army of whitened old men, of ghosts, trudging away from a calamitous defeat, unable even to speak. Their animals — oxen, asses, horses, dogs and cats — resembled alabaster figures come creakingly to life. Behind them on the highway they left a trail of ashy wheelmarks and footprints.

On one side of him, isolated crashes came from the olive groves. On the other, the sea seemed to be coming to the boil in a myriad of tiny fountains. There was a clatter of stones on the road ahead. His horse stopped, lowered its head, refused to move. Suddenly the edge of the cloud, which had seemed to be almost half a mile away, appeared to come rushing towards them. The sky was dark and whirling with tiny projectiles and in an instant the day passed from afternoon sun to twilight

and he was under a bombardment. Not hard stones but white clinker, small clumps of solidified ash, falling from some tremendous height. They bounced off his head and shoulders. People and wagons loomed out of the half-light. Women screamed. Torches dimmed in the darkness. His horse shied and turned. Attilius ceased to be a rescuer and became just another part of the panicking stream of refugees, frantically trying to outrun the storm of debris. His horse slipped down the side of the road into the ditch and cantered along it. Then the air lightened, became brownish, and they burst back into the sunshine.

Everyone was hurrying now, galvanised by the threat at their backs. Not only was the road to Pompeii impassable, Attilius realised, but a slight shift in the wind was spreading the danger westwards around the bay. An elderly couple sat weeping beside the road, too exhausted to run any further. A cart had overturned and a man was desperately trying to right it, while his wife soothed a baby and a little girl clung to her skirts. The fleeing column streamed around them and Attilius was carried in the flow, borne back along the road towards Herculaneum.

The shifting position of the wall of falling rock had been noticed at the city gates and by the time he reached them the traders were hastily packing away their goods. The crowd was breaking up, some heading for shelter in the town, others pouring out of it to join the exodus on the road. And still, amid all this, Attilius could see across the red-tiled roofs the normality of the fishermen

on the bay and, further out, the big grain ships from Egypt steering towards the docks at Puteoli. *The sea*, he thought: if he could somehow launch a boat, it might just be possible to skirt the downpour of stones and approach Pompeii from the south – *by sea*. He guessed it would be useless to try to fight his way down to the waterfront in Herculaneum, but the great villa just outside it – the home of the senator, Pedius Cascus, with his troop of philosophers – perhaps they might have a vessel he could use.

He rode a little further along the crowded highway until he came to a high pair of gateposts, which he judged must belong to the Villa Calpurnia. He tied his horse to a railing in the courtyard and looked around for any sign of life but the enormous palace seemed to be deserted. He walked through the open door into the grand atrium, and then along the side of an enclosed garden. He could hear shouts, footsteps running along the marble corridors, and then a slave appeared around a corner pushing a wheelbarrow stacked high with rolls of papyri. He ignored Attilius's shout and headed through a wide doorway into the brilliant afternoon light, as another slave, also pushing a wheelbarrow – this one empty – hurried through the entrance and into the house. The engineer blocked his path.

'Where's the senator?'

'He's in Rome.' The slave was young, terrified, sweating.

'Your mistress?'

'Beside the pool. Please – let me past.'

Attilius moved aside to let him go and ran out into the sun. Beneath the terrace was the huge pool he had seen from the liburnian on his voyage to Pompeii and all around it people: dozens of slaves and white-robed scholars hurrying back and forth ferrying armfuls of papyri, stacking them into boxes at the water's edge, while a group of women stood to one side, staring along the coast towards the distant storm, which looked from here like an immense brown sea-fog. The craft offshore from Herculaneum were mere twigs against it. The fishing had stopped. The waves were getting up. Attilius could hear them crashing against the shore in quick succession; no sooner had one broken than another came in on top of it. Some of the women were wailing, but the elderly matron in the centre of the group, in a dark blue dress, seemed calm as he approached her. He remembered her – the woman with the necklace of giant pearls.

'Are you the wife of Pedius Cascus?'

She nodded.

'Marcus Attilius. Imperial engineer. I met your husband two nights ago, at the admiral's villa.'

She looked at him eagerly. 'Has Pliny sent you?'

'No. I came to beg a favour. To ask for a boat.'

Her face fell. 'Do you think if I had a boat I would be standing here? My husband took it yesterday to Rome.'

Attilius looked around the vast palace, at its statues and gardens, at the art treasures and books being piled up on the lawns. He turned to go.

'Wait!' She called after him. 'You must help us.'

'There's nothing I can do. You'll have to take your chance on the road with the rest.'

'I'm not afraid for myself. But the library – we must rescue the library. There are too many books to move by road.'

'My concern is for people, not books.'

'People perish. Books are immortal.'

'Then if books are immortal, they will survive without my assistance.'

He began climbing the path back up towards the house.

'Wait!' She gathered her skirts and ran after him. 'Where are you going?'

'To find a boat.'

'Pliny has boats. Pliny has the greatest fleet in the world at his command.'

'Pliny is on the other side of the bay.'

'Look across the sea! An entire mountain is threatening to descend on us! Do you think one man in one little boat can do anything? We need a fleet. Come with me!'

He would say this for her: she had the willpower of any man. He followed her around the pillared walkway surrounding the pool, up a flight of steps and into a library. Most of the compartments had been stripped bare. A couple of slaves were loading what remained into a wheelbarrow. Marble heads of ancient philosophers looked down, dumbstruck at what was happening.

'This is where we keep the volumes which my ancestors brought back from Greece. One hundred and twenty plays by Sophocles alone. All the works of Aristotle, some in his own hand. They are irreplaceable. We have never allowed them to be copied.' She gripped his arm. 'Men are born and die by the thousand every hour. What do we matter? These great works are all that will be left of us. Pliny will understand.' She sat at the small table, took up a pen and dipped it in an ornate brass inkstand. A red candle flickered beside her. 'Take him this letter. He knows this library. Tell him Rectina pleads with him for rescue.'

Behind her, across the terrace, Attilius could see the ominous darkness moving steadily around the bay, like the shadow on a sundial. He had thought it might diminish but if anything the force of it was intensifying. She was right. It would take big ships – warships – to make any impression against an enemy on this scale. She rolled the letter and sealed it with the dripping candle, pressing her ring into the soft wax. 'You have a horse?'

'I'd go faster with a fresh one.'

'You'll have it.' She called to one of the slaves. 'Take Marcus Attilius to the stables and saddle the swiftest horse we have.' She gave him the letter and, as he took it, clasped her dry and bony fingers around his wrist. 'Don't fail me, engineer.'

He pulled his hand free and ran after the slave.

Hora nona

[15:32 hours]

'The effect of the sudden release of huge volumes of magma can alter the geometry of the plumbing system, destabilize the shallow reservoir, and induce structural collapse. Such a situation frequently increases the eruption intensity, inducing contact between phreatic fluids and magma, as well as explosive decompression of the hydrothermal system associated with the shallow reservoir.'

Encyclopaedia of Volcanoes

It took Attilius just under two hours of hard riding to reach Misenum. The road wound along the coastline, sometimes running directly beside the water's edge, sometimes climbing higher inland, past the immense villas of the Roman elite. All the way along it he passed small groups of spectators gathered at the edge of the highway to watch the distant phenomenon. He mostly had his back to the mountain, but when he

322

rounded the northern edge of the bay and began to descend towards Neapolis, he could see it again, away to his left – a thing of extraordinary beauty now. A delicate veil of white mist had draped itself around the central column, rising for mile after mile in a perfect translucent cylinder, reaching up to brush the lower edge of the mushroom-shaped cloud that was toppling over the bay.

There was no sense of panic in Neapolis, a sleepy place at the best of times. He had far outpaced the weary, laden refugees emerging from beneath the hail of rock and no word of the catastrophe enveloping Pompeii had yet reached the city. The Greek-style temples and theatres facing out to sea gleamed white in the afternoon sun. Tourists strolled in the gardens. In the hills behind the town he could see the redbrick arcade of the Aqua Augusta where she ran above the surface. He wondered if the water was flowing yet but he did not dare stop to find out. In truth, he did not care. What had earlier seemed the most vital matter in the world had dwindled in importance to nothing. What were Exomnius and Corax now but dust? Not even dust; barely even a memory. He wondered what had happened to the other men. But the image of which he could not rid himself was Corelia – the way she had swept back her hair as she mounted her horse, and the way she had dwindled into the distance, following the road he had set for her – to the fate that he, and not Destiny, had decreed.

He passed through Neapolis and out into the open

country again, into the immense road-tunnel that Agrippa had carved beneath the promontory of Pausilypon – in which the torches of the highway slaves, as Seneca had observed, did not so much pierce the darkness as reveal it – past the immense concrete grain-wharfs of the Puteoli harbour – another of Agrippa's projects – past the outskirts of Cumae – where the Sibyl was said to hang in her bottle and wish for death – past the vast oyster beds of Lake Avernus, past the great terraced baths of Baiae, past the drunks on the beaches and the souvenir shops with their brightly painted glassware, the children flying kites, the fishermen repairing their flaxen nets on the quaysides, the men playing bones in the shade of the oleanders, past the century of marines in full kit running at the double down to the naval base – past all the teeming life of the Roman superpower, while on the opposite side of the bay Vesuvius emitted a second, rolling boom, turning the fountain of rock from grey to black and pushing it even higher.

Pliny's greatest concern was that it might all be over before he got there. Every so often he would come waddling out of his library to check on the progress of the column. Each time he was reassured. Indeed, if anything, it seemed to be growing. An accurate estimation of its height was impossible. Posidonius held that mists, winds and clouds rose no more than five miles above the earth, but most experts – and Pliny, on

balance, took the majority view – put the figure at one hundred and eleven miles. Whatever the truth, the thing – the column – 'the manifestation', as he had decided to call it – was enormous.

In order to make his observations as accurate as possible he had ordered that his water clock should be carried down to the harbour and set up on the poop deck of the liburnian. While this was being done and the ship made ready he searched his library for references to Vesuvius. He had never before paid much attention to the mountain. It was so huge, so obvious, so inescapably *there,* that he had preferred to concentrate on Nature's more esoteric aspects. But the first work he consulted, Strabo's *Geography*, brought him up short. *'This area appears to have been on fire in the past and to have had craters of flame . . .'* Why had he never noticed it? He called in Gaius to take a look.

'You see here? He compares the mountain to Etna. Yet how can that be? Etna has a crater two miles across. I have seen it with my own eyes, glowing across the sea at night. And all those islands that belch flames – Strongyle, ruled by Aeolus, god of wind, Lipari, and Holy Island, where Vulcan is said to live – you can see them all burning. No one has ever reported embers on Vesuvius.'

'He says the craters of flame *"were subsequently extinguished by a lack of fuel",*' his nephew pointed out. 'Perhaps that means some fresh source of fuel has now been tapped by the mountain, and has brought it back to life.' Gaius looked up excitedly.

'Could that explain the arrival of the sulphur in the water of the aqueduct?'

Pliny regarded him with fresh respect. Yes. The lad was right. That must be it. Sulphur was the universal fuel of all these phenomena – the coil of flame at Comphantium in Bactria, the blazing fishpool on the Babylonian Plain, the field of stars near Mount Hesperius in Ethiopia. But the implications of that were awful: Lipari and Holy Island had once burned in mid-sea for days on end, until a deputation from the Senate had sailed out to perform a propitiatory ceremony. A similar explosive fire on the Italian mainland, in the middle of a crowded population, could be a disaster.

He pushed himself to his feet. 'I must get down to my ship. Alexion!' He shouted for his slave. 'Gaius, why don't you come with me? Leave your translation.' He held out his hand and smiled. 'I release you from your lesson.'

'Do you really, uncle?' Gaius stared across the bay, and chewed his lip. Clearly he, too, had realised the poten-tial consequences of a second Etna on the bay. 'That's kind of you, but to be honest I have actually reached rather a tricky passage. Of course, if you insist –'

Pliny could see he was afraid, and who could blame him? He felt a flutter of apprehension in his own stom-ach and he was an old soldier. It crossed his mind to order the boy to come – no Roman should ever succumb to fear: what had happened to the stern values of his youth? – but then he thought of Julia. Was it fair to expose her only son to needless danger? 'No, no,' he

said, with forced cheerfulness. 'I won't insist. The sea looks rough. It will make you sick. You stay here and look after your mother.' He pinched his nephew's spotty cheek and ruffled his greasy hair. 'You'll make a good lawyer, Gaius Plinius. Perhaps a great one. I can see you in the Senate one day. You'll be my heir. My books will be yours. The name of Pliny will live through you –' He stopped. It was beginning to sound too much like a valedictory. He said gruffly, 'Return to your studies. Tell your mother I'll be back by nightfall.'

Leaning on the arm of his secretary, and without a backward glance, the admiral shuffled out of his library.

A ttilius had ridden past the Piscina Mirabilis, over the causeway into the port, and was beginning his ascent of the steep road to the admiral's villa, when he saw a detachment of marines ahead clearing a path for Pliny's carriage. He just had time to dismount and step into the street before the procession reached him.

'Admiral!'

Pliny, staring fixedly ahead, turned vaguely in his direction. He saw a figure he did not recognise, covered in dust, his tunic torn, his face, arms and legs streaked with dried blood. The apparition spoke again. 'Admiral! It's Marcus Attilius!'

'Engineer?' Pliny signalled for the carriage to stop. 'What's happened to you?'

'It's a catastrophe, admiral. The mountain is exploding – raining rocks –' Attilius licked his cracked lips.

'Hundreds of people are fleeing east along the coastal road. Oplontis and Pompeii are being buried. I've ridden from Herculaneum. I have a message for you –' he searched in his pocket ' – from the wife of Pedius Cascus.'

'Rectina?' Pliny took the letter from his hands and broke the seal. He read it twice, his expression clouding, and suddenly he looked ill – ill and overwhelmed. He leaned over the side of the carriage and showed the hasty scrawl to Attilius: *Pliny, my dearest friend, the library is in peril. I am alone. I beg you to come for us by sea – at once – if you still love these old books and your faithful old Rectina.* 'This is really true?' he asked. 'The Villa Calpurnia is threatened?'

'The entire coast is threatened, admiral.' What was wrong with the old man? Had drink and age entirely dulled his wits? Or did he think it was all just a show – some spectacular in the amphitheatre, laid on for his interest? 'The danger follows the wind. It swings like a weathervane. Even Misenum might not be safe.'

'Even Misenum might not be safe,' repeated Pliny. 'And Rectina is alone.' His eyes were watering. He rolled up the letter and beckoned to his secretary who had been running with the marines beside the carriage. 'Where is Antius?'

'At the quayside, admiral.'

'We need to move quickly. Climb in next to me, Attilius.' He rapped his ring on the side of the carriage. 'Forward!' Attilius squeezed in beside him as the carriage lurched down the hill. 'Now tell me everything you've seen.'

Attilius tried to order his thoughts, but it was hard to speak coherently. Still, he tried to convey the power of what he had witnessed when the roof of the mountain lifted off. And the blasting of the summit, he said, was merely the culmination of a host of other phenomena – the sulphur in the soil, the pools of noxious gas, the earth tremors, the swelling of the land which had severed the matrix of the aqueduct, the disappearance of the local springs. All these things were interconnected.

'And none of us recognised it,' said Pliny, with a shake of his head. 'We were as blind as old Pomponianus, who thought it was the work of Jupiter.'

'That's not quite true, admiral. One man recognised it – a native of the land near Etna: my predecessor, Exomnius.'

'Exomnius?' said Pliny, sharply. 'Who hid a quarter of a million sesterces at the bottom of his own reservoir?' He noticed the bafflement on the engineer's face. 'It was discovered this morning when the last of the water had drained away. Why? Do you know how he came by it?'

They were entering the docks. Attilius could see a familiar sight – the *Minerva* lying alongside the quay, her main mast raised and ready to sail – and he thought how odd it was, the chain of events and circumstances that had brought him to this place, at this time. If Exomnius had not been born a Sicilian, he would never have ventured on to Vesuvius and would never have disappeared, Attilius would never have been dispatched

329

from Rome, would never have set foot in Pompeii, would never have known of Corelia or Ampliatus or Corax. For a brief moment, he glimpsed the extraordinary, perfect logic of it all, from poisoned fish to hidden silver, and he tried to think how best he could describe it to the admiral. But he had barely started before Pliny waved him to stop.

'The pettiness and avarice of man!' he said impatiently. 'It would make a book in itself. What does any of it matter now? Put it in a report and have it ready on my return. And the aqueduct?'

'Repaired, admiral. Or at any rate she was when I left her this morning.'

'Then you have done good work, engineer. And it will be made known in Rome, I promise you. Now go back to your quarters and rest.'

The wind was flapping the cables against the *Minerva*'s mast. Torquatus stood by the aft gangplank talking to the flagship commander, Antius, and a group of seven officers. They came to attention as Pliny's carriage approached.

'Admiral, with your permission, I would rather sail with you.'

Pliny looked at him in surprise, then grinned and clapped his pudgy hand on Attilius's knee. 'A scientist! You're just like me! I knew it the moment I saw you! We shall do great things this day, Marcus Attilius.' He was wheezing out his orders even as his secretary helped him from the carriage. 'Torquatus – we sail immediately. The engineer will join us. Antius – sound the

330

general alarm. Have a signal flashed to Rome in my name: "Vesuvius exploded just before the seventh hour. The population of the bay is threatened. I am putting the entire fleet to sea to evacuate survivors."'

Antius stared at him. 'The *entire* fleet, admiral?'

'Everything that floats. What have you got out there?' Pliny peered short-sightedly towards the outer harbour where the warships rode at anchor, rocking in the gathering swell. 'The *Concordia* I can see, is that? The *Libertas. Justitia.* And what's that one – the *Pietas*? The *Europa*.' He waved his hand. 'All of them. And everything in the inner harbour that isn't in dry dock. Come on, Antius! You were complaining the other night that we had the mightiest fleet in the world but it never saw action. Well, here is action for you.'

'But action requires an enemy, admiral.'

'There's your enemy.' He pointed to the dark pall spreading in the distance. 'A greater enemy than any force Caesar ever faced.'

For a moment Antius did not move and Attilius wondered if he might even be considering disobeying, but then a gleam came into his eyes and he turned to the officers. 'You heard your orders. Signal the Emperor and sound the general muster. And let it be known that I'll cut the balls off any captain who isn't at sea within half an hour.'

I t was at the mid-point of the ninth hour, according to the admiral's water clock, that the *Minerva* was

pushed away from the quayside and slowly began to swivel round to face the open sea. Attilius took up his old position against the rail and nodded to Torquatus. The captain responded with a slight shake of his head, as if to say he thought the venture madness.

'Note the time,' commanded Pliny and Alexion, squatting beside him, dipped his pen into his ink and scratched down a numeral.

A comfortable chair with armrests and a high back had been set up for the admiral on the small deck and from this elevated position he surveyed the scene as it swung before him. It had been a dream of his over the past two years to command the fleet in battle – to draw this immense sword from its scabbard – even though he knew Vespasian had only appointed him as a peacetime administrator, to keep the blade from rusting. But enough of drills. Now at last he could see what battle-stations really looked like: the piercing notes of the trumpets drawing men from every corner of Misenum, the rowing boats ferrying the first of the sailors out to the huge quadriremes, the advance guard already boarding the warships and swarming over the decks, the high masts being raised, the oars readied. Antius had promised him he would have twenty ships operational immediately. That was four thousand men – a legion!

When the *Minerva* was pointing directly eastwards the double bank of oars dipped, the drums began to beat below decks and she was stroked forwards. He could hear his personal standard, emblazoned with the

imperial eagle, catching the wind from the stern-post behind him. The breeze was on his face. He felt a tightening of anticipation in his stomach. The whole of the town had turned out to watch. He could see them lining the streets, leaning out of the windows, standing on the flat roofs. A thin cheer carried across the harbour. He searched the hillside for his own villa, saw Gaius and Julia outside the library, and raised his hand. Another cheer greeted the gesture.

'You see the fickleness of the mob?' he called happily to Attilius. 'Last night I was spat at in the street. Today I am a hero. All they live for is a show!' He waved again.

'Yes – and see what they do tomorrow,' muttered Torquatus, 'if half their men are lost.'

Attilius was taken aback by his anxiety. He said quietly, 'You think we are in that much danger?'

'These ships look strong, engineer, but they are held together by rope. I'll happily fight against any mortal enemy. But only a fool sails into combat with Nature.'

The pilot at the prow shouted a warning and the helmsman, standing behind the admiral, heaved on the tiller. The *Minerva* threaded between the anchored warships, close enough for Attilius to see the faces of the sailors on the decks, and then she swung again, passing along the natural rock wall of the harbour, which seemed to open slowly, like the wheeled door of a great temple. For the first time they had a clear view of what was happening across the bay.

Pliny gripped the arms of his chair, too overcome to speak. But then he remembered his duty to science.

'Beyond the promontory of Pausilypon,' he dictated hesitantly, 'the whole of Vesuvius and the surrounding coast are masked by a drifting cloud, whitish-grey in colour, and streaked with black.' But that was too bland, he thought: he needed to convey some sense of awe. 'Thrusting above this, bulging and uncoiling, as if the hot entrails of the earth are being drawn out and dragged towards the heavens, rises the central column of the manifestation.' That was better. 'It grows,' he continued, 'as if supported by a continual blast. But at its uppermost reaches, the weight of the exuded material becomes too great, and in pressing down spreads sideways. Wouldn't you agree, engineer?' he called. 'It is the weight that is spreading it sideways?'

'The weight, admiral,' Attilius shouted back. 'Or the wind.'

'Yes, a good point. Add that to the record, Alexion. The wind appears stronger at the higher altitude, and accordingly topples the manifestation to the south-east.' He gestured to Torquatus. 'We should take advantage of this wind, captain! Make full sail!'

'Madness,' said Torquatus to Attilius, under his breath. 'What sort of commander seeks out a storm?' But he shouted to his officers: 'Raise the main sail!'

The tranverse pole which supported the sail was lifted from its resting place in the centre of the hull and Attilius had to scramble towards the stern as the sailors on either side seized the cables and began to haul it up the mast. The sail was still furled and when it reached its position beneath the carchesium – 'the drinking-

cup', as they called the observation platform – a young lad of no more than ten shinned up the mast to release it. He scampered along the yard-arm, untying the fastenings, and when the last was loosened the heavy linen sail dropped and filled immediately, tautening with the force of the wind. The *Minerva* creaked and picked up speed, scudding through the waves, raising curls of white foam on either side of her sharp prow, like a chisel slicing through soft wood.

Pliny felt his spirits fill with the sail. He pointed to the left. 'There's our destination, captain. Herculaneum! Steer straight towards the shore – to the Villa Calpurnia!'

'Yes, admiral! Helmsman – take us east!'

The sail cracked and the ship banked. A wave of spray drenched Attilius – a glorious sensation. He rubbed the dust from his face and ran his hands through his filthy hair. Below decks, the drums had increased to a frantic tempo, and the oars became a blur in the crashing waves and spray. Pliny's secretary had to lay his arms across his papers to prevent them blowing away. Attilius looked up at the admiral. Pliny was leaning forwards in his chair, his plump cheeks glistening with sea-spray, eyes alight with excitement, grinning wide, all trace of his former exhaustion gone. He was a cavalryman on his horse again, pounding across the German plain, javelin in hand, to wreak havoc on the barbarians.

'We shall rescue Rectina and the library and carry them to safety, then join Antius and the rest of the fleet in evacuating people further along the coast – how does that sound to you, captain?'

'As the admiral wishes,' responded Torquatus stiffly. 'May I ask what time your clock shows?'

'The start of the tenth hour,' said Alexion.

The captain raised his eyebrows. 'So, then – just three hours of full daylight left.'

He left the implication hanging in the air, but the admiral waved it away. 'Look at the speed we're making, captain! We'll soon be at the coast.'

'Yes, and the wind which drives us forwards will make it all the harder for us to put to sea again.'

'Sailors!' mocked the admiral above the sound of the waves. 'Are you listening, engineer? I swear, they're worse than farmers when it comes to the weather. They moan when there isn't a wind, and then complain even louder when there is!'

'Admiral!' Torquatus saluted. 'If you will excuse me?' He turned away, his jaw clamped tight, and made his way, swaying, towards the prow.

'Observations at the tenth hour,' said Pliny. 'Are you ready, Alexion?' He placed his fingertips together and frowned. It was a considerable technical challenge to describe a phenomenon for which the language had not yet been invented. After a while, the various metaphors – columns, tree trunks, fountains and the like – seemed to obscure rather than illuminate, failing to capture the sublime power of what he was witnessing. He should have brought a poet with him – he would have been more use than this cautious captain. 'Drawing closer,' he began, 'the manifestation appears as a gigantic, heavy rain cloud, increasingly black. As with a storm viewed

from a distance of several miles, it is possible to see individual plumes of rain, drifting like smoke across the dark surface. And yet, according to the engineer, Marcus Attilius, these are falls not of rain but of rock.' He pointed to the poop deck beside him. 'Come up here, engineer. Describe to us again what you saw. For the record.'

Attilius climbed the short ladder to the platform. There was something utterly incongruous about the way in which the admiral had arranged himself – with his slave, his portable desk, his throne-like chair and his water clock – when set against the fury into which they were sailing. Even though the wind was at his back, he could hear the roar from the mountain now, and the towering cascade of rock was suddenly much nearer, their ship as fragile as a leaf at the base of a waterfall. He started to give his account once more and then a bolt of lightning arced across the roiling mass of cloud – not white, but a brilliant, jagged streak of red. It hung in the air, like a vivid vein of blood, and Alexion started to cluck his tongue, which was how the superstitious worshipped lightning.

'Add that to the list of phenomena,' commanded Pliny. 'Lightning: a grievous portent.'

Torquatus shouted, 'We're sailing too close!'

Beyond the admiral's shoulder, Attilius could see the quadriremes of the Misene fleet, still in sunlight, streaming out of harbour in a V-formation, like a squadron of flying geese. But then he became aware that the sky was darkening. A barrage of falling stones was exploding on

337

the surface of the sea to their right, creeping rapidly closer. The prows and sails of the quadriremes blurred, dissolved to ghost-ships, as the air was filled with whirling rock.

In the pandemonium, Torquatus was everywhere, bellowing orders. Men ran along the deck in the half-light. The ropes supporting the yard-arm were unhitched and the sail lowered. The helmsman swung hard left. An instant later a ball of lightning came hurtling from the sky, touched the top of the mast, travelled down it and then along the yard-arm. In the brilliance of its glare Attilius saw the admiral with his head ducked and his hands pressed to the back of his neck, and his secretary leaning forwards to protect his papers. The fireball shot off the edge of the pole and plunged into the sea, trailing fumes of sulphur. It died with a violent hiss, taking its light with it. He closed his eyes. If the sail had not been lowered it would surely have gone up in flames. He could feel the drumming of the stones on his shoulders, hear them rattling across the deck. The *Minerva* must be brushing along the edge of the cloud, he realised, and Torquatus was trying to row them out from beneath it – and abruptly he succeeded. There was a final lash of missiles and they burst back out into the sunshine.

He heard Pliny coughing and opened his eyes to see the admiral standing, brushing the debris from the folds of his toga. He had held on to a handful of stones and

as he flopped back into his chair he examined them in his palm. All along the length of the ship, men were shaking their clothes and feeling their flesh for cuts. The *Minerva* was still steering directly towards Herculaneum, now less than a mile distant and clearly visible, but the wind was getting up, and the sea with it, the helmsman straining to keep them to their course as the waves crashed against the left side of the ship.

'Encounter with the manifestation,' said Pliny, calmly. He stopped to wipe his face on his sleeve and coughed again. 'Are you taking this down? What time is it?'

Alexion tipped the stones from his papers and blew away the dust. He leaned towards the clock. 'The mechanism is broken, admiral.' His voice was trembling. He was almost in tears.

'Well, no matter. Let's say the eleventh hour.' Pliny held up one of the stones and peered at it closely. 'The material is a frothy, bubbled pumice. Greyish-white. As light as ash, which falls in fragments no larger than a man's thumb.' He paused, and added gently: 'Take up your pen, Alexion. If there's one thing I can't abide it's cowardice.'

The secretary's hand was shaking. It was hard for him to write as the liburnian pitched and rolled. His pen slipped across the surface of the papyri in an illegible scrawl. The admiral's chair slid across the deck and Attilius grabbed it. He said, 'You ought to move below deck,' as Torquatus stumbled towards them, bareheaded.

'Take my helmet, admiral.'

'Thank you, captain, but this old skull of mine provides quite adequate protection.'

'Admiral – I beg you – this wind will run us straight into the storm – we must turn back!'

Pliny ignored him. 'The pumice is less like rock, than airy fragments of a frozen cloud.' He craned his neck to stare over the side of the ship. 'It floats on the surface of the sea like lumps of ice. Do you see? Extraordinary!'

Attilius had not noticed it before. The water was covered in a carpet of stone. The oars brushed it aside with every stroke but more floated in immediately to replace it. Torquatus ran to the low wall of the deck. They were surrounded.

A wave of pumice broke over the front of the ship. 'Admiral –'

'Fortune favours the brave, Torquatus. Steer towards the shore!'

For a short while longer they managed to plough on, but the pace of the oars was weakening, defeated not by the wind or the waves but by the clogging weight of pumice on the water. It deepened as they neared the coast, two or three feet thick – a broad expanse of rustling dry surf. The blades of the oars flailed helplessly across it, unable to bring any pressure to bear, and the ship began to drift with the wind towards the waterfall of rock. The Villa Calpurnia was tantalisingly close. Attilius recognised the spot where he had stood with Rectina. He could see figures running along the

shore, the piles of books, the fluttering white robes of the Epicurean philosophers.

Pliny had stopped dictating and, with Attilius's assistance, had pulled himself up on to his feet. All around the timber was creaking as the pressure of the pumice squeezed the hull. The engineer felt him sag slightly as, for the first time, he seemed to appreciate that they were defeated. He stretched out his hand towards the shore. 'Rectina,' he murmured.

The rest of the fleet was beginning to scatter, the V-formation disintegrating as the ships battled to save themselves. And then it was dusk again and the familiar thunder of pumice hammering drowned out every other sound. Torquatus shouted, 'We've lost control of the ship! Everybody – below decks. Engineer – help me lift him down from here.'

'My records!' protested Pliny.

'Alexion has your records, admiral.' Attilius had him by one arm and the captain by the other. He was immensely heavy. He stumbled on the last step and nearly fell full-length but they managed to retrieve him and lugged him along the deck towards the open trap-door that led down to the rowing stations as the air turned to rock. 'Make way for the admiral!' panted Torquatus and then they almost threw him down the ladder. Alexion went next with the precious papers, treading on the admiral's shoulders, then Attilius jumped down in a shower of pumice, and finally Torquatus, slamming the trap behind them.

Vespera

[20:02 hours]

> 'During [the first] phase the vent radius was
> probably of the order of 100 metres. As the
> eruption continued, inevitable widening of the
> vent permitted still higher mass eruption rates.
> By the evening of the 24th, the column height had
> increased. Progressively deeper levels within the
> magma chamber were tapped, until after about
> seven hours the more mafic grey pumice was
> reached. This was ejected at about 1.5 million
> tonnes per second, and carried by convection to
> maximum heights of around 33 kilometres.'
>
> Volcanoes: A Planetary Perspective

I n the stifling heat and the near-darkness beneath
the *Minerva*'s decks they crouched and listened to
the drumming of the stones above them. The air
was rank with the sweat and breath of two hundred
sailors. Occasionally, a foreign voice would cry out in

some unrecognisable tongue only to be silenced by a harsh shout from one of the officers. A man near Attilius moaned repeatedly in Latin that it was the end of the world – and that, indeed, was what it felt like to the engineer. Nature had reversed herself so that they were drowning beneath rock in the middle of the sea, drifting in the depths of night during the bright hours of the day. The ship was rocking violently but none of the oars was moving. There was no purpose to any activity for they had no idea of the direction in which they were pointing. There was nothing to do but endure, each man huddled in his own thoughts.

How long this went on, Attilius could not calculate. Perhaps one hour; perhaps two. He was not even sure where he was below decks. He knew that he was clinging to a narrow wooden gantry that seemed to run the length of the ship, with the double-banks of sailors crammed on benches on either side. He could hear Pliny wheezing somewhere close, Alexion snuffling like a child. Torquatus was entirely silent. The incessant hammering of the pumice fall, sharp to begin with as it rattled on the timber of the deck, gradually became more muffled, as pumice fell on pumice, sealing them off from the world. And that, for him, was the worst thing – the sense of this mass slowly pressing down on them, burying them alive. As time passed he began to wonder how long the joists of the deck would hold, or whether the sheer weight of what was above them would push them beneath the waves. He tried to console himself with the thought that pumice was light: the engineers in Rome,

when they were constructing a great dome, sometimes mixed it into the cement in place of rock and fragments of brick. Nevertheless he gradually became aware that the ship was starting to list and very soon after that a cry of panic went up from some of the sailors to his right that water was pouring through the oar-holes.

Torquatus shouted at them roughly to be quiet then called down the gantry to Pliny that he needed to take a party of men above decks to try to shovel off the rock-fall.

'Do what you have to do, captain,' replied the admiral. His voice was calm. 'This is Pliny!' he suddenly bellowed above the roar of the storm. 'I expect every man to bear himself like a Roman soldier! And when we return to Misenum, you will all be rewarded, I promise you!'

There was some jeering from the darkness.

'If we return, more like!'

'It was you who got us into the mess!'

'Silence!' yelled Torquatus. 'Engineer, will you help me?' He had mounted the short ladder to the trapdoor and was trying to push it open but the weight of the pumice made it hard to lift. Attilius groped his way along the gantry and joined him on the ladder, holding on to it with one hand, heaving with the other at the wooden panel above his head. Together they raised it slowly, releasing a cascade of debris that bounced off their heads and clattered on to the timbers below. 'I need twenty men!' ordered Torquatus. 'You five banks of oars – follow me.'

Attilius climbed out after him into the whirl of flying pumice. There was a strange almost brownish light, as in a sandstorm, and as he straightened Torquatus grabbed his arm and pointed. It took Attilius a moment to see what he meant, but then he glimpsed it too – a row of winking yellow lights, showing faintly through the murk. Pompeii, he thought – Corelia!

'We've drifted beneath the worst of it and come in close to the coast!' shouted the captain. 'The gods alone know where! We'll try to run her aground! Help me at the helm!' He turned and pushed the nearest of the oarsmen back towards the trapdoor. 'Get back below and tell the others to row – to row for their lives! The rest of you – hoist the sail!'

He ran along the side of the ship towards the stern and Attilius followed, his head lowered, his feet sinking into the heavy blanket of white pumice that covered the deck like snow. They were so low in the water he felt he could almost have stepped down on to the carpet of rock and walked ashore. He clambered up on to the poop deck and with Torquatus he seized the great oar that steered the liburnian. But even with two men swinging on it the blade wouldn't move against the floating mass.

Dimly, he could see the shape of the sail beginning to rise before them. He heard the crack as it started to fill, and at the same time there was a ripple of movement along the banks of oars. The helm shuddered slightly beneath his hands. Torquatus pushed and he heaved, his feet scrabbling for a purchase in the loose

stone, and slowly he felt the wooden shaft begin to move. For a while the liburnian seemed to list, motionless, and then a gust of wind propelled them forwards. He heard the drum beating again below, the oars settling into a steady rhythm, and from the gloom ahead the shape of the coast began to emerge – a breakwater, a sandy beach, a row of villas with torches lit along the terraces, people moving at the edge of the sea, where waves were pounding the shore, lifting the boats in the shallows and flinging them back on land. Whatever place this was, he realised with disappointment, it was not Pompeii.

Suddenly the rudder jumped and moved so freely he thought it must have snapped and Torquatus swung it hard, aiming them towards the beach. They had broken clear of the clinging pumice and were into the rolling waves, the force of the sea and the wind propelling them directly at the shore. He saw the crowd of people on the beach, all trying to load their possessions into the boats, turn to look at them in astonishment, saw them break and scatter as the liburnian bore down upon them. Torquatus cried out, 'Brace yourselves!' and an instant later the hull scraped rock and Attilius went flying down on to the main deck, his landing cushioned by the foot-thick mattress of stone.

He lay there for a moment, winded, his cheek pressed to the warm, dry pumice, as the ship rolled beneath him. He heard the shouts of the sailors coming up from below decks, and the splashes as they jumped into the surf. He raised himself and saw the sail being lowered,

the anchor flung over the side. Men with ropes were running up the beach, trying to find places to secure the ship. It was twilight – not the twilight thrown out by the eruption, which they seemed to have sailed straight through, but the natural dusk of early evening. The shower of stones was light and intermittent and the noise as they scattered over the deck and plopped into the sea was lost in the boom of the surf and the roar of the wind. Pliny had emerged from the trapdoor and was stepping carefully through the pumice, supported by Alexion – a solid and dignified figure in the midst of the panic all around him. If he felt any fear he did not show it and as Attilius approached he raised his arm almost cheerfully.

'Well, this is a piece of good fortune, engineer. Do you see where we are? I know this place well. This is Stabiae – a most pleasant town in which to spend an evening. Torquatus!' He beckoned to the captain. 'I suggest we stay here for the night.'

Torquatus regarded him with incredulity. 'We have no choice about it, admiral. No ship can be launched against this wind. The question is: how soon will it carry that wall of rock upon us?'

'Perhaps it won't,' said Pliny. He gazed across the surf at the lights of the little town, rising into the low hillside. It was separated from the beach by the coastal road that ran all around the bay. The highway was clogged with the same weary traffic of refugees that Attilius had encountered earlier at Herculaneum. On the shore itself, perhaps a hundred people had congregated with their

possessions, hoping to escape by sea, but unable to do more than gaze hopelessly at the crashing waves. One fat and elderly man stood apart, surrounded by his household, occasionally throwing up his hands in lamentation, and Attilius felt a stir of recognition. Pliny had noticed him, too. 'That's my friend, Pomponianus. The poor old fool,' he said, sadly. 'A nervous fellow at the best of times. He'll need our comfort. We must wear our bravest faces. Assist me to the shore.'

Attilius jumped down into the sea, followed by Torquatus. The water was up to their waists at one moment, at the next it was swirling around their necks. It was no easy task to take off a man of the admiral's weight and condition. With Alexion's help Pliny finally got down on to his backside and shuffled forwards and as they took his arms he slipped into the water. They managed to keep his head above the surface, and then, in an impressive show of self-control, he shrugged off their support and waded ashore unaided.

'A stubborn old fool,' said Torquatus, as they watched him march up the beach and embrace Pomponianus. 'A magnificent, courageous, stubborn old fool. He's almost killed us twice and I swear he'll try again before he's finished.'

Attilius glanced along the coast towards Vesuvius but he could not see much in the gathering darkness except for the luminous white lines of the waves running in to batter the coast, and beyond them the inky black of the falling rock. Another line of red lightning split the sky. He said, 'How far are we from Pompeii?'

'Three miles,' answered Torquatus. 'Perhaps less. It looks like they're taking the worst of it, poor wretches. This wind – the men had better seek some shelter.'

He began wading towards the shore leaving Attilius alone.

If Stabiae was three miles downwind of Pompeii, and Vesuvius lay five miles the other side of the city, then this monstrous cloud must be eight miles long. Eight miles long, and – what? – at least five miles wide, given how far it reached out into the sea. Unless Corelia had fled very early she would have had no chance of escape.

He stood there for a while, buffeted by the sea, until at length he heard the admiral calling his name. Helplessly he turned and made his way through the restless shallows, up on to the beach to join the rest.

Pomponianus had a villa on the sea-front only a short walk along the road and Pliny was suggesting they should all return to it. Attilius could hear them arguing as he approached. Pomponianus, panicky, was objecting in his high voice that if they left the beach they would lose their chance of a place in a boat. But Pliny waved that away. 'No sense in waiting here,' he said. His voice was urgent. 'Besides, you can always sail with us, when the wind and sea are more favourable. Come, Livia – take my arm.' And with Pomponianus's wife on one side and Alexion on the other, and with the household slaves strung out behind them – lugging marble busts, carpets, chests and candelabra – he led them up on to the road.

He was hurrying as fast as he could, his cheeks puffed out, and Attilius thought, he knows – he knows from his observations what is about to happen. Sure enough they had just reached the gates of the villa when it came on them again like a summer storm – first a few heavy drops, as a warning, and then the air exploded over the myrtle bushes and the cobbled courtyard. Attilius could feel someone's body pressing into his from behind, he pushed into the man in front and together they tumbled through the door and into the darkened, deserted villa. People were wailing, knocking blindly into the furniture. He heard a woman's scream and a crash. The disembodied face of a slave appeared, illuminated from below by an oil lamp, and then the face vanished and he heard the familiar *wumph* as a torch was lit. They huddled in the comfort of the light, masters and slaves alike, as the pumice clattered on to the terracotta roof of the villa and smashed into the ornamental gardens outside. Someone went off with the oil lamp to fetch more torches and some candles, and the slaves went on lighting them long after there was sufficient light, as if somehow the brighter the scene, the more safe they would be. The crowded hall soon had an almost festive feel to it, and that was when Pliny, with his arm draped round the quivering shoulders of Pomponianus, declared that he would like to eat.

The admiral had no belief in an afterlife: 'Neither body nor mind has any more sensation after death

than it had before birth.' Nevertheless, he put on a display of bravery over the next few hours which none who survived the evening would afterwards forget. He had long ago resolved that when death came for him he would endeavour to meet it in the spirit of Marcus Sergius, whom he had crowned in the *Natural History* as the most courageous man who had ever lived – wounded twenty-three times in the course of his campaigns, left crippled, twice captured by Hannibal and held in chains every day for twenty months; Sergius had ridden into his final battle with a right hand made of iron, a substitute for the one he had lost. He was not as successful as Scipio or Caesar, but what did that matter? 'All other victors truly have conquered men,' Pliny had written, 'but Sergius vanquished fortune also.'

'To vanquish fortune' – that was what a man should strive to do. Accordingly, as the slaves prepared his dinner, he told an astonished Pomponianus that he would first like to take a bath and he waddled off, escorted by Alexion, to soak in a cold tub. He removed his filthy clothes and clambered into the clear water, submerging his head completely into a silent world. Surfacing, he announced that he wished to dictate a few more observations – like the engineer, he reckoned the dimensions of the manifestation at roughly eight miles by six – then allowed himself to be patted dry by one of Pomponianus's body-slaves, anointed in saffron-oil, and dressed in one of his friend's clean togas.

Five of them sat down to dinner – Pliny, Pomponianus, Livia, Torquatus and Attilius – not an

ideal number from the point of etiquette, and the din
of the pumice on the roof made conversation difficult.
Still, at least it meant that he had a couch to himself
and space to stretch out. The table and the couches had
been carried in from the dining room and set up in the
sparkling hall. And if the food was not up to much –
the fires were out and the best the kitchens could come
up with were cold cuts of meat, fowl and fish – then
Pomponianus, at Pliny's gentle prompting, had made
up for it with the wine. He produced a Falernian, two
hundred years old, a vintage from the consulship of
Lucius Opimius. It was his final jar ('Not much point
in hanging on to it now,' he observed gloomily).

The liquid in the candlelight was the colour of rough
honey and after it was decanted but before it was mixed
with a younger wine – for it was too bitter to be drunk
undiluted – Pliny took it from the slave and inhaled it,
catching in its musty aroma the whiff of the old
Republic: of men of the stamp of Cato and Sergius; of
a city fighting to become an empire; of the dust of the
Campus Martius; of trial by iron and fire.

The admiral did most of the talking and he tried to
keep it light, avoiding all mention, for example, of
Rectina and the precious library of the Villa Calpurnia,
or the fate of the fleet, which he supposed must be
broken up by now and scattered all along the coast.
(That alone might be enough to force his suicide, he
realised: he had put to sea without waiting for impe-
rial authority; Titus might not be forgiving.) Instead he
chose to talk about the wine. He knew a lot about wine.

Julia called him 'a wine bore'. But what did he care? To bore was the privilege of age and rank. If it had not been for wine his heart would have packed in years ago.

'The records tell us that the summer in the consulship of Opimius was very much like this one. Long hot days filled with endless sunshine – "ripe", as the vintners call it.' He swirled the wine in his glass and sniffed it. 'Who knows? Perhaps, two centuries from now, men will be drinking the vintage from this year of ours, and wondering what we were like. Our skill. Our courage.' The thunder of the barrage seemed to be increasing. Somewhere wood splintered. There was a crash of breaking tiles. Pliny looked around the table at his fellow diners – at Pomponianus, who was wincing at the roof and clinging to the hand of his wife; at Livia, who managed to give him a small, tight smile (she always had been twice the man her husband was); at Torquatus, who was frowning at the floor; and finally at the engineer, who had not said a word throughout the meal. He felt warmly towards the aquarius – a man of science, after his own heart, who had sailed in search of knowledge.

'Let us drink a toast,' he suggested, 'to the genius of Roman engineering – to the Aqua Augusta, which gave us warning of what was to happen, if only we had had the wit to heed it!' He raised his glass towards Attilius. 'The Aqua Augusta!'

'The Aqua Augusta!'

They drank, with varying degrees of enthusiasm. And it was a good wine, thought the admiral, smacking his

lips. A perfect blend of the old and the young. Like himself and the engineer. And if it proved to be his last? Well then: it was an appropriate wine to end on.

When he announced that he was going to bed he could see that they assumed he must be joking. But no, he assured them, he was serious. He had trained himself to fall asleep at will – even upright, in a saddle, in a freezing German forest. This? This was nothing! 'Your arm, engineer, if you will be so kind.' He wished them all good night.

Attilius held a torch aloft in one hand and with the other he supported the admiral. Together they went out into the central courtyard. Pliny had stayed here often over the years. It was a favourite spot of his: the dappled light on the pink stone, the smell of the flowers, the cooing from the dovecote set in the wall above the veranda. But now the garden was in pitch darkness, trembling with the roar of falling stone. Pumice was strewn across the covered walkway and the clouds of dust from the dry and brittle rock set off his wheezing. He stopped outside the door of his usual room and waited for Attilius to clear a space so that he could pull it open. He wondered what had happened to the birds. Had they flown away just before the manifestation started, thus offering a portent, if an augur had been on hand to divine it? Or were they out there some-where in the black night, battered and huddled? 'Are you frightened, Marcus Attilius?'

'Yes.'

'That's good. To be brave, by definition, one has first

to be afraid.' He rested his hand on the engineer's shoulder as he kicked off his shoes. 'Nature is a merciful deity,' he said. 'Her anger never lasts forever. The fire dies. The storm blows itself out. The flood recedes. And this will end as well. You'll see. Get some rest.'

He shuffled into the windowless room leaving Attilius to close the door behind him.

The engineer stayed where he was, leaning against the wall, watching the rain of pumice. After a while he heard loud snores emanating from the bedroom. Extraordinary, he thought. Either the admiral was pretending to be asleep – which he doubted – or the old man really had nodded off. He glanced at the sky. Presumably Pliny was right, and the 'manifestation', as he still insisted on calling it, would begin to weaken. But that was not happening yet. If anything, the force of the storm was intensifying. He detected a different, harsher sound to the dropping rock, and the ground beneath his feet was trembling, as it had in Pompeii. He ventured out a cautious pace from beneath the canopy, holding his torch towards the ground, and immediately he was struck hard on his arm. He almost dropped the torch. He grabbed a lump of the freshly fallen rock. Pressing himself against the wall he examined it in the light.

It was greyer than the earlier pumice – denser, larger, as if several pieces had been welded together – and it was hitting the ground with greater force. The shower

of frothy white rock had been unpleasant and frightening but not especially painful. To be struck by a piece of this would be enough to knock a man unconscious. How long had this been going on?

He carried it into the hall and gave it to Torquatus. 'It's getting worse,' he said. 'While we've been eating, the stones have been getting heavier.' And then, to Pomponianus, 'What sort of roofs do you have here, sir? Flat or pitched?'

'Flat,' said Pomponianus. 'They form terraces. You know – for the views across the bay.'

Ah yes, thought Attilius – the famous views. Perhaps if they had spent a little less time gazing out to sea and rather more looking over their shoulders at the mountain behind them, they might have been better prepared. 'And how old is the house?'

'It's been in my family for generations,' said Pomponianus proudly. 'Why?'

'It isn't safe. With that weight of rock falling on it – and on old timber, too – sooner or later the joists will give way. We need to go outside.'

Torquatus hefted the rock in his hand. 'Outside? Into this?'

For a moment nobody spoke. Then Pomponianus started to wail that they were finished, that they should have sacrificed to Jupiter as he had suggested right at the beginning, but that nobody ever listened to him –

'Shut up,' said his wife. 'We have cushions, don't we? And pillows and sheets? We can protect ourselves from rocks.'

Torquatus said, 'Where's the admiral?'

'Asleep.'

'He's resigned himself to death, hasn't he? All that nonsense about wine! But I'm not ready to die, are you?'

'No.' Attilius was surprised by the firmness of his answer. After Sabina had died, he had gone on numbly, and if he had been told his existence was about to end, he would not have cared much one way or the other. He did not feel that way now.

'Then let's return to the beach.'

Livia was shouting to the slaves to fetch pillows and linen as Attilius hurried back into the courtyard. He could still hear Pliny's snores. He banged on the door and tried to open it but even in the short time he had been away the path had filled again with debris. He had to kneel to clear it, then dragged open the door and ran in with his torch. He shook the admiral's fleshy shoulder and the old man groaned and blinked in the light.

'Let me be.'

He tried to roll back on his side. Attilius did not argue with him. He hooked his elbow under Pliny's armpit and hauled him to his feet. Staggering under the weight he pushed the protesting admiral towards the door and they were barely across the threshold when he heard one of the ceiling beams crack behind them and part of the roof came crashing to the floor.

* * *

They put the pillows on their heads crossways, so that the ends covered their ears, and tied them in place with strips torn from the sheets, knotting them tightly under their chins. Their bulging white heads gave them the look of blind, subterranean insects. Then each collected a torch or a lamp and with one hand on the shoulder of the person in front – apart from Torquatus, who took the lead and who was wearing his helmet rather than a pillow – they set off to walk the gauntlet down to the beach.

All around them was a fury of noise – the heaving sea, the blizzard of rock, the boom of roofs giving way. Occasionally Attilius felt the muffled thump of a missile striking his skull and his ears rang as they had not done since he had been beaten by his teachers as a child. It was like being stoned by a mob – as if the deities had voted Vulcan a triumph and this painful procession, stripped of all human dignity, was how he chose to humiliate his captives. They edged forwards slowly, sinking up to their knees in the loose pumice, unable to move any faster than the admiral, whose coughing and wheezing seemed to worsen each time he stumbled forwards. He was holding on to Alexion and being held on to by Attilius; behind the engineer came Livia and, behind her, Pomponianus, with the slaves forming a line of torches at the back.

The force of the bombardment had cleared the road of refugees but down on the beach there was a light and it was towards this that Torquatus led them. A few of the citizens of Stabiae and some of the men of the

Minerva had broken up one of the useless ships and set it on fire. With ropes, the heavy sail from the liburnian and a dozen oars they had built themselves a large shelter beside the blaze. People who had been fleeing along the coast had come down from the road, begging for protection, and a crowd of several hundred was jostling for cover. They did not want to let the repulsive-looking newcomers share their makeshift tent and there was some jeering and scuffling around the entrance until Torquatus shouted that he had Admiral Pliny with him and would crucify any marine who refused to obey his orders.

Grudgingly, room was made, and Alexion and Attilius lowered Pliny to the sand just inside the entrance. He asked weakly for some water and Alexion took a gourd from a slave and held it to his lips. He swallowed a little, coughed and lay down on his side. Alexion gently untied the pillow and placed it under his head. He glanced up at Attilius. The engineer shrugged. He did not know what to say. It seemed to him unlikely that the old man could survive much more of this.

He turned away and peered into the interior of the shelter. People were wedged together, barely able to move. The weight of the pumice was causing the roof to dip and from time to time a couple of the sailors cleared it by lifting it with the ends of their oars, tipping the stones away. Children were crying. One boy sobbed for his mother. Otherwise nobody spoke or shouted. Attilius tried to work out what time it was – he assumed

it must be the middle of the night but then again it would be impossible to tell even if it was dawn – and he wondered how long they could endure. Sooner or later, hunger or thirst, or the pressure of the pumice rising on either side of their tent, would force them to abandon the beach. And then what? Slow suffocation by rock? A death more drawn-out and ingenious than anything Man had ever devised in the arena? So much for Pliny's belief that Nature was a merciful deity!

He tugged the pillow from his sweating head and it was as his face was uncovered that he heard someone croaking his name. In the crowded near-darkness he could not make out who it was at first, and even when the man thrust his way towards him he did not recognise him for he seemed to be made of stone, his face chalk-white with dust, his hair raised in spikes, like Medusa's. Only when he spoke his name – 'It's me, Lucius Popidius' – did he realise that it was one of the aediles of Pompeii.

Attilius seized his arm. 'Corelia? Is she with you?'

'My mother – she collapsed on the road.' Popidius was weeping. 'I couldn't carry her any longer. I had to leave her.'

Attilius shook him. 'Where's Corelia?'

Popidius's eyes were blank holes in the mask of his face. He looked like one of the ancestral effigies on the wall of his house. He swallowed hard.

'You coward,' said Attilius.

'I tried to bring her,' whined Popidius. 'But that madman had locked her in her room.'

'So you abandoned her?'

'What else could I do? He wanted to imprison us all!' He clutched at Attilius's tunic. 'Take me with you. That's Pliny over there, isn't it? You've got a ship? For pity's sake – I can't go on alone –'

Attilius pushed him away and stumbled towards the entrance of the tent. The bonfire had been crushed to extinction by the rain of rocks and now that it had gone out the darkness on the beach was not even the darkness of night but of a closed room. He strained his eyes towards Pompeii. Who was to say that the whole world was not in the process of being destroyed? That the very force which held the universe together – the *logos*, as the philosophers called it – was not disintegrating? He dropped to his knees and dug his hands into the sand and he knew at that moment, even as the grains squeezed through his fingers, that everything would be annihilated – himself, and Pliny, Corelia, the library at Herculaneum, the fleet, the cities around the bay, the aqueduct, Rome, Caesar, everything that had ever lived or ever been built: everything would eventually be reduced to a shoal of rock and an endlessly pounding sea. None of them would leave so much as a footprint behind them; they would not even leave a memory. He would die here on the beach with the rest and their bones would be crushed to powder.

But the mountain had not done with them yet. He heard a woman scream and raised his eyes. Faint and miraculous, far in the distance and yet growing in intensity, he saw a corona of fire in the sky.

VENUS

25 August

The final day of the eruption

Inclinatio

[00:12 hours]

'There comes a point when so much magma is being erupted so quickly that the eruption column density becomes too great for stable convection to persist. When this condition prevails, column collapse takes place, generating pyroclastic flows and surges, which are far more lethal than tephra fall.'

Volcanoes: A Planetary Perspective

The light travelled slowly downwards from right to left. A sickle of luminous cloud – that was how Pliny described it – *a sickle of luminous cloud* sweeping down the western slope of Vesuvius leaving in its wake a patchwork of fires. Some were winking, isolated pinpricks – farmhouses and villas that had been set alight. But elsewhere whole swathes of the forest were blazing. Vivid, leaping sheets of red and orange flame tore jagged holes in the darkness. The scythe moved on, implacably, for at least as long as it

would have taken to count to a hundred, flared briefly, and vanished.

'The manifestation,' dictated Pliny, 'has moved into a different phase.'

To Attilius, there was something indefinably sinister about that silent, moving crest – its mysterious appearance, its enigmatic death. Born in the ruptured summit of the mountain it must have rolled away to drown itself in the sea. He remembered the fertile vineyards, the heavy clumps of grapes, the manacled slaves. There would be no vintage this year, ripe or otherwise.

'It's hard to tell from here,' Torquatus said, 'but judging by its position, I reckon that cloud of flame may just have passed over Herculaneum.'

'And yet it doesn't seem to be on fire,' replied Attilius. 'That part of the coast looks entirely dark. It's as if the town has vanished –'

They looked towards the base of the burning mountain, searching for some point of light, but there was nothing.

The effect on the beach at Stabiae was to shift the balance of terror, first one way and then the other. They could soon smell the fires on the wind, a pungent, acrid taste of sulphur and cinders. Someone screamed that they would all be burned alive. People sobbed, none louder than Lucius Popidius, who was calling for his mother, and then someone else – it was one of the sailors who had been prodding the roof with his oar – exclaimed that the heavy linen was no longer sagging. That quietened the panic.

Attilius cautiously stretched out his arm beyond the shelter of the tent, his palm held upwards, as if checking for rain. The marine was right. The air was still full of small missiles but the storm was not as violent as before. It was as if the mountain had found a different outlet for its malevolent energy, in the rushing avalanche of fire rather than in the steady bombardment of rock. In that moment he made up his mind. Better to die doing something – better to fall beside the coastal highway and lie in some unmarked grave – than to cower beneath this flimsy shelter, filled with fearful imaginings, a spectator waiting for the end. He reached for his discarded pillow and planted it firmly on his head then felt around in the sand for the strip of sheet. Torquatus asked him quietly what he was doing.

'Leaving.'

'Leaving?' Pliny, reclining on the sand, his notes spread around him and weighed down with piles of pumice, looked up sharply. 'You'll do no such thing. I absolutely refuse you permission to go.'

'With the greatest respect, admiral, I take my orders from Rome, not from you.' He was surprised some of the slaves had not also made a run for it. Why not? Habit, he supposed. Habit, and the lack of anywhere to run to.

'But I need you here.' There was a wheedling note in Pliny's hoarse voice. 'What if something should happen to me? Someone must make sure my observations are not lost to posterity.'

'There are others who can do that, admiral. I prefer to take my chance on the road.'

'But you're a man of science, engineer. I can tell it. That's why you came. You're much more valuable to me here. Torquatus – stop him.'

The captain hesitated, then unfastened his chin-strap and took off his helmet. 'Take this,' he said. 'Metal is better protection than feathers.' Attilius started to protest but Torquatus thrust it into his hands. 'Take it – and good luck.'

'Thank you.' Attilius grasped his hand. 'May luck go with you, too.'

It fitted him well enough. He had never worn a helmet before. He stood and picked up a torch. He felt like a gladiator about to enter the arena.

'But where will you go?' protested Pliny.

Attilius stepped into the storm. The light stones pinged off the helmet. It was utterly dark apart from the few torches planted into the sand around the perimeter of the shelter and the distant, glowing pyre of Vesuvius.

'Pompeii.'

Torquatus had estimated the distance between Stabiae and Pompeii at three miles – an hour's walk along a good road on a fine day. But the mountain had changed the laws of time and space and for a long while Attilius seemed to make no progress at all.

He managed to get up off the beach and on to the

road without too much difficulty and he was lucky that
the view of Vesuvius was uninterrupted because the fires
gave him an aiming-point. He knew that as long as he
walked straight towards them he must come to Pompeii
eventually. But he was pushing into the wind, so that
even though he kept his head hunched, shrinking his
world to his pale legs and the little patch of stone in
which he waded, the rain of pumice stung his face and
clogged his mouth and nostrils with dust. With each
step he sank up to his knees in pumice and the effect
was like trying to climb a hill of gravel, or a barn full
of grain – an endless, featureless slope which rubbed
his skin and tore at the muscles at the top of his thighs.
Every few hundred paces he swayed to a stop and some-
how, holding the torch, he had to drag first one foot
and then the other out of the clinging pumice and pick
the stones out of his shoes.

The temptation to lie down and rest was over-
whelming and yet it had to be resisted, he knew, because
sometimes he stumbled into the bodies of those who
had given up already. His torch showed soft forms, mere
outlines of humanity, with occasionally a protruding
foot, or a hand clawing at the air. And it was not only
people who had died on the road. He blundered into a
team of oxen that had become stuck in the drifts and a
horse that had collapsed between the shafts of an aban-
doned wagon, its burden too heavy to pull: a stone horse
pulling a stone cart. All these things appeared as brief
apparitions in the flickering circle of light he carried.
There must have been much more that mercifully he

could not see. Sometimes the living as well as the dead emerged fleetingly out of the darkness – a man carrying a cat; a young woman, naked and deranged; another couple carrying a long brass candelabrum slung across their shoulders, the man at the front and the woman at the back. They were heading in the opposite direction to him. From either side came isolated, barely human cries and moans, such as he imagined might be heard on a battlefield after the fighting was done. He did not stop, apart from once, when he heard a child crying out for its parents. He stopped, listening, and stumbled around for a while, trying to find the source of the voice, calling out in response, but the child went quiet, perhaps out of fear at the sound of a stranger, and eventually he gave up the search.

All this lasted for several hours.

At some point the crescent of light appeared again at the summit of Vesuvius, sweeping down, following more or less the same trajectory as before. The glow was brighter and when it reached the shore, or what he guessed was the shore, it did not die at once but rolled on out to sea before tapering away into the darkness. It was followed by the same easing in the fall of rock. But this time on the slopes of the mountain it seemed to extinguish the fires rather than rekindle them. Soon afterward his torch began to stutter. Most of the pitch had burned away. He pushed on with a renewed energy born of fear because he knew that when it died he would be left helpless in the darkness. And when that moment came it was indeed terrible – more horrible than he had

feared. His legs had vanished and he could see nothing, not even if he brought his hand right up to his eyes.

The fires on the side of Vesuvius had also dwindled to an occasional tiny fountain of orange sparks. More red lightning gave a pinkish glow to the underside of the black cloud. He was no longer sure in which direction he was facing. He was disembodied, utterly alone, buried almost up to his thighs in stone, the earth whirling and thundering around him. He flung away his extinguished torch and let himself sink forwards. He stretched out his hands and lay there, feeling the mantle of pumice slowly accumulating around his shoulders, and it was peculiarly comforting, like being tucked up in bed at night as a child. He laid his cheek to the warm rock and felt himself relax. A great sense of tranquillity suffused him. If this was death then it was not too bad: he could accept this – welcome it, even, as one might a well-earned rest at the end of a hard day's work out on the arcades of the aqueducts.

In his dreams the ground was melting and he was dropping, tumbling, in a cascade of rocks, towards the centre of the earth.

He was woken by heat, and by the smell of burning. He did not know how long he had slept. Long enough to be almost entirely buried. He was in his grave. Panicking, he pushed with his forearms and slowly he felt the weight on his shoulders yield and split, heard the rustle of stones as they tumbled off him. He raised

himself and shook his head, spitting the dust from his mouth, blinking his eyes, still buried below the waist.

The rain of pumice had mostly stopped – the familiar warning-sign – and in the distance, immediately before him, low in the sky, he saw again the familiar scythe of glowing cloud. Except that this time, instead of moving like a comet from right to left, it was descending fast and spreading laterally, coming his way. Immediately behind it was an interval of darkness which sprang into fire a few moments later as the heat found fresh fuel on the southern flank of the mountain; before it, carried on the furnace-wind, came a rolling boom of noise, such that if he had been Pliny he would have varied his metaphor and described it not as a cloud but as a wave – a boiling wave of red-hot vapour that scorched his cheeks and watered his eyes. He could smell his hair singeing.

He writhed to free himself from the grip of the pumice as the sulphurous dawn raced across the sky towards him. Something dark was growing in the centre of it, rising out of the ground, and he realised that the crimson light was silhouetting a town less than half a mile away. The vision brightened. He picked out city walls and watchtowers, the pillars of a roofless temple, a row of blasted, sightless windows – and *people*, the shadows of *people,* running in panic along the lines of the ramparts. The spectacle was sharp for only a little while, just long enough for him to recognise it as Pompeii, and then the glow behind it slowly faded, taking the city with it, back into the darkness.

Diluculum

[06:00 hours]

'It is dangerous to assume that the worst is over after the initial explosive phase. Predicting an eruption's end is even more difficult than predicting its beginning.'

Encyclopaedia of Volcanoes

He pulled off his helmet and used it as a bucket, digging the lip of the metal into the pumice and emptying it over his shoulder. Gradually as he worked he became aware of the pale white shapes of his arms. He stopped and raised them in wonder. Such a trivial matter, to be able to see one's hands, and yet he could have cried with relief. The morning was coming. A new day was struggling to be born. He was still alive.

He finished digging, wrestled his legs loose and hauled himself up on to his feet. The freshly ignited crop of fires high up on Vesuvius had restored his sense

of direction. Perhaps it was his imagination but he even thought he could see the shadow of the city. Vague in the darkness, the plain of pumice spread out around him, a ghostly, gently undulating landscape. He set off towards Pompeii, wading up to his knees again, sweating, thirsty, dirty, with the acrid stench of burning in his nose and throat. He assumed, by the nearness of the city walls, that he must be almost inside the port, in which case there ought to be a river somewhere. But the pumice had submerged the Sarnus into the desert of stones. Through the dust he had a vague impression of low walls on either side of him and as he stumbled forward he realised that these weren't fences but buildings, buried buildings, and that he was labouring along a street at roof level. The pumice must be seven or eight feet deep at least.

Impossible to believe that people could have lived through such a bombardment. And yet they had. Not only had he seen them moving on the city's ramparts, he could see them now, emerging from holes in the ground, from beneath the tombs of their houses – individuals, couples supporting one another, whole families, even a mother holding a baby. They stood around in the grainy brown half-light, brushing the dust from their clothes, gazing at the sky. Apart from an occasional scattering of missiles the fall of rock had ceased. But it would come again, Attilius was certain. There was a pattern. The greater the surge of burning air down the slopes of the mountain, the more energy it seemed to suck from the storm and the longer the lull before

it started anew. There was no doubt, either, that the surges were growing in strength. The first appeared to have hit Herculaneum; the second to have travelled beyond it, out to sea; the third to have reached almost as far as Pompeii itself. The next might easily sweep across the entire town. He ploughed on.

The harbour had entirely vanished. A few masts poking out of the sea of pumice, a broken sternpost and the shrouded outline of a hull were the only clues that it had ever existed. He could hear the sea, but it sounded a long way off. The shape of the coast had altered. Occasionally, the ground shook and then would come the distant crash of walls and timbers giving way, roofs collapsing. A ball of lightning fizzed across the landscape and struck the distant columns of the temple of Venus. A fire started. It became harder to make progress. He sensed that he was wading up a slope and he tried to visualise how the port had looked, the ramped roads leading up from the wharves and quay-sides to the city gates. Torches loomed out of the smoky air and passed him. He had expected to encounter crowds of survivors seizing the opportunity to escape from the town but the traffic was all the other way. People were going back into Pompeii. Why? To search for those they had lost, he supposed. To see what they could retrieve from their homes. To loot. He wanted to tell them to run for it while they had the chance but he hadn't the breath. A man pushed him out of the way and overtook him, jerking from side to side like a marionette as he scrambled through the drifts.

Attilius reached the top of the ramp. He groped through the dusty twilight until he found a corner of heavy masonry and felt his way around it, into the low tunnel which was all that remained of the great entrance to the town. He could have reached up and touched the vaulted roof. Someone lumbered up to him from behind and seized his arm. 'Have you seen my wife?'

He was holding a small oil lamp, with his hand cupped around the flame – a young man, handsome, and incongruously immaculate, as if he had been out for a stroll before breakfast. Attilius saw that the fingers encircling the lamp were manicured.

'I'm sorry –'

'Julia Felix? You must know her. Everyone knows her.' His voice was trembling. He called out, 'Has anyone here seen Julia Felix?'

There was a stir of movement and Attilius realised there were a dozen or more people, crammed together, sheltering in the passageway of the gate.

'She's not been this way,' someone muttered.

The young man groaned and staggered towards the town. 'Julia! Julia!' His voice grew fainter as his wavering lamp disappeared into the darkness. 'Julia!'

Attilius said loudly, 'Which gate is this?'

He was answered by the same man. 'The Stabian.'

'So this is the road which leads up to the Gate of Vesuvius?'

'Don't tell him!' hissed a voice. 'He's just a stranger, come to rob us!'

Other men with torches were forcing their way up the ramp.

'Thieves!' shrieked a woman. 'Our properties are all unguarded! Thieves!'

A punch was thrown, someone swore and suddenly the narrow entrance was a tangle of shadows and waving torches. The engineer kept his hand on the wall and stumbled forward, treading on bodies. A man cursed and fingers closed around his ankle. Attilius jerked his leg free. He reached the end of the gate and glanced behind him just in time to see a torch jammed into a woman's face and her hair catch fire. Her screams pursued him as he turned and tried to run, desperate to escape the brawl, which now seemed to be sucking in people from the side alleys, men and women emerging from the darkness, shadows out of shadows, slipping and sliding down the slope to join the fight.

Madness: an entire town driven mad.

He waded on up the hill trying to find his bearings. He was sure this was the way to the Vesuvius Gate – he could see the orange fringes of fire working their way across the mountain far ahead – which meant he could not be far from the House of the Popidii, it should be on this very street. Off to his left was a big building, its roof gone, a fire burning somewhere inside it, lighting behind the windows the giant, bearded face of the god Bacchus – a theatre, was it? To his right were the stumpy shapes of houses, like a row of ground-down teeth, only a few feet of wall left visible. He swayed towards them. Torches were moving. A few fires had

been lit. People were digging frantically, some with planks of wood, a few with their bare hands. Others were calling out names, dragging out boxes, carpets, pieces of broken furniture. An old woman screaming hysterically. Two men fighting over something – he could not see what – another trying to run with a marble bust cradled in his arms.

He saw a team of horses, frozen in mid-gallop, swooping out of the gloom above his head, and he stared at them stupidly for a moment until he realised it was the equestrian monument at the big crossroads. He went back down the hill again, past what he remembered was a bakery and at last, very faintly on a wall, at knee-height, he found an inscription: 'HIS NEIGHBOURS URGE THE ELECTION OF LUCIUS POPIDUS SECUNDUS AS AEDILE. HE WILL PROVE WORTHY.'

He managed to squeeze through a window on one of the side streets and picked his way among the rubble, calling her name. There was no sign of life.

It was still possible to work out the arrangement of the two houses by the walls of the upper stories. The roof of the atrium had collapsed, but the flat space next to it must have been where the swimming pool was and over there must have been a second courtyard. He poked his head into some of the rooms of what had once been the upper floor. Dimly he could make out broken pieces of furniture, smashed crockery, scraps of hanging drapery. Even where the roofs had been sloping they

had given way under the onslaught of stone. Drifts of pumice were mixed with terracotta tiles, bricks, splintered beams. He found an empty bird cage on what must have been a balcony and stepped through into an abandoned bedroom, open to the sky. Obviously it had been a young woman's room: abandoned jewellery, a comb, a broken mirror. In the filthy half-light, a doll, partly buried in the remains of the roof, looked grotesquely like a dead child. He lifted what he thought was a blanket from the bed and saw that it was a cloak. He tried the door – locked – then sat on the bed and examined the cloak more closely.

He had never had much of an eye for what women wore. Sabina used to say that she could have dressed in rags and he would never have noticed. But this, he was sure, was Corelia's. Popidius had said she had been locked in her room and this was a woman's bedroom. There was no sign of a body, either here or outside. For the first time he dared to hope she had escaped. But when? And to where?

He turned the cloak over in his hands and tried to think what Ampliatus would have done. *'He wanted to imprison us all'* – Popidius's phrase. Presumably he had blocked all the exits and ordered everyone to sit it out. But there must have come a moment, towards evening, as the roofs began to collapse, when even Ampliatus would have recognised that the old house was a deathtrap. He was not the type to wait around and die without a fight. He would not have fled the city, though: that would not have been in character, and besides, by then

it would have been impossible to travel very far. No: he would have tried to lead his family to a safe location.

Attilius raised Corelia's cloak to his face and inhaled her scent. Perhaps she would have tried to get away from her father. She hated him enough. But he would never have let her go. He imagined they must have organised a procession, very like the one from Pomponianus's villa at Stabiae. Pillows or blankets tied around their heads. Torches to provide a little light. Out into the hail of rock. And then – where? Where was safe? He tried to think as an engineer. What kind of roof was strong enough to withstand the stresses imposed by eight feet of pumice? Nothing flat, that was for sure. Something built with modern methods. A dome would be ideal. But where was there a modern dome in Pompeii?

He dropped the cloak and stumbled back on to the balcony.

Hundreds of people were out in the streets now, milling around at roof-level in the semi-darkness, like ants whose nest had been kicked to pieces. Some were aimless – lost, bewildered, demented with grief. He saw a man calmly removing his clothes and folding them as if preparing for a swim. Others appeared purposeful, pursuing their own private schemes of search or escape. Thieves – or perhaps they were the rightful owners: who could tell any more? – darted into the alleyways with whatever they could carry. Worst of

all were the names called plaintively in the darkness. Had anyone seen Felicio or Pherusa, or Verus, or Appuleia – the wife of Narcissus? – or Specula or the lawyer Terentius Neo? Parents had become separated from their children. Children stood screaming outside the ruins of houses. Torches flared towards Attilius in the hope that he might be someone else – a father, a husband, a brother. He waved them away, shrugging off their questions, intent on counting off the city blocks as he passed them, climbing the hill north towards the Vesuvius Gate – one, two, three: each seemed to take an age to come to an end and all he could hope was that his memory had not let him down.

At least a hundred fires were burning on the south side of the mountain, spread out in a complex constellation, hanging low in the sky. Attilius had learned to distinguish between Vesuvius's flames. These ones were safe: the after-effects of a trauma that had passed. It was the prospect of another incandescent cloud appearing above them on the crest of the mountain that filled him with dread and made him push his aching legs beyond the point of exhaustion as he waded through the shattered city.

At the corner of the fourth block he found the row of shops, three-quarters buried, and scrambled up the slope of pumice on to the low roof. He crouched just behind the ridge. Its outline was sharp. There must be fires beyond it. Slowly he raised his head. Across the flat surface of the buried builder's yard were the nine high windows of Ampliatus's baths, each one brilliantly

– defiantly – lit by torches and by scores of oil-lamps. He could see some of the painted gods on the far walls and the figures of men moving in front of them. All that was lacking was music: then it would have looked as though a party were in progress.

Attilius slithered down into the enclosed space and set off across it. Such was the intensity of the illumination he cast a shadow. As he came closer he saw that the figures were slaves and that they were clearing the drifts of pumice where they had been blown into the three big chambers – the changing room, the tepidarium and the caldarium – digging it out like snow with wooden shovels where it was deepest, or elsewhere merely sweeping it away with brooms. Patrolling behind them was Ampliatus, shouting that they should work harder, occasionally grabbing a shovel or a brush himself and showing how it should be done, before resuming his obsessive pacing. Attilius stood watching for a few moments, hidden in the darkness, and then cautiously began to climb towards the middle room – the tepidarium – at the back of which he could see the entrance to the domed sweating-chamber.

There was no chance he could enter without being seen so in the end he simply walked in – waded across the surface of the pumice, straight through the open window, his feet crunching on the tiled floor, the slaves staring at him in amazement. He was halfway to the sweating room when Ampliatus saw him – 'Aquarius!' – and hurried to intercept him. He was smiling, his palms spread wide. 'Aquarius! I've been expecting you!'

He had a cut in his temple and the hair on the left side of his scalp was stiff with blood. His cheeks were scratched and more blood had seeped through the coating of dust, carving red furrows in the white. The mouth was turned up at the corners: a mask of comedy. The dazzling light was reflected in his eyes, which were open very wide. Before Attilius could say anything he started talking again. 'We must get the aqueduct running immediately. Everything is ready, you see. Nothing is damaged. We could open for business tomorrow, if only we could connect the water.' He was talking very quickly, the words tumbling out of him, barely finishing one sentence before he went on to the next. So much in his head to express! He could see it all! 'People will need one place in the town that works. They'll need to bathe – it'll be dirty work, getting everything back in order. But it's not just that. It'll be a symbol to gather round. If they see the baths are working, it will give them confidence. Confidence is the key to everything. The key to confidence is water. Water is everything, d'you see? I need you, aquarius. Fifty-fifty. What do you say?'

'Where's Corelia?'

'Corelia?' Ampliatus's eyes were still alert for a potential deal. 'You want Corelia? In exchange for the water?'

'Perhaps.'

'A marriage? I'm willing to consider it.' He jerked his thumb. 'She's in there. But I'll want my lawyers to draw up terms.'

Attilius turned away and strode through the narrow entrance into the laconium. Seated on the stone benches

around the small domed sweating room, lit by the torches in their iron holders on the wall, were Corelia, her mother and her brother. Opposite them were the steward, Scutarius, and the giant gatekeeper, Massavo. A second exit led to the caldarium. As the engineer came in, Corelia looked up.

'We need to leave,' he said. 'Hurry. Everyone.'

Ampliatus, at his back, blocked the door. 'Oh no,' he said. 'Nobody leaves. We've endured the worst. This isn't the time to run. Remember the prophecy of the sibyl.'

Attilius ignored him, directing his words to Corelia. She seemed paralysed with shock. 'Listen. The falling rock is not the main danger. It's when the fall stops that winds of fire travel down the mountain. I've seen them. Everything in their path is destroyed.'

'No, no. We're safer here than anywhere,' insisted Ampliatus. 'Believe me. The walls are three feet thick.'

'Safe from heat in a sweating room?' Attilius appealed to them all. 'Don't listen to him. If the hot cloud comes, this place will cook you like an oven. Corelia.' He held out his hand to her. She glanced quickly towards Massavo. They were under guard, Attilius realised: the laconium was their prison cell.

'Nobody is leaving,' repeated Ampliatus. 'Massavo!'

Attilius seized Corelia's wrist and tried to drag her towards the caldarium before Massavo had time to stop him, but the big man was too fast. He sprang to cover the exit and when Attilius attempted to shoulder him aside Massavo grabbed him by the throat with his fore-arm and dragged him back into the room. Attilius let

go of Corelia and struggled to prise away the grip from his windpipe. Normally he could look after himself in a fight but not against an opponent of this size, not when his body was exhausted. He heard Ampliatus order Massavo to break his neck – 'Break it like the chicken he is!' – and then there was a whoosh of flame close to his ear and a scream of pain from Massavo. The arm released him. He saw Corelia with a torch clenched in both hands and Massavo on his knees. Ampliatus called her name, and there was something almost pleading in the way he said it, stretching out his hands to her. She whirled round, the fire streaking, and hurled the torch at her father, and then she was through the door and into the caldarium, shouting to Attilius to follow.

He blundered after her, down the tunnel and into the brightness of the hot room, across the immaculately cleaned floor, past the slaves, out through the window, into the darkness, sinking into the stones. When they were halfway across the yard he looked back and he thought perhaps that her father had given up – he could see no signs of pursuit at first – but of course, in his madness, Ampliatus had not: he never would. The unmistakable bulk of Massavo appeared in the window with his master beside him and the light of the window quickly fragmented as torches were passed out to the slaves. A dozen men armed with brooms and shovels jumped out of the caldarium and began fanning out across the ground.

It seemed to take an age of slipping and sliding to clamber back up on to the perimeter roof and drop

down into the street. For an instant they must have been dimly visible on the roof – long enough, at least, for one of the slaves to see them and shout a warning. Attilius felt a sharp pain in his ankle as he landed. He took Corelia's arm and limped a little way further up the hill and then they both drew back into the shadow of the wall as the torches of Ampliatus's men appeared in the road behind them. Their line of escape to the Stabian Gate was cut off.

He thought then that it was hopeless. They were trapped between two sets of fire – the flames of the torches and the flames on Vesuvius – and even as he looked wildly from one to the other he detected a faint gleam beginning to form in the same place high up on the mountain as before, where the surges had been born. An idea came to him in his desperation – absurd: he dismissed it – but it would not go away, and suddenly he wondered if it had not been in the back of his mind all along. What had he done, after all, except head towards Vesuvius while everyone else had either stayed put or run away – first along the coastal road from Stabiae to Pompeii, and then up the hill from the south of the city towards the north? Perhaps it had been waiting for him from the start: his destiny.

He peered towards the mountain. No doubt about it. The worm of light was growing. He whispered to Corelia, 'Can you run?'

'Yes.'

'Then run as you've never run before.'

They edged out from the cover of the wall.

Ampliatus's men had their backs to them and were staring into the murk towards the Stabian Gate. He heard Ampliatus issuing more orders – 'You two take the side-street, you three down the hill' – and then there was nothing for it but to start thrashing their way through the pumice again. He had to grind his teeth against the agony in his leg and she was quicker than he was, as she had been when she had darted up the hill in Misenum, her skirts all gathered in one hand around her thighs, her long pale legs flashing in the dark. He stumbled after her, aware of fresh shouting from Ampliatus – 'There they go! Follow me!' – but when they reached the end of the block and he risked a glance over his shoulder he could only see one torch swaying after them. 'Cowards!' Ampliatus was shrieking. 'What are you afraid of?'

But it was obvious what had made them mutiny. The wave of fire was unmistakably sweeping down Vesuvius, growing by the instant, not in height but in breadth – roiling, gaseous, hotter than flame: white hot – only a madman would run towards it. Even Massavo would not follow his master now. People were abandoning their futile attempts to dig out their belongings and staggering down the hillside to escape it. Attilius felt the heat on his face. The scorching wind raised whirls of ash and debris. Corelia looked back at him but he urged her forward – against all instinct, against all sense, towards the mountain. They had passed another city block. There was only one to go. Ahead the glowing sky outlined the Vesuvius Gate.

'Wait!' Ampliatus shouted. 'Corelia!' But his voice was fainter, he was falling behind.

Attilius reached the corner of the castellum aquae with his head lowered into the stinging wind, half-blinded by the dust, and pulled Corelia after him, down the narrow alley. Pumice had almost completely buried the door. Only a narrow triangle of wood was showing. He kicked it, hard, and at the third attempt, the lock gave way and pumice poured through the opening. He pushed her in and slid down after her into the pitch darkness. He could hear the water, groped towards it, felt the edge of the tank and clambered over it, up to his waist in water, pulled her after him, and fumbled around the edges of the mesh screen for the fastenings, found them, lifted away the grille. He steered Corelia into the mouth of the tunnel and squeezed in after her.

'Move. As far up as you can go.'

A roaring, like an avalanche. She could not have heard him. He could not hear himself. But she scrambled forward instinctively. He followed, putting his hands on her waist and squeezing hard, pressing her down to her knees, so that as much of her body should be immersed as possible. He threw himself upon her. They clung to one another in the water. And then there was only scalding heat and the stench of sulphur in the darkness of the aqueduct, directly beneath the city walls.

Hora altera

[07:57 hours]

*'The human body cannot survive being in temper-
atures over 200 degrees centigrade for more than a
few moments, especially in the fast moving current
of a surge. Trying to breathe in the dense cloud of
hot ash in the absence of oxygen would lead to
unconsciousness in a few breaths, as well as causing
severe burns to the respiratory tract . . . On the
other hand, survival is possible in the more distal
parts of a surge if there is adequate shelter to
protect against the surge flow and its high temper-
ature, as well as the missiles (rocks, building mate-
rials) entrained in the moving cloud of material.'*

Encylopaedia of Volcanoes

A n incandescent sandstorm raced down the hill
towards Ampliatus. Exposed walls sheared, roofs
exploded, tiles and bricks, beams and stones
and bodies flew at him and yet so slowly, as it seemed

389

to him in that long moment before his death, that he could see them turning against the brilliance. And then the blast hit him, burst his ear drums, ignited his hair, blew his clothes and shoes off, and whirled him upside down, slamming him against the side of a building.

He died in the instant it took the surge to reach the baths and shoot through the open windows, choking his wife who, obeying orders to the last, had remained in her place in the sweating room. It caught his son, who had broken free and was trying to reach the Temple of Isis. It lifted him off his feet, and then it overwhelmed the steward and the porter, Massavo, who were running down the street towards the Stabian Gate. It passed over the brothel, where the owner, Africanus, had returned to retrieve his takings, and where Zmyrina was hiding under Exomnius's bed. It killed Brebix, who had gone to the gladiators' school at the start of the eruption to be with his former comrades, and Musa and Corvinus, who had decided to stay with him, trusting to his local knowledge for protection. It even killed the faithful Polites, who had been sheltering in the harbour and who went back into the town to see if he could help Corelia. It killed more than two thousand in less than half a minute and it left their bodies arranged in a series of grotesque tableaux for posterity to gawp at.

For although their hair and clothes burned briefly, these fires were quickly snuffed out by the lack of oxygen, and instead a muffling, six-foot tide of fine ash, travelling in the wake of the surge, flowed over the city, shrouding the landscape and moulding every detail of

its fallen victims. This ash hardened. More pumice fell. In their snug cavities the bodies rotted, and with them, as the centuries passed, the memory that there had even been a city on this spot. Pompeii became a town of perfectly shaped hollow citizens – huddled together or lonely, their clothes blown off or lifted over their heads, grasping hopelessly for their favourite possessions or clutching nothing – vacuums suspended in mid-air at the level of their roofs.

At Stabiae, the wind from the surge caught the makeshift shelter of the *Minerva*'s sail and lifted it clear of the beach. The people, exposed, could see the glowing cloud rolling over Pompeii and heading straight towards them.

Everyone ran, Pomponianus and Popidius in the lead.

They would have taken Pliny with them. Torquatus and Alexion had him by the arms and had raised him to his feet. But the admiral was finished with moving and when he told them, brusquely, to leave him and to save themselves, they knew he meant it. Alexion gathered up his notes and repeated his promise to deliver them to the old man's nephew. Torquatus saluted. And then Pliny was alone.

He had done all he could. He had timed the manifestation in all its stages. He had described its phases – column, cloud, storm, fire – and had exhausted his vocabulary in the process. He had lived a long life, had seen many things and now Nature had granted him this

last insight into Her power. In these closing moments of his existence he continued to observe as keenly as he had when young – and what greater blessing could a man ask for than that?

The line of light was very bright and yet filled with flickering shadows. What did they mean? He was still curious.

Men mistook measurement for understanding. And they always had to put themselves at the centre of everything. That was their greatest conceit. The earth is becoming warmer – it must be our fault! The mountain is destroying us – we have not propitiated the gods! It rains too much, it rains too little – a comfort to think that these things are somehow connected to our behaviour, that if only we lived a little better, a little more frugally, our virtue would be rewarded. But here was Nature, sweeping toward him – unknowable, all-conquering, indifferent – and he saw in Her fires the futility of human pretensions.

It was hard to breathe, or even to stand in the wind. The air was full of ash and grit and a terrible brilliance. He was choking, the pain across his chest was an iron band. He staggered backward.

Face it, don't give in.

Face it, like a Roman.

The tide engulfed him.

F or the rest of the day, the eruption continued, with fresh surges and loud explosions that rocked the

ground. Towards the evening its force subsided and it started to rain. The water put out the fires and washed the ash from the air and drenched the drifting grey landscape of low dunes and hollows that had obliterated the fertile Pompeiian plain and the beautiful coast from Herculaneum to Stabiae. It filled the wells and replenished the springs and created the lines of new streams, meandering down towards the sea. The River Sarnus took a different course entirely.

As the air cleared, Vesuvius reappeared, but its shape was completely altered. It no longer rose to a peak but to a hollow, as if a giant bite had been taken from its summit. A huge moon, reddened by dust, rose over an altered world.

Pliny's body was recovered from the beach – 'he looked more asleep than dead', according to his nephew – and carried back to Misenum, along with his observations. These subsequently proved so accurate that a new word entered the language of science: 'Plinian', to describe 'a volcanic eruption in which a narrow blast of gas is ejected with great violence from a central vent to a height of several miles before it expands sideways'.

The Aqua Augusta continued to flow, as she would for centuries to come.

People who had fled from their homes on the eastern edges of the mountain began to make a cautious return before nightfall and many were the stories and rumours that circulated in the days that followed. A woman was said to have given birth to a baby made entirely of stone, and it was also observed that rocks

had come to life and assumed human form. A plantation of trees that had been on one side of the road to Nola crossed to the other and bore a crop of mysterious green fruit which was said to cure every affliction, from worms to baldness.

Miraculous, too, were the tales of survival. A blind slave was said to have found his way out of Pompeii and to have buried himself inside the belly of a dead horse on the highway to Stabiae, in that way escaping the heat and the rocks. Two beautiful, blond children – twins – were found wandering, unharmed, in robes of gold, without a graze on their bodies, and yet unable to speak: they were sent to Rome and taken into the household of the Emperor.

Most persistent of all was the legend of a man and a woman who had emerged out of the earth itself at dusk on the day the eruption ended. They had tunnelled underground like moles, it was said, for several miles, all the way from Pompeii, and had come up where the ground was clear, drenched in the life-giving waters of a subterranean river, which had given them its sacred protection. They were reported to have been seen walking together in the direction of the coast, even as the sun fell over the shattered outline of Vesuvius and the familiar evening breeze from Capri stirred the rolling dunes of ash.

But this particular story was generally considered far-fetched and was dismissed as a superstition by all sensible people.

Acknowledgements

'I have prefaced these volumes with the names of my authorities. I have done so because it is, in my opinion, a pleasant thing and one that shows an honourable modesty, to own up to those who were the means of one's achievements . . .'

Pliny, Natural History, *Preface.*

I'm afraid I cannot claim, as Pliny did, to have consulted 2,000 volumes in the course of my researches. Nevertheless, this novel could not have been written without the scholarship of many others and, like Pliny, I believe it would be 'a pleasant thing' – for me, at least, if not necessarily for them – to list some of my sources.

In addition to those works on volcanology cited in the text, I would like to acknowledge my debt to Jean-Pierre Adam *(Roman Building)*, Carlin A. Barton *(Roman Honor)*, Mary Beagon *(Roman Nature)*, Marcel

Brion *(Pompeii and Herculaneum)*, Lionel Casson *(The Ancient Mariners)*, John D'Arms *(Romans on the Bay of Naples)*, Joseph Jay Deiss *(Herculaneum)*, George Hauck *(The Aqueduct of Nemausus)*, John F. Healy *(Pliny the Elder on Science and Technology)*, James Higginbotham *(Piscinae)*, A. Trevor Hodge *(Roman Aqueducts & Water Supply)*, Wilhelmina Feemster Jashemski *(The Gardens of Pompeii)*, Willem Jongman *(The Economy and Society of Pompeii)*, Ray Laurence *(Roman Pompeii)*, Amedeo Maiuri *(Pompeii)*, August Mau *(Pompeii: Its Life and Art)*, David Moore *(The Roman Pantheon)*, Salvatore Nappo *(Pompeii: Guide to the Lost City)*, L. Richardson, Jr *(Pompeii: An Architectural History)*, Chester G. Starr *(The Roman Imperial Navy)*, Antonio Varone *(Pompei, i misteri di una città sepolta)*, Andrew Wallace-Hadrill *(Houses and Society in Pompeii and Herculaneum)* and Paul Zanker *(Pompeii: Public and Private Life)*.

The translations of Pliny, Seneca and Strabo are mostly drawn from the editions of their work published by the Loeb Classical Library. I made much use of the edition of Vitruvius's *Ten Books on Architecture* edited by Ingrid D. Rowland and Thomas Noble Howe. The *Barrington Atlas of the Greek and Roman World*, edited by Richard J. A. Talbert, helped bring Campania to life. The volcanological analysis of the eruption by Haraldur Sigurdsson, Stanford Cashdollar and Stephen R. J. Sparks in *The American Journal of Archaeology* (86: 39–51) was invaluable.

I had the great pleasure of discussing the Romans on the Bay of Naples with John D'Arms, over dinner with

his family in a suitably sweltering English garden, just before his death; I shall always remember his kindness and encouragement. Professor A. Trevor Hodge, whose pioneering work on the Roman aqueducts was crucial in visualising the Aqua Augusta, helpfully answered my inquiries. Professor Jasper Griffin's support enabled me to use the library of the Ashmolean Museum in Oxford. Dr Mary Beard, Fellow of Newnham College, Cambridge, read the manuscript before publication, and made many invaluable suggestions.

To all these scholars, I offer my thanks, and also the protection offered by that familiar rubric: the errors, misinterpretations and sheer liberties with the facts contained in the text are solely the responsibility of the author.

Robert Harris,
Kintbury, June 2003

**Order further Robert Harris titles
from your local bookshop, or have them delivered
direct to your door by Bookpost**

arrow books